"They Thought it was a Marvel"

"They Thought it was a Marvel"

Arthur Melbourne-Cooper

(1874-1961)

Pioneer of Puppet Animation

by Tjitte de Vries and Ati Mul

Rotterdam, December 2009

Amsterdam University Press

Portrait on the title page by illustrator Theo Gootjes, Schiedam.

Hardnekkig en onuitroeibaar is onze behoefte aan
heiligdommen waar wonderen mogelijk zijn
en waar alles klopt volgens een eigen orde.
Mariëtte Haveman, *De Smederij van Vulcanus.*
(In: *Ateliergeheimen, over de werkplaats van
de Nederlandse kunstenaar vanaf 1200 tot heden.*)[N1]

*Stubborn and ineradicable is our want of
sanctuaries where miracles are possible and
where everything fits in according to its own order.
Mariëtte Haveman in* The Forge of Vulcanus.
(In: Studio secrets – on the workshops of the
Dutch artists from 1200 to the present day.)

*We dedicate this book to the memory of
Arthur Melbourne-Cooper's daughter*
Ursula Constance Messenger
(20 October 1910 – 20 March 2008)

The publication of this book is made possible by grants from the Arthur Melbourne Cooper Fund.

Omslagontwerp: Magenta, Bussum
Lay-out: Paul Boyer, Amsterdam

NUR 674
e-ISBN 9789048507825
ISBN 978 90 8555 016 7

Contents

Preface

Arthur Melbourne-Cooper's Shadow of Doubt

By Donald Crafton

A 75-foot film lasting a little more than a minute on the screen is an unlikely source of controversy in the history of early cinema. Equally unlikely, given the nearly complete lack of camera negatives in the incunabula of cinema, the original footage of MATCHES APPEAL remained in the possession of the film maker, Arthur Melbourne-Cooper, for more than a half-century. The controversy centres on the claim by him, his family and his partisans that the short film acted out by animated matchsticks was made and shown in 1899. The date would monumentalize it as the first animated film to be exhibited in public. It precedes the known releases of other first-generation animations by J. Stuart Blackton, Walter R. Booth, Edwin S. Porter and Segundo de Chomón. It is years ahead of the first films of Emile Cohl and Winsor McCay. And as for Walt Disney, he was yet to be born.

The controversy has ramifications beyond the local interests of early cinema and animation specialists. It raises central questions about the admissibility of different types of historical evidence and the credibility of expert testimony. It's an object lesson about how film archives and historians reinforce canons, and how difficult it is to view the situation from outside those set frameworks. Tjitte de Vries and Ati Mul have made an inestimable contribution to film history with their persevering quest to determine the contributions of this misunderstood and all-but-forgotten pioneer. As is the case with so many questions of early cinema, the answers are qualified and may ultimately elude us.

André Bazin was not referring to Melbourne-Cooper when he wrote of the "fanatics, the madmen" of early cinema who were "obsessed with their own imaginings",[N2] but he might have included this cineaste in that

company had he known of him. But then, few people knew – or know – of Arthur Melbourne-Cooper. That will change.

He was born in St. Albans, near London, in 1874 (the same year as Arnold Schoenberg, Herbert Hoover, Fred Niblo, Mario Caserini, Raoul Barré and Cecil Hepworth) and worked for Birt Acres, the photographer, manufacturer and early film entrepreneur. In 1896, Melbourne-Cooper became an independent producer and immediately began directing films typical of the time: advertising, comedies, newsreels, dramas.[1] These were sold outright to exhibitors and resellers, such as R.W. Paul. By 1915, when he dissolved his film business, he had produced over 300 short films. This output in its own right ought to have attracted the scrutiny of film scholars and historians. Of these, at least 36, according to De Vries and Mul, contained animation in all or part. This places Melbourne-Cooper squarely among the pioneers of this specialized film form.

In a world obsessed with "firsts", MATCHES APPEAL might have headed the chronology of films using stop-motion cinematography to synthesize screen motion for exhibition to an audience, in other words, the first animated film. However, history is messy. The self-effacing personality of the film maker and the eagerness of his daughter to revive his legacy were factors, ironically, in keeping Melbourne-Cooper in the shadows of history. Furthermore, owing to hesitation on the part of a film curator, who was possibly misinformed, and a confusing piece of printed evidence, which may be coincidental, the dates of the completion and exhibition of Melbourne-Cooper's animated film have been in dispute for more than 50 years.

De Vries and Mul tell their side of the story compellingly, so we won't steal their thunder here. But what of the objections? I'll only comment on the three most substantive ones.

First, a curator at the Kodak Museum in Harrow, after examining a modern print of Melbourne-Cooper's film donated by his daughter, noted that the "dating marks on your Father's negative film (manufactured

1. Among the several disputes surrounding Melbourne-Cooper is his relationship to Acres and to George Albert Smith. Questions of dating and the validity of evidence, considered as practical and theoretical matters, may be found in these crucial essays by Gray and Bottomore. Although neither addresses MATCHES APPEAL directly, they focus on the central cause of the controversy, the paucity of physical evidence to document Melbourne-Cooper's early career: Frank Gray, 'Smith versus Melbourne-Cooper: History and Counter-History,' *Film History*, Vol. 11, No. 3 (1999), pages 246-261; Stephen Bottomore, 'Smith versus Melbourne-Cooper: An End to the Dispute,' *Film History*, Vol. 14, No. 1 (2002), pages 57-73.

by Kodak) also point at a 1915-18 date". This remark presumably referred to the edge codes that manufacturers printed on their processed film stock.

The second bit of evidence that has impinged profoundly on the history of MATCHES APPEAL relates to the idiosyncratic content of the film. An animated matchstick writes out on a blackboard a message urging the audience to donate "one guinea" to the manufacturer to subsidize shipments of matches to battalions of soldiers. In 1899, these soldiers would have been serving in the Anglo-Boer War in South Africa. The curator, exercising due diligence, sought external corroboration for the film's exhibition. His search could find no traces of an appeal for matches in 1899. He did, however, uncover a notice in the *Times* (London) from January 1915, during World War I, that announced a campaign by the same matches manufacturer offering to accept contributions. Although no film is mentioned, the wording of the appeal was somewhat similar to that in the animation.

A third consideration was that the animation technique, which convincingly creates the illusion of motion without too much jerkiness or flashed frames, was considered too advanced for its day. From these observations, the curator concluded that the film had been made as part of the Great War effort. He intransigently refused to accept the possibility that it was connected with a Boer War matches campaign.

The historiographic issues raised here are complicated but not atypical when reconstructing events without clear, undisputed evidence. In writing this preface, I feel a certain kinship with the noted palaeontologist, Stephen Jay Gould, who in 1980 wrote a short essay in which he evaluated the just-published "unbelievable" theory that an asteroid colliding with the Earth had led to the rapid extinction of Cretaceous plants and animals, notably the dinosaurs.[N3] Gould noted the traditional resistance to theories of radical change in his profession. "Thus many geologists, including myself," he wrote, "have long found themselves in the uncomfortable position of viewing extra-terrestrial catastrophes as inherently plausible but rooting strongly against them" (page 322). The position of De Vries and Mul is akin to the pre-1980 advocates of an asteroid collision: they have a many-faceted plausible theory, but without the hard evidence required to convince some scholars in the early-cinema community, the case for Melbourne-Cooper is meeting resistance. What are the chief issues?

First, as to the opinion of the Kodak Museum curator: the primary piece of evidence, the film itself, no longer exists. The daughter did not want the

footage to go to a film archive, having lost her faith in them following Kodak's summary rejection of her father's claim. She also thought that the duplicates on hand were adequate for study. After having been copied in 1956, the nitrate negative seems to have decomposed rapidly and completely. De Vries, who deemed it beyond any further usefulness and a safety hazard, later destroyed the residue. Although he may have been right, the decision was unfortunate. It might have been, or might be possible now or in the future (using some yet-to-be-invented forensic techniques), to glean interesting chemical or physical information from the nitrate remains.

I would add that the curator's statement concerning the edge codes is strange indeed. Kodak did not begin printing edge code dates on its raw stock until 1916 (1917 for film manufactured in the UK). Therefore, if the codes observed were on the *original*, and had been copied onto the print under examination, then the film was produced no earlier than 1916 or 1917. Not only would this definitely exclude the early date, but also it introduces the uncertainty of why the match company would sponsor a film two years or more after it had launched its "appeal". It might even exclude Melbourne-Cooper as the animator, since he definitely was not making films at that time. (The attribution to him has never been questioned.)

There is also the disturbing possibility that the curator misinterpreted the date of the stock of the dupe negative, made in 1956, as that of the original nitrate. This could happen because the edge codes for 1916 and 1956 (a full circle) are identical.[2] Is it even thinkable, though, that the curator could assume that the safety footage was Melbourne-Cooper's nitrate original? While it seems unbelievable that a trained archivist could be so naïve, mistakes do happen. In his defence, had he been given access to the original negative, which then still existed in good condition, such a blunder (if that's what it was) would not have occurred. Then, why not ask to look at the original? Clearly, a detailed photographic analysis of the best available copy is in order. It might confirm, for example, a recent examination of the 1956 contact print that detected shadows of the original

2. SabuCat Productions, Inc., 'Date Code Charts', http://www.sabucat.com/?pg=date codechart, accessed 29 June 2009. See also Paolo Cherchi Usai, 'Eastman Kodak Edge Codes, 1913-1928,' *Burning Passions: An Introduction to the Study of Silent Cinema* (London: BFI, 1994), pages 106-107. Between 1913 and 1916, Kodak film stock had variants of 'Eastman' printed on the edge. There is another speculative possibility: that Melbourne-Cooper had the original film copied onto Kodak stock around 1916-17.

perforations that may date from before 1909.[3] If accurate, this seriously calls into question the "1915-18" dating, and again points up the need for an intensive inspection of the extant copy by the archival community.

Second, despite the research by De Vries and Mul, no publications have been found to substantiate an 1899 matches campaign, or a film made to promote it. The 1899 date is based on oral testimony and circumstantial evidence, while the counter-argument for *circa* 1915 appears on the surface to be more factual. For hardheaded historians – and there's nothing wrong with that – the lack of physical evidence for the Boer War appeal is damning.

The primary evidence for the dating by De Vries and Mul is the film's content and the filmmaker's memories. Melbourne-Cooper repeated often that MATCHES APPEAL was made around the time of the Battle and Siege of Ladysmith (that is, from October 1899 to February 1900) and was screened at the Empire Theatre in Leicester Square, London, "before Christmas". It has been confirmed that at least two such patriotic matinees were held at the Empire, on 30 November and 8 December 1899.[4] Despite the well-known shortcomings of oral histories, which Bottomore has elucidated very thoughtfully, we should not completely dismiss good-faith first-person testimony as long as it has demonstrable usefulness. Similarly, despite the fact that no documentation has turned up about the circumstances of production, such absence does not mean that the appeal did not take place. My own brief online search readily came up with some additional clues.

Soon after the Anglo-Boer War broke out, the War Office issued an appeal: "Contributions of the following articles would be most gratefully received either from private individuals or from manufacturers. It will as a rule not be advisable for private individuals to purchase for presentation any of the articles mentioned in the following list, but money donations to enable the committee to make necessary purchases will be gratefully received [...]."[N4] Safety matches were on the list. The advice that individuals should donate money, rather than buy articles directly, was especially pertinent for matches, since the War Office explicitly stated that, "Parcels containing matches of any kind cannot be received."[N5] That the British

3. Letter from David Cleveland to Tjitte de Vries, 8 November 2005. The original stock probably would have been manufactured locally by the Blair Company, Kodak's chief competitor in the UK at the turn of the century.

4. Notices in *The Times* [Digital Archive, 1785-1985], 18 November 1889, page 9, and 6 December 1899, page 8. See also a letter from Frank Kessler to Tjitte de Vries, 7 January 2007. No films were mentioned in the 1899 Empire Theatre programmes, but this would not preclude such screenings, especially since MATCHES APPEAL was so short.

soldiers dispatched to the front suffered deprivations, including a lack of matches, is easily shown.[5] So the conditions were right for a matches appeal. But none of this proves that Melbourne-Cooper's film was made as part of such a campaign. Rather, it adds to the bits of evidentiary debris orbiting around an event that may or may not have occurred. By contrast, the 1914 matches appeal has ample documentation, including a kick-off announcement on 6 October and several display ads.[N6] While this doesn't help the case of De Vries and Mul much, it does not destroy it either because it might be that these WWI announcements indicate that the matches company was building on past experience in mounting another, larger-scale appeal.

As for the third counter-argument, regarding animation technique, we must be careful to avoid technological teleologies that assume steady progress over time in form and technique. Mechanical drawings and testimony (undated) exist to show that Melbourne-Cooper was able to modify his camera to open and close the shutter to expose one frame at a time without "flashing" intervening frames. (One sees such flicker in Blackton's first films, for example.) It seems entirely plausible that a technician who worked for another technician (Acres) would have been able to figure this out with minimum experimentation. A different area to analyze would be the lighting on MATCHES APPEAL. Melbourne-Cooper did not adopt artificial lighting until 1908 (as his 1907 animated film, A DREAM OF TOYLAND, clearly demonstrates). If MATCHES APPEAL can be shown to use natural lighting, then that argues for the earlier date; if artificial, then later.[6]

The situation raises the question, what constitutes acceptable evidence for assessing early films beyond a reasonable doubt? Moreover, what is the "gold standard" for identifying and dating early films? Certainly, contemporaneous records showing that a film was produced at a certain time and place by specific individuals or companies, and public documents that demonstrate that it was advertised and screened, are convincing. Prints of

5. For example, a veteran of the war wrote: "In concluding this chapter I must mention that the lack of matches was very sensibly felt. And when our stock of matches was exhausted we had to resort to the old-fashioned tinder-box and flint and steel. We found this expedient a very poor substitute for the lucifer match, but it was certainly better than nothing at all." (General Ben Viljoen, *My Reminiscences Of The Anglo-Boer War* [London: Hood, Douglas & Howard, 1902], page 504 [http://www.archive.org/stream/my reminiscenceso00viljiala/myreminiscenceso00viljiala_djvu.txt, accessed 29 June 2009]).

6. A disclaimer: although I viewed MATCHES APPEAL in 35mm at the BFI, it was ages ago and I haven't seen it since. (Note by the authors: All three MATCHES pictures show natural lighting: changing sunlight moves the shadows of the matchstick puppets..

the films with physical characteristics consistent with existing technology and verifiable provenances are reliable indicators. Lacking these indisputable material signs of authenticity, researchers and archivists assemble as much indirect evidence as possible. This is what De Vries and Mul have done. (And to some extent, this is what his detractors have done.) At this moment, it must be said that the physical evidence is not complete: there are no records of MATCHES APPEAL's production, exhibition or reception. The original film material is gone, although at least we know that it existed because its images survive in copies. The cultural content is ambivalent, as it could apply to either war. De Vries and Mul have made a convincing argument from circumstantial evidence, but the curator's opinions have continued to cloud the case. Despite the contested date, the BFI insisted as recently as 2005 that the film was made during World War I.[7] The instance of MATCHES APPEAL thus demonstrates the extent to which archival institutions not only preserve artifacts, but also manage knowledge.

In my opinion, admittedly based primarily on de Vries's highly speculative claims, Melbourne-Cooper is the current leading contender in a close race. This, however, misses the point. What is important is not whether Melbourne-Cooper wins the prize for the first animated film, but what is the cultural significance of such filmmaking. There is still much work remaining for researchers, historians and archivists.

In early cinema research, we have to learn to live with doubt. Unquestionably, we need rigorous standards. However, we also need collaborative research. This includes welcoming new theories, even undocumented ones, to the party. The arguments over dating and authorship should not obscure Melbourne-Cooper's extraordinary accomplishments – most of which are adequately documented. De Vries and Mul rightly indicate that the filmmaker experimented at an early date with editing to tell his stories.[8] He also embedded his labour-intensive animation sequences within live-action framing sequences, not only in order to extend his films to a normal length, but to provide greater narrative clarity and to create a context for the fantastic animation to follow.

7. "(...) presumably the battalions are British troops serving in the Boer War. However, I spoke with a curator at BFI who absolutely asserts that this film was made in the early 20th century and accordingly refers to the Great War." (F. G. Macintyre, 'MATCHES: AN APPEAL / User Comments,' *Internet Movie Database*, posted 2 April 2005, http://www.imdb.com/title/tt0000251/#comment, accessed 29 June 2009).

8. Gray and Bottomore, *op cit.*, have presented evidence against the claim that Melbourne-Cooper made a series of films traditionally attributed to G. A. Smith, notably GRANDMA'S READING GLASS (1900).

Perhaps the most stunning revelation is that MATCHES APPEAL may have been the filmmaker's third animated film, not the first. De Vries argues that it was made after two earlier experiments with matches playing volleyball and cricket. No doubt, here is the work of a cinema craftsman, on par with Blackton, Booth, Chomón or Porter at the same time. The films chart the transition of cinema from the fairground to the metropolitan music halls. Those with advertising content, such as MATCHES APPEAL, show how varied the first cinema projections were and how the medium was being accepted as a rhetorical form. Melbourne-Cooper's fondness for juvenile stories, toys and doll protagonists and his use of dream imagery distinguished later animation. Rather than the definitive word on an early-cinema controversy, the present book sets forth a research agenda for future historians and archivists to pursue. Certainly more gaps in the record will be filled. It is even possible that, one way or another, the shadow of doubt will dissipate. The theory of the catastrophic asteroid impact was met with derision when first proposed. Although it still is not now universally accepted, as evidence mounts, there is more agreement that it could have happened. Gould observed that "the history of life has some weak empirical tendencies, but it is not going anywhere intrinsically" (page 329). The history of cinema may be like that, and, if so, it would be best to keep an open mind. While elderly film makers' memories may be self-serving and unreliable, that need not always be so. And while archivists are usually reluctant to make blanket pronouncements based on incomplete or ambiguous evidence, that isn't always the case.

In conclusion, Tjitte de Vries and Ati Mul have brought to light the work of an important filmmaker and have sketched a fascinating life in cinema. While there are doubts about dates and authorship here and there, it is indisputable that Melbourne-Cooper was a prolific practising film maker of the nineteenth and early twentieth centuries who was intelligent and innovative. We clearly recognize the animation personality profile of the fanatic and madman, he who enlisted his family and friends – even his dentist – in his quest to visualize his imaginings. We also see in De Vries and Mul some of these same qualities of persistence, patience and dogged determination. And we are grateful.

Foreword

Danish comic cartoonist, bass player and animation film-maker Børge Ring (b. 1921), who lives and works in the Netherlands, won an Oscar in 1985 for his picture ANNA AND BELLA. After viewing the six surviving animation pictures of Arthur Melbourne-Cooper, he had the following to say.

COOPER IS SUPER

Watching Arthur Cooper films dating from the first decade after 1899 is a surprising and emotional experience. One is witnessing the genesis of animation on film, principally just as we know that today.

This birth was probably provoked by a vehement wish, a fantasy which resided in Cooper, just like it happened with the invention of sound reproduction, which was already an old dream 4000 years ago in China.

"It must be possible. It MUST be possible." Yes, but how?

Cooper's moving pictures from the years 1899 till 1914 betray that he was possessed with all the playful delights and artistic instincts which we find in all those proper animators who arose and blossomed throughout the 20th century.

Fig. 1. Børge Ring.

From whom or from where did he get it? If one only knew... Who was the teacher of the world's first double-bass player?

Were Cooper's short clips with sportsmen constructed of wooden matchsticks possibly inspired by the sketches of 'matchstick manikins' which we got to flounder in the corners of our schoolbooks? Cooper does not draw at all, but his animation of the matchstick characters has something of the zap and appeal of the cartoon animation which, fifteen years later, originated in New York with Paul Terry and in Kansas City with a very young Walt Disney.

Cooper's *magnum opus*, A DREAM OF TOYLAND, is an achievement that reminds me of the World Championship Tournament in Simultaneous Chess.

Let alone that he – with all these many 'happenings', and his white polar bear as star actor – would be able to playfully improvise. But... he is cold-blooded enough to have the motor-bus drive its bus route calmly and on schedule.

Cooper's capacity to concentrate is beyond me. Today, a first-class puppet film studio – like, in the 20th century, the Dutch *Joop Geesinks Dollywood* studios for instance – wouldn't dream of taking on a similar job without a great number of 'simultaneous' animators, each assigned to his own task.

After TOYLAND, Cooper was so pleased with his lovely new medium that he thought: "I am going to get my little puppets to tell stories!" That this was his aim is shown by the live-action scenes embracing A DREAM OF TOYLAND. The story of NOAH'S ARK was not lengthened with live action, but Cooper's lovable white bear and two white elephants appear to be inspiring 'scene stealers'.

With ROAD HOGS IN TOYLAND of 1911 Cooper becomes 'technical', and he sometimes combines two media on one film strip, namely cut-outs on top of animation. His aim is zany nonsense, and his labour is conscious – to think, to aim, to hit. This picture is capital and clownish just like the one-reel farces of his two contemporaries, Mack Sennett and Charlie Chaplin.

Cooper was a 'present-day' animation film maker ahead of his time. Grandmaster and Disney animation pioneer Art Babbitt once said: "The animation tells a lot about the animator". According to this view, Arthur Cooper was playful, inventive, passionate and with a far-reaching insight into the possibilities of the medium.

BØRGE RING, Ravenstein (NB), Netherlands

Acknowledgements

We could not have written this book without the support of the following people who are responsible for the fact that we never lost our enthusiasm for the subject.

First and most of all in sincere memory of
Audrey Kathleen Wadowska (25 November 1909-27 January 1982) and her husband **Jan Wadowski** (3 May 1908-10 January 1996), eldest daughter and son-in-law of Arthur Melbourne-Cooper, who made us enthusiastic about the subject, convincing us of the necessity of this book, and – besides being indefatigable hosts – making available to us all their resources unconditionally.

Ursula Constance Messenger (20 October 1910-20 March 2008), who just lived to see the completion of the manuscript for this book on which she as a warm and untiring hostess contributed with her knowledge more than she imagined.

and in admiration for their patience with us
Father abbott and monks of the St Adelbert Abbey who, in support of our Arthur Melbourne-Cooper project, assigned Tjitte his own cell in their

monastery in Egmond, North-Holland, where he regularly could work in all tranquillity and concentration.

Dr. Karel Dibbets, who taught us diplomacy in the minefield of film history research.

Prof. Margaretha Schenkeveld, who convinced us of the importance of compiling a basic paper, *A Documentation of Sources*,[N7] an enumeration of all the available material about Cooper, and guided us in writing this book.

Prof. Frank Kessler and **Dr. Sabine Lenk** not only warmly encouraged us, but also actively supported us with publishing our papers about Cooper in their yearbook on early film history KINtop, and became stimulating coaches.

Anthony Slide, author of countless books on silent film history and its stars, intimate friend of Cooper's daughter Audrey Wadowska, indispensable guide in our research.

Joke de Vries, who with great patience put hundreds of film synopses and advertisements from old catalogues and faded trade papers in the computer.

David & **Christine Cleveland** supported us with warm hospitality and anxious cheering up, with David not only allowing us the use of his interviews with Cooper's daughter Audrey Wadowska, but also critically reading our writings.

Kenneth Clark, supported us with his infectious love for animation, his help in text corrections and the use of his recorded interviews with Audrey and Jan Wadowski.

Of the Netherlands Filmmuseum in Amsterdam, we will not forget the support of director **Hoos Blotkamp**, and her successors **Rien Hagen** and **Rieks Hadders**.

Of the unique Netherlands Institute for Animation Film (NIAf) at Tilburg we mention with pleasure director **Ton Crone** and his right hand **Mette Peters** who, with their invitation for a lecture on Cooper's animation films, prompted us to write this book.

Dr. Hauke Lange-Fuchs of Kiel, Germany, film historian and Birt Acres specialist, who effectively coached us in the writing technique of a filmography.

Ronald Grant and **Martin Humphries** of the *Cinema Museum*, The Masters House, The Old Lambeth Workhouse, 2 Dugard Way, Kennington, London SE11, UK, a museum with profuse collections, a treasure island for anyone interested in film history.

Hans Olsson, specialist in B&W photography, who was indispensable for our photographic archive with many photo-reproductions and blow-ups of film frames.

And last but not least Oscar-winning Danish-Dutch animator **Børge Ring**, who with his fascinating enthusiasm about Cooper's animation pictures confirmed for the two of us that we were on the right track.

And in further sincere memory of

Christopher Wilkinson, and his wife **Meriol,** generous host and hostess, with Chris a true coach in the English language, and as local historian genially sharing with us his knowledge of Cooper and Birt Acres. Chris just saw the completion of this manuscript.

Frans Smekens, Alderman for the Arts of Antwerp, co-founder of the Flanders Film Society, who was the first to warmly advise us to set out upon the Cooper research.

Jan de Vaal, founder of the Netherlands Filmmuseum, co-founder of the FIAF, who believed in the importance of our research, and supported us from the start.

Geoffrey N. Donaldson, Australian-born Dutch film historian, a true and warm friend, the first to thoroughly research the Dutch silent film history, who introduced the two of us to Audrey and Jan Wadowski, who were then caretakers of a house in London where we first saw the films of Audrey's father, Arthur Melbourne-Cooper.

Introduction

In presenting this study to our readers we both feel the necessity of making a few remarks with regard to its scope.[9]

This book presents an introduction to the British film pioneer Arthur Frederick Melbourne-Cooper (15 April 1874 – 24 November 1961), together with a filmography of his animation pictures. We chose to write about Cooper and his puppet pictures because he was an innovator in this genre, and we consider him to be the founder of the technique of stop-motion cinematography. As far as we could ascertain, he was the first in film history to apply this technique. The filmography of animation pictures is as complete as we were able to compile.

Nevertheless, we cannot call Cooper an animator. This distinctive specialisation did not yet exist in his time. Besides, Cooper only devoted part of his time to make stop-motion pictures. He was an all-round cinematographer, which is demonstrated by the general filmography in Appendix 3 with more than 300 films in all genres which can be credited to him.

We have given our book the title, "They Thought It Was a Marvel", which is what Cooper said to Sidney Birt Acres, the son of British film pioneer Birt Acres (1852-1918), about the audience response to his first trick picture. Made with two cameras, Ducks on Sale or Return shows how a poulterer magically returns the feathers to the skin of a freshly plucked duck. "That was the first of it," recalled Cooper, "and it was shown at the Empire Theatre for weeks and weeks."

The first part of this book is an extended version of our lecture, on 21 September 2005, to the Netherlands Institute for Animation Film (NIAf) in Tilburg, and an elucidation of the filmography. It is titled Part One. Introduction, "Preparing something wonderful" – which is what Birt Acres

9. We write these words in tribute to and as a paraphrase of the first sentence of Henry V. Hopwood's preface to his 1899 study, *Living Pictures, Their History, Photo-Production and Practical Working*, the first historical study of the motion picture.

said he was doing when, in 1892, young Cooper asked him for a job.

Part Two contains the profuse filmography of 36 animation pictures. We gave it the title "Picture by picture, movement by movement", because this is precisely how Cooper made his first animation pictures.

The endnotes in both parts give ample acknowledgement of the sources we used with reference to the page numbers. T-numbers denote our archive numbers of interviews and transcriptions. Under each film title the reader will find the credits together with historical and circumstantial background information, offering as much material as possible to stimulate further studies.

When we prepared the lecture, we had at our disposal a filmography of 32 animation pictures and one live-action movie with an important animation shot inserted. Since then, we made some additional discoveries, and our filmography of Cooper's stop-motion pictures now contains 36 titles plus two live-action movies with inserted animation shots.

Part One could not have been written without Part Two and all its information which we found in the standard literature and other books, interviews, old magazines and catalogues, everything we gathered in this essential and factually verifiable filmography.

In many entries you will find information from no fewer than seventeen tape recordings with Cooper, as highly valued fundamental data from the man himself.

In an introduction 'How to use the filmography', we give an extensive account of how we developed a method to identify moving pictures which do not exist anymore, and how to credit them to our subject or not.

Is it possible to take Cooper's recollections on these seventeen recordings seriously – can they help us with reliable information?

In his foreword to John Barnes's first volume of his *The Beginnings of the Cinema in England*,[N8] Kodak Museum curator Brian Coe warns the reader not to rely on the reminiscences of elderly people whose recollections were often confused or biased. Barnes himself told us that all his studies were exclusively based on contemporary printed source material and examinations of surviving apparatus, and not on other people's memories.

Are old people's testimonies to be rejected or ignored? Of course, one has to be very cautious when descendants are recalling what a parent told them when they were young. Is not the same caution required with what is written on paper and printed in books?

Actually, oral testimony is the oldest form of recording known to men. This is what we eagerly glean from George Ewart Evans's book *Where Beards Wag All*[N9] about the old prior culture in rural Britain. Oral testimony,

Evans writes, "will still have its use in an age when scientific methods of keeping records are likely to multiply still further."

But can we trust it? Can we use it as evidence of any kind and give it historical weight? It has to be used with care and proper awareness of its limitations, says Evans, but: "The same principle applies to written and printed sources which are often oral in origin, and do not acquire some sort of mystical value by the simple process of being put on paper."

A written document, Evans argues, with humour, has to be looked in the face, so to speak, as searchingly as any informant. One should be aware of the informant's background, and should look for information precisely in those sectors where he has first-hand knowledge. He warns not to make too large a claim for oral testimony to transmit knowledge, "but oral testimony can help the researcher (...) by giving flesh to the material he has gathered from other sources."

With these arguments from an experienced researcher, both authors listen with confidence to Cooper's voice about his experiences in those formative years of cinematography, and about his own career as a film maker.

Because the book is about him and his moving pictures, we decided to reproduce verbatim what Cooper said when we are quoting him as a source, even though it could have been written in more proper English. But Cooper's voice is our guidance, though we shall correct and complement

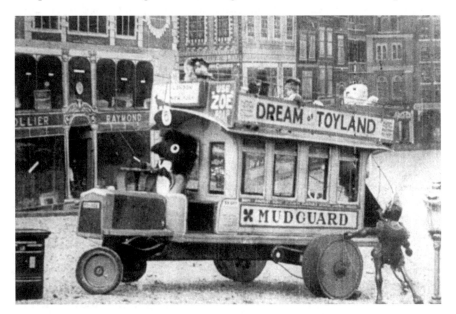

Fig. 2. The motorbus in A DREAM OF TOYLAND (1907) is the star of the show.

him whenever necessary. Quoting verbatim gives a direct impression of a person's character and personality. As a photograph gives an impression of the outside, a quote gives a picture of the inside.

Do we have to be doubly cautious because it was Cooper's own daughter Audrey Wadowska who made these recordings? Yes, we were very cautious as experience taught us. Still, Audrey reminded us of Madeleine Malthête-Méliès,[N10] who indefatigably crusaded for the rediscovery of her grandfather Georges Méliès, the fascinating French film pioneer. We are also reminded of Marian Blackton Trimble, author of that lovingly written personal account of her father's cinematographic career, *J. Stuart Blackton. A Personal Biography by His Daughter*.[N11]

Although Cooper is an almost forgotten film pioneer, the fact that we regularly come across in publications a still photograph of a toy motor-bus driven by a golliwog and with a sign 'Dream of Toyland' on one of its sides, we largely owe to Audrey, who performed an immense and admirable task.

She started to collect information about her father when, in 1955, she discovered that his name was hardly mentioned as a film pioneer. For 27 years she undertook a great amount of legwork, spent innumerable hours in libraries and archives, and travelled many miles all over England in order to compile an archive on her father. After her death she left more than twenty suitcases full of documents and archival material.[N12] Apart from the tape recordings of her father, there are her own 152 recorded interviews with people who had known her father as a film maker, 3000 letters, hundreds of documents, newspaper and magazine cuttings, 1020 photocopies from contemporary distribution catalogues, thousands of other photocopies, books, several manuscripts, some 2000 photographs and 154 films.

It is with much pleasure that we undertook the research for this book. Staying during the early years of our research as guests of Cooper's daughter Audrey and her husband Jan Wadowski, the following twelve years as guests of widower Jan, and the last ten years as guests of Cooper's youngest daughter Ursula Messenger had the great advantage that it enabled us to do a lot of research in England.

Researching the subject of a biography while, at the same time, being guests of the subject's family and using their files and archives bristles with many dangers. The greatest danger is to become entangled in family myths. We will be honest – we did! It took us several years and precious time researching these myths, in order sometimes to find ourselves in a cul-de-sac. Now that the main players are no longer with us – Audrey died in 1982, her brother Kenneth, born in 1912, died in 1994, her husband Jan in

1996, and her sister Ursula in 2008 – we are at liberty to present our material as truly and honestly as we found it.

In Cooper's time the words 'moving pictures' and 'animated pictures' defined all manner of films. However, this second term, as film historian John Barnes explained to us in a letter,[N13] was also used for a kind of short theatrical plays. We will therefore not use the word 'animated' for stop-motion films but identify them as *'animation pictures'*.

From the very beginning – as our acknowledgements disclose – we received much help from the Netherlands Filmmuseum, Amsterdam. Its late director, Jan de Vaal, gave us his unconditional support, inviting us to present our findings at the 1978 FIAF Congress in Brighton. His successor Hoos Blotkamp and her successors Rien Hagen and Rieks Hadders supported us throughout. Without them, and without the staff of the film restoration department, this book could not have been published.

We gladly award here our enthusiastic commendations to all the local libraries, studies centres, and regional archives that helped us, including the British Library Newspapers at Colindale Avenue, the Science Museum, the British Film Institute (BFI), and all the people who work there. These institutions make Great Britain unique, and it makes researching there a joyous enterprise. It is quite possible that their willingness to help and eagerness to assist us also caused our research to last rather a long time. Finally, we are grateful to Tom McGorrian of St Albans who, after the untimely death of our English editor Chris Wilkinson, helped us to turn what we wrote into proper English.

On behalf of Ursula Messenger we donated to the NIAf 35mm safety prints of the three surviving MATCHES films.

Ursula Messenger, Cooper's youngest daughter, was so eager to see this book in print, but she died on Maundy Thursday, 20 March 2008, in the week when we told her that the manuscript of her father's puppet animation pictures was completed. For many years, she was an untiring hostess, remembering in her modest way so much about the Blackpool period of her father, that it enabled us to extend the animation filmography with more titles. At the same time, she was very open-minded and appreciated our critical approach, recognizing the pitfalls of family myths.

This book is accompanied by a DVD containing the six surviving animation pictures of Arthur Melbourne-Cooper.

Rotterdam, December 2009.

Part One

"Preparing Something Wonderful"

How can one give life to a handful of dead chips? The tree is felled, its wood cut into beams and boards, some beams cut into slivers only fit for matches destined to their definite death by burning. How to breathe life into them? The best solution is to first invent cinematography.

CHAPTER I
A Want of Sanctuaries

I. To Animate Is to Give Life

It was the Australian-born Dutch film historian Geoffrey Donaldson (1929-2002) who, in 1975, introduced the two of us to a remarkable couple. Audrey Kathleen Wadowska, with her 5 feet 4 inches, was what might truly be called *petite*. She was the eldest daughter of a British film pioneer. Her charming husband Jan Wadowski was a former captain in the Third Carpathian Artillery Regiment of the Second Polish Army Corps who fought in North Africa and in Italy. He survived the Battle of Monte Cassino. The Wadowskis were caretakers of the London house of war painter James McBey's widow, Marguerite McBey, at 1, Holland Park Avenue. McBey acquired it in 1910 from John Galsworthy's father, the architect who had built a studio on top of the building.[N14] In this famous house Jan, with his 16mm film projector, showed us the films of Audrey's father, Arthur Melbourne-Cooper. One of the first pictures was A DREAM OF TOYLAND, and we knew we were watching something very special.

The heart of the film is a dream, as if we are on the eve of what the film industry will become – Hollywood, the dream factory.

A mother and her little son enter a toy shop. He can choose whatever he fancies from a wide range of toys. He makes a liberal choice. Back home, he is put to bed by his mother. He dreams. He is back in the street at the toy

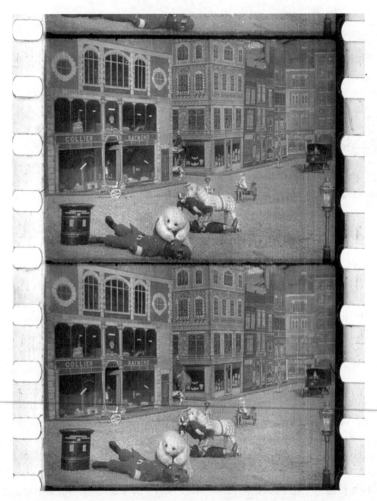

Fig. 3. A policeman is victim of an assertive white bear in A DREAM
OF TOYLAND (1907).

shop. There, all his toys have come to life. Puppets are walking up and
down. A monkey fights with a policeman. A rider is thrown from his horse.
A motor-bus full of passengers including a rebellious white bear passes by.
It is as if we, from a window, are watching the traffic in the street:
pedestrians, a milkman, motor vehicles, horse carts and cabs.

What is happening there? Is there no story? Or is it a collection of a
hundred stories? Are these events perhaps very early CCTV images? Or is
it a *tableau vivant*, one of those 'living pictures' which the Victorian theatre
goers appreciated so much?

Remarkable is that this moving picture was made as early as 1907.

This wonderful animation picture, which has no obvious story line, is still arresting our attention, and a second showing reveals many other incidents, because so many things are happening, so many stories are going on at the same time.

As in life, as in a real dream.

Remarkable, because this picture was made only a year after J. Stuart Blackton's well-known animation picture HUMOROUS PHASES OF FUNNY FACES and a year before Emile Cohl made, in France, his FANTASMAGORIE. We think that both pioneers, well-known from film history, will have to admit a companion when we compare their work with the craftsmanship of the maker of A DREAM OF TOYLAND.

Who was the maker of A DREAM OF TOYLAND? He was Arthur Melbourne-Cooper, a British film pioneer, who was born in St Albans and died in Coton near Cambridge. Cooper was an independent cinematographer. From 1892 he was, for a couple of years, assistant to another British film pioneer Birt Acres (1854-1918), who developed the first British moving picture camera, the Kinetic Camera. In 1901, Cooper started his own film production company in St Albans, the Alpha Trading Company.

There was a lot of confusion in the years after the first film shows of the Lumières and Birt Acres about what this new invention really was. No one had any idea of its potential. Before the turn of the century, the Lumière brothers had withdrawn their investments and sold the cameras to the men who operated them. English film pioneer Birt Acres stubbornly held on to the notion that his Kinetic Camera and Kineopticon were instruments for science and science only. He abhorred the idea that the newsreel he, in 1896, took of the Prince of Wales opening the Cardiff Exhibition would be shown at fair-grounds. There were even ideas, resembling the digital photo frames of today, of the cinematograph becoming literally a family album of 'moving photographs' shown in the living room, in small Kinetoscope-like cabinets in which you kept family portraits which actually moved, and perhaps even talked if combined with Edison's invention of the phonograph.

Christian Metz, in 'Some Points in the Semiotics of the Cinema'[N15] writes: "That over all these possibilities, the cinema could evolve into a machine for telling stories had never been considered."

Roy Armes in his impressive study *A Critical History of British Cinema*:[N16] "Birt Acres, who was not interested in a showman's career, faded from

view after 1897. (...) A fusion of film and narrative – unforeseen by the pioneers – was needed to allow the cinema to achieve a lasting universal appeal and enable the entrepreneurs to build a profitable industry."

Even though no one in the beginning had any idea what the new invention would become, and what its real potential was, the astounding fact is that in America in 1914 some 50 million people would go to the movies every week.

From 1896 the audiences flocked to the travelling fair-ground cinemas to see a great variety of filmed subjects in short lengths of one or two minutes. There was an excitement about the new medium we can hardly imagine today. Watching the pictures the audience experienced them as real. Animated pictures or photographs that contained real life were a marvel to them. Moving pictures became a representation of progress and modernity. Edward Wagenknecht[N17] was fascinated by what primarily was mere movement itself. It did not make very much difference what moved or why, the important thing was *that movement occurred*.

It is exactly this movement that makes us forget that there was once a machine that recorded this movement, that there was a man behind this machine to operate it, that a whole crew was behind this machine to make the movements in front of it possible. It is exactly this movement in A Dream of Toyland that makes a family of Dutch dolls walk naked and unhindered in a busy St Albans street, a little monkey skilfully drive his milk cart, and a white teddy bear win a fight with a policeman.

English film pioneer Robert W. Paul's projector rapidly helped to immensely popularise the animated pictures internationally. Paul justly called his machine the *Animatograph*, which literally means: apparatus to write or record life or soul.

On the basis of all available material, we submit the following propositions.
– Our first proposition is that even though 30 of his animation pictures are lost, the six surviving pictures are enough to grant us a look in his studio, the forge where he created miracles which still satisfy our stubborn and ineradicable want of sanctuaries.
– Our second proposition is that Cooper was the first to make moving pictures with puppets. Like a player with marionettes or a puppeteer with dolls on strings or rods, he was puppeteering with specially made or adapted dolls, filming them with stop-motion technique in order to give them life in projection on the screen. His six surviving animation pictures amply demonstrate that he is the founder of *puppet animation*.

Arthur Melbourne-Cooper belongs to a small group of stubborn cinematographers, like Alice Guy-Blaché and Georges Méliès in France, and Edwin S. Porter in America, pioneers who laboured to develop cinematography from its infancy of moving photographs to a storytelling medium. Cooper made series of moving images which he cut in a particular sequence, so that they came to tell, in their own coherent way, a story like the magic lantern shows had done until then, or the altar pieces and Stations of the Cross in churches and cathedrals had for centuries, but now without the obligatory preacher or narrator. The moving picture itself is sufficient. But Cooper did more.

2. 'A Waste of Time'

Let us, in this book, herald a reconnaissance of the studio where A DREAM OF TOYLAND was made.

We chose as the motto for our book the line about our stubborn and ineradicable want of sanctuaries where miracles are possible, from arts editor Mariëtte Haveman's introduction 'De Smederij van Vulcanus' (The Forge of Vulcanus) to *Ateliergeheimen* (Secrets of the Studio), a series of studies about the studios of Dutch artists through the ages. When reading her inspiring essay on artists' studios, we knew that she, even though writing about the workplaces of painters, sculptors, artists and writers, also meant film makers' studios. The Dutch word 'atelier' cannot be used for the workplace of a film maker, but what luck, the English word studio covers the same meaning in both languages. Moreover, her definition is most appropriate for the studio about which we want to write. It is Cooper's studio, the workplace where that little cinematographic wonder was born, which at the moment of this writing is more than a hundred years old, and which today is still able to enthrall people, young and old alike, with its more than adequate title of A DREAM OF TOYLAND.

Mariëtte Haveman defines the studio as a platform of human drama. There is still fascination in an ordinary workplace, a bicycle workshop, a garage. But the artist's studio has its extra dimension of an alluring two-sidedness, not only a sober place where things are made, but also the delivery room of art. And art creates its own worlds – worlds with its own laws, truths and legitimacies. And these are, of all worlds, created by animation film makers.

In the 19th century, Haveman writes, the studio is a preferred theme in the literature where the artist has to hold out in the eternal triangle with his

model and his work of art. In Cooper's live-action features there is no better example than A SCULPTOR'S DREAM (1909) in which a sculptor in his dream – yes, the dream again – is pursued by the continuous metamorphosis (rendered with the stop-action technique) of the female statue he just completed. This drama from the Alpha studios is a highlight of early cinematography.

The Alpha studio at Bedford Park in St Albans was Cooper's workplace where, in 1907, A DREAM OF TOYLAND was made. It was the delivery room where this instant of exciting deception came to light. Everything here fits in with its own order. There is no other order than that of this very busy street where a policeman nevertheless tries to bring some order, where a polar bear defies everybody in its way and where the traffic could not be busier than today. Little miracles of traffic accidents and resurrections are happening in this sanctuary of puppets, toy motor-buses and motor-cars, and everything fits in with a little boy's ineradicable toyland dream where all the toys sprang to life after he so stubbornly selected them in the toy-shop.

A DREAM OF TOYLAND, made at the same time that Blackton[10] and Cohl made their first animation pictures, reveals Cooper's grasp of the technique, his experience with frame-by-frame animation and his self-assured directing of the very complicated animation scene. It is clear that he must have made these kinds of pictures before. The live-action scenes also show his command as director. The acting in these scenes is natural, almost accidental as in a documentary, and they do not remind us of the broadly gesturing actors in old silent pictures!

Let us take a quick look at the period in which young Arthur started his film pioneering career as Birt Acres's assistant. It was the end of a century that seemed to challenge images, photographs, pictures and drawings to come to life, exemplarily demonstrated by Claude Monet's painting *Gare de Saint-Lazare* full of steam and movement of departing trains on their way to a new era. It was a period that was full of optical gadgets, visual toys and clever magic lantern projections. There were magic lantern slides which gave all kinds of illusions of movement by means of a lever system, double glass plates or biunial or triunial lanterns to show ships disappearing in a storm, little devils badgering people, humans pulling

10. Was Stuart Blackton interested in his work as an animation pioneer? We have the impression that he doubted or ignored his prominent place in this genre in film history. (Thanks to Anthony Slide.)

faces, and clouds or waves passing by. In short, the 19th century was a very visual era.[11]

Historians who aim to profoundly study the early development of cinematography sometimes start with cave drawings from the Stone Age, or with the Bayeux Tapestry that depicts the Battle of Hastings of 1066, suggesting it to be a forerunner of Todd-AO and VistaVision blockbusters from Hollywood. The 19th century, though, is early enough with its invention of photography, with its panoramas and dioramas, its travelling magic lantern showmen and with hundreds and hundreds of patents and patent applications in this field. These are many times seen as 'forerunners' in a kind of evolution theory of the film, but such a view does not take into account the singular features of what creative people produced in their time and denies the proper contemporary qualities of a moving picture. It is as film historian André Gaudreault wrote in 1984 in his study 'Theatricality, Narrativity, and Trickality. Re-evaluating the cinema of Georges Méliès' in *Journal of Popular Film and Television*,[N18]

> When one looks at the early cinema only as primitive forerunners of the movies after Griffith, one denies the proper contemporary qualities of this period. This error is the cause that the directors of the early movies have been inadequately studied, and the distinctions between them have grown blurred.

The early 19th century produced studies, most notably by Dr P.M. Roget and others, about the phenomenon of the 'persistence of vision' – the retina of the eye is supposed to contain an image longer than its actual existence, which would give the eye the opportunity to perceive movement of these images when presented in rapid succession. This theory was later criticized on several grounds. Film-writer Michael Chanan explains modern observations in his *The Dream That Kicks*[N19] in which perception is regarded as an active process.

In 1825 Dr John Ayrton Paris originated the Thaumatrope, a little disc with different pictures on each side, which melt into one when the disc is spun around by means of the springs on each side. A bird on one side appears to be sitting in a cage depicted on the other side, an equilibrist is dancing on a rope, a devil threatens a sleeping beauty. This was the beginning of Zoëtropes, Phenakistiscopes, and numerous other -scopes

11. We realise that the following sketch is much too brief and concise. There are numerous books with general histories and specific studies about the pre-cinema and early cinema period. We refer to our extensive bibliography, and to the titles mentioned in the end notes.

and -tropes that were invented as toys for grown-ups, making the suggestion that movement of images is possible.

In 1888 the patents that laid the base of cinematography were developed. The most important one was by the French physiology professor Jules Étienne Marey with his Chronophotographe which he used to study the movements of animals and humans. It was Marey's invention that possibly inspired Thomas Edison, when he visited Paris,[N20] to develop the Kinetoscope. Another basic cinematographic patent was the *Théâtre Optique* by Emile Reynaud. His perforated bands of drawings, projected on a screen by means of a complicated set of mirrors and projectors, made it possible to show humans and animals in projection as if they were alive. From 1892 till 1900, Reynaud had more than 12,800 successful shows at the Musée Grévin in Paris where 500,000 spectators saw his projections.

In the meantime all kinds of inventors produced their own designs towards moving pictures. There was Louis August Aimée Le Prince in Leeds, J.R. Rudge, William Friese-Greene and Mortimer Evans in Bath. There were W.C. Donisthorpe and W. Crofts, there was Georges Demenÿ, a former assistant of Marey in France, and back in England, there was Birt Acres, who patented an apparatus for the quick transportation of glass plates. Acres became quite well-known with his magic lantern projections of moving clouds and waves. Some of these series of clouds and waves, mainly taken at Ilfracombe in Devon, still exist.

It was finally Edison with his Kinetoscope, developed by William K.L. Dickson who, in 1894, set the standard of the actual moving picture as we still know it today, a 35mm strip with four perforations on each side of the frame. A year later, the Lumières in France demonstrated with their Cinématographe that films should not be shown individually in clumsy closets, but on a screen like the magic lantern shows. In England, at almost the same time, Birt Acres did the same with his Kinetic Camera or Kineopticon.

This is, in the tiniest nutshell possible, the delivery room of the cinema which young Cooper entered when he, in 1892, started as assistant-cameraman for Birt Acres. This short overview of the cinematographic origins may seem superfluous, but we should realise that Cooper, young as he was, was an active participant in this era of optical illusions. He was active as a photographer in his father's business and for himself. He assisted amateur photographers who came as tourists to take pictures of St Albans Abbey to develop and print their photographs. He earned some pocket money by giving magic lantern shows in church halls and

schoolrooms. He gave them free as a Sunday school treat at Christmas time.

Therefore, to undertake all kinds of experiments in making moving pictures was to him a natural thing to do. Most had never been done before.[12] Also, no one knew whether this new fad of moving pictures would last and where it would lead. Was it a flash in the pan? Was it a new gadget that would last a couple of years and then slowly disappear? There were no cinemas yet. There were no proper trading channels, or rules and customs. There was not yet a regular ancillary industry of equipment and film stock, a production industry with film studios, or a distribution branch of moving pictures. Nobody had any idea that the making and selling of moving shadows on long rolls of celluloid would become one of the busiest and very profitable industries in the world, surviving more than 110 years. We also should realise that, in 1895, Acres and Cooper were making films in the wake of Edison's Kinetoscopes and at exactly the same time as the Lumières in France.

While Birt Acres kept telling his young assistant that cinema was invented for scientific purposes only, Cooper discovered that he could earn a living by making short humorous films. Cooper found in Mrs Chapman a willing purchaser at the London Colney fair-ground near Barnet and St Albans. Soon he was selling even rejected strips of film to fair-ground showmen, and to anybody who wanted to show them. In the shortest time possible there grew, practically all over the world, an enormous demand for pictures that moved.

Arthur Swinson wrote:[N21] "The idea that it might develop into a form of entertainment and that the general public might even be prepared to pay money to see it, didn't occur to Acres for a moment. So when young Melbourne-Cooper asked him if he might take odd pieces of film and give shows in St Albans and the surrounding villages he merely thought it was a waste of time but had no objection. And so began the first hesitant steps forward to use the power of the film to entertain."

Cooper learned that, much more than magic lantern shows, it was the moving pictures that gave spectators a magic power to create their own

12. The use of close-ups in such a way that we can speak of objective and subjective camera shots is one instance of Cooper's cinematographic experiments, most notably in GRANDMA'S READING GLASS (1900) of which we have sufficiently established that it was made by him and not by G.A. Smith as was erroneously determined by Georges Sadoul; see our study 'Arthur Melbourne-Cooper, film pioneer: wronged by film history', in *KINtop-3*, 1994.

images, their own wonderland of desires, and their own kingdom of fantasy.

3. The Spectator Participates

There were no cinemas when the movies were invented. It was the fairgrounds and music halls in the first place that made them popular, and because of that, from the very beginning, they stood in bad stead with intellectuals and religious people from puritan circles. Moving pictures were decadent, it was said. They promoted the decay of morals and manners.

Edward Wagenknecht, who made us love film history with his book *The Movies in the Age of Innocence*[N22], writes about the darkness. The fact that films had to be shown in darkness handicapped them greatly with many Americans of the time. "Darkness was evil, or if not it might easily become a cloak for evil."

Some quotes from an article that compares literary books with going to the movies in a Dutch literary magazine[N23] may shed light on another aspect that certain social groups harboured against the moving pictures.

"The public flocks to it in order to amuse itself endlessly with the observation of the reality. The busy, exciting, sensational and facetious of the unexpected, stripped of beauty in thought, satire, humour or elevation, keeps the public busy for some time as children. They disappear with dissatisfaction and without any enduring gain."

"The bioscope does not belong to the refined entertainment of our little refined theatre-going public."

"In any case, there is no instrument of ingenious invention conceivable which is able to execute the perception of the reality more faithfully. But mechanical, that is without spirit and meaning."

"The kinematographe became an idle game of pastime, of keeping busy and stunned, of masses who came undone from their former paths of life."

This was written fifteen years after the first shows of the Lumières, half a century later confirmed by Siegfried Kracauer in his intellectual *Theory of Film*[N24] that "the cinema is materialistic minded; it proceeds from 'below' to 'above'".

"The Hollywood spectator, it is claimed, is little more than a receptacle; few skills of attention, memory, discrimination, inference-drawing, or hypothesis-testing are required." We glean this from a study about 'film language' by David Bordwell and others that has impressed us very much,

The Classical Hollywood Cinema.[N25] Bordwell continues: "Now this is clearly too simple. Classical films call forth activities on the part of the spectator." And they are not simple activities. There is Bordwell's beautiful conclusion: **"The spectator *participates* in creating the illusion"**. (Bold is ours, italics are Bordwell's).

Modern computer scanning instruments demonstrate that our brains are more active than ever when watching a moving picture as if we, the viewers, become ourselves the creators of what we see. Isn't it a miracle that we are even able to see spirit and meaning in puppets and toy motor-cars, in rag dolls and wooden motor-buses?

Let us look at a practical point we already touched on in our preface. In his *American Animated Films*[N26] Denis Gifford when writing about the 'Universal Animated Weekly' points out that the word 'animated' in the title of this regular newsreel in its then current sense of 'animated pictures' was an alternative term for 'moving pictures' and does not imply a weekly release of animated cartoons. The term 'animated' sometimes causes confusion for beginner media historians.[13]

In a book *Puppet Animation in the Cinema,*[N27] devoted to the animation of three-dimensional objects, the author L. Bruce Holman describes DREAMS OF TOYLAND as "a film using live-action and trick film techniques". And then: "Children's toys were animated to produce what may have been the earliest example of puppet animation. Cooper's NOAH'S ARK, also 1908, used similar techniques." This is confusing, in one paragraph three diffe-rent terms for the same technique: 'trick film', 'animated' and 'animation' in a book dedicated to this very form of cinematography, in spite of giving Cooper a dubious credit that A DREAM OF TOYLAND (which is the correct title) "may have been the earliest example of puppet animation". We will later see that this film is number 12 in our filmography of Cooper's animation pictures, and most probably the tenth puppet animation picture that he produced.

It may be useful to adhere to the definitions which were laid down by Donald Crafton, the first film historian to study profoundly the first decades of stop-motion pictures.[N28] "*Animation,*" he writes, "is the broadest term referring to the technique of photographing by single-frame exposure with the intention of producing a synthetic movement on the screen (although perceptually there is no distinction between animated

13. The Introduction of Part Two – Filmography, explains several terminologies in more detail.

movement and ordinary movement). The term also refers to the class of all films made by this technique."

Animated cartoon usually refers only to films made by the technique of drawing animation. Crafton refers those interested in a technical discussion to Jean Mitry's *Esthétique et psychologie du cinéma*.[N29]

Following this guideline we will use the term *animation pictures* for moving pictures that were made frame-by-frame or in other words with the technique of stop-motion. We do this in order to avoid confusion with 'animated pictures', a typical expression for films in general in Cooper's time, the time that we are going to write about. "We are going to the (moving or animated) pictures,"[14] was the standard phrase in those days. Cooper's daughter Audrey Wadowska recorded interviews with many old assistants of her father and with people of St Albans who almost always use the word 'pictures' and not 'movies' or 'films'. When these latter words are used, they often refer to videos or television.

The single-frame technique we will call 'stop-motion', even though a film maker uses two frames for each 'move'. Even then the expression 'frame-by-frame' or 'stop-motion' is generally used and understood. All other manners of manipulation can be called 'trick film techniques'.

Producer... And there we have another term that may cause confusion because we are writing about an early period in film history where everything still had to find its place, a period where the economical division of the tasks of producing, distributing and showing were often still in one and the same hand. No one actually knew what the possibilities were of this new invention and what the future of the moving pictures would be. Directors were almost always behind the camera as the 'producers' of the picture that was in the making.

Therefore – *cameraman, director, producer* – we must be on our guard when we come across these words in the first fifteen years of film history. By 'producer' or 'cameraman' most of the time one meant the director, a term that was hardly used in the beginning, as it was in those days mainly associated with orchestras.

We may call Cooper a *cinematographer*, as independent film makers of today are often called. In company papers he calls himself *kinematographer*. This is exactly what Cooper wanted to be, in order to make his own films independently from and not influenced by what he called his 'agents', the

14. In the US, people will say 'going to the movies', and the word 'cinema' is never used for the building because films are shown there in theatres (or theaters). With thanks to Chris Wilkinson and Anthony Slide.

buyers and distributors of his moving pictures. The forge of Vulcanus from the motto of this book applies indeed to Cooper's Alpha film studios in St Albans.

Arthur Melbourne-Cooper was his own producer and director. However, we find for instance in Gifford's catalogues the name of R.W. Paul mentioned first as the producer of a picture DOLLY'S TOYS (1901) that was made by Cooper. Cooper gets a *D:* for director, but this means only that he, in a time when there was not yet a film rental system, sold his film in a number of copies outright to Paul. The same film could be sold in a different number of copies to another distributor. The buyers of these films often did with them what they liked, giving them different titles, making them shorter, or even duplicating (also called 'duping') them and thereby robbing the film maker of his income.

An example of this practice can be found in a catalogue published by Charles Urban,[N30] with hundreds of newsreels and documentaries, and one animation picture, NOAH'S ARK of 75 feet, a little more than one minute in projection, which is a shortened version of Cooper's THE FAIRY GODMOTHER (1906) of 140 feet, almost 2½ minutes, in which a nurse puts children to bed after which they see the animals of their toy ark come to life. Urban cut the live-action scene away from this picture to use the animation sequence as an introduction to a long series of animal documentaries, titled NOAH'S ARK. LIFE IN THE ANIMAL KINGDOM.[N31]

4. Animating Slides to Get Movement

In 1955, Audrey and her husband Jan Wadowski attended a lecture on the Beginnings of the Cinema by John Huntley.[N32] Audrey noticed that her father was not mentioned. During question time she got up and asked Huntley:

Have you ever heard of Melbourne-Cooper?
Oh, yes, he said. *But he's been dead for years!*
And she said: *Oh no, he hasn't.*
He said: *How do you know?*
She said: *Well, I should do, because he is my father.*

And of course, that started it off.

Audrey was convinced that her father's name was left out of the list of early British film pioneers. In the Twenties, she, her sister Ursula Constance

Fig. 4. In 1957, Arthur Melbourne-Cooper is interviewed by film historian and lecturer John Huntley.

(the family called her Con) and their brother Ken assisted their father in his studio in Blackpool. They listened to his stories about those first exciting years of moving picture history when he started his career. That was during the last fifteen years of Cooper's career when he was producing lantern slides and advertising animation pictures for the British cinemas. When we visited her in Bognor Regis, Ursula told us:[N33] "Father was a bit emotional about that period. He got tears in his eyes when he was talking about the early years. That is why I knew how important it had been to him. He said, he made his best films during that time."

Do memories have no value when they come from someone who is over 80 years old? Anyone who listens to the seventeen recordings with Cooper will notice that he, in old age, seems neither confused nor biased. He sounds reasonable, and shows an alert and clear mind. He knows what he is talking about, though he makes errors with names and dates, but these are facts that can be checked. Cooper, during these more than fourteen hours, mentions his films more than 290 times. He does not always mention the title and he seldom knows the distribution title, but his memories about

the pictures made by him turn out to be reliable when checked against the catalogues. He names 173 different films that he made.

This is the source from which we, basically, work. We add these data to the other material Audrey collected and what we found ourselves.

An important source too was Cooper's daughter Ursula. Most of our writings about Melbourne-Cooper were scrutinized by her. Thanks to her remarkable memory just like her father, we were able to extend the filmography of animation pictures with two more titles of advertising pictures made during the years 1925 to 1930 in Blackpool.

Arthur Melbourne-Cooper, born in St Albans, a small town with an old cathedral north of London, was the son of photographer Thomas Milburn Cooper (1832-1901). Born in Hertford, Thomas changed his career from grocer's assistant to photographer. Around 1852, he started a portrait studio in St Albans where he settled and where he was in business until he died in 1901, the year Queen Victoria died.

Fig. 5. Thomas M(ilburn) Cooper,
photographed in the 1860's by Alfred Ellis,
Upper Baker Street, London.

Fig. 6. Arthur Frederick as a child.

Arthur was the eldest son of five children from Thomas's second marriage to Catherine Dalley. Thomas's first wife Agnes died around 1870. We know little of the children from that first marriage except that two of them joined the Salvation Army. One of them, eldest son Edward, should have succeeded his father as local portrait photographer, but he found his career as Salvation Army officer more important. Therefore, Arthur became the intended successor.

Still a child, Arthur assisted his father in the darkroom. When, in 1892, he applied to Birt Acres for a job, he was eighteen years old and a competent photographer.

Birt Acres was the son of British parents who emigrated to America. His parents lost their lives during the American Civil War. In about 1885, Birt Acres came to England and started a career in photography. He became well-known because of his illustrated lectures. He specialised in speeding up emulsions which made fast exposures possible without loss of contrast and gradation. He got a job as manager with Elliott and Sons, a firm producing photographic materials, in Barnet, Hertfordshire, just north of London. Elliott and Sons can be compared in those days with Lumière in France.

Fig. 7. Birt Acres.

From 1892, Acres experimented with a construction designed to make movement possible in the projection of clouds and waves. He therefore was in need of a personal assistant. He had just patented a photographic camera with a transport system to make exposures on a series of glass plates with high speed, 4 to 5 per second.[15] We assume that Cooper was the one who had the privilege to develop and print all those slides and make them ready for projection. Incomplete series of prints of some of these stills survive in the Acres family.

Cooper became a handyman – *gofer* in modern jargon – assistant and cameraman for Acres, in this way directly involved with the development of England's first 35mm cinematographic camera.

Cooper gave his daughter Audrey an eye-witness account of how Acres developed his first successful moving picture camera:[N34]

15. British patent no. 23,670 (3 December 1893), a structure for 'exposing successive photographic plates, and for exhibiting magic lantern slides'. Acres's grandson Alan Birt Acres recently finished a biography about his grandfather *Frontiersman to Filmmaker* in which he calls this glass plate camera 'hopper feed system'.

Acres started to make (photographs) animated. He wanted to animate the slides in the first place. To get movement. And he spent a lot of time trying to get any moving pictures by use of glass plates. When the glass plates had gone, and Eastman started putting on film (putting celluloid on the market), Acres then started experimenting with the camera, when there was no perforations in the early films and film was hard to get. And Acres had to depend on getting these snapshot films which he cut to a width. He coated that on celluloid to get the movement. Then he has to get his camera. He (first) made a camera with a number of lenses, to change it with what was not satisfactory, well, with the glass plates. Then he put the film in and made the film camera. The difficulty was in getting the movement. See? When he got the movement of the film into time, he struggled to get a machine for showing it. His difficulty was getting the shutter to come into contact for each exposure, and exposure with the movement of the film was a very difficult matter – to get the film stationary, make the exposure and move. It took him some considerable time. (...) His camera was so built, it held the film tight, while the arm made them while it moved. Well, then he starts with one hole. When he came – it didn't end as such with a spring, the spring was to go into the hole to hold the film while making the exposure. At the introduction of the Kinetoscopes, with a squint (peephole), the perforations was there. And this sprocket wheel he had made into was adapted to the filmcamera. Well, then he got his camera. A success, he worked out a successful camera. He was the first to do it. And he showed these pictures. And the pictures were first shown at Sunday schools and under the free schools[16] in short lengths, twenty foot, thirty foot. So were the films, the snapshot films that were joined up.

In 1893, Acres experimented with strips of celluloid. George Eastman had put on the market Kodak-cameras with 70 mm roll film. Acres bought a number of these films and joined them together to make longer lengths. At the end of 1893 or the beginning of 1894, Acres, with a camera and such a film, made a moving picture of a farmer harrowing a field. On 1 January 1894, Acres filmed the commercial opening of the Manchester Ship Canal. The official opening was performed some months later by Queen Victoria. Later that year, Acres, with Cooper as his assistant, filmed the Henley Regatta. Nothing of these early experiments survived other than the stories which were told by Cooper and Acres to their children. The tangible exception is a strip of negative of the 1894 Henley Royal Regatta, kept by the Museum of Modern Arts in New York. A contact print of this strip of 70 mm film is kept by the grandchildren of Birt Acres.

16. Did Cooper mean the basements of the free churches, or just at the free schools?

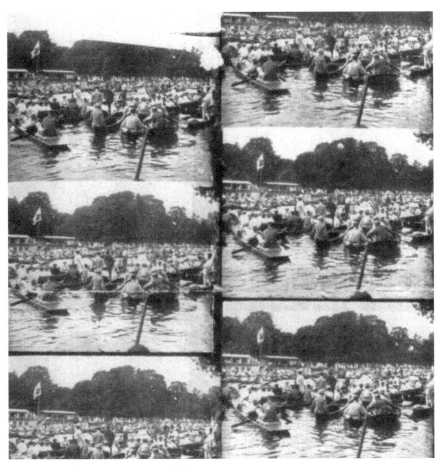

Fig. 8. HENLEY REGATTA, - contact print of the strip of 70 mm film taken by Birt Acres at Henley during 5-7 July 1894.

In the same year 1894, Edison marketed his Kinetoscopes and established the standard of 35mm film width. One of the brothers of the leading German chocolate manufacturers, the multinational Gebr. Stollwerck, was Ludwig Stollwerck, whose hobby was slot-machines.[N35] He provided chains of shops with these machines where one could buy chocolate bars and all kind of sweets but also household goods like tooth-brushes, Bryant & May matches, etc. by inserting a coin. Stollwerck wanted to acquire the Kinetoscopes for his slot-machine shops. In April 1895, an agreement with Maguire & Baucus in London was made for the supply of 300 Kinetoscopes, the first ten on 1 July for $300 a piece. But Stollwerck foresaw

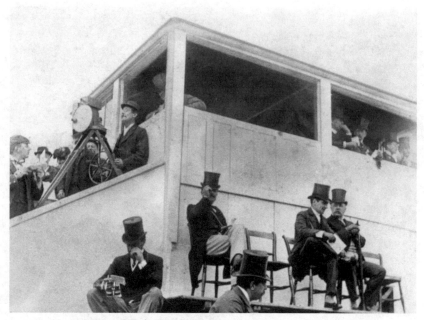

Fig. 9. Birt Acres filming at Epsom the Derby on 29 May 1895.

their Achilles heel, the software: films. He was aware that when a customer had seen the miracle of a moving picture once or twice, he would not come back unless something new, another thrill, a fresh excitement could be watched. The Kinetoscopes would only return their heavy investment[17] in machines and their batteries, the source of the necessary electrical power, if their programmes could be changed regularly with new pictures in order to get customers often returning.

After the appearance of the Kinetoscopes in London, Acres reconstructed his 70 mm camera to the Edison gauge of 35mm film perforated along both edges. From February 1895, Acres was able to make films on 35mm suitable for the Kinetoscopes of Edison. An experimental camera is in the Science Museum, Kensington – a donation from Birt Acres's son Sidney Birt Acres. This is the camera that could have been used the year before as a prototype 70 mm camera – a 'bread model' as Acres's grandson Alan used to call it.

17. Edison sold Kinetoscopes for $200 to $250 a piece to his agents who in their turn sold them for $300 to $350 a piece, in England £75, in France Fr.1500, in Germany 1500 M. Robert Paul sold his Kinetoscopes much cheaper.

Birt Acres was the first to film meteorological phenomena, historical events and royalty. On 29 May 1895, he filmed the Derby with the new 35mm camera which had a clumsy pulley and belt outside the camera case fitted on the tripod, as can be seen on the well-known photograph of Acres standing on the jury platform at Epsom.

Acres was slightly ahead of the Lumières. Some of those early films still exist: ROUGH SEA AT DOVER and THE DERBY OF 1895.[18] The film stock that Acres and Cooper used was manufactured by themselves on celluloid purchased from the English Blair Company at St Mary's Cray in Kent.

Around the same time, Acres through one of Elliott's employees came into contact with an instrument maker Robert William Paul, who was copying Kinetoscopes, which were not patented by Edison in England. In exchange for films for these Kinetoscopes, Paul agreed to construct an improved 35mm camera. The improvement most probably concerned the construction of a hand-cranked drive mechanism inside the camera. The camera was finished in time, and patented as the Kinetic Camera.[19]

Through his London branch, Ludwig Stollwerck was brought into contact with Birt Acres who had acquired fame with his lectures on photography illustrated with moving projections. It is THE DERBY OF 1895 with its three consecutive scenes that Acres demonstrated to Stollwerck's London representative Ernest Searle. Two weeks later Acres met Stollwerck in Cologne.[N36] Acres was not unknown in Germany.[N37] He was praised in German photographic magazines for his photographs with their 'beautiful operation of light and clouds'. Later he was reported to walk with his Kinetic Camera on its tripod shouldered like a rifle.

Acres took the improved version of his Kinetic Camera with him to Germany, where, in June 1895, he filmed the OPENING OF THE KIEL CANAL, THE KAISER REVIEWING HIS TROOPS and THE KAISER ON HIS YACHT HOHENZOLLERN. The German emperor sailed in front of an international regatta of ships through the new canal from Brunsbüttel to Kiel.[N38] Through Stollwerck, Acres got into contact with Edison who bought several of his films. Acres sold copies of his camera to Denmark and the United States. At the end of 1895, at least five Acres cameras were in operation in four countries.

18. Wednesday, 29 May 1895, Lord Rosebery's Sir Visto winning, jockey S. Oates, trainer M. Dawson. A copy of the film was discovered in 1995 and restored by the NFTVA (now BFI National Archive).

19. Patent application for a *Kinetic Lantern*, 27 May 1895, British Patent No. 10,474.

It was Birt Acres who gave the first official British film show, on 14 January 1896 for the Royal Photographic Society in London, a month before the first Lumière film shows in England. On 21 March he started public film screenings with his Kineopticon at 2, Piccadilly Mansions, on the corner of Shaftesbury Avenue. The Cinématographe of the Lumières, under Mr Félicien Trewey, started film shows on 20 February 1896 at Marlborough Hall, the London Polytechnic in Regent Street. In April 1896, several of Acres' films were shown at the Koster & Bial's Music Hall, New York, during the first public film projection in the United States.

Birt Acres disagreed completely with what very soon became the most important aspect of movie making. Acres considered himself to be a follower of the French physician and film pioneer Professor Jules Étienne Marey, the inventor of the Chronophotographe, the predecessor of the Cinématographe. The filming of clouds and waves, the reporting of the opening of bridges and canals, and the launching of ships was of scientific and historical interest, but the use of cinematography for entertainment disgusted him. Today, we may ridicule such an attitude, but we have to realise that during the first five or ten years, nobody knew what one could do with moving pictures except to make money. The first film shows literally were what the posters said: projections of photographs that moved, *living photographs, moving pictures.* It would take some twelve years before the first cinemas opened as we know them today.

Acres, first with capital from British industrialist W.H. Hills, and later from his German client Stollwerck, started his own company, the Northern Photographic Works, manufacturing raw film stock. Acres's old employer Elliott and Sons apparently saw no market for it. Kodak, at first, had not seen it either.

5. "They Thought It Was a Marvel"

How did Cooper come to make a dream sanctuary like A DREAM OF TOYLAND? What was his way of achieving this?

As future cinematographer he learned from Birt Acres what he needed to know. From August 1895, he became a freelance cameraman, promising Acres assistance at any moment when his former boss needed it. He used Acres's old 35mm camera to start an independent career. Acres' first camera was not an easy instrument to operate with its pulley outside. The leather belt would slacken in sunshine and come off. It is with this camera

Fig. 10. Barnet, 45 Salisbury Road was from 1895 till 1898 or 1899
Birt Acres' workshop and film studio with a stage in the back garden.

that Cooper made his first trick films. He most probably used the same machine to give his own first film shows.

Cooper was able to sell his moving pictures to his former boss. If Acres did not like what he made, Cooper could easily sell it to fair-ground showmen or to Robert Paul for his Kinetoscopes or his shows in the

Olympia and Alhambra Theatre in London. Cooper filmed short performances like Twins Tea Party (1895) and Arrest of a Pickpocket (1896) staged in the open air on a wooden floor built in the garden of Acres's workshop at 45, Salisbury Road, Barnet, using the existing laboratory facilities for developing and printing his pictures.

Cooper, like many other early film makers, made a great number of trick pictures. It was so easy to stop the camera and replace a couple of objects with other items. Dozens and dozens of spooky hotels and haunted bedrooms were filmed.

With great pleasure Cooper recollects the making of a very early trick film, Ducks on Sale or Return (1897) when, on a Sunday in May 1956, he visited the son of his employer of long ago, Sidney Birt Acres, at Southend-on-Sea.[N39] Cooper remembered that he used two cameras.

> The first one that I took for a trick picture I had your father's camera, turned it upside down and another camera, I think it was a Wrench, and stuck it beside it. And I took this trick picture of a man, selling my mother back door a duck. He came up with this old crate they used to have ducks in them, and he opened the top and got this duck out, and he tried it. This is a silly picture I know, she came to the door and she said she would have it and then she wouldn't have it, and so he turned it back. And of course I had another duck which was already stripped and skinned, and this was ready for it. He gave her this duck and she wouldn't have it, she gave it him back, in fact she throw it at him. He took it up, put it in his basket, turned it over, and you saw all these feathers flying backwards, which were thrown out when he was picking it there from the reversal, the reversal end to end of the thing-a-me-bob. And all these feathers he put it on to this very duck and he showed my mother this duck with all its feathers on and he put it in his basket and he went away. And that was shown at the Empire Theatre there for weeks and weeks. And they thought it was a marvel. And that was with one camera turned one way, and the other one I had turned upside down, and the two ends were taken and put together. That was the first of it.

This picture was a commercial success for many years. Gifford, in his catalogues, still mentions Ducks on Sale or Return in 1904 under no. 0918:

> Alpha Trading Co., D: Arthur Cooper. Trick. Farmer plucks duck and then film reverses. (Date uncertain).

These reversals were as popular a fashion as the haunted hotels. The Lumières, in 1895, paved the way with a picture of a wall being pulled

down which, after the job was completed, came magically upright again. Men felled a tree that mysteriously got erect as if nothing had ever happened. The film from the upside down camera was printed, turned around so the shot was the right way up, and spliced onto the end of the other camera print. Cooper remembered this when Bert Barker, honorary secretary of the British Fairground Society, came to visit him:[N40]

> *"You had to find the scenes. And then of course you had the reversals with a camera up-and-down. You had a different effect. Supposing you would go in to take* The Felling of the Monarch. *You had two men in a forest, you took two cameras. You took one direct and the other one upside down, like that. And the Monarch by these men was sawn up. And when you showed it you see it falling down and when you showed the reversal, put it on, the bally tree was jumping up, came and stood up back there again. (...) You had to get something big, and out of the ordinary. That was the trick. It took a long time to take it, there was no stage to take in the picture."*

The action to be reversed was taken with the camera upside down on the tripod. The positive print was turned around in order to get the beginning of the shot joined next to the end of the previous (or subsequent) shot. The action would then go backwards. Generally, it was done with one camera, but the action had then to be repeated, and in that case one needed for instance two ducks.

Cooper made his reversals with two cameras, producing two negatives both in the right order because the second camera was upside down. This is what Cooper, in 1958, said when he was interviewed on the radio.[N41] The BBC did not ask at random someone to interview him but one of the most outstanding experts in the field of British film history, curator Ernest Lindgren of the National Film Archive.

> Lindgren: *You told me an amusing story, – about the story of the feathers?*
> Cooper: *Oh, well, that was while reversing the camera, having two, one upside-down, synchronized with the one that was stood up. And as the man pulled the feathers from the duck and threw them into the air...*
> Lindgren: *This was a comedy film, wasn't it?*
> Cooper: *A comedy, yes. That was shown at The Empire on the screen, not at the same night, but as a novelty film.*
> Lindgren: *So that when the film was shown on the screen, it seemed as though the feathers were coming to the duck instead of the other way around?*
> Cooper: *They did it both ways.*
> Lindgren: *They did it both ways?*

Cooper: *The man plucked the duck and gave it to the maid at the door and she took it in. It wasn't a satisfactory one. When she brought it back again and gave it to him; she really took it away, but still – when she gave it to him (laughing) he began to collect the feathers from the air and put them in. That was the first Alpha reversal of a film. When I went down to Tunbridge Wells, that was some two years afterwards, the girls went down the high dive, see. They came down and when the film was reversed they jumped up out of the water unto the running board.*

These films must have been made in 1898 when an indoor swimming pool was constructed in Royal Tunbridge Wells to celebrate Queen Victoria's Diamond Jubilee. This swimming pool in Monson Road acquired national fame because the Cygnus Swimming Club trained there its champion water polo team and exercised high diving for men... and women.[20] Cooper explained to his daughter Audrey:[N42]

The HIGH DIVING business was at the same place. The camera was reversed. The film was taken in reverse and so it gave the impression of the girls diving into the water from the spring board, you see, they dived in the water the camera was moving and the film was joined up, so that when they jumped into the water they came back again.

Another trick picture which he did with two cameras was on commission for Birt Acres. Cooper to Bert Barker:[N43]

I went up there to take the pictures, – if you got anything that was of interest, a factory chimney felling, – I went up there to take the felling of a factory chimney because the governor thought it was scientific. (...) Yes, it was at Stockton (-on-Tees). I sat down there while they were doing – they take some bricks out at the base of it and put a piece of timber in it and another piece, and so forth. And they burn these, set fire to it and I sat up there waiting for bally hours, while they were burning these damned timbers, and I almost lost part of it. I was waiting for it to go and then the thing went down before I was ready. But I got enough of it. Because I had taken it beforehand, while it was standing and then of course, naturally enough when it is projected on the screen it was standing in the way it went. They didn't know I was squatting down there.

One of Cooper's first advertising pictures was for KEEN'S MUSTARD. We are doubtful whether Cooper made it with a special stop-motion camera. It is clear that he had by then enough experience in making trick pictures.

20. We are indebted for this information to the helpful assistants of Tunbridge Wells Library.

Audrey:[N44] "Stockton was a commission. Anyway Acres paid for that. So you see, you can say that is a commission. They wanted him to do things like that. And he went to Blackpool. I don't know whether for Acres or on his own. About 1896, to take this sunset. That was for KEEN'S MUSTARD, and Blackpool is famous for its sunsets. And of course while there he took a pan of the pier and such things."

Cooper himself remembered KEEN'S MUSTARD many times to his children. According to Audrey, KEEN'S MUSTARD was made pretty early, in 1896. Cooper's biographer John Grisdale[21] writes in his manuscript[N45] that the film maker went to Blackpool for KEEN'S MUSTARD to obtain the scene of a sunset on the golden sands. Cooper's son Kenneth Melbourne-Cooper:[N46] "He was by that hotel in red brick, The Imperial Hotel. It was a tubular tripod and it came down with its sharp points. He was standing on the beach and looking around the skyline, and looking down: the legs of the camera had gone down."

Many manufacturers in Victorian times placed their products in the radiance of a world embracing British Empire. Associations of their products with the 'Empire' were bountiful. A manufacturer like Keen promoted its mustard with the slogan that the sun never set on it. The idea was to let the sun rise over KEEN'S MUSTARD. That is what Cooper filmed in Blackpool.

We placed this picture as the first in our animation filmography, because we are sure that Cooper applied the principles of stop-motion animation in this very early advertising film, though likely not actually frame-by-frame. We assume that he filmed it with an upside down camera cranking it just a couple of frames at a time.

Film historian David Cleveland in a letter[N47] to the authors informed them about an early Moy 35mm camera with two tripod screw holes. One bush in the top, the other one in the bottom so that the camera could be used with the bottom up while filming an 'upside down' film, that would later be used as a reversal.

We consider KEEN'S MUSTARD as Cooper's first purposeful step as maker of animation pictures. Birt Acres did not object to advertising films. They apparently did not contradict his scientific principles, and in this period Cooper made several. Not long after KEEN'S MUSTARD Cooper made

21. In 1960, the English language teacher John Grisdale of Southwold, Suffolk, formerly of St Albans, wrote an unpublished biography based on his personal interviews with Cooper. When he moved to a job in Japan he handed it over unfinished to Audrey Wadowska, who tried to finish it.

an advertising film for BIRD's CUSTARD.[22] Again, we are not sure whether this was a trick, an animation picture or a combination. We assume that Cooper took it in the stop-motion fashion by cranking the camera a couple of frames at a time.

Audrey Wadowska told Cleveland[N48] that her father made trick films like KEEN's MUSTARD and BIRD's CUSTARD, but that was not real animation, she thought. "There is a picture of a man in a frame and that man steps out of the frame. Somebody says it is animation, but I have my doubts. Not real animation, isn't it? Trick?"

In an earlier interview when Audrey assured Cleveland[N49] that MATCHES APPEAL was her father's first real animation picture, she argues:

"But I am not dead sure that this advertising film (BIRD's CUSTARD) is frame-by-frame. Some years ago somebody reported it was frame-by-frame. By his description of it: a man steps from a frame and falls down the stairs. You know BIRD's CUSTARD advertising, he falls down the stairs and breaks the eggs. And then, this particular man has no trouble because he uses Bird's Custard powder."

This is what Cooper said to Birt Acres's son Sidney during his visit to Southend:[N50]

> Oh, we took BIRD's CUSTARD when we were at Barnet in Mr Acres' place there. Yes, we took it there. That is one of the things we did take.
> Sidney Acres: That's one of the things my father DID think might be useful for advertisements.
> Cooper: Yes, that was true. I don't think I did do any matches (then). That particular one was done for BIRD's CUSTARD and was given away. Birds gave us a pound a time for each one we placed for him.[23] For instance on the circus grounds. All the circus people had one and they would give us ten bob for it and Bird's would give us a pound. Dickie Bird was with them. But that's in Paul's catalogue. Even in the Warwick Trading Company. We were all there, not Mr Acres, but with the other chaps we were there, we did it among ourselves and did it for BIRD's CUSTARD there.

There is a list of film titles, written in the hand of Mrs Kate Melbourne-Cooper which contains the title BIRDS CUSTARD with the remark 'earlier'. The list is authorized by her husband. The title BIRDS CUSTARD, again without the apostrophe, appears on an additional list of film titles in Mrs

22. Though this brand name is often written as 'Birds', the official name is with an apostrophe.
23. Note Audrey Wadowska: "That is on the fair-ground shows."

Fig. 11. Easter, 1 April 1956, Arthur Melbourne-Cooper has visitors in his
'Lantern Cottage' in Coton near Cambridge; from left to right: Cooper,
son-in-law Bob Messenger, daughter Audrey Wadowska, and
W.J. Collins, director of the London advertising agency Pearl & Dean Ltd.

Cooper's handwriting. These lists with their valuable information were
sent to Audrey.

We know quite a lot about this BIRD'S CUSTARD picture, because W.J.
Collins, director of London's important advertising agency, Pearl & Dean Ltd.
wrote about it in different papers. In the *Kinematograph Weekly*[N51] he wrote:

"Arthur Melbourne-Cooper, who was cameraman to Birt Acres in 1892 and
onwards to the turn of the century (...) made an advertisement film for BIRDS
CUSTARD [sic] powder which was shown as early as 1897. The contemporary
poster for Birds Custard powder was brought to life by kinematography, 'an old
man walking down the stairs, slipping and dropping a tray of eggs ... a chef
mixing Birds custard powder looks on and laughs ... he is not worried about
broken eggs, he uses Birds custard powder.' Simple, but effective, this film was
shown extensively by the early fair-ground showmen. Trading conditions
between advertiser, producer and exhibitor were peculiar. The advertiser paid

nothing for the production of the Birds custard film and the fair-ground showmen got nothing for showing it. But Birds paid the producer £1 for every copy of the film sold and supplied to travelling showmen, according to Arthur Melbourne-Cooper.

Audrey even discovered who played the old man. It was a Mr MacLeash from Barnet.

6. Not Tricks but Animation Gives Life

In July 1958, on the occasion of an exhibition on early filmpioneers in Southend,[24] Cooper was interviewed by ITV television.[N52] The interviewer asked him:

> *I believe we had you to blame or bless for these frequent interruptions in our programme. You were the first person to start animated advertising? 1896?*
> Cooper: *Yes, the first one I did was for* BIRD'S CUSTARD. *Then followed a film for Bryant and May of animated matches. This was used for the special appeal for donations to send one box of matches to each soldier in the battalion.*
> Interviewer: *Did you have any difficulty in getting people interested in the idea?*
> Cooper: *We did have some difficulty because there was nowhere to show them once they were made. We had to give shows in fair-grounds and in private houses. But the companies did give us £1 a showing.*
> Interviewer: *But did you see the enormous commercial possibilities of this?*
> Cooper: *At the time we did it just for fun – although we did think about its future quite a lot.*

Cooper was right – where or when do you show these marvelous moving pictures you just made? At a trade show for instance. *St Albans Times* had a report about the St Albans Trade Exhibition at the Drill Hall.[N53] In January 1898, the local newspaper *Herts Advertiser* where 'the cinematograph was greatly enjoyed, a good number assembled to see the pictures'. The reporter mentions demonstrations of the phonograph, Cadbury's Cocoa, Alfred Bird & Sons Custard Powder, Holder's Bakery demonstrating the

24. Live interview on ITV introduced by Ludovic Kennedy in connection with an exhibition, organised by Kennedy Melling that opened on Monday, 14 July 1958, at the Odeon in Southend, *The Moving Shadow*, on film pioneers Birt Acres, G.W. Noakes and Arthur Melbourne-Cooper.

making of both 'White and Brown Bread with his machinery', and demonstrations in 'The Art of Hairdressing'.

Not only is the 'cinematograph' showing 'what are popularly called Animated Pictures', it also demonstrates the 'art of advertising', which is how the reporter with tongue-in-cheek describes some of the moving pictures.

"Some of the subjects were comic, but a great many of the 'bits' thrown on the screen by the Cinematograph had reference to somebody's tyres, or somebody's Special Invention. It was all very interesting. Whilst noting the movements of a young man, who, on a cycle journey, had very considerately taken charge of another fellow's sister, one was apt to forget that the lesson he gave us of pneumatic tyre repairing was another illustration of the sweet uses of advertisement. This is where the 'Art' comes in!"

Audrey concludes from this report, and mentions this in some of her interviews, that her father made a moving picture BREAD MAKING AT HOLDER'S BAKERY, together with NESTLE'S MILK, also called THE STOLEN MILK, and PAPER TEARING. The last one is possibly a trick picture in the tradition of CUTTING AN APPLE and HAUNTED HOTEL. The *Herts Advertiser* reporter mentions at least two pictures. One is called by Audrey RIVAL CYCLISTS, recommending the virtues of a specific pneumatic tyre, FLUES'S TYRES. The other one is on some occasions referred to as COLLIER'S TYRES or COLLIER'S NEW INVENTION, a tyre that would not flatten after a puncture. Tyres were a very popular subject when bicycles came into vogue, because the roads were not especially fit for riding on them, often causing punctures. Cooper himself was an ardent cyclist, taking his camera with him when he cycled to Brighton.

We are not at all sure that these pictures were done with some animation or trick work, and we left them out of our filmography, giving mention to RIVAL CYCLISTS and COLLIER'S TYRES in the final chapter 'Probables and (Im)possibles'.

Apart from the several reversals and other trick pictures like DUCKS ON SALE OR RETURN, it was KEEN'S MUSTARD and BIRD'S CUSTARD that formed the up-beats for his first apparent stop-motion pictures: his ANIMATED MATCHES PLAYING VOLLEYBALL, ANIMATED MATCHES PLAYING CRICKET and MATCHES APPEAL.

Birt Acres, in 1895, produced a series of trick films for which Cooper was the cameraman, TOM MERRY THE LIGHTNING CARTOONIST, where an artist made sketches on big sheets of paper of popular personalities like Kaiser Wilhelm of Germany. This was a typical musical hall act taken with

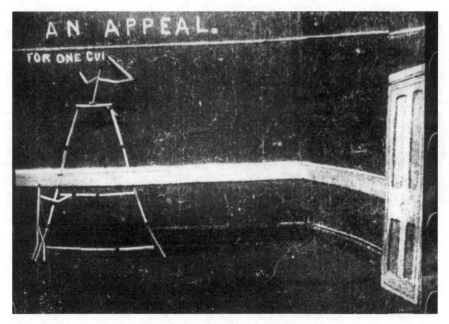

Fig. 12. MATCHES APPEAL (1899).

a camera cranked slower than the usual 30 to 40 frames that were necessary for showing in Edison's Kinetoscopes. These lightning sketches are not animation but examples of trick film technique.

In making pictures like A DREAM OF TOYLAND, Cooper deliberately manipulated three-dimensional objects in such a way that we can no longer speak of trick films. Film makers like Georges Méliès in France, Walter Booth in England, and J. Stuart Blackton in his early years in America made trick films, where the camera was stopped for a short period of time in order to move one or more objects.

In the Twenties, one of Cooper's former actresses, Jackeydawra Melford, wanted to make animation pictures. Some fifteen years before, Jackey and her sister Mavis, daughters of a then well-known actor Mark Melford, had many times observed how Cooper made animation pictures. She now had bought a stop-motion camera and asked her former director for advice. Cooper wrote her a long letter with many detailed instructions. He explained how to animate a puppet in frame-by-frame movements, how the movements of puppets and toys have to be adapted to the distance from the camera, and how each movement has to be gradually executed.

It is a pity that we have only some fragments left of that letter, but even these fragments show the craftsmanship with which Cooper made his animation pictures. He made a great number of little drawings demonstrating how to animate the footsteps of a matchstick-like puppet. This is essentially different from the trick film techniques. To get a white teddy bear in A DREAM OF TOYLAND to look like he is actually walking, fighting and climbing on a motor-bus, a simple stopping of the camera is not sufficient. His legs and paws have to make movements at the same time, and these movements have to be analysed and cut into segments of a fraction of a second. Cooper took one frame, sometimes two, for each movement. Every step of the bear meant he had to be manipulated ten to twelve times or more for every second in projection.[25]

His legs, arms and most of the time his head too had to be moved bit by bit. And when you develop and print this piece of film, and put it in a projector, this polar bear suddenly springs to life, walking, gesturing, wrestling with policemen and climbing motor-buses. You don't stop the camera simply to move dead objects, but to give an assertive white bear a soul. He suddenly gets an *anima* – and that is what *animation* means – to give life.

7. Foundation for Creativity

How do we look at old moving pictures? In the same way as we look at Shakespeare and his plays? At Jane Austen, her novels and her time? Byron? T.S. Elliott?

Their plays, books and poems are still there as complete as possible. A lot is known about the authors and about their times. Balanced opinions and honest reviews of their work are in abundance. This is almost impossible to achieve as soon as we look at the first decades of a phenomenon that gained a permanent and very influential place in practically no time in cultures all over the world.

Too many of the moving pictures from before the Thirties disappeared. An objective opinion on those early film makers, a balanced review of their work, and an honest marking of each of their films seem almost impossible,

25. Handcranked projection speeds varied in the early days. We therefore assume a generally agreed average speed of 16 fps, but that does not mean that a picture would appear too slow or too fast. Projectionists could run them faster in order to get in more shows or, at the end of the night, to finish and get home earlier. (With thanks to Anthony Slide.)

let alone a well-considered judgement on their social importance and influence on society.

Cooper's A Dream of Toyland, this jewel of stop-motion animation of 1907, most probably survived because it was distributed in many copies due to its commercial success, a number of 300 according to our sources. As in nature, its survival chance lay in its numbers. A Dream of Toyland was made and distributed in the same period when J. Stuart Blackton and Emile Cohl were called the founders of animation. But why was it never recognized as another founding stone of animation history?

It may seem generous to a fault to pay so much attention to this unknown pioneer of cinematography, but that does not alter the fact that a number of independent witnesses confirm directly and indirectly Cooper's profound and productive involvement in moving pictures as producer, director and cameraman. We take a pick at random from the Audrey Wadowska estate:[N54] a picture postcard mailed to Cooper from Blackpool with the message:

> Dear, do you know I was really startled to see my own face in the "Scotchman" at the Palace today. I am having a fairly good time here, weather not too nice (signed) *Ruby Vivian*.

Ruby Vivian was one of the two actresses in MacNab's Visit to London (1905; a distribution title of this live-action picture was The Scotchman), and it is Ruby who plays the mother in the live-action scenes of A Dream of Toyland.

There is E.G. Turner of Walturdaw, Ltd., who, on 16 November 1907, took 75 copies of A Dream of Toyland with him to the United States on the maiden voyage of the Mauretania. There are the interviews with Stanley Collier who, for ten years, was one of Cooper's closest assistants, always organising the transport for the many outdoor locations and taking care of the necessary motor-cars. It was Stan Collier who designed the sets for A Dream of Toyland which were painted by his sister Jessie, and who made the motor-bus with the advertisement for *Zoe Soap*, because Zoe was his girlfriend at the time.

An exciting strong statement from one of Cooper's assistants was printed in the *Kinematograph Weekly* in 1947,[N55] by Henry Maynard, who saw many celebrities of stage and screen watching Cooper at work down in the basement of 4 and 5, Warwick Court, including Urban, G.A. Smith, Robert Paul, Moy, and many others.[26]

26. With much thanks to Ronald Grant. See chapter 4 for the complete letter.

There are those who interviewed Cooper, his biographer Grisdale and National Film Archive curator Ernest Lindgren. The recordings of their interviews are part of the collection of seventeen audio tapes with Cooper's voice. Then there are BBC presenter Richard Whitmore, journalist Joe Curtiss, British Fairground Society's honorary secretary Bert Barker, and writer Arthur Swinson. We mentioned the more than 150 former actors, actresses and local people who were interviewed by Cooper's daughter Audrey Wadowska. An important source for most of the facts that my partner and I got to know about Cooper are our own interviews with Audrey.

We can try to dig up as much as possible that is in print, we can critically listen to children and grandchildren of the film pioneers, and we can make a conjectured judgement on the basis of some of the moving pictures that arbitrarily survived and were restored on safety material. But in sharp contrast to writers, poets, painters and composers, this is all that we can do for early film makers who, in less than two decades, had such a great share in providing and diffusing a new and shining muse that conquered the world in all stratas of society and all walks of life.

The following is possibly also rather striking. John Barnes, author of no less than five volumes on the *Beginnings of the Cinema in England*,[N56] and Rachael Low, author of seven volumes on *The History of the British Film*[N57], both give hardly attention to animation even though their books are of great importance as works of reference.

We therefore felt greatly encouraged with our Arthur Melbourne-Cooper research when no less than three important authors on animation pictures mentioned his name, and specifically record his very early Matches Appeal of 1899 as a possible first example of stop-motion filming.

In London, we visited animator John Halas to interview him just after the publication of his work *Masters of Animation*,[N58] who assured us that Cooper was an imaginative artist, a true pioneer of three-dimensional puppetry. He wrote: "In Britain, Arthur Melbourne-Cooper had come up with what is often considered to be the world's first animated commercial. It was a stop-motion film of 'moving matchsticks' reputed to have been made in 1899, and promoted by Bryant & May, having the appropriate title Match Appeal [*sic*]."

Then, in America, there was Donald Crafton, one of the first to thoroughly research the very first years of animation film history. "Some people will no doubt be surprised to learn that there was any animation at all before Mickey," he writes in *Before Mickey. The Animated Film 1898-1928*.[N59] "In fact there was so much that I had trouble assimilating it."

And: "Animation, let alone silent animation, is admittedly a minor branch of the history of cinema. (...) More recently, film scholars have tended to ignore early animation or to condemn it to the domain of film-buffism." Crafton, with a fine frame still from A DREAM OF TOYLAND, gives, to our surprise, sufficient attention to Cooper:

"This versatile film maker began his career as Birt Acres's cameraman in 1898. The primitive advertisement MATCHES APPEAL (1899) shows Cooper's early grasp of the principles of stop-motion photography, but he also directed comedies and dramas as well as trick films. DOLLY'S TOYS (1901) may have also used animation."

In his next book *Emile Cohl, Caricature, and Film*,[N60] Crafton goes even further, boldly suggesting that Cooper's animation pictures could have been the source of inspiration to J. Stuart Blackton, a giant in the early history of animation pictures:

"British film maker Arthur Melbourne-Cooper's first experiment in object animation appears to have been MATCHES APPEAL, a Boer War propaganda film said to have been released in 1899, although the date has not been confirmed. But either Cooper's DOLLY'S TOYS, released in 1901, or THE ENCHANTED TOYMAKER, of 1904, could have provided inspiration for Blackton if they contained true animation, since it is likely that they were both duped and distributed by Edison.[27] The February 1903 catalogue describes ANIMATED DOLLS, a film in which sleeping children are visited by a fairy.

"The dolls which are dressed as boy and girl, come to life and begin to make love to each other. They make so much noise, however, that they wake up the children. Upon seeing the action of the little people, the children are very much amused, and sitting up in bed, they watch the performance. Finally the dolls, upon seeing that they are discovered, resume inanimate form, and the children jump out of bed to get them."

While this may have been a remake by Edison's special effects buff, Edwin S. Porter, it seems more likely that the film was simply a retitled dupe of Arthur Melbourne-Cooper's original. The same may be said for THE TOYMAKER AND THE GOOD FAIRY described in the September 1904 catalogue.

Halas and Crafton are not the only ones supporting us in the credibility of Cooper being a true film and animation pioneer. From Italy comes Giannalberto Bendazzi's thorough comprehensive study of animation pictures, *Cartoons*[N61]. With Crafton he shares an amazement about the lack

27. Edison did not like anyone copying his inventions or pictures. Was this a retaliation for the Kinetoscope being copied and sold to everyone in the UK and abroad?

of serious attention, animation unjustly being associated with cartoon magazines and books for children. Animation, says Bendazzi, is a rich area, linguistically, technically and stylistically. As an expressive form it is indeed autonomous. It is quite understandable, he writes, that animation has taken a course parallel to, but not the same as, that of mainstream cinema, and has a history of its own.

One of the founding fathers of this particular autonomous history is the subject of our book. We find this supported by Bendazzi: "If animation comes into play not when its techniques were first applied, but **when they became a foundation for creativity**, then the first animated film could very well be Matches: An Appeal, by the Briton Arthur Melbourne-Cooper. Made in 1899, with animated matches, Matches: An Appeal was a public address inviting British citizens to donate matches to the soldiers fighting in the Boer War (...)" (bold by us).

"Arthur Melbourne-Cooper (St Albans, 1874 – Barnet [sic], 1961) was the creator of the 'first' animated film ever, Matches: An Appeal (1899). Cooper had learned the technique of 'moving pictures' by working with the pioneer of British cinematography, Birt Acres; later, he became a producer, cinema owner, and director of all kinds of short films."

Supported by three giants in the field of animation film history, we find ourselves now bold enough to start our second chapter on the true history of Matches Appeal.

"In early British film," Richard Crangle writes in his contribution 'Astounding Actuality and Life. Early Film and the Illustrated Magazine in Britain' in *Cinema at the Turn of the Century*,[N62] "so little of which has survived, there is the additional problem of all the information we don't have: the many lost films which might give a different impression of the technical development of the medium."

Thousands of films, especially from the first twenty years, were thrown away or destroyed, mainly because they lost their commercial value. But with their destruction a clear view is lost on what inspired and animated our parents and grandparents, on their choices and confidentialities, their dreams and realities, their hopes and expectations. In short, we lost a view on an earlier era that formed the today that we live in and that could explain many topical questions.

Martin Scorcese calls it a 'massive tragedy' in his preface to Paolo Cherchi Usai's *The Death of the Cinema*[N63] when he speaks of all the moving images that are already lost to us forever. There will be no vaults for them, and no fundraising efforts will ever bring them back to us. Even the

colours, after only a couple of years, are lost. What we often see are the faded shadows of what once was.[28]

Usai wrote several books on silent cinema, incessantly pleading the necessity of its conservation. The subtitle of his book, *History, Cultural Memory and the Digital Dark Age,* says enough of the author's fear for the future of the moving picture. The successful experiment on Saturday, 15 December 2007, of a satellite broadcasting to 700 cinemas all over the world of the live performance of Gounod's opera *Roméo et Juliette* at the Metropolitan Opera in New York signifies a dangerous precedent. Tomorrow, one or two digital copies of a moving picture on a hard disk will be enough to service thousands of cinemas all over the world without feeding the actual film material into a projector on the spot. The Netherlands Opera shall, in the next season, show several operas via satellites in fourteen cinemas in the country. And with ultra-high definition we shall soon receive cinemascope-TV in our living rooms.

It is as if cinema has passed its zenith, and we are left with the stale commercial waste of HD-TV, blu-ray, and internet on PCs. Digital satellite shows in many cinemas at the same time without film projectors are already here to stay. With the vanishing of the film itself, will film history now become a footnote in the history of digital technology,[29] just an appendix in the rear of the Gates hagiography?

Numerous early cinematographers are forgotten. Justifiable or not, their work would have given us a clearer look on their time. Had more pictures of Cooper survived, the chances are that he would not have been almost forgotten today.

Still, we are confident enough that we will yet be able to demonstrate sufficiently our three propositions in the next chapters with the six surviving animation pictures of Cooper, starting with three simple looking pictures made with matchsticks.

28. In recent years we donated our nitrate film collection to the Netherlands Filmmuseum, knowing that it continuously works on conservation, recently receiving €35 million for conservation and digitalizing the collection in co-operation with five national archive institutions. Thanks to the project *Beelden van de Toekomst* (Images of the Future) it will be possible to view favourite Dutch moving pictures or television programmes at any moment at home.

29. See for these possibilities, or if one prefers: dangers, Frank Kessler's oration *Het idee van vooruitgang in de mediageschiedschrijving* (The idea of progress in the media historiography), Utrecht (University Utrecht), 2002, pages 15-19.

8. The Cinema Is Where Movies Belong

A movie is a sham product. If you are not a distributor or exhibitor, you cannot take it with you. You cannot wrap it in a gift paper and present it to someone you love. You cannot stack it away on the shelf.

Yes, you can. You can stack hundreds of videos and thousands of DVDs on your shelves. But they are not cinema. No lights that go out. No: "Shush, the movie begins!" What's more, tomorrow, the industry will ensure that videos will not be viewable anymore as soon as your player breaks down. Their successors, the DVDs, have a life-expectancy of ten to fifteen years, but the industry, in the meantime, is forcing upon us new technologies like Blu-ray and high definition. A movie is the out-of-date product that sham salesmen recommend at the top of their voices at the Portobello Road market with the guarantee of your eternal life and everlasting bliss.

Of Toys, Dolls, Puppets and Hamleys

What are those toys in Toyland? Are they mechanical dolls with inside springs that can be wound up? Are they just marionettes? But where are the strings or the rods? Must we call them dolls? Where are the hands that move them from inside or outside?

In the world of animation cinema, they are called *puppets*, a word from the Latin *pupa*, or *poupée* in the French language. Instead of being moved by an inside hand, or outside with strings or rods, the puppets are moved bit by little bit and photographed after each movement.

Because books and publications on animation pictures most often give only passing reference to puppet animation, we will collect a couple of quotes from some leading authors in this field to honour the puppets and their animators. John Halas and Roger Manvell in their *The Technique of Film Animation*[N64] give this definition: "We intend the generic term puppet film to include not only the animation of dolls but any solid object."

Film critic Giannalberto Bendazzi in his standard work, *Cartoons. One hundred years of cinema animation*,[N65] writes: "Dream of Toyland, in which toys, given as presents to a child, come alive in the child's dream. The puppets are animated with precision and delicacy."

L. Bruce Holman, in his *Puppet Animation in the Cinema*[N66] defines it as follows: "In general it is a film made by using free-standing, articulated

puppets made from wood, plastic, or other materials. These puppets are photographed on a single frame of motion picture film, moved slightly and photographed again on the next frame of film, and so on until the action has been completed."

"Puppet films are made with stop-motion photography, the same as animation that is hand-drawn. The puppet's position is altered slightly for each single-frame exposure. During projection the puppet appears to move." This is Donald Heraldson's definition in his *Creators of Life*.[N67]

Jiří Trnka, son of a doll-making family, was an original Czech puppeteer and innovator. He brought the theatrical puppetry traditions of his country to the cinema screen. A craftsman and artist, he mostly resembles Cooper 40 years later when he starts with his first puppet animation, an almost story-less THE CZECH YEAR, which is full of mood, poetry and meaning. His biographer Jaroslav Boček[N68] writes the following, and it is as if he writes about Cooper:

> The basis of all art is craftsmanship, and Trnka's craftsmanship is as solid and honest as that of a joiner or blacksmith. He wanted what he created to stand as firmly as a good table stands, without coming apart at the joints. The art critics compared his studio with truth to the workshop of old painters. To bring the creative work to life required more than craftsmanship: it was a creative task. To the uninitiated there might seem to be some sort of magic in this giving of soul to dead matter, but there was nothing magic about it, unless there was magic in the fantastically hard work with which Trnka and his fellow workers approached their task.

Looking at Cooper's first three stop-motion pictures which were made with matchstick men, one will notice that they are made in such a way that they can be operated like puppets. For his next animation pictures, Cooper went to the famous Hamleys Toyshop in London. Hamleys, in the next years, made many dolls for Cooper on order. The puppets he used needed specially prepared joints so that their limbs would not break off when moved 10, 12 or more times for every second of projected film. Hamleys manufactured dolls for him that allowed movement of limbs hundreds of times during a movie production.

Hamleys Toyshop in Regent Street was founded in 1760 by William Hamley and called 'Noah's Ark'. It was at one time the largest toyshop in the world. Cooper in his time probably ordered his puppets from the High Holborn branch.

A real movie is different. It has to be watched in a cinema as its own theatre where it belongs. A real movie only exists in a projector which is turned on after the lights have been put off. After the show, as soon as you leave the cinema, there are all kinds of memories in your head, above all the memory that you have been in something wonderful, something living, something more real than the cold reality outside the cinema. The movies, therefore, were quite a revolutionary product. They could only have been invented in the 19th century as a by-product of an on-going process of industrialisation. As a product of capitalism it is a perfect product. Theatrical plays, musicals, football matches – they all have their players who can be touched and traded for great sums of money. The movies, after the light has gone up and the proscenium curtains have closed, leave you alone. You can only try to get a grip on the players through newspapers and magazines, and through all the paraphernalia that arose as byproducts of the movie industry. Especially the magazines with which one tries to confirm and prolong those images of pleasure, those pictures that satisfy, fulfill and evoke euphoria.

Movies cannot be properly watched and understood on television. The screen is too small, and the lights are always on. There is no collective theatrical experience but the interruption by your partner: "More coffee? Or is it time for a beer?" Or even worse, your partner falls asleep against your shoulder. Most of all, the cinema with its big screen gives you the chance to neglect your surroundings, to forget where you are in time and place, and to be swallowed up by the events on the screen. How big the so-called home cinema screen may be and how high the Blu-ray definition, the living room is not a movie theatre. Full stop.

We deeply and sincerely wish, because of our love for the movies, that every acadamic institution, every university where they teach film, should be obliged to have a lecture theatre with facilities that make it resemble an old-fashioned cinema. Only in that way we can re-create what our parents or grandparents experienced when they went 'to the pictures'. Only then we can come to some idea about the movies and their audience from long ago.

"Such films had to be seen in your friends' company," writes journalist Frits Abrahams about THE TEN COMMANDMENTS in an obituary of Charlton Heston.[N69] "Only after the show, during a long evaluation at the edge of the curb, the picture becomes burned into your memory for the rest of your life."

Once, a long time ago, in our own little home cinema equipped with a Kalee 21-projector for 35mm film and CinemaScope, we sometimes showed ourselves old silent films on nitrate base. We were beginning

collectors, and as amateur projectionists very naive, not realising its dangers. But this screening was a miracle! We were astounded at its clarity, its sharpness, its depth of focus, its almost three-dimensional images in which the actors and actresses moved and acted as if they were able to detach themselves from the screen and, in front of it, continue their acting in our little cinema. After 30 years we still remember those private shows as exciting and wonderful events. We experienced what movie-goers of long ago must have experienced.

Real film buffs and film collectors have their own miniature cinema at home in the attic or in their garage. They sometimes are real little gems of home cinemas equipped with not only 8mm and 16mm projectors, but sometimes even 35mm. Outsiders, especially in a country like Holland where there is hardly any film culture, call these movie lovers 'film nutters'. And silent movies are mockingly called "stomme films" (mute in the sense of stupid).[30] This must have obliged the film trade enormously. Get lost with that old stuff of yesterday!

But stupid they are not. And to call them even 'silent' is a mockery, because they are able to tell so much about the days when they were new and exciting. When the title was announced in the show-case in front of the cinema, it would already create a thrilling feeling of expectation. What those movie nutters and film collectors want to re-create at home is the theatrical experience, the nostalgia of the theatre as it was.

Anyway, it was these film nutters who picked up from the waste bins what the trade threw away after it had outlived its commercial life span. The authors started their own film collection buying, amongst others, from a businessman who had a silver washing enterprise. If we were willing to pay more than the expected proceeds of silver from what he bought from distributors, he would consider selling a film to us. Thanks to these collectors who were there from very early on, film archives, film museums, cinémathèques and film institutes now possess rare and irreplaceable collections of old films. But too much has been lost.

What survived still gives us the opportunity to be Bordwell's spectator who participates in creating the illusion, an illusion that our grandparents and great-grandparents enjoyed so much that it caused a world-wide new industry in no time.

30. Even the National Museum of music boxes and barrel organs in Utrecht announced in April 2008 the showing of the silent movie GAVROCHE AU LUNAPARK twice as a 'stomme' children's picture.

And now we have the cinematograph. It brings our photographs to life, and all that moves appears to be alive again for an endless number of times. Its name comes from graphein, the Greek for writing, because in long bands of photographs it writes down the kinèma, the movement. That is why, in the beginning, Kinematography was often written with a K. What next?

The next step is very simple if one just takes time and patience. Now that we have the movement of the pictures, we also have the power to stop it. And in the frozen space between each two pictures we now can breath life into those lifeless matchsticks, and make real men out of them!

CHAPTER 2

Everything to Its Own Order

1. A Tea Caddy with an 1899 Animation Negative

Between the thousands of photographs in the Audrey and Jan Wadowski estate, we discovered an interesting series of twelve snapshots. Arthur Melbourne-Cooper received some important guests at his cottage in Coton, his home when he retired. Cooper, his guests and both his daughters are in the front garden. It is Easter, 1 April 1956. The photographs show a relaxed and cheerful group of people. Cooper, as we know from the seventeen tape recordings, was a born *raconteur*, and it is clear from the snapshots that he has his guests' undivided attention for what he is enthusiastically telling them. Cooper as their host creates a warm atmosphere with his extrovert charm. One guest is Pearl & Dean director W.J. Collins.

The other guest is Brian Coe, author and film and photography historian, at that time deputy curator of the then still existing Kodak Museum at Harrow, of which Dr R.S. Schultze was the curator.

In May, Collins will publish the articles we already mentioned, one in *Kinematograph Weekly*, 'Advertising was there from the very start', and

Fig. 13. More visitors in the 'Lantern Cottage' garden, from left to
right: Bob Messenger and his wife Ursula, Cooper, Audrey Wadowska,
W.J. Collins, and Brian Coe, deputy director of Kodak Museum, Harrow.

'Advertising was in at the beginning'[N70] in *World's Press News*. In both
articles Collins will give Cooper ample credit for his BIRD'S CUSTARD (1897)
and for MATCHES APPEAL (1899). Cooper's daughter Audrey is present too,
as is his other daughter Ursula with her cheerful husband Bob Messenger.
Audrey's husband Jan Wadowski, called Jasiek by everybody, is taking the
photographs.

There is a moving snapshot of Cooper and Coe at the back of his garden.
Both men are standing on a small lawn. Cooper is apparently telling Coe
about his gardening hobby, showing him his patches of vegetables. He
loved to grow fruit, vegetables and all kinds of home produce. We see some
neat patches and rows of lettuce. This picture demonstrates Cooper's trait
of character. He is capable of giving attention and concentrated affection to
time-consuming chores in the garden. It is this same loving attention and
caring affection that he gave to the production of animation pictures.

In 1981, Audrey told us the following about the photographs:[N71] "Should
be Coton because there is the old school, the cottage is behind this way. This
is Brian Coe talking to dad here. Kodak's publicity man, he is the big chief
now that Dr Schultze retired. (...) Collins was the boss of Pearl and Dean,

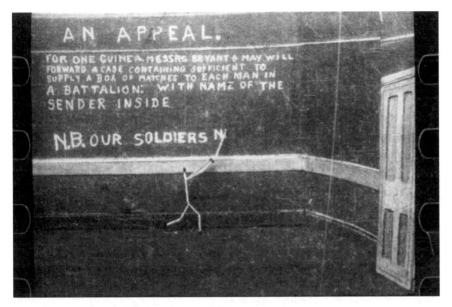

Fig. 14. MATCHES APPEAL (1899) - the appeal is written, the finishing touch is a heart-rending 'pay-off': "Our soldiers need them."

advertising agency. (...) He was interested in the advertising films that father made. And he wrote that article that appeared somewhere around Observer Exhibition[31] time, in *Kinematograph Weekly* where it says: Advertising was there from the beginning. And he mentions father and BIRD's CUSTARD."

This visit during Easter 1956 is an important occasion. We know that Audrey made some important preparations, because it is on this occasion that Cooper donated to the Kodak Museum a new 35mm print from the negative of his 1899 animation picture MATCHES APPEAL, which he so carefully kept during all those years. Three months later, 26 June 1956, Schultze writes to Cooper:[N72]

> Dear Mr. Cooper, Mr Brian Coe has handed over to us the 'Matches appeal film', which you have very kindly donated to the Kodak Museum. We are very pleased to add this to our collection of old films, and we thank you very much for this gift.

31. The Observer Film Exhibition, *60 Years of Cinema*, London, 1956.

The negative survived 57 years thanks to a missing opening sequence, the commercial pitch, in which a Bryant & May box of matches opens, and out of it come several matches which form themselves into matchstick figures.

In 1908, the opening sequence was used by Cooper for a new animation picture with matchsticks. That was during the time when he moved his Alpha studios from Bedford Park to premises at Alma Road, almost opposite his new cinema, the Alpha Picture Palace in St Albans. When Cooper finished the animation on the new picture MAGICAL MATCHES, he decided to put the opening scene of MATCHES APPEAL in front of it. We can imagine that the following happened. Cooper, in the turmoil of the removal, looked around for the negative, found it, and cut from it the scene with the Bryant & May matchbox opening itself. Then he looked around for a tin to safely put the old negative away. He went into the kitchen of his house which formed part of the new studio premises, with the roll of negative film in his hands, and asked his wife for an empty tin or tea caddy. He got what he wanted, and in it he put away the negative of MATCHES APPEAL without its opening sequence, which he took back to the studio to put it in front of his new picture, distributed in that same year by Charles Urban's Urbanora company as MAGICAL MATCHES, also known as MYSTERIOUS MATCHES. Unwittingly, the negative was kept in the family household, and in this way stayed out of the estate of the Alpha Trading Company when, in 1915, it folded up, and the last stock of negatives was sold. The tin or tea caddy – Audrey absent-mindedly sometimes talks about an old camera case – was forgotten until it was opened when the family moved from Carleton to Coton after Cooper's retirement in Blackpool. Cooper, when he saw it again, knew at once what it was. He told Ernest Lindgren about it during his interview for the BBC radio on 11 July 1958. That is why we know what exactly is missing, the beginning part that actually made it an "industrial", as Cooper used to call it, an advertising picture with an added source of income.

Audrey took care that the negative went to a film laboratory, Cinefex. Her name is still there on the leader of the positive print as the consignee.

Cooper himself handed over the film to Brian Coe, the same Brian Coe who will write in his later function as curator of the Kodak Museum the foreword for John Barnes's first volume of his *The Beginnings of the Cinema in England*:[N73] "...the reminiscences of elderly people whose recollections were often confused and biased." We would not pay attention to this quote, if it was not for the confusing aftermath of Cooper's donation. We will try to unravel this.

2. Animation, the Cinderella in Film Land

"They really do exist," writes film critic Rob Wijnberg in the serious Dutch newspaper, *NRC-Handelsblad*,[N74] "grown-ups who fundamentally do not watch animation cartoons because they think they are too old for it. Not even as a toddler was I so prejudiced. And still I sometimes feel substitutional grief when I discover that someone does not know THE SIMPSONS. I can understand one is not acquainted with the master works of Kant or Heidegger. Tough fare. But THE SIMPSONS: that is compulsory philosophy." At the 2007 première of the cinema feature of THE SIMPSONS, this is a current assessment of a badly neglected form, a neglect demonstrated by a journalist of the daily tabloid *Trouw*, Peter Dekkers, who compensates the regular news overdose of war, murder and misery with watching from time to time a "funny, deliciously naive Disney animation".[N75] Naive animation... Deliciously naive...

"(Animation) still lacks serious critical appreciation," says animator and writer John Halas.[N76] "It has few critics who are able to analyse what is good or bad, or who know what values to look for in an animated film. Many make the mistake of comparing animation with live-action productions, making unfair comparisons between two very different disciplines."

"Why is there such a chasm between the richness of creative minds on one side and the lack of a receptive audience on the other?" asks Bendazzi in his *Cartoons*.[N77] Is it caused by the mechanisms of film distribution, because animators release mainly short films and are therefore rarely seen in cinemas? Bendazzi argues that it is quite understandable that animation has taken a course parallel to, but not the same as, that of mainstream cinema. It has its own history. The most visible and imposing aspects of fashionable currents and trends of live-action cinema have hardly any influence on animators who, instead, have chosen to develop their own trends and movements.

Bendazzi mentions the world-wide proportions, especially over the last decades, of the cultural ghetto in which animators have segregated themselves as a last step in a process of isolation. They have their own specialised festivals, their own institutions, their own outlets for discussion. Bendazzi assesses that linguistically, technically and stylistically, animation as an expressive form is indeed autonomous, confined only to the very broad definition that is laid down in the statutes of ASIFA:[32]

32. ASIFA is the French acronym of the International Association of Animated Film Artists.

animation is everything which is not a simple representation of live-action shot at 24 fps.

Generally, books about film history almost avoid the first fifteen or twenty years, which actually were the most exciting years. They start with Lumière, and if the reader is lucky he will be given a quick glance at the 'inventors' of animation. In 1906 J. Stuart Blackton in America with his HUMOROUS PHASES OF FUNNY FACES, followed in 1907 by his immensely popular picture with a combination of stop-action tricks and animation, THE HAUNTED HOTEL. In 1908 in France at FANTASMAGORIE of Emil Cohl, who had seen the films of Blackton.[33] Sometimes, an even quicker glance is given at Segundo Chomón who made (likely in 1907) his own account of a stay in a mysterious hotel with EL HOTEL ELECTRICO where luggage transports itself and clothes hang themselves in the wardrobe.

When someone therefore claims that there were animation pictures made seven or eight years earlier, is it then plausible to consider this as something of an anomaly? Is it really an anomaly contrary to historical facts?

We are inclined to say that there existed movie mythology from very early on in a tough entertainment business where the trade vied for public favour with a product of only light and shadows. Why should stop-motion filming only have been executed more than ten years after the invention of cinematography? It does not seem logical, because animation existed long before the movies were invented. The Victorians knew Zoëtropes, Thaumatropes and numerous other visual toys bringing drawings to life. There were the flip books which only needed one's thumb to animate series of drawings, and picture postcards with inside parts which transforms the image if slid sideways.

An enduring beautiful example of that visually impressive 19th century still exists. It is in the Dutch city of The Hague, the Panorama Mesdag,[N78] with its overwhelming colourful 360 degrees screen of 1680 m² designed by the impressionist painter Hendrik Willem Mesdag giving a lively view of the sandy beach of fishing village Scheveningen with its fishing boats, the fishermen and their women. Viewed from the inside, spectators walk around, listening to the sound of waves on the sand, and imagining in this surrounding vista that in the very next moment everything will come to

33. Two impressive film history source books, *Cinema Year by Year* and *Chronicle of the Cinema* (both Dorling/Kindersley, London, 1995; both are actually the same book), on page 64, give the name as John Stuart Blackton, but his daughter Marian Blackton Trimble in her personal biography *J. Stuart Blackton* is clear about her father's Christian name: James.

life, and the fishing boats will set off to sea. Almost 130 years old, it is one of the few surviving panoramas in the world. A couple of years ago, it was splendidly restored, and today is still capable of giving us a glimpse of what our baffled greatgrandfathers and -mothers marveled at.

The culmination is found in Paris, in Émile Reynaud's impressive *Théâtre Optique* with its magnificent projections of series of animated drawings.

This – in short – is the exciting bustle of visual gadgets and theatrical phenomena, variety theatres and amateur photographers, magic lantern shows and flip books, a turmoil in which the umpteenth new visual gadget of cinematography had to find its own place in a form and capacity which it had to develop for itself. Animation, therefore, can be seen as an application of this new ingenuity.

3. 1899 – Stop-Motion Pictures are Born

Just before the turn of the century stop-motion animation was born in England.

Place of birth: 1, Osborne Terrace, later 99, London Road, St Albans. Cooper still lived here with his parents, brother Bert and sisters Agnes and Bertha. It was a semi-detached house built against the embankment of the new London Road where his father Thomas M. Cooper, since around 1868, had his photographic business. The basement with its dark rooms opened onto a large garden with a portrait studio. In the next year, Cooper would take here a series of remarkable short moving pictures with close-ups.

According to Audrey Wadowska, Matches Appeal and its companions were made in the basement of Garrick Mansions, 12, Charing Cross Road, London W1. But was that possible in a time when there was hardly electricity available?

Although, Cooper had rented for some time a showroom and sales office at Garrick Mansions, we disagree with Audrey that her father's Matches pictures were made here. Partly because the gliding and sometimes fading shadows of the matchstick puppets on the floor betray the sunlight, and it is difficult to imagine enough sunlight for lighting an animation set getting down an eight storey building.[34]

It was in the long garden of his father's portrait studio at 1, Osborne Terrace, St Albans, where we find the delivery room of animation pictures

34. With thanks to research at Google Earth by Peter Mul.

Fig. 15. Garrick Mansions, 12, Charing Cross Road, London.
From approx. 1897 till 1901, Cooper had his Cinematograph
Syndicate Company in the basement of the building with the
bull's eye on top. Until the 1960s, the basement still had a
white projection screen painted on a wall.

in the capacity that Giannalberto Bendazzi calls an 'autonomous form of
expression'.

Here, in all untroubled quietude – above the sounding brass and tinkling
cymbals of motion picture publicity and claims of a film trade speaking with
its tongues of angels – a film pioneer, looking through a glass darkly, abideth
his patience, skill and imagination, these three, but the greatest of these is

love, the love with which he develops his art of breathing life into simple small splints of wood from matches. Three of these animation pictures with their lively matchstick beings miraculously survived.

The Cinématographe of the Lumières, which had started film shows on 20 February 1896 at Marlborough Hall in Regent Street, moved in March to the Empire Theatre of Varieties at Leicester Square where it stayed for almost 18 months till August 1898. Still, after that, the programme hand-outs of the Empire in 1899 and 1900 regularly announce the screening of films as part of their regular variety attractions. Many are just announced as War Pictures.[35]

It was at this time that Cooper, with a friend, William Jeapes, technician and projectionist at the Empire Theatre, established the *Cinematograph Syndicate Company*, or 'Cine Syndicate' for short, with the aim to produce, exploit and sell 'industrials' – advertising films.

Audrey:[N79] "Father used to say, Billy always included in his programme something that father made. And that is where DUCKS ON SALE OR RETURN was shown, during that period, before the Boer War."

Cooper needed his own premises for making films, developing and printing them, because Birt Acres had moved his Northern Photographic Works from 45, Salisbury Road to Nesbitt's Alley, a former rope factory in Barnet. Cooper made many of his films outdoors, where he had the least problem with the lighting. For a while he most probably did his developing and printing at his father's photographic studio until he established, in 1901, his Alpha Cinematographic Works and Alpha Trading Company at Bedford Park, Beaconsfield Road, St Albans.

Cooper and Jeapes rented a shop with a basement at 12, Charing Cross Road. From her father Audrey knew that it was his friend Billy's mother, Mrs Jeapes, who sometimes lent them the money for the rent. It was close to the Empire Theatre. Nearby, on 24 October 1899, the Garrick Theatre opened. Almost around the corner was Cecil Court, known in the trade as 'Flicker Alley', because Gaumont, Hepworth and Williamson had sales offices there. The shop became a meeting place not only for sellers and buyers of moving pictures but also for actors and actresses, and for performers at the Empire.

Audrey:[N80] "(Billy Jeapes) was at The Empire and possibly that is where he met him. Father used to sell his films or loan his films to him. It must have been before the Boer War because when father made that MATCHES film, they rented this downstairs underneath that shop next to the Garrick

35. Email from Theatre Museum Enquiries, London, 16 January 2007.

Theatre. (...) I have been down there, some twenty years ago. The man was very nice. He said, when they first went there, there was a stage and a screen erected at the bottom. It had been a studio, and that is where the MATCHES films were made."

Osborne Terrace does not exist any more. It is a derelict stretch of weeds and garbage opposite a ramshackled cinema, the Odeon, which in its very beginning was Cooper's Alpha Picture Palace.

Garrick Mansions is still there, number 12 being a tobacconist and newspaper shop. According to the shopkeeper the basement is fairly spacious.

Year of birth: 1899.

In 1899, Edward William Elgar's *Enigma Variations* celebrate their first night. In London, 28 new borough councils are established. In Oxford, Ruskin College for working men and women is opened. Percy Pilcher, British aviation pioneer dies in a crash with his glider Hawk. Millionaire Andrew Carnegie opens the umpteenth public library in the United Kingdom, many of which in recent years were very helpful in providing information and data for this book. Queen Victoria celebrates her 80th birthday. She is visited by her grandson Kaiser Wilhelm II much to the chagrin of her son the Prince of Wales, who is a regular visitor of the Empire Theatre.

And 1899 is the year in which a stubborn Calvinistic Boer, Paul Kruger, on 11 October, dares to declare war against the world-encompassing British Empire, which did not react to his ultimatum to withdraw the concentration of their troops at the borders of two small and independent Boer republics, Transvaal and Orange Free State. They were officially the South African Republic with Kruger as president. The discovery of diamonds and gold around Johannesburg attracted many foreigners. The Boers now felt even more threatened.

That was the start of the Boer War, officially called the Anglo-Boer South African War. It lasted from October 1899 to May 1902. It caused a wave of chauvinism in England. Effigies of Kruger were burned all over the country. It was also a costly affair, both financially and in terms of casualties, damaging the reputation of the British army.

Against a professional army of more than 100,000 men and 75,000 in reserve, Kruger's declaration of war seemed a daring challenge. But there were only 10,000 British troops in Natal and Cape Colony. On 8 September the Cabinet in London had decided to double that strength. It was in the second half of September that the War Office decided to dispatch 47,000 troops to South Africa, but at the outbreak in October there were only

14,000 troops. The War Office in London tried in vain to convince the Cabinet that it needed more time to prepare for the war.

The mood at home was exuberantly patriotic. The English people were convinced that 'our boys' would teach those rebellious peasants a lesson, and all would be back home by Christmas – the same conviction that was expressed fifteen years later. The Anglo-Boer War was the first war in which substantial numbers of volunteers, from working class to upper class and all the varieties in between, supplemented the British Army. This shows how interested thousands of people in Great Britain were in this war, more than in any colonial conflict before. The *Daily Mail* sold almost a million copies every day in 1900.[N81] Cinematographic films were sent home by several correspondents.

The first successes were for the Boers who were almost always mounted riflemen, some 48,000 of them. The British infantry had hardly any knowledge of the vast open terrain, had no experience with guerrilla warfare, and were short of all kinds of essential supplies.

On 11 October, the Boers advanced into Natal and Cape Colony. On 13 October, under General Piet Cronjé, they surrounded Mafeking held by Colonel Robert Baden-Powell, and two days later they besieged Kimberley. On 30 October, 'Mournful Monday', the Boers, led by Piers Joubert, started a long siege of the troops under General George White at Ladysmith in Natal with 1200 British losses. A month later they defeated the British at Magersfontein in Cape Colony. Earlier British columns were defeated at Stromberg, and later at Spion Kop.

From 10 till 15 December, the newly arrived Commander-in-Chief Sir Redvers Buller, executing disastrous tactics, was defeated in the battle of Colenso in Natal with heavy losses. It was a third defeat in 'Black Week'.

After February 1900, when the incompetent Redvers Buller was replaced by Lord Roberts with Major-General H.H. Kitchener as Chief of Staff, the British advanced with success into the Boer republics which met with mass rejoicement in England.

A guerilla warfare under General Christiaan de Wet by the Boers on horseback followed, and it took the British, after many reinforcements of troops, among which 40,000 from Australia, New Zealand and Canada, three years before they could establish their authority in the whole of South Africa, and to round up the Boer guerillas. That was done after inhumane tactics of burning their farmsteads and putting their women and children in concentration camps where thousands died of malnutrition and diseases. "Thus the British introduced to history the dread phrase 'concentration camp'," writes Allister Sparks in his well-known book *The Mind of South Africa*.[N82]

4. Our Soldiers Need Them

What happened in the year 1899 in the delivery room of animation pictures?

Three short pictures survived as fruits of the labour. They all start with a Bryant & May matchbox opening. Matches jump out of it to form themselves into little puppets. In one picture the puppets start to play cricket, in a second they play volleyball. The third picture is called MATCHES APPEAL. It is a most remarkable one. A matchstick figure climbs a ladder that is being held steady by another figure. The one on the ladder starts to write on a black wall an early form of grafitti which reads as follows:

> An appeal. For one guinea, Messrs Bryant & May will forward a case containing sufficient to supply a box of matches to each man in a battalion with name of the sender inside. NB. Our soldiers need them.

It is odd and exciting to realise that one is looking at the results of the earliest true examples of moving pictures that were made according to the principles of stop-motion technique.

When viewed on DVD frame by frame, it is clear that MATCHES APPEAL was indeed made with stop-motion. The other two animated matchstick pictures, ANIMATED MATCHES PLAYING VOLLEYBALL and ANIMATED MATCHES PLAYING CRICKET, were acquired by Audrey from collectors. The missing opening scene in all three films, the matchbox, was of course the sales pitch of the brand name of Bryant & May.

Matches were a popular subject in those years. Donald Crafton in his *'Emile Cohl, Caricature, and Film'* [N83] gives several examples of cartoons in French and English illustrated magazines in which drawn matchstick men fight with each other and play all kinds of tricks. Cooper's matchstick sportsmen are not significantly unusual beings.

Audrey Wadowska always called the first one ANIMATED MATCHES PLAYING FOOTBALL – but Rotterdam sports coach Ard van Pelt told us that this was an early form of volleyball.[N84] In 1895, volleyball started in the United States and was soon played in Europe as well. The kicking with feet and heels and headers seemed to have been allowed in some places before international rules were established.

In our original animation filmography, we gave MATCHES APPEAL number 3, and MATCHES PLAYING VOLLEYBALL and MATCHES PLAYING CRICKET numbers 4 and 5. We did this because Cooper told Lindgren that

MATCHES APPEAL was his "earliest really animated one". But Cooper, who never knew that his two earlier Bryant & May 'industrials' VOLLEYBALL and CRICKET had survived, apparently forgot about them.

The filmography in Part Two has in the meantime been complemented with more titles, and we are now sure that MATCHES APPEAL was made after the two sports pictures. We changed our archive numbers. ANIMATED MATCHES PLAYING VOLLEYBALL is number 4, and ANIMATED MATCHES PLAYING CRICKET number 5. MATCHES APPEAL as number 6 is therefore not Cooper's first animation picture, but his third one. It is the missing opening scene with the opening Bryant & May matchbox that tells us this.

When Cooper needed this scene in 1908 for another matches picture, he cut it from one of his three matches negatives, which was MATCHES APPEAL, because this was last made and still contained the opening scene, which was removed earlier from the CRICKET and VOLLEYBALL versions.

EMPIRE THEATRE.—Cattle Show Attractions.
—Mrs. BROWN-POTTER will RECITE "Ordered to the Front," at 9.45.—HOME of BALLET.—Another Empire Triumph. TO-NIGHT, at 10, a new grand characteristic, up-to-date Ballet, entitled ROUND THE TOWN AGAIN. Varieties by Miles-Stavordale Quintette, the Carangeot Troupe, Prellé, Les Alex, The Lockfords, Belloni's Bicycling Cockatoos, Melot Hermann, and the Egger-reiser Troupe. Doors 7.30. SPECIAL MATINÉE TO-DAY (Thursday), at 2.15, in aid of our Soldiers and Sailors' Fund.

Fig. 16. *The Times*, Thursday, 7 December 1899. (With thanks to research by Prof. Frank Kessler.)

That Cooper made the two send-ups on sports before the appeal stands to reason because of other motives, too. After the success of his trick picture BIRD'S CUSTARD for which he received a pound for each copy sold to the fair-grounds, he must have made a deal with Bryant & May. The sum of £1 per copy sold to fair-ground showmen and distributed in their complicated network is not much when one considers how many times it was screened for an eager public without much competition of other advertisers. Would Cooper otherwise have made three Bryant & May animation pictures? One may therefore assume that Cooper successfully made ANIMATED MATCHES PLAYING VOLLEYBALL and ANIMATED MATCHES PLAYING CRICKET as 'industrials' for Bryant & May as sponsors.

When, in 1899, war broke out in South Africa, British troops were hastily dispatched to Durban, even though the War Office pleaded for more time to organise and prepare this. The result was that in the first months of the Anglo-Boer War the British troops suffered many shortages. One of the most serious shortages was not bullets, but matches, because they were essential for the most practised pastime by soldiers: smoking.

When the famous matches company was approached by a Ladies Welfare Committee for Soldiers and Sailors, requesting its assistance to provide the soldiers with matches, Bryant & May commissioned Cooper to make MATCHES APPEAL. It most probably had its first showing at a special charity matinée 'in aid of our Soldiers and Sailors' Fund' in the Empire Theatre on Thursday, 7 December 1899, as announced in *The Times* on the same day.

There is yet an old connection of Cooper with Bryant & May through his former employer Birt Acres, who had a contract with the German chocolate manufacturer Ludwig Stollwerck to supply his Kinetoscopes with moving pictures. Bryant & May supplied Stollwerck with their famous brand of matches for the Stollwerck slot-machines. In 1896, Birt Acres even produced a film titled BRYANT & MAY.[36]

Cooper was lucky with his friendship with Billy Jeapes, the projectionist of the Empire Theatre where he, in a world for several years without cinemas, had a secure place for exhibiting his moving pictures next to the fair-grounds.

5. Stop-Motion and Bellows

The year 1899 is disputed by some, who consider it to be too early for stop-motion animation. Possibly, during his visit to Cooper, Kodak's Brian Coe supposed that, as all film books have 1906 or 1908 as the dates of the first stop-motion pictures, the old film pioneer must surely have confused the dates in his memory. But Collins published the following some time later:[N85]

36. The title appears as no. 11 in the stock list of the British Toy and Novelty Company, December 1896, as photographed by Birt Acres. We also know from Prof. Martin Loiperdinger that Bryant & May were, together with Stollwerck Brothers, founders and shareholders of the London and Provincial Automatic Machine Company which was shareholder of the Deutsche Automaten Gesellschaft Stollwerck & Co (DAG). Bryant & May appear in the Kineopticon advertisement for Birt Acres's Queen's Hall shows in August 1896: "Support Home Industries – Bryant & May's Matches are manufactured only at Fairfield Works – London". With thanks to German film historian Dr Hauke Lange-Fuchs.

Another advertisement film of 50 feet made by Arthur Melbourne-Cooper was for Bryant & May's Matches early during the Boer War, 1899-1900. There was a shortage of matches among the troops, and in 50 feet of film he tackled the problem in this fashion. Using the one frame, one picture, technique – he was probably the first man in the world to use it for advertising purposes – Arthur Melbourne-Cooper made a matchbox open, the matches emerging to form simulated human figures engaged in a tussle climbing up a wall, where they formed up making the slogan 'Send 1 pound and enough matches will be sent to supply a regiment[37] of our fighting soldiers'.

An expert on animation films, Bendazzi, in his book *Cartoons* and in a recent article on Matches Appeal,[N86] gives the right date of 1899.[38]

Again, a 'first' is defected, Arthur Melbourne-Cooper (Great Britain) dethrones Emile Cohl (France). It concerns, actually, a 'first' of early days: during many years, film history books marked down Emile Cohl as the father of the animation movie, and his Fantasmagorie as the first true and real moving picture of that kind. (...) In short, Matches Appeal is a truly animated moving picture in which the technique of frame-by-frame exposure is not applied as a 'trick' or a special effect, but it exactly shapes a special imaginative language.

Would early cinematographers really not know how to make stop-action tricks with a camera? Cooper, son of a photographer, was for some years trained by the very person who knew how to stop and start a camera, film-pioneer Birt Acres, who was well-known for his lectures on the subject of movement of images, and who had a great knowledge of all those visual toys and of the chronophotographic experiments of Professor Marey.

"It does not take long," writes Richard Crangle in his contribution 'Astounding Actuality and Life. Early Film and the Illustrated Magazine in Britain' in *Cinema at the Turn of the Century*,[N87] "to show the great variety of technique and content evident in early film, even if the sample is restricted to a single country, manufacturer or genre: the first ten years of film production displayed the greatest relative rate and variety of technical progress the medium has seen."

37. Collins makes an error. The picture says: "(...) a box of matches to each man in a battalion." A battalion is about 800 to 1000 men. A regiment has an infinite number of battalions. With thanks to Chris Wilkinson.
38. I am grateful to Fr Nico van der Drift OSB for the translation from the Italian language.

Were Cooper's puppet pictures anomalies in those early years? Were they exceptions? It was the era of flip-books and zoëtropes. The principle of stop-motion was very well known and popular long before the moving pictures were invented. When Ernest Lindgren interviewed Cooper for the BBC he was told:[N88]

Lindgren: *Talking about trick pictures, I believe you made a film yourself with animated matches, didn't you?*
Cooper: *Oh yes! That was during the Boer War. It was an appeal for matches, when soldiers couldn't get them.*
Lindgren: *And how was this film made?*
Cooper: *The film was made by a box of matches coming in and opening, and matches getting out of the box and forming up as a man and with a spare match for a brush with which he painted on a board the appeal...*
Lindgren: *And this was made by taking the film picture by picture?*
Cooper: *Yes! Picture by picture and movement by movement!*
Lindgren: *Just as Walt Disney makes his cartoon films today. This surely was the earliest animated film made, wasn't it?*
Cooper: *Yes! It was the earliest really animated film. Of course, I had taken several up-side-down-camera pictures to get the 'reversals'. I went down to Tunbridge Wells and took HIGH DIVING FOR GIRLS on two cameras.*

Audrey's husband Jan Wadowski, who was an engineer on the Polish railways before the war, an artillery captain in the Polish Army during the war, and who became, after the war, a watchmaker in High Holborn, London, explained to us how his father-in-law, with some rather simple modifications, fitted up a moving picture camera with which he was able to make stop-motion pictures.

Cooper probably made use of a Moy camera adapted with a photographic shutter and a spring pin mechanism onto the sprocket to make frame-by-frame exposure possible. Jan Wadowski:[N89]

"He made some arrangement how to stop exactly. Probably some engineer made it for him, but he told him how to do it so that the frame was dead on and you could not make a mistake. Automatically with a pin and some spring, very simple on the outside, some local mechanic made it for him exactly, dead on, so that you cannot do anything else and cannot go further. It was not a complete turn, because that was two or three frames. You have to press it to release the spring and then you can go to the next frame. He also advertised: without flickering. He did not patent it. He did not find it important. A simple little thing."

This mechanism, on Cooper's instructions, was made by a local precision instrument maker. We are certain that Cooper used a camera with a stop-motion possibility in 1898 or 1899 when he started to make the Bryant & May's matchstick pictures, because these films still exist. We think that Cooper applied the mechanism, as described by his son-in-law Jan, in later camera models.

According to film historian Cleveland,[N90] some cameras exposed with each turn of the crank 8 frames, other camera types exposed 4 or even 2 frames at each turn. Some cameras even had a special facility for making single frame exposures. From the beginning, making stop-motion pictures could never have been a problem. Technically, making a stop-motion picture like MATCHES APPEAL as early as 1899 is therefore not an anomaly. Cleveland, who studied the transitional years from magic lantern projections to early moving pictures shows, writes:

"Like using the camera upside down, I reckon the early film makers soon discovered how to take one frame at a time and produce what we might call 'animation'. Acres was taking cloud studies a frame at a time so that they were speeded up. And Cooper was certainly ahead of his time making DOLLY'S TOYS in 1901. So he probably was making or experimenting with stop frame well before that – hence MATCHES APPEAL."

Cooper fixed the shutter of a photographic camera onto a 35mm film camera of which, in 1898, there were already a lot of different types and makes on the market which could produce excellent pictures. He attached racked bellows in order to bridge the short distance, acquiring a perfect focus.

Martin Sopocy, author of a sympathetic and thorough study of British film pioneer James Williamson[N91] (1855-1933), points out to us that the American journalist Frederick Talbot, as early as 1912 in his *Moving Pictures How They Are Made and Worked*,[N92] wrote about stop-motion.

Talbot interviewed James Williamson in a chapter 'Trick Pictures And How They Are Produced' about his film A BIG SWALLOW (1901). A man, irritated by the sight of a cinematographer, advances towards him with open mouth and swallows the whole apparatus and operator, the final scene shows him apparently enjoying his meal.

The problem that had to be solved was the actor getting out of focus when he comes so close to the camera. According to Williamson, writes Talbot, a camera fitted in front with the racking bellows of a photographic camera was used. The subsequent distances between camera and actor were measured and marked on the ground with a corresponding mark on the basement of the bellows. At the word 'go' the actor advanced to the first

mark, stood stock still, the camera bellows racked into the correct focus and the 'stop-motion' principle was applied. This went on until the open mouth of the actor covered the whole lens after which the process was reversed. In a blackened room a camera and operator, positioned in a window, were pushed through the opening, falling downwards on a mattress. The scene with the falling camera and operator were later inserted between the frames that had been darkened by the wide open mouth of the actor.

"Of course it turns out to be an interesting example of stop-motion, and the evidence is fairly overwhelming that he learned it from Cooper. In fact it wouldn't surprise me if Cooper didn't serve as his guru in trick photography during his first years as a film maker, even though the style of wit strikes me as Williamson's own." Thus Martin Sopocy.

In March 1907, Stuart Blackton astounded audiences with THE HAUNTED HOTEL. His Vitagraph company had just opened a branch office in Paris, where it was released as L'HOTEL HANTÉ, FANTASMAGORIE ÉPOUVANTABLE. It was the most successful American film sold in France. How were all these tricks done? Cinema-goers were really puzzled. At the Gaumont studios, they said it was a trade secret only recently learned at the studio.

However, Donald Crafton[N93] concludes: "The technique used in L'HOTEL HANTÉ was almost as old as cinematography. Like many aspects of early filmmaking, animation was discovered and developed more or less simultaneously in Europe and America."

Until around 1908, film makers who applied tricks that simulated frame-by-frame animation turned the handle one-quarter or one-eighth, exposing 4 or 2 frames at a time, with the risk that the next picture was exposed as well. We read this in Alexander Sesonske's article in 'The Origins of Animation' in *Sight and Sound*, Summer 1980, about the beginnings of animation pictures. On some of the animation pictures of J. Stuart Blackton, one can still see a hand which was not pulled back in time after moving an object.

We don't know if he is right. Audrey Wadowska told us that her father said that for every second of exposure of a live-action scene you have to make three turns with the camera handle. One-and-twenty, one-and-twenty, etc. Three turns per second means 18 to 20 frames, which means that a 1/8th turn gets you only one frame or less and a ¼ turn gives you a possible 2 frames. But doing it this way produces inaccurate animation results anyway.

David Cleveland writes to us:[N94] "The speed films were taken at is difficult to get right, as everyone turned their handles of cameras and

projectors at different speeds. In an article in the SMPE journal in 1928, they state that even at that late date, silent films were shown at between 75 and 115 feet per minute. It was the sound track that produced a set standard of 24 frames per second. In the time of Cooper, some of the early projectors had a one blade shutter – and at slow speed this would produce a good deal of flicker. Then came two bladed shutters, which was about the time of A DREAM OF TOYLAND (1907). Three bladed shutters, which produced less flicker, must have come in about 1912. In fact, there is no set time for these introductions, as different manufacturers had their own pet ideas. Mitchell and Kenyon films vary. Some of them, by the speed of action, must have been shot at about 12 frames per second. This may have been something to do with the Prestwich camera. Was it like the other cameras of the time – one turn exposing 8 frames per second, or was it less frames per one turn? According to what Audrey says about her father turning the handle three times per second, this would indicate to me that the Prestwich camera was different to other cameras, and exposed only 5 or so frames per handle revolution. When shown they might have been speeded up, but I reckon not too much, as people wanted to see themselves, so the projectors were probably run at 12 frames per second – even with a two bladed shutter this would have flickered a bit."

6. Temperamental Matchstick Sportsmen

When the matchstick pictures are viewed frame by frame, it is apparent that Cooper in all likelihood animated the picture at 10 to 12 frames per second.

Here it is, on this small stage, with these tiny figures made of bits of wood, that Cooper made his first puppet animations. A member in the audience at our Tilburg lecture in 2005 said that one could clearly see that these matchstick pictures were made long before a picture like A DREAM OF TOYLAND, because it seemed to him rather crudely made.

We disagree. Just make yourself a matchstick figure from parts of matches. Connect the pieces with tiny bits of copper wire in such a way that you will be able to bend knees and elbows, like in the three pictures. Get them upright and steady with pins or needles. Try to make them walk like humans. It seems so simple and basic, but it turns out to be rather complicated.

In ANIMATED MATCHES PLAYING VOLLEYBALL, it is hilarious to see how the players try to keep the ball in the air. Isn't this the principle of volleyball: football in the air with hands not feet?

First there are two players, after a while accompanied by a third one, and when the play nears its end there are five players. The ball is sometimes high up in the air, out of sight to the amazement of the players. The fight for the ball, especially when the number of players grows, is a genuine comedy. At the end it seems they will get the ball over the net, but it falls back between the players, and one of the players gets his arm stuck onto the net. Another player pulls at it, but the net comes down, and everybody is now flat on the floor.

ANIMATED MATCHES PLAYING CRICKET is less complicated than VOLLEYBALL, which shows a better grasp of and possibly more experience in developing characters and comedy effects. Two wickets are prepared, and we are served with a rather straightforward game of cricket between two, later three players. Even though the players are made out of a couple of matches, they are believable characters in a game that is rather funny to watch.

Cooper's first two advertising pictures with trick animation, KEEN'S MUSTARD and BIRD'S CUSTARD, have not survived, but these two commercials for Bryant & May did survive and are possibly the earliest stop-motion pictures ever made. Both were reissued in a weekly cinema series "On the Town" in 1919, in which ANIMATED MATCHES PLAYING CRICKET was titled *Vestas v Pine*. Swan Vesta matches were made from pine wood.

The sets of ANIMATED MATCHES PLAYING VOLLEYBALL and ANIMATED MATCHES PLAYING CRICKET are exactly the same as in MATCHES APPEAL. It is the door at the right, drawn or painted on a piece of board or wood, that makes the set at once recognisable. This door with its four panels looks amazingly similar to an actual door used in the background sets of several later films made by Cooper, but also like the door on film stills in Robert W. Paul's film sales catalogues.

The bodies of the players in each of the three pictures are constructed in the same way with arms and legs connected to a long matchstick functioning as a body with the head of the match functioning as a human head. They resemble exactly the matchstick cartoon characters from contemporary illustrated magazines. Arms and legs are bent or cut in half to appear as knees and elbows. The limbs are animated from these joints. Cooper may have used the same matchstick characters in all three pictures. The matches with their white wooden bodies are perfectly visible with their clear contrast against the black background and floor.

Matchsticks in general are available in lengths between 1½ and 2¼ inch (3½ and 5½ cm). In Cooper's days, one could buy matches of a length of 1 inch, 1½ inch, and even 3, 4 or 5 inches long. The matchstick figures in the three

pictures are composed of four or five matches. Our estimation is that the larger format of matches was used, measuring a little over 2 inches. One puppet is therefore some 4 inches (10 cm) high.

We made a mock-up of the set in order to make an estimation of the original one. We assume it had a width of 20 to 24 inches (50 to 60 cm), a depth of 14 to 16 inches (approx. 35 cm) and, considering the height of the matchstick puppets, a height of 10 to 12 inches (25 to 30 cm). The foreground is slightly sloping towards the camera, giving it a natural spatial impression.

All three pictures show a remarkable depth of field. When viewed frame by frame, the matchstick puppets stay in focus, whatever their position is. Each image is sharp and does not lose its depth of field.

More interesting than this is the question of the joints. This applies especially for the two other matches pictures, where the sportsmen are making a lot of moves, and their joints are bent some 6 to 8 times per second or even more.

The arms and feet are apparently made of one match which is cut in the middle. The cricketeers and volleyball players move their knees and elbows, they move their legs and arms. Each matchstick figure must therefore have 8 joints. Did Cooper use thin copper wire to connect the limbs movable to the matchstick body? Copper wire can last a long time when it is bent repeatedly in order to simulate movement of arms and legs eight to ten times per second or more. But after a hundred times or more, copper wire will break. Did he replace the copper joint with another piece of wire?

How did Cooper keep the little matchstick puppets upright? It is clear to see that they always have one foot on the floor. Is this foot pinned to the floor with a sharp thin pin? If the blackened floor is soft enough the camera will not see the pinholes after each step.

Audrey told us[N95] that the toys in A Dream of Toyland were secured with safety pins and hat pins. She interviewed a Mr Rolphe in St Albans who, as a young boy, animated one of the toys. Not only local youths but adults also assisted with the animation. Audrey:[N96]

"They would each have a toy to manipulate. This man, Mr Rolphe, had one and they had hair pins, safety pins, all sorts of pins."

It is safe to assume that Cooper used pins to secure his matchstick puppets.

We discovered that the jump in Matches Appeal, when there is suddenly a big chunk of text on the black background, is not a break in the film but deliberately done, because there are no signs of a cut in the film.

Did Cooper not have enough time for its production? Or was the film becoming too long?

- MATCHES APPEAL in its original screening time including the Bryant & May matchbox opening scene lasts 1.15 minutes at the contemporary average speed at 16 frames per second. When screened at the television speed of 24/25 fps it lasts 48 seconds.

- ANIMATED MATCHES PLAYING CRICKET lasts without its match box opening scene 1.15 min. at 16 fps in which much is happening. Too much, if viewed at television speed (50 seconds). The action is more transparent and more or less played according to the rules when the picture is screened at the original speed.

 We are not sure whether CRICKET was made first, and then VOLLEYBALL. The last contains some jokes, and one can almost imagine the five different characters that are playing. The cricket players are rather stiff, though not in movement.

 It is amazing how natural the matchstick men walk and move, how they play the bat or hit the ball. Watching it with the pause button of the DVD-player, it is fascinating to see the build-up of each move.

- ANIMATED MATCHES PLAYING VOLLEYBALL without the matchbox opening scene lasts 50 seconds when projected at the contemporary speed (38 seconds at television speed). It is a picture full of action. One needs to see it a couple of times to see all that is happening.

 When viewed on DVD or video, the action goes too fast. When viewed at a speed of 16 or 18 frames per second, there is much more to enjoy. Like Cooper's little joke of the player who jumps up so furiously that the upper part of his body is going too fast for the feet to follow. Cooper's sense of humour is also shown in the temperament of the players who, when they don't seem to be able to get the ball over the net, become frustrated and angry, and involuntarily play it as football. They play, they quarrel, and finally when they are out of breath and one of the limbs is stuck to the net, the picture comes tumbling to its end.

Technically, the animation can be called basic. There is not much leading in and leading out of each movement, but a sophisticated technique like this would be rather difficult with these basic puppet figures.

Cooper told his children that the animation of the ball was done by using a hair from his mother. She had strong hairs which were grey, and the camera did not catch them. It is indeed impossible when scrutinizing it frame by frame to discover how the ball was floating through the air. It makes the players and their game very believable.

The most amazing thing, in the first place, is that Cooper was able before our eyes to animate five very believable volleyball players full of character and wit. In the second place, is it not amazing as well that, after more than a hundred years, we still see them as sportsmen playing a rough game of volleyball?

Remarkable is also that on this small scale, the film maker is capable of imitating human movements and even emotions in such a way that we at once believe in them as being gifted with a soul and a mind that can reason and act.

Our first conclusion is that in these early years, most of Cooper's contemporary film makers were able to make convincing animation from early on, but they abstained from doing so. Cooper, after making a number of trick films, some of them with stop-motion effects, now made three genuine stop-motion pictures.

It is obvious why his fellow pioneering film makers did not make them. The technique is very time-consuming, and time was precious. A film pioneer could make three, four or more films in the same time it would take to produce one animation picture, and make a much better income. Why waste time on a stop-motion picture which took a week or more to produce? We think, for this reason only, one will find in the first ten years of film history many trick pictures, yes, but not many true stop-motion pictures.

Our second conclusion is that the three matches pictures tell us something about its maker.

Cooper invested a lot of patience, a lot of inventiveness, much craftsmanship, and much time. This demonstrates his love for his profession. He wanted to develop something new, something that was not done before, and something that would amaze and astonish the audiences that came to watch the fruits of his labour. Matchsticks which act and walk around as if they are genuine living creatures – who had ever heard of that? Let alone seen it with his or her own eyes?

Of course, he made the first two matches pictures also in an effort to make an income out of them. Because copies of these two survived, it is safe to assume that they were not only shown in the Empire Theatre, but that Cooper sold a number of copies to the fair-grounds and other variety theatres. The reissue, in 1919, of VOLLEYBALL and CRICKET demonstrates the popularity of the two animation pictures. The greater the number of prints which were brought into circulation, the greater the chance today that somewhere a print is unearthed.

What can the three pictures tell us about their creator? Cooper regularly filmed football games and cup finals, horse races, boat races and regattas. Yet he invested much time in two short comedies about sports. One is about a very English sport, cricket. This picture seems more serious and straightforward than the second one. Did he make the spoof on volleyball as a counterbalance to the cricket one? Volleyball was a very recently developed game from the United States. It is obvious that Cooper made fun of the fact that it so quickly became fashionable in his country.

Cooper liked sports, and he got a regular income from filming sports events. But both animation pictures show that he did not lose himself in them and that he kept a sound distance from the madness created by supporters that surrounded the sports already in those days. MATCHES APPEAL was made in the anti-Boer euphoria that swept over the country, and we are sure that Bryant & May collected many guineas for matches to be dispatched overseas.

Cooper received a letter of thanks from Kodak Museum's curator Schultze,[N97] who at the same time told Audrey that her father's film was not made in 1899 but in 1917. Was this not uncivil to accept a rather unique historical moving picture from the maker himself, and then without any discussion telling the donor's daughter that her father is mistaken about the date?

Let us see who is right, Cooper who made MATCHES APPEAL or Schultze who probably was responsible for the *'reported physical evidence'* which the BFI mentions on its website, suggesting that MATCHES APPEAL *'is of a later date than 1899 and therefore presumeably relates to the First World War'*, with twice a question mark after Cooper's name, first as maker and then as producer.

7. Decomposition of Matches Appeal[39]

After her father had donated a copy of MATCHES APPEAL to the Kodak Museum at Harrow, Audrey received several letters from Dr R.S. Schultze, curator of the Kodak Museum, upholding that he was sure her father confused two wars, the Anglo-Boer War and First World War. A year after her father's death, he wrote:[N98]

39. For a complete survey of the MATCHES APPEAL file, see Part Two – Filmography, 6. MATCHES APPEAL.

I have now obtained authoritative information which shows that the 'Matches Appeal' was made not during the Boer War, but during the beginning of the First World War. This information has been supplied by Lt. Col. C.B. Appleby, D.S.O., F.S.A., Director of the National Army Museum, Sandhurst, Camberley, Surrey, and I have pleasure in enclosing a photo-copy of some references in *The Times* in which reference 4 is the most important one, mentioning an appeal by Bryant and May for donations in *The Times* of January 5th, page 11. It seems very likely that your father produced this film in 1915.

This article in *The Times* of 5 January 1915 is as follows:

SAFETY MATCHES FOR THE TROOPS
Messrs. Bryant and May (Limited) of Fairfield Works, Bow, will receive donations, even in small amounts, for sending out supplies of safety matches to the troops. These can be sent in guinea cases, which provide a box for every man in a battalion. For many who would like to send a gift, the sum of one guinea is too much, but the firm undertake to send a case for each guinea subscribed in smaller amounts. Messrs. Bryant and May are prepared to give The Times Red Cross Fund 2s. for every guinea so collected.
If donors of smaller amounts than one guinea will make suggestions as to the battalion, battery, or other unit to which they would like that matches to be sent, the firm will be glad to follow suggestions in rotation.

Audrey answered him confirming that the message certainly corresponded with that of the film, but she was convinced that there could also have been a shortage of matches during the Boer War.

There is a significant difference in both texts, that of *The Times* in 1915 and that in Cooper's film of 1899. It is the word *'safety'*. No appeal for safety matches in 1899, but extra attention for them in 1915. There are more differences: Bryant & May, for instance, in 1915, accepts smaller amounts than 1 guinea.

The publications in *The Times* did not mention in any way that there were no shortages in 1899. Schultze's reaction less than a week later introduced an unexpected, new but unsubstantiated argument:[N99]

"My informant was quite sure that no Matches Appeal was made during the Boer War, but only during the First World War. The dating marks on your Father's negative film (manufactured by Kodak) also point at a 1915-18 date."

Schultze was confident that MATCHES APPEAL was not made in 1899. We

need to take his objections seriously, because it is obvious that BFI's website refers to it. Schultze did not give Audrey copies of the disputing arguments of his informant against a shortage of matches in 1899, nor provided particulars concerning the *dating marks* that he had seen. Nor does the BFI give any information about their 'reported physical evidence'.

They carry the weight of very serious objections, but without any substantiating argument or evidential material, both BFI and Kodak's Schultze have launched statements that are only sounding brass and tinkling cymbals.

Audrey never donated the original nitrate negative of MATCHES APPEAL to the NFA (today: BFI National Archive). Unfortunately, the negative does not exist anymore. We are both to blame for that. When in 1980, we assisted Jan and Audrey to move from two rooms in damp servant quarters in London to a new flat in St Albans, we came across several film tins. Some of them were extremely smelly. One tin carried the label MATCHES APPEAL The nitrate negative was in its last and very dangerous state of decomposition. The film could not even be unwound anymore. With great regret we burned it on the lawn at a safe distance from their new home, in the knowledge that there was a safety negative and that several copies had been made on 35mm as well as on 16mm.

Why did Audrey and Jan never give their costly film for safe keeping at the NFA? After the correspondence with Kodak's Schultze, they apparently had become suspicious and lost their trust in official institutions.

Who is correct in the MATCHES APPEAL case? Let us look at the three arguments.
1. The film is too sophisticated for its time.
Brian Coe's visit to Coton during Easter 1956 and his subsequent foreword about confused and biased recollections of elderly people in John Barnes's first book suggest an almost axiomatic understanding between film historians in general that there was no true animation in the first ten years. Film historian Barry Salt demonstrates this in his impressive reference book *Film Style & Technology, History & Analysis.*[N100] He devotes less than a page to animation. He concludes that the first true animation motion picture was made in America by J. Stuart Blackton in 1906, HUMOROUS PHASES OF FUNNY FACES, and that

> it was only after this that single frame animation technique was used in European films. Claims that this happened earlier appear to be bogus.

He expressed strong reservations to Donald Crafton[N101] about the dating of

animation films by Melbourne-Cooper earlier than 1906. Salt neglects no fewer than 14 animation pictures until 1906 produced and/or directed by Birt Acres, Robert Paul, Walter Booth and Cooper, as published by Denis Gifford in his *British Animated Films, 1895-1985*.[N102]

We feel uneasy about Salt's strong convictions for the following two reasons.

Of all the films made in the first ten years of film history, more than 70% is lost. We can only make a guess about what disappeared. If one makes adequate statements about this period, it is on the basis of less than 30% of what is available. Can one then be so sure that no stop-motion pictures were made in Europe before 1906?

"The art of animation did not begin with cinema proper," writes film historian David Robinson in an article 'Animation' in *Sight & Sound*.[N103] "Although the cartoon film-makers were using a new medium, in the camera and the celluloid film, they were employing basic animation techniques that had been practised and developed for upwards of seventy years before the cinema", and he gives an extensive survey of the subject from 1833 till 1893.

The next reason is – and we made it clear on the preceding pages – that technically it was for a pioneer film maker no problem at all to make stop-motion trick pictures or true animation pictures. Even Cooper's subject matter, the contemporary popular sporting matchstick characters, fits seamlessly in the period when he made his first animation pictures.

Radio Times, 8 March 1957:

First Animated Cartoons

While discussing the International Animated Film Festival in Panorama (the BBC television programme) on February 18, Richard Dimbleby referred to *Felix the Cat* as the first animated cartoon film. Actually an Englishman named Melbourne Cooper is credited with having made the very first one at the time of the South African War – twenty years before Felix appeared. But Emile Cohl of France is regarded as being the creator of the first popular film cartoon character, called Fantioche and shown in 1908. It was not until the First World War – in 1917 – that the American Pat Sullivan introduced Felix the Cat.

Morris Freedman, London, S.E. 18.

2. *There was no shortage of matches with the troops in 1899, but there was in 1914.* Kodak's museum director and expert writes to Audrey:

> My informant (Lt. Col. C.B. Appleby, D.S.O., F.S.A., Director of the National Army Museum, Sandhurst, Camberly, Surrey) was quite sure that no MATCHES APPEAL was made during the Boer War, but only during the First World War.

We have exchanged letters and emails with the Imperial War Museum in London and the National Army Museum in Chelsea, formerly at Sandhurst, but military historians at these renowned institutes could give us no decisive answers about the validity of this statement.

Schultze sent Audrey typescripts of no fewer then five short reports in *The Times* from October 1914 till January 1915 about safety matches and their shortages with the troops. A footnote by Pearl & Dean director Collins to his article[N104] on early advertising films in which he dates MATCHES APPEAL during the Boer War 1899-1900 seems to confirm Schultze's statement:

> "The same thing happened at the outbreak of war in 1914. I landed on August 14 at Boulogne with the Seventh Brigade R.H.A., and 'alumettes', i.e. matches, was the first cry of the French boys and the first article we eagerly bought on our way to found St Martin's camp, through which a great host of our successors passed later, on their way to some of the greatest battles in world history."

We realise that negations are always difficult to substantiate. How can Appleby and Schultze prove that there was no shortage of matches at all in South Africa in 1899? An impossible task.

Schultze's letter to Audrey compelled us to build up a small library on the Anglo-Boer War of 1899-1902. We both spent much time studying the literature about the Boer War. There is an unbelievable number of books about this subject alone... We were not able to find anything that could possibly confirm directly or indirectly the statement "no shortage of matches with the British troops in South Africa in 1899".

On the other hand, we are now able to devote a great number of pages to all kinds of shortages with the British troops in the second half of 1899 when the Cabinet, urged by a wave of national chauvinism, decided to send troops sooner than the War Office thought wise because of the necessary time-consuming preparations.

Tabitha Jackson in her study *The Boer War*[N105] concludes that the War Office was singularly unprepared for dispatching what would eventually be the largest army sent abroad in British history:

The War Office in Britain was not as well equipped as it should have been. The British Army did not expect to be detained long by a force without any parade-ground discipline or even a uniform. It seemed inconceivable to the British public, and indeed to the British Army, that this ragged band of Bible-wielding farmers could hold out for long against the might of Her Majesty's troops. The phrase 'it will all be over by Christmas' soon gained popular currency but proved to be as over-optimistic as it was when it was used just fifteen years later in 1914.

A British correspondent M. Hales, staying with the troops of General Rundle, reports to the home front:[N106]

> Are people whose hand trembles when they pick up their gun, not because of fear or of wounds, but of weakness and lack of blood and muscles, caused by regular hunger, are those people capable to attack a kopje? You are standing in your music halls to sing the glory of your soldiers, those 'brave boys over there', and you let them starve in such a way that I have often during the march seen them fighting with a negro for a handful of flour.

We will refer to a clear and short statement in a recent study *The Boer War 1899-1902*[N107] by Gregory Fremont-Barnes as an example of a great number of statements that we came across, all with the same message.

> Stringent economies in the army in recent years meant that weapons, ammunition, horse equipment, transport and other essential articles were insufficient for anything beyond small-scale operations. As soon as campaigning began, stocks of all manner of things ran short.

Did the soldiers, suffering all kind of shortages, even ammunition, not suffer a shortage of matches? Smoking in those days was so common, and in an era with no television or internet, no radio, no cinema yet, smoking a pipe, cigar or cigarette was a welcome, comforting and widespread pastime.

No shortage of matches? Why is the postmaster-general in a report in *The Times* of 15 December 1899 emphatically warning the public not to include matches in their parcels to South Africa?[40]

40. Thanks to research by Prof. Frank Kessler.

MATCHES WITH PRESENTS OF TOBACCO. We have received the following from the Post Office: -
The Postmaster-General finds that many persons who are sending presents of tobacco by Parcel Post to soldiers serving in South Africa are enclosing lucifer matches therewith. The Postmaster-General points out that it is contrary to law to send matches by post at all, and that their conveyance by ship as part of the mails is especially dangerous. Any parcel which is observed to contain matches has to be detained at the risk of this appointment both to sender and receiver.

The literature is clear. In the first months of this war, when the British troops suffered great losses and were besieged on several places, they suffered shortages of all kind, even food and ammunition, let alone matches.[41] Schultze's military friend and museum colleague Colonel Appleby seems to be still a warm British Empirist, but it is apparent that in the first months of the Anglo-Boer War, the British troops were under-equipped and under-provisioned, even sometimes being under-nourished.

No one was amazed when, in December 1903, Whitehall announced wide-ranging reforms in the army and navy after the reorganization of the committee of imperial defence. The new committee started studying a report of the Royal Commission into the Boer War, a report which highlighted weaknesses in the army organization and chain of command. The army never had a proper plan of campaign, regarding the war as a minor colonial skirmish, not a major affair against a well-organized enemy equipped with artillery, fighting in a style well suited to the terrain.

Finally, what about the shortage of matches in the First World War of which Schultze's informant Colonel Appleby was so convinced? Rebecca Hawley of the Imperial War Museum[N108] informs us:

I am afraid that a search of our collections revealed no references that would be of assistance to you. I am not aware of any match shortage during the First World War, and could find no references to support a shortage in publications held here on First World War supply. We do have one Bryant and May matchbox in our collection which dates to the First World War. (...) It is interesting to note that the matchbox does have *'please use matches sparingly'* written on it.

3. *Edge markings indicate a possible later date.*
It seems such a decisive argument: there are markings on the edges of the film.

41. We were told that 'Vinolia' also organised an appeal because of a shortage of soap.

"The dating marks on your Father's negative film (manufactured by Kodak) also point at a 1915-18 date," writes Schultze to Audrey.

This is rather an amazing remark. In 1916, Kodak started to mark its film stock on its edges with what they called *'year symbols'*: a circle for 1916, a square for 1917 and a triangle for 1918.

Why does Schultze mention 'a 1915-18 date' covering at least three different year symbols? In 1915 there were not yet marks on the film edges.

Schultze signs his letters with his function 'research librarian and curator'. He is a true Kodak expert, but does not use the official company's term 'year symbol'. Most striking is the fact that he does not mention which specific year symbol or dating mark he noticed 'on your Father's negative film (manufactured by Kodak)'. If he had seen a dating mark, was it so difficult to remember if it was a circle, a square or a triangle? These are such obvious and simple symbols. Schultze's authorative attitude only weakens his argument.

It is possible that the donated positive print contained a 'year symbol' of a certain date, which is not mentioned by Schultze. Mrs Kate Melbourne-Cooper writes to her daughter Audrey:[N109]

*Re. Dr. S. letter about the Matches Film. Dad is **very** surprised Kodaks say the NEG. was made in 1917. It is impossible! Even if he had reproduced it, as he seems to remember he did some of the old NEGS, it would have been before 1917.* (Bold by Mrs Cooper.)

The letter of Schultze to Audrey is lost, because she sent it to Coton. But Schultze mentions here the year 1917, and the year symbol should therefore have been a square. In his later letter he just wildly covers a wide period, 1915-1918, almost the whole First World War period.

Schultze made his conclusions on the basis of a positive copy made in 1956 of the original negative. A 35mm dupe negative of MATCHES APPEAL[42] in the BFI National Archive was recently examined by David Cleveland,[N110] who observes:

"This in my opinion was made from an original 1899 print. The original must have come from Audrey Wadowska, as her name is on the front information frame as 'producer' (though this information was added in recent times.) There is a faint shadow of the original perforation on the 1899 print which has been copied through to this dupe neg. This appears to be a

42. Could this possibly have been taken from a contemporary print? Or from the positive print donated in 1956 by Cooper to the Kodak Museum, now in the collection of the National Media Museum, Bradford?

small type perforation. This would indicate that it is before 1909 when Bell and Howell introduced a standardisation for perforations, which from then on were of the negative type, still used today. I have seen this small type of perforation on other British films of this time, when perforations of film stocks varied slightly in shape and position. So I would say it was taken from an original 1899 print. Where this is now is not recorded."

The remark about 'pointing dating marks' from a Kodak expert is therefore rather curious. He must have seen something on the print which Audrey ordered from a laboratory, but did he really see a genuine year symbol of the original negative? Because no further explanation is given, Schultze's random remark about 'dating marks' should be forgotten.

Bryant & May have nothing about it in their archives.[43] "They didn't keep records during the Boer War," says Audrey. She went to Bryant & May's head offices to make inquiries about it. Bryant & May representatives later visited Audrey and Jan Wadowski, St Albans, 1980. They never disputed to them the date of 1899. As Audrey says: "Father used to say, it was made at the time around Ladysmith, and Billy Jeapes included that in the program at the Empire before Christmas at the time of Ladysmith, so it must have been 1899, before Christmas."

Trevor T. Moses, film historian and resident expert on South African film history of the National Film, Video and Sound Archives in Pretoria, assures us:[N111]

> I would say that 1899 would be the most likely year when MATCHES APPEAL was made. I am quite sure that the NFA's then resident experts would not have put World War I footage under Boer War footage when they catalogued and classified the material. Our cards state the date as 1899-1902 which means that it was definitely made in the time of the War. So far as I am concerned, the 1914 date is irrelevant.

43. F.H. Dawson, sales manager Bryant & May Ltd., Fairfield Works, Bow, London, to Mr F. Law, Hon. Secr. South African War Veterans' Association, Norbury, London, 7 September 1956: "It was brought to our notice a few months ago that a portion of this film had been found, and we were asked whether we had a remainder or a copy of the whole film. We have made an extensive research in our records but are unable to trace anything. It may well be, however, that in the intervening years such records have been destroyed." (Letter in Melbourne-Cooper Archive.)

8. "When Soldiers Couldn't Get Them"

Could MATCHES APPEAL have been made in 1915 for the soldiers in the First World War?

Yes, it could, but Cooper himself is sure about the Boer War. In the BBC interview of 11 July 1958 with NFA curator Lindgren,[N112] who asks him emphatically about MATCHES APPEAL:

I believe you made a film yourself with animated matches, didn't you?

Cooper's answer comes straight, and without hesitation he first gives the date, even though he has not been asked about it, and then the subject:

Oh yes! That was during the Boer War. It was an appeal for matches, when soldiers couldn't get them.

Lindgren, a leading British film historian, does not dispute this for a single moment but even indirectly confirms it by asking: "And how was the film made?"

We assume, as is the usance at the BBC, that there was ample time before the actual interview for a preliminary talk to prepare it. If Cooper's memory, because of his age, was 'confused or biased', Lindgren had enough chance to rectify this, but apparently he felt no cause to do so. On the recording tape of the actual interview that was kept in Audrey and Jan Wadowski's estate, Cooper's voice is clear, and with directness and alertness he reacts to Lindgren's questions. There is no reason not to believe Cooper's words. For, six days later, being interviewed by ITV television,[N113] he was no less direct and certain:

Interviewer: *I believe we had you to blame for these frequent interruptions in our programme. You were the first person to start animated advertising in 1896?*
Cooper: *Yes. The first one I did was for BIRD'S CUSTARD. Then followed a film for BRYANT & MAY of animated matches. This was used for the special appeal for donations to send one box of matches to each soldier in the battalion.*

In June 1961, Cooper donated a copy of MATCHES APPEAL to Pieter Germishuys, the founder of the South African Film Archive.[N114]

I have much pleasure in sending you a positive print of the film which I made in

connection with the Anglo-Boer War MATCHES "APPEAL". It is unfortunately, incomplete, as only a fragment of my negative has managed to survive the intervening years, but I trust this may, in some small measure, prove helpful to you in your present endeavour.

On three different occasions Cooper gives, without hesitation, the South African Boer War of 1899-1902 as the date of MATCHES APPEAL. Why would Cooper not be correct about a film he made himself?

A strong second argument is the following. There is a very practical consideration why MATCHES APPEAL was not made as an appeal for First World War soldiers. Around 1914 or 1915, even in Great-Britain, film distribution had become highly organised. Films were no longer sold by the foot, but rented, because the American rental system had been introduced a couple of years before. Catalogues and trade papers gave extensive synopses of all new productions. If MATCHES APPEAL had been made in 1915, why is it not published in the trade press or in distribution catalogues?

If anyone would have been capable of tracing MATCHES APPEAL in the period of the First World War, it would have been Denis Gifford, but there is no trace of them in his catalogues. However, we do find in Gifford's *The British Film Catalogues 1895-1970/1895-1985/1895-1994*, also in his *British Animated Films 1895-1985*,[N115] the following title: ANIMATED MATCHES under no 01893/01802 and no 19, as produced and directed by Arthur Melbourne-Cooper in 1908. This most probably is the same picture, distributed by Charles Urban as MAGICAL MATCHES for which Cooper, in 1908, needed the scene with the Bryant & May matchbox opening which he cut off from the negative of MATCHES APPEAL.

Our third argument is a matter of psychology and logic. Above everything else, the two dates of 1899 and 1915 were very important in Cooper's life. In 1899 he had just started the first of his film production businesses, the Cinematograph Syndicate Company. In 1915 he had lost it all. Two very different dates in his career. It seems to me unlikely that he would confuse the beginning of his career with the end of it. If he had made MATCHES APPEAL in 1915, why would he lie about it and give such an outstandingly different date that would be enough to catch him out?

From 1912 till 1915, Cooper was managing director of two companies, Heron Films Ltd and Kinema Industries Ltd., both at 4-5 Warwick Court, High Holborn, London W1. This was a rather big office with a film laboratory in the basement. At the outbreak of the First World War, Cooper's financial partner, Andrew Heron, withdrew his capital and took

active service in the navy. The two companies were dissolved in 1915. Cooper volunteered and got training to become a munitions inspector, in which function he served till 1918 at a munitions factory in Luton.

Audrey's mother writes her:[N116]

At that time he had sold all his equipment to Butchers (when he left London in 1915) & he had no facilities for making films, no dark room, etc. not even a camera! So there must be a mistake somewhere!

Cooper's youngest daughter, Mrs Ursula Messenger, told us:[N117]

How can they think that my father still made films in 1915? He had no studio anymore. He worked in Luton and we lived nearby in Dunstable.

We found indeed in Dunstable the address where the Cooper family found lodgings during the period of 1915-1918. There was no room for a studio. For the making of animation pictures, you need a safe place where you can work undisturbed. At the end of 1914, when British soldiers again suffered a shortage of matches for their pipes or cigarettes, Cooper did not have such a place anymore.

Our last argument is of a technical and artistic nature. MATCHES APPEAL is much too coarse and rudimentary for the period of the First World War. In 1915, would an appeal have any success if done with such a primitive moving picture? Compared with animation pictures made after 1910, the style and technique of the three matches pictures are very unsophisticated and basic. If made in 1915, Cooper would have taken many steps backward in comparison with A DREAM OF TOYLAND of 1907. During the First World War, the three crude matches pictures could only be considered as 'quickies', made by an amateur, productions which would be entirely out of step with Cooper's character.

He made a respectable number of animation films between all his other film work. He loved making moving pictures. It was his flesh and blood. During slack times like summer holidays, he had the patience to work for days and weeks on end on one production alone that lasted only 5 or 6 minutes in projection. MATCHES APPEAL, together with the two ANIMATED MATCHES, is technically as well as artistically at the start of his creative achievements and decisively not at the end of it.

Our filmography of the animation pictures of Cooper, of which all the collected material and photographs are kept in seven bulky ledgers, counts no fewer than 36 titles made in the periods 1896 till 1914 and 1925 till 1930.

Unfortunately, only 6 animation pictures survived. Discussions about proper dates, how interesting they may seem, divert our attention and even obscure our view from some essential issues. The surviving animation pictures together with what we know about the other 30 pictures are enough to offer a good impression of Cooper's talent as an independent film maker. The three matches pictures demonstrate how Cooper liberated moving pictures from their incubator, the Kinetoscopes, and gave them their own independent life. It is fascinating to see how a completely new form of creativity is born – animation as an autonomous expressive form.

How did Cooper come to build this sanctuary which fully possesses its own order? How is it that he is able to take us by the hand and lead us into his own dreams?

Thanks to cinematography, splinters and shivers can now play volleyball or cricket. What's more, they are even able to write moving humanitarian appeals on a wall. But can they do more than this? Can they play more than single shot scenes, can they be more than simple beings playing sports in a moving photograph, a living picture? Will they be able to capture my imagination for more than just a couple of minutes? In short, can they tell stories?

CHAPTER 3

Stubborn and Ineradicable

1. Design for a Film Language

Are movies sham products? Can something that is able to create a world with its own truth be bogus? Or is it an industrial product? Can we produce it on a conveyor belt? Is it bogus to advertise it as art?

The first thing we are entitled to expect of any work of art is, argues Ernest Lindgren, who established one of the leading film archives in the world, in his *The Art of the Film* [N118] that it shall have unity. We must be able to appreciate it for its own sake, it must be complete in itself, not marred by redundancies, irrelevancies or omissions. A fiction film should present an imaginary story of the thoughts and actions of individual human beings, and Lindgren does not exclude animals, referring to Aesop's Fables and the films of Disney. Yes, why should film not be art? Why should we not call A DREAM OF TOYLAND a fine piece of art?

Is every painting art? Can every book that was written be art? Can an industry make art? Is an industry capable of creating a studio as Mariëtte Haveman defines it, a real workplace as a Vulcanus forge?

In 1978 the International Federation of Film Archives (FIAF) organised a congress in Brighton. We were very interested in this congress because for three years the two of us had been studying the early years of British film

history, especially the film pioneers Acres and Cooper. We received support and encouragement from the Netherlands Filmmuseum. The director Jan de Vaal invited us to attend this FIAF Congress,[44] which was joined by a host of young, enthusiastic film historians.

The lectures, the presented papers and the reports were published in two volumes, *Cinema 1900-1906*.[N119] During the congress and its preliminary week we saw some 900 moving pictures from the period 1900-1906. Reading the reports after 30 years, it appears that much of the research into that early period was of a technical nature. On the following pages we will try to give priority to Cooper's intentions and meanings, because we have the seventeen tapes with Cooper's voice as a primary source.

Early moving picture shows offered what television and internet do today: most of it is not fiction, but dealing with sport, news and events, even staged events like beauty or singing contests. Early film shows do not seem to have been much different. Richard Crangle writes in his contribution 'Astounding Actuality and Life. Early Film and the Illustrated Magazine in Britain' in *Cinema at the Turn of the Century*[N120] that early film was strongly documentary in content and appearance. The camera was used more to record occurring events than to portray events staged or scripted for the purpose of filming.

John Barnes lists in his magnum opus *The Beginning of the Cinema in England*[N121] almost 1500 titles of films, but only 253 are classified by him as fiction. All the others are news and non-fiction.

This is demonstrated by a fascinating DVD with 50 short films from the period 1896-1916, *Europäische Jahrmarktkino*,[N122] giving a sample of what the public would see at fair-grounds in travelling cinema shows with endless reports on pageants and processions, filmed variety acts and stage performances, and surprisingly pretty coloured theatrical shows in the Méliès tradition. It seems to demonstrate that Acres was correct with his disgust for fiction.

A beautifully bound and richly illustrated film catalogue published in 1906 by Charles Urban[N123] – with the appropriate slogan 'We Put the World Before You' – offers 200 pages of newsreels, sporting events, reports on actions by royalty and parliament in England and abroad, documentaries on industry and animal films, but comedies and staged features form only a fraction of what the Charles Urban Trading Company has to offer. Pathetically, we

44. Instead of Tjitte's partner who was not able to attend because of her job, Audrey Wadowska, with the consent of Jan de Vaal, accompanied him at the Congress.

found in this catalogue with its hundreds of films only one animation picture, the already mentioned cut-off from Cooper's THE FAIRY GODMOTHER of 1906,[45] NOAH'S ARK of 75 feet,[N124] a little more than one minute in projection.

2. Alpha Film Studios 1901-1911

In 1900, Cooper used the photographic studio of his father at Osborne Terrace in St Albans to make a number of astonishing pictures that became world famous, because they are considered to be the first with interpolated close-ups – close-ups that are deliberately cut at specific places into a scene.

That was something astounding. Cooper cut a camera negative on purpose into several pieces. He put between them other short pieces of film and stuck it together as if it was one whole film altogether. It was a revolutionairy way of making a moving picture. Something like that had never been done before. Exhibitors used to cut several films into one big roll to make a projection more efficient, but never before had a movie maker cut into a costly camera negative.

Cooper did it with the picture GRANDMA'S READING GLASS (1900). For the first time, a film maker applied the art of deliberately cutting a number of pre-defined close-ups into pre-defined places of a medium action sequence.

That is how Cooper discovered the first steps of telling a story with the film images themselves. With animation pictures you create movement by stopping the film. With film stories you make the story by breaking up the film itself. By using your scissors and cutting your negative into bits and pieces, you can create realities in other people's heads.

Three, four or more little matchstick men playing cricket and volleyball and writing a message on a wall are still in the young fashion of the newly invented cinema: moving photographs that showed workers leaving a factory where a cameraman put up his tripod near the gate, or the traffic of pedestrians and horse carts on a bridge, the goal made by a winning football team or Cambridge students winning a boat race.

45. Urban, in his catalogues of 1906 and 1909: "NOAH'S ARK, 2116. LIFE IN THE ANIMAL KINGDOM. Showing the wooden animals of the Children's Ark, descending the gangway in pairs. This section is adaptable to precede the 'Animal Kingdom' Series, thus carrying out the nature of the title. Length 75 feet." – Audrey Wadowska to Tjitte de Vries, London, 13 April 1979 (To36): "Urban, ANIMAL KINGDOM, I believe these are compilations. Here, NOAH'S ARK. But there were no copyrights. He then gives OUR FARMYARD FRIENDS, and some of these were taken at the Wagon and Horses. Some chickens were father's chickens. Old films, all dug up and stuck together, compiled in a series."

Fig. 17. London Road, St Albans. Audrey Wadowska is standing at the right of 1, Osborne Terrace, where local photographer Thomas M. Cooper had his portrait studio. In 1899, Audrey's father made in its back garden MATCHES APPEAL and two other animation pictures with matchstick puppets. On 4 July 1900, her father filmed here GRANDMA'S READING GLASS and several other short pictures with close-ups.

Now the tables are turned. Cinema is developing muscles. The movies will now show that you can smell it, taste it, feel it, hear it, in short the stories are coming.

A boy and a girl are playing grandson and grandmother. Thanks to Cooper who recalled the story for his daughter Audrey on one of the tape-recordings[N125] we know that the beginning, where the boy enters the scene, is missing.

> What about the film GRANDMA'S READING GLASS. It was an early film. And then you can give it a posh start. Grandma is reading her newspaper and her grandson enters. (...) Then she falls asleep. And then the grandson comes in. He pinches her glass and proceeds to examine various things on the screen. This causes laughs because it is something peculiar.

The boy starts to play with grandmother's magnifying glass. He points it at several objects, a newspaper with an advertisement for Bovril. We see how

Fig. 18. GRANDMA'S READING GLASS (1900) with Albert Francis Massey and Bertha Melbourne-Cooper. Later, Brighton film pioneer George Albert Smith made his own version.

he picks up the paper and looks at it. And then suddenly – *we* are looking at the Bovril advertisement.

The boy puts the paper down. He looks through the magnifying glass at a canary in a cage. And at that moment it is again *we* that see the canary magnified on the screen. The boy points at grandmother's eyes and uses the magnifying glass to look at her eye. And grandmother's eye can be seen a hundred times magnified, looking at us from the big screen.

Every time when the boy looks at something through the reading glass, we are seeing it also. We are looking at it through the eyes of the boy. From objective spectators we become subjectively involved in the actions of the boy. His eyes are becoming our eyes. We are looking through his eyes to the world which is there in the film. We have become his participants in everything he is doing while grandmother is darning a sock. As by magic we are sucked into the white screen, forgetting the whole world around us, – forgetting everything outside the black borders of the projection screen. That is precisely the enchantment of this moving picture, and this is what made people laugh when they experienced it.

It was Cooper's youngest sister Bertha who plays grandmother. Albert Francis ('Bert') Massey, a boy from the neighbours, is playing the curious

grandson. The enlarged eye in close-up was that of Audrey's grandmother Catherine Cooper *née* Dalley. Film historians in general agree that this film is the first example of the deliberate use of close-ups interpolated into one and the same medium shot.

We are certain of the date when GRANDMA'S READING GLASS was made because during more than a week we assisted Audrey researching newspapers in the British Library. She finally discovered that the enlarged piece of newspaper with the Bovril advertisement came from the *Daily Express* of Wednesday, 4 July 1900.

Cooper made several other films at the same time. We don't know if they were made earlier than GRANDMA'S READING GLASS or later. They were: THE CASTLE OF BRICKS in which a little boy destroys the toy castle his sister just built.

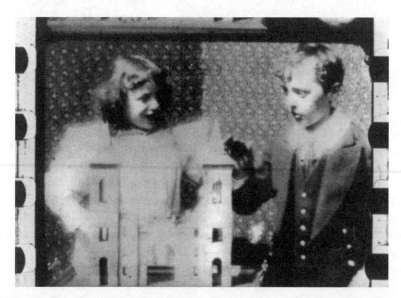

Fig. 19. THE CASTLE OF BRICKS (1900), with Mary and Ralph Massey, has the same folding screen - common in photographic studios - as background as in GRANDMA'S READING GLASS.

Thanks to the magic of Cooper's second upside-down camera, with one sweep of his hand the boy restores the castle. The background of this picture is the same as in GRANDMA'S READING GLASS, but it has no close-ups.

There is THE LITTLE DOCTOR, in which a young boy plays a veterinary surgeon coming to cure the sick kitten of a girl. The picture is interrupted

by a close-up of a young cat licking milk from a spoon. WHAT THE FARMER SAW, about a farmer who discovers through a telescope how a gallant young man ties the shoelace of his girl friend, got Cooper into trouble when he showed it as a Sunday school treat. Just before the young lady's shoe was to be shown enlarged on the screen, the projection was interrupted by the Sunday school teacher. Cooper was going too far. Showing a lady's ankle enlarged on the screen was considered indecent. THE OLD MAID'S VALENTINE, in which an old maid receives a Valentine card, contains the same folding screen as background as GRANDMA'S READING GLASS. The Warwick Trading Company and William Jury offered these films for sale in their catalogues and trade advertisements. GRANDMA'S READING GLASS was remade by Pathé in France as LA LOUPE DE GRANDMÈRE, and by Edison in the United States as GRANDPA'S READING GLASS. It indicates how popular this film was.

Again, Cooper misses the bus in world film history. During the Forties, a French film critic, Georges Sadoul, in his book *L'histoire du Cinéma Mondial*,[N126] credited GRANDMA'S READING GLASS to George Albert Smith of Brighton, because Sadoul encountered the title in a sales list of Smith,[46] printed in a catalogue of 1903 of distributor Charles Urban. Not only was there the title of GRANDMA'S READING GLASS but also the titles of the other pictures. Since Sadoul's publication, Smith was seen by English film historians as the leader of the so-called 'Brighton School', a name coined by Sadoul. We stress so-called, because if the word school is used as a metaphor, we generally understand that there is a leading personality whose followers are collectively called 'school'. The 'Brighton School' consisted of chemist and film pioneer James Williamson, who made many moving pictures but mainly sold film apparatus, George A. Smith who was employed or commissioned by Charles Urban to manage a film laboratory in Brighton and who made a number of films, portrait photographer Esme

46. Sadoul met Smith, and made the curious observation in his *British Creators of Film Technique*: "We failed to arouse his interest in our questions as to the reason why he thought of creating the first sequences known in the history of films in GRANDMA'S READING GLASS and THE LITTLE DOCTOR. (...) However, we firmly believe that Smith never attached any importance to a process which he only employed in five or six films (...)", and in *Histoire du Cinéma* he writes: "L'indifférence de l'inventeur était naturelle. Il comprenait mal qu'on s'étonnait devant le premier emploi au cinéma d'un procédé déjà utiliser ailleurs." Sadoul strongly believed, if one would search long enough, one would surely find series of magic lantern slides with the story of GRANDMA'S READING GLASS, or AS SEEN THROUGH THE TELESCOPE (Cooper's title: WHAT THE FARMER SAW).

Collings who produced a number of short films during a limited period, and Alfred Darling who managed an engineering workshop until 1931, producing many high-class cameras and projectors for several brand names. There is no significant name to lead this 'school'. At best, one could call it the 'Brighton group'. Smith left a cash and account book to the BFI. The titles of most of his films can be traced back in them, but not a single title of the five of the GRANDMA'S READING GLASS series of pictures can be found.

After looking into all the arguments and memories of Cooper's children, studying all the available material, listening to the recordings with Cooper himself, and after researching the possibilities that Smith could still have been the maker indeed – research from which Smith did not emerge completely unblemished – there is enough circumstantial evidence that GRANDMA'S READING GLASS and the other films from this series can be credited to Arthur Melbourne-Cooper of St Albans. We have argued this in extenso in our publication in the German yearbook of early movie history KINtop.[N127]

We have the evidence that Smith made his own version and was not responsible for the version that was rediscovered in Denmark in the early Sixties. We have in our possession a strip of a couple of frames from the negative of Smith's version of GRANDMA'S READING GLASS with an unsteady moving eye, possibly a pig's eye, enclosed in a black circle that looks much different from Cooper's version in which, though the eyeball is moving, the eye itself is steady in the centre of the circular mask. Smith gave the original negative, half a century later, to the Brighton film collector Graham Head. It is now in the Graham Head Collection of the Cinema Museum, London. Smith also made his own version of WHAT THE FARMER SAW and titled it AS SEEN THROUGH THE TELESCOPE.

As early as 1956, Audrey Wadowska told the BFI that GRANDMA'S READING GLASS was made by her father. One of the films from its series, THE CASTLE OF BRICKS is credited to Arthur Melbourne-Cooper as THE HOUSE THAT JACK BUILT in the Catalogue of Viewing Copies of 1971 published by the NFA.

In 1901, Birt Acres moved his raw film stock factory from Nesbitt's Alley in Barnet to a large plant in Whetstone, closer to London.

And 1901 was the year when Queen Victoria died. In the same year Cooper's father died. Thomas's old photographic studio at Osborne Terrace was shut down. Cooper now formed his own Alpha Trading Company and established the Alpha Cinematograph Works with premises at the two-acre site of Bedford Park in Beaconsfield Road, St Albans.

Fig. 20. Bedford Park, studios for the Alpha Cinematograph Works from 1901 till 1908. The studio building (cottage in the centre) is still there.

Here he started one of the busiest moving picture studios in England before the First World War, producing many comedies, dramas, newsreels, documentaries and animation pictures. It was a spacious park with two revolving open air stages, and a cottage with two floors and an attic. Here he fitted up his own film laboratory, workshops and dressing rooms for actors and actresses. Bedford Park and its cottage still exist. The cottage can be seen in some films.

3. Favourite Theme Noah's Ark

We know from a visit to Mrs Russell Jones in Penarth, who as Nellie Dewhurst[N128] lived in St Albans near the Alpha film studios where as a child actor she played in several pictures, that Cooper had a talent of dealing with children. In 1901, she most probably played the lead in DOLLY's TOYS (or DOLLYLAND). Cooper films a young girl falling asleep. She has her doll with her. She dreams that her doll comes to life. It is a simple picture with two shots, a length of 80 feet and a running time of 1.20 minutes. The first scene is live-action and prepares us for what comes next. The second shot is on the level of the doll. It stands to reason that Cooper uses for this shot the same camera that was specially prepared for making the three matches

pictures, because with this camera and its lens in front of racking bellows you can get small objects like a doll in perfect focus on a short distance, and animate it shot by shot. He probably used this camera to make the series of close-ups that are interpolated in GRANDMA'S READING GLASS.

DOLLY'S TOYS is to be found in Robert W. Paul's catalogue of Animatograph pictures.[N129] Denis Gifford[N130] gives Cooper credit, but he makes a reservation for Walter Booth, a trick film specialist, as a possible maker. Donald Crafton[N131] suggests that DOLLY'S TOYS or THE ENCHANTED TOYMAKER could have provided inspiration for Blackton if they contained true animation.

According to what Audrey Wadowska remembered of what her father told her, there was only one doll:[N132] "I suppose they were pretty short experiments, like his first doll film. According to Gifford it was the first, 1901, which is fairly early for that type of thing. A little girl falls asleep and her doll comes to life. This is only one doll, not like A DREAM OF TOYLAND. This was an early experiment."

Audrey was sure it was animation. On the typescript of a tape recording with her father,[N133] Audrey made a note, "The trick film studio was then moved to the Old Poly, St Albans, that would become later the Alpha Picture Palace." However, the St Albans Polytechnic was built in 1904.

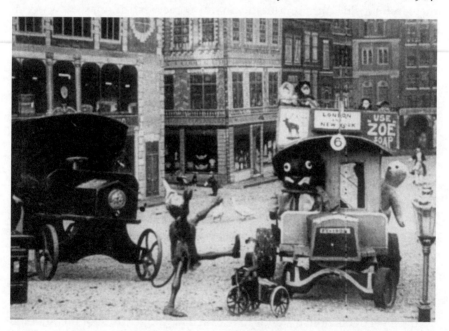

Fig. 21. A traffic congestion in A DREAM OF TOYLAND (1907).

The trick work for DOLLY'S TOYS, and A BOY'S DREAM made two years later in 1903, as well as the live-action were done at Cooper's new studio at Bedford Park, Beaconsfield Road, St Albans, after the closing down of his father's photographic studio at Osborne Terrace.

From now on Cooper will produce at least one animation picture each year, but in 1902 it is only a scene used as a close-up in a live-action comedy. It is CHEESE MITES with a total length of 160 feet, running time 2.30 minutes.

Apparently Cooper, in 1902, was not able to produce a time-consuming animation picture. He was engaged by the British Mutoscope and Biograph Company to make the 35mm version of the CORONATION OF KING EDWARD VII which he took from the Canadian Arch, a coronation that was planned in June but postponed to 9 August because of illness of the king. It was a job that took up most of the summertime.

In CHEESE MITES, a man having lunch discovers something funny with his cheese, and using a magnifying glass discovers all kind of mites crawling around. There are three shots. The first is live-action with the man at the table, reading a newspaper and eating a piece of cheese. The second shot is the close-up of so-called mites, crab-like creatures with long spiny hairs and legs, according to the Urban Trading catalogue of 1903. In the third shot the man, frightened of the mites, throws the cheese away, full of disgust.

Pictures in which true bugs or lively insects under a microscope can be seen enlarged on the screen were made often in those days. With his sense of humour, Cooper made fun of these pictures. Audrey remembered CHEESE MITES on several occasions. Her father used for the first time an animation subject that she herself saw him applying when he, during the Twenties, made advertising animation pictures for the cinemas. Cooper liked making creepy creatures out of cotton wool and wire. Her father's assistant, Stanley Collier, remembered CHEESE MITES, too. Audrey:[N134] "Stan Collier recalled that. It was an early one. You saw the cheese, crawling with bugs and then he enlarged it – the interpolated type, I suppose. You saw these ghastly cheese mites which he made himself. Same as in Blackpool for milk, the CLEAN MILK CAMPAIGN. He made bugs and things himself with wire and cotton wool."

For a number of years, the films of the French film maker Georges Méliès were very popular ingredients in moving picture programmes all over the world. It was Charles Urban of the Warwick Trading Company, an important distributor of Cooper's films, who imported Méliès's Star Film productions in Britain. In 1902, Méliès produced his greatest success, VOYAGE À LA LUNE, inspired by the novels of Jules Verne.

Fig. 22. THE ENCHANTED TOYMAKER (1904) with Hattie Makins as the fairy.

In 1903, the French moving picture producer Léon Gaumont, who had a studio in London, introduced his sound cinema system, the Chronophone. It consisted of a projector mechanically coupled with a grammophone player. Cooper made a number of sound films in Gaumont's studio in London.[N135]

In 1903, A BOY'S DREAM, also known as THE MINIATURE CIRCUS, with its 200 feet and a running time of 3½ minutes is again longer. It is about a boy who dreams that his toys are leaving the toy-box in order to give a circus performance. Unfortunately, we know very little of this picture, which probably has the well-known routine of a live-action shot of a child going to bed, and animated toys in a second scene. It is possible that the picture concludes with a third scene in which the child wakes up and finds that it was all a dream.

The following year, Cooper produced THE ENCHANTED TOYMAKER which, with a length of 190 feet, runs a little over three minutes. A toymaker falls asleep. A fairy enters his workshop. With her wand she enlarges a Noah's Ark. The toys touched by the toymaker come to life and march into the ark. When the toymaker locks the ark and puts a toy soldier on guard, it fires its gun which wakes up the toymaker.

Other trade titles for this picture are: THE FAIRY GODMOTHER, and TOYMAKER AND THE GOOD FAIRY. "The first animated film we can definitely attribute to Arthur Cooper," says Gifford. Donald Crafton writes:[N136]

"Cooper's animation career really commenced in 1904 with THE ENCHANTED TOYMAKER, produced by R.W. Paul. This film also marked the beginning of Cooper's long infatuation with the theme of Noah's Ark."

Crafton regrets that the picture does not exist anymore because he presumes that American film makers were inspired by Cooper's animation pictures. "This would explain the reason for Blackton's silence concerning his alleged status as the inventor of animation," is Crafton's supposition. The American Film Institute Catalogue 1893-1910 mentions the picture as being exported in July 1904 by Arthur Cooper as well as by his Alpha Trading Co. Robert W. Paul published it in his 1904 catalogue with a still from the film, when the fairy enlarges a toy ark.[47]

Audrey discovered that the fairy was played by Hattie Makins, a bailiff's daughter of Salisbury Hall near Ridge Hill, a hamlet between St Albans and Barnet. It is on the road which Cooper got to know so well when he worked for Birt Acres, travelling on his bike up and down from St Albans to Barnet.

In 1905, when Cecil Hepworth produced the seven minutes long successful live-action picture RESCUED BY ROVER, Cooper made DOINGS IN DOLLYLAND, a picture of 375 feet and running more than six minutes. All we know is that it is about the adventures of puppets.

It makes painfully clear that too much is lost from those early years of film history to make blunt statements like "there was no animation in Europe before 1906".

In the next year, Cooper made THE FAIRY GODMOTHER.[48] It is 140 feet long and runs 2.20 minutes when screened at the usual sixteen frames per second. It starts with a live-action scene of two children tucked up in bed by their nurse. When the nurse falls asleep, a fairy enters to bring their toy ark to life to the delight of the children who watch in astonishment how wooden animals in pairs descend by the gangway from the ark. The animation scene, which forms more than half of the picture, is concluded by a final live-action scene in which the nurse wakes up.

The picture was distributed by Cricks & Martin who advertised it in their Lionshead catalogue. It can also be found in catalogues of Charles Urban in the cut version under the title NOAH'S ARK as introduction to his documentary series LIFE IN THE ANIMAL KINGDOM.[49]

47. See our survey in Part Two – Filmography, 9. THE ENCHANTED TOYMAKER.
48. This is a different picture than THE ENCHANTED TOYMAKER (1904), which at some time was reissued as THE FAIRY GODMOTHER.
49. See our survey in Part Two – Filmography, 11. THE FAIRY GODMOTHER.

According to Audrey THE FAIRY GODMOTHER was a popular picture. Cooper made use of a well-known subject, Noah's Ark, which was popular with children with all its different animals, like Lego is today.

Who were Cooper's competitors, at home or abroad, in the field of stop-motion animation? We were not able to find any indications about others who made this kind of object animations.

Very early pictures with 'lightning' sketch cartoonists were probably the forerunners of a host of stop-action trick pictures with quick sketching artists. In 1895, Cooper, most probably as cameraman, assisted Birt Acres in a series of 'lightning sketches', filming the vaudeville cartoonist Tom Merry (William Machin) drawing in rapid motion the portraits of famous personalities like Kaiser Wilhelm II and Lord Salisbury. In America, J. Stuart Blackton, a newspaper cartoonist, started to make 'lightning cartoons' for the Kinetoscopes.

Another vaudeville artist was Walter R. Booth,[50] a conjuror who, from 1901, made a series of trick films for Robert Paul and later Charles Urban with live-action and stop-action animation. Booth's pictures mainly had an artist as subject who made sketches which magically came to life forming themselves into live-action actors.

Many trick pictures were produced with stop-action tricks, when the camera stopped at a certain point and re-started when a substition was made creating the illusion of a metamorphosis. Cooper made a haunted hotel type of trick film, A NIGHT OF HORROR (probably the same as Warwick's MIDNIGHT INTERRUPTIONS, 1902), in which a guest in a private hotel is haunted by spooks, running up the wall, along the ceiling and down the other side to get away from the spooks.[N137]

Striking is Segundo de Chomón's picture SCULPTEUR MODERNE (Pathé, 1906), in which a woman shows a picture frame. Inside it, miniature *tableaux vivantes* can be seen, small animated 'living pictures' like those that

50. Walter R. Booth (1869-1938), conjuror and trick film pioneer, started his career in music halls, performing during intervals at moving pictures shows. He made trick films at the studios of Robert W. Paul and the Alpha studios in St Albans, and later had his own studio at Isleworth, making advertising films. One of his well-known trick pictures is THE HAND OF THE ARTIST (1906). Audrey Wadowska to Tjitte de Vries, 16 August 1978 (T022): "He used to be father's cameraman." 20 August 1978 (T031): "The trouble is, Walter Booth worked for father too." 13 April 1979 (T036): "He did work for Paul first, I believe. Then he did work for us, and Cricks, or he hired himself out. He did work for Cricks at the same time he did for father." 30 July 1979 (T175): "He employed Walter Booth. Booth used to be free-lance cameraman for father in those days."

were quite fashionable on the stage in those days. Innumerable Haunted Hotels were made in this way, with J. Stuart Blackton and Albert Smith's The Haunted Hotel in 1907 as probably the most successful picture.

One of Booth's pictures survived, The Sorcerer's Scissors of 1907, in which an animated teddy bear with a pair of scissors cuts paper shapes which form themselves by stop-motion into live-action actors, but there is no other animation. We assume, considering the synopses of his other films, that once Booth created his own technique, those too were mainly based on the technique of stop-action substitution. Cooper's daughter Audrey assumed that Booth, for a while, worked at the Alpha Film Studios in St Albans, which explains that his films, after 1906, did not appear anymore in the Paul catalogues but in those of Charles Urban. "He used to be one of Alpha's free-lance cameramen."[N138]

Of the 36 animation pictures that Cooper made, eleven have live-action scenes. In the Enchanted Toymaker (1904) a toymaker falls asleep and dreams that his toys come to life. A little boy dreams in A Boy's Dream (1904) that the presents for his birthday suddenly lead their own lives.

Did the film maker want to lengthen his productions in a quick and cheap way? This seems a sufficient explanation but for the fact that most distributors in those days wanted their films as short as possible because of the price per foot.

Cooper's film production output now became thriving. The demand for moving pictures was great, and during this time he made a new film almost every day. Cooper's films were sought-after because of his many outdoor locations. One of his popular dramas was The Blacksmith's Daughter (1904) about a young girl deceived by the local squire.

In 1905 he made a remarkable documentary, A Visit to the Royal Mint: The Empire's Money Maker. It is one of the earliest surviving examples of available light documentaries, because Cooper was not allowed to use artificial light when filming inside the Royal Mint.

In the same year, we can see the pioneer himself being most active in a live-action slapstick comedy in the best Mack Sennett traditions to come, MacNab's Visit to London, in which he plays the lead of a mean Scotsman, MacNab, a golf enthusiast.

The picture gives us examples of his special kind of humour with which he satirises the new fashion of playing golf. There is even a slapstick joke in that typical English comedy tradition in which tv-comedy series like *Spitting Images* and *Absolutely Fabulous* are produced, teasing the curiosity about what a Scotsman might wear under his kilt, when MacNab, in his golf playing frenzy, loses it. Well, in Cooper's case, when his hostess tears

Fig. 23. Arthur Melbourne-Cooper as MacNab in MacNab's Visit to London (1905).

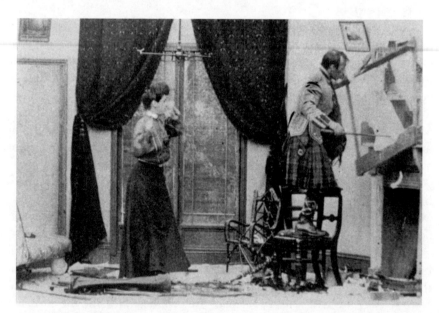

Fig. 24. MacNab's Visit to London (1905), with Cooper and Ruby Vivian, who also acted in A Dream of Toyland (1907).

his kilt off him, it is a decent pair of boxing shorts. In 1905, when a woman's ankle was still a taboo, this scene was almost salacious. Cooper sold many copies of MACNAB'S VISIT TO London.

Another success was RESCUED IN MID-AIR of 1906, in which a professor in a flying machine rescues a damsel in distress from a church spire, three full years before Louis Blériot succeeded in winning the prize of £1000 offered by the *Daily Mail* when he crossed the Channel from Calais to Dover.

In 1907, the Great Western Railway (GWR) commissioned Cooper to make a travelogue after it opened an express rail service linking Cork and Waterford with London via the new ports Rosslare and Fishguard on 30 August 1906. Cooper's LONDON TO KILLARNEY, at 3000 feet in length, 50 minutes viewing, can be considered one of the longest films made in that time. That was at the same time when he made his animation picture A DREAM OF TOYLAND, which was probably his greatest success in that year.

4. A Dream of Toyland – Surpassing the Limits

A true cinematographer when making a new moving picture shall always try to surpass the limits of what is technically possible.

During the autumn of 1907, Cooper made in his Bedford Park studios, on one of his open air stages, a secure place for the table-top stage of A DREAM OF TOYLAND, an animation gem that still enthrals young and old.

It became one of Cooper's great commercial successes, as testified, almost half a century later, by E.G. Turner of the Walturdaw Trading Company who distributed the picture: "The novelty of it created much interest, and I sold many copies."[N139]

The commercial success of A DREAM OF TOYLAND may surely have contributed to the fact that Cooper carried on making those time-consuming animation pictures at an average of two, sometimes three productions a year.

The animation of A DREAM OF TOYLAND with its ongoing action in several positions on the set reminds us of that modern cinematographic masterpiece RUSSIAN ARK (2002) by Alexander Sokurow who, in one continuous shot of 90 minutes with no visible joins, filmed in a single day historic and ballroom scenes in the lustrous halls, corridors and rooms of the Hermitage in St Petersburg without one boring second. Cooper, too, surpassed his technical limits in a clear and convincing manner.

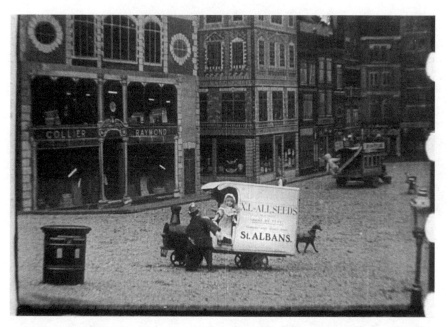

Fig. 25. A free plug for a St Albans seed company in A DREAM OF TOYLAND (1907).

The animation sequence reminds us also of films by American director Robert Altman, whom we admired greatly, whose comical drama of A WEDDING spans one day in which the destinies of many cynical and pathetic characters are intertwined during a ceremony followed by a party. Or even better the dazzling musical mosaic of NASHVILLE, another masterpiece with dozens of connecting and disconnecting short and longer stories of tragedy and romance, again all in one day. Both films are as classical as A DREAM OF TOYLAND, obeying the laws of unity of time, place and action.

Considering its cinematographic achievement, Cooper's A DREAM OF TOYLAND is a classic picture. We viewed it many times on DVD at a speed of 12 fps, which comes close to the contemporary average projection speed of 16 fps. At every viewing our admiration grew for Cooper's inventive and steadfast direction of the animation. His creativity, his imagination, and his sense of humour amaze us, but most of all his daring to surpass the limits of what was cinematographically possible in those days. At the same time, this production is a testimony of endurance.

In August 1991, we visited a private photographic museum near Totnes, Devon. Between pots and plants in a conservatory we discovered

by accident several rolls of nitrate films wrapped in old newspapers. One of the films started with a close-up of a telegram. Clearly written in Cooper's handwriting there was the address of 14, Alma Road, St Albans, Cooper's Alpha studios. The film was FOR AN OLD LOVE'S SAKE (1908), a fine piece of Victorian melodrama about a father sacrificing his life for his foster-daughter's happiness. There were five more films by Cooper. One of them was A DREAM OF TOYLAND, a nice, clean, sharp print in splendid condition.[51] We were very glad with the discoveries, five unknown Alpha films and, as an extra bonus, a crystal clear copy of A DREAM OF TOYLAND. This bonus appeared to be a double one: Cooper's original start title was there. The letters correspond with the letters from one of the alphabet letterboxes in the estate of Audrey and Jan Wadowski – letterboxes which according to Audrey were once used by her father to make film titles.

Several years later, we donated the collection to the Netherlands Filmmuseum in order to guarantee its safe keeping. The Filmmuseum, meanwhile, has made conservation copies.

It is exceptional that A DREAM OF TOYLAND still exists considering the many films that are lost. A film maker found it worth his while to spend much time and effort in producing it, and directing six to eight adults and juveniles to animate a collection of no fewer than 40 objects.[52] This shows his passion for his craft.

A DREAM OF TOYLAND is exceptional because we were not able to find a comparable example of stop-motion object animation in the same period when J. Stuart Blackton and Emile Cohl were active.

A DREAM OF TOYLAND, as a very early highlight of puppet animation, is a natural result of the path that Cooper started as early as 1899 with the three MATCHES pictures, a path which he, in the next seven years, in the spare time between all his other film-making activities, followed up with five other animation pictures: DOLLY'S TOYS, A BOY'S DREAM, THE ENCHANTED TOYMAKER, DOINGS IN DOLLYLAND, and THE FAIRY GODMOTHER. Of these, only the three MATCHES pictures still exist.

It stands to reason that after 1907 A DREAM OF TOYLAND was followed by a great number of other puppet pictures, but of these, again, only a couple survived: NOAH'S ARK and ROAD HOGS IN TOYLAND. From 1899 until 1915, Cooper made no fewer than 28 animation pictures in total, not

51. We had to pay a lot of money for them when the owner of the museum realised how determined we were to buy these rolls of dusty old nitrates: £500.
52. See Appendix 2a: '40 Animated Film Stars'.

Fig. 26. William Taylor's Bioscope Show at Newport Pagnell, Buckinghamshire, 1902.

counting some short animation inserts in live-action pictures. In the Twenties and Thirties he made, as far as we could trace them, eight animated advertising pictures.

Even though we cannot view anymore the animation pictures that Cooper made between 1900 and 1906, after seeing the three MATCHES films and then A DREAM OF TOYLAND, one thing becomes evident. Cooper became a well-experienced organiser of rough and chaotic material, which he seems to whip with ease, humour and flair into a coherent whole. The material of the animation, a collection of long and short narratives, is implemented into an embracing tale of a loving mother and her young charge. The highlight of the picture is the animation part. It shows the rhythm of life itself, as if Cooper wanted to give a premature demonstration of modern theories about narrative.

Could his animation not stand on its own? Perhaps, but the embracing live-action scenes primarily served the way in which moving pictures were shown in those early years. They were shown at fair-grounds, in variety theatres and in small shops. In Audrey's collection of photographs we found pictures of splendid travelling fair-ground cinemas.

They played such an important role in the development of the cinema. Films were short and joined at random together on one or two reels to make up a show. Sometimes a picture had a title, many times not. They were of many different genres and types, and a scene in which dolls suddenly played all kinds of pranks could very well use the introduction of live-action scenes as a kind of excuse for what was to come.

Cooper used the subtlety of embracing live-action scenes at its best in A DREAM OF TOYLAND. The acting is natural and self-evident. As a matter of course, a mother and her young charge are walking in a relaxed but purposeful manner on a high street looking at shops. The actress and the little boy, who is some five or six years old, are playing a believable mother and son.

When they are near the camera, they enter a shop. What follows is a studio shot of the interior of a toy shop. The shop manager recommends enthusiastically all kinds of toys to the little boy who is put upon a chair to have the best look at what is offered. The next shot is again the location of the street when mother and son are leaving the shop, hands filled with packages and boxes. A fourth shot is a studio set of a bedroom, when the boy is put to bed. The set is used again for the concluding shot when the boy wakes up from his dream, the same dream that we as spectators were allowed to dream with him.

The street used for the location shots is St Peter's Street in St Albans. At the back, we can still see the trees surrounding St Peter's Church. The shops near the camera, in one of which the mother and her son are entering, were recently occupied by Woolworth. According to local historian Christopher Wilkinson, there had indeed been a barber who sold all kinds of goods as a sideline. The interior of the shop and the bedroom were set up at the open air stages of Cooper's Bedford Park studios.

The important fifth scene, a close-up of a table-top representing a long shot, was also made there, in the open air, in the sunshine! We can clearly notice on the painted backdrops the quick streaks of shades and sunlight shining through the cover of glass panes above the stage. Bendazzi writes in his *Cartoons*:[N140]

"The puppets are animated with precision and delicacy despite rotating shadows which give rise to a somewhat bizarre atmosphere (instead of artificial illumination, the animator still used sunlight and the frame-by-frame work was affected by the earth's rotation)."

As soon as the boy is tucked in bed, a golliwog in his hands, he lifts his head, says a few words to his mother, and falls asleep, thumb in his mouth. The scene fades into black.

With A DREAM OF TOYLAND Cooper gives a clear opinion about the future of traffic in the streets. While the actual St Peter's Street in St Albans is shown as a quiet shopping street, the consecutive shopping square in the boy's dream has regular traffic congestions, troublesome drunkards, aggression against policemen without much authority, and public transport which is rather unscrupulous towards other participants in the traffic.

In 1896, Cooper took RUSH HOUR AT LONDON BRIDGE registering on a Sunday morning amazingly busy traffic in Britain's capital. This is the time when protests against industrialization, mass production and urbanization became expressed in Art Nouveau and in the Arts and Crafts movement. Eleven years later, Cooper warns his contemporaries about a future of aggressive automobiles, traffic jams, and lonely policemen who are not able to control it. At the same time he is the educator with this tale of a young boy who, in his dream, is seemingly reprimanded for the greediness with which he made such an excessive choice of toys in the toy-shop.

After the fade-in, we see a table-top scene of a street or square with shops at the left and at the back, and with two side-streets. Numerous little stories are going to happen here, some simultaneously, others at intervals.

A little puppet, apparently drunk, is reprimanded by a policeman, who is kicked to the ground. A motor-bus arrives from a side-street. It is the double-decker we saw earlier on the counter in the toy-shop with the signs Dream Of Toyland and Mudguard on the sides. The dutiful driver is a friendly golliwog. Several passengers have taken a seat on the open upper deck.

Golliwogs, Dutch dolls and rag dolls were immensely popular with children in those days. A golliwog for a child did not have today's racist connotations. It was just a rag doll depicting a black male or female. Completely in Cooper's character, there is a futuristic accent in A DREAM OF TOYLAND that is caused by the motor-bus. Motor-buses were a rare phenomenon in those years.

More traffic appears, a little motor-car, geese, a dog wagging its tail, a cart with a milk churn, a Dutch doll, a rider with no control of his horse,[53] horse carts, and a cart with a traffic sign that rides over the policeman and the drunkard. The policeman gets up. The motor-bus drives towards the camera, with a rather assertive polar bear as the conductor hanging on its back.

53. Proverb: If wishes were horses, beggars would ride.

This is the opening scene, as if it is early morning, getting steadily busier and busier. All kinds of vehicles appear, horse carts, bicycles, even traction engines. It is a believable scene in a busy street or square, like St Peter's Street in St Albans on market day.

The bear with its aggressiveness is lively and credible. All the puppets are very much alive. They go where they want to go, and they do what they want to do. The playful monkey, the golliwog policeman who always tries to mediate and put the situation in order, the inebriate horse-rider, each one of them seems to have his or her own character.

Our curiosity about the policeman is aroused. Will he be capable of keeping order here? The rush hour that follows has our full attention. It shows a little lorry, a Chinaman with a rickshaw, a five-wheel vehicle with the driver in front, tall skinny Dutch dolls, a two-wheel donkey cart and a cab with a chauffeur in the open front part. The motor-bus runs over a dog, and the golliwog driver hangs outside to warn the other traffic. The bus drives over a motorised tricycle. A mischievous monkey with a white face pulls it away and throws it to the side. The policeman has a fight with the bus conductor and loses. The monkey enters the bus without paying. He loses a struggle with the white bear. The man on horseback is still pestered by his steed. And so it goes on, with the motor-bus dutifully doing its rounds.

You cannot help but wonder how many different kinds of transport vehicles were invented in that time, any way in the shape of toys. There is a little ingenious carrier, front-wheel driven with a steam engine, and with a sign on the white cover: 'XL-ALL SEEDS ST ALBANS'. There are barrows and bigger hand-carts, a little two-wheel pony cart, and a big black Royal Mail van.

The monkey with his pointed cap is amusing, when he kicks the opinionated tricycle out of the way of the motor-bus, after which he wants a free ride but gets into a fight with the conductor. During the whole scene it is especially the white bear that gets our warm attention.

The bus has an unexpected collision with a steam-driven vehicle, because it could not stop in time when the vehicle appeared suddenly in front of it. The bus runs over it, the driver falls out on one side, several passengers fall out on the other side. It is a disastrous crash. There is smoke. The smoke becomes heavier, resulting in an explosion which causes so much smoke that the screen is filled with it. The white smoke fades into the white sheets of the bed from which the little boy has fallen out. He cries out loud, his mother soon enters his room to comfort him, and to put him back to bed. It is amazing how fresh and captivating A DREAM OF TOYLAND is.

Is Cooper overplaying his hand with this animated dream? The animation lasts almost three minutes at the correct projection speed, but seems to be much longer because of all that is going on.

5. "We Had to Move Them Every Picture We Took"

Cooper's A DREAM OF TOYLAND is still able to tempt us today into the dream of the little boy. The natural acting of the players, the camerawork and editing, it all helps us with conviction into the nightmare of the street with its busy traffic of toys.

Whenever shown, 100 years later, audiences, children and adults alike, are surprisingly thrilled even now by the lively goings-on of all these vivacious dolls and toys in that busy street. As if the dream is now our own.

The quality of the stop-motion animation is amazing, considering that most of the objects are simple toys. Whenever possible they are moved limb by limb. The white bear is sometimes even very professionally animated with induced and concluding movements.

The bear is promptly directed and has very funny moments. For instance when fighting with the monkey, it turns its head towards an invisible audience as if to say: Watch me! What will I do next? It then rushes forward with its steam locomotive to attack the monkey.

There is the golliwog driver of the motor-bus who comes up from his seat to lean out of the motor-bus to see if the driver of the little motor-car is alright after being run over. Not to forget the skinny Dutch doll ending a fight between a monkey and a policeman by inviting them to a round dance. There are many of these little stories and anecdotes.

Cooper must have been proud of it because, half a century later, in his clear Hertfordshire accent, he is able to describe it in detail to the NFA curator Lindgren in the 1958 BBC interview.[N141]

Lindgren: *What now, you did make a film called* DREAM OF TOYLAND, *I believe. I am interested in this film, because we have a copy of it preserved, you know, in the National Film Archive in London. I wonder if you could tell me a little bit about this film and how it was made.*

Cooper: *Well, it was staged out-of-doors, because there wasn't (...).*[54] *But all the toys*

54. Cooper probably wants to say that he had not yet electrical arc lights to light the set as he had them the following year in the indoors studio in the basement of the Alpha Picture Palace, where he then made his animation pictures.

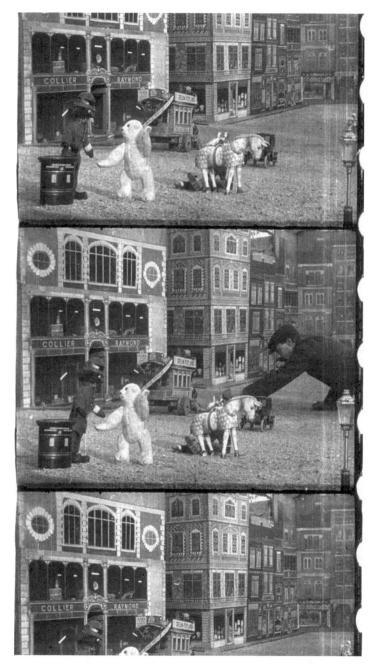

Fig. 27. A single frame catches unintentionally assistant animator Stanley Collier moving an object in A Dream of Toyland (1907).

and things and the motor-bus, which was not on the road at the time, we had to make
ourselves. The scenes, the background and things, was all painted in oil and they were
kept out at the back.
Lindgren: *These were toys and they were animated?*
Cooper: *Animated, yes.*
Lindgren: *So as to behave like real people?*
Cooper: *Well, they walked. They walked, and then down, the fire engine came down of*
a rush. The teddy bear was on the bus to take the tickets. A golliwog was the driver of the
bus and so forth. Yes, all toys it was.
Lindgren: *This film surely has been a great success at the time, wasn't it?*
Cooper: *Yes, it was. There is no doubt about that. But there was not the places as much*
to show them.
Lindgren: *No, of course not, no.*
Cooper: *You see, it was all handicapped.*
Lindgren: *But within the limited field of the time – ?*
Cooper: *Well, Mr Turner, they took the rights. They did the export of it, they tell me*
they exported 75 went over to America. And that was, what was the date?
Lindgren: *In 1907, was it? So, in those days we were exporting to America and not*
importing from America?
Cooper: *That's a fact, yes. Well it was that, but of course when the war broke out, the*
Americans stopped the importation of film.

A DREAM OF TOYLAND received four long write-ups in the trade papers
which call it: 'very ingenious' and 'of brilliant photographic quality'.[N142]
'The most amusing, novel, and interesting film of the season. Marvellous
Tricks – Grand Quality. It will bring the House Down'.[N143] Also: 'It is
thoroughly worked out and forms the most fascinating spectacle it is
possible to conceive for children'.[N144] And: 'A very ingenious subject which
is sure to have big sale'.[N145]

A moving picture in those years usually was made in less than a couple
of days. Was A DREAM OF TOYLAND made in just two or three days?

Audrey:[N146] "We know it took a long time to make and it was made
during fine weather, because he had to wait for sunlight. They were
dependent on the weather, and it took months to do. I have met people in
St Albans who remember seeing that being done. And the dolls and that
were fixed into position with hat-pins and other pins."

In a lecture to the St Albans Film Society[N147] she said: "It took months to
do." In three interviews with us she suggested that the production started
as early as 1906, referring to the advertisement on one of the motor vehicles
for XL-All Seeds, a St Albans enterprise[55] by J. Rowntree, which folded up

in 1907. Audrey, therefore, is under the impression that the picture must have been made before 1907.

What has Cooper himself to say? In 1956, he told Sidney Acres,[N148] the son of his former employer, about A DREAM OF TOYLAND:

> *There was a chap who now is a parson, and an architect, a dentist and a big draper. Old Pamphilon from St. Albans was the draper. He has got three or four (shops) now. We worked on moving these toys for it. (...) 75 foot long.[56] And I think there was about over 3000 pictures and it was on the average of 10 movements on the second. It took six weeks to take it in our spare time.*

There is a short disturbance in the recording. Cooper most probably said 175 feet, which almost gives the correct length of the animation sequence of 170 feet, or 2730 frames.

"It took six weeks to take it in our spare time," says Cooper. It sounds like an excuse. So much time spent on a picture that lasted less than six minutes. Unlike live-action shots you do not see any movement when working on it. The director and his assistants only see static objects on which they are working. They must have considerable loyalty, maybe even more an appreciable faith in the outcome, which will reward all that patience requiring hours of delicate handiwork with no direct results. Where other film makers, at the same time, are producing a number of complete films, Cooper and his assistants have to await the outcome.

But the reward is that magic surprise when all those lifeless toys spring into life as if this is the most natural thing for them to do, and you are caught unaware by this enchanting power of the white screen. Because of his earlier pictures Cooper's assistants knew about the spell that was coming. This charmed them into doing what they did. During long hours they moved the limbs of dead objects with endless patience. They knew about the end result that was waiting, the spell of the moving picture projector that miraculously would breathe life into a collection of just toys.

55. This company advertised itself in a pageant souvenir in 1905 as "The most remarkable business enterprise of modern times. 'XL-ALL' SEEDS which are sold at the uniform price of ONE PENNY PER PACKET." The company voluntarily folded up rather than spend much money on legal fees by going to court after an injunction by Ryder Seed Merchants of St Albans concerning unlawful competition. Cooper had invested £100 in XL-All Seeds, a sum which he subsequently lost.
56. 1 foot is 16 frames; 3000 frames is 187 ½ feet.

From Cooper and from Audrey's research we know who the players in the live-action scenes are. The mother is played by London actress Ruby Vivian. She can also be seen in MacNab's Visit to London, of which we have a confirmation of a picture postcard from herself. The little boy is Eric Lavers, a son from the neighbours. The shopkeeper is played by Frank Hawkins Clarke, member of a prominent St Albans family.

Fig. 28. Signature of F.H. Clarke (deputy Alpha Trading Company) at the formation of the Kinema Manufacturers Association (KMA), 19 July 1906. Clarke plays the shopkeeper in A Dream of Toyland (1907).

He was book-keeper of the Alpha Trading Company, and a shareholder with an interest of £400 in the enterprise, according to Audrey.[N149] He was proxy for Cooper at official functions. Clarke's signature on behalf of the Alpha Trading Company is on one of the documents when the Kinema Manufacturers Association (KMA) was established. He can be recognized on a photograph in the *Kinematograph Weekly* of a KMA meeting.[57]

Cooper's production assistant Stanley Collier designed the scenery and the motor-bus. His sister Jessie Collier painted the backdrops. Several

57. *Kinematograph Weekly*, 3 May 1956, page 43: "The first picture to be published of a trade association function – the Kinematograph Manufacturer's Association dinner at the Holborn restaurant in November 1907." Clarke is fifth in the front row.

puppets were made with special movable joints by Hamleys Toyshop[58] in London, other toys came from local shops or were made to scale by local carpenter Percy Blow.

On a shop are painted the names *Collier* and *Raymond*. Charles Raymond was a local actor who regularly helped out at Cooper's studio. Both Collier and Raymond belonged to the troupe of animators. 'Use Zoe Soap' says a sign on the bus. In those days, Stan Collier was in love with Zoe Raymond.

According to Audrey it was the family physician, Doctor Dobbs, who animated the polar bear. Doctor Dobbs was intrigued by all the goings-on at the Alpha film studios. He was a regular visitor, this time paying for these visits by animating one of the lead characters in the dream.

Several friends, young people and brother Herbert too, assisted Cooper with the animation. Each of them got one or two toys to animate.

Fig. 29. Stanley Collier and Bert Cooper with their new motor-bikes.

58. Today, Hamleys owns The English Teddy Bear Company. In Cooper's time teddy bears became enormously popular, as testified by Sebastian Flyte, the main character with his childish passion in Evelyn Waugh's *Brideshead Revisited* (1945).

They had to carefully follow Cooper's instructions. Cooper:[N150]

> *"We had to move them every picture we took. We moved them in the distance an inch, and when we got near a half inch, right the way down."*

There are at any given moment seven or more animators at work. This allowed for many things to happen. Cooper possessed great patience and educational gifts to continually instruct each of them with their own toy or puppet.

The patrons in Cooper's days clearly enjoyed his ambiguous message. In a time with no proper cinemas, he was able – according to several sources – to sell no fewer than 300 copies. There were 75 copies sold to the United States, as confirmed by distributor E.G. Turner of the Walturdaw Company, who visited Cooper many years later.

The Evening News, 22 November 1955:[59]

FIRST FILM CARTOON

I have been in the film industry since 1896, and in 1904 founded the Walturdaw Cinema Supply Company. At that time the United States looked to Britain and the Continent as the main source of supply of films.

Mr Montague [sic] Cooper had a film studio at St Albans trading as the Alpha Film Company. One of his pictures was 'A DREAM OF TOYLAND', the cartoon film about which a correspondent recently inquired.

I took this film with a number of others to New York in 1907. The novelty of it created much interest and I sold many copies.

In my opinion Mr Cooper was the first to make a film of this nature.

E.G.Turner, Higham-street, Walthamstow.

Even though the long write-ups in the trade papers date from 1908 and Gifford gives this year as the distribution date, A DREAM OF TOYLAND was produced in 1907. In the first place, because it was on the maiden voyage of

59. See for Turner's complete letter: Part Two – Filmography, 12. A DREAM OF TOYLAND, under Correspondence.

the Mauretania that Turner took 75 copies with him to the US. The Mauretania left England for its first journey on 16 November 1907.

In the second place, there is a little steam puffing white vehicle with a female chauffeur and with a sign on its side: "XL-ALL SEEDS, ST ALBANS". If the film was made later than 1907, this advertisement would not have appeared in the picture, because the company had dissolved by then.

A third argument is that Cooper, from 1908, had indoor studios with electric light at his disposal when he opened his first cinema, the Alpha Picture Palace. A DREAM OF TOYLAND was made before that in the open air in Bedford Park.

A DREAM OF TOYLAND in Walturdaw's first advertisement[N151] in February 1908 is 350 feet long and would last approx. six minutes. In a reissue in 1910 Walturdaw called it DREAM OF TOYLAND,[N152] and cut it back to 300 feet, five minutes in projection. This demonstrates the dislike of British distributors for long moving pictures. Short pictures meant more trade in quantities of them. Distributors would rather cut it up than look at the quality of the picture itself.

Fig. 30. Retired film distributor E.G. Turner visiting Cooper in Coton, August 1957.

Audrey:[N153] "My father said our copy of A Dream of Toyland is not complete. The end part is missing. E.G. Turner says he cut off the end part and released it as a separate film."

Cooper told John Grisdale[N154] about two films he made in 1907 and 1908:

> "*In Quest of Health and Grandpa's Pension Day, two of the best, they were nearly 500 foot long. I took them to Turner of Walturdaw and they said: Too long! Too long! I don't think they did fair, because the people wanted them. They wouldn't do it, they would not pay the money for them.*"

Films in that time were sold per foot. The buyers, in their turn, sold them to exhibitors, and as we said before, they did with the films whatever they liked. They considered what they bought as their own property. They cut the films up, shortened them, combined them with other films and even duplicated them.

"Utoxing" is the inexplicable term that Cooper used for such a practice. He used to send copies of a new film on approval to possible distributors, but tinted such a copy with a red colour in order to make surreptitious duplicating impossible. To counteract the practice of on the sly duplicating of films is the reason why, in 1906, Cooper became one of the founder-members of the Kinematograph Manufacturers Association, KMA, in order to protect his rights as maker and producer.

Even though Cooper published his own film catalogues, most of his pictures can only be traced back in the catalogues of his distributors, unfortunately without giving credits. George Albert Smith of Brighton could therefore without any problem put several films of Cooper under his own name in his sales lists published in the Urban Trading Company catalogues.

Advertisements give £8 15s[60] as the sales price for A Dream of Toyland. If we assume that Cooper's portion was 50%, it means that he made a turnover of £1200. This provided him the next year with the capital to refurbish the St Albans Polytechnic at the London Road into a cinema of his own design, the Alpha Picture Palace.

A Dream of Toyland is a favourite show piece in television programmes on the history of animation and at animation festivals. It was shown several times on BBC television, for the first time on 'Tonight' on 15 July 1958. Then on BBC1, 'A Look at the Past, Movie Milestones', 19 January

60. At that time £1 was $4.

The Picture Palace, St. Albans.

Fig. 31. Alpha Picture Palace (1908), St Albans, interior design Fred Karno.

1978. And on Friday, 16 November 1979, BBC2, 'Animation at Cambridge'. It was further shown at the National Film Theatre, the Cambridge Animation Festival in 1979, and many other festivals, like Film International Rotterdam in 1979, Gent in Belgium in 1980, and Annecy in France in 1981.

Watching it today, we can still understand that this animation picture was very popular in its own time. The popularity explains that at least two copies have survived, one at the BFI National Archive and one from our collection now at the Netherlands Filmmuseum.

6. Negative Splices Indicate Daring Methods

Impressed by the animation sequence, which lasted 2.50 minutes in projection in Cooper's day, we studied frame by frame the nitrate copy of A DREAM OF TOYLAND which we will designate "our copy". We came to some conclusions.

The first is that Cooper did not follow a general method to develop the camera negatives and to make a number of positive prints from them right away in order to assemble and edit these into the required number of release copies. The splices are physically in the positive prints that were sold to the distributors. The advantage of this method of not editing the negative but assembling and joining the positive prints is that each separate positive print can be tinted in different colours like red for a

dangerous scene, blue for a night scene, etcetera, and then accordingly assembled and spliced together as the release print.

David Cleveland[N155] explained to us that this was common practice even into the 1920s. As Cecil Hepworth describes it in his autobiography *Came the Dawn*, film makers developed the different rolls of negative, made prints from them and assembled these prints for release copies. We know that Hepworth had to re-film RESCUED BY ROVER (1905) twice.[N156] Because of the popularity of this film the negative had worn out in the printer.

Cooper followed another working method. We discovered that the negative of A DREAM OF TOYLAND was edited in two parts, and positive prints were joined together from these two parts. A title was added later.

We discovered 23 white splices in the animation sequence. There are also a small number of the same white splices in the live-action shots.

These splices brought both our conclusions to light. Most of the splices are thin, white horizontal lines which indicate the hand of a professional editor at work joining two bands of film together in such a way that his printing apparatus is not hindered by them.[61]

We compared our copy with a 35mm copy in our archive, which came from the Audrey Wadowska collection. In contrast with our copy, we will call this the 'BFI copy'. It is a step-print and was most probably taken from a dupe-negative made from the 35mm copy Audrey bought from the BFI National Archive.[62] Audrey's step-print is muddy, and the lighter frames sometimes over-expose many details.

The results of our frame by frame examination of both copies can be found in Appendix 2b "Scene Lengths of A DREAM OF TOYLAND", and in 2c: "Animation Sessions in 8 Possible Day Periods".

But what is the meaning of the 23 negative splices in our copy of A DREAM OF TOYLAND which, more than a hundred years ago, came from Cooper's own laboratory installed in the cottage in his Bedford Park studios? It is clear that they signify that Cooper edited the negative of the 52 meters (170 feet) long animation sequence. Cooper took the negative out of the camera to develop it after every working session in the morning, and in the afternoon.

61. Appendix 2c shows that we also came across a few splices which according to our knowledge were applied less professionally because part of the frame or the whole of it was out of focus and sometimes dirty.

62. This print from the BFI, erroneously titled IN THE LAND OF NOD, came from the Hanbury Collection item no. 133. (Thanks to David Cleveland.)

Not every splice has to mean the end of the shooting of an animation session. There could have been a mistake while filming. An object could have fallen or been misplaced. An under- or over-exposed image had to be removed. Some splices could be repairs of the negative during printing. That is all possible.

However, we think that Cooper, after every animation session, wanted to be sure of what was taken. He took the negative out of the camera and developed it. He could have watched this negative in projection but in order not to take the risk of damage, he could have made a positive print to check if the animation came out all right.

It was no problem for Cooper to take the negative out of the camera after every session, as most wooden camera models in these years – including Cooper's favourite, the Moy – were able to hold light tight boxes for 100 feet (running time 1 minute 40 seconds) or for 300 feet (5 minutes) of film. These negative stock lengths were standard available.

It is possible that Cooper used a box with 300 ft of film, and after an animation session cut the film below the gate, took the bottom box to his laboratory, and replaced it with an empty box. The positive print of each length of negative gave Cooper the opportunity to check if all the objects on the table-top were in the correct position for the first exposure of the next animation session.

As Cleveland confirms: "After each day's filming he may have taken the film out of the camera and developed it to see if it was working properly. I quite favour the idea of the film being developed in sections as it took so many days to make, and the camera seems to have moved slightly at some of the joins. I doubt he could have left the film in the camera all the time. After all that slow physical animation work, he would want to see if the film was all right up to that point."

It stands to reason that Cooper joined the negatives of the whole animation sequence together into one piece. Otherwise, selling 300 copies of this picture would have meant that many thousands of splices had to be made in the release prints.

The BFI copy has the same 23 splices in the animation sequence which confirms what we discovered. Besides, the BFI copy too shows several negative splices in the live-action scenes, especially at places where you would not expect it, for you will find them exactly at the places where the different shots are joined together. We found physical wet splices in our copy at two important places. The first physical splice connects the title with the first live-action scene. The second splice connects title and first four scenes with the animation sequence. After the animation sequence it

is again in the negative that the remaining two live-action shots are assembled.

It is therefore obvious that Cooper edited the camera negatives of his A Dream of Toyland in two parts. The positive prints of these two parts could now much more easily be assembled into release copies, and provided with a title if the buying distributor wanted it, saving a lot of time in his laboratory.

There are a few differences too. Our copy shows some white negative splices in the live-action scenes which are absent in the BFI copy. This copy has a clear repair splice in another place. Two significant differences appear in the animation sequence. At one-third our copy has a dirty physical splice and several frames are missing, but the BFI copy has only a white negative splice. Our copy shows almost half-way a tape-splice followed by a perceptible jump. The objects leap backwards and repeat the eight preceding frames. The BFI copy lacks this splice and backward jump.

These differences make it clear that our copy was made later, because the wear and tear of the negative made repairs necessary.

7. A Labour of Six Weeks

The second conclusion is that Cooper, with foresight and pluck, deliberately invested much time and energy in the production of this picture. The tape recording of his interview with his biographer Grisdale renders the scorn in his voice when he is telling how he proudly presented two of his finest moving pictures to distributor Walturdaw, where he was told "Too long! Too long!"

"I don't think they did fair, because the people wanted them," said Cooper putting his finger on the sore question of why the British film industry, then still ahead of the Americans, would so very soon lose its position. The production of A Dream of Toyland indeed lasted six weeks, a time-span lost for making many live-action pictures.

Cooper says: *"It took six weeks to take it in our spare time."* This is a remarkably long time in those days. Does Cooper exaggerate?

Making an animation picture is a trial of patience and endurance. We are impressed by the effectiveness with which the table-top set is designed and executed. The floor of the set runs upwards in the front towards the camera, and is going upwards again at the back. In perspective, the table-top set looks much bigger than in reality. The spatial impression is very convincing.

Fig. 32. Cunard's Mauretania painted by Montague Dawson.

Our frame by frame investigation produced five single frames in which three different persons can be seen, and a hand in a sixth frame. The animators – as far as we are able to distinguish they are three different males – are reaching out for or touching an object to be moved. On the basis of old photographs we assume that they could have been Cooper's brother Bert, Stan Collier, and Roger Pamphilon, the draper's son.

The fact that we see them gives us a good indication about the scale of the set. The person whom we think to be Collier reaches far out into the set. Our estimation of the set is that it is at least two meters (seven feet) wide. The motor-bus, made by Collier, is probably twenty inches long, which is an indication of the width of the front of the set, some 70 centimeters (2.4 feet). We think that the set with its upward sloping ground in the front and upward again at the back is at least some 3.5 meters (twelve feet) long.

One can imagine that A Dream of Toyland must have taken a lot of preparation. Including the design, the planning, the building of the table-top set and the construction of the toys, the production took some time. Six weeks in their spare time, this sounds believable considering the number of 40 objects that was animated. They had to hold on for periods with enough light. The rather large set with many figures and toys needed light. Making animation pictures then and today is still a process of learning and gaining experience as Stanley Collier testifies when, in 1958, his old 'governor' and Mrs Cooper are visiting him in Aldeburgh.

Collier:[N157] "Toyland, I remember doing that. (...) I remember it lasted for days and days. And of course, the sun would come out some time and there would be a shadow on the scenery. And that is what you would have to put up with, where in an ordinary studio today it wouldn't have any effect."

When 75 copies had to go to America, Cooper had to finish them in time before Saturday, 16 November 1907, when the newly built Mauretania left from Liverpool with E.G. Turner on board to sell these copies in the United States. 75 copies is a high number to be printed from one set of camera negatives.

Therefore, we are left with an intriguing question. How many days or weeks did it take to make A Dream of Toyland? Six weeks? Taking the week of 11 till 16 November into account for developing the negative, editing and splicing it, printing 75 copies, drying them, assembling the printed parts, winding them, putting them in cans and delivering them to E.G. Turner in time before his departure on Saturday, the work must have started on Monday, 24 September.

It could not have started weeks or months earlier. The trees in St Peter's Street, and the trees of the Bedford Park studios which are reflected in the glass doors of the toy shop cabinet and in the side-windows of the motor-bus show almost bare branches. It is late autumn! Trees in September are not so bare as the trees in Bedford Park at the time when the film was made.

The table-top of the animation set was put up in the open air. Cooper needed daylight to light the set. Collier rightly made a remark about the problems with the sunlight. Considering the bare trees, also visible on top of one of the painted shop fronts at the back of the set, the animation work must have been done in the four weeks between Monday 14 October and Saturday 9 November. That seems to be enough time. Or is it?

From a DVD, we timed the moments of clear sun and of diffuse grey light at 25 fps and also at 12 fps, calculating this up to the general projection

speed in Cooper's time of 16 fps. Later, at the Dutch Filmmuseum's department in Overveen, we scrutinised our nitrate copy of A DREAM OF TOYLAND.

The frame counter of the viewing table at the Filmmuseum showed 2730 frames of the animation sequence. This approaches Cooper's own estimation of 3000 pictures. Cooper's enigmatic remark, *"It was on the average of 10 movements on the second"*, most probably relates to the projection speed in his time of an average of 16 fps. Ten frames to make up a full second of projection means that *'on the average'* every second animated frame was taken twice. Therefore, Cooper and his team of assistant animators made about 1800 animations. An unbelievable task to perform, considering that at one time four to six, at another time fourteen to twenty objects, and sometimes even more were animated.

Because it was filmed in the open air of the Bedford Park studios, this gives us the advantage to look for strokes of sunlight and shadow. The set was directed towards the south, and it was therefore several times possible to detect sunlight moving from the right, sliding gradually to the middle, and accordingly to the west, making in the last instance sometimes very long shadows, demonstrating that they worked till late in the afternoon until the light became too low to make any more exposures.

We were able to distinguish eight consecutive periods. There could have been at least eight days with animation sessions. Was the animation done in eight days?

A session could have been interrupted and continued on another day. There could have been moments or even days which were too cloudy or rainy. When studying the animation sequence frame by frame, the changing of the light on the set seems to be a continuous problem. It is autumn, and the weather is unreliable – that seems to be confirmed by the regular change of the quality of the light. Sometimes the sun gives clear, sharp shadows, but most of the time the light is sunny but diffuse or grey and diffuse.

Eight days means that every day an average of 225 animations had to be executed. This clearly seems too much of a work load. With seven people or more to be directed, and an average of ten objects to move and secure in their places with needles, paperclips, nails and hairpins, we assume that every animation took at least a minute or two, sometimes more, to be carried out. Making long hours is hardly possible in the autumn. An average autumn day gives 6 hours of sufficient light. If we make an estimation – 1800 frames on an average of two minutes or more – the complete animation sequence would have taken at least 60 to 80 hours of

labour, twelve to sixteen working days. The work would be interrupted for lunch. In those Edwardian times, Sunday was a holy day.

Considering unworkable days because of the weather, they would then have worked three to four weeks on the animation. It means they must have worked very hard.

The 23 splices in the negative could represent 24 periods of animation, suggesting twelve days with two periods per day, but some splices are possible reparations in the negative during the printing. Some six to eight splices join only a couple of frames. The other splices stand for 16 to 18 lengths of negative. They represent each a morning's or afternoon's animation session, eight or nine days, possibly more, between them. With reference to Appendix 2B and 2C, we counted the length of the animation sessions in seconds. There are three sessions of one second, ten sessions of 2 to 4 seconds. There are five sessions of 5 or 6 seconds. And during the last days they doubled their efforts to finish the job in time with periods of 8, 9, 11 and 16 seconds. The last session means that they made on the final day no fewer than 160 animations.

We observed that the camera was moved at least two times with a perceptable change of position. Just watch the position of the pillar box in relation to the left side of the frame. Even though the strokes of sunlight betray the protecting glass screens above the set, the table-top and camera most probably were moved to a safe and dry place between the animation sessions or during the night.

Was A Dream of Toyland made in six weeks as Cooper suggests? It was made "in our spare time", says Cooper enigmatically. Did he mean to be unobtrusive? We know that Cooper used Saturdays to film sports events, which secured him a regular income. Was there much non-spare time left to make other moving pictures? Unless he means the moments when filming was not possible because there was not enough light, or too much wind or rain.

If we take into consideration one or two preceding weeks of preparation for A Dream of Toyland – the making of the set, the construction of the unique motor-bus, the painting of the back drops, the choice of the toys, and the building of two sets for live-action scenes, – three or four weeks for the animation, and one week to present E.G. Turner his 75 copies, we arrive at the total of Cooper's six weeks.

About our surprise discovery of eight consecutive frames which were repeated, David Cleveland writes: "The duplicate action over a few frames could have been re-done at the time of shooting, and cut out in subsequent prints, but happened to be left in one. Or when that print was reprinted on

the step printing machine, there was a 'pull back' by the operator, who stopped for some reason and went back a few frames to start again." This last suggestion seems very likely after a reparation of the negative.

When A Dream of Toyland was distributed, animation 'between 1908 and the First World War was gradually defined as a cinema genre by Emile Cohl and Winsor McCay,' writes Crafton in *Before Mickey*.[N158] Gifford in *British Animated Films, 1895-1985*[N159] gives many titles based on the lightning sketches fashion. Noticeable is the name of Charles Armstrong, who made many silhouette pictures for distributor Cricks & Martin with his The Sporting Mice from 1909. There are also the needle or scissors-and-cotton types, or the clay animations, like Walter Booth's Animated Putty (1911). The technical basis of most of these pictures is still the old-fashioned stop-action substitution effect.

After Emile Cohl's Fantasmagorie (1908) we gradually come across more animated cartoon pictures, most of the time based on comic strips in newspapers and magazines. A famous American comic strip artist was Winsor McCay who in 1911 adapted Little Nemo from his famous weekly strip 'Little Nemo in Slumberland'. The term 'animated cartoons' was coined.

Because of its high number, around 300 copies, and its international distribution, we wonder how many film makers would have seen A Dream of Toyland.

Cooper:[N160] *"We had a contract with someone in Norway, in Oslo.[63] He always took one of anything. And there were some people in Spain, Barcelona, they came over and they took everything, but they did not pay very well. (...) Well, it was for the export. Most of my stuff went to America."*

Audrey:[N161] "They went to Germany. A Mr Greenbaum was his German agent. And Rossi was his Italian agent, Herringdon Australian, and Olsson – is it Norway or Denmark? Norwegian, I believe. And the man in Barcelona."

Ursula Messenger:[N162] "He just mentioned his pictures went to Spain, to New Zealand, his pictures went all over the world, we just took it for granted."

Puppet film animators were scarce and few. Between 1908 and 1915 Cooper made no fewer than 16 puppet animations. However, these

63. Nordisk Film of Mr Olsson in Copenhagen, Denmark, where in the early 1960s a copy of Grandma's Reading Glass was discovered.

pictures stayed sequestered between the worldwide output of moving pictures. From the very few puppet animators we may include Wladyslaw Starewicz,[64] who started his career in 1909 and became well-known for his original and brilliant animations with animals like ants and beetles, and fantasy puppets. And around 1911, Berlin saw the first animated advertisements of Julius Pinschewer.[65]

Cooper did not make A DREAM OF TOYLAND by himself. Without his seven or more assistants he could never have made it in six to eight weeks' time. Did Cooper's competitors work with a staff of seven or more assistants? Blackton made use of the staff of his Vitagraph Company which he founded with Albert Smith and William T. Rock in 1899. Chomón worked in France for Pathé-Frères which had a great staff, and Emile Cohl as chief trick cameraman could rely on Gaumont's studio personnel.

Cooper's investment in time in 1907 – time lost for making other productions – was rewarded four years later when he was threatened with bankruptcy. It was film producer Frank Butcher of Blackheath who came to the rescue and offered Cooper and his family a house and a studio in Lee. Here, Cooper would make eight puppet films in less than four years.

64. A.k.a. Ladislas Starevich, 1882-1965, Polish film maker and animator, working in Russia, later in France.
65. Born in Berlin in 1883 where he started his work, but after 1934 working in Switzerland where he died in 1961, he made mainly advertising trick pictures, but also propaganda pictures during the First World War.

Pictures that move can tempt us into seeing matches playing sports and writing graffiti, white bears molesting non-paying passengers, and doves discovering olive branches on drowned fields. Cats can play football, and Cinderella lets a prince find her because of a lost shoe. All this thanks to light divided from darkness, to creatures brought into life between the seams of the moving frames, and to the creative breath of the cinematographer.

And now, what we finally want to know is this: is it possible to encounter this captivating mind? Can we meet his spirit? Is there a chance to know the creator himself who gave life to all those creatures?

CHAPTER 4

Making Miracles Possible

I. Far into the Night

We came to the above questions thanks to a French writer Roland Barthes who, in 1973, wrote *Le Plaisir du Texte*,[N163] a title which we gladly paraphrase into: The pleasure of the image. Let us now paraphrase one of his paragraphs: 'When I enjoy reading this sentence, this story or this word–'

'When I enjoy watching this scene, this story or this close-up, this is caused by the pleasure with which it was filmed (this pleasure is not in contradiction with the moaning of the film maker). But the reverse? To make cinema with pleasure, is that assuring me of the pleasure of my patrons? Not at all. I have to look for (chatting them up) those who are going to watch my movies *without knowing who they are* (italics by Barthes). A wide berth of pleasure is created in this way. It is not the 'person' of the other that I need, but the space: the possibility of a dialectic of the desire, of an *unpredictability* (italics by B.) of the delight: lest the cards are not shuffled, lest it ends in a play.'

This is how we see ourselves as those who watch the moving pictures of Cooper, the creating film maker. This is a beautiful text that makes one feel responsible as 'consumer' of articles, books and movies for what writers and film makers have created. Cooper and his contemporary pioneers had to find out all by themselves a new 'language' of images to tell stories with a completely new medium. A medium that is elusive as a final result but has to be made with concrete means in the form of equipment, materials and unpredictable beings, whether human or animal. They had to do it. They had to forge 'living pictures' and 'moving photographs' into pictures that would be able to tell moving stories. Otherwise, the new invention would have become no more than one of the many short-lived novelties that soon wear out. *The momentary glories fade, the short lived beauties die away.*

Inspired by Roland Barthes, we would say that at the very moment when your glance admits the projected image, you are inwardly changing. You become an anti-hero in a Barthesian sense: you are allowing the entanglement of the images to make you a happy being.

The simplicity of Emile Cohl's plain lines which shape a living figure before our eyes, and Cooper's matchsticks that form themselves into little beings with a personality which are even able to write messages on a wall for everyone to see.

Cooper, without knowing who or where they are, searched for the spectators of his moving pictures, and he did this with the desire that the spectators enjoy themselves and lose themselves in what he was making at that moment. There is no better example than A Dream of Toyland. Cooper himself was amazed by how many copies he was able to sell of this picture. But when we watch A Dream of Toyland, Noah's Ark or the last survivor of his animation pictures, Road Hogs in Toyland, we feel as if somebody from the past is knocking at our door.

Kinematograph Weekly, 13 November 1947:

An Employee of Charles Urban Recalls "The Old Days".
I was very interested in the first instalment of "History of the British Films",[66] which took my memory back to those early days in Wardour Street, when, as a boy, I served under the late Chas. Urban. There was one name that I did not see mentioned, *i.e.*, Melbourne

66. An article in a previous issue of *Kinematograph Weekly*.

Cooper, who, at that time, was producing trick toy films in a basement at 4 and 5, Warwick Court, Holborn.

After leaving Chas. Urban, I went to work for him and assisted on "Dolls Circus",[67] "Road Hogs in Toyland", "Baby's Dream"[68] and many others.

Using a special geared Prestwich camera, two mercury-vapour tubes and a table top for stage, Melbourne Cooper would work all day and far into the night making his beloved models and toys come to life on the screen.

He made everything himself except the dolls, which he purchased from Hamleys. He showed unlimited patience in handling these, as, of course, all these films were one picture one turn.

We took four to five weeks to produce one film of 400 ft., and Messrs. Prieur, of Gerrard Street, handled them and most of them were great successes. I have seen many celebrities of stage and screen down in that basement watching him at work, including Chas. Urban, Smith, Paul, Moy, Newman, and many others who have now passed over.

The tricks I learnt from him stand me in stead to-day, even though we have advanced so wonderfully, and I think I can safely say that Melbourne Cooper was the pioneer of what we term to-day "special effects".

I am looking forward to reading more articles similar to last week's. H. MAYNARD, 93, Maidstone Road, New Southgate, N11.

It is for a couple of reasons quite a challenge to take up the endeavour of an encounter with Cooper as a cinematographer. In the first place because there is so much lost of the movies that were made. Second, to assert anything about a film maker from that period is almost presumptuous. Therefore, we decided to limit ourselves with this book, and start first with Cooper's animation pictures. Will what we are writing now be of any use after so much time?

Nevertheless he was there, and he was known in his own time. A clear proof of this is the little gift from heaven sent to us by Ronald Grant of the Cinema Museum in London,[N164] the letter by Henry Maynard. From

67. THE HUMPTY DUMPTY CIRCUS (1914).
68. Most probably LARKS IN TOYLAND (1913).

interviews with Cooper we know that "young Maynard" was a son of the family that manufactured the famous Maynard Sweets, like the wine gums. Maynard, in 1907, was one of Cooper's assistants when the latter made his long travelogue LONDON TO KILLARNEY.

2. Alpha Picture Palaces

Cooper acquired a genuine taste for experimenting with stop-motion. Before A DREAM OF TOYLAND he had made a live-action picture with an animation insert, PROFESSOR BUNKUM'S PERFORMING FLEA. With its more than 500 feet, it ran almost 8½ minutes. The first scene and the last, a customary chase, were filmed in September on location at the Barnet Fair. The other scenes and the animation insert were filmed on sets in his Bedford Park studios.

It is about Professor Bunkum who has a tent at Barnet Fair where he shows under a microscope the miracles of a harnassed flea pulling a wagon. An old lady comes in, pays a penny and looks through the microscope. What she observes can be seen by us on the big screen as well. The lady is satisfied with what she sees, and she shakes hands with the professor when she leaves. Another lady enters, but there is no flea anymore. The professor is in panic. His livelihood has gone, he runs out of the tent, seeing all kind of people scratching their legs. He thinks he can catch his treasured flea. It all ends in a chase as many of the comedies did in those years.

Cooper to Bert Barker:[N165] *"Hamleys made me a flea that size, the flea was as big as that, the biggest ever I would think. After using it I took it to the hospital."*

This picture must have been a success because it is known by eight different titles, like THAT WONDERFUL FLEA or A PHENOMENAL FLEA, which would mean that several distributors bought it. We may be sure it was the animation scene with the enlarged flea that contributed to its success.

During the winter of 1907 or early in 1908, Cooper made an animation picture, IN THE LAND OF NOD, which has a length of 365 feet and a screening time of more than six minutes. As usual, the heart is a dream scene, but this time the dream is in several parts. For the first time the dream is now telling a story.

A father falls asleep while his children are sitting at the table and playing with toys, a doll's house and a toy fire-engine. The father dreams that the toys are alive. Suddenly there is a fire in the house. The puppets call for the fire-engine which draws up in front of the house. The firemen are pumping the water up to the smoke in the doll's house and right in father's

face, who is awakened by the water squirted from the miniature pump with which the children are playing. The central attribute this time is a doll's house, another very popular children's toy.

IN THE LAND OF NOD got five long reviews in the trade papers. It was reissued in 1910 by Walturdaw, and in 1911 and 1912 by Empire Films as GRANDPA'S FORTY WINKS and FATHER'S FORTY WINKS.

In 1908, Cooper made a colourful trick picture using the stop-motion technique. Audrey Wadowska:[N166] "Mother remembered Stan Collier and father studying an old kaleidoscope for hours, and they eventually made it into a trick film, and I have seen it listed as THAT WONDERFUL KALEIDOSCOPE or THAT MARVELLOUS KALEIDOSCOPE. I have seen no description."

It was possibly made as flat animation. It was 365 feet, a little over six minutes long. It was sold hand-coloured. Kaleidoscopic magic lantern slides, called *chromatropes*, with two rotating colourful glass discs were popular in those years, together with Fantoccini slides or mechanical shadow or silhouette slides, and other kind of effect slides.

In the same year, Cooper made another trick picture in the same mould but instead of coloured pieces of glass he used ordinary matches which form themselves into all kinds of figures, flowers and decorative arrangements. It was called MAGICAL MATCHES, also MYSTERIOUS MATCHES. The picture was released in 1908, and reissued in 1912 as ANIMATED MATCHES or A BOX OF MATCHES. We came across this title in several lengths, from 250 feet to almost 400 feet with running times from more than four minutes to almost seven minutes. We assume that with a duplicate print it could be arbitrarily lengthened without any problem considering the subject-matter. It was possibly sold in a tinted version too. MAGICAL MATCHES reminds us of Cooper's live-action films REEDHAM ORPHANAGE BOYS FANCY DRILL, and REEDHAM ORPHANAGE GIRLS FANCY DRILL both made in 1907, in which a large group of boys or girls are performing military drills and gymnastics in kaleidoscopic patterns. REEDHAM ORPHANAGE BOYS FANCY DRILL still exists, but MAGICAL MATCHES, in its own magical way, saved the negative of its predecessor, MATCHES APPEAL of 1899.

The year 1908 was the peak in Cooper's career. He was, next to his normal work of making documentaries, comedies and newsreels, much too busy to spare a lot of time for more animation pictures. He opened a cinema. He moved his studio to another location. And he was engaged to be married early the next year. With the Fourth Olympic Games being organized in London, when Rome was not able to finance the organization, and with a Franco-British Exhibition at Shepherd's Bush, Cooper and his cameramen

were much occupied by all the current affairs, not to mention the many demonstrations of suffragettes, in this year and the years to come.

After more than ten years, the moving pictures were now becoming a major industry. From 1906 in the USA and 1908 in Europe, there was a spectacular growth of film entertainment. The time was undisputably in Cooper's favour.

He called his first cinema the Alpha Picture Palace – a palace for moving pictures. For several years he had already given very regular film shows in the St Albans Polytechnic with variety turns during the intervals. That is why his Picture Palace was for many years still called by its nickname: The Old Poly, or The Poly Cinema.

Cooper had the building restructured. *The Shell Book of Firsts*[N167] considers the Alpha Picture Palace in St Albans to be one of the first cinemas as we know them today: a sloping floor, a separate fire-proof projection booth, uniformed ushers and usherettes who sold Cadbury's chocolate during the intervals, and with the cheapest seats in the front, not at the back. All these features got special attention in the press. The Alpha Picture Palace in St Albans was a commercial success from the very start.

At the Franco-British Exhibition in Shepherd's Bush, uniformed staff manned the Cadbury's Chocolate stand. These uniforms were later bought by Cooper from Cadbury's for his Picture Palace staff.

On Saturday, 26 July 1908, Cooper closed down his studios at Bedford Park and moved his Alpha Cinematograph Works and Alpha Trading Company to 14, Alma Road. With its two acres of studio grounds, it was almost as big as Bedford Park. It had more buildings to house a larger film laboratory, and offered much more dressing space for actors and actresses. His Picture Palace was around the corner in London Road. Above all, Cooper could start his own family here, because in the following year, 17 February 1909, he married, on her birthday, young Kate Lacey. In November the same year their first child, Audrey Kathleen, was born.

The trade magazine *The Bioscope*[N168] reported on 18 September under the heading "The Alpha Trading Co. Open New Works at St Albans, special interview with Mr A. Melbourne-Cooper" that St Albans in Hertfordshire is the home of one of the most enterprising firms in the film-picture business. The reporter writes:

> The photographic equipment is of the most up-to-date description, apparatus by the leading makers, both for studio and outdoor work being the best obtainable. The more mechanical departments for developing, printing, toning,

perforating, etc., are all under the direction of experts, and the rapidity with which the work is turned out bears eloquent testimony to the admirable "system" which pervades the whole establishment.

Touching the question of rapid output, we would remark that "rush work" is quite a speciality here. It is no uncommon occurrence for an order for films, received by the morning's post, to be executed the same day.

We have already indicated that nothing in the way of film production comes amiss to the Alpha Company. Here is a tip. Whenever a difficult job arises, send to St. Albans. If Mr. Melbourne-Cooper and his merry men can't master the situation, it is more than likely that nobody else can.

In February 1909, Cooper was in Paris in the company of many European film pioneers who are famous today, like Georges Méliès, Charles Pathé, Léon Gaumont, Charles Urban, Cecil Hepworth, Oskar Messter, and many others. He had been in Paris before on a business trip. He now represented his Alpha Trading Company at the International Congress of Film Manufacturers in order to secure the rights of film producers. The British distributors refused to introduce the American rental system and formed in opposition to the Kinematograph Manufacturers Association their Cinematograph Trade Protection Society (CTPS). In order to try for a compromise, the KMA appointed a new board with E.G. Turner as chairman and among others Cooper as member of the board.[N169] Walturdaw was no member of the CTPS because, for several years, they rented their pictures.

On 6 December of the same year, encouraged by the success of his new cinema in St Albans, he opened in Letchworth a second Picture Palace. This was not a success in a 'garden city' populated by church-going people who disliked the moving pictures. There was twice a fire with a lot of damage.

Early in 1909, Cooper was visited by the local press. Under the title 'How Bioscope Records Are Made', the editor of the *Herts Advertiser and St Albans Times*, Carrington – whose daughter Beryl, half a century later, interviewed Audrey several times – wrote a long article about the Picture Palace and Cooper's filmmaking.

The editor discovered that "it is proposed to go as far back as the flood for a subject. The Ark is even now in course of erection, and a full complement of animals – all specially jointed so as to allow of life-like attitude – is expected to arrive before long. These pictures will be composed on the same principle as those illustrative of 'Toyland', which meets with general approval whenever shown."

'Stop-and-start films' Cooper used to call his animation pictures like A DREAM OF TOYLAND. He made NOAH'S ARK in the first half of 1909. It again

Fig. 33. Alpha Picture Palace (1909), Letchworth, built after Cooper's own design.

tells a story, the well-known biblical story of the flood and of Noah building an ark, saving his family and all the animals. With its 440 feet it has an original screening time of almost 7½ minutes. It has three embracing medium live-action shots. On the surviving print, the first minutes with mother and child are missing. There are only a couple of frames left with the head of the mother. The final live-action scene of the awakening of the child is completely missing.[69]

The three live-action scenes are in a garden. A mother watches how her daughter plays with a Noah's Ark and its animals. The second shot shows the little girl falling asleep. Then follows animation which lasts 6.40 minutes. The animation consists of no fewer than nine shots, all are close-ups of a table-top representing long shots.

Though the animation in NOAH'S ARK seems simple, it is amusing and keeps our attention. The animals are smaller because there is a greater distance. The set seems to be some six to eight feet wide. Is there a distance out of respect for the Bible story? There are many animals going into the

69. Film collectors know that often the beginning titles and first scenes, the end scene or both of a moving picture are shortened, damaged or completely missing. Sometimes the titles were replaced by something considered more commercially attractive or by a title in a foreign language. The start and end pieces of a film became abused by putting the film between others on bigger rolls, whereby a couple of frames were used for splicing, but in the long run many 'couple of frames' disappeared in the waste bins of movie theatre projection booths.

Picture Making.

HOW BIOSCOPE RECORDS ARE MADE:

Since the year 1894, when Edison introduced his Kinetoscope, which was really a development of the old Zoetrope, a device by which figures revolving in quick succession when viewed through an aperture were given the semblance of living things, there has been an enormous advance in the art of producing living pictures. But we move with such rapid strides along the road of science, and new wonders are so frequently revealed, that we have long since ceased to go into raptures over every new achievement of scientific genius. We even regard, in quite a matter-of-fact way, the privilege of being able to sit in a comfortable hall and see re-produced, as realistically as if the actual characters walked upon the stage before us, events of national and even world-wide importance. What would our grandfathers have thought of such facilities? Imagine the blank astonishment of a veteran villager who had never wandered more than a few miles beyond the limits of the parish in which he was born but who had often heard of the wonderful doings in the great City of London, having placed before him a living and moving representation of some great national procession in the streets of London. What an education it would be to him! In like measure the Bioscope, as we know it to-day, is the medium through which thousands of our people are made familiar with many events of importance in the world's history. As a melancholy instance of this may be mentioned the terrible earthquake in Messina. Photographs of the ruined city, with its tottering and smouldering buildings and many other accompaniments of that time of terror, were, within a comparatively short period after the actual occurrence, displayed before large audiences at St. Albans, and in that way the people were helped the better to understand the accounts which they read of the disaster from time to time. But apart from its educational side, the Bioscope offers unlimited facilities for amusement, as those who gather nightly at the St. Albans Picture Palace and other similar places of entertainment know well.

Through Mr. A. Melbourne-Cooper, the managing director of the Alpha Trading Company, and lessee of the Picture Palace, St. Albans possesses exceptional advantages for seeing the best productions in animated photography, for Mr. Cooper is not alone an exhibitor, but an actual manufacturer of bioscope films; an industry in which he has been so long engaged that he can lay claim to be one of its pioneers. He is therefore competent to give reliable information as to the manner in which the pictures are made which interest spectators in many parts of the world—for films made at St. Albans are extensively shipped to customers abroad.

When invited by a "Herts Advertiser" representative to talk upon the subject, Mr. Cooper readily consented to do so, cheerily observing, "There are no secrets in our business."

Our conversation took place in the basement of the Picture Palace, surrounded by numerous "properties" for the purpose of picture-making. An excellent studio, fitted by Messrs. Tilley and Giffen with exceptionally powerful Davy photographic electric lamps, consuming a current of about 200 amps. supplied by the local station, capable of giving a candle power of 700,000 candles, has been provided here, in addition to an open-air studio in Alma-road, standing in about two acres of old garden, and as we chatted, a carpenter at his bench was busily occupied in the manufacture of other "properties."

"The pictures for reproduction," said Mr. Cooper, "are taken at the rate of twenty per second, the exposure given being one one-thousandth part of a second at f16. The pictures thus secured upon non-inflammable film, each measures 1 inch by ¾ inch, and the average number of such pictures that go to make one subject is 7,000. Each individual picture is perfect in itself, and is capable of enlargement and reproduction; it is not an uncommon thing, in fact, for us to provide films for the reproduction of pictures in the Press. When thrown upon the screen, these tiny pictures are magnified to 50,000 times their own size."

In some subjects, we were informed, the number of individual pictures runs into hundreds of thousands.

After exposure, the film is wound on to a specially-constructed frame and immersed in a bath of very strong developer in the same manner as an ordinary dry photographic plate, and the fixing and washing are also carried out similarly. The next step is the production of a positive from the negative, and this is done by contact printing under the rays of a powerful incandescent gas lamp or electric light. The print being at last obtained, it remains only to be tested before presentation to the public. A special plant has been put down for colouring, toning and dyeing, and arrangements are in contemplation for the production of nature-tinted pictures. The coloured pictures at present shown are coloured by hand—a delicate and tedious process.

Mr. Cooper, it is interesting to know, has given a command performance at Chatsworth House. At one of the celebrated garden parties given by the late Duke of Devonshire in honour of the King and Queen, he was responsible for the securing of a photographic record of that imposing spectacle and for re-producing it in the ballroom the same evening. On another occasion he beat the record by photographing the Grand National and producing living pictures of it the same night at the London Empire. For this purpose a special coach was attached to the London and North-Western train from Liverpool, and as the train sped on towards London, members of his staff were busily occupied in the development of the films, which, when displayed, were naturally received with great enthusiasm. A similar achievement was made in regard to the Lincolnshire Handicap the same week. In respect to strictly local matters a like enterprise has been manifested, for, at the last Lifeboat Demonstration, a pictorial record was secured and presented the same evening at the Drill Hall.

For the maker of living pictures there is open an absolutely unlimited field. At St. Albans, it is proposed to go back as far as the flood for a subject! The Ark is even now in course of erection, and a full complement of animals—all specially jointed so as to allow of life-like attitudes—is expected to arrive before long. These pictures will be composed on the same principle as those illustrative of "Toyland," which meet with general approval whenever shown.

An effort is being made now to secure pictures of local interest. Mr. Cooper and his staff will be on the look-out for outstanding local events, and they also encourage suggestions from their patrons. In response to an invitation of this kind, quite a number of plots have been received, some of which, we are informed, are quite good, and will probably be adopted for sets of pictures in the future. It is also proposed to utilise local talent for the enactment of the scenes and episodes to be reproduced. What an opportunity for aspiring amateur actors and actresses!

These made-up pictures are produced in the same manner as a stage play, each person in the casts taking his or her appointed part; so that he who undertakes this interesting work must have added to his qualifications those of play-producer and stage-manager.

At the Picture Palace the pictures are exhibited under the best conditions. Electric light is used, giving exceptional clearness of definition, and the enjoyment of the scenes depicted is not interrupted by the continual whirr of the films as they pass over the rollers, for the operator's box is divided from the hall by a specially-constructed sound-deadening and fire-proof screen, forming an entirely separate apartment over the main entrance, thereby affording immunity from accident.

Fig. 34. *Herts Advertiser and St. Albans Times*, March 13, 1909.

Ark, but it is clear that Cooper this time did not use an army of assistant animators as in A DREAM OF TOYLAND.

We see the Ark of Noah with a gang-way of seven steps down to a grassy foreground. In the distance we see mountains painted on a backdrop and a kind of temple with pillars. Noah comes out of the ark and steps down. A white and a grey mouse appear. They are the first to enter the ark. Noah puts a sign-post in the grass. An elephant approaches, two giraffes follow. Two white doves settle on the roof, walking up and down.

There are a number of comical incidents, typical of Cooper's sense of humour. When a giraffe looks out of a window it is teased by the elephant. A white bear interferes, and his mate pulls the elephant overboard back on land. But he does not want to leave the elephant alone and pulls him back on the gangway into the ark. The elephants and bears are heavy animals, because you can see the ark rolling on the water. When all the bears, monkeys, poodles, zebras, lions, geese, deer, hyenas and many other animals are inside, a white dove settles itself in the window.

A final small piece of humour is Noah's wavering what to do with the sign-post. He removes it and takes it with him on board, but then throws it down the gangway into the water. The sign-post has no use anymore.

When the rain starts and the floods are coming, Noah apparently forgot to take the gang-way on board. Did he leave it there for any living being who wanted to come on board in the knick of time? Later it is clear that Noah took up the gang-way. Then the rain starts pouring down. Water flows through the grass, and rises. There is lightning, and the ark drifts away. After a while the ark is completely alone on the water.

Finally the ark is at rest, and a dove flies out to return with an olive branch. A little later the ark is stranded on dry land, there are high mountains in the

70. Franz Anton Nöggerath Junior (1880-1947) was a Dutch theatre manager, moving pictures producer and distributor. His father, Franz Anton Nöggerath Senior (1859-1908), a variety manager who, in 1891, came from Germany to the Netherlands with his family, became manager of the prominent Amsterdam Flora Theater of varieties, and was a pioneer in film production and a major distributor of moving pictures. In 1896, Senior operated a Charles Urban Bioscope projector in his theatre. He became agent for the Warwick Trading Company, managed by Charles Urban, in the Netherlands, Denmark and Norway. Warwick, at the turn of the century, was one of the largest distributors of films and equipment, especially the Charles Urban Bioscope projector. Urban in his turn acquired Dutch newsreels and documentaries from Nöggerath's FAN-film company, the name being an acronym of his name. Senior established one of the first Dutch film studios on top of the Flora Theatre. The variety shows in the Flora Theatre were generally concluded with a Royal Bioscope show of moving pictures. In 1897, Senior sent his son Franz Anton Nöggerath Junior to London, to Charles Urban, to be educated in every aspect of film production and distribution. Junior became a cameraman and film developer at Warwick.

back. The ark is stuck on a mountain-top, on solid dry but rocky ground. Noah picks up the gangway, and our playful elephant assists him in securing it on the ground. The animals can now leave the ark. In the beginning the camera point of view is high. It is lowered in one of the next scenes. During the flood the camera is on the level of the ark, and in the final scene it is very low, showing the ark high on the side of the mountain where it landed.

The live-action scenes for Noah's Ark were taken on the grounds of the new studio at Alma Road. The animation was done in the basement of his Picture Palace where he had electricity, one of the first in St Albans. The animation scenes could now be lighted with care.

The nine animation scenes show that it was lovingly made, with attention for detail, and with respect and awe for the biblical tale. It tells in almost seven minutes with exactness and humour a well-known story with its toy ark which was popular with children.

It must have been something exclusive for those days. A camera, from some distance, reports as an eye-witness the well-known Bible tale of the flood. Sunday school teachers must have loved telling the story of Noah and the flood during the projection of the picture.

The scene in which the ark is floating on the water may seem a little stretched but we shouldn't forget that from the very beginning film projections were accompanied by music. In St Albans' Picture Palace it was Mrs Sarah Monks on the piano[N170] and a violin player.

The mother was played by a St Albans actress Nellie Hope, real name Eleonora Fox. She was married to the Dutch theatrical manager Franz Anton Nöggerath Junior who, at that time, was getting an all-round training as film producer at the Alpha studios.[70] Their daughter Amanda Agnes plays with the ark and dreams of it.

In 1903, when Urban left Warwick to start his own company, Anton Nöggerath came to St Albans to work as cameraman and assistant producer at Cooper's Alpha film studios. In 1906 he was sent by Cooper to Norway to film the Coronation of King Haakon. He also acted in films directed by Cooper. In 1900 Anton Nöggerath Junior married Eleanora Fox (artist name Nellie Hope), an actress from St Albans, with whom he had a variety act, *The Magic Kettle*. They had five children. His wife and his daughter Amanda Agnes appear in Noah's Ark (1909). (The children with their dates of birth are mentioned in Part Two – Filmography, 16. Noah's Ark.) With actor/director Dave Aylott he made plans to establish a film production and distribution company at St Albans, but when Senior died in December 1908, he returned to Amsterdam to take over, with his mother, the management of the Flora Theatre and the film distribution. He opened a Bioscope Theatre in Amsterdam, the first purpose built cinema in the Netherlands with (unique for its days) the cheap seats at the front and the most expensive at the back, and a second Flora Theatre in The Hague. In January 1910, his wife and children followed him to Amsterdam after the birth of their fifth child in 1909.

The fact that a copy of NOAH'S ARK survived is again an indication that it was a popular moving picture sold in many copies. It was reissued in 1911 by Butcher's Empire Films as LOTTIE DREAMS OF HER NOAH'S ARK. From a synopsis in a Butcher catalogue, one may conclude that prints were coloured or partly coloured, because a rainbow is mentioned in the synopsis when the dove flies back with the olive branch. The BFI National Archive have a tint record with their copy of NOAH'S ARK which indicates the colours copper, blue and sepia for several scenes. The scenes with the ark floating on the flood waters were taken at home in the family bath-tub which could not be used for several days. According to Audrey her mother was very annoyed, although this time it was Cooper's wife who provided the invisible hair with which the dove is flying.

In the first scenes, the child is put to rest on what was called in those days a Dutch chair, a type of small seat with half a back and an elbow-rest on only one side. It was a red plush affair coming from the household of Cooper's parents. It appears in several of Cooper's moving pictures. It stayed in the Cooper family as part of their furniture and went with them from St Albans, to Manor Park, from Southend to Carleton, and finally from Coton to Notting Hill. The authors sat in it several times, always reminded by Audrey how Amanda Nöggerath fell asleep in it in NOAH'S ARK. No final return for the Dutch chair to St Albans. It was sold at a London auction by Audrey and Jan when they moved to St Albans.There was no room for it in their new flat here, and they needed the money.

According to Audrey, cataloguers at the National Film Archive had this picture first dated as 1917, then 1913. But with the report in the *Herts Advertiser*, Audrey could show them that the proper date was 1909.

NOAH'S ARK is a worthy successor of A DREAM OF TOYLAND. It makes one curious about the missing pictures made in between, and even more about the pictures that Cooper made later. One would like to see the development not only of his art, but also of his craftmanschip in the stop-motion technique.

In 1909, Cooper made his successful live-action picture, A SCULPTOR'S DREAM, demonstrating the pitfalls of Vulcanus's forge to the inattentive artist who neglects the lure of what he just created, a deluding female beauty haunting him forever in his dream. Cooper, as a true artist, possibly never came closer to reveal his personal life and ambitions in his work.

3. Satirizing Features of Life Today

In the years 1910 and 1911, Cooper made four animation pictures, THE TOYMAKER'S DREAM, OXFORD STREET UP-TO-DATE, and THE CATS' CUP FINAL (or THE CATS' FOOTBALL MATCH) in 1910, and TOPSY'S DREAM in 1911.

THE TOYMAKER'S DREAM is 420 feet long with a screening time of seven minutes. Cooper uses the dream again in which toys are endowed with life and a free will. A toymaker gets from his son a model aeroplane to repair. He falls asleep, and we see a street scene where pedestrians narrowly escape a rushing motor-car. Flying machines are entering a *Daily Mail* contest for a £10,000 prize. Soon we see them circling around St Paul's. Some planes are in a collision and crash. One of the machines ends in the jungle, is surrounded by curious natives and threatened by wild animals. The aeroplane sets off, which ends the dream of the toymaker.

The boy was again played by Eric Lavers who later wrote[N171] to Audrey that he got sixpence for his part. "The film was actually shown some long time after it had been taken at the Poly Cinema for three nights. As I had a 'star' part I attended the Poly on each of these three days to the detriment of my meager pocket money. The name of the film was THE TOYMAKER'S DREAM."

It was several times reissued by Butcher's Empire Films under slightly different titles and in slightly different lengths. When Butcher advertised it in 1912 it had a length of 315 feet, and the price was £5 5s.[N172] It had five write-ups in trade papers. The *Film House Record*[N173] calls it: "A fine example of 'stop-camera' work" and "toy figures (...) are made to satirise some of the features of life today".

The *Kinematograph and Lantern Weekly:*[N174] "We can heartily recommend an inspection of this film, which is one of the most ingenious we have seen for many months."

In OXFORD STREET UP-TO-DATE, Cooper has another chance to amaze himself and us about the bustle of traffic in general and that of the famous Oxford Street in particular.

The catalogue of Butcher & Sons[N175] wonders: "The lightning rapidity of motion is very amusing, whilst the extraordinary movements and situations created with the toys in animation is so remarkably clever that one asks: 'How is it done?'"

Made just like its two predecessors in the basement studios of the Alpha Picture Palace. It is 350 feet long with a running-time of 5.40 minutes. It has no live-action scenes.

Originally Cooper had other plans for his next production, THE CATS' CUP FINAL, than to make it as a three-dimensional puppet film. He wanted to make it as cartoon animation, and he visited two famous artists, Harry Furniss and Louis Wain. Furniss was an illustrator with *Punch* magazine. He made more than 2600 drawings for it. When Furniss realised how many pictures were needed for just a couple of minutes of film, 600 to 900 per minute, he declined. Two years later he went to Hollywood to make cartoon pictures for Edison.

Louis Wain was a famous illustrator and painter of cats.[N176] He lived in Kilburn in a house with dozens of cats. He died in a mental institution, Napsbury Hospital, near St Albans.

THE CATS' CUP FINAL is about toy cats playing a football match. Injured players are carried off on wheel barrows by monkeys. It was 360 feet with a running time of six minutes. It had no live-action scenes. It was reissued by Butcher two years later.

Cooper told John Grisdale:[N177]

I went to see Louis Wain, went to see him to make animated films, but he wanted too much money. I looked for someone to drawing THE CATS' CUP FINAL and wanted to engage Louis Wain, 1910, but he wanted 1000 pounds down to start it. But I would always find a way doing the job, so I used puppets. I bought the cats from Hamleys in London. I used to squeeze on my way back the package in which they were and ladies would think I had real cats in there. I needed chaps to do the work, and if it was not right, I would brake it up and do it all over again. Football playing cats, finished up with a monkey pushing a barrow carrying off the injured cat-players. One had a stomach ripped open. Before that I tried to get Harry Furniss on the job, a Punch illustrator but he saw no future in it.[71] With someone who would draw illustrations for me I would have followed a procedure like this: take for instance an earthquake, have it outlined, wash the rest away, and in reversal it would come again. I would have used a double reversal camera, to do the filling in, and 'washing' out, paint the picture out in white till the outline, and in reversal it would seem as if all came to pieces.

Audrey remembers:[N178] "There was a scrap on this football pitch, some of the cats got injured, one had its stomach ripped open. And a monkey came on as a Red Cross aid carrying a stretcher. It was funny, you know."

71. Illustrators shrank from the great amount of drawings that had to be made for an animated cartoon picture. In 1924, when Cooper moved to Langfords Advertising Agency in Blackpool, he had several disputes with the illustrators about the many drawings needed for the animated advertising pictures they were producing there.

When an animation picture was finished, Cooper used to give the puppets away.

Ursula: "I think, I had one of the cats as a toy. Ken had a rabbit, you remember?" Audrey: "I had an elephant."

Ursula: "I remember this cat, I wore all the fur off."

Audrey: "When I visited Auntie Bertha when she was in this old folk's home, she had a black doll from TEN LITTLE NIGGER BOYS, but I was just too late, she had given it to some child."

Actress Jackeydawra Melford told Audrey[N179] that she saw THE CATS' CUP FINAL with her father Mark Melford. "We didn't stop laughing. Even father laughed, and it took something to make him laugh. It was the funniest film I have ever seen."

THE CATS' CUP FINAL demonstrates Cooper's interest in sports. He was an ardent cyclist from the days he worked for Birt Acres going down from St Albans to Barnet six days a week on his bicycle. He even once, for a day or so, took part in a seven-day cycling race at the Crystal Palace. As a moving picture reporter he was interested in all kinds of sports.

It would have been Cooper's crowning glory of his animation career if he had been able to produce it as a cartoon picture. The animations of Stuart Blackton and Emile Cohl were made as cartoon drawings, and soon in America Winsor McKay would release his popular cartoon LITTLE NEMO IN SLUMBERLAND as an animation picture. Cooper would have beaten him by a year.

In 1910, Cooper's second child was born, Ursula Constance. In that year he made an effort to go public with his cinemas, the St Albans Picture Palaces Ltd. He needed more capital to keep his businesses running and to compete with German, French and most of all a growing share of American import. The public wanted longer films. That required more investments per production. However, his effort was unsuccessful because it was undersubscribed.

Cooper:[N180] *"Of course when I furnished the place it cost me a lot of money, nearly spending all my money. I put it up [going public]. They said: pictures would not last and of course they would not back me."*

King Edward VII died in May 1910. Cooper filmed the funeral procession. In June 1911 King George V was crowned as head of the world's greatest empire. It is in this year that Cooper got into financial trouble. Did he, with his film productions and two cinemas, have too many irons in the fire? When father Thomas died, Arthur, as the eldest son at home, had become

responsible for his mother, his brother Bert and his two sisters Agnes and Bertha. A third sister Louisa had died young. The sisters got jobs in the Picture Palace, but money disappeared from the till without a trace. The fires in Letchworth enlarged his total of unpaid debts.

There were also domestic problems. His wife was jealous of all those handsome and smartly dressed actresses from London who came over to play in her husband's pictures. While the Picture Palace in St Albans was a success, in Letchworth a full house was an exception.

In 1911, Cooper made the last animation picture in his basement studios of the Picture Palace. That was TOPSY'S DREAM. With a running time of almost six minutes, it had a possible length of 350 feet. It is a Victorian Sunday school drama that starts with a live-action scene depicting a seat on the Thames embankment on which a little girl falls asleep. She dreams of Toyland where all the puppets are alive. When the snow starts to fall, a policeman wakes her. The policeman was played by Bob Willmott who was for several years a uniformed doorman of the Alpha Picture Palace.

Little is known of TOPSY'S DREAM, most probably because when the picture was finished Cooper had no time to make enough positive prints or to introduce it properly to potential distributors. Creditors were taking over his cinemas. Bailiffs were in the house and the studios making lists of furniture and goods.

It is of course a coincidence that in France in the same year Georges Méliès got into financial difficulties. It is apparent that compared with the American dramas produced by D.W. Griffith, the staged events by Méliès filmed with a static camera position became less popular. In a period of fifteen years, Méliès made some 500 pictures in his own typical style. Charles Pathé now became his financier with the studio in Montreuil and his films as security.

Is it because animation and its history are hardly taken seriously by the official league of film writers and historians that most of Cooper's puppet films are lost and that we have to satisfy ourselves mainly with old catalogues, with what has been written in trade papers, and with the memories that have been recorded in one way or another? We think about what an old staunch friend, film researcher Anthony Slide, once wrote in his *Aspects of American Film History Prior to 1930*:[N181] "There can be no complete history (of the American cinema today) until the work of every company, however obscure, every technician, and every actor has been examined and recorded."

Therefore, it does not matter if Cooper's importance in those early years of British film history is big or small, it is valuable in itself that what we as authors know about him is examined and recorded.

Still, it was heart-warming to unexpectedly come across in a British bookshop a whole chapter on Arthur Melbourne-Cooper with the title "Genesis of the British Film Industry" in a most informative book, *I Never Knew that about England*[N182] by Christopher Winn, mentioning Cooper's early trick film BIRD'S CUSTARD as Britain's first film advertisement, and MATCHES APPEAL as "the world's first known use of animation".

A strip with four frames from A DREAM OF TOYLAND on which the white bear can be seen driving the steam locomotive is depicted in Patricia Warren's *The British Film Collection 1896-1984*[N183] together with a still from NOAH'S ARK in which animals are boarding the ark, with the caption: "**Early Trick Photography**. Arthur Melbourne-Cooper had made one of the earliest known British examples of animation (and probably commercials) when in 1899 he made a film for Bryant & May which in effect was an appeal for funds to supply the troops in South Africa – not for ammunition, food or clothing but ... matches – something the Ministry [War Office] seemed to have overlooked. Some years later, Melbourne Cooper made two delightful films, featuring animated toys, THE TALE OF THE ARK, 1909 and DREAMS OF TOYLAND, 1908."

Let us not forget the chairman of the Ephemera Society, Patrick Robertson, who with his enormous collection of vintage magazines devoted more than one space in his *(The New) Shell Book of Firsts*[N184] or his *Guinness Film (or Movie) Book of Facts and Feats*[N185] to Cooper and his achievements and to Birt Acres, Cooper's mentor and boss in the formative years.

Robertson in his *The New Shell Book of Firsts* mentions BIRD'S CUSTARD POWDER (1897) as the first advertising film made by Cooper. He mentions "an appeal by BRYANT & MAY (1899), a film that is notable for its use of animated cartoon technique".

In his *Guinness Movie Facts & Feats*, he writes: "The earliest known British example of animation is an untitled advertising film made by Arthur Melbourne-Cooper of St Albans, Herts, for Messrs Bryant & May. Dating from 1899, it consists of an appeal for funds to supply the troops in South Africa with matches, as it seems this was something the Army authorities had overlooked."

Robertson next mentions: "two charming films featuring animated toys, NOAH'S ARK (GB 08) and DREAMS OF TOYLAND (GB 08). Strutting teddy bears were featured in the latter with particularly engaging effect."

Of course, Robertson then mentions Stuart Blackton and Albert E. Smith's Vitagraph production THE HAUNTED HOTEL (US 07), and: "The first cartoon film was J. Stuart Blackton's HUMOROUS PHASES OF FUNNY FACES (US 06)." And: "The first cartoon film to tell a story was Emile Cohl's FANTASMAGORIE (Fr 08)."

4. "It Is as Real Life"

Cooper set out with single-shot advertising pictures with a rising sun or a stumbling old man breaking his eggs. He followed these up with single-scene animation pictures with playful matchstick puppets. They all lasted less than or a little over one minute.

His next animation pictures combined stop-motion scenes with live-action. In 1901, it was a girl falling asleep who introduced the audience to her dream. It is the same effect as in the live-action GRANDMA'S READING GLASS where we, as the audience, suddenly see what the boy sees through grandmother's magnifying glass and where we willingly borrow the boy's eyes to see what he observes. It is now the dream of the girl that magnifies what she observes, and let us dream with her a sweet dream about her doll.

The live-action scenes justify what is following in the next scenes, at the same time seducing us as spectators to enter a world in which objects that normally are lifeless now are suddenly animated, have a soul and their own free will, even if they are just some splinters and slivers. And we unquestioningly believe in this world because does it not happen in front of our own eyes?

CHEESE MITES was not an unusual picture compared with the general output in those years, but the close-up gives an early demonstration of Cooper's sense of humour in designing and animating creepy crawlers which, enlarged on a screen, could frighten us. Cooper's later employer in Blackpool, Jim Schofield, testified to this.[N186]

The dream returned in A BOY'S DREAM and the following animation pictures. A dream of a toymaker and his fairy that justifies a child's belief that the animals of its Noah's Ark are really alive. The films were getting longer. Two or even three minutes was no exception. No dream anymore in THE FAIRY GODMOTHER, but the nurse falling asleep enables the children to get assistance from a fairy godmother to free their animals from Noah's Ark. The animation was embraced by live-action scenes of the nurse falling asleep and waking up.

Twelve years after the invention of moving pictures, Cooper showed with A DREAM OF TOYLAND how the cinema can be turned into a narrative tool that can express messages of the cinematographer on separate levels at the same time. A greedy little boy is compared with the greedy hustle and bustle of an industrialized city. Audrey showed A DREAM OF TOYLAND

herself at the Animation Festival in Annecy in 1981 as her father's best known animation picture. We are convinced that it is a corner-stone in the early history of animation because it shows all the basic elements in full function of true stop-motion animation. Two years later, Cooper confirmed his strong hold on his craftmanship with NOAH's ARK. Again he is telling us something through a double narrative. There is the mother, her little girl and the toy Noah's Ark. Then there is the dream of Noah and the flood.

The preceding live-action scenes not only give a motivation, but also tempt us to enter the world that the cinematographer is opening to us. The mother, in the spare couple of frames that were still saved, can be seen in a loving conversation with her little daughter. The girl plays with the little animals. It is clear that the mother is telling her the story of the flood and how a brave man saved the animals by building this ark. How important is story-telling? Does the young girl understand this age-old biblical story? We will soon know, because the live-action scenes of the mother and her little girl lead us into the story itself, enacted by the toy animals and a puppet. The live-action scenes are requisite because the film maker has something to tell his audience.

We watch her falling asleep near her toy ark with all the toy animals. She dreams that Noah appears to lead all the animals to his life-saving ark. We are now dreaming the dream of the little girl. We are undergoing the deluge and, when the land is dry again, it is we who are allowed to leave the ark and step onto dry new land.

The dream introductions, filmed in the 'real' world, in which we are objective spectators, are used by Cooper to make us subject to a world that normally does not exist, but that can be so real that it still hovers in our mind when we wake up from the dream when the film is finished.

Today, we find it a normal experience when leaving the cinema after a captivating movie that the spirit of what we saw is still alive. As if we actually had been in the movie itself, and not in a plush cinema seat.

In Cooper's time this was a very new experience, and that is why the first moving picture spectators said: It is as real life. Cooper wanted it to be possible to take us into that 'real life' of the projected pictures, even if the screen showed toy animals to represent a much loved Bible story. With all his craftmanship he takes us into his world of toys and puppets and makes us listen to it, makes it our dream world. Even today, the spirit of A DREAM OF TOYLAND and NOAH's ARK is still able to linger on when we watch these pictures a hundred years later.

5. The Butcher-Heron Period

The year 1911 saw the Sidney Street siege of anarchists, strikes for a minimum wage, a demonstration of 40,000 suffragettes, Kaiser Wilhelm II wanting a 'place in the sun' for Germany, a heat wave in August in London which took the lives of 2500 children, expressionist painters Wassily Kandinsky, Franz Marc and their group *'Der Blaue Reiter'*, the coronation of King George V, and Roald Amundsen beating Captain Robert Scott in reaching the Antarctic.

All this world-shocking news paled when the bailiffs knocked at Cooper's door. Accountants advised him to go bankrupt, but Cooper refused. In those days, a bankruptcy was very shameful and a great obstacle in any further career. His cinemas were sold for a song to a provincial chain which, to his dismay, offered to let him become a manager.

Audrey:[N187] "They did not get my father to agree to go bankrupt, and I suppose he would have saved himself, but you see, mother was too shocked. She would not have it and he wanted to pay up his debts and he did. He freed himself that way. Mr Dawson[72] wanted him to remain in the Picture Palaces as his manager, but father said, he wasn't going to have that. If he couldn't be boss in his own Picture Palaces he wanted to be left out."

Frank Butcher of the firm of W. Butcher & Sons at Blackheath, who had established his own film company Empire Films with offices in London, came to the rescue. He had regularly purchased new pictures from Cooper, the last ones being OXFORD STREET UP-TO-DATE and THE CATS' CUP FINAL. Butcher procured the Alpha studios film laboratory equipment and a part of the stock of negatives. Under the trademark Acme Films, they were reissued. A number of other pictures were reissued by Cooper's London agent R. Prieur from stock kept by Cooper. The remainder of the negatives was sold to other distributors.

Frank Butcher built a studio at 42a, Manor Park in Lee, near Blackheath. Manor Park is not only a park but also an avenue with detached residences.

Cooper, with his young family, left St Albans and moved to 26, Manor Park. Right behind it was Butcher's studio. In order to ease the rent, the second floor was let to an actress with her daughter. From 1912 till 1915 we found 'Cooper Arthur' in the local directories living at 26, Manor Park.

Gradually, he paid all his debts by managing, in the evenings, under an

72. Dawson – with Walker and Turner – formed the 'daw' in Walturdaw Trading Company Ltd.

alias a newly built cinema in Harrow, the Picturedrome. During the day he made animated puppet films for Frank Butcher's Empire Films.

ROAD HOGS IN TOYLAND is the first puppet picture that Cooper made in 1911 at Butcher's new studio. It is 330 feet long, which gives 5½ minutes on the screen. Butcher sold it for £5 10s. It got a very pretty and enticing advertisement in the trade papers.

Again, it is a masterpiece. Apart from the technical qualities of a three-dimensional animation picture, it is also a prime example of how to tell a story with filmed images only. Like NOAH'S ARK it has a clear storyline. It is noteworthy because it contains no fewer than six different set scenes. Someone designed six different backgrounds. The subject is a motor-car race. Marathons, bicycle and motor-car races became very popular in those days. Special racing cars were designed. We can see their models in this picture as living toys. The drivers are genuine road hogs in town and the countryside.

The surviving copy of ROAD HOGS IN TOYLAND has its finish cut off just when an aeroplane comes to the rescue of two crashed racing drivers. It still has a couple of frames of the original title left. It is a nicely designed title with decorations in the fashionable Arts and Crafts design. It contains the enigmatic predilection of Cooper's producer Frank Butcher: "A story enacted entirely by mechanical toys."

ROAD HOGS IN TOYLAND opens with a rural setting in which a donkey kicks at a man, while three racing cars with numbers on their sides are approaching a tavern. A lady in a wide pettycoat performs acrobatic turns on a chair, but only a flock of geese admire what she is doing and try to imitate her. The three racing cars are leaving, but they are in each other's way and in the way of the geese. The girl waves them good-bye.

The second scene shows a viaduct over a road and a canal. A steep road leads down to the canal. Here, a little drama develops. A lady in black is waiting, accompanied by her nursemaid with a pram. When the nursemaid is leaving, a gentleman in black appears and wants to kiss the lady but she pushes him away. A gentleman in a grey coat appears. With his cane he hits the other man hard on his head. The victim falls down. A boy in a sailor's uniform looks on. The man in grey, in fury, continues beating the other man. Racing cars suddenly rush down from the viaduct onto the scene, damaging fences and roadsides.

A whimsical horse and its rider appear in the third scene, which is rural again. A plump policeman tries to assist the unfortunate horse rider who is suddenly hit by a racing car which is hit in its turn by a second car. A third racing car carelessly drives over them. Other racing cars wisely drive

around them. The policeman helps the driver of the first car to lift it back on its wheels but is rewarded by being pushed away.

In a fourth rural scene a poodle is run over by a racing car, and chickens are also run over. Racing car number 2 loses a wheel. A giant with enormous shoes appears on the scene. The driver in despair asks the giant to help him. The giant lifts the car, and the driver puts the wheel back on its axle. The giant lifts the driver up and puts him back in his seat. Driver and giant shake hands, and number 2 is off.

In the fifth scene the cars drive down a back road with buildings and gardens on both sides. A small motor-car crosses the road. Racing car 2 tries in vain to avoid it. He stops, but the driver of the little car is so angry, it bumps several times hard into number 2 without causing any damage. A donkey and a clown appear. The clown is hit hard by the donkey.

The last scene shows houses at the back and an inn on the right. Three racing cars from different sides approach at great speed. The numbers 2 and 5 are in a head-on collision, bumping each other high into the air, and then both fall down with the drivers on the road. Vaguely, the approach of a flying machine is visible just before the film prematurely ends.

Daringly produced in six different sets, ROAD HOGS IN TOYLAND has no live-action scenes to introduce what is coming. There is a nasty race going on, and the way in which it is executed suggests the topical events of the day. The large numbers which are painted on the racing cars may even give a chance for betting, a popular pastime in Britain. ROAD HOGS IN TOYLAND shows much movement, and a lot of speed and action. Each of the six scenes has a different anecdote happening aside from the race, which is the main story. There are modern racing cars and a lot of bystanders. The change of scenes gives the picture even more drive and suspension. All these puppets and toys are so alive, is it not plainly visible that they have a life of their own?

At any given moment there are some five or six animators at work. There were possibly more. There is some lovely animation, for instance, when the desparate driver of the car who lost a wheel asks the giant to help him. There is humour, when a small motor-car, hit by a racing car, angrily bumps the car to no avail.

And there is a surprise! There is, in the second scene, suddenly a hand visible. It is a chubby little hand that holds the black gentleman. The hand of a child or a grown-up? It is not seen in projection, because there is only one frame in which the hand that animates the gentleman can be seen. It is a clear proof that the puppets are not mechanical, but frame-by-frame animated.

How ingenious Cooper's animation pictures may be, despite all their humour, comedy and slapstick, despite the social comment, from very early on, the emphasis in the trade papers is on children as the prospective patrons. R.W. Paul, in 1904, advertises Cooper's THE ENCHANTED TOYMAKER with 'An excellent picture for children'.[N188] Or otherwise 'A very seasonable picture' as Cricks & Martin advertises in 1906 Cooper's THE FAIRY GODMOTHER.[N189]

"The most fascinating spectacle it is possible to conceive for children. Order at once," commands *The Bioscope* in 1908 about A DREAM OF TOYLAND,[N190] and *The Kinematograph and Lantern Weekly*[N191] about the same picture: 'An ideal subject for Juvenile Audiences.'

About ROAD HOGS IN TOYLAND *The Kinematograph and Lantern Weekly* reports:[N192] "Just a picture for children's matinees, etc., during the festive season. A clever film will also please and bewilder all your patrons." And *The Bioscope*[N193] announces: "All the youngster's pet toys in animation." As if animation pictures are already put into the corner of merely for children.

Announcing a 'ruthless devastation' the Butcher catalogue blurbs:[N194] "A sensational drama, if it were not a screaming farce, all the characters being mechanical toys specially made for the purpose. The principal features of the nursery are introduced, and the peculiarly life-like movements of the characters will amuse children, and bewilder the parents."

Introducing the features of a nursery? A drama of adultery and brutal murder in front of our eyes – are these features of a nursery? Did Cooper make his animation pictures for children in the first place? Are his social comments for the young in the first place? We doubt it. We are afraid that the tradespeople are commercially putting it away as entertainment for children just because it is 'only animation'. It feels as if a kind of discrimination has already set in.

As an extra attraction, Butcher advertises ROAD HOGS IN TOYLAND as *'enacted entirely by mechanical toys'*. Butcher continually gave emphasis to the mechanical aspect. "Another picture taken of mechanical toys in action", they wrote in their 1911 catalogue about THE TOYMAKER'S DREAM.[N195] The same about OXFORD STREET UP-TO-DATE:[N196] "Buses, cabs and pedestrians represented by mechanical toys."

Apparently, it is still a great mystery to the general public how all these toys and puppets can act as if they are alive. Audrey was very annoyed about it. "They were animated, and not mechanical," she used to say.

Why 'mechanical'? Because 'animated' was used for moving pictures in general, there was not yet a specific expression for this kind of film in which puppets behave like human beings. How to address them in a way

that would offer an enticing explanation? The word 'mechanical', in a metaphorical sense, seemed to be the solution.

Kenneth Clark[N197] explains: "They referred to the toys as 'articulated' or 'mechanical', rarely 'animated', but that did not concern the patrons, they only came to enjoy the novelty." Cooper's puppets were indeed articulated with their joints many times specially made by Hamleys.

ROAD HOGS demonstrates some technical rules when making three-dimensional pictures, such as the landscape that cannot be flat. The stage floor, a street or landscape, has to bend upwards in front of the camera in order to curve downwards away from the camera, but at the end it has to bend upwards again in order to create a perspective that is fit for the relatively small figures that have to be animated in the small space before the camera.

6. "Seeming Intelligence of Performers"

In 1912 a son Kenneth was born, but Cooper was not able to pay the bill of the doctor who delivered the newborn, nor the high bill for the rates of the big house. Cooper was imprisoned in Brixton Gaol for several weeks, sowing mail bags, as he told Audrey during one of the recordings, but pretending in London that he was filming travelogues in Scotland. As soon as the rates were paid, he took his camera and immediately went off to Scotland to come back with pictures of the Highlands. It was the year in which the Titanic sunk. It is also the year in which British film censorship was installed.

Cooper used the Manor Park facilities for four other animation pictures. Early in 1912 he made SPORTS IN MOGGYLAND of 350 feet, running time 5.40 minutes. All kinds of circus animals, monkeys, dogs, even beetles and fleas, and a company of Dutch dolls perform a range of athletic and circus acts including highwire cycling.

In Cooper's time, the children's books by Florence and Bertha Upton about all kinds of adventures by Dutch dolls and golliwogs who were inseparable friends were immensely popular. "What is a moggy?" Audrey once asked her father in one of the taped interviews.[N198] "You are," his answer was, because his daughter always used make-up. 'Moggy' is not only slang for cat, but it is also the fancy dressed doll with pursed red lips and pink cheeks.

The write-up in *The Bioscope*[N199] sums up: "One is first of all struck by surprise at the seeming intelligence of the performers, which merges into

Fig. 35. Sports in Moggyland (1912). From a review in *The Bioscope*, 5 Sept. 1912. (With thanks to British Library Newspapers, Colindale, London.)

envious admiration of the extraordinary patience of the instructor.(...) This is a film which will cause intense delight to all the children; and all well-regulated parents, after seeing this excellent film, will treat their children's dolls with vastly increased respect."

Audrey confused this lost picture with the surviving The Wooden Athletes, which was according to her a part of Sports in Moggyland. However, we established on several grounds that Audrey was mistaken and that The Wooden Athletes was not made by Cooper at all. The animation is crude and primitive. When for instance, an audience is entering the fair-ground booth, they are just shoved step by step and their limbs are not animated in their movements. For 1912, it is a very primitive picture compared with all the preceding animation pictures of Cooper. Could it have been a cheap "quicky"? This is not in Cooper's character. Maynard's letter testifies to this: "Melbourne Cooper would work all day and far into the night making his beloved models and toys come to life on the screen. (...) He showed unlimited patience in handling these, as, of course, all these films were one picture one turn."

Not long after that, Ten Little Nigger Boys, with 380 feet, and almost 6½ minutes in projection, was produced. Just like Road Hogs in Toyland and Sports in Moggyland, there are no live-action scenes to account for the

animation scenes. Also, Cooper's following animation pictures will no longer contain live-action scenes. They will all be merely animation pictures.

TEN LITTLE NIGGER BOYS was a very popular nursery rhyme in the tradition of the Struwwelpeter children books. In this nursery rhyme, boys disappear one by one. The first chokes himself during a dinner, another one is swallowed by a fish, one is stung by a bee, and one shrivels up in the sun. The last survivor gets married and disappears in this way.

As inspiration for this animation picture, Cooper used a series of magic lantern glass slides, TEN LITTLE NIGGER BOYS, as they were successfully published by W. Butcher & Sons for a great number of years. Inspired by another one of the many lantern slide series of Butcher, Cooper made in that year OLD MOTHER HUBBARD who is not able to give her dog even a bone. With a little over 400 feet, it ran 6.50 minutes in projection. It was completely enacted by puppets.

Cooper now started a daring production of an old fairy tale, a famous pantomime story, the tale of CINDERELLA, the little step-sister who thanks to a compassionate fairy godmother will go to the ball and dance with the prince.

It was his cherished plan which he possibly nourished for several years. It now became a prestigious project, on which his wife and several others worked together.

Cooper's children remembered many details of CINDERELLA, a sign that it was a beloved subject in the family. They told us that according to their father, it was his most successfully executed animation picture. For the time it was long, 1000 feet, almost 17 minutes in projection, possibly the longest animation picture at the time.

Cooper grew a large pumpkin for the metamorphosis of the coach, but the night before they wanted to use it, it was stolen. The coach was cut from cardboard with an enlarged photograph of the lord mayor's coach onto it. Cooper bought the puppets from Hamleys. They were as usual especially jointed for him.

According to Audrey, films in the genre of CINDERELLA were usually released before Christmas, but were made many months before. Audrey:[N200] "Jackey Melford remembers seeing him making the coach. She says it was a beautiful thing. He made the whole complete set. We have a still of it."

Cooper's biographer Grisdale[N201] informs us that the wooden puppets were some six inches and would usually cost in the region of 4/6 each, in today's money 22½ pence. A local hairdresser assisted in making the hairdresses of the puppets. For the Cinderella puppet he needed a double in a different, shabby dress.

Audrey told us:[N202] "For CINDERELLA, he bought the magnificent, what people used to call a 'princess doll' in those days, and mother dressed her. Her dress was made out of some beautiful lace which he brought back in 1909 when he went to the Paris Convention, for her to wear on her dress. In those days, they had gas mantles with a circular shade, and on the balustrade, in that famous scene where she comes down the steps into the ball, there was red silk with a crystal beaded fringe from the gas mantles, that was draped over the back of the steps. So you can see how big it was. It was just about the width of a gas mantle. He made those stairs himself. He grew the pumpkin himself. The coach in which Cinderella drives, he made out of cardboard himself. He copied it more or less from the Queen's coach. He had a big photograph of this royal coach which he mounted on this, the base, to let it look like the real thing. According to Jackey Melford it was magnificent."

Butcher advertised it with a double spread in *The Bioscope* of 5 December with a large photograph and a drawing.[N203] The text says: "It is a Pantomime – good, old-fashioned CINDERELLA, acted entirely by Nursery Dolls. CINDERELLA, enacted entirely by Mechanical Toys. It is a film that Children and grown-ups will alike delight in. The antics of the doll-actors are irresistibly funny. The old-fashioned fairy story is seen in a new and novel light."

The advertisement fuss makes it clear that Cooper made it in his own style and put his kind of humour in it, shunning the usual way in which the worn-out fairy tale was told or performed on stage. During all those years Cooper kept a coloured photograph of it. It is all that survived. It is very unfortunate that this animation picture is no longer extant.

Cooper became acquainted with Andrew Heron, a retired naval officer who put up the capital for two new enterprises, Heron Films Ltd to produce pictures with the well-known actor Mark Melford and his company, and Kinema Industries Ltd which assisted in fitting up cinemas.

Cooper produced some remarkable industrial documentaries for Kinema Industries among which the still existing THE MANUFACTURE OF WALKING STICKS (1912).

Frank Butcher's studio at 42a, Manor Park, behind the house of the Coopers, went over to Mascot Film Co. Cooper's next animation pictures were made in the basement studio of 4 and 5, Warwick Court as Kinema Industries productions. It was here that actresses Jackeydawra and Mavis Melford visited Cooper several times to observe him making several pictures.

127222

THE COMPANIES (CONSOLIDATION) ACT, 1908.

COMPANY LIMITED BY SHARES.

Memorandum of Association

— OF —

REGISTERED
22341
17 FEB 1913

KINEMA INDUSTRIES, LIMITED.

1. The name of the Company is "KINEMA INDUSTRIES, LIMITED".

2. The registered office of the Company will be situate in England.

3. T

(1

WE, the several persons whose names and addresses are subscribed, are desirous of being formed into a Company in pursuance of this Memorandum of Association, and we respectively agree to take the number of shares in the capital of the Company set opposite our respective names.

NAMES, ADDRESSES AND DESCRIPTIONS OF SUBSCRIBERS.	Number of Shares taken by each Subscriber.
Andrew Heron Tweddale Warren Road Chingford Essex Gentleman	one
A.F.M. Cooper 26 manor Park Lee S.E. Kinematographer	one

DATED the *17* day of February, 1913.

WITNESS to the above signatures :—

H. Pumfrey Jr.
14 Paternoster Row
Solicitor E.C.

Fig. 36. Company papers of the new enterprise Kinema Industries Limited, shareholders Andrew Heron, gentleman, and A.F.M. Cooper, kinematographer, 17 February 1913.

In 1913 Cooper produced here LARKS IN TOYLAND, which was 500 feet long and more than eight minutes in projection. We know little about this picture which was released again during a transition in Cooper's circumstances. The Motion Picture Offered List[N204] carries on 22 November 1913 the blurb: "They are new and up-to-date. The dramas are truly

Fig. 37. Kinema Industries was situated at 4 and 5 Warwick Court, High Holborn, London.

pathetic, with bright seasonable happy endings. The LARKS IN TOYLAND are real, riotous larks. The film will please kiddies and grown-ups alike."

In 1913, a month after the British parliament rejected votes for women, Cooper made with his brother Bert a remarkable newsreel, THE SUFFRAGETTE DERBY, which is still regularly shown all over the world in programmes and documentaries about female emancipation. On Wednesday, 14 June, the suffragette Emily Wilding Davison threw herself in front of the King's horse Anmer with jockey Herbert Jones at the Derby at Epsom, in protest of the arrest of several suffragettes. She suffered terrible injuries and died four days later in hospital. Cooper's brother photographed the incident when the horses in full gallop rounded the sharp bend at Tattenham Corner just before Cooper himself filmed the finish with a second camera.

Cooper was fond of gardening. He had kept his own fruit and vegetable garden for his mother and the family in a corner of the Bedford Park studios. There was a big garden at the back of 26, Manor Park. He now used his vegetables and fruits for a five minute animation, LIVELY GARDEN PRODUCE (1914), in which these vegetables and fruits perform triffid-like stunts.

Cooper's last animation picture in this period that we know of is THE HUMPTY DUMPTY CIRCUS in 1914. It is almost 450 feet long, 7½ minutes screening time. It was produced as an Acme picture, the name being an acronym of Cooper's own name. Since 1911, several old Alpha pictures have been reissued as Acme films. It was not released anymore by Butcher's Empire Films (M.P.), but by R. Prieur, an agent who had already represented Cooper's films for some years, because Frank Butcher was not involved anymore.

Actress Jackeydawra Melford remembered it. Her husband Wallace Colegate remembered Henry Maynard assisting with the animation. Mavis and Jackey Melford watched Cooper working on it. When it was finished, Mavis asked for the lion.

Audrey told us:[N205] "Father gave her this lion. It was a circus performance of animals, and apparently you saw a crowd of dolls going along in cars to the circus, and then you saw this circus performance, animated tigers and lions and other circus animals. Denis Gifford has a still from the scene where they are going to the circus. On it is a white patch like a flag saying: to the circus."

Inspiration was provided by the American Schoenhut company, which had produced since 1903 a box with toys, 'Schoenhut's Humpty-Dumpty Circus. The toy wonder, 10,001 new tricks, unbreakable jointed figures'. It

was named after a famous British clown who called himself Humpty Dumpty. The circus contained a clown, a donkey, an elephant and other circus animals, together with all kinds of objects with which the child owner could perform tricks.

Cooper's Alpha Trading Company was dissolved in 1915. Several of Cooper's animation pictures had been reissued by Empire films, by Prieur and by other distributors. Because of title changes, it is almost impossible to trace them all. Still, our filmography contains a number of reissues.

And 1914 was the year when a *petite* American actress, Mary Pickford, established world fame with her picture Tess of the Storm Country.

7. Advertising Pictures in Blackpool

And then the First World War broke out. Cooper's partner Andrew Heron took active service in the Navy, and both their companies were dissolved in the next year.

We now lose track of Cooper and the family. He was sent to Woolwich on a training course and became an inspector of ammunition, stationed at Luton. He found a boarding house for his family in nearby Dunstable.

"My mother was so glad that she could count on a steady income, secure of housekeeping money every week," remembered Ursula Messenger[N206] about the time in Dunstable. According to the family, Cooper was asked to become a war camera man, but his wife insisted: from now on no film making anymore.

Ursula: "Mother said it was too precarious, she wanted security."

Audrey: "She remembered exactly how much she had at Dunstable, £3.10 a week. And she said, it was much better to have £3.10 every week than what she had in St Albans. One week she had 20 pounds – ."

Ursula: "And then nothing."

Audrey: " – because he had to pay it out on the cinema or film making. And of course she was landed with bailiffs in the house twice. That was quite a frightening thing for a young wife."

Cooper, after the war, did not go back to London.

Audrey:[N207] "Mother wouldn't let him, because there were three young children, and she used to say, the happiest time of her life was during that war. She got 3 pounds 10 a week regular."

Ursula:[N208] "I don't blame my mother with three children preferring him to have that steady job with a regular income instead of getting to the war

with the risk of getting killed and leaving her with three children. Unlike Audrey I do not blame her stopping him taking that job. I didn't agree with Audrey mum stopping him. Audrey sometimes made me mad, saying that she stopped him. There are ways of saying it."

When the war was over, the family lived for a while in Westcliff near Southend. Just before the war, Cooper found a house for his sisters Agnes and Bertha and his brother Bert in Beedell Avenue. For several years, Bertha Melbourne-Cooper can be found in local directories as dressmaker. Bert made an income as a projectionist in a cinema,[73] and filming topical events as a freelance cameraman. He served in the army and became a prisoner of war. After the war the Germans just opened the gates of the prison camps and let everyone take care of himself. Bert died on his way back home. His name can be found in the Book of Remembrance in the former chapel of Prittlewell Priory in Southend as Herbert M. Cooper.

The families living together was not a great success. There was a legal dispute about the ownership of the house. Cooper moved his family to a house called 'Berry Brow' at Lancaster Road, Eastwood. The children went to school in Rayleigh. Cooper tried to make an income as seasonal and portrait photographer.

Selling garden produce and eggs in Southend, Cooper made an additional income. With a partner he started a poultry farm and put all his savings in it. Soon thereafter the partner disappeared with his savings. The family then moved to a house on Hart Road in Thundersley called 'Silverleigh'.

Cooper was also making picture postcards and cigarette cards of churches for Churchman's Cigarettes in Ipswich.

Audrey:[N209] "Ken did recollect something I didn't remember. He remembered when we lived at Rayleigh, before we went to Blackpool, dad taking photographs for Churchman's cigarette cards."

Ursula: "I remember dad took quite some photographs of churches. He did a lot of photographs too. I remember him taking that old church (in Thundersley) looking out over five counties."

Audrey: "When I was on Camden market they had a whole roll of cigarette cards, and they said that Churchman stopped publishing in the 30s. They hadn't got any black and white photographs of churches."

Kenneth:[N210] "I remember helping him, when we were doing photography in Thundersley in those sheds in the garden. He was making things for CHURCHMAN'S CIGARETTES, little pictures, genuine bromide print. I can

73. As far as we could ascertain, it was the Mascot Cinema.

remember them going out. I think they were at Ipswich or Norwich, the Churchman's Cigarette people there. And they took a set, he got a set of churches, or cathedrals or what. And the order was so big, he couldn't print them and in Thundersley or Westcliff,[74] along there somewhere, there used to be a commercial printer. They were done in a roll, and they were going in a packet of twenty. They were genuine photographs, small ones."

In 1925 we find Cooper in Blackpool. He once started his career there making an advertising picture for KEEN'S MUSTARD. He now ended his career back in Blackpool making advertising animation pictures and cinema glass slides.

The children assume that their father answered an advertisement in the *Kinematograph Weekly*, but find it also possible that he himself put an advertisement in it. Was it his own proposal to advertising agency Langford & Co. Ltd. in Blackpool to put cinema advertisement slides on film and animating them? Or was it an idea of general manager Jim Schofield, whose mother was the main shareholder in the business? Even though advertising moving pictures was there from the beginning, Cooper's children told us Langford was probably one of the first to regularly produce the rather expensive advertising films for the national cinemas.

Kenneth Melbourne-Cooper told his brother-in-law Jan Wadowski:[N211] "There was a friction in the company. I don't think the other director, Ingham, had as many shares, because there was always friction between them. Jim Schofield was about 30, and the other one about 50. Young ideas with old ideas don't work. I don't think it was jealousy, but one was more far-sighted than the other."

Cooper became artistic manager of Animads Film Publicity, a special department of Langford & Co. Cooper now could devote himself again to what he loved to do most of all – making moving pictures. It did not matter whether they were advertisements or not. He was now an employee with a steady income. In a studio at 72a, Cookson Street, and after 1930 in premises at New Preston Road, he installed his own stop-motion camera above an animation desk with pins and a glass plate for the execution of cartoon advertisements applying drawings on celluloid sheets.

Cooper first lived in Blackpool as a lodger in Portland with a Lancashire landlady who served him apple pudding with every meal. When his wife

74. According to Ursula Messenger the Churchman's Cigarette church pictures could have been printed by works in Basildon.

came up, they found a house for the family, *Krahnholm*[75] at Carleton, Poulton-le-Fylde. The family moved there in the second week of May, 1926, during the general strike, with the result that they had to wait for some time before the furniture arrived. At the back of the house was a garden where Cooper could do his gardening.

All three of Cooper's children, for a shorter or longer period, assisted in the production of advertising animation films and glass slides for the cinemas. They qualified themselves in different capacities, Audrey as letterer, Ursula as colourist, and Kenneth as camera operator and several other capacities. They liberally shared their recollections with us. They still remembered several titles of advertising animation films as did their former employer, Langford's managing director Jim Schofield.

Kenneth[N212] remembered the names of some of the artists who worked there. Jack Brownbridge who stuttered, Frank Ball, and a young woman. "There was a girl, who did a tremendous amount of drawings on celluloid, where you pin them down. They are all punched. You put them on top of the other. Movement, let us say there is a rabbit involved. You do one, then another, and you move that up half an inch so that you get a complete movement. Once you have done these drawings of somebody walking, you keep repeating the same thing and you make them walking a mile. She was a nice girl too, she was an artist. This was before Walt Disney was thought of."

Kenneth told his brother-in-law: "It was in Cookson Street, a garage, a building like a tunnel for cars to go into the garage that was at the back. There we made all the slides and the films, straight up, three stories. A lot of history was made there."

The firm later moved to New Preston Road. Kenneth: "It was private then. Just over there was a pond, and when they came over from Cookson Street all these slides were dumped into this pond. It must have been thousands and thousands of these slides, all dumped in there and it got concreted over. So there is a concrete floor with millions of these slides on Preston New Road."

During the First World War, the government had taken over a factory at Preston New Road, and extended it to make aircraft parts. After the war it changed hands again.

75. It possibly means 'jetty'. On two different occasions Ursula told us that it is a German or Scandinavian name meaning 'bottom-of-the-hill'. The Swedish word 'kran' (in German 'Krahn') means little boat; 'holm' means in Swedish a little island, in German a small hill near the water or a jetty. With thanks to Dr Hauke Lange-Fuchs.

Kenneth: "Jim Schofield's sister married Jack Parkinson. They constructed roads and bridges. They had these big army huts left over from the war, big metal ones with corrugated roofs. Langford bought one of these and converted it into a film studio. It was covered with asphalt. Once at lunch time they had a bonfire over there and the wind blew the paper on this asphalt and it started flaming up. I got a fire extinguisher and got it practically out.

I remember the old fellow (father) having this thing built. Four big posters like the furniture today, like pinewood, knotty pine, all four of them. And it was so made that the camera was up on the top like a platform that could be let down on these things and taken up. I think it went on bicycle chains if I remember rightly now. He got some bike chains and sprockets and the old crank wheel, so he could wind it up. He could position it up and down, and the table did the self-same thing. You could drop that, so I suppose he made it so that you could get the maximum distance away.

I had to go up and wind the camera so many turns for so many frames, I always can remember this puppet one.[76] It was all done along these very fine strings. It took hours. The patience the old fellow had. Me, being a bit impatience, I must have spent hours up there waiting for him to tell me to wind the camera. I don't know whether he made these puppets himself.

Jan: Was there no difficulty with the parts, moving the limbs?

Ken: Yes, so that they do not spring back.

Jan: Otherwise you have to push them up, so that they are not moving. But father-in-law always used to emphasise that he liked them to behave like human beings. That is why it maybe takes longer to move it, but in a much more natural way." Kenneth did not remember how many films were made by his father.

Audrey told us:[N213] "Father had a free hand. The only thing is he used to annoy mother. He had the car and we never knew when we would get home. We did not want to leave him behind, even though we were driving as well in those days. As Jim Schofield says, he sometimes would work all day and all night, and he never ate while working. Mother would prepare a meal for 6 or 8 o'clock and we wouldn't turn up. We never got (paid for) overtime."

Kenneth remembered to his sister Audrey:[N214] "He built the dark room and had a tank made for dipping the film in. You know when he was in the

76. Clifton Chocolates. They were later taken over by Barker and Dobson of Liverpool.

garden (of Bedford Park) and had these racks for drying? Somebody made them out of oak or something, and they kept splitting and leaking. He had bitumen inside which seems to stop the leaking, but it wore off and distorted, a right flop they were."

To us he remembered:[N215] "He had these wooden development tanks made, about that wide, with racks with pins on them, so he could wind films on a donkey. The camera might have been a Williamson, a rather square one, but he played around with DeBries. We nearly set the studio on fire at one time."

Kenneth told Jan: "They used to project the films, we had a projector there. The studio lighting, he had all these three legged tripods. They had the lamps made of aluminium, and these big thousand watters screwed in. They had two arc lamps from that big London company that did lighting. I think we were on DC or we had a big regulator on the wall that would cut the voltage in, whether it was 220 coming down to 110, I don't know. But something went wrong one day, that over-voltaged it. When it was switched on, the wire not being heavy enough to take the load, it immediately absolutely right along the floor left a burn mark where it laid. It just went red, and all the insulation burned off. There wasn't someone electrocuted."

Several of the dates and most of the lengths of the Langford advertising films are our estimates. We assume that after the recession of 1929 there was scarcely a demand for advertising animation pictures which were time-consuming to produce and expensive for cinema screening. For this reason we dated the Langford Animads pictures for which we have no production information as made between 1925 and 1930.

Kenneth supposes that when the Depression came, it stopped the production of films. Langford had to return basically to slides, of which a number of copies were made of each. Langford paid the cinemas for showing them.

Kenneth: "They used to sign them up on contracts. Say, a cinema like the Grand Theatre would be signed up for 12 months for Langford slides only. I can remember that they were talking sometime about it, saying they lost cinema so-and-so. The competition offered more money."

The slides were on a standard size of $3\frac{1}{4}$ and $3\frac{1}{4}$ inch. Kenneth: "The originals were on cards, I think 12 or 10 by 15 or 12. The artists used to draw and paint up these, and then they used to come through to the camera, and we photographed them down to $3\frac{1}{4}$ and $3\frac{1}{4}$. But he (father) had to make positives, not negatives. They were coloured in the actual size. There was no magnification. When you saw them on the screen, how

sharp the edge was, it didn't run off the face. Those girls must have had jolly good eyesight. They painted with little, tiny (brushes). They used Johnson dyes. We made the positives. They were contacts. The girls coloured them.

Jan Wadowski: Without magnifying glass?

Kenneth: No, they didn't, they just did it with their eyesight. They had these frames with a square in, a bit of white paper to reflect the light, and these bottles of John & Johnson of Hendon dyes. All these bottles and tiny brushes. They used to very often wet the emulsion so that on a cheek you get a fade-out not a hard line. They went all over the country, these slides. We never paid any attention, it was just a normal job, but some craft went into those. They had to choose the colours themselves. When the customer wrote in: We want the frock green, they would do the frock green, otherwise they used their own colours. Of course the film job seemed to die out when Depression set in. It seemed to get from bad to worse. They stuck onto these slides jobs for years."

None of the eight films we could trace back have survived, save for several strips of 35mm film. More films than these eight could very well have been made during Cooper's time at Langford, but we don't know of them. Langford, around 1940, folded up, and the departments were taken over by other firms.

Cooper started his job at Langford with a cartoon animation of cooks preparing a sponge cake on which jam and sugar are applied generously, after which it is rolled up and presented to the chef for inspection. Kenneth remembered that this first film was done on celluloid sheets, drawing after drawing on register pins. There is a photograph of the story-board for that film, drawn by Langford's illustrator Frank Ball, with a note in Audrey's handwriting on the back: *"Drawings for advertising film for Swiss Rolls (1925)"*.

Apparently, SWISS ROLLS, as a jam filled, rolled up sponge cake, was marketed as a new commodity brand. One finds it today as 'Swiss rolls' in the cookery books. The Cooper children all remembered the SWISS ROLLS advertising film. There was no doubt that Cooper made it.

Audrey, showing the drawings of Frank Ball:[N216] "This artist could not get on with father. He didn't understand the animation technique. He could not understand why you needed several drawings to get the movement of an arm. It bored him, and they quarrelled."

Ursula: "They were used to do it just for the one slide."

Audrey: "Anyway father had difficulties with this artist, though he was quite well-known. But the bosses let father get on with it, because they knew he was reliable."

Cooper's next animated advertisement, a puppet picture made in 1926, was CLIFTON CHOCOLATES, which was very well remembered by Ursula Messenger, not only because she appears in the live-action pay-off, presenting a luxurious box of Clifton Chocolates to the cinema audience, but also because she and the other girls at Langford had to reimburse Clifton for eating the chocolates after the box had done its duty under the hot studio lights.

Audrey:[N217] "We had it for several weeks. It took quite a time to make. They were pretty stale when it was finished. Then one of the staff thought, well, and the box went round, and we all had one each. But shortly afterwards we were sent the bill. We had to pay for this old box of chocolates! And it worked out about a shilling each."

Ursula: "That was a lot of money in those days."

CLIFTON CHOCOLATES is puppet animation. Romeo and Juliet have a romantic dispute. A soldier intervenes with a box of chocolates after which the young couple embrace each other. Some strips of positive and negative 35mm film survived.

Kenneth:[N218] "I can remember the CLIFTON CHOCOLATES one. He made it up in Cookson Street, before we went to Preston New Road. That was done right up on the top floor above Arkley's Garage. We had the same type of wooden thing there. And I was the one who did these three turns. There were puppets hanging on strings. There was a little settee, I remember. There was a lady puppet and a male puppet that sat there making love, and somebody comes there over the back, looked over with a box of Clifton Chocolates, and you see the girl leaves him, going to the bloke with the chocolates."

The next year, 1927, Cooper made crawly creeping microbes from pieces of wire and cotton wool, which grow in your milk if you don't buy pasteurized milk. The combined object and cartoon animation picture was a commission of the Clean Milk Campaign. This campaign was organised by Wilfred Buckley who established a Clean Milk Movement, improving the quality of milk and promoting the consumption of pasteurized milk. A short strip of 35mm film survived. The British Milk Board has no information about it. We were told that their archive was destroyed during the war.

Audrey:[N219] "We had to make a film in those days for a CLEAN MILK CAMPAIGN. He made an enlargement through a magnifying glass, like he did many years ago for GRANDMA'S READING GLASS." Her sister Ursula remembered the enlarged microbes as horrible looking bugs.

He made an advertising picture for PADDY FLAHERTY WHISKEY, but all we know about it are several vague memories of the children, and there is a strip of 35mm negative film with a bottle and the text, "Say 'Paddy' the

best thing next time you order", followed by the Animads trademark. It suggests a combination of object and cartoon animation.

Cooper made for the famous Gladhill company of Sheffield at least two cartoon advertising pictures. The first was to advertise a new invention, a cash register that was able to print a receipt on a small roll of paper after receiving payment from a customer, GLADHILL'S TILLS. The second, GLADHILL'S CLOCKING-IN CLOCK, was to promote a clock-in clock, which registered the times when an employee entered or left the factory gate or office entrance.

Kenneth: "If I remember rightly, it had a big dial and holes in it, and you had a number and you put it up and pushed it. I don't think it had a card, just a big wheel with all these holes. Say, you are number 10. When you went in, in the morning, you brought this finger around, pushed it in the number 10 hole, and it clocked you in."

Audrey remembered the blurb "Gladhills Tills the World". Her brother Kenneth told us that it was made on celluloid sheets. He was up on the animation stand to operate the camera.

Kenneth:[N220] "That was on clear celluloid, pin registered, flat on the table. We had light underneath. Dad had Hewitts, the early ones of the mercury-vapoured tubes, two long Hewitts, and they gave him no end on it. They had magnetical starters, tick, tick, a long time before warming up, clattering away before they started."

Cooper did an advertising picture for CHURCHMAN'S CIGARETTES. We have no idea how it was done, object or flat animation. Did he make use of an old motif, the rural churches which he photographed as cigarette cards from 1918 till 1925 for the Churchman company? These cards have become quite rare today.

The last advertising animation picture we are sure about is MOORES BREAD, made in some kind of stop-motion animation. Not only retired Langford manager Jim Schofield remembered the title but also the children as well.

Ursula:[N221] "I do remember a loaf of bread. I thought it was Derbyshire, that is a big firm in Blackpool, but according to Jim Schofield it is MOORES BREAD. I can remember this loaf, see it standing there, and all of a sudden it's all wrapped up."

Jim Schofield:[N222] "I think at that time it had to do with producing rough bread[77] that was just getting out. And MOORES BREAD was one of the few who were coming out with rough bread."

77. Wholemeal bread.

We have some indicators that Cooper made a puppet advertisement for Quality Street, with set designs by Jack Brownbridge and Kenneth at the camera. The camera rides in on a bay window, where drop curtains open to offer a view outside where a soldier is winning the heart of a young lady offering her sweets. The soldier and the lady are like the famous lady in long purple dress and soldier in red gala uniform on the tins and boxes of Quality Street sweets, the famous produce of MackIntosh now owned by Nestlé Rowntree. But other than the anecdote of Ken, who was camera operator, about a Lalique vase, a wedding present of Langford manager Schofield, that fell into potsherds during or after the production, we have no other indicators, and did not add it to the filmography. Everything we know about this possible animation picture, and everything else we know about other possible and non-possible pictures can be found in the final chapter of this book, Possibles and (Im)probables.

In 2005, we took photographs in Blackpool of a boarded-up 72a, Cookson Street, a building of four stories with double bay windows on top of an entrance to a derelict garage, apparently awaiting its demolition.

In 1938, Audrey, now a renowned letterer, moved to a better job at an important advertising agency in London where, in 1941, she narrowly survived the Blitz after being bombed out of her digs. She recuperated in Scotland. After the war she met a Polish officer, Jan Wadowski, whom she married.

Around 1939, Langford was taken over by the competition, the printing department sold to a local printing firm, and the advertising department to a firm that went to London. Ursula, an experienced colouring artist, went in 1939 with the new company to Wardour Street in London, later becoming chauffeur for a wealthy gentleman. She married Bob Messenger, whose removal business suffered severely from the bombings. Kenneth went to Burnley, working as a block maker for a printing company. He married and had two daughters, Angela and Susan.

Cooper retired when Langford folded up. He moved with his wife to Little Shelford, near Cambridge, where her parents lived. When they died, Cooper and his wife moved to Coton, also near Cambridge. He died there in 1961. His wife died a year later. They are buried at the cemetery of St Peter's Church, just opposite the 'Lantern Cottage' where they lived their last years. Until some weeks before he died, he actively assisted his daughter Audrey to build up an archive about his work and career as an early film pioneer. The seventeen tape recordings bear witness to that.

Audrey died in 1982 in her native town of St Albans. Her husband Jan died there too in 1996. Both are buried at Hatfield Road Cemetery near the grave of Audrey's grandparents, Thomas and Catherine Cooper. Kenneth, who died in 1994, is buried in Selsey near Chichester. Ursula one day became unwell in her nursing home in Felpham, Bognor Regis. She was taken to St Richards Hospital in Chichester, where she died in her sleep, on the following day, Maundy Thursday, 20 March 2008. Ursula's ashes are scattered on the grave of her parents at St Peter's churchyard in Coton.

8. His True Element

Film history author Anthony Slide is, with his prolific output, one of the first to try and satisfy his own plea[N223] for a complete history of the cinema with every company researched and every actor, director and assistant recorded. But all the moving images that are lost will never return in spite of the laments of conservationists. On top of this we have the condescending attitude of the majority of film historians towards animation pictures.

Therefore, it hardly seems worthwhile to ask why Arthur Melbourne-Cooper is forgotten. Why, in the same period when J. Stuart Blackton and Emile Cohl are called the founders of the animation picture, do we not find Cooper there with his A DREAM OF TOYLAND? Yet, the maker is forgotten, and the famous *Shell Book of Firsts*, next to J. Stuart Blackton and Emile Cohl, mentions in 1906 Walter Booth, known from his trick films, as the first English animation film maker.

There is a complex of causes why Cooper stayed out of sight of film historians. These causes are intertwined with the arguments mentioned above. Not enough is known about all these early companies and their directors, actors and assistants. Too many films – 70 percent? more? – have not survived. And with those films the information disappeared which they directly and indirectly contained.

An important direct reason for the mist around Cooper, though he was directly involved in the development of cinematography from 1892, is that he was one of the first in England to specialize in the production of moving pictures. He sold his films to fair-grounds and distributors, and left it to third parties to show them to audiences. He specialized as producer, because he wanted to make his own films independently and without interference from others. His films "disappeared" anonymously in the catalogues of distributors, often under a different title. Even though he

published two or three Alpha trade catalogues with his own productions, only a handful of pages from these catalogues survived. Cooper's tragedy is that his moving pictures cannot be found in the canon of titles of the first silent movies. Not only Georges Sadoul, but film historians in general assumed without any question that the publishers of these catalogues were at the same time the makers of all the films. The films that those catalogues and trade publications eagerly advertise are mainly lost, underlining Richard Crangle's indictment[N224] about the little that survived and all the information we don't have. That is how this independent spirit disappeared into the shadows, after such a brilliant start.

Indirect reasons may surely be that, after 1918, he gave up the idea to resume a career as cinematographer in order to keep peace at home. The work at Langford in Blackpool, far away from the London cinematographic in-crowd, seemed a somewhat bleak compromise. Still, he did things there which were not done before, producing animated advertisements with brand names for the national cinemas.

When veterans from the very first years organised themselves during the Thirties in a *Veterans Club*, Cooper did not join them. To keep peace at home? Or did he consider himself to have been away from London too long and from the circles of film producers who concentrated around Wardour Street near his old addresses at Charing Cross Road and Warwick Court?

Giannalberto Bendazzi, in his recent article about Arthur Melbourne-Cooper and MATCHES APPEAL,[N225] is critical of English film historians because of all the questions they neglected.

"Di un fantomatico archeo-animatore brittannico si era sussurrato, ma senza informazioni né prove. (...) Il paradossale destino di Melbourne-Cooper fu quello di precipitare nell'oblio degli studiosi, specialmente dei suoi compatrioti, e di essere di conseguenza cancellato dagli annali." (*They had heard whispers about a shadowy British arch-animator but without research or evidence. (...) The paradoxical fate of Melbourne-Cooper was that he became forgotten by the historians, and especially by his countrymen, and subsequently disappeared from the annals.*)[78]

Cooper, in February 1909, was one of the delegates at the Paris Congress of film makers, where agreements were to be made about the film rental system to replace the uncontrollable sale of films by the foot. He was there as a member of the British Kinema Manufacturers Association of which he, in 1906, was one of the founder members, as his signature under the articles

78. Translation with thanks to Fr Nico van der Drift OSB.

of association witnesses. Furthermore, he was not just a local freelance cameraman, but founder of several film companies, facts which were published in contemporary trade magazines *The Bioscope* and *Kinematograph Weekly* and in the local press, *Herts Advertiser and St Albans Times*.

From 1901 till 1911, Cooper made no fewer than fourteen animation pictures as productions of his Alpha Trading Company. He made in this period at least two live-action comedies that we know of with animation inserts, close-ups of creepy cheese mites and of a specially made flea that was animated in a harnass pulling a wagon. This means that he, between all his other film work, spent much time making these time-consuming puppet pictures. It meant something to him. It was ten years of one long feast of experimenting with animation picture-making. From the love letters to his fiancée that are saved in the Melbourne-Cooper Archive we know that he, in 1908, experienced the fitting up of his own cinema, the Alpha Picture Palace, as a highlight in his career. These letters of Cooper to his young bride-to-be are overflowing with enthusiasm about the success of his cinema which had a full house the first evening, and many evenings after.

Cooper knew of the disdain of intellectuals and the disgust of churches about the cinema. His aim with his Picture Palace was to uplift going to the pictures from the province of fair-grounds to a well-accepted form of going to the theatre. Besides that, his cinema would be a place where he could show his own pictures uncut as he himself had meant them to be.

Unfortunately, his cinemas became a considerable cause of the downfall in his career. From 1911 film producer Frank Butcher, and from 1912 financier Andrew Heron supported him. While older titles were reissued, he made in this short period another eight animation pictures. He worked hard to get the creditors off his back.

The Great War cut off his cinematographic career. Ten years later we find him in the North, in Blackpool, where he created a niche for himself in which he could be happy doing the things he liked to do most of all, experimenting with new ways and means to make objects move on the big screens in the cinemas. He made at his own Animads (animated advertisements) film studios at least eight animation pictures that we know of. It was probably more, but commercials have a much shorter life span than feature films, documentaries or newsreels, and they are much sooner discarded. We are lucky that Cooper kept several film strips.

Life is the very short moment between the past of only a minute ago and the future of the next minute. A moving picture is the life that wedges itself between those two serried minutes. How does a movie maker do that? How does Cooper do it? Does he steal unaccounted time from us? No, he serves us with his dreams, and in making them ours, he prolongs our time between those two minutes, effectively prolonging our life.

CHAPTER 5

An Imaginative Pioneer

I. Six Pictures Say a Lot about the Maker

In recapitulation, Cooper's 28 puppet animation pictures and eight commercials with puppet and cartoon animation or a combination of both are part of a filmography of more than 300 titles. Let us now look at the propositions in our first chapter.

1. Are the six surviving puppet animations enough to say something about Cooper as a film pioneer, as an artist?
2. Can we call him the founder of puppet animation? May we compare him with greats like Guy-Blaché, Méliès and Porter?

No fewer than 30 of Cooper's animation productions have disappeared. As luck will have it, three of the surviving pictures are from 1899, the start of his animation career. A four-year period of 1907 till 1911 leaves us with the other three pictures. Of his cinema commercials only a couple of film strips survive.

The animation in A Dream of Toyland is on one location, one level, but a hundred little stories are told, as in real life, told with puppets, to the delight of children no doubt, but showing a futuristic street-scape in which the spontaneous street games of children have completely disappeared. Compare Cooper's picture with the hustle and bustle of Pieter Brueghel's painting *Children's Games*, which depicts more than 80 different games of

children.[N226] Today most of these games have completely disappeared. Was it a prophetic foresight of Cooper?

Look at the cunning camera levels in NOAH'S ARK. First we are looking from high above down on what that infantile Noah is doing with that big ark of his. In disbelief, we see a horde of animals, all different, going into that thing. When it rains, our point of view is almost on the level of the water. Are we drowning? Are we swimming? Finally, we are looking up at the ark which landed on top of the mountain, above our view. Noah is the winner.

And in ROAD HOGS OF TOYLAND – a 'toyland' in which we, the grown-ups, are causing the mayhem – there are six different scenes telling a story in true Mack Sennett fashion. Cooper makes puppets move in such a way that they are alive and kicking. His style is to the point, he shows us streets, landscapes and mountains, all direct references to common places and ordinary life.

With the two matchstick sports pictures, Cooper shows a humoristic view on sports with the fiery vollyball players and stiff-upper-lip cricketeers. The three pictures from 1907 till 1911 show Cooper himself. His ideals, his concern about urbanisation and the keeping up of law and order can be seen in A DREAM OF TOYLAND. In NOAH'S ARK he displays his religious side. We meet his sardonic view on our toyland society in ROAD HOGS IN TOYLAND, underlining his ironic meaning of the noun 'toyland'. Was this a true 'delight for all children', these monstrous racing vehicles, destroying the landscape and each other in their motorized frenzy?

From the synopses in the trade catalogues we know that Cooper made more animation pictures in this vein, THE TOYMAKER'S DREAM and OXFORD STREET UP-TO-DATE, both in 1910. This was not understood by the trade, which put it on the market as "a delight to all the children".

Is an industry capable of creating a studio as Mariëtte Haveman defines it, a real workplace as a Vulcanus forge?

Cooper tried it, and he made it. Not only A DREAM OF TOYLAND, but also the three MATCHES pictures, NOAH'S ARK and ROAD HOGS IN TOYLAND meet the requirements defined by Lindgren, and his Alpha studio is a forge of Vulcanus. No wonder that Cooper loved to spend so much time there. As artisan and as artist, he was in his true element there.

Is it art? Can an industrial product be art? Let us look at Ernest Lindgren's definition as we rendered it in chapter 3. We realise it is a somewhat old-fashioned way of looking at art, but we prefer to look at Lindgren's definition because, after all, he was (as curator of the National Film Archive in Great-Britain, in 1958) Cooper's interviewer on the BBC.
The first thing we may expect of any work of art, he said, is that it shall have unity. We must be able to appreciate it for its own sake, it must be

complete in itself, not marred by redundancies, irrelevancies or omissions, and present an imaginary story of the thoughts and actions of individual human beings or puppets and animals. Not only A DREAM OF TOYLAND answers to all of Lindgren's definitions, but NOAH's ARK and ROAD HOGS IN TOYLAND too, and therefore we may call them art.

We dealt with Cooper's 36 puppet pictures in this book, paying hardly any attention to his more than 300 other films. However, in the aspect of his animation pictures, we met his character as independent cinematographer, a true individual unlicensed film-author, a narrator of pictures that move. Cooper expresses best of all patience, love and craftmanschip in his animation work. He realises that there are risks involved, like losing the grace of your audience, as happened to Méliès.[79]

Even though more than 83 percent of Cooper's animation work did not survive, the remaining 17 percent is enough to admire him as a creative experimentor and renewer who was ahead of most of his fellow film pioneers.

An artist must constantly be in love with all things, with his subject, with life, says Spanish-Rotterdam sculptress Dora Dolz in a documentary by her daughter Sonia Herman Dolz.[N227] That is conditional for a meeting with the artist through his work. Cooper loved his work. One has only to realise that in the period 1911 till 1914, he made no fewer than eight animation pictures, next to all his other work as film director, producer, cinema manager, and manager of two companies.

Cooper expressed himself in the technique of object stop-frame animation without contemporary examples. He had to master it himself from the beginning, at the same time developing a style that enabled him to say something to all of us.

Without knowing who we are, he chatted us up to his point of view. Look through my eyes, he says to us. Enjoy what I am doing and love the life I am showing you.

Yes, we can clearly meet Cooper the man in the six surviving pictures, all the more reason to be sad about those lost.

79. Bendazzi in his Cartoons (1994) analyses sharply why it went commercially wrong with Méliès and his principle that the camera should be like a gentleman in his armchair. The actors in the Frenchman's pictures seem like figurative elements. The camera is stationary and all the action occurs as if in an animated puppet theatre. "This is where Méliès' cinema contains the seeds of its own negation; for, if there is a stylistic clash in his films, it lies in the contrast between the two-dimensional scenery and the clumsy movement of the three-dimensional actors."

2. Founder of Puppet Animation

Animation as an autonomous cinematographic genre did not exist before Cooper, in 1899, started to make tiny sports-playing puppets out of matches. Cooper is therefore the founding father of puppet or three-dimensional animation.

It is certain, in spite of unsubstantiated suggestions to the contrary, that Cooper made his Matches Appeal, Animated Matches Playing Volleyball and Animated Matches Playing Cricket in 1899 with stop-motion technique. These are therefore the oldest existing animation pictures in the world. That makes the maker unique. We can call them puppet animations, because the matchstick men behave like characters with a free will and determination. The viewer recognizes them as such at once. With reserve considering all the lost contemporary movies, the three matchstick pictures are most probably the first puppet pictures ever made.

"Arthur Melbourne-Cooper was the creator of the 'first' animated film ever," confirms Bendazzi.[N228] "If animation comes into play not when its techniques were first applied, but when they became a foundation for creativity, then the first animated film could very well be Matches: An Appeal, by the Briton Arthur Melbourne-Cooper, made in 1899 with animated matches."

And in a later article, Bendazzi writes.[N229] "L'agire dei personaggi è sicuro, per quanto rudimentale. Essi manifestano una personalità, sono dunque animati, non semplicemente mossi. La vicenda si dipana all'interno di un mondo di fantasia, senza la presenza umana di un marionettista che giustifichi l'assurdo di oggetti di legno che assumono una vita autonoma. Matches Appeal insomma costituisce un film d'animazione a pieno titolo, nel quale la tecnica dell'immagine-per-immagine non viene utilizzata come 'trucco' o effetto speciale ma costruisce anzi un linguaggio visivo specifico." (*The action of the characters is clear, rudimentary it may be. They represent persons, thus they are living, not only moving. The events unwind themselves in a world of fantasy, without the presence of a puppet-show master, who justifies the absurdity of wooden things which assume a life of their own. In short, Matches Appeal is a truly animated moving picture, in which the technique of frame-by-frame exposure is not applied as a 'trick' or a special effect, but it exactly shapes a special imaginative language.*)[80]

80. Translation with thanks to Fr Nico van der Drift OSB.

Animator John Halas called him a true imaginative pioneer of three-dimensional puppetry.[N230] American film historian Donald Crafton, a foremost researcher of animation history, confirming Cooper's early grasp of stop-motion filming, suggests strongly that his early animation pictures, DOLLY'S TOYS (1901) and THE ENCHANTED TOYMAKER (1904), may have been the inspiration for J. Stuart Blackton and Edwin S. Porter.[N231]

Just as Cooper created life in a couple of matchsticks, making believable living beings of them with their own will and capable of independent action, he was in the following years able to breathe life into puppets, toy animals and other toys. He conjured them into beings living in a world of their own.

The indications are strong that the three matchstick pictures are the first surviving examples of stop-frame technique, because of a simple reason – it was easy to make stop-motion pictures, but this technical possibility on some of the early cine cameras was almost only used for trick filming, which is a much more cost-effective and economical way of making movies than the time-consuming method of frame-by-frame filming.

The matchstick men in MATCHES APPEAL act as true puppets. Little wonder that Brian Coe was sceptical about the date of 1899, a scepticism that is actually a compliment for Cooper's achievement, as was the BFI cataloguer's remark that NOAH'S ARK was probably made in 1917, but not earlier than 1913, until Audrey could convince him with the printed evidence of 1909, an article in the *Herts Advertiser and St Albans Times*.[N232]

What was the use of spending so much time, wasting so much energy on frame-by-frame filming? It was to generate movement out of lifeless objects. Cooper was the first to invent and develop methods and techniques to achieve this. He started to construct simple, small-scale puppets within close range of a racking camera lens. He made them from slivers of matches invisibly connected with copper wire.

He analyzed the movements of human arms and legs, dissecting the movements of the body and of each limb. He learned from Birt Acres to do it frame by frame. He saw this from Acres's experiments from 1892 till 1894 when the latter was trying to re-create movement on the screen, first with glass slides, later with bands of celluloid. More than 65 years later, Cooper was able to give his daughter Audrey an eyewitness account of how Acres finally reached his goal:[N233]

Acres started to make (them) animated. He wanted to animate the slides in the first place, to get movement. And he spent a lot of time trying to get any moving pictures by use of glass plates.

Cooper's new technique is precisely what distinguishes puppet animation from trick filming. And when doing so, Cooper unwittingly – unwillingly, we are sure – created a separation between cinematography and animation cinematography.

Animation pictures, film historians Crafton and Bendazzi assure us, suffer from a lack of serious attention and are unjustly associated with cartoon magazines, a negligible form of output just for children.

As far as we are able to ascertain, the apartheid policy started with R. W. Paul who in his 1904 *Animatograph Catalogue* gives THE ENCHANTED TOYMAKER the following praise: "An excellent picture for children." Was Paul confused about the title, or biased about the subject matter when he decided that this was a picture for children? Therefore, it started with Cooper's pictures that animation became put in the neglectable corner of a market segment 'for children'. It was possibly a clever thought commercially, because distributors reached two targets in one goal, the children and their parents.

Probably they did not know what to do with this genre, and handled it clumsily, neglecting any respect for the cinematographic values of the production and the intentions of its creator. This happened notwithstanding his ROAD HOGS IN TOYLAND being a moving picture meant for an adult audience in the first place with its grim slapstick and cynical message. Cooper's benevolent producer Frank Butcher, advertising his animation pictures as 'done by mechanical toys', did not prevent the puppet animations from receiving their stigmatic hallmark: "delight to all the children".

Crafton and Bendazzi also assure us that animation is a rich area, autonomous as an expressive form, taking a different but parallel course to mainstream cinema, and with its own history. This autonomy started with Cooper. His three matchstick animations make it clear that true frame-by-frame animation starts here.

Not only did Cooper exercise the breaking-down of movements, he gradually developed character studies in order to be able to give individual puppets their own personality. An example is that of the assertive white bear in A DREAM OF TOYLAND. Another fine example is Noah's wondering what to do with the sign-post 'To the ark'. He first wants to keep it and take it on board, but then decides that it has no use anymore, and he drops it in the water between the ark and the land. This shows Cooper's grasp of puppetry.

It is safe to assume that Cooper's experience with the simple matchstick puppets made him ask the famous Hamleys Toyshop to manufacture for

him dolls with special joints to be used as puppets. Hamleys had experience manufacturing puppets on strings or rods for theatrical puppeteers.

We may therefore repeat Bendazzi's conclusion[N234] that when animation became a foundation for creativity, it was Arthur Melbourne-Cooper who was the first to apply it.

Movies from before the introduction of sound are considered to be primitive, but A DREAM OF TOYLAND of 1907 with its striking deep perspective and its avant-garde way of story telling is setting all the conditions of what one may call art. It is a true classic, and its maker is indeed a co-founder of what we may call 'film language'. At any rate, the maker is a co-founder of the language of our imagination.

His name should be mentioned with great names in film history like Alice Guy-Blaché, Georges Méliès and Edwin S. Porter, true independent cinematographers who, each in their own way, were able to make stories with pictures that moved.

3. The Screen, a Mesmerizing World

"Have you ever heard of Melbourne-Cooper?" asked Cooper's daughter Audrey Kathleen in 1955 at a lecture by John Huntley about the early days of the cinema. "Yes, but he has been dead for years," was the film historian's reply to the daughter who, a couple of days before, had seen her father alive and whose pictures, in his day, had seen much success in view of their many reissues.

Not only was Cooper forgotten, not long after this incident he became poorly misjudged, when he donated a new safety copy of one of his own films to the Kodak Museum. The misjudgement concerns the disbelief about Cooper's assurance that his MATCHES APPEAL was made in 1899, a rather cynical disbelief of two Kodak Museum curators.

Would a film maker, who was able to make little masterpieces like A DREAM OF TOYLAND, NOAH'S ARK and ROAD HOGS IN TOYLAND, never have been able to make a MATCHES APPEAL in 1899? Cooper's claim was never properly researched, and his MATCHES APPEAL never related to his later animation pictures.

Cooper's puppet animation work, perhaps more than his other work, makes it clear how the cinema developed itself from just strips of moving photographs into coherent series of images which each time tell longer and more complex stories, and in this way create a new art form, saving

cinematography from a short-term destiny as a flash-in-the-pan, a short-lived gimmick like the Mutoscopes and Kinetoscopes.

From his general filmography it is Cooper's puppet animations, especially MATCHES APPEAL and A DREAM OF TOYLAND, which make it clear that he was an exceptionally creative film maker.

Cooper's visual eye was sceptically extant in a moving pictorial A DREAM OF TOYLAND, where the hustle and bustle of city traffic speaks for itself. The film has a plot in which the live-action shots have an unmistakable function to make clear the double message of the film maker. NOAH'S ARK is his biblical story of hope and salvation. The underlying message is simple and resolute – resurrection is possible, even if by the hand of one carpenter.

A couple of years later, Cooper demonstrates in ROAD HOGS IN TOYLAND the destruction of the quiet countryside and the rural way of life, when modern racing cars plough through pastoral bliss, ending in pure chaos. Does salvation arrive from above in the shape of a modern aeroplane? Or does it cause even more chaos? We will never know because the end is missing.

ROAD HOGS IN TOYLAND is without live-action scenes. It is a full-grown feature with a plot and several little side dramas. It stands on its own with its substantial images and story outline. It is the terminus of what we know about Cooper as an animation pioneer, who twelve years before let two simple matchstick puppets write a humanitarian appeal on a wall for soldiers more than 9000 kilometers from home.

We are sure that he would never consider himself an artist but an artisan, a craftsman who made movies, and who was always trying to make something new, something different, something that was not done by someone else before, in order to astound himself and his audience. His most powerful tool was his imagination.

What causes the power of imagination? Children possess the enormous capacity to see at once living beings in dolls. As grown-ups we lose this power. Cooper found a way to bring us back and let us experience the power of imagination without patronizing us. He is the story-teller losing himself in his audience, at the same time letting them lose themselves in his narrative. With the title the anticipatory pleasure begins. We find in Cooper's titles words like dream, fairy, enchanted, and Land of Nod. These words and titles alone invite us to the promised land and the mesmerizing world of the cinema screen.

Cooper never meant that live-action scenes like in A DREAM OF TOYLAND and NOAH'S ARK should make the films longer. On the contrary, these scenes, carefully filmed and directed, are Cooper's own hand with

which he takes us, the audience, into his fantasy world, because that is where the real miracles of his workplace are happening. This is his world, and in a silent agreement we are allowed to see what he sees, and to live in a tremendous experience, surrounded by puppets and motor-cars, donkey-carts and steam engines, all creating mischief and disorder in this toy town.

The message of A DREAM OF TOYLAND was not exaggerated. On the contrary. Already in 1903, a royal commission proposed new roads, tramways and rail systems for London, because street congestion had increased dramatically in recent years.

And so, this picture from 1907 is a fine example of how movies of a hundred years ago are able to tell us a lot about what people thought and how they experienced their own times. It is a precise argument for the need to conserve our movies as best as possible, not only in digital forms which will have outlasted their practical application whenever industry and commerce dictate new forms of reproduction. A DREAM OF TOYLAND proves beyond doubt the necessity of the plea for film conservation.

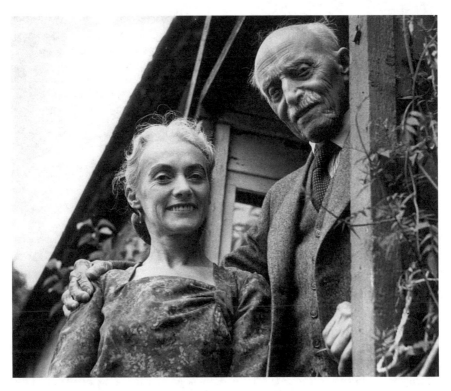

Fig. 38. Arthur Melbourne-Cooper with his daughter Audrey, Coton, August 1961.

A last look at A DREAM OF TOYLAND, our 'toyland', the world in which we so dangerously play with fuel and CO_2, with natural resources and military power.

Yes, very possibly the puritans had an argument. Still in their infancy the movies became a considerable force of representation and imagination.

4. A Final Praise and Concern

What did we, the two authors, learn from this study of the animation pictures of an obscure British film pioneer? Was it worth all the time, effort and expense to research Arthur Melbourne-Cooper? Was it, in particular, worthwhile being compelled to undertake a kind of cinematographic archeology?

Fig. 39. In 1967, Audrey Wadowska visits what once were the buildings of the Alpha Studios at 14, Alma Road, St. Albans, shortly before their demolition.

The first thing we had to develop and practise was a method of identifying films and film titles, and crediting them, a method applied in the next part of this book. Films, in the early days, were sold by the foot. Cooper sold his pictures to anyone who would buy them. Film titles can be found in

advertisements and catalogues, but the name of the maker is never mentioned, a maker who was at the same time his own producer, cameraman, director and laboratory worker. Distributors added their own titles, retitling again when reissued a couple of years later. In addition, many surviving films have lost their titles through wear and tear. An added hurdle is that most of the films made in the early years were not fiction but documentaries, newsreels, sports reports and recordings of nature.

If one wants to draw conclusions from the historiography of the cinema, the moving pictures must be understood in the context of their own times. Never underestimate film makers of those years, and never call their pictures 'primitive'. Each picture was, at its premiere, understood by the audiences as the 'acme' of their time, the ultimate object of all the preceding moving pictures. Even the very first moving pictures are still a joy to watch, and reveal wonderful observations as Martin Loiperdinger demonstrated with *Lumière-Filme aus Deutschland, 1896-1897*,[N235] an amazing collection of the earliest Lumière movies made in Germany.

It is the same with paintings from the Middle Ages, which have to be *read* in order to be understood, not to be looked at in aesthetic admiration. In order to be able to read those old moving pictures, one has to learn their language of symbols and allegories. Only in that way will we experience a remarkable and enduring meeting with living people of many years and many ages ago. And only in that way we will be able to see how Cooper successfully forged the necessary fusion of moving pictures and narrative which was needed to allow, in the words of Roy Armes,[N236] "the cinema to achieve a lasting universal appeal and enable the entrepreneurs to build a profitable industry."

In 1987, during a personal conversation with the authors at the silent film festival *Le Giornata del Cinema Muto* in Pordenone, Italy, its Honorary President, French film historian Jean Mitry, told us that film history cannot be understood without the knowledge of the economic and industrial conditions of its development. He explained that it was necessary for every new branch of undertaking, in order to survive, to divide itself into specialisations. He told of the problems which an early pioneer like Cooper had to deal with, when the newborn film industry, in order to outlive its inception commercially, had to develop into the well-known specialisations of manufacture, distribution and retail: production, distribution and exhibition. Mitry said that he placed the start of specialising in film production around 1903-1904, but he believed us when we told him that as early as 1901 Cooper started his Alpha Trading Company as 'producer for the wholesale trade only'. It was a

time when moving pictures began to attract viewers other than the fair-ground visitors, middle-class patrons who wanted stories and longer pictures.[81]

Cooper was one of the first to specialize in production for the distribution trade several years before the commercial division of the industry took place. This in itself does not make Cooper special.

What made him special – and according to us worthwhile to devote this study to his puppet films alone – was his A DREAM OF TOYLAND of 1907 which, even then, shows all the basic principles of frame-by-frame animation as they are still applied today.

With its long, intricate and complex animation sequence, it was made at the same time as historiography situated the first frame-by-frame cartoon animations in America and France. Film historians Denis Gifford and Donald Crafton drew our attention to the fact that Cooper had already made a number of animation pictures before this date. These animations could, according to Crafton, very well have served as early examples and inspiration for American animation pictures. Cooper's daughter Audrey showed us three animation pictures with matchstick puppets made as early as 1899. We have, with ample detail, demonstrated that these three matchstick pictures were indeed made in 1899, advancing the 'official' date of the first frame-by-frame films by seven to nine years. This alone made all our trouble to produce this book worthwhile. While writing it and verifying our data, we came to the conclusion that Cooper was a passionate moving picture puppeteer.

Though only six pictures survived of the 36 animations that he made, we still could gain a good impression of Cooper the man, his personality and his creative drive, who, as one of many, took up cinematography in the very early years, and helped to develop it into a worldwide industry.

We find it a great pity that the puppet animation CINDERELLA (1912) is lost, a picture which Cooper himself considered to be his finest work and greatest achievement. It is therefore an invaluable loss for film history. However, we want to end this study with a final praise.

When we, in April 1970, moved from culturally rich Amsterdam to Rotterdam, though still one of the biggest harbours in the world, it was a city still deeply scarred by the German bombardments of May 1940, when many houses, shops, churches, cafés, theatres and most of the cinemas went up in smoke.

81. Jean Mitry's *Histoire du Cinéma – I, 1895-1914*, (Éditions universitaires, 1967), helped us a lot.

What we missed most of all in Rotterdam was the generous choice of good movies which we used to enjoy in Amsterdam. We started to make up for this want by buying a small Zeiss Ikon standard 8mm projector and a number of short films by Charlie Chaplin, Laurel & Hardy, Zigoto, Larry Semon, Lupino Lane and many other comedies in the public domain. It beat television. We loved to watch those unknown comedians and episodes from very old movies. One of our standard 8mm favourites is the serial THE MYSTERY OF THE DOUBLE CROSS (1917) with Molly King, a charming female lead, in control of all the action.

Soon we became collectors, not only of 8mm but also of 16mm films, and later even of 35mm after friends helped us to fit up a Philips FP4 in our living room. There were a number of film collectors in and around Rotterdam. There were even more in England, a reason to visit that country regularly.

And so we came to love old movies. Old movies are like old, wrinkled and sometimes scarred hands of history, stretching out from the white screen. *Do not forget. We too were once young, and beautiful and full of suspense. Your parents and grandparents dreamt their dreams with us...*

In the meantime Rotterdam got its Film International festival (now International Film Festival Rotterdam) where, in 1979, Audrey was invited to show her father's films. Two years later, we contributed to Film International from our collection with a mini-festival of 40 *Hollywood B-movies 1930-1940* from the RKO studios.

After the FIAF congress in 1978 in Brighton about *Cinema 1900-1906*, archives and film historians all over the world gradually became aware of the importance of old nitrate material. The attitude towards films from the past changed. Film archives and film institutes received more means and better funding to acquire, archive and preserve their valuable collections of old movies.

Not only the Italian *Le Giornata del Cinema Muto* testifies to this, showing the restored treasures from these archives, the publications of *Domitor*, an official organisation of film historians, do too. While Jean Mitry, some twenty years ago, was one of the very few, today film historians and scientists are doing much work to understand and study those very old films in all their contexts and relations. The German yearbook on early film history, *KINtop*, was one of the forerunners, next to periodicals such as *Film History* and *Early Popular Visual Culture*. And today, digitalisation brings collections to the reach of many interested people. TV-documentalists and historians are making abundant use of these treasure storehouses.

Thanks to the Netherlands Filmmuseum we were able to undertake the frame by frame analysis of the original nitrate print from our former collection of A Dream of Toyland. A study on DVD does not allow, for instance, a look at splice lines between the frames. It made us understand better the way in which film makers in those early years had to work.

Yet we have some concern. As film critics and former private collectors,[82] we learned to appreciate the quality of the film material and its durability. It seems old-fashioned to be worried about it or mourn the loss of it. A disbelief in the power of progress. In the next couple of years, a new 'progress' in the history of cinema will take place. After the introduction of sound, of colour movies, of CinemaScope and Cinerama, it is now hard drives from which the programmes are downloaded into computers for digital projection, or digital satellite receivers installed in the cinemas. No film rolls anymore, no wear and tear, no expensive transport of heavy film cans, no possibility of illegal duping, but high definition projection directly from Hollywood. What more do we want? Film archives may try and rescue the last rolls of celluloid film. And then it is over. Or is it over?

Can we speak of progress in film history? Is that beautifully restored Panorama Mesdag in The Hague only a primitive form of a much superior CinemaScope projection, 70 years later, with Henry Koster's The Robe (1953)? We think that this way of looking at film history, in the tradition of C.W. Ceram's *Archeology of the Cinema* (1965), is primitive and restrictive.

We find confirmation in Frank Kessler's oration at the University of Utrecht in 2002 about *Het idee van vooruitgang in de mediageschiedschrijving* (The idea of progress in media historiography). His oration invited us to look again at the question of Arthur Melbourne-Cooper's 'being forgotten'. Kessler puts this in a possible new light.

Was Cooper really forgotten? Several of his live-action and animation pictures, undisputably made by him and in general also credited to him, like A Dream of Toyland, MacNab's Visit to London, The Motor Pirate and Noah's Ark, are regularly shown in programmes about 'old' movies.

It is much better not to speak of a 'forgotten', but of a 'vanished' film pioneer. He disappeared from the sight of early film historians like Georges Sadoul, Rachael Low and John Barnes because in their 'historical' view on cinema history, Cooper's moving pictures were most probably too difficult to classify.

82. Our collection of more than a thousand 35mm and 16mm films was donated to the Netherlands Filmmuseum, but we kept our 8mm film collection.

Is the problem with Cooper's pictures that he was too much ahead of his time, that he was not a follower of trends, and that his pictures were his personal exploits? Is this the difficulty in despatching them to the traditional course of accepted film history? Even though much is lost, we hope to have a closer look at this question in our next study, and at the same time we hope to be able to trace how Cooper succeeded in making moving pictures tell enthralling stories.

Notes on Part One

(The T before a number refers to the transcription of an audio tape or cassette.)

1. Mariëtte Haveman, et. al. red. *Ateliergeheimen. Over de werkplaats van de Nederlandse kunstenaar vanaf 1200 tot heden*, Lochem/Amsterdam (Uitgeverij Kunst en Schrijven), 2006, page 16.

2. André Bazin, 'The Myth of Total Cinema,' *What Is Cinema?* (Trans. Hugh Gray, (Berkeley: University of California Press, 2005), page 22.

3. Stephen Jay Gould, 'The Belt of an Asteroid,' *Hen's Teeth and Horse's Toes*, (New York: Norton, 1983), pages 320-331.

4. 'The War. The Military Situation', *The Times [Digital Archive, 1785-1985]*, 27 October 1899, page 10.

5. 'Comforts for the Troops', *The Times [Digital Archive, 1785-1985]*, 31 March 1900, page 13.

6. 'Special Safety Matches for the Troops,' *The Times [Digital Archive, 1785-1985]*, 6 October 1914, page 11; advertisement, *The Times [Digital Archive, 1785-1985]*, 24 December 1914, page 11.

7. Tjitte de Vries, 'Arthur Melbourne-Cooper (1874-1961), a Documentation of sources concerning a British film pioneer', in *KINtop, Jahrbuch zur Erforschung des Frühen Films*, Frankfurt am Main (Stroemfeld/Roter Stern), Autumn 2005.

8. John Barnes, *The Beginnings of the Cinema in England*, London (David & Charles), 1976, page 6.

9. George Ewart Evans, *Where Beards Wag All*, London (Faber and Faber), 1970, pages 17-21.

10. Madeleine Malthête-Méliès, *Hommage aan George Méliès. Schepper der Filmkunst, 1861-1961*. Amsterdam (Nederlands Filmmuseum), February 1963. – Frank Kessler, Sabine Lenk, 'Ein Leben für Méliès. Ein Interview mit Madeleine Malthête-Méliès, der Enkelin des Zauberers von Montreuil', in *Georges Méliès – Magier der Filmkunst*, KINtop 2, Basel/Frankfurt am Main (Stroemfeld/Roter Stern), 1993.

11. Marian Blackton Trimble, *J. Stuart Blackton. A Personal Account by His Daughter*. No. 7 in the Filmmakers Series edited by Anthony Slide. Metuchen NJ and London (Scarecrow Press), 1985.

12. De Vries, *KINtop*, 2005, ibid.

13. Letter from John Barnes to Tjitte de Vries, St Ives, 28 December 2005.

14. Nicolas Barker (ed.), *The Early Life of James McBey*, Oxford (University Press), 1977, page 120.

15. Christian Metz, 'Some Points in the Semiotics of the Cinema', in *Film Language*, (Oxford University Press), 1974, page 93.

16. Roy Armes, *A Critical History of British Cinema*, London (Secker & Warburg), 1978, pages 15-28.

17. Edward Wagenknecht, *The Movies in the Age of Innocence*, Norman New York (University of Oklahoma Press), 1962, pages 20-22.

18. André Gaudreault, 'Theatralität, Narrativität und Trickästhetik. Eine Neubewertung der Filme von Georges Méliès', in *Georges Méliès – Magier der Filmkunst*, KINtop 2, Jahrbuch zur Erforschung des frühen Film, Basel/Frankfurt am Main (Stroemfeld/Roter Stern), 1993, page 31. Originally in *Méliès et la naissance du spectacle cinématographique*, Madeleine Malthête Méliès, ed., Paris (Klincksieck), 1984.

19. Michael Chanan, *The Dream that Kicks. The Prehistory and Early Years of Cinema in Britain*, London, Boston and Henley (Routledge & Kegan Paul), 1980, pages 54-60.

20. In a study, much appreciated by us, by fellow research journalist Léo Sauvage, *L'affaire Lumière. Enquête sur les origines du cinéma*, Paris (Lherminier), 1985, pages 73-146. Paul C. Spehr in his *The Movies Begin. Making Movies in New Jersey 1887-1920*, Newark NJ, (Newark Museum), 1977, has other views. Indispensable on Edison is Gordon Hendricks with his thorough *Origins of the American Film*, New York (Arno Press & The New York Times), 1972.

21. Arthur Swinson, ms. interview with Arthur Melbourne-Cooper, Coton/St Albans, 1956, (T433).

22. Wagenknecht, 1962, ibid., pages 15-21.

23. Is. P. de Vooys, 'De Kinematograaf in de Litteratuur', in *De Beweging*, January 1910, pages 7, 10 and 12.

24. Siegfried Kracauer, *Theory of Film*, (Oxford University Press) (quoted from Wagenknecht, 1962, ibid. pages 21-22).

25. David Bordwell, Janet Staiger and Kristin Thompson. *The Classical Hollywood Cinema. Film Style & Mode of Production to 1960*. London, Melbourne & Henley (Routledge & Kegan Paul), 1985, pages 3-11, and 157-158.

26. Denis Gifford, *American Animated Films: The Silent Era, 1897-1929*, Jefferson NC and London (McFarland), 1990.

27. L. Bruce Holman, *Puppet Animation in the Cinema. History & Technique*, South Brunswick and New York/London (Barnes/Tantivy), 1975.

28. Donald Crafton, *Emile Cohl, Caricature and Film*, Laurenceville (Princeton University Press), 1990, page 327.

29. Jean Mitry, *Esthétique et psychologie du cinéma*, vol. 1. Paris (Éditions Universitaires),

1965, pages 314-416.

30. 'Urban Films, List of New High-class and Original Urban Film Subjects', The Charles Urban Trading Comp., supplement to *Film Catalogue*, London, June 1905, August 1906/November 1906.

31. Audrey Wadowska to Tjitte de Vries, London, 27 December 1976, (T076), 3 January 1978, (T018a), and 13 April 1979, (T036), while studying Urban catalogues 1906, 1909.

32. Audrey Wadowska to Tjitte de Vries, London, 2 January 1978, (T008).

33. Ursula Messenger to Tjitte de Vries, Ati Mul, Felpham, Bognor Regis, 9-10 August 2002, (T158), 29 December 2002 (T163).

34. Arthur Melbourne-Cooper to Audrey Wadowska, Coton, Aug. 1960, (T047, tape XV, cd 15/17).

35. Martin Loiperdinger, *Film & Schokolade, Stollwercks Geschäfte mit lebenden Bildern*, KINtop Schriften 4, Frankfurt am Main (Stroemfeld/Roter Stern), 1999, pages 17-36, 57-69.

36. Loiperdinger, 1999, ibid. pages 71-108.

37. Hauke Lange-Fuchs, *Birt Acres, der Erste Schleswig-Holsteinische Film Pionier*, Kiel (Walter G. Mühlau), 1987, page 15. Hauke Lange-Fuchs, *Der Kaiser, der Kanal und die Kinematographie*, Schleswig (Landesarchiv Schleswig-Holstein), 1995.

38. Lange-Fuchs, 1987, ibid. Lange-Fuchs, 1995, ibid.

39. Arthur Melbourne-Cooper's visit to Sidney Birt Acres, Southend, 20 May 1956 (T001, tape VI, cd 1/17).

40. Arthur Melbourne-Cooper to Bert Barker, hon. secretary British Fairground Society, Chiswick, August 1960 (T006, tapes XIII, XIV, cd's 13a/17; 13b/17; 14/17)

41. Arthur Melbourne-Cooper in BBC radio interview by Ernest Lindgren, curator NFA, London, 11 July 1958 (T002, tape XII, cd 3/17).

42. Arthur Melbourne-Cooper to Audrey Wadowska, Coton, 2 September 1960 (T068, tape VIII, cd 16/17).

43. Cooper to Bert Barker, 1960, ibid.

44. Audrey Wadowska to Tjitte de Vries, London, 15 August 1978 (T181).

45. John Grisdale, ms. *Portrait in Celluloid*, Coton/St Albans, 1960, based on interviews with Arthur Melbourne-Cooper.

46. Kenneth Melbourne-Cooper to Tjitte de Vries, 2 August 1983 (T088).

47. Letters from David Cleveland to the authors, Manningtree, 9 June 2007, 14 April 2008.

48. Audrey Wadowska to David Cleveland, 11 October 1979 (T407).

49. Audrey Wadowska to David Cleveland, 19 December 1977 (T420).

50. Cooper to S.B. Acres, 1956, ibid.

51. W.J. Collins, Publicity Director Pearl, Dean and Youngers Ltd., 'Advertising was there from the very start', in *Kinematograph Weekly*, London, 3 May 1956, page 77.

Written note on cutting 3rd column top: *"Old man in Birds film: McLeish – Barnet"*. W.J. Collins, 'Advertising was in at the beginning' in Supplement to *World's Press News*, London, 11 May 1956.

52. Arthur Melbourne-Cooper interviewed by ITV television, Southend, 17 July 1958, in a programme by Ludovic Kennedy (T072, T082, T390).
53. *Herts Advertiser & St Albans Times*, St Albans, 29 January 1898.
54. De Vries, *KINtop*, 2005, ibid.
55. 'Letter to the Editor. An Employee of Charles Urban Recalls "The Old Days"' by H. Maynard, New Southgate N11, in *Kinematograph Weekly*, London, 13 November 1947.
56. John Barnes, *The Beginnings of the Cinema in England*, 1894-1901, 5 volumes, Exeter (University of Exeter Press), 1997/1998.
57. Rachel Low,*The History of the British Film 1895-1939*. London (George Allen & Unwin/Routledge), 7 volumes, 1948-1985/1997.
58. John Halas, *Masters of Animation*, London (BBC Books), 1987, page 18.
59. Donald Crafton, *Before Mickey. Animated Film 1898-1928*. Cambridge, Massachusetts/London (The MIT Press), 1982/1987, pages xviii, 4-5, 223-224.
60. Crafton, 1990, ibid., pages 129-131.
61. Giannalberto Bendazzi, *Cartoons. One hundred years of cinema animation*, London (John Libbey), 1994, pages 7, 40-41.
62. Richard Crangle, 'Actuality and Life. Early Film and the Illustrated Magazine in Britain', in *Cinema at the Turn of the Century*, Quebec/Lausanne (Éditions Nota bene/Payot), 1999, page 93.
63. Paolo Cherchi Usai, *The Death of Cinema. History, Cultural Memory and the Digital Dark Age*. London (BFI Publishing), 2001, preface, pages 125-127.
64. John Halas & Roger Manvell, *The Technique of Film Animation*, London (Focal Press), 1987, page 263.
65. Bendazzi, 1994, ibid., pages 40-41.
66. Holman, 1975, ibid., page 11.
67. Donald Heraldson, *Creators of Life, a History of Animation*, New York/London (Drake), 1975, page 183.
68. Jaroslav Boček, *Jiří Trnka, Artist and Puppetmaker*, London (Paul Hamlyn), 1963, pages 222-223.
69. Frits Abrahams, 'Acteur', back page of *NRC-Handelsblad*, Rotterdam, 7 April 2008.
70. Collins, 1956, ibid., page 77.
71. Audrey Wadowska to Tjitte de Vries, London, 30 May 1981, (T127).
72. Letter from R.S. Schultze, Research Librarian and Curator, Kodak Museum, to Mr Melbourne-Cooper, Harrow, 26 June 1956.
73. Barnes, 1976, ibid., page 6.
74. Rob Wijnberg, 'Vanaf zes jaar en ouder' (From six years and older) in *NRC-Handelsblad*, Rotterdam, 16 August 2007.

75. Peter Dekkers in *Trouw*, 17 April 2008, page 19.

76. Halas, 1987, ibid., page 9.

77. Bendazzi, 1994, ibid., pages xv, xvi.

78. *Magisch Panorama. Panorama Mesdag, een belevenis in ruimte en tijd* (Magical Panorama. Panorama Mesdag, an experience in space and time), Yvonne van Eekelen (ed.), Zwolle (Uitg. Waanders), 1996. A wonderful, delicious book.

79. Audrey Wadowska to Tjitte de Vries, London, 12 April 1979 (T040).

80. Wadowska to De Vries, 1979, ibid. (T040).

81. Gregory Fremont-Barnes, *The Boer War 1899-1902*, Essential Histories, Oxford (Osprey Publishing), 2003, page 10.

82. Allister Sparks, *The Mind of South Africa*, London (Heinemann), 1990, page 128.

83. Crafton, 1990, ibid., pages 87, 276.

84. Letter from Ard van Pelt, sports teacher, Rotterdam, 21 April 2004.

85. Collins, 1956, ibid., page 77.

86. Giannalberto Bendazzi, 'Fiammiferi superstar' (Matchsticks superstar), in *Il Sole 24 Ore*, weekly cultural supplement of the daily newspaper, 14 August 2005.

87. Crangle, 1999, ibid., page 93.

88. BBC radio, 1958, ibid. (T002)

89. Jan Wadowski to Tjitte de Vries, 4 May 1991, St Albans (T276).

90. Cleveland, 2007, ibid.

91. Martin Sopocy, *James Williamson. Studies and Documents of a Pioneer of the Film Narrative*, Cranbury NJ/London/Ontario (Associated University Presses), 1998.

92. Frederick A. Talbot, *Moving Pictures, How They are Made and Worked*, Philadelphia/London (Lippincott/Heineman), 1912; reprint New York (Arno Press & NY Times), 1970, pages 254-257.

93. Crafton, 1990, ibid., page 127.

94. Cleveland, 2007, ibid.

95. Audrey Wadowska to Tjitte de Vries, London, 18 August 1978 (T026).

96. Audrey Wadowska to Tjitte de Vries, London, 27 December 1976 (T076).

97. Schultze, ibid., 26 June 1956.

98. Letter from R.S. Schultze to Mrs Audrey Wadowska, Harrow, 18 December 1962.

99. Letter from R.S. Schultze to Mrs Audrey Wadowska, Harrow, 11 January 1963.

100. Barry Salt, *Film Style & Technology, History & Analysis*, London (Starword), 1983, pages 71-72.

101. Crafton, 1990, ibid., page 328, note 59.

102. Gifford, 1987, ibid., pages 1-9.

103. David Robinson, 'Animation. The first chapter 1833-1893', in *Sight & Sound*, Autumn 1990, Volume 59, no. 4.

104. Collins, 1956, ibid.

105. Tabitha Jackson, *The Boer War*, London (Channel 4 Books/Macmillan), 1999, pages 25-27.

106. Major I. Scheibert, *Der Freiheitskampf der Buren*, – Supplement- und Schlußband, Berlin (A. Schröder Verlag), 1902, page 53.

107. Fremont-Barnes, 2003, ibid., page 24.

108. Letter from Rebecca S. Hawley, Imperial War Museum, London, to Tjitte de Vries, 16 July 2007.

109. Letter from Mrs Kate Melbourne-Cooper, Lantern Cottage, Coton, to Audrey Wadowska, London, July (?), 1956.

110. Letter from David Cleveland, Manningtree, to Tjitte de Vries, 8 November 2005.

111. Trevor T. Moses, film historian and resident expert on South African film history of the National Film, Video and Sound Archives, Pretoria, to the authors, 15 January 2007.

112. Cooper to Ernest Lindgren, BBC 1958, ibid.

113. ITV, 1958, ibid. (T390).

114. Letter from Arthur Melbourne-Cooper to Pieter Germishuys, Johannesburg, South Africa; Coton, 5 June 1961.

115. Denis Gifford, *The British Film Catalogue 1895-1970*, Newton Abbott (David & Charles), 1985, no. 1893; *The British Film Catalogue, Volume I, Fiction Films, 1895-1994*, London/Chicago (Fitzroy Dearborn), 2000, no. 01802, page 64; *British Animated Films 1895-1985*, Jefferson NC/London (McFarland), 1987, no. 19, page 20.

116. Letter Mrs Cooper, 1956, ibid.

117. Mrs Ursula Messenger to Tjitte de Vries and Ati Mul, Felpham, 20 October 2004 (T382).

118. Ernest Lindgren, *The Art of the Film. An Introduction to Film Appreciation*, London (George Allen and Unwin), 1948, pages 35-40.

119. Roger Holman, ed., *Cinema 1900/1906. An Analytical Study by the National Film Archive (London) and the International Federation of Film Archives*, Brussels (FIAF), 1982.

120. Crangle, 1999, ibid., pages 94-97.

121. John Barnes, 1976, ibid.

122. Crazy Cinématographe, *Europäische Jahrmarktkino 1896-1916*, DVD. Luxembourg/Trier (Edition filmmuseum; edition-filmmuseum.com), 2007.

123. *Urban Films*, 1905/1906, ibid.

124. Audrey Wadowska to Tjitte de Vries, London, 27 December 1976/13 April 1979 (T076/T036).

125. Arthur Melbourne-Cooper to Audrey Wadowska, Coton, 2 September 1960 (T068, tape VIII cd 16/17).

126. Georges Sadoul, *Histoire du Cinéma*, Paris (Librairie Flammarion), 1962, pages 44-45. Georges Sadoul, *Histoire du Cinéma Mondial, des origins a nos Jours*, Paris (Flammarion), 1949/1974, pages 42-44. Georges Sadoul, *Histoire Générale du Cinéma, II, Les Pionniers du Cinéma (de Méliès à Pathé) 1897-1909*. Paris (Les Éditions DeNoël), 1947, pages

169-180. Georges Sadoul, *British Creators of Film Technique, British Scenario Writers, the creators of the language of D.W. Griffith, G.A. Smith, Alfred Collins and some others*, London (BFI), 1948, pages 3-5.

127. Tjitte de Vries, 'Arthur Melbourne-Cooper, film pioneer: wronged by film history', in *KINtop, Jahrbuch zur Erforschung des Frühen Films*, Frankfurt am Main (Stroemfeld/Roter Stern), 1994, pages 143-160.

128. Mrs Russell Jones, née Nellie Dewhurst, to Tjitte de Vries and Ati Mul, Cardiff, 7 August 1986 (T362/363/364/365).

129. R.W. Paul, *Paul's Animatographs & Films*. London (R.W. Paul), 1901.

130. Gifford, 1987, ibid., page 6.

131. Crafton, 1990, ibid., pages 129-130.

132. Audrey Wadowska to Tjitte de Vries, London, 4 August 1979 (T177).

133. Arthur Melbourne-Cooper to Audrey Wadowska, Coton, 1959 (T005, tape II, cd 7/17).

134. Audrey Wadowska to Tjitte de Vries, London, 31 March 1978 (T019).

135. Tjitte de Vries, 'Sound-on-Disc Films 1900-1929 and the Possibilities of Video Transfer', in *Cinema 1900/1906. An Analytical Study*, Brussels (FIAF), 1982, pages 339-349.

136. Crafton, 1990, ibid., pages 129-130.

137. Arthur Melbourne-Cooper to his grandchildren at a Christmas family evening, 26 December 1956 (T003, tape III, cd 2/17).

138. Wadowska to De Vries, ibid., 16 August 1978 (T021); ibid. (T022); ibid. 20 August 1978 (T030); ibid. 10 April 1979 (T039); ibid. 12 April 1979, (T040); ibid. 13 April 1979, (T035); ibid. 30 July 1979, (T176); ibid. 17 April 1981, (T052).

139. E.G. Turner, 'First Film Cartoon' in *Evening News*, 17 November 1955.

140. Bendazzi, 1994, ibid., page 40.

141. BBC radio, 1958, ibid. (T002, tape XII, cd 3/17).

142. *The Kinematograph and Lantern Weekly*, 20 February 1908, page 276.

143. *The World's Fair*, Saturday, 29 February 1908.

144. *The Bioscope*, 27 February 1908, page 6.

145. *The Kinematograph and Lantern Weekly*, 1908, ibid., page 287.

146. Audrey Wadowska to Tjitte de Vries, London, 26 December 1976 (T075).

147. Audrey Wadowska, *Lecture Herts to Hollywood*, St Albans Film Society, 31 March 1966 (T101).

148. Cooper to S.B. Acres, 1956, ibid. (T001).

149. Arthur Melbourne-Cooper to Audrey Wadowska, Coton, 1959 (T005), page 15, footnote 60.

150. Cooper to S.B. Acres, 1956, ibid. (T001).

151. *The Kinematograph and Lantern Weekly*, ibid, page 276.

152. *The Bioscope*, London, 8 September 1910, page 39.

153. Audrey Wadowska to Kenneth Clark, London, 24 October 1978 (T197/198/199).

154. Arthur Melbourne-Cooper to John Grisdale, Coton, July 1960 (T096, tape I-B, cd 12/17).

155. David Cleveland in a letter to the authors, 5 November 2008.

156. Cecil M. Hepworth, *Came the Dawn*, London (Phoenix House), 1951, page 67.

157. Stanley Collier to Mrs and Arthur Melbourne-Cooper, Aldeburgh, 20 July 1958 (T090, tape X, cd 4/16).

158. Crafton, 1982/1987, ibid. page 9, 59 and following.

159. Gifford, ibid., pages 1-34.

160. Cooper at Christmas family meeting, ibid., 26 December 1956 (T003).

161. Audrey Wadowska to David Cleveland, 11 October 1979 (T419).

162. Ursula Messenger to Tjitte de Vries, Felpham, 24 July 1983 (T205).

163. Roland Barthes, *Le Plaisir du Texte*, Paris (Editions du Seuil), 1973.

164. Letter from Ronald Grant, The Cinema Museum, Kennington, to the authors, 5 June 2007.

165. Cooper to Bert Barker, 1960, ibid. (T006).

166. Audrey Wadowska to Tjitte de Vries/Ati Mul, London, 15 April 1977/3 January 1978/31 March 1978/19 August 1978/29 July 1979 (T072/016/020/028/046). St Albans, 28 May 1981 (T058).

167. Patrick Robertson, *The Shell Book of Firsts*, London (Ebury & Michael Joseph), 1974, page 39. Patrick Robertson, *The New Shell Book of Firsts*, London (Headline), 1994/1995, page 73.

168. *The Bioscope*, 18 September 1908, pages 19-20.

169. *The Kinematograph & Lantern Weekly*, 25 March 1909, page 1287.

170. Audrey Wadowska to Tjitte de Vries, London, 28 May 1981 (T059). Mrs Sarah Monks Jr to Audrey Wadowska, St Albans, 1964/1970 (T081/T182).

171. Letter from Eric Lavers to Audrey Wadowska, 1975 (T207).

172. *The Bioscope*, 8 February 1912, page 146.

173. *Film House Record*, 15 October 1910, page 242.

174. *The Kinematograph and Lantern Weekly*, 16 April 1908, page 497.

175. W. Butcher & Sons Ltd., Camera House, Farringdon Avenue EC, catalogue 1911, page 199.

176. Rodney Dale, *Louis Wain. The Man who drew Cats*, London (Chris Beetles), 1991.

177. Cooper to Grisdale, 1960, ibid. (T043).

178. Audrey Wadowska and Ursula Messenger, London, Autumn, 1980 (T208).

179. Audrey Wadowska to Tjitte de Vries, London, 17 April 1981 (T053).

180. Cooper to Audrey, 1960, ibid. (T068).

181. Anthony Slide, *Aspects of American Film History Prior to 1920*, Metuchen NJ & London (Scarecrow Press), 1978, page xi.

182. Christopher Winn, *I Never Knew That About England*, London (Ebury Press), 2005, pages 112-113.

183. Patricia Warren, *The British Film Collection 1896-1984. A History of the British Cinema in Pictures*, London (Elm Tree Books), 1984, page 7.

184. Robertson, 1974, ibid., page 65. Robertson, 1994/1995, ibid., pages 128-146.

185. Patrick Robertson, *The Guinness Book of Film Facts and Feats*, Enfield (Guinness Books), 1980, pages 124, 203, 241, 246; *Guinness Film Facts and Feats*, Enfield (Guinness Books), 1985, pages 110, 172, 206, 210; *Guiness Book of Movie Facts and Feats*, Enfield (Guinness Books), 1988, pages 111, 181, 213, 217/New York (Abbeville Press), 1991, pages 184, 190, 203.

186. Jim Schofield to Audrey Wadowska, Blackpool, 1963 (T094/T231).

187. Audrey Wadowska to Tjitte de Vries, London, 26 December 1976 (T074).

188. R.W. Paul catalogue 1904, ibid. page 44.

189. *Cricks & Martin Lions Head*, 1906, ibid. page 37.

190. *The Bioscope*, 1908, ibid.

191. *Kinematograph and Lantern Weekly*, 1908, ibid. page 287.

192. *The Kinematograph & Lantern Weekly*, 23 November 1911, page 136.

193. *The Bioscope*, 7 December 1911, page 676.

194. W. Butcher & Sons, 1911, ibid., page 199.

195. W. Butcher & Sons, 1911, ibid., page 199.

196. W. Butcher & Sons, 1911, ibid., page 199.

197. Kenneth Clark, *More Movements in Animation. Pioneers of the British Animated Films*. Manuscript 2007, forthcoming publication in 2010, pages 13-15.

198. Audrey Wadowska to Tjitte de Vries, London, 27 December 1976 (T076).

199. *The Bioscope,* 5 September 1912, page 749.

200. Wadowska to Schofield, 1963, ibid. (T094).

201. Grisdale, ms. 1960, ibid., pages 157, 160.

202. Audrey Wadowska to Tjitte de Vries, London, 27 December 1976 (T076).

203. *The Bioscope*, 5 December 1912, pages 692-693.

204. *Supplement to the M.P. Offered List and Buyer and Seller*, 22 November 1913 (no page no.).

205. Wadowska to De Vries, ibid., 1976, (T076).

206. Audrey Wadowska and Ursula Messenger to Tjitte de Vries, London, 14 April 1979 (T078).

207. Kenneth Melbourne-Cooper to Audrey Wadowska, London, 24 October 1973 (T304).

208. Ursula Messenger to Tjitte de Vries, Ati Mul, Felpham, 4 May 2003 (T171).

209. Audrey Wadowska and Ursula Messenger, London, August 1975 (T207).

210. Kenneth to Audrey, 1973, ibid. (T304).

211. Kenneth Melbourne-Cooper to Jan Wadowski, St Albans, 17 May 1984 (T210).

212. For this and the next few quotes re. Langford: Kenneth to Jan Wadowski, 1984, ibid. (T210).

213. Audrey and Ursula to De Vries, 1979, ibid. (T078).

214. Kenneth to Audrey, 1993, ibid. (T304).

215. Kenneth Melbourne-Cooper to Tjitte de Vries, 2 August 1983 (T088).

216. Audrey and Ursula to De Vries, 1979, ibid. (T078).

217. Audrey and Ursula to De Vries, 1979, ibid. (T078).

218. Kenneth to Audrey, 1973, ibid. (T304).

219. Audrey to Clark, 1978, ibid. (T197/198/199).

220. Kenneth to Audrey, 1973, ibid. (T304).

221. Audrey and Ursula to De Vries, 1979, ibid. (T078).

222. Schofield to Audrey, 1963, ibid. (T094).

223. Slide, 1978, ibid. page xi.

224. Crangle, 1999, ibid. pages 93-97.

225. Bendazzi, 2005, ibid.

226. Ati Mul, *Straatspelen. Verdwenen kindercultuur,* (Street games. A lost juvenile culture.) Lelystad (Stichting IVIO-AO), 1974.

227. *Portret van Dora Dolz,* d. Sonia Herman Dolz, documentary 2006. See also Gerdien Verschoor ed., Dora Dolz, Heino-Wijhe (Hannema-de Stuer Fundatie), 2001.

228. Bendazzi, 1994, ibid., pages 7, 40.

229. Bendazzi, 2005, ibid.

230. Halas, 1987, ibid., page 18.

231. Crafton, 1990, ibid., pages 129-131.

232. Audrey Wadowska to Tjitte de Vries, London, 1 June 1978, (T062).

233. Arthur Melbourne-Cooper to Audrey Wadowska, Coton, Aug. 1960, (T047, tape XV, cd 15/17).

234. Bendazzi, 1994, ibid. pages 7, 40-41.

235. Martin Loiperdinger, *Lumière-Filme aus Deutschland, 1896-1897,* VCR attachment to *Film & Schokolade,* KINtop Schriften 4, Frankfurt am Main (Stroemfeld/Roter Stern), 1999.

236. Roy Armes, 1978, ibid., pages 15-28.

Fig. 40. Arthur Melbourne-Cooper, in 1908 photographed by William H. Cox, Luton.

Fig. 41. Audrey and Jan Wadowski, caretakers of 1, Holland Park Avenue, London.

Fig. 42. The Thaumatropes (1825) of Dr John Ayrton Paris were the fore-runners of many tropes and scopes that were invented in the 19th century.

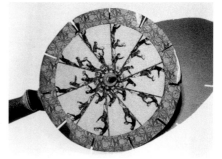

Fig. 43. A Phenakistoscope, constructed by Joseph Plateau in 1830.

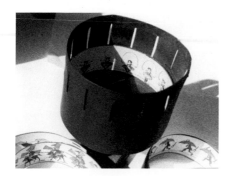

Fig. 44. A replica of a Zoëtrope. It was presented in 1867 in the United States by William E. Lincoln.

Fig. 45. Edison's Kinetoscope, an expensive visual gadget which didn't last long, but was the start of the 35 mm cinema movie.

Fig. 46. Holiday picture postcard, postmark 22 Sep. 1906 Blackpool, to
"A. Melbourne Cooper, Warwick Villa, St Albans, Herts" by Ruby Vivian:
"I was quite startled to see my own face in THE SCOTSMAN [MACNAB'S VISIT] at
the Palace. R.V." At the address side she wrote: "I'm having a fairly good time
here. Weather not too nice. R.V.".

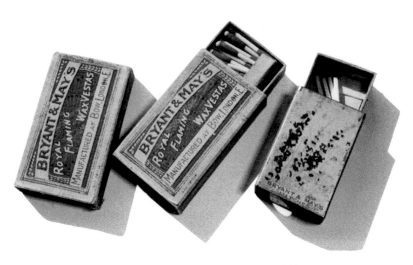

Fig. 47. Bryant & May's matches, 1890s.

Fig. 48. An effort to roughly recreate the set of the three animated matches pictures in order to make a guess of its size with matchstick men made from large size matches.

Fig. 49. The eye in GRANDMA'S READING GLASS (1900) stays steady in the centre.

Fig. 50. Cooper's mother Catherine Cooper née Dalley, who lent her eye to GRANDMA'S READING GLASS (1900).

Fig. 51. Strip of the original negative of G.A. Smith's GRANDMA'S READING GLASS (1903) which was clearly a different version.

Fig. 52. The eye in the circular mask as it appears in Smith's version of GRANDMA'S READING GLASS (1903) is not steady but moves around.

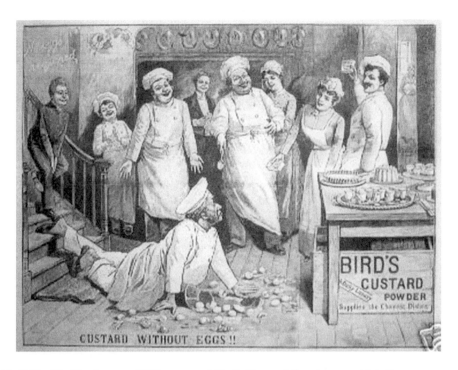

Fig. 53. The famous 1897 poster of Bird's Custard Powder on which Cooper based his animated advertisement pictures in which Mr MacLeash of Barnet played the part of the man who tripped and broke the eggs.

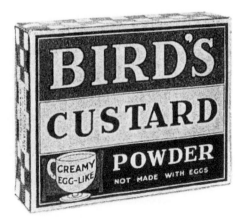

Fig. 54. Bird's Custard Powder, 1890s.

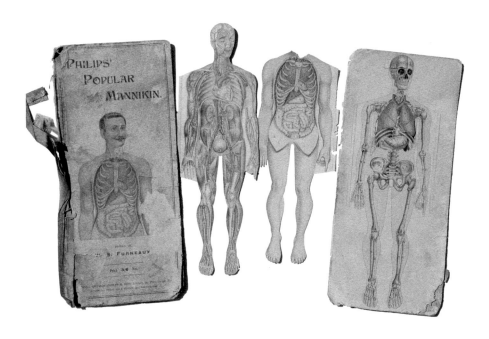

Fig. 55. *Philips' Popular Mannikin* from the Cooper family estate was probably used for an animation picture or sequence, ANATOMY MAN.

Fig. 56. A golliwog, today called a golly, and Dutch dolls, popular toys with children, from *The Adventures of Two Dutch Dolls and a "Golliwog"* by Florence and Bertha Upton, 1895.

Fig. 57. The title of a magic lantern slides series *Old Mother Hubbard* published by W. Butcher & Sons. *(This slide and the following 58 and 59: thanks to Richard Rigby of The Magic Lantern Society.)*

The dame made a curtsey,
The dog made a bow;
The dame said, "Your servant,"
The dog said, "Bow, wow."

Fig. 58. A magic lantern slide from the series *Ten Little Nigger Boys*.

Fig. 59. The final slide from *Ten Little Nigger Boys*, published by W. Butcher & Sons.

Fig. 60. Cooper considered CINDERELLA (1912), a lost puppet picture, his best.

Fig. 61. Summer 2003 - Cooper's youngest daughter Ursula
Messenger at 26, Manor Park, Lee, where she lived as a child when
her father made CINDERELLA (1912) and other puppet animation
pictures in Butcher's film studio behind their back garden.

Fig. 62. Just before demolition in 2005: 72a Cookson Street, Blackpool, where, on the second, third and top floor Cooper started his Animads film studio for Langford & Co. Ltd.

Fig. 63. Letter-head of Cooper's Animads Film Publicity, which later moved to Langford House, New Preston Road, Blackpool.

Fig. 64. CHURCHMAN'S CIGARETTES (1925-1930). Before Cooper made an advertisement picture for Churchman's, he photographed churches and cathedrals for Churchman's Cigarette cards (1.5 x 2.7 inch/3,5 x 6,7 cm.)

Fig. 65. Churchman's Cigarettes box.

Fig. 66. PADDY FLAHERTY (1925-1930), Irish whiskey.

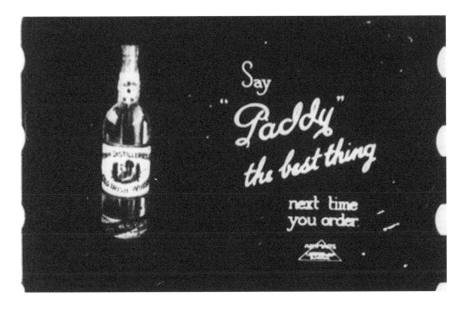

Fig. 67. Frame from PADDY FLAHERTY advertisement picture which were hand coloured by Cooper's daughter Ursula.

Fig. 68. Arthur Melbourne-Cooper and his wife being interviewed by
BBC newsreader Richard Whitmore, Coton, 1960.

Fig. 69. In May 2005, Ursula Messenger visited the authors in Rotterdam.

Part Two

"Picture by Picture
Movement by Movement"

The Filmography

36 Animation Pictures by
Arthur Melbourne-Cooper

How to Use the Filmography

"Picture by picture, movement by movement." That is how, in 1899, film-pioneer Arthur Melbourne-Cooper took his Boer War picture MATCHES APPEAL as he described it in 1958 to National Film Archive curator Ernest Lindgren in a BBC radio interview.

The filmography on the following pages of 36 animation pictures by Arthur Melbourne-Cooper is the first result of our work about this film pioneer. Cooper made these pictures between the years 1896 and 1914, and between 1925 and 1940. Ten pictures were combined with live-action scenes.

Only Six Survived

We were able to locate 36 titles of Cooper's animation pictures. As far as we know, only six pictures have survived. Besides the animation pictures, Cooper sometimes applied short stop-motion scenes to live-action pictures. We know of CHEESE MITES (1902) and PROFESSOR BUNKUM'S PERFORMING FLEA (1907).

The 36 animation pictures form but a small part of Cooper's total body of creative work. They should not be seen in isolation from his comedies, his dramas, his documentaries, his newsreels and sporting events. (See *Appendix 3* for a chronological list of more than 300 film titles.)

Cooper was a complete film maker, a truly independent cinematographer. We came to know this of him and were able to compile this filmography of his animation pictures after many years of research and after sorting out and archiving the estate of Audrey and Jan Wadowski. Audrey collected an admirable amount of material about her father but never seemed to find the time to organise and file it.

In this second part we present all the material *pros and cons* that we could find of every individual animation title in the estate of Audrey and Jan, and in our own files.

Production Dates and Titles

The filmography on the following pages gives a full account of each film,

title by title. We always searched for the correct date of production in order to get as close as possible to Cooper's productional circumstances. If this was not possible, we fell back on Denis Gifford's dates of release (see the *Bibliography: 4. Cinematography – Gifford*).

We also searched for Cooper's original production titles, and consequently we were able to disentangle several mistakes and confusions, most of them from Audrey Wadowska, as well as one or two from Gifford. These are explained in the final chapter *Possibles and (Im)probables*. Audrey and Gifford are not to blame. The origins of the confusions are obvious. Distributors buying Cooper's pictures considered them as their property, cut them down to what they considered better marketable lengths and gave them titles which they considered vendable.

Denis Gifford

The name of the late Denis Gifford deserves special mention. He was a film historian that we had the privilege of meeting several times during our years of research. We greatly admired his tenacity in collecting data about all the moving pictures made in Great Britain from 1894 onwards, attempting to be as complete and accurate as possible. Also, we admired his craftsmanship in archiving and filing it in such a way that it was available in print in a verifiable manner for the purpose of future study.

Stars as Evidential Values

Each head title is allocated one or more stars with four stars as the maximum. The stars do not express our appreciation but act as an evaluation of our evidential material. From this material we derived as many indicators as possible, appraising these into one or more stars. Four stars mean that there is no doubt about Cooper being the maker. One star means enough certainty to credit Cooper as the director and producer of this particular film, but more indicators would be welcome.

Seven Categories

We have classified our sources of information into 7 categories:
1 – primary source: Arthur Melbourne-Cooper,
2 – contemporary sources,
3 – complementary sources,
4 – publications,
5 – correspondence,
6 – recorded interviews,
7 – unpublished manuscripts.

1. **Primary source – Arthur Melbourne-Cooper**. We consider the seventeen tape recordings with Cooper's voice as our primary, i.e. most important source. See *Appendix 4* for an exhaustive contents list of these tapes.

 Here is the voice of our prime subject guiding us to what we want to know. His 'voice' can also be heard in one or two other primary sources, for instance the list of film titles written down by Mrs Kate Melbourne-Cooper and authorized by her husband. There are contemporary interviews with Cooper in newspapers and trade magazines.

 We know about the objections of giving too much credibility to the recollections of elderly people, but in the end, it is Cooper himself who is our prime authority concerning his career as a very early film pioneer. Besides, there is enough corrective material available in the supplementary sources.

 Cooper is the subject of this book. Therefore, we start with what he himself is still able to tell us. These seventeen tapes with a film pioneer who was there from the beginning allow us to have a look into the 'moving picture' that was yesterday.

2. **Contemporary sources.**
 Printed documents are extremely valuable – contemporary trade catalogues, trade magazines, advertisements, newspapers. We used these as much as we could, but with the same caution as with spoken words. There is a comprehensive list of what we used in the *Bibliography: 10. Contemporary sources & Archive Catalogues*.

3. **Complementary sources.**
 An important complementary source for us was the seven impressive books of film history researcher Gifford who collected his data concerning English films from 265 different sources, and who had a special zeal for animation pictures. See *Bibliography: 4. Cinematography – Gifford*. We also made use of the data published by his German counterpart Herbert Birett. We supplemented this with everything that we found in the catalogues of the National Film Archive and the American Film Institute.

4. **Publications.**
 We were glad of any scrap of information that we could find in magazines, books and newspapers after 1940 about Cooper and his films, when he was retired. Our *Bibliography: 1. Publications* gives ample account of this source material.

5. **Correspondence.**
 From the more than 3000 letters in the estate of Audrey and Jan Wadowski, we used what would enlighten the pros and cons of each

picture. The Bibliography gives account of this in *Archive Material: 8. Documentation* – subject of a comprehensive (English language) publication in the German year-book of early movie history *KINtop*.[N1]

6. **Recorded interviews.**

The recorded interviews are numbered. Each number is preceded by a T (for transcription): these are our archive numbers. *Archive Material: 9. Recorded Interviews* gives a summary of all the interview material that is available (more than 450 different recordings). Audrey Wadowska interviewed 152 people who knew her father, local people, actors and actresses. Film historians David Cleveland and Kenneth Clark gave us permission to use their interviews with Audrey. Our interviews with Audrey were recorded during film viewings, and while discussing film catalogues, trade magazines, photographs, newspaper clippings, documents, and Audrey's vast amount of notes.

7. **Unpublished manuscripts.**

We made use of nine manuscripts which deal directly or indirectly with Cooper as their subject. The relevance and reliability of what we found became obvious when compared with all the other material. We got permission from the authors to use their findings. They are listed in *Archive Material: 11. Unpublished Manuscripts*.

An important source is John Grisdale's manuscript 'Portrait in Celluloid'. Grisdale, an English language teacher, based it on personal interviews with Cooper. It was commissioned by Audrey and Jan Wadowski, but never published because Cooper strongly objected to the style and treatment of the subject matter. The scattered pages of the manuscript together with Audrey's efforts to rewrite it were sorted out by us as best as possible, bound and indexed. Bound copies can be seen at the Netherlands Filmmuseum, Amsterdam, and the City Museum, St Albans, Herts.

The ninth manuscript is Audrey's comprehensive A-Z index book of film titles made by her father. She wrote it in the eight or nine months before her death in January 1982. A tenth manuscript, an undated thesis by Claire Heseltine, Cooper's great-granddaughter, was written for an unnamed study.

Editorials
The editorials at the end of each title give our critical appraisals.

Possibles and (Im)probables
Audrey was quite sure that her father could be credited with many specific

film titles, but we opened a chapter *Possibles and (Im)probables* for those pictures for which we could not find adequate corroboration. For instance, we deliberately excluded NURSERY RHYMES, not because Cooper did not make it – he did – but because it is apparent that it is not an animation picture. One film that still exists and was considered by Audrey as her father's work has been excluded, because we are sure that Cooper had nothing to do with THE WOODEN ATHLETES. This title has been confused by Audrey Wadowska as well as by Gifford with SPORTS IN MOGGYLAND. There are several other titles that leave us with too many question marks.

35mm and 16 Frames per Second

Our filmography deals with the films in their 35mm form, still in existence or lost. An account of existing copies, whether on 35mm or 16mm and DVD, is given in Appendix 1. The running times are given for a projection speed of 16 fps, a speed that comes closest to the screening practices in those early years, when projectors were hand-cranked at speeds between 14 or 15 and 20 or 22 fps, depending on the number of blades of the shutter.

Credits

In the film credits we hardly distinguish between the functions of producer, director and cameraman. We are certain that Cooper, in these beginning years, combined all these functions, taking the initiative to make a picture, and next directing it as well as tending the camera. Names of assistant animators and of people acting in the live-action parts are given when we know them.

Terminology

The term 'animated' sometimes causes confusion. Gifford in his *American Animated Films*[N2] points out that the word 'animated' in the contemporary sense of 'animated pictures' was an alternative term for 'moving pictures' and does not imply animation cartoons. Kenneth Clark[N3] writes: "Critics referred to the toys as 'articulated' or 'mechanical', rarely 'animated'."

Mette Peters[N4] of the Netherlands Institute of Animation Films (NIAF) writes: "I came across a great number of terms to describe the practised (film/animation) technique:

> 'trick film' – 'trick or animated picture' – 'trick or animated picture with live-action' –
> 'live-action trick film' – 'animation picture' – 'stop-motion animation' – 'stop-motion
> cartoon animation' – 'stop-motion animation of objects combined with cartoon and
> lettering animation' – 'stop-motion object animation' – 'puppet animation' – 'animated

puppets' – 'animated dolls' – 'object animation' – 'object animation of book illustrations'
– 'combined object and two-dimensional animation' – 'live-action and animation' –
'live-action and stop-motion animation' – 'live-action with stop-motion animation
scene' – stop-action substitution – flat animation – frame-by-frame animation –
(shadow) cut-out or silhouette animation – live-action with animation inserts."

We cannot help it if these terms are used in quotes, but we will try to limit
ourselves to the following terms.

- *Animation pictures*, with which we want to distinguish pictures that use stop-
 motion technique from animated pictures, the contemporary term for
 moving pictures in general.
- *Trick film* or *stop-action* has to be distinguished from animation pictures. A trick
 film is not an animation or cartoon picture, but uses the 'trick' of temporarily
 stopping (one or more times) the camera in order to move/remove objects or
 persons on or from the filmed set. Another trick is the speeding up or slowing
 down of the camera in order to get the reverse effect in the projection. There is
 no complete application of the stop-motion technique, and there is no
 intention of 'animating' lifeless objects into 'beings' with an individual
 personality.
- *Live-action*, to distinguish films or scenes from stop-motion animation.
- *Puppet animation*, rather than 3-D or object animation, to be distinguished
 from cartoon animation or *flat animation* and *cut-out or silhouette animation*
 (which is a different technique, and is actually 3-D animation with flat pieces
 of paper or cardboard).
- *Animation insert* or interpolated stop-motion insert for an insert or close-up of
 a relatively short animation scene in pictures which are generally live-action.
- *Stop-motion* or stop-motion animation as the technical term rather than the
 term frame-by-frame technique or frame-by-frame animation.

Abbreviations & Explanations

Notes = We are using footnotes and end notes. End notes are
 distinguished by the capital N in front of the number, and are
 used for sources and their relevant page numbers. Footnotes
 are given when something in the text needs direct clarification.

01–(101) = The number preceding each title is our database number.
 A number between brackets means that this title is not in our
 database section 'Animation pictures', but in the section
 'General films'.

No number means that this film is not in our database, because it has nothing to do with our subject, and is only mentioned because the title comes up in our material.

a.k.a. = Also known as.

fps = Frames per second. The recorded running times are given for a speed of 16 fps (foot per second) which was the average projection speed in those early years.

* * * * = All the indicators give clear evidence of Arthur Melbourne-Cooper as the director.

* * * = There are sufficient indicators for Cooper being the director.

* * = There is sufficient circumstancial evidence of Cooper being the director.

* = There is circumstantial evidence of Cooper being the director.

Credits = We give all the film-credits which we could discover in our sources.

Dates = The given dates are mainly the release dates, but in several cases, when known to us, they are the production dates. The release dates can be found in Gifford.

ft. = Length in feet, mainly provided by contemporary trade catalogues or by Gifford. Film lengths are always given for 35mm film.

Coloured = This is given if we have indications that the film was tinted, toned or hand-coloured. In all other cases the film is black-and-white. When 'also coloured' is indicated, this generally means that the buyer had the choice between black and white or coloured.

CHAPTER 6

28 Animation Pictures
and Two Inserts

1. **Keen's Mustard** * *, 1896, approx. 40 ft., running time 40 sec.
Advertisement. Trick or animation picture, or combination of both.

Credits

Directed and animated by Arthur Melbourne-Cooper on location at
Blackpool and at the studio of film pioneer Birt Acres, 45, Salisbury
Road, Barnet. Independent production. Direct sales to fair-ground and
other showmen.

Synopsis

A sun is rising over the advertised product, a tin of Keen's Mustard.

Details

Cooper went to Blackpool "to obtain the scene of a sunset on the golden
sands" as his biographer John Grisdale wrote. He filmed the sunset most
probably with an upside down camera and stop-motion technique, in
order to have it later shown as a sun rising over the product.

Primary source – Arthur Melbourne-Cooper

**Arthur Melbourne-Cooper during family meeting, Christmas, Clapham,
26 December 1956** (T003, tape III, cd 2/17).

Audrey Wadowska: "And then there were two advertising films. The
early one was BIRD's CUSTARD, wasn't it? In 1896? *Cooper:* "Yes, about
that time." *Audrey:* "And then KEEN's MUSTARD?" *Cooper:* "Yes."

**List of film titles in Mrs Kate Melbourne-Cooper's handwriting and
authorized by Arthur Melbourne-Cooper, 1956:**

"KEENS MUSTARD – B'Pool, approx 1890-s."

Recorded interviews

"Then some enterprising advertisers of the day were quick to realise the
enormous possibilities of the new medium, and in 1896 father went up
to Blackpool for the making of an advertising film for KEEN's MUSTARD,

which was soon followed by another for BIRD's CUSTARD powder." **(Audrey Wadowska at her lecture for the Royal Photographic Society, London, 26 January 1977,** T128.**)**

Audrey Wadowska: "And these early advertising films – he would not say he was the first but he was pretty early. In 1896 he went to Blackpool to make a film for KEEN's MUSTARD. And of course, having a camera with him, he took local scenes. That reminds me, yes, the Archive has got that film, the first film taken at Blackpool. I have ordered it without seeing it. That must be father's because I am sure no one else went there before." **(Audrey Wadowska to Tjitte de Vries, London, 15 April 1977,** T073.**)**

Audrey Wadowska: "And another thing he mentioned. He was going to Stockton and he went to Blackpool to make KEEN's MUSTARD, in 1896 I think it was. He went to Blackpool to take the sunset and scenes of the promenade and on the tram. He got his camera on the tram. BLACKPOOL PROMENADE. They have got that in the Archive recently, and I asked Jeremy (Boulton) for that. Supposed to be the first film taken at Blackpool." **(Audrey Wadowska to Tjitte de Vries, London, 1 January 1978,** T082.**)**

Audrey Wadowska: "He combined the two: he advertised and entertained. *Tjitte de Vries:* So, in 1898 you had already commercials? *Audrey:* Oh yes, of course BIRD's CUSTARD was before that, 1896, 1897, during Acres's days. And KEEN's MUSTARD. Father went to Blackpool in 1896 to take the sunset there for KEEN's MUSTARD. *Tjitte:* That was an Acres production? *Audrey Wadowska:* "I imagine so, but father made the film." **(Audrey Wadowska to Tjitte de Vries, London, 19 August 1978,** T028.**)**

"In 1896, he went to Blackpool for a film that he made for KEEN's MUSTARD." **(Audrey Wadowska to Kenneth Clark, London, 24 October 1978,** T199.**)**

Audrey Wadowska: "The real animation – he made trick films like, not KEEN's MUSTARD – he went to Blackpool to make KEEN's MUSTARD. No, BIRD's CUSTARD. *David Cleveland:* Advert? Was made when? *Audrey:* Yes, in 1897. Might be 1896. *David:* Was that animation? *Audrey:* Not real animation." **(Audrey Wadowska to David Cleveland, London, 11 October 1979,** T407.**)**

Audrey Wadowska: "Well, he went to Leeds the same as he went to Blackpool in 1896. He went actually for KEEN's MUSTARD to take a film of the sunset in Blackpool on the sands. They have marvellous sunsets up there. And he went on a tram ride upon the front and took various scenes. And in Leeds he did a similar thing. He went up there to film a

factory and to Newcastle and various other places." **(Audrey Wadowska to Tjitte de Vries, London, 17 April 1981,** T052.**)**

Audrey Wadowska (looking at photographs): "That is Blackpool Tower. He was in Blackpool filming in 1896. And we lived in Blackpool in the Twenties. *Tjitte:* This could be 1896, no cars, a lot of carriages on the sea front. *Audrey:* He took views of the town, the promenade in particular, because that is all there is in Blackpool, and that tower. And from the top of a tramcar. But his purpose for going there was for an advertisement film for Keen's Mustard. Why he had to go up there I don't know, but it was to film the beautiful sunset. Considering it was black and white film, I wouldn't think it mattered, but Blackpool is famous for its sunsets. It got six miles of beautiful sands where they do horse riding, beautiful golden sands. And beautiful sunsets and in colour they are beautiful. Those horses and carriages might be for the visitors." **(Audrey Wadowska to Tjitte de Vries, London, 30 May 1981,** T127.**)**

"He was by that hotel in red brick, The Imperial Hotel. It was a tubular tripod and it came down with its sharp points. Standing on the beach, looking around the skyline, he looked down: the legs of the camera had gone down." **(Kenneth Melbourne-Cooper to Tjitte de Vries, Burnley, 2 August 1983,** T088.**)**

Unpublished manuscript

"For Keen's Mustard he went to Blackpool to obtain the scene of a sunset on the golden sands, for which it was, and still is, famous. (…) Keen's Mustard which found its way to the fair-grounds as far as Bamph and Inverness in Scotland." **(John Grisdale,**[N5] **1960.)**

"Keen's Mustard (1896)"

(Audrey Wadowska, A-Z manuscript, 1981, page K.**)**

Editorial

It is not clear whether Cooper made use of a specially prepared camera for the stop-motion technique. Some cameras at that time had an extra tripod bush (tripod screw hole) on the top so that they could be put on the tripod upside down.[1] Cooper remembered this picture on one of the seventeen audio tapes when he was interviewed.

1. Film historian David Cleveland, in a letter of 9 June 2007, informs us: "The stop-motion technique is just a matter of exposing one frame at a time. Most cameras had a separate gear which the handle went on, which didn't turn at the speed, but did one frame per turn of the handle instead of eight frames. So you just put the handle in that slot, turned it once from twelve o'clock round to twelve o'clock, and it took one frame. I am not sure what camera Cooper was using at this time, but most of them, Moy and that sort of big wooden cameras, had that facility."

In these early years of film-making, Cooper, as he is telling himself on
the audio tapes, traveled through England in order to take moving
pictures of workers leaving factories, and selling these and his other
films to travelling fair-ground showmen. Thirty years later, Cooper and
his family moved to Blackpool to work for an advertising agency,
Langford and Co. Ltd.

The sun rising over Keen's Mustard symbolises the British Empire:
the product could be found all over the world, the sun never set on it.
Imperial motives were often used in advertising. Keen also used to
advertise their product with a portrait of Queen Victoria.

Gregory Fremont-Barnes writes in his study *The Boer War 1899-
1902*:[N6] "One had only to glance at a map of the world to confirm this:
Britain's dominions in red stretched across every continent, illustrating
the adage: 'the sun never sets on the British Empire'."

2. Bird's Custard * * * *, 1897, approx. 40 ft., running time 40 sec.
 A.k.a. THE THIRD CUP.
 Advertisement. Trick or animation picture combined with live-
 action.

Credits

Directed and animated by Arthur Melbourne-Cooper at the studio of
film pioneer Birt Acres, 45, Salisbury Road, Barnet. Semi-independent
production.
The old man in the picture was played by Mr MacLeash from Barnet.
Possible assistant animators Will Dyer, M. Honour and Richard Bird.

Synopsis

The famous contemporary poster for BIRD'S CUSTARD powder of an old
man walking downstairs, slipping and dropping a tray of eggs comes to
life through stop-motion (possibly not single-frame) technique. A chef
mixing Bird's Custard Powder looks on and laughs. He is not worried
about broken eggs, he uses Bird's Custard Powder.

Details

Alfred Bird & Sons paid Cooper £1 for every copy sold to showmen.
The showmen paid 10s per copy. According to Cooper's biographer
Grisdale, 60 copies were sold.

Primary source – Arthur Melbourne-Cooper

**Arthur Melbourne-Cooper to Sidney Birt Acres, Southend, 20 May
1956** (T001, tape VI, cd 1/17).

Cooper: "Oh, we took BIRD'S CUSTARD when we were at Barnet in the place there. (...) Yes, we took it there. That is one of the things that we did take."

Sidney Birt Acres: "That's one of the things my father *did* think might be useful for advertisements."

Cooper: "Yes, that was true. (...) That particular one, done for Bird's Custard, was given away. Birds gave us a pound a time for each one we placed for him. For instance on the circus grounds. All the circus people had one, and they would give us ten bob for it, and Bird's would give us a pound. Dickey Bird was with them. But that's in Paul's catalogue. Even in the Warwick Trading Company. (...) We were all there, but not Mr Acres, but with the other chaps. We did it among ourselves and did it for BIRD'S CUSTARD there."

Arthur Melbourne-Cooper during family meeting, Christmas, Clapham, 26 December 1956 (T003, tape III, cd 2/17).

Audrey Wadowska: "And then there were two advertising films. The early one is BIRD'S CUSTARD, wasn't it? In 1896. *Cooper:* Yes, about that time."

List of film titles in Mrs Kate Melbourne-Cooper's handwriting authorized by Arthur Melbourne-Cooper, Coton, 1956:
"BIRDS CUSTARD."

ITV television interview with Arthur Melbourne-Cooper, ITV studio London, 17 July 1958,[2] (T390).

"*Interviewer:* I believe we had you to blame for these frequent interruptions in our programme. You were the first person to start animated advertising in 1896?

Cooper: Yes. The first one I did was for BIRD'S CUSTARD. Then followed a film for Bryant and May of animated matches. This was used for the special appeal for donations to send one box of matches to each soldier in the battalion.

Interviewer: Did you have any difficulty in getting people interested in the idea?

Cooper: We did have some difficulty because there was nowhere to show them once they were made. We had to give shows in fair-grounds and in private houses. But the companies did give us £1 a showing.

2. This live interview with Cooper on an ITV programme introduced by Ludovic Kennedy was in connection with an exhibition opened on Monday 14 July 1958 at the Odeon in Southend, *The Moving Shadow,* on early film pioneers Birt Acres, G.W. Noakes and Arthur Melbourne-Cooper.

Interviewer: But did you see the enormous commercial possibilities of this?

Cooper: At the time we did it just for fun – although we did think about its future quite a lot."

Complementary sources

Gifford-1973, 1986, 2000:[N7] "00487/00496 – Dec 1901, THE THIRD CUP (50) Warwick Trading Co., Advert. Bird's Custard Powder. (Date uncertain)".

Publications

"Arthur Melbourne-Cooper, who was cameraman to Birt Acres in 1892 and onwards to the turn of the century (...) made an advertisement film for BIRDS CUSTARD powder which was shown as early as 1897. The contemporary poster for Birds Custard powder was brought to life by kinematography, "an old man walking down the stairs, slipping and dropping a tray of eggs ... a chef mixing Birds custard powder looks on and laughs ... he is not worried about broken eggs, he uses Birds custard powder." Simple, but effective, this film was shown extensively by the early fair-ground showmen. Trading conditions between advertiser, producer and exhibitor were peculiar. The advertiser paid nothing for the production of the Birds custard film and the fair-ground showmen got nothing for showing it. But Birds paid the producer £1 for every copy of the film sold and supplied to travelling showmen, according to Arthur Melbourne-Cooper."[3] **(W.J. Collins, 1956.)**[N8]

"It was, however, in the field of animation that Melbourne-Cooper made one of his biggest contributions to the growing film industry. As early as 1897 he produced an animated advertising film for BIRDS CUSTARD Powder." **(Gordon Hansford, 1973.)**[N9]

"GB. The first advertising film was made in 1897 for BIRD'S CUSTARD powder by Arthur Melbourne-Cooper of St Albans, Hertfordshire (see also Film: Public Performance; Film Close-up). The film brought to life a contemporary poster for Bird's Custard, showing an old man walking downstairs with a tray of eggs, slipping and, of course, breaking all the eggs. The message was that he had no cause to worry as he used Bird's Custard Powder. The company made an agreement with Cooper that he should be paid 1 pound for every copy of the film distributed." **(Patrick Robertson, Shell, 1974, 1994/95.)**[N10]

3. Written note on cutting 3rd column top: "Old man in Birds film: McLeish – Barnet."

"It was as a free-lance, while still working in Barnet with Acres, that he made one of the first advertising films. This was for BIRDS CUSTARD, made sometime before the turn of the century, and was to awaken his interest in animation. In the film he made a contemporary Bird's poster appear to take on a life of its own. Animation, though, was and is a very expensive and time consuming method of making films and it was not until he left Barnet and set up his own studios on the death of his father in 1901, that Cooper was able to make animated films of his own choosing without a commission." (**Luke Dixon, 1980.**)[N11]

"Rather more ambitious was a production by Arthur Melbourne-Cooper of St Albans, which brought to light a contemporary poster for BIRD'S CUSTARD. An old man is seen walking downstairs bearing a large tray of eggs. He misses his footing, trips, and the eggs cascade onto the floor. Cook has no need to worry, though, because she has a liberal supply of Bird's Custard Powder. The company made an agreement with Melbourne Cooper that he should be paid £1 for every copy of the film distributed." (**Patrick Robertson, Guinness, 1980, 1985, 1988, 1991.**)[N12]

"**Les Allumettes Animées...** L'apport le plus original de Melbourne-Cooper au cours de cette première décennie de l'histoire du cinéma se situe sans doute dans le domaine de l'animation. Son premier film animé, un publicitaire pour BIRDS CUSTARD powder, daterait de 1897. MATCHES APPEAL cependant existe toujours et remonte à 1899.

From animated matches... Melbourne-Cooper's most original contribution during this first decade in the history of the cinema was most certainly in the field of animation. His first animated film, an advertising film made for BIRDS CUSTARD powder, is supposed to date back to 1897. MATCHES APPEAL, however, is still in existence and was made in 1899." (**JICA 81, Festival d'Annecy 1981.**)[N13]

"His first film was an advertising short for Birds Custard, made in 1897, in which a Birds poster appeared to take on a life of its own." (**Stuart Morrison, 1982.**)[N14]

"He claimed to be the first man in Britain to make an advertising film when, in 1897, he shot a film for Bird's Custard Powder. It was simple and, as with most of his work, contained a degree of humour. It showed a contemporary Bird's poster coming to life; an old man walked downstairs carrying a tray of eggs. Predictably, he tripped over, smashing them. The message was that he had no cause to worry because – he used Bird's Custard Powder." (**Richard Whitmore, 1975/1987.**)[N15]

"As with the emergence of cinema generally, advertising films were an international phenomenon. In Great-Britain, Arthur Melbourne-Cooper was hired in 1897 by BIRD's CUSTARD Powder to make a film based on one of the company's advertising posters." (**Jeffrey Klenotic, 2005.**)[N16]

"In 1897, he made Britain's first film advertisement for BIRD's CUSTARD POWDER, which showed an old man falling downstairs with a tray of eggs – not a major disaster, since he was equipped with Bird's Custard Powder." (**Christopher Winn, 2005.**)[N17]

Recorded interviews

Audrey Wadowska (interviewing at Barnet Mr Nichols, former employee of Elliott and Sons): "There is a man called Henry Short, Honour, Dyer, Walter Francis, George Kinns, and an elderly man called MacLeash. Do you remember him? *Nichols:* There were three MacLeashes. *Audrey:* This was about 1895, 1896 to do with a film BIRD's CUSTARD. *Nichols:* Must have been one of their sons. *Audrey:* That was a film shown locally, an early film. *Nichols:* I remember, when Birt Acres was up there, he packed up in the finish, because there it was, they said he could do the work but he had no idea of the business. The others sucked his brains." (**Audrey Wadowska to Mr Nichols, Barnet, 8 November 1963**, T041.)

Audrey: "It was worked in such a way that the poster came to life, and it showed a man, he was a local man, he was called MacLeash. He was also working for Birt Acres. (...) Anyway, he took the part of the old man who walked down the stairs with the eggs in a bowl." (**Audrey Wadowska to Mrs & Mr Dyer, Barnet, 8 November 1963**, T041.)

"Then some enterprising advertisers of the day were quick to realise the enormous possibilities of the new medium, and in 1896 father went up to Blackpool for the making of an advertising film for KEEN's MUSTARD, which was soon followed by another for BIRD's CUSTARD powder." (**Audrey Wadowska, lecture Royal Photographic Society, London, 26 January 1977**, T128.)

"But I am not dead sure that this advertising film is frame-by-frame. Some years ago somebody reported it was frame-by-frame. By his description of it: a man steps from a frame and falls down the stairs. You know BIRD's CUSTARD advertising, he falls down the stairs and breaks the eggs. But this particular man has no trouble because he uses Bird's Custard powder." (**Audrey Wadowska to David Cleveland, London, 19 December 1977**, T420.)

Audrey: "The real animation – he made trick films like, not KEEN's MUSTARD – he went to Blackpool to make KEEN's MUSTARD. No, BIRD's

CUSTARD. *David Cleveland:* Advert? Was made when? *Audrey:* Yes, in 1897. Might be 1896. *David:* Was that animation? *Audrey:* Not real animation." (**Audrey Wadowska to David Cleveland, London, 11 October 1979**, T407.)

Audrey Wadowska (looking at photographs):[4] "Should be Coton because there is the old school, the cottage is behind this way. This is Brian Coe talking to Dad here, Kodak's publicity man. He is the big chief now that Dr Schulze retired. But he never admits that he has been to Coton, like John Huntley. That are skeletons in their cupboards. The odd thing was, when a man called Collins of Pearl and Dean started asking questions, Brian Coe went like that (making silencing gestures). They didn't want to know. As early as that. He went down there and didn't want to know. *Tjitte de Vries:* Who was Collins? *Audrey:* He was the boss of Pearl and Dean, advertising agency. *Tjitte:* What did Collins want to know? *Audrey:* Well, he was interested in the advertising films that father made. And he wrote that article that appeared somewhere around Observer Exhibition time, in *Kinematograph Weekly* where it says: 'Advertising was there from the beginning'. And he mentions Father and BIRD'S CUSTARD. *Tjitte:* You were not fresh enough to tell Collins to just go ahead with his questions when you saw Coe's finger? *Audrey:* I was too naive in those days. I saw him do that when we were in the garden, and Collins had a black patch on his eye, I don't know what was wrong with his eye. I saw Coe do that. It was quite obvious that he did not want Collins to question Father." (**Audrey Wadowska to Tjitte de Vries, London, 30 May 1981**, T127.)

Unpublished manuscripts

"As early as 1897 he produced an animated advertising film for BIRD'S CUSTARD POWDER. (...) Several of the early film producers made advertisement films. They were usually 50 feet in length, and among the first advertisers to use this type of publicity were Birds of custard powder fame; KEEN'S MUSTARD; Bryant and Mays matches. (...) A 40 foot advertisement film for BIRD'S CUSTARD POWDER was made in the garden of 45, Salisbury Road, Barnet. The contemporary poster for Bird's was actually brought to life by kinematography – 'an old man walking downstairs slips and drops a tray of eggs... A chef

4. Photograph series (our archive no. 1225) in the garden of Cooper's Lantern Cottage, Coton, April 1956, with Brian Coe, W.J. Collins, Cooper, Audrey Wadowska, Bob and Con Messenger. See photographs 11 and 13.

busily mixing custard powder looks on and laughs – he is not worried about broken eggs, for he uses Bird's Custard Powder!' Simple but effective, this film was extensively shown by the early fair-ground showmen. Trading conditions between advertiser, producer and exhibitor in those days were peculiar. The advertiser paid nothing for the production of the film, and the showmen got nothing for showing it. But Bird's paid the producer one pound for every copy of the film he supplied to the travelling showmen, relates Melbourne-Cooper. (...) This film was shown extensively by the early fair-ground showmen, and Melbourne-Cooper sold 60 copies." (**John Grisdale, 1960.**)[N18]

"Cooper was still working for Acres when he made the BIRDS (CUSTARD) film. (...) That film no longer exists and was presumably no more than an example of trick cutting, but it was an early attempt by Cooper to make something inanimate (a poster) take on life and movement of its own, and shows how quickly films came to be used for advertising." (**Luke Dixon, 1977.**)[N19]

"BIRD'S CUSTARD (1896)"
(**Audrey Wadowska, A-Z manuscript, 1981,** page B.)
"In the garden of 45, Salisbury Road, Cooper took one of the earliest advertising films, BIRD'S CUSTARD POWDER. The contemporary poster for Bird's Custard Powder was truly brought to life. An old man walking down a flight of stairs, slips and drops a tray of eggs. A chef, busily mixing custard powder, looks on and laughs for he is not worried about broken eggs: he used Bird's Custard Powder. Bird's paid a pound for each place where this film was shown. The fair-ground men would pay 10 shillings for a print of the film, and Bird's paid them a pound on top of that." (**Alan Acres, 2006.**)[N20]

"In addition to his live-action filmwork, Cooper readily turned his hand to the very first short advertising films. He made an amusing commercial for Bird's Custard Powder in 1897, in which a Bird's poster depicting an old man walking downstairs carrying a tray of eggs comes to life by means of a straight cut from the drawing to a live-action replica of the scene. As one might expect, the old man trips over and the eggs are smashed. Disaster is averted by – you've guessed it! – Bird's Custard Powder." (**Kenneth Clark, 2007.**)[N21]

Editorial
We call this a semi-independent production, because the picture was more or less sponsored by the company of Alfred Bird and Sons, paying Cooper £1 for every copy sold, and also because Cooper at that time still

did much commissioned work for Birt Acres who had no objections against advertising pictures, announcing in an 1896 Kineopticon advertisement that this was a BRYANT & MAY picture.

According to his son-in-law Jan Wadowski, Cooper could have used an adapted Moy camera with photographic shutter and a pin with spring mechanism on the sprocket to effect registered frame-by-frame pictures. The mechanism, on his instructions, was made for him by a

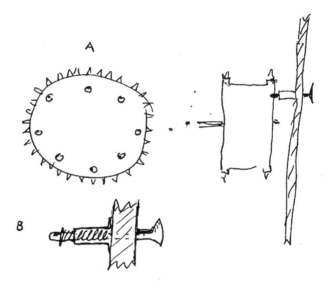

Fig. 70. Rough sketch by Cooper's son-in-law Jan Wadowski of a springed pin and sprocket applied in a movie camera for making stop-motion pictures. Cooper most probably used this system, constructed by a St Albans engineer, in cameras of a later model.

local precision engineer. It is certain that he used such a camera to his own design in 1899 when making the Bryant & May's matchstick pictures. It is quite possible that Cooper still used a camera with frame-by-frame possibilities as explained by David Cleveland. See our Editorial at KEEN'S MUSTARD.

In an interview with us, Audrey Wadowska mentions the names of Willie Dyer and Harry Honour, who worked in Acres's workshop at 45, Salisbury Road. They assisted Cooper when he was making his own pictures, and according to what he tells Sidney Birt Acres, it was Dyer

and Honour who assisted him in the making of BIRD'S CUSTARD. Dyer worked for Elliott and Sons, was then employed by Acres, and later had his own business as photographer and moving picture showman. Honour was not employed but volunteered.

There were many advertising pictures made in those years. Gifford mentions in December 1901 a Bird's Custard advertisement in a Warwick catalogue with the title *The Third Cup*. Because Cooper specifically mentions Warwick, this most probably is a reissue of his 1897 picture. Cooper sold many of his films to Warwick's manager Charles Urban.

Bird's custard is based on cornflour and doesn't need eggs to thicken when mixed with milk. Alfred Bird, of Birmingham, developed it in 1837 because his wife was allergic to egg. It is still a very popular product in Great Britain.

3. The Magic Apple *, 1898 (?), 40 ft. (?), running time 40 sec.
A.k.a. KNIFE CUTTING AN APPLE. Stop-motion animation only.

Credits
Directed and animated by Arthur Melbourne-Cooper. Independent production. Studio: film pioneer Birt Acres, 45, Salisbury Road, Barnet.

Synopsis
A knife, as if moved by an invisible hand, peels and cuts an apple.

Recorded interviews
Audrey Wadowska: (going through old issues of *The Bioscope*): "APPLES OR 'TIT FOR TAT', comic 200 feet, 1½ shilling. I remember father used to say, an early experiment in his start-and-stop technique was the slicing of an apple with a knife. What I remember is that he says, you saw this knife clear on the scene without a hand on it, and it cuts an apple up. That is one of his early ones." (**Audrey Wadowska to Tjitte de Vries, London, 3 January 1978**, T015.)

Audrey Wadowska: (Going through Urban catalogues of 1906/1907): "I remember Kemp Niver once asked me whether I knew anything about that, THE APPLE OF DISCORD. *Tjitte de Vries:* (Reading the synopsis): The gist is, they show half an apple and in it all kind of love scenes. *Audrey:* He did one with the stop and start technique and it starts off, I remember him saying, by a knife cutting an apple into sections and nobody holding the knife. It looks as though it's not that one." (**Audrey Wadowska to Tjitte de Vries, London, 31 March 1978**. T021.)

Audrey Wadowska: "I heard father say that in the early experimenting days before the DREAM OF TOYLAND, or that other one, that he did one with cutting an apple done in animation. You saw the knife, it looks as if somebody got hold of the knife, and it slices an apple. But I haven't seen a synopsis of that. Then there were scissors, he had scissors cut up a piece of cloth. *Kenneth Clark:* Miraculously. *Audrey:* But what Walter Booth did in animation, I don't know. *Ken:* THE HAND OF THE ARTIST was his first film, which was of course the 'lightning cartoon' type. During the war there were a lot who were making cartoons." **(Audrey Wadowska to Kenneth Clark, London, 24 October 1978, T198.)**

Audrey Wadowska (going through her old notes which she made before photocopy facilities were available): "TIRED TAYLOR, 27 August 1907 – I think that is in the Kemp Niver collection, and I think Denis Gifford says it was made by Walter Booth, but I remember Kemp Niver's secretary, Barbara something, wrote and asked me, but it is a trick film. The tailor is doing something, and he is going to sleep, and his scissors are cutting out unaided from the material. He is dreaming. I know he made one which is in the Williamson list, where a knife cuts an apple unaided. Dad doesn't know the title, but he recalled that as one of his early experiments. *Tjitte de Vries:* How early? *Audrey:* I Don't know. *Tjitte:* Early? 1900? *Audrey:* Might be. Might be 1901, 1902. *Tjitte:* Which catalogue? *Audrey:* I thought I saw it in a Williamson, but he didn't know the title. He just remembered a KNIFE CUTTING AN APPLE unaided. Done by animation. And another one, he made a title or something with orange peels or sections of an orange. An orange flies apart and forms a title. I don't know what the title was. I suppose it were pretty short experiments, like his first doll film, which according to Denis Gifford was the first, 1901, which is fairly early for that type of thing. A little girl falls asleep, and her doll comes to life, that is only one doll, not like DREAM OF TOYLAND. That was an early experiment. *Tjitte:* What was the title of the doll film?[5] *Audrey:* He did one DOLLY'S DOINGS. It is in Gifford's book. How does he know? He doesn't tell us where he gets it from. *Tjitte:* But with so many titles credited to your father..." **(Audrey Wadowska to Tjitte de Vries, London, 4 August 1979, T177.)**

Audrey Wadowska: (Going through old notes): "THE MAGIC SCISSORS, 1907, I believe was Walter Booth. That was in the Kemp Niver collection.

5. Dolly's Toys, a.k.a. Dollyland. 1901, 80 ft.

They wrote to me and asked whether I knew anything about it. And I forgot or didn't have time to look after it. That was Urban. I got Walter Booth down here. I don't know what happens in it. I think some scissors cut some cloth out, something like that, you know, without help. I don't know how that is done. Father experimented in the early days, before this with a KNIFE CUTTING AN APPLE. I don't know whether you call that animated? *Tjitte de Vries:* Yes, that is animated trick work. I think it is earlier than 1907. *Audrey:* Oh yes, it was an early experiment that was. I couldn't tell you an exact date. I have not seen it listed, but I know he used to say, he experimented with an apple being peeled with a ladies knife. *Tjitte:* Did he call it THE MAGIC KNIFE or something? *Audrey:* THE MAGIC APPLE. Tinted. *Tjitte:* (Who saw the film) It is very nicely done and very short, after 30 or 40 seconds the apple is peeled, the knife is dancing away and the peel is floating down the screen. It would be early, 1901, 1902. Anyway, we'll have a title like THE MAGIC APPLE on our list. *Audrey:* Maybe we will not find it. What we really want to look at is The World's Fair, to read these early fair-ground bits. It would be early if he was experimenting." (**Audrey Wadowska to Tjitte de Vries, London, 17 April 1981,** T052.)

Editorial

In four years' time, Audrey Wadowska tells a rather consistent story five times about that very early experiment of her father with animation – an apple is peeled and cut without any visible influence of human action.

Audrey gives very strong indicators, believable because of the difference in several little bits she is adding to her recollection. Kemp Niver tried to get more information from her. There were also orange peels animated, possibly as an opening title, and the piece of cloth that is cut.

Neither Audrey nor we found any confirmation in contemporary sources. Therefore, we grant it only one star. We are aware that many early film makers in Europe and in the US made this kind of experimental film, and several of these still exist. Of course, we can never be sure that the short piece in our old standard 8mm film collection of the apple that is magically peeled was ever made by Cooper. But he could have made it.

4. **Animated Matches Playing Volleyball** * * * *, 1899.
Length approx. 50 ft., running time 50 sec.
Stop-motion animation only.
35mm prints at the Netherlands Institute of Animation Films (NIAF), Tilburg;
35mm restored negatives and positives, and 16mm prints in the Audrey and Jan Wadowski collection in the East Anglian Film Archive, Norwich; 16mm prints in the Tjitte de Vries/Ati Mul (Film) Collection, Rotterdam, Netherlands.
Reissue in weekly series *'Around The Town'*, from 30 October 1919. 35mm and 16mm prints in the Audrey and Jan Wadowski collection at the East Anglian Film Archive, Norwich.

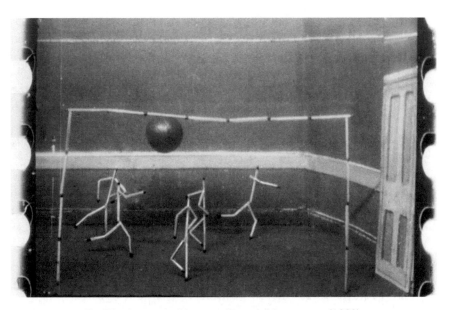

Fig. 71. ANIMATED MATCHES PLAYING VOLLEYBALL (1899).

Credits
Directed and animated by Arthur Melbourne-Cooper. Independent production. Studio: 1, Osborne Terrace, London Road, St Albans.
Synopsis
A Bryant & May matchbox opens and matchsticks jump out, forming themselves into animated figures who perform the game of volleyball.

Full synopsis (of existing picture)

One scene, one camera angle, one shot.

Close-up of a table-top scene representing a medium shot from a high point of view.

At the right stands a pole made up of four matches, some 7 inches high or 18 centimeters, but this is our estimate. The netting is symbolised by a line running from the top of the pole to the left side of the stage and consists of 7 matches, stretching to our estimate some 30 centimeters or 12 inches.

The opening scene shows two players, one is standing in the corner of the room on the right, the other at the left of the stage. Soon, a third one comes in from the left, making clearly animated movements with his legs and arms. Knees and elbows are moving. A ball is thrown in from the left, and all three players have their full attention on the ball. They are playing the ball up, and when the ball comes down, one of them is playing the ball to his partner, who tries an unsuccessful smash over the line. The ball drops behind him on the floor.

One player works the ball up and plays it to number one, who plays it to number three. But the ball is on the floor again. Someone works the ball up and even jumps up with the ball. He jumps with such enthusiasm that half of his body jumps high up together with the ball, while his legs are still firmly on the floor. He tries to play the ball and is back on his feet, literally.

The ball is almost out of sight. All three are after it and work it up. Someone tries a smash with his arms over the net. The ball is back on the floor, and it is clear that it is kicked up high with someone's foot. All three players are after the ball, but someone kicks it again with his foot. It seems he finally got it over the net, but failed.

The ball is now very high and disappears out of sight. It falls back on one of the players and on the floor. A player jumps up, and the ball bounces to the right. Two of the players are quarreling, pushing and pulling at one another on the way to the ball. One of them wrenches himself free and kicks the ball with his leg. The third player stumbles over it, and again they kick with their feet at the ball in anger.

A fourth player enters from the left. He kicks the ball with his leg, and another player kicks the ball high trying to get it over the net. The ball disappears at the left, when three players are trying to get hold of it. The bal comes back together with a fifth player. Three, four players are trying to get the ball up high. When the ball is on the floor it is kicked again with their feet. One player kicks it with his heel, and another one

gives it a header. Finally, the ball passes the net. It disappears upwards out of sight. All five players are looking up in expectation of the ball falling back in the field. They walk up and down, and then the ball is back. They kick it up, almost over the net, and next they play the ball with their hands. They use feet, hands and heads to try and get it over the net. A player pushes the ball high. It disappears and falls back between the players. One of the players seems to lose his arm. The other four players seem to have fainted. The arm is hooked to the net. Our player pulls his arm from the net, which falls completely down.

Details

The picture was first shown in The Empire Theatre, Leicester Square, where Cooper's Cine Syndicate partner, William Jeapes, was an operator.

The three 35mm nitrate matches films in the collection of Audrey and Jan Wadowski had no titles. The original negative of MATCHES APPEAL had been kept all those years by Audrey's father. Audrey Wadowska acquired slightly different 35mm nitrate prints two times from different film collectors. The second set of ANIMATED MATCHES PLAYING VOLLEYBALL and ANIMATED MATCHES PLAYING CRICKET (titled CRICKET. VESTAS V. PINE) were reissues in the 1919-1920 cinema series *'Around the Town'*. In 1973, the St Albans Film Society[6] most probably was responsible for the opening title: 'ANIMATED MATCHES' covering both volleyball and cricket episodes.

The opening scene is missing of the Bryant & May matchbox that opens and from which matches are coming out. This matchbox scene is rather crucial in making it an advertising (or more modern 'advertorial') picture for the producer of this brand of matches. Cooper called this kind of pictures "industrials". Because it is the same set as in MATCHES APPEAL, it is clear that the volleyball and cricket episodes were also made in the garden of his father's photographic studio, 1, Osborne Terrace, London Road, St Albans.

The bodies of the players are constructed with arms and legs connected to a long matchstick functioning as a body with the head of the match functioning as a human head. Arms and legs are bent or cut in half to appear as knees and elbows. The limbs are animated from these joints. The ball was animated by the use of a hair from the head of Cooper's mother. "I was shown two pictures in which matchsticks were animated, showing matchstick men playing two sports, that were according to me

6. A local film club which, on Tuesday, 23 October 1973, organised at St Albans City Hall a show of films by Arthur Melbourne-Cooper, 'Film Pioneers in Hertfordshire'.

an early form of volleyball[7] (with a line instead of a net), and cricket."
(**Letter from Ard van Pelt, sports teacher, Rotterdam, 21 April 2004.**)
Complementary sources

Gifford-2000 (page 221): "05991 – AROUND THE TOWN (Series) (750) Oct. 30, 1919 (B). Around the Town (Gau), p. Aron Hamburger. No. 1 of a magazine film series issued weekly on Thursdays. (Remainder not catalogued)."

Recorded interviews

Audrey Wadowska: "During this time, Father was showing pictures with Billy Jeapes, his pal, who was responsible for showing pictures at the Empire Theatre. Father was going there in and out. And they hired a room in a place at Charing Cross Road. It had erected a screen, near Cecil Court. And they used to gather there, some of these actors from the Empire. *Tjitte de Vries:* The matches pictures were made there, 1898, 1899? *Audrey:* 1899, I would not say before that. It was under a shop which is still there. During the intervals at Leicester Square, they used to congregate here and that is where the matches films (were made). He used to keep films and stuff there, they had a screen and they used to put on (film shows). You see, that is how the film is dated. Because Father used to say, it was made at the time around Ladysmith, and it was shown by Jeapes, who always had a couple of father's films in his shows, naturally, being pals, there was always something of Father there. Billy Jeapes included that before Christmas at the Empire in the program at the time of Ladysmith, so it must have been 1899, before Christmas. (...) That was a battle in the Boer War, a famous battle like Mafeking, only Mafeking came later. That is all Boer War history. That started about November 1899, I think. (...) You see, Dr Schultze of Kodak says: the First World War, but it couldn't have been. I believe there was a shortage of matches during that war, but there were rules and regulations in the postage, because they were inflammable. (...) The two others are soccer and cricket. Because Dave Wyatt[8] was saying that it was clever because this football is suspended in the air, but it got a dark hair around. It might have a string on, but the funny part about it is, they use the same ball for the football as he does for the cricket. But the match box still does not appear. You see, father used to say, the match box was used again for MYSTICAL MATCHES, they formed themselves into (...)

7. In 1895, volleyball was developed in the U.S.
8. A silent film historian and film collector.

and I had asked Dave whether the owner, apparently one of his colleagues, was going to throw this away. It was attached to a piece of In Old St Albans, some scenes before that. It was a compilation again, like the other. He happened to show it to Dave, and he recognized the backdrop of father's matches. So he had 16mm prints made for us, and then I asked him whether the owner was willing to sell it. He said yes, and when we came around, last week, he presented us – no, at this convention, Dave said, the owner would like to exchange something else with it. We have got some American films, and always our idea was to swap them for films we want. We want father's films, and anybody who can help us may have them."
(**Audrey Wadowska to Tjitte de Vries, London, 10 April 1979**, T039.)
"It must have been before the Boer War because when father made that Matches film, they rented this downstairs underneath that shop next to the Garrick Theatre, and sometimes they could not pay the rent, and Mrs Jeapes would loan them the money for that. (...) Number 10, Charing Cross Road,[9] it was next to the Garrick under a shop, and that shop is still there. And twenty years ago it was the same sort of shop, it was a tobacconist. Practically on the corner of Cecil Court, where all the film makers were. And you went downstairs to it. I think it was called Garrick Mansions (...) you could see over the doorway: Garrick Mansions. The theatre is very close. Cecil Court was known as Flicker Alley in those days. Gaumont, Hepworth and Williamson, I believe, they all had London offices there, and eventually Father did under (...) Cinematographic Company, something like that, they called it always the Cine Syndicate. It was a syndicate, formed by various people. There was Hough, he had a small part, he wasn't a very important man as far as I know. (...) (It was) I think mostly Jeapes and Father. They put the money down for it. Father used to say, Billy always included in his programme something that Father made. And that is where Ducks on Sale or Return was shown, during that period, before the Boer War." (**Audrey Wadowska to Tjitte de Vries, London, 12 April 1979**, T040.)
"Sometimes he put a special piece of furniture or wallpaper and doors in it. Look at Matches Appeal, the same door is drawn in it as in the other films."
(**Jan Wadowski to Tjitte de Vries, St Albans, 4 May 1991**, T276.)

9. 12, Charing Cross Road.

Editorial

Audrey Wadowska used to call this picture "Playing Football" or "Soccer", but Rotterdam sports teacher Ard van Pelt assured us that the matchstick figures are playing an early form of volleyball, invented in the US.

Our assumption is that the two ANIMATED MATCHES pictures were made before MATCHES APPEAL, and these comical skits on sports inspired the Ladies Welfare Committee to ask Cooper to make the MATCHES APPEAL picture. However, Cooper, in the BBC interview on July 20th, 1958, with BFI curator Ernest Lindgren confirms a pertinent question: "It was the earliest really animated one", though he previously made trick films. Cooper obviously forgot the two sports pictures which emerged only after his death, or simply included them in his statement. The matchbox scene was used as a start for all three films. MATCHES APPEAL survived because of a fourth re-use of it in 1908 for MAGICAL MATCHES. It stands to reason that this scene previously was used on the two sports films, and not later. Otherwise, it would have been one of the two sports films that survived, and not MATCHES APPEAL.

5. **Animated Matches Playing Cricket** " " " ", 1899.
Length approx. 75 ft., running time 1.15 min.
Stop-motion animation only.
35mm prints at the Netherlands Institute of Animation Films (NIAF), Tilburg;
35mm restored negatives and positives, and 16mm prints in the Audrey and Jan Wadowski collection in the East Anglian Film Archive, Norwich; 16mm prints in the Tjitte de Vries/Ati Mul (Film) Collection, Rotterdam, Netherlands.
Reissue in weekly series 'Around The Town', from 30 October 1919.
35mm and 16mm prints in the Audrey and Jan Wadowski collection at the East Anglian Film Archive, Norwich.

Credits

Directed and animated by Arthur Melbourne-Cooper. Independent production. Studio: 1, Osborne Terrace, London Road, St Albans.

Synopsis

A Bryant & May matchbox opens and matchsticks jump out, forming themselves into animated figures who play cricket.

Full synopsis (of existing picture)

One scene, one camera angle, one shot.

Close-up of a table-top scene representing a medium shot at a high point of view.

From the left a matchstick man walks onto the scene, carrying three stumps with which he makes a wicket in the corner of the room on the right of the miniature stage. The little man walks exemplary with clear elbow and knee movements. He walks back. The same man appears again with 3 stumps, and he makes a wicket at the left of the stage.

A player appears with a match in its hands, functioning as a bat. The batsman positions himself at the right wicket. The bowler appears, positioning himself before the left wicket. He bowls the ball to the batsman. The ball is hit back.

The bowler catches the ball and bowls it again. The third time, the ball is hit out of sight. The sixth time, the ball is hit high up in the air out of sight. The bowler runs out of sight to catch the ball while the batsman leans on his bat. When the ball is bowled again for the eighth time, it is hit back far over the head of the bowler who is not able to catch it. The bowler runs out of sight to catch it. The batsman puts the bat on his shoulder and walks to the left out of sight.

Fig. 72. ANIMATED MATCHES PLAYING CRICKET (1899).

The bowler returns with the ball and positions himself now in front of the right wicket. The batsman is now at the left. The player at the right is able to catch the ball, bowls it to the batsman, who misses and loses the bat. He also loses a bail. He makes a run and is almost out of sight at the right. It looks as if the batsman tries to stop the bowler with his bat. The bowler is out of sight, the batsman is ready at the left wicket. The bowler is back throwing the ball.

A third player enters the field. The action is now very fast. He stops the ball with his foot, takes it up and bowls it two times to the bowler, who catches it and runs to the left out of sight. The batsman walks to the right. The third man picks up the left wicket and walks out of sight. The batsman disappears at the right out of sight. The right wicket is left alone.

Details

The picture was first shown in The Empire Theatre, Leicester Square, where Cooper's Cine Syndicate partner, William Jeapes, was an operator. The three 35mm nitrate matches films in the collection of Audrey and Jan Wadowski had no titles. The original negative of MATCHES APPEAL had been kept all those years by Audrey's father.

Audrey Wadowska acquired two sets of 35mm prints of ANIMATED MATCHES PLAYING VOLLEYBALL and ANIMATED MATCHES PLAYING CRICKET from different film collectors. The second set was a reissue from the 1919-1920 cinema series 'Around the Town' in which ANIMATED MATCHES PLAYING CRICKET has the title: 'CRICKET VESTAS V PINE'.[10] In 1973, the St Albans Film Society[11] most probably was responsible for the combined opening title of the volleyball and cricket episodes: "ANIMATED MATCHES".

The opening scene of the Bryant & May matchbox that opens and from which matches come out is missing. This matchbox scene is rather crucial in making it an advertising (or more modern 'advertorial') picture for the producer of this brand of matches. Cooper called this kind of pictures 'industrials'. Because it is the same set as in MATCHES APPEAL, it is clear that the volleyball and cricket episodes were also made in the garden of his father's photographic studio, 1 Osborne Terrace, St Albans.

10. According to a Bryant & May representative who, in 1980, visited the Wadowskis in St Albans, Swan Vesta matches were made from pine wood. This title was added in the reissue.
11. See footnote 6.

The bodies of the players are constructed with arms and legs connected to a long matchstick functioning as a body with the head of the match functioning as a human head. Arms and legs are bent or cut in half to appear as knees and elbows. The limbs are animated from these joints. Cooper used a white hair of his mother to animate the ball.

Much is happening in this picture, too much in less than a minute. The action is clearer and more or less according to the rules of the game when the picture is shown at a much slower speed, at 16 fps or slower.

Complementary sources

Gifford-2000 (page 221): "05991 – AROUND THE TOWN (Series) (750) Oct. 30, 1919 (B). Around the Town (Gau), p. Aron Hamburger. No. 1 of a magazine film series issued weekly on Thursdays. (Remainder not catalogued)."

Recorded interviews

See previous entry.

Editorial

See previous entry.

6. **Matches Appeal** * * * *, 1899, length approx. 75 ft. running time 1.15 min.

A.k.a. MATCHES: AN APPEAL, MATCH APPEAL and BRYANT & MAY'S MATCHES APPEAL. Stop-motion animation only.

35mm positive from original negative in the Kodak Collection at the National Media Museum, Bradford; 35mm positive from original negative at the National Film, Video and Sound Archive, Pretoria, S.A.

35mm & 16mm prints at Cinémathèque Québècoise, Canada; BFI National Archive, London; Netherlands Institute of Animation Films (NIAF), Tilburg; 35mm restored negatives and positives, and 16mm prints in the Audrey and Jan Wadowski collection in the East Anglian Film Archive, Norwich; 16mm prints in the Tjitte de Vries/Ati Mul (Film) Collection, Rotterdam, Netherlands.

35mm 'stretched' print from dupe negative at Bryant & May, London; 35mm 'stretched' print from dupe negative in Mike Oliver's private collection.

Credits

Directed and animated by Arthur Melbourne-Cooper. Independent production. Studio: 1, Osborne Terrace, London Road, St Albans.

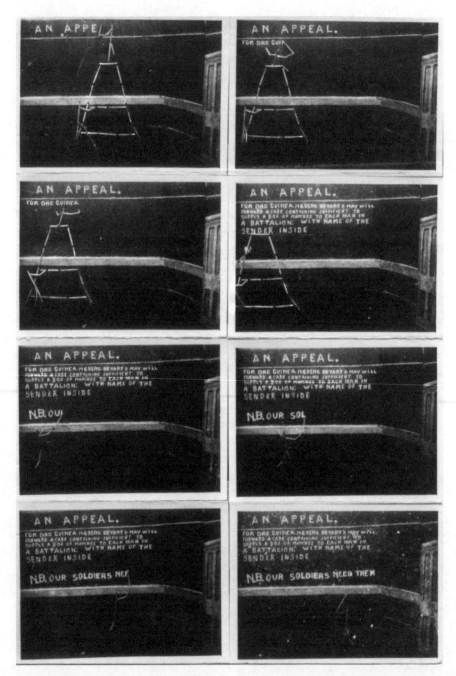

Fig. 73. MATCHES APPEAL (1899). Eight frame enlargements, in 1956, sent by Kodak Museum curator R.S. Schultze to Arthur Melbourne-Cooper.

Synopsis

Matches are animated in stop-motion when they march out of a Bryant & May matchbox and form themselves into two matchstick figures and a ladder. One figure keeps the ladder steady and the other one climbs it so that he can write a message on a black wall:

> *"An appeal. For one guinea, Messrs Bryant & May will forward a case containing sufficient to supply a box of matches to each man in a battalion with name of the sender inside. NB. Our soldiers need them."*

Full synopsis (of existing picture)

One scene, one camera angle, one shot.

Close-up of a table-top set representing a medium shot from a low point of view.

A tiny, thin figure made of matchsticks and matchstick pieces is standing on top of a ladder made out of matchsticks which is held steady by a second matchstick figure.

The scene resembles a room. There is a dark floor, a dark back wall covering some two-thirds of the background with a corner where a wall with a door is slanting to the right. The walls are separated by a plinth from the dark painted floor. At one-third from the floor there is a white band on both walls, and at the top there is a white line. The door is white, has four panels, and is drawn with pencil or charcoal.

The figure on the ladder is writing above the white line on top of the black wall the words: AN APPEAL. When the picture begins the first six letters are already written. The figure is busy writing the letters A, L and the final full stop.

The matchstick man then writes, also in capital letters: FOR ONE GUINEA. It takes each time 3, 4 or more frames to draw a complete letter.

The figure then steps off the ladder and suddenly the following text appears on the wall: MESSRS BRYANT & MAY WILL FORWARD A CASE CONTAINING SUFFICIENT TO SUPPLY A BOX OF MATCHES TO EACH MAN IN A BATTALION. WITH NAME OF THE SENDER INSIDE.

At the same time the ladder is drawn back to the left out of the picture. The writer is now writing below this text the words: N.B. OUR SOLDIERS NEED THEM.

The writer turns around and points his stick at these final words. This lasts some 18 seconds.

Details

The picture was a commission of the Ladies Welfare Committee for

Soldiers and Sailors in the Boer War and sponsored by Bryant & May.[12] The picture was first shown in The Empire Theatre, Leicester Square, where Cooper's Cine Syndicate partner Jeapes was an operator.

The opening scene of the Bryant & May matchbox that opens and from which matches are coming out is missing. This matchbox scene is rather crucial in making it an advertising (or more modern 'advertorial') picture for the producer of this brand of matches. Cooper called this kind of pictures 'industrials'. This opening scene, most probably, was previously used for ANIMATED MATCHES PLAYING VOLLEYBALL and ANIMATED MATCHES PLAYING CRICKET. In 1908, Cooper removed it from the MATCHES APPEAL negative in order to use it for a new matchstick animation MAGICAL MATCHES. The original 35mm negative of MATCHES APPEAL was, for the time being, put in an emtpy tea caddy or camera case in the kitchen and forgotten until it was discovered after Cooper and his wife moved to Coton, Cambridge.[13]

There is a connection between Cooper and Bryant & May through his former employer Birt Acres, who had a contract with the German chocolate manufacturer Ludwig Stollwerck. Bryant & May supplied Stollwerck with their famous brand of matches for the Stollwerck slot-machines. In 1896, Birt Acres produced a film titled BRYANT & MAY [14]

12. The appeal is one guinea for a case of matches, enough for a box for each man in a battalion. Is that expensive or cheap? A box of matches, in those days, we assume, would have costed a penny, the cheaper ones possibly half a penny. A battalion consisted of 800 to 1000 men. A case would then have a street value of 3 or 4 guineas (£3 6s – £4 8s).

13. And not after Cooper's death – as his daughter Audrey once said in a lecture, an incorrect statement repeated in later interviews. As far as we know, positive prints from the original negative were made in 1956, when Cooper was still alive, one of which was donated to the Kodak Museum. The family story of the tea caddy content discovery is therefore the most plausible. The date of the discovery is uncertain. Around 1939, after Cooper's retirement, he and his wife moved from Carleton, near Blackpool, first to Little Shelford, Cambridge, where they were caretakers for a while, then to a cottage in nearby Coton. The discovery of the negative was probably made during one of these removals, and before 1956. The Kodak copy is now in the collection of the National Media Museum of Bradford. In later years, Audrey Wadowska, most probably assisted by the St Albans Film Society which needed 16mm prints for their 'Film Pioneers in Hertfordshire' show in 1973, had safety negatives made from the three matches films, and from these several positive prints were made on both 35mm and 16mm. Audrey ordered additional step-negatives.

After it was shown on 20 February 1896 for the first time in England at the London Polytechnic, the Cinématographe Lumière under Mr Trewey moved to the Empire Theatre of Varieties at Leicester Square from March 1896 till August 1898. The programme hand-outs of the Empire in 1899 and 1900 mention the screening of films as part of their regular attractions, but they are just announced as War Pictures.[15]

Advertisement in *The Times*, 7 December 1899, page 8.[16]

> "EMPIRE THEATRE. – Cattle Show Attractions. – Mrs BROWN-POTTER will RECITE "Ordered to the Front." at 9.45. – HOME of BALLET. – Another Empire Triumph, entitled ROUND THE TOWN AGAIN. Varieties by Miles-Stavordale Quintette, the Carangeot Troupe, Prellé, Les Alex, The Lockfords, Belloni's Bicycling Cockatoos, Melot Hermann, and the Egger-reiser Troupe. Doors 7.30. SPECIAL MATINÉE TO-DAY
> (Thursday) at 2.15, in aid of our Soldiers and Sailors' Fund."

Most probably, at this charity matinée, MATCHES APPEAL was screened for the first time.

Primary source – Arthur Melbourne-Cooper

National Film Archive curator Ernest Lindgren interviews Arthur Melbourne-Cooper, BBC Broadcasting House, London, 11 July 1958 (T002, tape XII, cd 3/17).

Lindgren: Talking about 'trick' pictures, I believe you made a film yourself, didn't you, with animating matches?

Cooper: Oh, yes, that was during the Boer War.

Lindgren: Boer War, yes...

Cooper: Appeal for matches. Soldiers couldn't get them. They had trouble to put it through to them.

Lindgren: And how was the film made?

Cooper: The film was made by a box of matches coming in and drawing out and matches getting out of the box and forming up.

14. With thanks to German film historian dr Hauke Lange-Fuchs. The title appears as no. 11 in the stock list of the British Toy and Novelty Company, December 1896, as photographed by Birt Acres. We also know from Prof. Martin Loiperdinger that Bryant & May were, together with Stollwerck Brothers, founders and shareholders of the London and Provincial Automatic Machine Company which was shareholder of the Deutsche Automaten Gesellschaft Stollwerck & Co (DAG). Bryant & May appear in the Kineopticon advertisement for Birt Acres' Queen's Hall shows in Augustus 1896: "Support Home Industries – Bryant & May's Matches are manufactured only at Fairfield Works – London."

15. Email from Theater Museum Enquiries, London, 16 January 2007.

16. With thanks to the research of Prof. Frank Kessler.

Lindgren: Very much as...

Cooper: They formed up as a man and with a spare match for a brush.

Lindgren: I see.

Cooper: And he painted on a board the appeal for matches. Anyone sending out, I think it was, sending a pound in then – .

Lindgren: And this was made by taking the film – .

Cooper: One – .

Lindgren: Picture by picture?

Cooper: – picture by picture, movement by movement.

Lindgren: So this must have been surely the earliest animated film made, wasn't it?

Cooper: Yes. It was the earliest really animated one. Of course, I had taken several upside-down camera pictures to get the reversals, things coming upright. I went down to Tunbridge Wells and took HIGH DIVING FOR GIRLS, ladies and things there, on two cameras.

ITV television interview with Arthur Melbourne-Cooper, ITV studio, London, 17 July 1958,[17] **(T390).**

Interviewer: I believe we had you to blame for these frequent interruptions in our programme. You were the first person to start animated advertising in 1896?

Cooper: Yes. The first one I did was for BIRD'S CUSTARD. Then followed a film for Bryant and May of animated matches. This was used for the special appeal for donations to send one box of matches to each soldier in the battalion.

Interviewer: Did you have any difficulty in getting people interested in the idea?

Cooper: We did have some difficulty because there was nowhere to show them once they were made. We had to give shows in fair-grounds and in private houses. But the companies did give us £1 a showing.

Interviewer: But did you see the enormous commercial possibilities of this?

Cooper: At the time we did it just for fun – although we did think about its future quite a lot.

Arthur Melbourne-Cooper, Coton, letter 5 June 1961 to Pieter Germishuys, Johannesburg, South Africa.

"Dear Mr Germishuys. In response to your request, passed on to me by my daughter Mrs Audrey Wadowska, I have much pleasure in sending you a positive print of the film which I made in connection with the

17. See foot-note 2.

Anglo-Boer War MATCHES "APPEAL". It is unfortunately, incomplete, as only a fragment of my negative has managed to survive the intervening years, but I trust this may, in some small measure, prove helpful to you in your present endeavour.

I was most interested to hear of the Film Museum you have under way, and would like to take this opportunity of expressing my best wishes for the future success of this institution in South Africa. Yours sincerely (signed Arthur Melbourne-Cooper. Late ALPHA TRADING COMPANY)".

Complementary sources

Gifford-1987 (page 4): "MATCHES: AN APPEAL, 1899, Birt Acres (?), D:S:A: Arthur Cooper. Animated matchsticks. A box of Bryant and May's matches opens and the matchsticks chalk up this appeal: 'For one guinea Bryant and May will forward a case containing sufficient to supply a box of matches to each man in a batallion, with the name of the sender inside.' The date of this film is controversial, as recent research sets it as produced in the Great War of 1914. This may, however, be a reissue as the setting of this film is identical with ANIMATED MATCHES (1908). Print preserved in the National Film Archive."

Publications

"Emile Cohl has always been credited as the originator of animated films, but now his claim has been disputed by an Englishman, Melbourne-Cooper, who entered films in 1895 and made a charming animated film at the time of the Boer War." **(Richard Buckle, 'Sixty Years of Cinema', 1956.)**[N22]

"Another advertisement film of 50 feet made by Arthur Melbourne-Cooper was for Bryant & May's Matches early during the Boer War, 1899-1900. There was a shortage of matches among the troops, and in 50 feet of film he tackled the problem in this fashion. Using the one frame, one picture, technique – he was probably the first man in the world to use it for advertising purposes – Arthur Melbourne-Cooper made a matchbox open, the matches emerging to form simulated human figures engaged in a tussle climbing up a wall, where they formed up making the slogan 'Send 1 pound and enough matches will be sent to supply a regiment [sic] of our fighting soldiers'." **(W.J. Collins, 1956.)** [N23]

"**Do you remember????** ANIMATED CARTOONS 1899-1902. This Bryant & May Match Appeal FILM was shown during these years in the Fair-grounds. 'For one guinea Bryant & May will forward a case containing sufficient to supply a box of matches to each man in a Battalion. N.B. Our soldiers need them.'

If you can remember or if you have any information please write to Arthur Melbourne-Cooper, 100, Wavendon Avenue, London, W.4. Tel.: Chiswick 6735." (**Audrey Wadowska, *The World's Fair*, 1956.**)[N24]

"**First Animated Cartoons**. While discussing the International Animated Film Festival in Panorama (the BBC television programme) on February, 18, Richard Dimbleby referred to *Felix the Cat* as the first animated cartoon film. Actually an Englishman named Melbourne Cooper is credited with having made the very first one at the time of the South African War – twenty years before Felix appeared. But Emile Cohl of France is regarded as being the creator of the first popular film cartoon character, called Fantioche and shown in 1908. It was not until the First World War – in 1917 – that the American Pat Sullivan introduced Felix the Cat. *Morris Freedman, London, S.E. 18.*" (***Radio Times*, 1957.**)[N25]

"**Late Honour**. It is generally accepted that the 'father' of the animated cartoon was Frenchman Emile Cohl, whose short 'Felix' cartoon strips started to make their appearance after the turn of the century. He was not. And an exhibition at St Albans proves it. For the exhibition was to depict St Albans's contribution to the film industry. And one of the organizers is the daughter of the man who did. He is Mr Arthur Melbourne-Cooper, retired 86-year-old pioneer, who now lives near Cambridge.

The daughter produced documents and 'stills' concerning the two earliest Melbourne-Cooper cartoons. One was a matchstick animation produced for advertising purposes during the Boer War in 1899. It clearly preceded Cohl's work by several years. The other was the famous DREAM OF TOYLAND – the type of Cooper cartoon which many modern cinema-goers considered the latest technique. Both were produced at St Albans, where Mr Melbourne-Cooper ran one of the first cinemas in Britain. He was also responsible for the sloping floors we know today the world over. Mr Melbourne-Cooper's modesty is such that only a careful examination of the documents revealed that cartoon honours should go to Britain, not France. He had never dreamed of countering the French claim." (***Dunedin Press*, 1957.**)[N26]

"Emile Cohl is usually credited as the originator of animated films, when, around 1908 in France, he began to make his little white matchstick figures jump about against a black background. In this new comprehensive work on film animation,[18] the authors do not mention the prior claim of an Englishman, Melbourne Cooper, who made an

18. John Halas and Roger Manvell, *The Technique of Film Animation*, London, 1959.

animated film as far back as the Boer War." (*Technology,* **1959.**)[N27]

"The son of a professional photographer, he entered the film industry in 1892 with Birt Acres, and claimed to be the first person to produce an animated film – one made for Bryant & May's matches during the Boer War." (**Obituary** *The Times,* **1961.**)[N28]

"His productions include some interesting examples of animation: a matchstick film made for Bryant & May during the Boer War (1899-1900), and DREAM OF TOYLAND, which enjoyed success in countries other than Britain – over 300 copies were sold in the U.S.A." (**Obituary Society for Film History Research,** *Newsletter* **1962.**)[N29]

"During the Boer War, Melbourne-Cooper made a short animated cartoon advertising Bryant & May matches. The film was concerned with the shortage of matches amongst the troops. A match box opens, and the matches emerge to form simulated human figures engaged in a tussle, trying to climb a wall. Formed up on the wall, they make the slogan 'For one guinea, Messrs. Bryant & May will forward a case containing sufficient to supply a box of matches to each man in a battalion with name of sender inside. N.B. Our soldiers need them.' Mrs Audrey Wadowska, daughter of the film pioneer is currently working on a biography of her father, and owns several of his films, including ANIMATED MATCHSTICKS and two other animated cartoons, NOAH'S ARK and DREAMS OF TOYLAND, both made in 1907." (**Anthony Slide, 1967.**)[N30]

"As early as 1897 he produced an animated advertising film for BIRDS CUSTARD POWDER. Again in 1899 he produced the famous 'MATCHES' APPEAL for Bryant & May, using the one-frame, one-picture technique." (**Gordon Hansford, St Albans Film Society, 1973.**)[N31]

"In 1899 he made what is believed to be the earliest surviving British advertising film, an appeal by Bryant & May for donations to supply the troops in South Africa with matches, as it seems this was something the Army authorities had overlooked. The film is notable for its use of animated cartoon technique, the 'performers' being match-stick men who climb up a wall and form themselves into the legend: 'Send £1 and enough matches will be sent to supply a regiment of our fighting soldiers.'" (**Patrick Robertson, Shell, 1974, 1994/1995.**)[N32]

"Melbourne-Cooper's unique contribution to film history however was his pioneer work in animation. He claimed to have produced an animated film for BIRDS' CUSTARD POWDER as early as 1897; and in 1899 to have animated match-sticks in a film financed by Bryant and May to appeal to the public to send matches to the Boer War troops." (*BFI Newsletter,* **1974.**)[N33]

"Two years later he made what is believed to be the earliest surviving British advertising film, sponsored by Bryant and May and taking the form of an appeal to the public to buy matches to send to troops fighting in the Boer War." **(Richard Whitmore, 1975.)**[N34]

"Father had established Kinema Industries, financed by Andrew Heron with offices at Warwick Court in London – the same premises which he knew so well from the earliest days of his long and intimate association with Charles Urban. At the outbreak of the War in 1914, he was sent to Woolwich on a training course and became a government Inspector of Ammunition stationed at Luton. (...) The next film you will see is the MATCHES APPEAL which father made in 1899 for the Boer War. Originally it started with a matchbox appearing on the screen and the matches tumbling out and forming up; but we haven't got that section, because he cut it off and used it for a later production called MYSTICAL MATCHES. That was a trick film by animating the matches, forming intricate patterns. But with this (MATCHES APPEAL) it is so dated that he couldn't possibly use it again. We found this after he had died in an old camera case. I happened to shake it and there was something in it – the negative of this MATCHES APPEAL, just this small part of it. I don't think he realised he had still got it."[19] **(RPS lecture Audrey Wadowska, 1977,** T128)[N35]

"**Wholly Moses**. A campaign for Bryant and May, aimed at persuading cinema audiences to send the company money, will be screened in Cambridge next month. But the animated plea, directed by Arthur Melbourne-Cooper, is confidently expected to fail as it was conceived and produced in 1899 in an attempt to boost the Boer War effort.

The commercial is being revived as part of the Cambridge Animation Festival, which runs from 9 November to 14 November, and it's one of several arcane discoveries made by the festival's organiser, Antoinette Moses. 'It's a complete fallacy that British animation didn't exist before the Americans started doing it,' she says. 'Melbourne-Cooper is one of the long-neglected pioneers of animation. We'll also be showing the first talking cartoon, which was made in 1929 for Rowntrees'." **(*Eastword*, Cambridge, 1979.)**[N36]

19. What did Audrey Wadowska find after her father's death? The negative of MATCHES APPEAL? But the curator of the Kodak Museum at Harrow, R. S. Schultze, in 1956, made a set of stills from a print donated to him for her father, sending it in a letter c/o Mrs Wadowska. Or did Audrey find the matchbox opening sequence? If so, in 1980, it was destroyed together with the dangerously deteriorating original negative of MATCHES APPEAL. See also footnote 13.

"Pre-Disneyland. Animated cartoons are generally thought to be American preserve but, as the Cambridge Animation Festival which starts today intends to prove, they started in England. The Festival's British Retrospective, the main item of the programme, begins with one second of film from 1895 and continues with what is probably the first piece of cartoon propaganda – some animated matches with the message 'Our troops need them – please send matches to the Boer War'. This was devised by Arthur Melbourne-Cooper, who originated the close-up in a 1900 advertisement for Bovril." (***The Daily Telegraph, 1979.***)[N37]

"(Birt) Acres' young assistant at this time was Arthur Melbourne-Cooper, who used the stop-motion facility to animate matches and children toys." (**Ken Clark, 1979.**)[N38]

"Among the films shown at the festival was the MATCHES APPEAL made in 1899 in which matchstick men write a message for 'our boys over there', the boys being soldiers in the Boer War." (***Review and Express, 1979.***)[N39]

"After Méliès, the next genuine animation sequence seems to be that created in England around 1900 by Arthur Melbourne-Cooper. Again it appears in a propaganda/commercial film, an appeal for the Boer War done with animated match sticks." (**Alexander Sesonske,** *Sight & Sound,* **1980.**)[N40]

"Conventional cinematography was but a few years old when Arthur Melbourne-Cooper was animating matchsticks and three-dimensional models in front of the camera." (**David Williams,** *Film Making,* **1980.**)[N41]

"**Les Allumettes Animées...** L'apport le plus original de Melbourne-Cooper au cours de cette première décennie de l'histoire du cinéma se situe sans doute dans le domaine de l'animation. Son premier film animé, un publicitaire pour Birds Custard Powder, daterait de 1897. MATCHES APPEAL cependant existe toujours et remonte à 1899. Il s'agit d'un appel à la générosité des citoyens en faveur des militaires engagés dans la guerre des Boers: contre une guinée, la société Bryant and May s'engage à envoyer des boîtes d'allumettes aux soldats au front. Dans une émission de radio en 1958, Melbourne-Cooper a raconté à Ernest Lindgren comment il a realisé ce film."

"**From animated matches...** Melbourne-Cooper's most original contribution during this first decade in the history of the cinema was most certainly in the field of animation. His first animated film, an advertising film made for Birds Custard Powder, is supposed to date back to 1897. MATCHES APPEAL, however, is still in existence and was

made in 1899. The film is an appeal to the generosity of the British
public for the soldiers fighting in the Boer War: for each guinea received,
Bryant and May promised to send matches to the soldiers at the front. In
a radio interview with Ernest Lindgren in 1958, Melbourne-Cooper
explained how the film was made." **(JICA 81, Festival d'Annecy 1981.)**[N42]

"The earliest known British example of animation is an untitled
advertising film made by Arthur Melbourne-Cooper of St Albans,
Herts, for Messrs Bryant & May. Dating from 1899, it consists of an
appeal for funds to supply the troops in South Africa with matches, as it
seems this was something the Army authorities had overlooked."
(Patrick Robertson, Guinness, 1980-1991.)[N43]

"The primitive advertisement MATCHES APPEAL (1899) shows Cooper's
early grasp of the principles of stop-motion photography." **(Donald
Crafton, 1982.)**[N44]

"The true single-frame animation technique was applied to a series of
drawings by J. Stuart Blackton in 1906 to produce the first true filmed
animated motion pictures in HUMOROUS PHASES OF FUNNY FACES, and it
was only after this that single frame animation technique was used in
European films. Claims that this happened earlier appear to be bogus."
(Barry Salt, 1983.)[N45]

"**Early Trick Photography**. Arthur Melbourne-Cooper had made one of
the earliest known British examples of animation (and probably
commercials) when in 1899 he made a film for Bryant & May which in
effect was an appeal for funds to supply the troops in South Africa – not
for ammunition, food or clothing ... matches – something the Ministry
seemed to have overlooked. Some years later Arthur Melbourne-Cooper
made two delightful films, featuring animated toys. THE TALE OF THE
ARK, 1909, and DREAMS OF TOYLAND, 1908." **(Patricia Warren, 1984.)**[N46]

"Animated cinema in Britain dates back, in one form or another, to the
very early days of the moving picture. Because animation is based on
single-frame, step-by-step motion, the apparent movement of inanimate
objects, without human intervention, could be achieved by the same
'trick' photography as was employed by Méliès and his contemporaries.
Arthur Melbourne-Cooper's MATCHES APPEAL (c. 1899) exploited this
principle in a simple advertisement for Bryant and May's matches,
asking cinema patrons to send boxes of matches to the British troops in
South Africa. The film employs matchstick characters which move
around and chalk up the words of the message on a board. Not only is
MATCHES APPEAL possibly the first British animated film; it is also the
first in a line – which extends forward to the present day – of films

Fig. 74. HUMOROUS PHASES OF FUNNY FACES
(1906), by the American film pioneer
J. Stuart Blackton, is generally considered to
be the first animated moving picture.

financed by commercial (or, more rarely, cultural) sponsorship. Melbourne-Cooper made a number of animated and trick films during the next fifteen years, and also produced live-action shorts, both fiction and non-fiction. This was a rare combination. Most of the 'animators' who started work in Britain before the First World War were lightning cartoonists, with established careers in the music hall, or illustrators who produced film-enhanced lightning cartoons from their own

newspaper and magazine work. In most cases, of course, the actual animation was done by others, but the artists were given the credit." (**Elaine Burrows, 1986.**)[N47]

"Meanwhile, in Britain, Arthur Melbourne-Cooper had come up with what is often considered to be the world's first animated commercial. It was a stop-motion film of 'moving matchsticks' reputed to have been made in 1899, and promoted by Bryant & May, having the appropriate title MATCH APPEAL [*sic*]. Melbourne-Cooper was an imaginative artist, a technician and a true pioneer of three dimensional puppetry." (**John Halas, 1987.**)[N48]

"...the oldest surviving British advertising film made for Bryant and May's Matches during the Boer War. (...) It was for this film that he used a technique for which he is now acknowledged as a pioneer – animation – or the use of a series of single-frame exposures of models to create a sequence of moving pictures. He made a box of Bryant and May matches open up and the contents pop out one at a time and march like soldiers to form a ladder to a blackboard where one 'wrote' the message: 'For one guinea Messrs Bryant and May will forward a case containing sufficient to supply a box of matches to each man in a battalion: with the name of the sender inside'." (**Richard Whitmore, 1987.**)[N49]

"British film maker Arthur Melbourne-Cooper's first experiment in object animation appears to have been MATCHES APPEAL, a Boer War propaganda film said to have been released in 1899, although the date has not been confirmed." (**Donald Crafton, 1990.**)[N50]

"If animation comes into play not when its techniques were first applied, but when they became a foundation for creativity, then the first animated film could very well be MATCHES: AN APPEAL, by the Briton Arthur Melbourne-Cooper. Made in 1899, with animated matches, MATCHES: AN APPEAL was a public address (...) Arthur Melbourne-Cooper (St Albans, 1874 – Barnet [*sic*], 1961) was the creator of the 'first' animated film ever, MATCHES: AN APPEAL (1899). Cooper had learned the technique of 'moving pictures' by working with the pioneer of British cinematography, Birt Acres; later, he became a producer, cinema owner, and director of all kinds of short films." (**Giannalberto Bendazzi, 1994.**) [N51]

"In 1897, he made Britain's first film advertisement for BIRD'S CUSTARD POWDER, which showed an old man falling downstairs with a tray of eggs – not a major disaster, since he was equipped with Bird's Custard Powder. He followed this, in 1899, with a filmed appeal on behalf of BRYANT & MAY for donations to supply matches to the troops fighting the Boer War.

This included what is possibly the *world's first known use of animation* – matchstick men climbing on to a wall and forming themselves into the words: 'Send £1 and enough matches will be sent to supply a regiment of our fighting soldiers.'" (**Christopher Winn, 2005.**)[N52]

"Again, a 'first' is defected, Arthur Melbourne-Cooper (Great Britain) dethrones Emile Cohl (France). (...) During many years, film history books marked down Emile Cohl as the father of the animation movie, and his FANTASMAGORIE (1908) as the first true and real moving picture of that kind." (**Bendazzi, *Il Sole 24 Ore*, 2005.**)[N53]

Fig. 75 Frames from Emile Cohl's FANTASMAGORIE, Gaumont 1908.

"There were also a number of early uses of stop-motion for films aimed at a more adult audience. The English producer Arthur Melbourne-Cooper animated a collection of matchsticks in a Boer War propaganda film called MATCHES APPEAL (1899)." (**Richard Rickitt, 2006.**)[N54]

"MATCHES: AN APPEAL, Stop-motion animation. A matchstick man on a stepladder paints on a wall the following appeal: 'For one guinea Messrs Bryant & May will forward a case containing sufficient to supply a box of matches to each man in a battalion with the name of the sender

inside'. Note: This film has been traditionally dated as 1899 and hence referring to the Boer War, but reported physical evidence suggests that it is of a later date and therefore presumably relates to the First World War. UK 1899. 1 min.

Availability. A viewing copy of this title is available. A 16mm print of this title is available to hire. The print of this title is from the National Archive.

Cast and crew. Animator Arthur Melbourne-Cooper (?). Cinematographer Arthur Melbourne-Cooper (?). Technical information Country UK. Year 1899. Full date 1899 (?). Black and white. No soundtrack. Running time 1 min. Length 12." (**BFI website, 2007.**)[N55]

"Matches: An Appeal (1899). Directed by Arthur Melbourne-Cooper. Genre: Animation/Short.

> User Comments: The very first stop-action animation. I viewed a print of this short film in the archives of the British Film Institute. MATCHES: AN APPEAL is the earliest known example of stop-animation, or indeed any form of movie animation. It is therefore of vital historic importance despite its crudity. The very brief film shows a stick-figure made of matchsticks, who climbs a stepladder to swab a paintbrush against a wall. In a technique that probably looked extremely unconvincing even to contemporary audiences, words form on the wall, presumably painted by the match-man. The message reads: 'For one guinea Messrs Bryant & May will forward a case containing sufficient to supply a box of matches to each man in a battalion with the [sic] name of the sender inside'. As the film is dated 1899 (when matches were still comparatively expensive items), presumably the battalions are British troops serving in the Boer War. However, I spoke with a curator at BFI who absolutely asserts that this film was made in the early 20th century and accordingly refers to the Great War. As I viewed an acetate dupe print rather than the original footage, I shan't offer any opinion as to the film's provenance. By modern standards, this film is almost laughably crude. But its historical significance is undeniable. I'll rate this very short film 8 out of 10." Author F. Gwynplaine MacIntyre, Minffordd, North Wales.
>
> Additional details. Country UK. Color: Black and White. Sound Mix: Silent."
> (**Website IMDb, 2007.**)[N56]

Publications – Anglo-Boer war

British correspondent M. Hales, staying with the troops of General Rundle:
"Are people," asks Mr Hales, "whose hand trembles when they pick up their gun, not because of fear or of wounds, but of weakness and lack of blood and muscles, caused by regular hunger, are those people capable

to attack a kopje? (...) You are standing in your music halls to sing the glory of your soldiers, those 'brave boys over there', and you let them starve in such a way that I have often during the march seen them fighting with a negro for a handful of flour." **(Scheibert, *Der Freiheitskampf der Buren*, 1902.)**[N57]

"It was easier for the British to find the men than the necessary supplies. Economy had ever been in the minds of the members of the Parliament when examining the military estimates; the nation was now to pay dearly for it. After the failure of the Bloemfontein conference, Wolseley had recommended that stores, ordinance, and transport be accummulated in South Africa, but the Cabinet had rejected the idea. Now, three months later, with war almost upon them, the army found itself woefully unprepared: in the army depots there were only scarlet and blue uniforms, none of the new khaki adopted for field service in the Sudan campaign of 1898; there were no reserves of horses, saddles, or horseshoes; the rifles in the reserve all had defective sights; and there were only 80 cavalry swords to spare. Worst of all, the supplies of ammunition were inadequate. (...) Not only was there a shortage of everything that would be needed to wage war, but no one at the War Office thought to alert armaments manufacturers until some time in

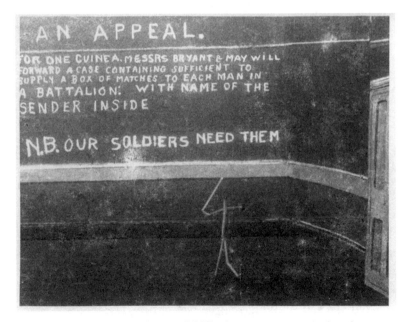

Fig. 76. MATCHES APPEAL (1899), the message is completed.

October that they might expect increased demands on their facilities; in other words, not until a few days before, or perhaps after, the war began." (**Byron Farwell, 1976/1977.**)[N58]

" Despite all Buller's efforts, there was no shortage of things to grouse about. The men were unshaven, and their belts, boots and faces were all one colour: khaki. (...) the food was the usual soldiers grub: bread and beef. No wonder some of the soldiers looted and stole." (**Thomas Pakenham, 1979/2004.**)[N59]

"Stringent economies in the army in recent years meant that weapons, ammunition, horse equipment, transport and other essential articles were insufficient for anything beyond small-scale operations. As soon as campaigning began, stocks of all manner of things ran short." (**Gregory Fremont-Barnes, 2003.**)[N60]

Correspondence

Kodak Limited, Wealdstone, Harrow-Middlesex, R.S. Schultze, Research Librarian and Curator, Kodak Museum, to Mr. Melbourne-Cooper, c/o Mrs Wadowska, 100, Wavendon Avenue, London, W4, 26 June 1956.

"Dear Mr. Cooper, Mr Brian Coe has handed over to us the 'Matches appeal film' which you have very kindly donated to the Kodak Museum. We are very pleased to add this to our collection of old films, and we thank you very much for this gift.

We have made enlargements of one frame each at the beginning and the end of the film, which we shall be showing as specimens of one of the unusual types of animation in our forthcoming exhibition, '60 Years of Cinematography' at Kodak House, Kingsway, London, WC 2. Due acknowledgement will of course be given to you. Yours very truly, KODAK LIMITED, R.S. Schultze, Research Librarian and Curator, Kodak Museum. Please give my regards to Mrs. Wadowska."

Mrs Kate Melbourne-Cooper, Lantern Cottage, Coton, Cambridge, to Audrey Wadowska, 100 Wavendon Avenue, London, W4. July (?), 1956.

"Dear Audrey, Thank you for your letter. Dad does not think it worth while coming to London for the Film Exhibition, as (we) do not suppose there is any thing new to see. Mrs Akhurst & her friend will be staying with us & we cannot leave them here alone.

Re. Dr. S. letter about the Matches Film. Dad is **very** surprised Kodaks say the NEG. was made in 1917. It is impossible!

Even if he had reproduced it, as he seems to remember he did some of the old NEGs, it would have been before 1917.

At that time he had sold all his equipment to Butchers, (when he left

London in 1915) & he had no facilities for making films, no dark room etc not even a camera! So there must be a mistake somewhere!

If you have anymore about it, let us know. I will send you a list of Dads films later as he has remembered several others he made. A trick film called "NOAHS ARK" is one of them. Hoping you & J. are well.

Love M & D."

Kodak Limited, Wealdstone, Harrow-Middlesex, R.S. Schultze, Research Librarian and Curator, Kodak Museum, to Mr. Melbourne-Cooper, c/o Mrs Wadowska, 100, Wavendon Avenue, London, 14 August 1956.

"Dear Mr Melbourne-Cooper, Following a suggestion by Mrs. Wadowska, I have great pleasure in sending to you, for retention, eight enlargements of different frames from your 'MATCHES APPEAL FILM'. They show the progress of the animation very nicely. Yours very truly, Kodak Limited, R.S. Schultze."

F.H. Dawson, sales manager Bryant & May Ltd., Fairfield Works, Bow, London, to Mr F. Law, Hon. Secr. South African War Veterans' Association, Norbury, London, 7 September 1956.

"We have received your letter of the 5th September and are very interested to have your enquiry regarding a film which was being shown at the time of the Boer War. It was brought to our notice a few months ago that a portion of this film had been found, and we were asked whether we had a remainder or a copy of the whole film. We have made an extensive research in our records but are unable to trace anything. It may well be, however, that in the intervening years such records have been destroyed. It is, of course, very interesting to us to know that as long ago as the Boer War Bryant & May were apparently making use of films in this way, but we must regret being unable to assist you with any further information. In reply to your enquiry as to whether Mr. Melbourne-Cooper wishes to interest Bryant & May or the Film Industry; we believe that this matter first arose as a result of an article published under the name of W.J. Collins who is a Director of Pearl & Dean Ltd., who, you are no doubt aware are associated with film advertising. This article appeared in a supplement of the World's Press News dated 11 May 1956.

As requested we are returning to you the letter which you received from Mrs. Wadowska together with prints from the film. There is no doubt that the offer of the supply of a box of matches to each man in a battalion for the sum of £1/1/- seems very remarkable today, but not only have values altered very considerably since the days of the Boer War, but at

that time no Excise Duty was chargeable on matches: this, as you know is now rather more than half the price of the box of matches."

P. Law, Hon. Secr. South African War Veterans' Association, London, to Mrs Audrey Wadowska, London. No date.

"Dear Madam, <u>Animated Matches.</u> I am sorry to tell you that Bryant & May cannot find any trace of their offer of Matches during the South African War, nor can any of our members remember anything about having received gift matches. Yours faithfully."

P.M. Woolley,[20] Bryant & May Ltd., Fairfield Works, Bow, London, to Mrs Audrey Wadowska, London, 6 February 1957.

"Thank you very much for your letter of February 5th and for the enclosed photostat. I am glad to hear that so much interest has been shown in your father's work; I am, however, sorry that I have not been able to be of more help to you over finding out a few more details of the original of the Boer War Film. Believe me, I and indeed Bryant & May would be only too pleased to run this fox to earth."

John Huntley, Distribution Officer, The British Film Institute, London, to Audrey Wadowska, 12 February 1957.

"We shall be glad to help with the Exhibition and are very pleased to hear that this is to take place. (...) Will you be showing the film which we know under the name of "Animated War Appeal" film?"

Kodak Limited, Wealdstone, Harrow-Middlesex, R.S. Schultze, Research Librarian and Curator, Kodak Museum, to Mrs Wadowska, 100, Wavendon Avenue, London, 2 June 1958.

"Dear Madam, In Dr. R.S. Schultze's absence at a conference in Paris, I have pleasure in sending you, by Kodak van, the copy of the 'MATCHES APPEAL FILM' made by your father, Mr Melbourne-Cooper. I understand that you asked for the loan[21] of this film in a letter to Mr. E. E. Blake, Kodak Ltd., Kingsway. Yours very truly, Kodak Limited, Janet M. Eggleston (Mrs.) Secretary to Dr R.S. Schultze."

20. There is more correspondence with Bryant & May, but we reproduce here only the paragraphs which are directly relevant to the subject. Bryant & May confirm their lack of archive material about the early periods and their house magazine starts only about 1920.
21. This is a mystery. A loan? Audrey Wadowska on behalf of her father, two years before, donated a copy of MATCHES APPEAL to Kodak. Did Audrey not have a print herself and is she now borrowing this copy? Or is the secretary mistaken and is she sending back what Audrey's father originally donated to Kodak? We found in the Wadowski estate the original negative of MATCHES APPEAL as well as a safety negative and several positive prints, one set of which is – on behalf of Cooper's daughter Mrs Ursula Messenger – donated to the Netherlands Institute of Animation film (NIAf).

Pieter Germishuys to Audrey Wadowska, Chiswick, London, 30 March 1961.

"Dear Mrs. Wadowska, Yes, just over a year ago we arrived back in S.A. and although a little late, I would like to thank you and your husband for all your kindness. I am now busy compiling the international filmography concerning the cinema during the Anglo-Boer War (1899-1902), and still hoping that you will send me your father's recollections re the 'faked' Boer War films, and either the neg. or a dupe positive of the 'matches' film. A Film Archive or Film Museum is underway ... would you consider donating or selling the old camera to this institution in South Africa? We would like to add it to the collection, particularly because it has some connection with the Boer War films. I am hoping to hear from you soon."

Audrey Wadowska to Rosemary Heaword, Society for Film History Research, Chislehurst, 10 April 1961.

"We have recently heard from South Africa, asking us to consider donating (or selling!) the 'Animated Matches' film and our old Bioscope camera to their Museum for safe keeping... but I have tried to explain our reluctance to part with what remains in our possession at least while my father is still with us – and I do hope they will understand our sentiments concerning this matter."

Audrey Wadowska to Pieter Germishuys, Johannesburg, South Africa, 6 June 1961.

"Dear Mr. Germishuys, At last!!! We have managed to get a contact print made for you of my father's Anglo-Boer War 'MATCHES APPEAL' film, and must apologise for the delay, due to the many unforseen difficulties we encountered before finally obtaining someone to do the job for us. Though we have decided not to part with the negative, at least for the present, my father is very happy to be able to give you a copy, and hopes it will amuse the younger generation in particular, when comparing his primitive fragment with the perfected techniques of today.

Regarding his personal recollections of the 'faked' film 'BRITON v. BOER' – he vividly recalls staging it one Saturday afternoon in Hadley Woods, near Barnet. The incident represented the entrenched enemy fleeing in fear at Bayonet Point, and was enacted by members of the local Volunteers. A ditch – otherwise the Trench – was dug in the woods, and the chief actor playing the part of a Briton standing on an eminence, was a recent Volunteer named Starbuck, a Cornet player, who incidentally, was experienced in the 'art-of-silent-film-acting', having previously taking part in several of my fathers early productions.

At the time, the fact that 'BOER V BRITON' was faked was not disclosed to the public – and when it was first shown, people leaped up in their seats cheering with excitement. They thought they were seeing the real thing! The 'BATTLE OF COLENSO' followed some little time afterwards, and my father being a 'free-lance' film-maker was engaged by James Williamson to produce (or 're-produce'!) scenes of the skirmish, which were actually staged on the Su. [?] There was another instance representing the burning of Kruger's body, which was enacted on Hadley Common, but I think that comes under the heading of a 'trick' film rather than a 'fake'. Perhaps you might also be interested to know that it was my father who was responsible for developing and printing Joe Rosenthal's negatives for the Warwick Trading Company, as and when they arrived from South Africa."

Pieter Germishuys, Johannesburg, South Africa, to Arthur Melbourne-Cooper, 23 June 1961.

"Dear Mr Melbourne-Cooper, My sincere thanks for the copy of your film 'BOER WAR MATCHES APPEAL' which your daughter has just sent to me. I can assure you that it is an important acquisition not only for our collection, but also for South Africa it will be definitely one of the most important films in the collection.

I am just deeply sorry that I could not meet you personally, but my last few months in England were extremely busy, I just could not get as far as Cambridge. Your daughter has, however, sent valuable information and I have asked for further details. She will probably approach you in time about the matter. Once again thank you for the film, coming as it does, from a true pioneer. Yours sincerely."

Kodak Limited, Wealdstone, Harrow-Middlesex, R.S. Schultze, Research Librarian and Curator, Kodak Museum, to Mrs Wadowska, 100, Wavendon Avenue, Chiswick, London, W.4., 18 December 1962.

"Dear Mrs Wadowska, You will remember that there has been some doubt as to the year in which your father, Mr. Melbourne-Cooper, produced his animated match stick film 'MATCHES APPEAL'. I have now obtained authoritative information[22] which shows that the 'MATCHES APPEAL' was made not during the Boer War, but during the beginning of the First World War. This information has been supplied by Lt. Col. C.B. Appleby, D.S.O., F.S.A., Director of the National Army Museum, Sandhurst, Camberly, Surrey, and I have pleasure in enclosing a photo-

22. There was no attachment to the letter with this information. The only attachment was a two-page copy of a typescript of a number of references in *The Times* of 1914 and 1915.

copy of some references in *The Times* in which reference 4 is the most important one, mentioning an appeal by Bryant and May for donations in *The Times* of January 5th, page 11. It seems very likely that your father produced this film in 1915. I hope you will be interested in the above information. With my best wishes to your Husband and yourself for Christmas and the New Year, Yours very Truly, R. S. Schultze, Curator, Kodak Museum. Enc."

Attachment:

"Imperial War Museum: MATCHES FOR THE TROOPS, FIRST WORLD WAR. SECTION I. REFERENCES TO 'THE TIMES'."

(1) "KING'S GIFT TO THE TROOPS. As a mark of their keen interest in the welfare of their troops, the King and Queen have presented a large supply of matches for the use of men of the Expeditionary Force.

It has now been decided to allow gifts of matches to be sent to the Expeditionary Force. Safety matches only should be sent, and they should be packed in sealed tin boxes, and forwarded carriage paid to the Military Forwarding Officer, Southampton Docks, for transmission overseas." [THE TIMES, 5 OCTOBER 1914, page 8 column f.]

(2) "SPECIAL SAFETY MATCHES FOR THE TROOPS. Messrs. Bryant and May will supply a case of their special safety matches, tin-lined and sealed, in accordance with the with the [sic] War Office requirements, and forward it carriage paid, to any battalion or other unit of the Expeditionary Force. The case will contain sufficient to supply a box of matches to each man in a battalion, and will be forwarded with the name of the sender and the address of the unit outside. The cost of the case is one guinea." [THE TIMES, 6 OCTOBER 1914, page 11 column d].

(3) "Safety matches may now be sent to the Expeditionary Force by parcel (but not by letter) post. Each box must be separately enclosed in a single wrapper of tissue paper, and the boxes must then be packed in a sealed tin so tightly that they do not shift when the tin is shaken. The parcel must be marked 'Safety matches – each box separately wrapped in tissue paper'." [THE TIMES, 29 OCTOBER 1914, page 3 column d].

(4). "SAFETY MATCHES FOR THE TROOPS. Messrs. Bryant and May (Limited) of Fairfield Works, Bow, will receive donations, even in small amounts, for sending out supplies of safety matches to the troops. These can be sent in guinea cases, which provide a box for every man in a battalion. For many who would like to send a gift, the sum of one guinea is too much, but the firm undertake to send a case for each guinea subscribed in smaller amounts. Messrs. Bryant and May are prepared to give The Times Red Cross Fund 2s. for every guinea so collected. If donors of smaller amounts than one

guinea will make suggestions as to the battalion, battery, or other unit to which they would like that matches to be sent, the firm will be glad to follow suggestions in rotation." [THE TIMES, 5 JANUARY 1915, page 11, column b]. (5). "NO MATCHES BY POST TO THE TROOPS. MAILS DESTROYED BY FIRE. The following official intimation is made: – The Postmaster-General regrets to announce that the dispatch of matches by post has resulted in numerous fires which have destroyed a large number of mails. It has consequently been necessary to withdraw concession which permitted the dispatch of (matches)." [THE TIMES, ibid.].

Copy at/ "Lantern Cottage" Coton, Nr. CAMBRIDGE. To Dr. R. S. Schultze, Curator, Kodak Museum, Wealdstone, Harrow, MIDDLESEX, 6 January 1963.

"Dear Dr.Schultze, Thank you very much for your letter of December 18th. enclosing the photo-copy. I am indeed extremely interested in the information you have so kindly sent me, as I have myself spent much time in searching for some form of evidence which would help towards establishing the date my Father produced the Bryant and May 'Matches Appeal' film, and so far, I have only come across references to a shortage of matches and a general appeal issued during the early part of the Boer War. But nothing enlightening. The wording quoted from *The Times* in reference 2 certainly corresponds with that of the film, which suggests some connection with it – and I am very grateful to you for passing this invaluable information on to me. After a whole year of complete stand-still I hope soon to be able to resume my activities in connection with my Father's life and work – at the moment we have overwhelming problems and difficulties to face up to. With best wishes for the New Year from us both. Yours sincerely, A.W. (Audrey Wadowska)."

Kodak Limited, Wealdstone, Harrow-Middlesex, R.S. Schultze, Research Librarian and Curator, Kodak Museum, to Mrs Wadowska, "Lantern Cottage", Coton, nr. Cambridge. 11 January 1963.

"Dear Mrs Wadowska, Thank you very much for your letter of 6th January 1963. My informant was quite sure that no MATCHES APPEAL was made during the Boer War, but only during the First World War. The dating marks on your Father's negative film (manufactured by Kodak) also point at a 1915-18 date.[23] I am pleased to know that you will be able to resume your work on the biography of your Father. I am sorry

23. In 1916, Kodak started to mark its film stock on its edges with what they called 'year symbols'. Before that there were no date marks. Schultze should have mentioned a specific one, either a circle for 1916, a square for 1917, or a triangle for 1918.

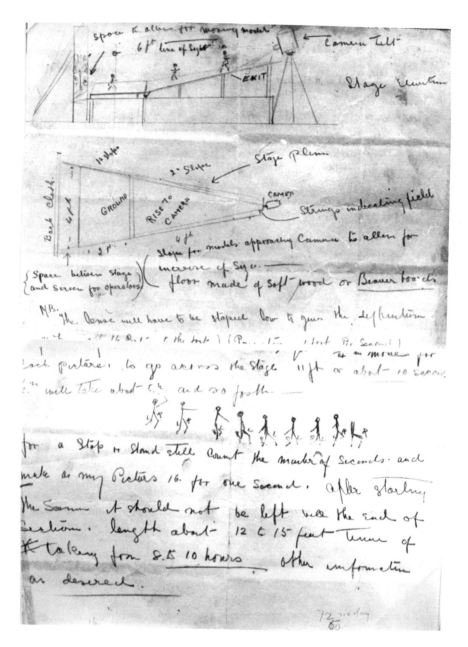

Fig. 77. Pages from an instructive letter, in the 1920's, sent by Cooper to actress Jackeydawra Melford who bought a camera to make animation pictures.

to learn from the newspaper cutting you enclosed that your Mother has died, and I should like to express my sympathy in your bereavement. I was interested to see that your Mother had taken such an active part in the early film work of your Father. Yours very truly, R.S. Schultze, Curator, Kodak Museum."

Letter to Mike Oliver from Audrey Wadowska, London, 22 January 1980.
"The 'MATCHES APPEAL' film, made by my father, Arthur Melbourne-Cooper, for Bryant and May in 1899 is now ready and I am pleased to be able to deliver it to you in time for your meeting. The preservation of this 80 years old animated film is fraught with complicated difficulties! But I have managed to get the best possible non-inflammable 35mm dupe print 'stretched' to 24 frames per second, enabling it to be projected on a modern machine in accordance with our mutual agreement, on the understanding that it is for your own private use. The sole copyright, of course, will remain in my possession. Should you at any time wish to use the film (or 'stills' made from it) for advertising purposes, the appropriate Royalties would be due to me. I am very sorry I was not able to get you a 16mm reduction print made for you in time for your meeting on Wednesday. Hoping the film will give you much pleasure in the future."
Addition in red ink: "We agree to the above stipulations. For the agreed fee of £50, signed; – Mike Oliver (D.D.B. Ltd.)."

Elaine Burrows, NFA Viewing Supervisor, BFI, London, to Audrey Wadowska, 28 May 1980.
"Dear Audrey. We have been asked by the Brussels Cinémathèque, (...) if we could help them by co-operating with this year's BILIFA (International Co-ordinating Bureau of Institutes of Animated Film) Conference. The Conference takes place at Gent, Belgium, and lasts from June 30th until July 2nd. They will be having screenings for delegates, and would like to include, in their 'Pioneers of Animation' section, two of your father's films, DREAMS OF TOYLAND and MATCHES APPEAL.

Would you have any objection to us lending our viewing copy of DREAMS OF TOYLAND for this Conference? As we have only a preservation copy of MATCHES APPEAL, would you be able to lend them a print yourself? If so, we would collect it from you and ship it with the other films we are lending, of course at the expense of the Conference. Best wishes to you and Jaschik, yours sincerely."

Jan Wadowski to Ms Clare M. Smith, Film Officer, The British Council, London, 5 August 1985.

"In response to your request I am presenting you a second copy of MATCHES APPEAL on 16mm for use in any non-commercial show, including The Australian Film Institute's Project. I agree without any conditions and reservation to use MATCHES APPEAL on video tape in 'The Highlights of British Animation'. – However, I would like, if it is possible, to have a copy of this video tape, as a record for Arthur Melbourne-Cooper Collection and for my private study."

David Cleveland, Manningtree, to Tjitte de Vries, 8 November 2005.
"I have examined the two 35mm rolls of 'MATCHES APPEAL' in the National Film and Television Archive. These are both recent dupes.
<u>35mm dupe negative – dated as 1899 on the leader and on the can</u>. This in my opinion was made from an original 1899 print. The original must have come from Audrey (Wadowska), as her name is on the front information frame as 'producer' (though this information was added in recent times.) There is a faint shadow of the original perforation on the 1899 print which has been copied through to this dupe neg. This appears to be a small type perforation. This would indicate that it is before 1909 when Bell and Howell introduced a standardisation for perforations, which from then on were of the negative type, still used today. I have seen this small type of perforation on other British films of this time, when manufactures of film stocks perforations varied slightly in shape and position. So I would say it was taken from an original 1899 print. Where this is now is not recorded. The negative copy has not been properly duped. The original picture area would have been that of the silent film frame. The dupe has an area for a sound track left clear. This is an error probably made by an outside laboratory that did the duping work. A NFTVA title has been added on the front in recent times. It says 'MATCHES APPEAL', by Arthur Melbourne Cooper".

David Cleveland, Manningtree, to Tjitte de Vries, 19 November 2005.
"Before 1916 there was no way of dating film except by content, perforations sizes, and by producer's written copyright notices down the side of the film, but this latter was only common to big producers such as Pathé or Edison, etc."

Trevor T. Moses, film historian and resident expert on South African film history of the National Film, Video and Sound Archives, Pretoria, to the authors, 15 January 2007.
"We have much Anglo-Boer South African War (this is the politically correct designation as handed down to us by the Department of Arts and Culture) footage, including MATCHES APPEAL, and you are correct in saying that it is the first and earliest known animation of its kind. As the

NFA's expert on SA film history (I have written an as yet unpublished book on it entitled *Riding The High Wind*) I would say that 1899 would be the most likely year when MATCHES APPEAL was made. I am quite sure that the NFA's then resident experts would not have put World War I footage under Boer War footage when they catalogued and classified the material. Our cards state the date (this is for all our ABWar footage) as 1899-1902 which means that it was definitely made in the time of the War. So far as I am concerned, the 1914 date is irrelevant."

Email to Tjitte de Vries from Bryony Dixon, curator silent film BFI, London, 2 April 2007.

"It's a bit of a mystery – Denis Gifford seems to have put the rumour into print first without quoting any sources whatsoever! I can find no primary evidence for the existence of this film – or that it was by Melbourne-Cooper or anything else. I have eliminated the 1908 ANIMATED MATCHES, which is clearly the Cohl version and not the same film at all (*Kine and Lantern Weekly*, 12 Nov 1908). There is no trace of the original material – our earliest element is a 16mm pos acquired in 1978 from an Audrey Wladowska [*sic*] of whom no trace... the acquisitions documentation clearly states that it is Arthur Melbourne Cooper and that it was made to raise funds for Boer War but that this was based not on a ref to another source (which would be usual) but to viewing notes of the officer the date 1899 is speculative and probably derives from an assumption that it was for the Boer War. Where the idea came from that it was a First World War film – I don't know. We can examine the 16mm pos to see if any clues – the 35mm material may well be a blow up from the same source unless the Cinematheque Ontario have something original."

Letter from David Cleveland, Manningtree, to the authors, 7 May 2007.

"It seems matches in drawn cartoons in the newspapers and other publications were all the rage in the 1890s, so it seems logical that Cooper may have been influenced by such things, and that makes the 1899 date even more correct in my mind."

Email to Tjitte de Vries from Alastair Massie, National Army Museum,[24] Chelsea, 12 July 2007.

"In reply to your letter of 9 July, I had not heard of a match shortage with the troops in South Africa. Since the Appleby correspondence, even if it survives would be on microfilm and effectively unsearchable, the best advice I can give is that you consult the archives of the Bryant and May match company."

24. In 1971, the National Army Museum at Sandhurst, Surrey, moved to Chelsea.

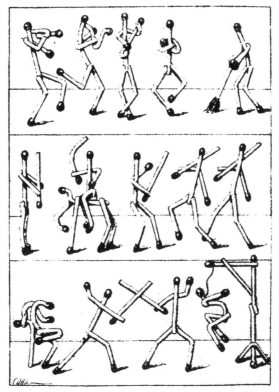

126. "Amusement for the Winter Evenings," *Judy*,
January 29, 1896.

Fig. 78. Illustration showing the popularity of matchstick figures.

Rebecca S. Hawley, Imperial War Museum, London, to Tjitte de Vries, 16 July 2007.
"Unfortunately, the Boer War falls outside of the period covered by the Imperial War Museum terms of reference which cover all aspects of international conflict since August 1914. You might wish to contact the National Army Museum at Royal Hospital Road, Chelsea, London. (...) I am afraid that a search of our collections revealed no references that would be of assistance to you. I am not aware of any match shortage during the First World War, and could find no references to support a shortage in publications held here on First World War supply. We do have one Bryant and May matchbox in our collection which dates to the

First World War. (...) It is interesting to note that the matchbox does have *'please use matches sparingly'* written on it. I have searched through our Women's Work Collection which is a collection of primary sources relating to First World War. This collection is usually a good source of information on benevolent schemes organised during the First World War period, but no mention of the Bryant and May match appeal occurs."

Email to Tjitte de Vries from Marco de Blois, curator animation, Cinémathèque Québècoise, Montréal, Canada, 24 September 2007.

"According to my documentation, our positive copy of MATCHES: AN APPEAL was bought in 1984 from a person named J. Wadowski by the intermediary of Antoinette Moses.

An interneg was struck after that copy and given to the BFI in 1996. We used that interneg to make a screening copy for our collection."

Recorded interviews

"Made for Bryant and May's, MATCHES APPEAL for the troops at the beginning of the Boer War in 1899. And this again is made according to stop-and-start technique. Every match – the matches are prepared in the form of figures, and it is done by movement again. One movement, one frame. It is extremely historical. But it is not very long. Some of the wording is cut off." (**Audrey Wadowska in a lecture for St Albans Film Society, 31 March 1966, T101.**)

"Tjitte de Vries: ANIMATED MATCHES, what time was that that? *Audrey Wadowska:* That is for the Boer War, 1899. That was shown in London before Christmas 1899. And that is not complete. It should start with a matchbox coming on to the screen. These matches tumbling out and forming into figures. But he used that for another film later on. So we haven't got that. He could not use this again because it is obviously Bryant & May's appeal." (**Audrey Wadowska to Tjitte de Vries, London, 26 December 1976, T075.**)

"MATCHES APPEAL 1899, that was shown at The Empire Theatre before Christmas or during Christmas. They were appealing for matches to be sent to the soldiers and the public had to make a donation of 1 pound. Bryant and May have no record of it. I have written to them. They say they didn't keep records during the Boer War. They started in 1914 or 1915, from the First World War,[25] I asked Father at the time. Apparently, two ladies came. He had this little office in London. He was free-lancing at the time. He had this office at Charing Cross Road, because he used to

25. See: W. Lucas, *A Hundred Years of Match Making, Bryant and May 1861-1961*, 1959.

– Billy Jeapes used to show at the Empire Theatre at Leicester Square, and Father being a pal of his, Billy used to show Father's films." (**Audrey Wadowska to Tjitte de Vries, London, 27 December 1976**, T076.)

"*David Cleveland:* What gave your father the idea to use frame-by-frame animation. If he was the first, what gave him the idea that it would work?

Audrey Wadowska: Toyland was not really the first. *Cleveland:* What was the first? *Audrey:* As far as I know 1897 he made an advertising film. *Cleveland:* In the interview he says it was the MATCHES.

Audrey: But I am not dead sure that this advertising film is frame-by-frame Some years ago somebody reported it was frame-by-frame. By his description of it: a man steps from a frame and falls down the stairs. You know BIRD's CUSTARD advertising he falls down the stairs and breaks the eggs. And then, this particular man has no trouble because he uses Bird's Custard powder.

Cleveland: What is the first one you have? *Audrey:* The MATCHES. *Cleveland:* That is? *Audrey:* 1899. *Cleveland:* That is the Boer War matches? *Audrey:* Yes, MATCHES APPEAL. *Cleveland:* Every book says, the first animated film was made by Emile Cohl. *Audrey:* Yes, I know. Of course, he animated a doll in a film about 1901. A child goes to sleep and sees her doll. Only 50, 60 foot.

Cleveland: The matches film was made in St Albans? *Audrey:* No, at premises hired at Charing Cross Road.[26] Next to the Garrick Theatre used to be a tobacconist shop, on the corner of Cecil Court. *Jan Wadowski:* There was someone who helped Father. *Audrey:* Billy Jeapes who helped him to show his films at the Empire. They formed the Cine Syndicate.

Jan: There is missing part of it, I remember Father(-in-law) told there was a box of matches comes to the table, is rolling on, and opens itself like magic. And after that there walk matches from it. Very ingenious. And there were two men doing it, Father(-in-law) and this friend Billy Jeapes. And his mother, Mrs Jeapes, she had a theatre or some sort of show, she sponsored it, she had a little money. You have to have some finances. Father(-in-law) had not much money. A committee of ladies

26. Google Earth shows, at the back of 12, Charing Cross Road, London, hardly enough space where one undisturbedly could make use of the sun for lighting an animation scene over several days. Electric light was not yet available, and it stands to reason that Cooper made the matches pictures in the garden of his father's photographic studio in St Albans. (With thanks to research by Peter Mul.)

decided they want to help soldiers, to supply them, they were short of matches. They approached Father(-in-law) whether he would make it. And every film was used at the fair-ground shows, there were no cinemas. They pay him for every film shown on the fair-ground one pound, which was quite good for him. And there was this small underground. Only two man operating it in the small cellar underground. And with matches it is very difficult.

You see, these matches – it is the most difficult thing to do. It is very complicated these matches and of course to keep the figures in upright position is the most difficult thing to do, and all the movement. With a slight movement you may damage everything. And there are very good movements. It was a lot of patience. It is very short. It is amazing how he made that writing for example. And he has suddenly jumped, for he thought: Gracious it must be too long, because the text is so long." (**Audrey and Jan Wadowski to David Cleveland, London, 19 December 1977**, T420.)

"And it was at the time of Ladysmith father made this matches film, by the beginning of the Boer War." (**Audrey Wadowska to Tjitte de Vries, London, 1 January 1978**, T011.)

"*Kenneth Clark:* You have the BRYANT AND MAY One? *Audrey Wadowska:* We have the original negative." (**Audrey Wadowska to Kenneth Clark, London, 24 October 1978**, T198.)

"They hired a room in a place at Charing Cross Road. It had erected a screen, near Cecil Court. (...) It was under a shop which is still there. During the intervals at Leicester Square, they used to congregate here and that is where the matches films (were made). He used to keep films and stuff there, they had a screen and they used to put on (film shows). You see, that is how the film is dated. Because Father used to say, it was made at the time around Ladysmith, and it was shown by Jeapes, who always had a couple of Father's films in his shows. Naturally, being pals, there was always something of Father there. Billy Jeapes included that in the program at the Empire before Christmas at the time of Ladysmith. So it must have been 1899, before Christmas. That was a battle in the Boer War, a famous battle like Mafeking, only Mafeking came later. That is all Boer War history. That started about November 1899, I think." (**Audrey Wadowska to Tjitte de Vries, London, 10 April 1979**, T039.)

"(Billy Jeapes) was at The Empire and possibly that is where he met him, Father used to sell his films or loan his films to him. It must have been before the Boer War because when Father made that MATCHES film, they

rented this downstairs underneath that shop next to the Garrick Theatre, and sometimes they could not pay the rent and Mrs Jeapes would loan them the money for that. (...) I suppose then they gave up this office and projection room. I have been down there, some twenty years ago. The man was very nice. He said, when they first went there, there was a stage and a screen erected at the bottom, and it had been a studio. And that is where the MATCHES films were made." (**Audrey Wadowska to Tjitte de Vries, London, 12 April 1979**, T040.)

"We have the original. We found it in Father's camera case. But it is not complete. (...) It starts by a match box and the matches coming out of it and forming into figures and they write this slogan on the wall. I got a still from it. (...) What Father did was, he reused the match box part in 1907 or 1908 for a prelude to another film called MYSTERIOUS MATCHES or something like that and they come out of the box and form up into shapes and funny things. We haven't got that part." (**Audrey Wadowska to Antoinette Moses, about the forthcoming Cambridge Animation Festival, London, 22 May 1979**, T191.)

Jan Wadowski: "We met an old man in London and he told us and later we asked Father-in-law and he said it was exactly as it is: a box of matches opens it(self) and matches come out and started to walk. And of course he uses it for another film, for MAGICAL MATCHES. Because it was during coffee break, he cut it off, put it in his pocket and asked: Have you anything to put it in? Oh, a coffee tin. So they put MATCHES APPEAL in the coffee tin. *Ken Clark:* And forgot about it. *Jan:* And forgot it and took it from one place to another. And some day, Mrs Cooper was making some order in her kitchen and: Look, there is some old film here. That is why it was saved." (**Jan Wadowski to Kenneth Clark, St Albans, Sunday, 21 February 1988**, T410.)

Tjitte de Vries: "You are telling me that Cooper came on his idea of frame-by-frame because he worked with Acres on this glass plate camera? *Jan Wadowski:* Acres was looking for someone who could make lantern slides. And Acres made the camera that made several plates in 1 second, and they discovered for a smooth movement you needed 14 or 16 plates. That was the first camera to obtain proper movement. He (Cooper) made some arrangement how to stop exactly. Probably some engineer made it for him, but he told him how to do it so that the frame was dead on and you could not make a mistake. Automatically with a pin and some spring, very simple on the outside, some local mechanic made it for him exactly, dead on, so that you cannot do anything else and cannot go further. It was not a complete turn, because that was two or three

frames. You have to press it to release the spring and then you can go to the next frame. He also advertised (projectors): Without flickering. *Tjitte:* He made it only for himself? He did not patent it and he did not sell it? *Jan:* He did not find it important. A little simple thing." (**Jan Wadowski to Tjitte de Vries, St Albans, 4 May 1991**, T276.)

Ursula Messenger: "It could not have been the 1914-1918 war, because Dad had given up film production. He was working in Luton, we were living in Dunstable. He wasn't filming then. The Boer War was before that. The Crimean was the one before that. It was the Boer War definitely. (...) Dad used to talk about it. He said, it was an appeal to the public. Because the soldiers were short of matches. *Tjitte de Vries:* There is evidence showing that the film was made in 1914, during the Great War. *Ursula:* No, definitely out of the question. He was not filming anymore. We were living in Dunstable." (**Ursula Messenger to Tjitte de Vries, Felpham, Bognor Regis, 20 October 2004**, T382.)

Unpublished manuscripts

"But what about the films themselves? First must be mentioned a film called simply 'MATCHES', which is recognized to be the first animated film and was made in 1901. A copy is now in the Kodak Museum. At that time there was a general appeal for matches for the troops in the Boer War. ('One Pound will provide matches for a whole Battalion') and Melbourne-Cooper hit on the idea of using the matches themselves to tell the story. To do this he had to have a camera that would take a given number of frames and then stop so that the matches could be moved. He still calls animated film 'Stop-and-start films'." (**Arthur Swinson, 1956.**)[N61]

"Again in 1899 he produced the famous MATCHES APPEAL for Bryant & May, using the one-frame one-picture technique which at the time was a new aspect in filmmaking. (...) Of the numerous advertisement films he manufactured during the early days, the Bryant and May matches 'APPEAL' is probably the most valuable, as this comparatively trivial item marked the beginning of a new technique for the advertising medium and set in motion the puppet cartoon craze that was to develop enormously a few years later.

It has been authoritively stated that the animated cartoon film has its roots in the drawings made from zoetropes, phenakistiscopes and in Reynaud's exquisite creations for his praxinoscope and Théatre Optique. Émile Cohl has always been credited as the originator of animated films, but in actual fact Arthur Melbourne-Cooper made a charming animated cartoon film [*sic*] at the time of the Boer War. This

was a commissioned advertisement made in 1899 for Messrs Bryant and May Ltd., match manufacturers. There was a shortage of matches among the troops in South Africa, and in fifty feet of film Melbourne-Cooper tackled the problem in this fashion. Using the one frame one picture technique – he made a matchbox open, the matches emerging to form simulated human figures engaged in a tussle climbing up a wall, where they formed up making the slogan 'Send £1 and enough matches will be sent to supply a regiment of our fighting soldiers'." (**John Grisdale, 1960.**)[N62]

"Although it has become generally accepted that the animated 'MATCHES APPEAL' made for Bryant and May was made in 1899, the date has been the subject of some controversy. (...) The late Dr. Schulze, curator of the Kodak Museum at Harrow, was doubtful whether the film was made during the Boer War as Cooper himself remembered. Schulze felt that Cooper's memory was unreliable where dates were concerned (he was an old man by the time any interest was taken in his work) and believed it more likely that the film had been made during the First World War. On the research that Schulze carried out in attempting to date the film only two pages of reference to a matches appeal during the First World War have survived, but they do show clear evidence in support of his theory. Undoubtedly there was a well-publicised campaign to send matches to the British troops in 1914 as the following item from *The Times* shows:

> "SPECIAL SAFETY MATCHES FOR THE TROOPS. Messrs. Bryant and May will supply a case of their special safety matches, tin-lined and sealed, in accordance with the War Office requirements, and forward it carriage paid, to any battalion or other unit of the Expeditionary Force. The case contains sufficient to supply a box of matches to each man in a battalion, and will be forwarded with the name of the sender and the address of the unit outside. The cost of the case is one guinea. (From *The Times*, October 6th 1914)."

The wording of the press report and the actual words used in the film, which are as follows, are very close: 'AN APPEAL. For one guinea, Messrs Bryant & May will forward a case containing sufficient to supply a box of matches to each man in a battalion with name of the sender inside. NB. Our soldiers need them.' The fact that the price is the same would seem to leave little room for doubt in the matter. But perhaps the 1914 appeal was a repeat of an earlier successful appeal. It should be noticed that this is a very primitive film remembered by Cooper as being very early, and looking decidedly less sophisticated than Cooper's

other work such as NOAH'S ARK. 1899 would have been very early for animation work. By 1914 Cooper's career in films was almost at an end. The Kinema Industries Ltd., which he set up in the previous year having proved a commercial failure." (**Luke Dixon, 1977.**)[N63]

Editorial

After the success of his trick picture BIRD'S CUSTARD (1897) for which he received a pound for each copy sold to show- and fair-ground men, Cooper established with his friend William Jeapes, the projectionist of the Empire Theatre, the Cinematograph Syndicate Company – short Cine Syndicate – at the Garrick Mansions in Shaftesbury Avenue. This company specialized in what they called 'industrials', sponsored pictures or plain advertising films. We therefore assume that he successfully made MATCHES VOLLEYBALL and MATCHES CRICKET as 'industrials' for Bryant & May as sponsors, who later commissioned him to make MATCHES APPEAL on behalf of the Soldiers and Sailors Fund.

The beginning of the three matchstick films is missing: a Bryant & May box of matches opens, and out of it come several matches which form themselves into figures. Cooper used the negative of this opening scene subsequently for other animated matches pictures, finally in 1908, for MAGICAL (or MYSTERIOUS) MATCHES. We can safely assume that the other two matches films were made before MATCHES APPEAL because it was this third picture that still contained the negative of the opening scene, when he needed it for MAGICAL MATCHES.

According to family tales the negative was found by Mrs Cooper, when cleaning the kitchen, in a tea caddy after the Coopers had moved from Little Shelford to Coton, Cambridge. But Audrey sometimes tells a different story, keeping us on our toes.

As far as we are able to reconstruct it now, Audrey and Jan Wadowski ordered a safety negative from Cinefex Film Laboratories, which also made several positive prints on 35mm and 16mm. Second so-called step-prints were later made of all three matches films. In 1956, Cooper donated prints from the original negative to the Kodak Museum at Harrow, and to Peter Germishuys, founder of the South African Film Archive, Johannesburg. Later, prints were sold to Bryant & May, to a private collector and to the Cinémathèque Québècoise at Montreal, Canada, who in their turn made a copy for the BFI National Archive, where the leaders carry the name of Audrey Wadowska as the consignee. Jan Wadowski presented a 16mm copy to the British Council. The Audrey and Jan Wadowski collection in the East Anglian Film

Archive contains different versions of MATCHES APPEAL, where the first images are missing in some prints.

The original MATCHES APPEAL negative does not exist anymore. When in 1980, my wife and I assisted Audrey and Jan Wadowski to move from two damp servant quarters in London to a new flat in St Albans, we came across a couple of film tins containing very smelly deteriorating nitrate films in their last and very dangerous state. One of the tins had the label MATCHES APPEAL. We burned the films on a lawn at a safe distance from their new home in the knowledge that Audrey and Jan kept safety negatives in their film collection. They never gave the original negative in safe keeping to the NFA or the Kodak Museum. When we tried to save at least a couple of frames, they more or less melted away with a very bad smell between our fingers.

MATCHES APPEAL was shown 21 October 1977 at the National Film Theater in a programme dedicated to Arthur Melbourne-Cooper. It was shown at several festivals, among them Cambridge Animation Festival in November 1979, and Gent, Belgium, June/July 1980. The British Council included it in 1985 in a film animation package 'The Highlights of British Animation 1899-1974' on 16mm and video. The Australian Film Institute screened it in 1986 as part of an animation package in a number of cities. The BBC, in 2005, used it for the opening of the programme *Animation Nation*. These are just some examples of public screenings that we know of.

Dispute

When was MATCHES APPEAL made, 1899 or 1914/1915? We discussed this in Part I of this book. To recapitulate, the objections against the date of 1899 are, in short:

1) The film is too sophisticated for its time.

2) There was no shortage of matches with the troops in 1899, but there was in 1914.

3) Edge markings indicate a possible later date.

Re 1. Considering the total output of Cooper's animation pictures of which six have survived, MATCHES APPEAL and the two other matchstick pictures form a logical start to all his later stop-motion work. They are no anomaly at all but fit very well in their period considering all the sophisticated moving picture, silhouette, shadow and magic lantern shows, the Théâtre Optique, the Panoramas and Dioramas, the Tachyscope, Phenakistiscope, Kinetoscope and Mutoscope shows in theatres, on the fair-grounds, in parlours, in church rooms, and at home. *Re 2.* Even if Sandhurst experts are convinced that there was no shortage

of matches in the beginning of the Second Anglo-Boer War in South Africa, the literature about this war (and there are hundreds and hundreds of books on the Anglo-Boer War alone!) is more than convincing about shortages of practically everything because of the great haste with which the troops were being shipped down. It would have been a sheer miracle if matches had formed an exception, but they didn't. Plenty of matches in 1899 but a shortage in 1914/1915? Rebecca Hawley of the Imperial War Museum wrote us (see above): "I am not aware of any match shortage during the First World War, and could find no references to support a shortage in publications held here on First World War supply."

Did the soldiers in the Anglo-Boer War – suffering all kind of shortages, even ammunition – not suffer a shortage of matches? Smoking in those days was so common, and in an era with no television or internet, no radio, no cinema yet, smoking a pipe, cigar or cigarette was a welcome, comforting and widespread pastime. No shortage of matches? Why is the postmaster-general emphatically warning the public not to include matches in their parcels to South Africa?[27]

"MATCHES WITH PRESENTS OF TOBACCO

We have received the following from the Post Office: -

The Postmaster-General finds that many persons who are sending presents of tobacco by Parcel Post to soldiers serving in South Africa are enclosing lucifer matches therewith. The Postmaster-General points out that it is contrary to law to send matches by post at all, and that their conveyance by ship as part of the mails is especially dangerous. Any parcel which is observed to contain matches has to be detained at the risk of this appointment both to sender and receiver." **(The Times, 15 December 1899.)**

Re 3. Why is Schultze not more specific? If there were dating marks, or date marks, the year would have been clear. Kodak called them year symbols: a circle for 1916, a square for 1917 and a triangle for 1918. Why does Schultze mention 'a 1915-18 date' covering at least three different date marks? In 1915 there were not yet stock marks. It is possible that the negative was re-made, but a duplicate negative would have a stock mark of a much later date. This is not mentioned by Schultze. David Cleveland, after examining the 35mm copies in the National Film and Television Archive, concludes that the shadows of a small type perforation of the original indicate a date before 1909, the date of the

27. Thanks to research by Prof. Frank Kessler.

standardisation of perforations. The remark about the date marks from a Kodak expert, therefore, is rather curious considering that the Museum was presented with a print that was most probably made on Kodak stock from the original negative. Because no explanation whatsoever is further given about year symbols, Schultze's arguments about dating marks should be forgotten.

Cooper, at the beginning of the First World War had no studio anymore, his film companies were dissolved, and he was trained as inspector of munition, settling his wife and three children in a boarding house in Dunstable.

Concerning circumstantial evidence, the legal profession always applies the following rule. All circumstantial evidence must be consistent, and all circumstantial evidence must point in the same direction. And that is exactly the case with MATCHES APPEAL. Therefore, there can be no doubt about Cooper being the author of this stop-motion picture being made in 1899 on the occasion of the Second Anglo-Boer War.

7. **Dolly's Toys** * * *, 1901, 80 ft., running time 1.20 min.
 A.k.a. DOLLYLAND. Live-action and stop-motion animation.
 Reissue DOLLYLAND, Butcher 1911 (80 ft.).
Credits
 Directed and animated by Arthur Melbourne-Cooper as an independent production. Studio (possibly) Thomas M. Cooper's[28] photographic studio, Osborne Terrace, London Road, St Albans, or the new Bedford Park studios, Beaconsfield Road, St Albans.
Synopsis
 A small girl dreams that her doll comes to life.
Complementary sources
 Gifford-1973, 1978 (page 70), 1986, 2000: "00485/00494 – Dec. 1901 (80), DOLLY's Toys, R.W. Paul, D: (Arthur Cooper). Trick, child dreams toys come to life."
 Gifford-1987 (page 6): "1901 (80). DOLLY's Toys, R.W. Paul's Animatographe. Live-action/animated toys. A small girl falls asleep and dreams that her dolls come to life. The plot is so similar to many later films made by Arthur Cooper, that it could be his first production. Cooper was working for Birt

28. Arthur Melbourne-Cooper's father Thomas M(ilburn) Cooper (1832-1901), photographer.

Acres at this time, and Paul released many of Acres's productions. Alternatively, it could be another of Walter R. Booth's regular trick films made at Paul's Animatograph. Released December 1901."

Publications

"DOLLY'S TOYS (1901) may have also used animation, or a variant of Booth's stop-action substitution." (**Donald Crafton, 1982.**)[N64]

"British film maker Arthur Melbourne-Cooper's first experiment in object animation appears to have been MATCHES APPEAL, a Boer War propaganda film said to have been released in 1899, although the date has not been confirmed. But either Cooper's DOLLY'S TOYS, released in 1901, or THE ENCHANTED TOYMAKER, of 1904, could have provided inspiration for Blackton if they contained true animation, since it is likely that they were both duped and distributed by Edison.[29] The February 1903 catalogue describes ANIMATED DOLLS, a film in which sleeping children are visited by a fairy.

The dolls which are dressed as boy and girl, come to life and begin to make love to each other. They make so much noise, however, that they wake up the children. Upon seeing the action of the little people, the children are very much amused, and sitting up in bed, they watch the performance. Finally the dolls, upon seeing that they are discovered, resume inanimate form, and the children jump out of bed to get them.

While this may have been a remake by Edison's special effects buff, Edwin S. Porter, it seems more likely that the film was simply a retitled dupe of Arthur Melbourne-Cooper's original. The same may be said for THE TOYMAKER AND THE GOOD FAIRY described in the September 1904 catalogue (...). This subject and its treatment resemble Melbourne-Cooper's THE ENCHANTED TOYMAKER, which has been released earlier in 1904 by R.W. Paul. (...) The animated toy-theme in both Cooper films may also have been a likely influence on THE HUMPTY DUMPTY CIRCUS.[30] Unfortunately neither of the British films nor their American versions have been located, and some historians have questioned whether there were any truly animated British films before the technique was learned from Blackton." (**Donald Crafton, 1990.**)[N65]

29. Edison did not like anyone copying his inventions or pictures. Was this a retaliation for the Kinetoscope being copied and sold to everyone in the UK and abroad?

30. 1904/1905, J. Stuart Blackton and Albert E. Smith, Vitagraph. Not in the American Film Catalog. Not to be confused with Cooper's THE HUMPTY DUMPTY CIRCUS, Kinema Industries, 1914.

"As cameraman, producer and director, Arthur Melbourne-Cooper, for many years, worked in the world of cinematography, and added to his bulky filmography at least some twenty other short films produced with his animation technique, dating from the year 1901 (DOLLY's TOYS) until HUMPTY DUMPTY CIRCUS." (**Giannalberto Bendazzi,** *Il Sole 24 Ore,* **2005.**) [N66]

"...the first animated film that could properly claim this name was probably DOLLY's TOYS (1901), a mixture of live-action and stop-motion puppet animation believed to be the work of Arthur Melbourne-Cooper who went on to make many similar films such as DREAMS OF TOYLAND (1908)." (*BFI Screenonline,* **Animation, 2005.**) [N67]

Recorded interviews

"DOLLYLAND, that will be DOLLY's TOYS, 1901, that is a short one, a sort of experiment." (**Audrey Wadowska to Kenneth Clark, London, 24 Oct. 1978,** T197.)

Audrey Wadowska: "I thought I saw it in a Williamson, but he (Father) didn't know the title. He just remembered A KNIFE CUTTING AN APPLE unaided. Done by animation. And another one, he made a title or something with orange peels or sections of an orange. An orange flies apart and forms a title. I don't know what the title was. I suppose they were pretty short these experiments, like his first doll film. According to Gifford it was the first, 1901, which is fairly early for that type of thing. A little girl falls asleep, and her doll comes to life. That is only one doll, not like A DREAM OF TOYLAND. That was an early experiment. *Tjitte de Vries:* What was the title of the doll film? *Audrey:* DOLLY's eh, – . He did one DOLLY's DOINGS. It is in Gifford's book. How does he know? He doesn't tell us where he gets it from." (**Audrey Wadowska to Tjitte de Vries, London, 4 August 1979,** T177.)

"He started in a small way. About 1901 he made one. I believe Denis Gifford mentions it. As I said I don't know where he got his information from. He made one where a young girl dreams her doll comes to life. Just one doll (DOLLY's TOYS). That was animation." (**Audrey Wadowska to David Cleveland, London, 11 October 1979,** T407.)

Jan Wadowski: "Wait, DOLLY's TOYS, R.W. Paul (Arthur Cooper). *Ken Clark:* That is not completely incorrect, if Arthur Cooper made the film, and sold it to Paul for distribution, then that is correct. *Jan:* It is misleading. Paul didn't do nothing, he made the money. (...) *Clark:* DOINGS IN DOLLYLAND, credited to Urban, in brackets: Alpha. He attempts to be fair." (**Jan Wadowski to Kenneth Clark, St Albans, 21 February 1988,** T409.)

Unpublished manuscripts

"Dolly's Toys (animated)"

(**Audrey Wadowska, A-Z manuscript, 1981,** p. D.)

"In the year of inauguration (of King Edward VII), Arthur released Dolly's Toys (1901), the first in a series of animated toy sequences and films. The simple 'dream' formula repeated again and again with slight variations involved a little girl who falls asleep and dreams that all of her dolls 'come to life'. Critics referred to the toys as 'articulated' or 'mechanical', rarely 'animated', but that did not concern the patrons, they only came to enjoy the novelty. (...) – And we have not mentioned Melbourne-Cooper's further commitment to animation. As we have seen, Arthur specialised first with animated matchstick figures, while the remainder of his animated output under the Alpha label consisted of charming little adventures 'performed' by children's toys and dolls. After an interval following the release of Dolly's Toys, he began to include animation in his films once more, commencing with The Enchanted Toymaker (1904)." (**Kenneth Clark, 2007.**)[N68]

Editorial

There is a confusing note by Audrey Wadowska on a typescript of one of the tape recordings of her father[31] when he is talking about establishing his Alpha Trading Company, which suggests that Dolly's Toys would have been made in a building, the Polytechnic in St Albans, that yet had to be built. We are almost sure that it was made in his new Bedford Park studios.

Gifford-1987 writes: "Cooper was working for Birt Acres at this time and Paul released many of Acres' productions." This is not entirely correct. Cooper was trained by and later worked freelance for Birt Acres

31. Tape recording T005, Coton, early 1959, Arthur Melbourne-Cooper talking to Audrey Wadowska. Note Audrey: "The trick film studio was then moved to the Old Poly, St Albans, that would become later the Alpha Picture Palace." The Polytechnic was built in 1904. The trick work for Dolly's Toys (or Dolly's Adventures), 1901, and A Boy's Dream, 1903, was most probably done at his new studios at Bedford Park, St Albans, after the closing-down of his father's photographic studio at 1, Osborne Terrace, early 1901. In 1908, the Polytechnic at London Road, St Albans, was converted into Cooper's Alpha Picture Palace. He had arc lights from Westinghouse installed, and from then on he did his animation work here. He was probably one of the first film makers to use studio arc lights for lighting. Mr Rolph from St Albans, whose father as a carpenter had worked on the conversion of the Polytechnic, recalled helping from time to time. He knew that the dolls and figures were manipulated by hatpins to keep them in position. He remembered that these puppet films were made indoors under the 'Old Poly'.

from 1892 or 1893 onwards until 1901. In that year, Cooper, as independent producer and film maker, established Alpha Trading Company and Alpha Cinematograph Works at Bedford Park, St Albans. The index of film titles in the Grisdale manuscript contains a wrong reference to DOLLY's TOYS as if it is an alternative title for KIDDIES DREAM (1910), which it is not. We deal with KIDDIES DREAM, which might be a Cooper animation picture, in the chapter *Possibles and (Im)probables*.

There are some remarkable entries in the *American Fim Institute Catalog*[N69]. The first is ANIMATED DOLLS of Pathé Frères, 1903, the second is DOLLY's TOYS, which refers to THE CHILDREN's TOYS THAT CAME TO LIFE, which is the third entry. The Pathé picture has as alternative titles CHRISTMAS NIGHT and NUIT DE NOËL, and the Edison summary speaks about two little girls who, before going to sleep, are being told by their parents that the fairies will bring them dolls. The fairy brings them a boy and a girl doll, which come to life, making love with such a noise that the children wake up, watching their performance, after which the dolls become inanimate again. THE CHILDREN's TOYS THAT CAME TO LIFE (1902) is a Robert W. Paul production distributed by Edison, and the catalogue summary tells about four children receiving a great number of tin soldiers and sailors. When the children are asleep, the toys enlarge, come to life and dance the hornpipe. The children, waking up, join in the festivities. It is clear that this Paul production is a live-action film with tracking shots.

(454.) Cheese Mites * *, 1902, 150 ft., running time 2.30 min.
Live-action interpolated with a stop-motion scene.

Credits
Directed and animated by Arthur Melbourne-Cooper. Production Alpha Trading Company. Studio Bedford Park, Beaconsfield Road, St Albans. Actor unknown. Assistant animator Stanley Collier.

Synopsis
A gentleman at lunch discovers that something is wrong with his cheese. With his magnifying glass he discovers that mites are crawling in all directions. His discovery is enlarged in the screen, and the audience too can see the uncanny creatures.

Contemporary sources
Urban Trading Co., catalogue, London, 1903: 2501
"Special ... CHEESE MITES. A gentleman reading the paper and seated at

lunch, suddenly detects something the matter with his cheese. He examines it with his magnifying glass, starts up and flings the cheese away, frightened at the sight of the creeping mites which his magnifying glass reveals. A ripe piece of Stilton, the size of a shilling, will contain several hundred cheese mites. In this remarkable film, the mites are seen crawling and creeping about in all directions, looking like great uncanny crabs, bristling with long spiny hairs and legs. *Magnified 30 diameters on film*. Length 150 feet."

Complementary sources

Gifford-1973, 1986, 2000: "00705/00722 – September 1903, CHEESE MITES (150). Urban Trading Co – Micro Bioscope. D: F. Martin Duncan. COMEDY. Diner examines cheese through magnifying glass and sees mites magnified '30 diameters'."

Gifford Non-Fiction Film-2000: "02307 – 1903, *The Unseen World* (Series) Aug. 8 (E), Urban, *ph.* F. Martin Duncan, 02307.2 CHEESE MITES (150)

Gifford Non-Fiction Film-2000: 02310 – 1903, *The Living Unseen World* (Series) Aug. 15 (E), Autoscope, *p.* Will Barker, 02310.04 CHEESE MITES (50)

Gifford Non-Fiction Film-2000: 02343 – 1903, *The Unseen World* (Series 2) Sep. (cat), Urban, *d/ph.* F. Martin Duncan, 02343.3 CHEESE MITES (50)."

Catalogue of Viewing Copies, The National Film Archive, London, 1971, (page 87):

"GB. 1903. CHEESE MITES [incomplete] (p.c. Urban). One of the Unseen World series. A magnified shot of cheese mites. [NF.257]. 35 St. 48 ft."

Recorded interviews

Audrey Wadowska (going through old catalogues): "CHEESE MITES, 150 feet, that is Alpha. 'A gentleman reading the paper and seated at lunch suddenly detects something the matter with his cheese. He examines it with his magnifying glass, starts up and flings the cheese away, frightened at the sight of the creeping mites.' He did that technique when we were in Blackpool. This is 1903. *Tjitte de Vries:* Also an example of interpolated close-ups? *Audrey:* Possibly he made the mites out of wool and wire. *Tjitte:* It could be animated? *Audrey:* Could be. A close-up anyway, magnified 30 diameters." **(Audrey Wadowska to Tjitte de Vries, London, 3 January 1978, To15.)**

"*Audrey Wadowska:* These CHEESE MITES – Father made one called CHEESE MITES, but I don't think it had to do with lilliputians. I think it was done with his favourite idea of hand made bugs, made of wire and cotton wool, enlarged through the magnifying glass. *Tjitte de Vries:* Animated? *Audrey:* Yes. Stan Collier recalled that. It was an early one.

You saw the cheese, crawling with bugs and then he enlarged it – the interpolated type, I suppose. You saw these ghastly cheese mites which he made himself. Same as Blackpool for milk, CLEAN MILK CAMPAIGN. He made bugs and things himself with wire and cotton wool." (**Audrey Wadowska to Tjitte de Vries, London, 31 March 1978**, T019.)

Audrey Wadowska: "Now, that one, ON ACCOUNT OF A MOTH, 140 feet, Stan Collier recalled this moth one, and he also recalled one to do with CHEESE MITES. It's typical buffoonery for the time, I suppose. And it is not the one they have got in the Archive under this title." (**Audrey Wadowska to Tjitte de Vries, London, 16 August 1978**, T021.)

Audrey Wadowska: "I don't know about that one, A PIECE OF LIMBURG CHEESE. If it got bugs in it, it might be [father's]. CHEESE MITES is the title that Stanley Collier remembered. But they got one in the Archive where it are lilliputians. Did we not see it at Brighton?[32] *Tjitte de Vries:* A PIECE OF LIMBURG CHEESE, yes. *Audrey:* Yes, that was not father's, no, that was not the same. Father's was bugs in a piece of cheese, and it was blown up through a magnifying glass. *Tjitte:* What we saw in Brighton were real mites, actual mites.

Audrey: I understood father's to be animated mites that he made himself. Not the lilliputians. You remember, it was done by a reflection. It was a man eating in a restaurant, but I didn't understand that to be his. I believe he made some of the bugs himself. You might have seen actual bugs in a cheese, but the big blow-up shown through this disk of a magnifying glass were huge, horrible bugs. But what we saw were worms." (**Audrey Wadowska to Tjitte de Vries, London, 16 August 1978**, T022.)

Audrey Wadowska: "Here is another one that Collier recalled as being very funny. You know that one, CHEESE MITES. He told that father made one called CHEESE MITES, and there were maggots, hand made. They were enlarged. We did a similar thing in Blackpool, and the maggots were in bread this time. Black bread came into being this time, supposed to keep the maggots, or insects out. He did the same thing, and made his own maggots out of wire and cotton wool. Stan Collier said the same.

Now there is a CHEESE MITES. One is made, I believe, with real cheese, a blue cheese, Stilton or something. And enlarged, made by a Duncan or somebody, a famous scientific film maker. And the other is to do with lilliputians in a restaurant. And I think we saw that at Brighton,

32. The FIAF Congress 'Cinema 1900-1906', Brighton, 1978. The author remembers seeing a film CHEESE MITES, apparently French, with actual mites crawling under a microscope in close-up.

where a man is sitting in a restaurant and in the background you see these little midgets. I don't think you see the actual mites in the cheese. He is stuffing himself at the table. But in Father's, he shows this big enlargement of the cheese, maybe it was interpolated even, crawling with these huge home-made maggots. And Stan referred to it as THE CHEESE MITES. But it is not one of the two I have seen catalogued.

Tjitte de Vries: So that could not be the proper title? *Audrey:* Maybe it is changed, but that is the subject." (**Audrey Wadowska to Tjitte de Vries, London, 13 April 1979**. T035.)

Audrey Wadowska: "Now, CHEESE MITES, that is not what we thought it was. The CHEESE MITES that Stan Collier remembered – Father made insects out of wire and cotton wool, which you saw moving around in a piece of cheese. But this isn't. *Tjitte de Vries:* We saw in Brighton real mites under a microscope, remember? *Audrey:* What they showed us when we had a viewing session was a man sitting at a table with lilliputians, I think it was, dancing on the table. That was not his. This was nothing to do with cheese mites." (**Audrey Wadowska to Tjitte de Vries, London, 17 April 1981**, T051.)

Audrey Wadowska: "CHEESE MITES – I was going to cross it out, but he made one with cheese mites, because Stan Collier recalled it. It was done with (animated) insects in the cheese, but what they showed us, wasn't. It was a man stuffing himself at the table and lilliputian figures in the distance, doing a jig or something. *Tjitte de Vries:* Your father's one was animated? With cotton and wire? *Audrey:* Yes, he animated it. (...) 'The Unseen world' includes CHEESE MITES. A diner examines cheese with a magnifying glass that is crawling with hundreds of mites, Stilton cheese – I imagine that's his. Hairy? Magnifying 30 times? Could that be his? That is in (Charles Urban's) 'The Unseen World' series." (**Audrey Wadowska to Tjitte de Vries, London, 19 April 1981**, T056.)

Editorial

It is clear that Cooper's CHEESE MITES (1902) should not be confused with R.W. Pauls's trick film THE CHEESE MITES (1901) (Gifford 00432 – September 1901. "THE CHEESE MITES; OR, LILLIPUTIANS IN A LONDON RESTAURANT (70 ft) R.W.Paul. D: (W.R.Booth). Trick. Six-inch high sailors dance upon diner's cheese.") Walter Booth was a conjuror who made very early trick films, working on and off at the Alpha film studios in St Albans or at the film studios of R.W. Paul. Gifford has Booth's name between brackets, apparently not being certain of crediting it to him.

Charles Urban's CHEESE MITES (1903) seems to be the one that Cooper made. Some pictures of Cooper were mis-treated by Urban who,

behaving as a rightful owner – as most distributors did in those early years when films were bought by the foot – did with them what he thought was commercially in his best interest and released them in his own time. Films of Cooper were sometimes cut up in different short lengths with individual titles. Sometimes sections from a film by Cooper were cut into other films. This happened, for instance, with the animation scenes from THE FAIRY GODMOTHER (1906) which Urban titled NOAH'S ARK, and recommended in his 1909 catalogue to precede his animal series 'Our Farmyard Friends'.

With CHEESE MITES, we imagine that the following happened. In 1902, Urban bought the original CHEESE MITES from Cooper, cut the inserted close-up with the comical insects out of it, and replaced them with a close-up through a microscope of real mites filmed by F. Martin Duncan, in this way making the film to fit into his series of microscope pictures 'The Unseen World'.

Audrey's recollections about CHEESE MITES are rather strong. It fits well in Cooper's regular output of pictures in these years. In 1901 he made an animation picture DOLLY'S TOYS, in 1903 it was A BOY'S DREAM as an animation picture. Considering Urban's habit never to release his films too hastily, the production date of 1902 seems to us to be realistic. It tallies with the fact that Cooper made at least one animation picture every year, in this case a comedy with an animation insert.

8. A Boy's Dream*, 1903, approx. 200 ft., running time 3.20 min.
A.k.a. THE MINIATURE CIRCUS and THE BOY'S CIRCUS.
Live-action and stop-motion animation. Also coloured.

Credits
Directed and animated by Arthur Melbourne-Cooper. Production Alpha Trading Company. Studio Bedford Park, Beaconsfield Road, St Albans. Child actor unknown.

Synopsis
A boy dreams of his box of toys opening, and the toys come to life and give a circus performance.

Contemporary sources
William Jury Catalogue, London, 1905 – page 10.
"THE MINIATURE CIRCUS. A Boy's dream of his Box of Toys – a most wonderful series of pictures showing a full Circus Performance by the miniature box of toys. Magnificently coloured. *10 minutes*."

Recorded interviews

"Around this time, 1904, Father also made another one, called THE BOY'S DREAM, and a box of toy soldiers come to life, but I haven't seen that one." (**Audrey Wadowska to Tjitte de Vries, London, 3 January 1978, T018A.**)

Audrey Wadowska: "There is also the one with the box with the toy soldiers that come to life. I haven't found the title of that one yet. Nor the circus one that Jackeydawra[33] remembers being made in Warwick Court for Kinema Industries.[34]

Tjitte de Vries: The box with the toy soldiers, that could be in this one?

Audrey: Could it? I understood Father said it was a boy. A boy's box with toy soldiers, he said, came to life. (...) But animated dolls, I am sure, it is his. It might have been called DREAMLAND ADVENTURES,[35] because that is one of Father's titles, it might be that. I would not like to touch these things[36] until I have more evidence." (**Audrey Wadowska to Tjitte de Vries, London, 19 August 1978, T029.**)

(Going through old catalogues): "We have not found THE BOY'S CIRCUS or THE BOY'S BOX OF SOLDIERS yet. They come to life, and it is this early, 50 or 60 foot. (...) The MINIATURE CIRCUS, ten minutes, this is it! A boy's dream of his box of toys." (**Audrey Wadowska to Tjitte de Vries, London, 20 August 1978, T030.**)

"THE ENCHANTED TOYMAKER (1904) – there is a boy's dream there, he dreams that his toy soldiers come to life." (**Audrey Wadowska to Kenneth Clark, London, 24 October 1978, T198.**)

"*Tjitte de Vries:* He made at least two toyland films? *Audrey Wadowska:* Several. One was THE LITTLE FAIRY[37] where a fairy with a wand strikes an ark. It is a sort of NOAH'S ARK, but it is not like NOAH'S ARK[38] because this follows the story of the flood. But it is possibly the same ark. That was made about 1904. I think it is in Paul's catalogue anyway. He made A BOY'S DREAM where he dreams that his toys come alive. He made

33. Actress Jackeydawra Melford, daughter of actor Mark Melford.

34. THE HUMPTY DUMPTY CIRCUS, 1914, Arthur Melbourne-Cooper, Kinema Industries Ltd./R. Prieur.

35. DREAMLAND ADVENTURES, 1907, 540 ft. Gifford 01691: Urban/W.R. Booth. See our chapter Possibles and (Im)probables.

36. Audrey Wadowska is referring here to Kemp Niver's *American Mutoscope & Biograph Bulletin 100*, 8 June 1907, DOLLS IN DREAMLAND, which definitely was not made by Cooper.

37. THE FAIRY GODMOTHER, 1906.

38. NOAH'S ARK, 1909.

A TOYMAKER'S DREAM[39] and GRANDPA'S FORTY WINKS."[40] (**Audrey Wadowska to Tjitte de Vries, London, 28 May 1981,** T057.)

Unpublished manuscripts

"BOY'S DREAM (animated Toys) Box of Toys"

(**Audrey Wadowska, A-Z manuscript, 1981,** page B.)

Editorial

The production date is probably 1903, because from now on Cooper usually produces a puppet film each year.

There is confusion by Audrey Wadowska about the picture. She mixes up A BOY'S DREAM with THE ENCHANTED TOYMAKER, and mistakes one story line for the other: 1) A box of toys opens and there is a circus performance; 2) a box with toy soldiers opens.

Screened at 16 fps this picture lasts a little less than $3\frac{1}{2}$ minutes in projection and not the advertised 10 minutes.

Though we are certain that Cooper made A BOY'S DREAM, it is Audrey's uncertainty that allows it only a single star until we come across more indicators.

9. The Enchanted Toymaker * * * *, 1904, 190 ft.,
running time 3.10 min.
A.k.a. THE FAIRY GODMOTHER, and TOY MAKER AND GOOD FAIRY.
Live-action and stop-motion animation.

Credits

Directed and animated by Arthur Melbourne-Cooper. Production Alpha Trading Company. Studio Bedford Park, Beaconsfield Road, St Albans.

With (probably) Samuel Chote as the toymaker, and Hattie Makins as the fairy.

Synopsis

An old toymaker dreams that a fairy brings to life his toy animals who are entering an enlarged Noah's Ark.

Contemporary sources

R.W. Paul, *Animatograph Films,* **catalogue, London, Sept. 1904,** page 44.
"A busy toy maker is confronted by a good fairy, who causes the toys to take life. The Noah's Ark enlarges and the animals majestically enter.

39. THE TOYMAKER'S DREAM, 1910.
40. IN THE LAND OF NOD, 1907.

The man locks them in and sets a toy soldier on guard. The latter fires his gun to the shopman's bewilderment. An excellent picture for children. Code word Ark, length 190 feet."

Complementary sources

Gifford-1973, 1978, 1986, 2000: "00840/00856 – June 1904 (190), THE ENCHANTED TOYMAKER *also*: THE OLD TOYMAKER'S DREAM, Alpha Trading Company, (Paul), P:D:S:A: Arthur Cooper. Trick. 'Old man dreams fairy enlarges his Noah's Ark and toy animals enter it'."

Gifford-1987: "1904, (190). THE ENCHANTED TOYMAKER, a.k.a. THE OLD TOYMAKER'S DREAM, Alpha Trading Company – Paul, P:D:S:A: Arthur Cooper. Animated toys/live-action. 'The first animated film we can definitely attribute to Arthur Cooper, who had by this time left the employ of Birt Acres to establish his own small studio, the Alpha Trading Company, at St Albans, Herts.' Released June 1904."

The American Film Institute Catalog 1893-1910 Indexes, Metuchen, 1995, page 92: "Cooper Arthur, 1904, Jul (day undetermined), TOY MAKER AND GOOD FAIRY."

The American Film Institute Catalog 1893-1910 Indexes, Metuchen, 1995, page 133: "Alpha Trading Co. 1904, Jul (day undetermined), TOY MAKER AND GOOD FAIRY."

The American Film Institute Catalog 1893-1910 Film Entries, Metuchen, 1995, page 1082. "TOY MAKER AND GOOD FAIRY, A15734 – Alpha Trading Co.; Robert W. Paul. Dist. Edison Mfg. Co. Catalog listing Jul 1904. b&w; 190 ft. [code no. 5983; code name: Vangrad; source: ECJY4]. Country of origin Great Britain. Dir. Arthur Cooper. Alternate title: THE ENCHANTED TOYMAKER [BFC title]; THE OLD TOYMAKER'S DREAM [Alternate BFC title]."

Publications

"Cooper's animation career really commenced in 1904 with THE ENCHANTED TOYMAKER, produced by R.W. Paul. This film also marked the beginning of Cooper's long infatuation with the theme of Noah's Ark." (**Donald Crafton, 1982.**)[N70]

"Either Cooper's DOLLY'S TOYS, released in 1901, or THE ENCHANTED TOYMAKER, of 1904, could have provided inspiration for Blackton if they contained true animation, since it is likely that they were both duped and distributed by Edison. The February 1903 catalogue describes ANIMATED DOLLS, a film in which sleeping children are visited by a fairy.

'The dolls which are dressed as boy and girl, come to life and begin to make love to each other. They make so much noise (...) that they wake up the children. Upon seeing the action of the little people, the children are very

much amused, and sitting up in bed, they watch the performance. Finally the dolls, upon seeing that they are discovered, resume inanimate form, and the children jump out of bed to get them.'

While this may have been a remake by Edison's special effects buff, Edwin S. Porter, it seems more likely that the film was simply a retitled dupe of Arthur Melbourne-Cooper's original. The same may be said for THE TOYMAKER AND THE GOOD FAIRY, described in the September 1904 catalogue: "(The toymaker) is surprised to see all the toys he touches move as though alive... (Toys) march along in rapid succession until all are inside the ark." This subject and its treatment resemble Melbourne-Cooper's THE ENCHANTED TOYMAKER, which had been released earlier in 1904 by R.W. Paul.

Circumstantial evidence exists in the fact that Edison freely duped and distributed Pathé films during this period. Paul's films were distributed in the United States by Williams, Brown and Earle and by Miles Brothers.

The animated toy scene in both Cooper films may also have been a likely influence on THE HUMPTY DUMPTY CIRCUS.[41] Unfortunately, neither of the British films nor their American versions have been located, and some historians have questioned whether there were any truly animated films before the technique was learned from Blackton.[42] However, pointedly, it now seems, Smith had referred to his Vitagraph film as "the first stop-motion film in *America*" (my emphasis), so the possibility of foreign inspiration should not be hastily dismissed. It is reasonable to conclude that the Blackton and Smith film, if existed, was made around late 1904 and was patterned either directly on Cooper's films or, indirectly, on Porter's imitations. This would explain the reason for Blackton's silence concerning his alleged status

41. 1904/1905, J. Stuart Blackton and Albert E. Smith, Vitagraph. Not in the American Film Catalog. Not to be confused with Cooper's THE HUMPTY DUMPTY CIRCUS, Kinema Industries, 1914.

42. Notwithstanding his argumentation concerning Cooper's influence on, or his films possibly being duped by Edison, Crafton has in this paragraph two peculiar end notes to clarify his 'questioned'. "I am grateful to (Kirstin) Thompson, Charles Musser, and Patrick Loughney for their opinions regarding my hypothesis. I am also grateful to Barry Salt, who, in a 1988 conversation, expressed strong reservations about the dating of the Melbourne-Cooper films mentioned. Obviously this is an area for further research." The second end note quotes Barry Salt: "Claims that this (i.e. the use of 'single frame animation technique') happened earlier (in European films) are bogus," from his *Film Style and Technology, History and Analysis*, 1988, page 72.

as the inventor of animation. He knew that it was not true." (**Donald Crafton, 1990.**)[N71]

Recorded interviews

Audrey Wadowska (going through old catalogues): "This one, THE ENCHANTED TOY MAKER, Father's original title apparently was THE FAIRY GODMOTHER, it is the Noah's Ark theme. This is 1904. (Reads:) *A busy toymaker is confronted by a good fairy, who causes the toys to take life. The Noah's Ark enlarges and the animals majestically enter. The man locks them in and sets a toy soldier on guard. The latter fires his gun to the shopman's bewilderment. An excellent picture for children.* It is animated, that's right. Around this time Father also made another one, called THE BOY'S DREAM, and a box of toy soldiers come to life, but I haven't seen that one. (...)

This is **not** Father's NOAH'S ARK, it is the story. You see here the fairy from THE ENCHANTED TOYMAKER. That little fairy girl scouts the ark and out come the animals. Just a short version." (**Audrey Wadowska to Tjitte de Vries, London, 3 January 1978**, To18A.)

Audrey Wadowska: "THE ENCHANTED TOYMAKER, (1904). There is a boy's dream there, he dreams that his toy soldiers come to life.[43] (...) *Kenneth Clark:* FAIRY GODMOTHER has nothing to do with CINDERELLA? *Audrey:* No. FAIRY GODMOTHER is another title for THE ENCHANTED TOYMAKER. (...) And in the other early one, THE FAIRY GODMOTHER, which is THE ENCHANTED TOYMAKER, there is this little girl dressed as a fairy with this ark. She strikes this ark, it is much shorter.

It is quite short, I can give you the length of that because that appears in Robert Paul's catalogue. I think it is 140 (?), something like that. And you just see the animals go into the ark. And in the other one -. *Ken:* That is THE FAIRY GODMOTHER or THE ENCHANTED TOYMAKER? *Audrey:* Yes, that is the same one. That is father's title, the other is in Paul's catalogue. *Ken:* Your father was first with THE ENCHANTED TOYMAKER? Robert Paul's is THE ENCHANTED TOYMAKER." (**Audrey Wadowska to Kenneth Clark, London, 24 October 1978**, T199.)

"Then he made another one, which is in Paul's catalogue, with a Noah's Ark, where a little girl, and her name was Makins, she is in the still that is published, you see her about to strike an ark with a wand. Just a short one, a few hundred feet, where these animals come out of the ark. I think it is called THE FAIRY GODMOTHER." (**Audrey Wadowska to David Cleveland, London, 11 October 1979**, T407.)

43. Audrey Wadowska confuses the title with the story of A BOY'S DREAM.

Audrey Wadowska (going through old notes): "THE FAIRY GODMOTHER. Two children are put to bed by a nurse and a fairy godmother waves her wand and over the Noah's Ark on the table, etc. And they have the animals. It was very... when it was done, that is 1908, but it was made before that." (**Audrey Wadowska to Tjitte de Vries, London, 16 April 1981,** T056.)

Unpublished manuscripts

"ENCHANTED TOYMAKER (Animated) -> Fairy Godmother.
FAIRY GODMOTHER (Puppets – 1903-4)."
(**Audrey Wadowska, A-Z manuscript, 1981,** page F.)

"After an interval following the release of DOLLY's TOYS he began to include animation in his films once more, commencing with THE ENCHANTED TOY MAKER (1904). (...) Among his animated toys films (...) the dream sequence scenario enjoyed the greatest popularity. In THE ENCHANTED TOY MAKER a good fairy appears before a busy toymaker and then causes the toys to come to life by exercising her magic. The toys march into Noah's ark, and the flood waters rise. Noah releases a dove who returns with a leafy twig. Many people were employed to animate the various dolls and animals over a period of two months, during which at no small inconvenience, Cooper filmed the entire event in his domestic bathtub where, with tap and bath-plug, he had complete control of the flood waters. Suspension of the dove during the flying sequences gave him trouble at first when fine thread, fishermans line, thin wire, all showed up on film. Eventually, he remembered his earlier solution to flying football and cricket balls, and the problem was solved with the aid of a couple of fine hairs from his wife's head.

Cricks & Sharp's released their version of the same film, THE FAIRY GODMOTHER (1906) with an alternative opening, this time it began with a maidservant who is asked to babysit, predictably, she falls asleep, and the child watches the ensuing action of the toys. Charles Urban possessed a copy of Cooper's original film and re-titled it THE STORY OF THE ARK; and since it was his habit to cut-and-splice in order to make compilation films – the Noah's Ark sequence was included in one of them. During her researches, Audrey Wadowska discovered her father's individual films released under many different titles."
(**Kenneth Clark, 2007.**) [N72]

Editorial

THE FAIRY GODMOTHER was Cooper's original title according to Audrey Wadowska. This is not correct because it is a different picture. See THE FAIRY GODMOTHER, 1906. Kenneth Clark, possibly according to what

Audrey told him, also supposes it to be the same film, explaining the differences in the catalogue descriptions by assuming that Cricks & Sharp gave their THE FAIRY GODMOTHER (1906) an alternative opening. However, the animation sequences are also different. In THE ENCHANTED TOYMAKER the animals are entering the ark. In THE FAIRY GODMOTHER, made two years later, the animals are leaving the ark.

Gifford 00840/0856: "*also* THE OLD TOYMAKER'S DREAM". This may have been its alternative title in the US, it is not correct because it is a different film. See THE TOYMAKER'S DREAM, 1910.

Further comment on Gifford: at the end of 1901, after his father's death and Acres' move to Whetstone, Cooper rented Bedford Park, Beaconsfield Road, St Albans, which with its 2 acres and a 2-storey cottage could not be called "small". Here he established his Alpha Trading Company (ATC) and Alpha Cinematograph Works (the studios and laboratory).

According to film historian Barry Salt, there were no animation films made in other countries than the US before 1906. How does Salt know this? He does not give evidence for this statement. Hardly any animation or so-called animation pictures from this period have survived to clarify his rash statement. Neglecting the fact that several early film cameras were equipped with simple techniques to make frame-by-frame exposures,[44] he writes: "The true single-frame technique was applied to a series of drawings by J. Stuart Blackton in 1906 to produce the first true filmed animated motion picture in HUMOROUS PHASES OF FUNNY FACES, and it was only after this that single frame animation technique was used in European films. Claims that this happened earlier appear to be bogus." (**Barry Salt, 1988.**)[N73]

On the other hand, Stuart Blackton never made much, if any, comment on his work as animator. He ignores it as if he doubted his prominence in this area.

However, not only Gifford, also the American Film Institute Catalog, based on contemporary sources, credits Cooper as the director of the 1904-Alpha production, TOYMAKER AND THE GOOD FAIRY (THE ENCHANTED TOYMAKER). This animation picture deserves in full confidence its four stars.

44. See footnote no. 1, letter of David Claveland, 9 June 2007.

10. Doings in Dolly Land * *, 1905, 375 ft., running time 6.15 min.

A.k.a. DOLLY'S DOINGS. Stop-motion animation only.
Reissue DOLLY'S DOINGS, Walturdaw 1913-1914 (500ft.).

Credits

Directed and animated by Arthur Melbourne-Cooper. Production Alpha Trading Company. Studio Bedford Park, Beaconsfield Road, St Albans.

Synopsis

Adventures of animated dolls.

Contemporary sources

Walturdaw Trading Co., catalogue, London, 1913-1914:

"4. Animated Toy Comedies. DOLLY'S DOINGS, 500 FT."

Complementary sources

Gifford-1973, 1986, 2000: "01205/01224 – Nov. 1905 (375). DOINGS IN DOLLY LAND, Urban Trading Co. (Alpha?). Trick. Adventures of animated dolls."

Recorded interviews

Audrey Wadowska (going through Walturdaw catalogues 1913-1914): "Now, these animated cartoons, DOLLY'S DOINGS is Father's. (...) They would be reissues. I am not sure about THE MAGIC PIG, but DOLLY'S DOINGS is quite early." **(Audrey Wadowska to Tjitte de Vries, 20 April 1979, T038.)**

Tjitte de Vries (going through Audrey Wadowska's notes): "What was the title of the doll film?[45] *Audrey Wadowska:* Dolly's, eh – he did one DOLLY'S DOINGS. It is in Gifford's book. How does he know? He doesn't tell us where he gets it from. *Tjitte:* But with so many titles credited to your father..." **(Audrey Wadowska to Tjitte de Vries, 4 August 1979, T177.)**

Audrey Wadowska (going through her old notes): "I got here 'Copyrighted by Urban: IN DOLLYLAND'. As far as I know it is bluff. At the Public Record Office are only five or so films copyrighted. Anyway, IN DOLLYLAND is one of Father's early animation films. (...) But IN DOLLYLAND is Father's. But it says in Urban's catalogue, December 1905, that it is copyrighted." **(Audrey Wadowska to Tjitte de Vries, London, 18 August 1979, T117.)**

Audrey Wadowska (going through old notes): "THE FAIRY GODMOTHER,

45. DOLLY'S TOYS, a.k.a. DOLLYLAND, 1901, 80 ft.

Cricks 140 feet, is made by Father and is that toy one I told you about. A toy Noah's ark. Made in 1904 not 1906. (...) That is a toy film. That comes after DOINGS IN DOLLY LAND. Maybe the same ark was used as in NOAH'S ARK, but it is not the same. (...) DOINGS IN DOLLYLAND is Alpha. Denis Gifford puts it down as 1901. Better check that. (...) *Tjitte de Vries:* Gifford 1901 is DOLLY'S TOYS. A child dreams that her toys come to life. *Audrey:* And here it is, DOINGS IN DOLLYLAND, so it must be another one [than DOLLY'S TOYS], 1905." **(Audrey Wadowska to Tjitte de Vries, London, 19 April 1981,** T054.)

"*Kenneth Clark:* DOINGS IN DOLLYLAND is credited to Urban, in brackets: Alpha. He (Gifford) attempts to be fair. *Jan Wadowski:* He is alright. Sometimes he puts it right. *Ken:* When you are doing a book like this, you must follow cast-iron rules." **(Jan Wadowski to Kenneth Clark, St Albans, 21 Febr. 1988,** T409.)

Editorial

Screening time of the original picture is more than 6 minutes, which is quite long for those days. What did Walturdaw add to advertise its reissue eight years later as 500 feet, running time 8.20 minutes? Perhaps Walturdaw added a lot of titles.

This film should not be confused with DOLLY'S TOYS, 1901.

Because this film and many, many other films from this period are lost, it is clear that we suffer an enormous disadvantage in not being able to actually see the films in order to give proper judgements. Therefore, it is also a great pity that Audrey Wadowska, who studied unceasingly so many old distribution catalogues and trade magazines on the basis of what she knew from her father, neglected to make a title index system of some sort. It would have prevented her being confused about a number of titles and title changes.

I I. The Fairy Godmother **, 1906, 140 ft., running time 2.20 min.
A.k.a. THE LITTLE FAIRY.
Live-action and stop-motion animation.

Credits

Directed and animated by Arthur Melbourne-Cooper. Production Alpha Trading Company. Studio Bedford Park, Beaconsfield Road, St Albans.

Synopsis

Two children tucked up in bed by their nurse, see a fairy bringing the

animals of their toy ark to life, which are then disembarking.

Contemporary sources

Cricks & Martin Lions Head no. 93, London, December 1906, page 37, "THE FAIRY GODMOTHER. Price £3 10s. 140 ft or 43 meters. Code word Fairy. 'Two little children are being tucked up in bed by the nurse, who then sits down to read but drops off to sleep. The Fairy Godmother appears and waving her wand over an immense Noah's Ark standing on a table, the animals are seen to walk out in procession, to the huge delight of the children. The Fairy Godmother moves slowly off just as the maid wakes up. A very seasonable picture'."

'Urban Films', The Charles Urban Trading Company Film Catalogue, London, November 1906, pages 138-143. "NOAH'S ARK. 2116 ... LIFE IN THE ANIMAL KINGDOM."

"2116* ... NOAH'S ARK (Section H), EXTRA. 'Showing the wooden animals of the Children's Ark, descending the gangway in pairs. This section is adaptable to precede the 'Animal Kingdom' Series, thus carrying out the nature of the title'. Length 75 feet."

'Urbanora',[46] General Catalogue of Classified Subjects, London, 1909, page 109.

"2116* NOAH'S ARK (Section H), EXTRA. 'Showing the wooden animals of the Children's Ark, descending the gangway in pairs. This section is adaptable to procede [sic] the 'Animal Kingdom' Series, thus carrying out the nature of the title'. 75""

Complementary sources

Gifford-1973, 1986, 2000: "01493/01483 – Dec. 1906, (140). THE FAIRY GODMOTHER, Alpha Trading Co. (Cricks & Sharp) d. Arthur Cooper. Trick. Child watches toy Noah's Ark come to life while maid is asleep."

Gifford-1987 (page 9): "THE FAIRY GODMOTHER, AKA NOAH'S ARK, Alpha Trading Company-Cricks & Sharp. P:D:S:A: Arthur Cooper. Animated toys.

'Maidservant falls asleep and her young charge watches a toy Noah's Ark whose animals come to life. Released December 1906. Print preserved in the National Film Archive under NOAH'S ARK'."

Publications

"THE FAIRY GODMOTHER (1906) featured a child who stared in amazement as the animals in his toy ark paraded around his sleeping nanny, and Noah's beasts were the stars of the 1909 TALE OF THE ARK." **(Donald Crafton, 1982.)**[N74]

46. Charles Urban Trading Company, Urbanora House, London.

Recorded interviews

"THE FAIRY GODMOTHER, yes, this is Alpha. This one was made before DREAM OF TOYLAND. I got here Little Fairy." (**Audrey Wadowska to Tjitte de Vries, London, 20 August 1978,** T030.)

"THE FAIRY GODMOTHER is made by father and is that toy one I told you about. A toy Noah's ark. Made in 1904 not 1906. It is in Paul's catalogue with a still. There is a fairy with a wand who is about to strike an ark, just a little thing, a little girl dressed out like a fairy. That is a toy film. That comes after DOINGS IN DOLLY LAND. Maybe the same ark was used as in NOAH'S ARK, but it is not the same." (**Audrey Wadowska to Tjitte de Vries, London, 19 April 1981,** T054.)

"THE FAIRY GODMOTHER, two children are put to bed by a nurse and a fairy godmother waves her wand over the Noah's Ark on the table, etcetera. And they have the animals. It was very (popular) when it was done, that is 1908, but it was made before that." (**Audrey Wadowska to Tjitte de Vries, London, 19 April 1981,** T056, 2nd interview.)

Unpublished manuscripts

"FAIRY GODMOTHER (Puppets – 1903-4)".

(**Audrey Wadowska, A-Z manuscript, 1981,** page F.)

"Cricks & Sharp's released their version of the same film, THE FAIRY GODMOTHER (1906) with an alternative opening, this time it began with a maidservant who is asked to babysit, predictably, she falls asleep and the child watches the ensuing action of the toys. Charles Urban possessed a copy of Cooper's original film and re-titled it THE STORY OF THE ARK; and since it was his habit to cut-and-splice in order to make compilation films – the Noah's Ark sequence was included in one of them. During her researches, Audrey Wadowska discovered her father's individual films released under many different titles." (**Kenneth Clark, 2007.**)[N75]

Editorial

THE FAIRY GODMOTHER, Walturdaw 1908, 690 ft. (running time 11.30 minutes!) is considering its length most probably not an animation picture but a live-action performance of the fairy theme.

Gifford gives the synopsis of NOAH'S ARK (1909) which is a different film than THE FAIRY GODMOTHER. Audrey Wadowska in her turn confuses this film with THE ENCHANTED TOYMAKER (1904). Kenneth Clark, too, confuses both films. Because of all the confusion we award this title only two stars.

In The ENCHANTED TOYMAKER the animals are entering the ark, while in this film the animals are disembarking. In NOAH'S ARK the

animals are both embarking the vessel, and disembarking after the flood.

Charles Urban cut the animation sequence (75 feet, running time 1.15 minutes) out of the original THE FAIRY GODMOTHER picture in order to use it as an introduction to his *The Animal Kingdom* series of live nature films (length 1950 feet, total running time 32½ minutes!)

(258). Professor Bunkum's Performing Flea * * * *

1907, 505 ft., running time 8.25 min.

A.k.a. THE TERRIBLE FLEA, THE WONDERFUL FLEA, THAT AWFUL FLEA, THE SHOWMAN'S TREASURE, ADVENTURES OF A PERFORMING FLEA, WANDERINGS OF A FLEA, A PHENOMENAL FLEA and FLEA PERFORMING.

Comedy. Live-action with only one animation close-up.

Credits

Directed and animated by Arthur Melbourne-Cooper. Production Alpha Trading Company. Location live-action scenes Barnet fair. Studio scenes and animation at Bedford Park, Beaconsfield Road, St Albans.

Synopsis

In a tent at Barnet fair, Professor Bunkum, for a penny, shows a visiting lady under a microscope a harnessed flea pulling a toy waggon. Another lady entering the tent sees no flea. The professor with a magnifying glass searches for his treasure, finds it on a lady's ankle who escapes him with the traditional mayhem of a chase all over the fairground as the result.

Details

The 18-inch flea with special joints and with harnass and wagon was supplied by Hamleys Toyshop, Regent Street, London for the sum of £3 3s.

Primary source – Arthur Melbourne-Cooper

List of film titles in Mrs Kate Melbourne-Cooper's handwriting, authorized by Arthur Melbourne-Cooper, Coton, 1956.
"PERFORMING FLEA".

Arthur Melbourne-Cooper to Bert Barker of the Fairground Society, London, August 1960 (T006A, tapes XIII/XIV, cd 13a/17, 13b/17 and 14/17).

"That was a bigger affair, that was a staged affair, you see, fixed up in a tent. You took a tent, at Barnet, when the fair was on, that was taken. Professor Bunkum was a man dressed up as a professor. He goes in the

tent, and he comes out of the tent. That is then alright. To get that, you have to get this old woman, and you have to stage it, a table and a microscope. She pays the penny when she gets inside the tent, and she goes to the microscope. After she looks at it, she leaves it. Then you have to show the microscope and the flea. You got to join up the film and put up your microscope. You have the old woman looking in the microscope, and you cut the film when she looks away. Then you see the ring, the microscope, and the flea in there and what it is doing there. Then she looks up again. Then you join that up again and the old woman goes out. That is how that was taken in there. (...)

Hamleys made me a flea that size, the flea was as big as that, the biggest ever I would think. After using it I took it to the hospital. Then you have to harness that into that thing, and you have this ring of the microscope as big as a hoop. You cut that and you put that in. And when you are looking at it, you see the woman puts her head over the microscope, and you see the ring with the flea in it. That was a change-over, you see. And then she clicks off. As soon as you have got that, the woman goes out, and you have another woman coming in and looking at the microscope, there is nothing in it. You only had one flea in it. She turns to the professor and tells him."

Arthur Melbourne-Cooper to John Grisdale, Coton, March 1960 (T043, tape IV, cd 9a/17 and 9b/17).

"The flea shots were taken in the studio. (...) She looks into the microscope and she sees this thing on the table with a waggon behind, and she looks, she shakes the hand of the professor. Another one comes in, and she looks into it, and there is no flea. He goes into the microscope, the flea is gone. She went into the crowd."

Contemporary sources

The Kinematograph and Lantern Weekly, London, 12 September 1907, page 285.

"Latest productions. Walturdaw Co. ADVENTURES OF A PERFORMING FLEA, 350 feet."

Walturdaw Ltd. Catalogue, London, 1907, page 7.

"THE TERRIBLE FLEA. 350 ft."

The Kinematograph and Lantern Weekly, London, 19 September 1907, page 300.

"Graphic Films.[47] – Unsurpassed for Steadiness and Photographic

47. The Graphic Cinematograph Co., 154, Charing Cross Rd., London, was Cooper's friend William Jeapes's distribution company.

Excellence. – THE SHOWMAN'S TREASURE. The 'star' turn of the show, a giant flea, escapes from its stronghold owing to an accident resulting from useful inquisitiveness, and having gained its freedom loses no time in making its presence felt to various individuals. It is the flea's day out! and being no respecter of persons, it has a beanfeast!!! The showman – to whom the flea is daily bread and butter – seeks high and low for it, and with a large magnifying glass to aid him in his search, leaves no stone unturned, nay, he leaves no person 'unturned' whom he may suspect of harbouring his 'treasure'. The slightest evidence of discomfiture amongst those who cross his path escapes not his eagle eye, and the magnifyer is brought to bear upon all and sundry with little success, until at length his persistent efforts are rewarded by the capture of the 'treasure' under circumstances which provide a scene redolent of humour, and which is the cause of yells of laughter from audiences before whom it is shown. This is a real tickler. Length 505 ft. Price, £8 8s. 4d. nett."

The "WALTURDAW" Animated Pictures catalogue, London, 1907, page 125. "Set 1738. THE ADVENTURES OF A PERFORMING FLEA. A performing flea escapes from a booth where he is 'engaged', and alights on the person of a lady. She tears off, pursued by the proprietor, anxious to regain his 'artist'. Others join in the pursuit, but the flea gets away, after many accidents have occurred in trying to recover him. 350 feet."

The Kinematograph and Lantern Weekly, London, 15 Oct. 1908, page 6. "The Artograph Co., (Central Film Exchange.) 8, New Compton Street, Charing Cross Road, London, W.C. New Films at 2d per ft., WANDERINGS OF A FLEA, 350."

The Kinematograph and Lantern Weekly, London, 15 Oct. 1908, page 7. "The Artograph Co., (Central Film Exchange.) We do not Hire! New Films at 2½ d per ft., PHENOMENAL FLEA, 395."

Urban Trading co. catalogue, London, 1909, page 32. "3237 – A PHENOMENAL FLEA. The favourite performing flea of a showman escapes from its owner. His frantic efforts to recover possession of his money-earner are even more ludicrous than are the struggles of the creature's victims to rid themselves of its unwelcome presence. 395."

The Kinematograph & Lantern Weekly, London, 27 May 1909, page 112.
"Walturdaw Ltd. These Films are NEW and have been used as Stock Samples only. FLEA PERFORMING (Comic) length 350 ft. Price per ft. 2d."

Complementary sources

Gifford 1973, 1978 (page 70), **1986, 2000:** "01720/01649 – September

1907, (350), THE ADVENTURES OF A PERFORMING FLEA, Alpha Trading Co. (Walturdaw), D: Arthur Cooper. Comedy. Showman searches for escaped flea."

Gifford 1973, 1978 (page 70), **1986, 2000:** "01727/01656 – THE SHOWMAN'S TREASURE, September 1907, (505), Graphic. D: (Arthur Cooper), Chase. Showman uses magnifying glass to search for escaped flea."

Recorded interviews

"My father made a film about a performing flea, PROFESSOR BUNKUM'S PERFORMING FLEA, some comic situation, a flea jumping from one person to another. Lots of scenes were taken locally." (**Audrey Wadowska to Gordon Fisher, St Albans, August 1964,** T042.)

"Now, FLEA PERFORMING (350 ft), that will be Father's PROFESSOR BUNKUM'S PERFORMING FLEA. It has several other titles. It was also called THE WONDERFUL FLEA. Bunkum means a silly fool, a fake, a stupid man, if somebody tells you a story which you don't believe, you'd say: That is bunkum. It is also called THAT AWFUL FLEA, and Graphic, Jeapes's company, called it, which is the best title as I reckon, THE SHOWMAN'S TREASURE." (**Audrey Wadowska to Tjitte de Vries, London, 3 January 1978,** T015.)

"THE TERRIBLE FLEA – that is Father's PROFESSOR BUNKUM'S PERFORMING FLEA, which is an Alpha. Bunkum is, if you are telling a yarn that is not true – if you are passing something off on someone who is gullible. There was a typical fair-ground hall: it is bunkum. You see, this thing that he made, this early one, some of these old films are based on actual things that happened in his childhood, childhood re-enactments. This is PROFESSOR BUNKUM'S PERFORMING FLEA. Now, some of the scenes were taken at Barnet Fair, and he had the flea especially made for him, and you see a great big enlargement of it, this ghastly flea. And I met someone who remembered having seen it, and mother remembered it actually, and she would say it was about that size, she wouldn't give you exact measurements, we reckon it was about 18 inches (45 centimetres). It might be a foot." (**Audrey Wadowska to Tjitte de Vries, London, 31 March 1978,** T019.)

"I wonder if that is Hamleys because he used to buy his toys from Hamleys (Toyshop, Regent Street, London). Hamleys made him his flea. He used to, sometimes especially, make them for him. It cost him three guineas. (...) Urban admits himself he had them sometimes two or three years before he put them in the catalogue. He bought them in bulk." (**Audrey Wadowska to Tjitte de Vries, London, 16 August 1978,** T021.)

"For PROFESSOR BUNKUM'S PERFORMING FLEA, that has a piece of animation in it. There is some old lady visits a flea-circus on a fairground. This has four or five different titles. And he had specially made by Hamleys a flea that we estimated was just about that length, 18 inches. He had that made especially for the old lady through her magnifying glass." (**Audrey Wadowska to Kenneth Clark, London, 24 October 1978**, T197.)

Audrey Wadowska (going through trade catalogues): "Distributors put their own titles on. PROFESSOR BUNKUM has 5 titles, THAT MARVELLOUS FLEA, THE WONDERFUL FLEA, THE PERFORMING FLEA, all the same technique, they all have the magnifying glass. *Ursula Messenger:* Hamleys made that flea for dad, didn't they? *Audrey:* Yes, a flea special made and jointed for that purpose." (**Audrey Wadowska to her sister Ursula Messenger, London, autumn 1980**, T208.)

Unpublished manuscripts

"PROFESSOR BUNKUM'S PERFORMING FLEA was a real winner, the film being called later THE SHOWMAN'S TREASURE. A lady comes into a fairground tent to view the Professor's giant flea under a microscope and leaves, apparently amazed by the phenomenon. Another lady enters, looks through the instrument, sees nothing and, with wild gestures of annoyance argues with the professor. He looks in the microscope and is utterly distraught. The precious flea has flown. Then the fun begins. The Professor dashes into the fair-ground. He must find his valuable flea – it is his living – he will starve without it. It was a wonderful insect that could load coal and be harnessed to and pull a cart and many other miraculous things. He must be found. Then is enacted the most searching drama of the professor with a huge magnifying glass scouring the fair-ground for his flea. A girl scratches her leg, and the professor instantly lifts it up and searches with his glass; an old woman scratches her head, and he is there searching among the grey hairs – so desperate is he. A baby in a pram scratches, and the professor starts hunting for his flea and receives a violent slap from a nurse, and so it goes on. Finally, his efforts to retrieve this miserable breadwinner are rewarded under circumstances which, the synopsis states, provide a scene redolent of humour, and which is the cause of yells of laughter from audiences before whom it is shown. This 505 feet film is, in other words, a real tickler! The actual making of this slapstick film was interesting and incorporated fake techniques. The flea was a model made to scale measuring approx. 18" long by Hamleys of London for three pounds. The flea is also supplied with a harness and toy wagon

for his various tricks under the microscope. The flea shots were taken in the studio, whilst those of the fair were actually realistic and taken at Barnet Fair, the films being joined at the appropriate places." (**John Grisdale, 1960.**) [N76]

"PROFESSOR BUNKUM'S PERFORMING FLEA (Alpha).

SHOWMAN'S TREASURE (Graphic).

WONDERFUL FLEA (Walturdaw).

WANDERINGS OF A FLEA (Pathe)."

(**Audrey Wadowska, A-Z manuscript, 1981,** page P.)

Editorial

The film was apparently chopped up by several distributors to more marketable lengths of 350 ft and 395 ft., according to their insights, just like they retitled it each according to their own commercial tastes.

12. **A Dream of Toyland** * * * *, 1907, 350 ft., running time 5.50 min.

A.k.a. DREAMS OF TOYLAND and IN THE LAND OF NOD.

Live-action and stop-motion animation.

Reissue DREAM OF TOYLAND, Walturdaw, 8 Sept. 1910 (300 ft).

Restored 35mm print at the BFI National Archive, London; original nitrate and restored 35mm print from the Tjitte de Vries/Ati Mul Collection at the Netherlands Filmmuseum, Amsterdam; 35mm negative positive and 16mm print in the Audrey and Jan Wadowski collection now in the East Anglian Film Archive, Norwich; a 16 mm print at the Netherlands Institute of Animation Films (NIAf), Tilburg; 35mm step-print and 16mm print in the Tjitte de Vries/Ati Mul (Film) Collection, Rotterdam, Netherlands.

Credits

Directed and animated by Arthur Melbourne-Cooper. Production Alpha Trading Company. Studio: Bedford Park, Beaconsfield Road, St Albans during late autumn of 1907.

Cooper was assisted with the animation by studio staff members Stanley Collier and Herbert Cooper; locals Charles Raymond, Roger Pamphilon and a son of local architect Mence; by young Rolphe, and also by the family dentist, by family doctor Dobbs, and by several children from the neighbours, especially the Massey, Barnes and Lavers families.

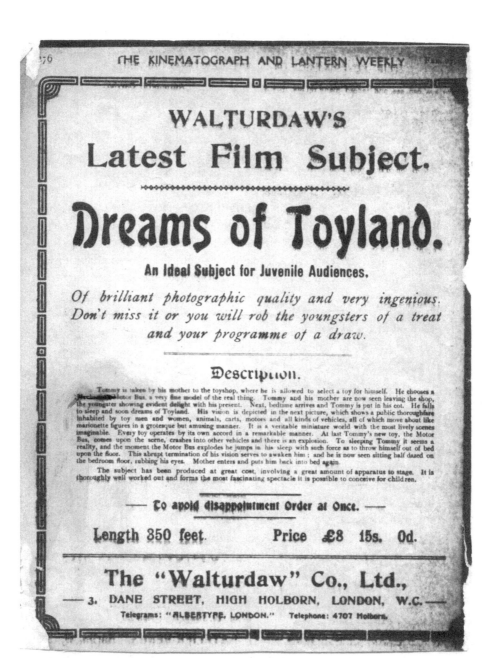

Fig. 79. Walturdaw's advertisement of A DREAM OF TOYLAND (1907) in the
Kinematograph and Lantern Weekly, 27 February 1908. Audrey Wadowska, indignant,
crossed out the word 'Mechanical'.

The toy shop manager is played by Alpha book-keeper and proxy Frank Hawkins Clarke,[48] the mother is played by London actress Ruby Vivian, and her 'son' is played by a boy from next door, Eric Lavers.

Design motor-bus and set-design Stanley Collier, Percy Blow. Oil paintings of backdrops Jessie Collier. Toys by Hamleys Toyshop.

Synopsis

In a live-action scene, a mother and her son enter a toy shop in St Peter's Street, St Albans. The boy gets numerous dolls and other toys as a present. After he is put to bed by his mother, he dreams that all those toys come to life.

In one long stop-motion animation sequence animals, puppets, horse carts, motor-cars and a motor-bus create dangerous traffic scenes especially when an assertive white bear wants to have things his own way. The motor-bus crashes into another vehicle, there is an explosion, and the boy wakes up from his dream, soon receiving consolation from his mother.

Full synopsis (of existing picture, total running time at 24 fps 3.40 minutes. Original title 3 seconds.)

SCENE 1. Long shot, exterior, 9 seconds.

At the left side are shops, at the right a street. Far away are trees. Left of the screen in front are shops with signs 'Dry Cleaners' and 'Dyers', and a sign-board with 'Private Room for Ladies'. Closer still is a shop with a sign-board 'Shaving', and even closer is a sign 'Dry Cleaners Luton'.

A lady in a long frock-coat, white shawl and big flowery hat is walking on the pavement towards the camera. She has a young boy with a cap and white collar by the hand. They stop for a short while to look at a shop-window, then walk on and stop in front of the shop with the shaving sign. The woman and the boy are talking very animatedly. They enter the shop.

SCENE 2. Medium shot, interior, 54 seconds.

There is a counter in the middle of the scene with a chair in front of it. On top of it a lot of toys like puppets and animal figures. Behind the counter a balding man who is displaying all these toys. Behind him on the wall is a cabinet showing more toys and a clock on funny little feet. From the left side the woman and the boy enter the scene. She puts the boy standing on a chair. He immediately starts playing with the puppets and animals. She sits down at the right of the screen. The

48. Frank Hawkins Clarke invested £400 in the Alpha Trading Company which he later withdrew when he went to Australia.

salesman behind the counter shows more toys, demonstrates little carts, a clown figure and a carriage. He leaves the scene at the right and comes back with more toys. All the time he and the woman are talking animatedly.

The mother is saying something to the boy. The salesman disappears and comes back with a model motor-bus. It is an open doubledecker bus of possibly 20 inches long. On its sides and top are the words "DREAM OF TOYLAND" and beneath the windows "MUDGUARD". The boy puts at once all kind of puppets and animals on top of the bus.

The woman looks in her purse and takes money out of it. The salesman is writing figures on a piece of paper. He returns small change. The boy puts a polar bear on top of the bus. He leans far over the counter to have a good look at more toys. The salesman takes the bus with him out of sight. The woman lifts the boy from the chair, kisses him and puts him on his feet on the floor. The salesman returns twice with parcels wrapped in packing-paper. The woman takes the parcels, and the little boy may also carry one. He still has some little toys in his hands. He looks briefly up at the camera. They say goodbye to the salesman who bows. They walk to the left out of sight.

SCENE 3. Long shot, exterior, 4 seconds.

Same scene as in 1, the street with the shops at the left.

The woman and the boy with all their parcels are leaving the shop with the shaving sign. They walk to the right towards the camera and disappear from the scene.

SCENE 4. Medium shot, 19 seconds.

A bedroom scene. Wallpaper on folding screen at the back. There is a little painting hanging on it which wobbles on the unsteady wall or in the wind on the open air studio stage. At the left is a door with four panels painted on it. At the back to the right a cabinet on top of which is the same clock on animal-like feet as in the shop. The wallpaper decorations are big bowls with flowers.

The woman enters the scene through the door. She is now dressed in a dark frock with short puff sleeves and with her hair put up high. She carries the little boy who is in a white night gown. She takes off his socks putting them on a chair. She unfolds the blankets on the bed, lifts the boy up and puts him in bed. She tucks him in. His eyes are closed. He has a golliwog in his hands. He lifts up his head, says something to his mother who disappears through the door at the left. The boy now sleeps with a thumb in his mouth.

Fade out in black.

SCENE 5. Big close-up of a table-top scene representing a long shot, 1 min. 54 seconds, with additional live-action close-up representing a long shot, 4 seconds.

Fade-in from the black. A table-top scene of (according to our estimation) approx. 200 cm or seven feet wide, and 350 cm or twelve feet deep.[49]

A very sharp and light scene appears. The scene consists of shops painted on back-drops forming a wide street or square. There are eight shops which have a prosperous look. They run from the left of the screen to the back. There are also shops at the back. At the left side, approx. at 1/3rd distance, there is a side-street. There is another side-street to the left at the end of the set. The first two shops have huge double-breasted shop-windows. The first shop on the left has signs atop the shop-windows: COLLIER and RAYMOND. There is a pillar box in front at the far left.[50]

The fade-in from the black opens with a little puppet behaving like a drunkard. A policeman tries to reprimand him but gets thrown to the ground, is kicked and rolls away. A motor-bus arrives from the side-street. It is the same bus that we have seen before on the counter in the toy shop with the signs DREAM OF TOYLAND and MUDGUARD painted at the sides. It is driven by a golliwog[51] and has several passengers sitting on the open upper deck.

From the back comes a little motor-car. At the left, two geese arrive. In the foreground appears a cart carrying a traffic sign. It rides over the policeman and the drunkard. From the right arrives a monkey with a cart loaded with a milk churn. There is a dog wagging its tail. The policeman is back on his feet and walks to the right together with the cart with the milk churn and the dog. A Dutch doll enters, and they now all walk to the left.

At the far right a black Royal Mail van arrives. The motor-bus drives towards the camera, it has a polar bear hanging at its back, apparently

49. See for our estimations of the set Chapter 3, sub-chapter 7- 'A labour of six weeks'.
50. Audrey says in interviews that "A.M.Cooper appears on another shop", but we haven't seen this in the film, exept on a still from it where 'Cooper' was retouched on a shop front. Cooper mentions a fire engine, we haven't noticed this. Cooper possibly meant the black Royal Mail van, and confused this with the fire engine in THE ENCHANTED TOYMAKER.
51. Golliwogs (black rag dolls, today called 'gollies'), like Dutch dolls (wooden, mainly undressed, dolls with movable joined limbs), were very popular with children in those days. Florence Kate Upton, illustrator of children's books, created the golliwog in 1895 in *The Adventures of Two Dutch Dolls and a "Golliwog"*, inspired by a blackface minstrel doll she had as a child in America.

its conductor. On top of the front of the motor-bus are several signs. In the middle it says: LONDON AND NEW YORK, on the right: USE ZOE SOAP, and on the left is a drawing of a deer (*hart*), the symbol of Hertfordshire, with: CLARK & SON. The policeman picks up something from the street and drops it in the letter-box. Two Dutch dolls parade in the foreground with their naked wooden limbs. The policeman falls on his back at the pillar box.

There is a Chinaman with a rickshaw, there is also in the busy traffic a five-wheel vehicle with a driver in front and a puppet sitting in the back. At the right a taller Dutch doll appears. The motor-bus is cutting capers, driving forward, going back. The little motor-car has taken over. The geese still walk in front of the big shop at the left. The black van has in the meantime overtaken the motor-bus from the left.

In front is now a two-wheel donkey cart. A Dutch doll with arms spread wide now walks animatedly across the square to the left front.

A cab with its chauffeur in the open part in front drives out of view at the right. The donkey cart is pestered by two little Dutch dolls. Someone throws the driver from the motor-bus that runs over a dog. The golliwog driver hangs on the side of the bus to warn the traffic. Just in front of him there is a little three-wheel bicycle. The motor-bus now drives to the right front, and the black van turns from the left to the right and does the same.

From the left a monkey appears. It has a white face and rigid legs. It goes to the cyclist. On top of the bus are passengers. The bus drives over the three-wheel cycle and stops. The monkey pulls it away and throws it at the side.

The golliwog looks towards the back, and positions himself back at the wheel. The polar bear looks around: the bus can ride again. The monkey climbs on the bus at the back under protest of the polar bear, who tries to grab him, pulls him on top of the bus and falls off it on the other side. The bus drives to the left. Behind it one can see several figures, like the two geese, a pedestrian, and a tramp on a horse. The horse suddenly sits on top of its rider. A golliwog policeman arrives, and the bear makes a complaint. He then pushes the policeman away, picks him up, swings him around and throws him onto the street. He falls, and the policeman then throws himself on top of the white bear.

In the meantime, all kinds of things are happening in the square. The horseman still has problems with his horse, which picks up a passer-by and swings it around with its mouth. A lorry arrives with a Dutch doll

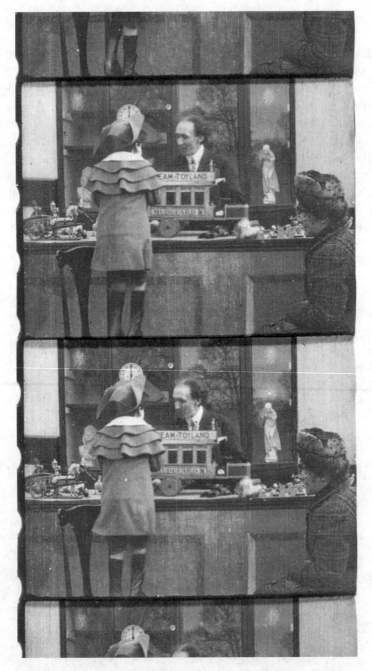

Fig. 80. A young boy in A DREAM OF TOYLAND (1907) makes an
ample choice of toys.

at the wheel. It disappears to the right. The horse trots away to the right. The horseman is attacked by the two geese. He falls, and they peck him in front and on his behind. All kinds of small and bigger vehicles cause heavy traffic.

The golliwog policeman tries to free the fallen horseman from the geese. He picks up a goose and tries to smother it.

A Chinaman passes by with a drum. The monkey is back. A little white van driven by a steam engine drives up from the back. On its side is painted: "XL-ALLSEEDS – ST ALBANS". All kinds of puppets are driving and walking up and down, and from left to right. There is a monkey with a cart and milk churn. A puppet is wrestling with a female and is being deposited in the cart with the milk churn. A Dutch doll rides on the horse that earlier sat down on its rider.

The steam engine van returns to the scene. The monkey has a peaked cap. There is a two-wheel carriage, a Chinaman with a rickshaw, and from the right a Dutch doll pulling a cart with a female doll as passenger.

The policeman reprimands the monkey with the peaked cap. The black Royal Mail van is back again and drives from the left to the shops at the back. Someone gets out of it and climbs on the roof. It is the horseriding tramp who in the beginning had problems with his horse.

The policeman is kicked by the monkey. The tramp jumps from the van and sits now straddle-legged on top of the cab with its driver in the open front. Next, the tramp falls on the ground. At the back, the black van backs up and parks. To unload cargo? No, it drives forward again towards us. From the left arrives the Dutch doll who tries to pull the policeman and the monkey apart, whereupon the three of them rejoice in a round dance. The black van comes from the back and rides over the tramp. The joyful dance ends in a spill.

There are sometimes sudden fast streaks of sunlight and shadows on the wall of the shop at the corner of the side-street.

At the back, several vehicles constitute a lot of traffic. The polar bear arrives in a steam-mobile. The square is now full of pedestrians and vehicles. The tramp is fighting with the policeman. The monkey with its peaked cap stops the steam-mobile of the polar bear. The bear kicks the monkey, who shows him his behind. The bear then drives hard against the bottom of the monkey. The monkey threatens him, but the white bear tries to run him over, passes him, and drives around him. The monkey mounts a toy horse and gallops after the bear in his steam-mobile.

The motor-bus arrives from the back. The bear drives away and knocks down the monkey on its wooden little horse.

There is the motor-bus again. From the right comes a family of Dutch dolls. There are many people in the street. The polar bear in the steam-mobile rides aggressively up and down. He is suddenly hit by the motor-bus which cannot stop in time with a collision as a result. The motor-bus slants over the steam-mobile with the bear. The golliwog driver falls out of the bus, and passengers fall out of it on the other side. It is a disastrous collision. There is some smoke, the smoke gets heavier and then there is an explosion. Smoke fills the whole screen, making it almost completely white...

SCENE 6. Medium shot, bedroom, 13 seconds.

It is the white of the sheets of the bed of the little boy who fell out of it. He cries out loud, and rubs his eyes with his little fists. The mother enters through the door on the left, embraces the boy, gives him back his doll and lifts him up. She stands up and puts him back in bed.

Details

Cooper's assistant, Stanley Collier, made the motor-bus and fire engine, and painted them. His sister Jessie painted the backgrounds in oil. Other models were made to scale by local carpenter Percy Blow.[N77] Several dolls were supplied by Hamleys Toyshop, London.

The almost bare branches of the trees in St Peter's Street and in Bedford Park, as betrayed in glass panels of a cabinet and toy motor-bus windows, make it clear that the picture was produced in the late autumn. An advertisement for XL-All Seeds makes it clear that it was 1907. Cooper had a share of £100 in this company which, in 1907, had to fold up after an injunction concerning unlawful competition. On 16 November 1907, E.G. Turner of distribution company Walturdaw took 75 (or 74, or 76 as it is sometimes said) copies with him to the USA on the maiden voyage of the SS Mauretania.

The 35mm nitrate copy from our collection was donated to and restored by the Netherlands Filmmuseum. This copy has the original title and is at the end a little longer than the 35mm and 16mm copies in the Audrey and Jan Wadowski estate, which come from the original in the BFI National Archive, and has the incorrect title IN THE LAND OF NOD, which is another animation picture by Cooper.

The title is A DREAM OF TOYLAND, and was made according to Audrey with the letters which are still in one of the letter-boxes used by Cooper for making film titles, in the Audrey and Jan Wadowski estate.

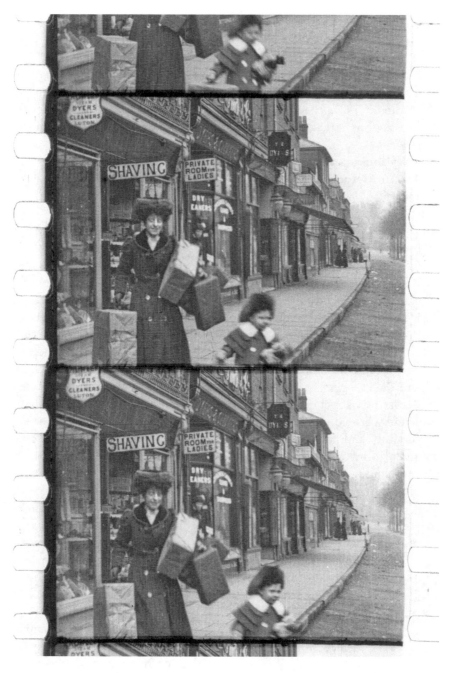

Fig. 81. Overloaded with parcels mother and son leave the shop in St Peters Street, St Albans, in A DREAM OF TOYLAND.

The original screening time at 16 fps is 5.50 minutes. Walturdaw cut it down to 5 minutes.

The glass doors of the cabinet in the shopping scene reflect the branches of the high trees of Bedford Park, an indication of the open air studio floors of Cooper's Alpha Cinematograph Works. One of the studio floors was used for the table-top set of the animation sequence, and floating streaks of sunlight can be seen on the backdrops of the set.

Primary source – Arthur Melbourne-Cooper
Arthur Melbourne-Cooper to Sidney Birt Acres, Southend, 20 May 1956
(T001, tape VI, cd 1/17).

Cooper: "(Turner) was my agent for it. I sold more of that thing than my own. I had a road built, myself and some friends. There was a chap who was apprentice for an architect[52] and some other chaps in their spare time. We painted a town, a street you know, and put the names on the shops, and when things were all up there, then we staged it with toys. Hamleys made me some, and some I made, and some the other boys made, you know, and we started this DREAM OF TOYLAND.

A little boy goes to sleep, well, he goes to the store first, and then he goes around the store and sees something, we had about 50 foot of that, and then he goes to sleep, and when he sleeps he dreams. And in his dream this street comes alive. And there is a big motor-car we had. There were no motor-buses in those days, we had to bring it in. We certainly had an advertisement on the motor-bus, this big motor-bus, and a golliwog was driving it, a black faced golliwog, and a teddy bear was hanging on the back as a conductor, and all the little toys were running about.

There was a girl with an automatic tin milk can, you know, coming walking down the street. There was a fire engine and a fire escape, that tore down the street. We had to move them every picture we took. We moved that in the distance an inch, and when it got near a half inch, right the way down, and the fire escape followed it in there. There was a donkey barrow. We had to move all those toys one by one separately.

There was a chap who now is a parson, and an architect, a dentist, and a big draper. Old Pamphilon from St. Albans was the draper. He has got three or four (shops) now. We worked on moving these toys for it

52. Mence, son of a local architect.

(...), 75 foot long.[53] And I think there was about over 3000 pictures, and it was on the average of 10 movements on the second. It took six weeks to take it in our spare time. And it was the first of it, of the single picture film.

Sidney Birt Acres: First of the caricatures?

Audrey Wadowska: But you did do a small picture with matchsticks in 1899?

Cooper: Oh yes. That was out of a matchsticks box, another picture. The first one that I took for a trick picture, I had your father's camera, turned it upside down and another camera, I think it was a Wrench, and stuck it beside it. And I took this trick picture of a man, selling my mother back door a duck".[54]

List of film titles in Mrs Kate Melbourne-Cooper's handwriting, authorized by Arthur Melbourne-Cooper, Coton, 1956: "Trick: DREAM OF TOYLAND."

National Film Archive curator Ernest Lindgren interviews Arthur Melbourne-Cooper, BBC, Broadcasting House, London, 20 July 1958 (T002, tapeXII, cd 3/17).

Lindgren: What now? You did make a film called DREAM OF TOYLAND, I believe. I am interested in this film, because we have a copy of it preserved, you know, in the National Film Archive in London. I wonder if you could tell me a little about this film and how it was made.

Cooper: Well, it was staged out-of-doors, because there wasn't a place. All the toys and things and the motor-bus, which was not on the road at the time, we had to make ourselves. The scenes, the background and things, were all painted in oil and they were kept out at the back.

Lindgren: These were toys and they were animated...

Cooper: Animated, yes.

Lindgren: ...so as to behave like real people?

Cooper: Well, they walked. They walked, and then the fire engine came down of a rush. The teddy bear was on the bus to take the tickets. A golliwog was the driver of the bus and so forth. Yes, all toys it was.

Lindgren: This film surely has been a great success at the time, wasn't it?

Cooper: Yes, it was. There is no doubt about that. But there was not the places as much to show films much, at that time...

Lindgren: No, of course not, no.

53. There is a slight disturbance in the tape recording. Cooper probably meant not 75 feet (1203 frames) but 175 feet (2807 frames); 3000 frames is 187 feet.
54. DUCKS FOR SALE OR RETURN.

Cooper: ...you see, it was all handicapped.

Lindgren: But within the limited field of the time...?

Cooper: Well, Mr Turner, they took the rights. They did the export of it, they tell me they exported 75 went over to America. And that was, what was the date? In 1907.

Lindgren: In 1907, was it? So, in those days we were exporting to America and not importing from America?

Cooper: That's a fact, yes. Well it was that, but of course when the war broke out, the Americans stopped the importation of film.

Mrs and Mr Arthur Melbourne-Cooper visiting Stanley Collier, Aldeburgh, 20 July 1958 (T090, tape X, cd 4/17).

Mrs Melbourne-Cooper: "Do you remember painting the scenery? *Stan Collier:* Yes, for TOYLAND, I remember doing that. (...) I remember it lasted for days and days. And of course, the sun would come out some time, and there would be a shadow on the scenery. And that is what you would have to put up with, where in an ordinary studio today it wouldn't have any effect."

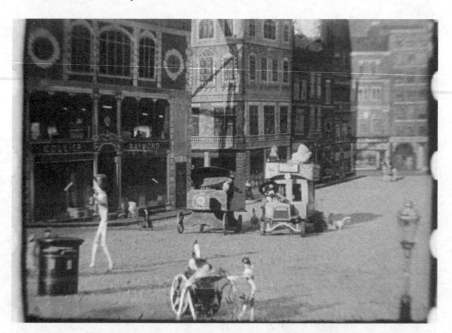

Fig. 82. The sunstreaks on the shop fronts give away that A DREAM OF TOYLAND was made in the open air, and that it was a stop-motion picture.

Contemporary sources

Pageant Souvenir Advertisements, St Albans, 22 April 1905. (No page numbers.)

"The Most Remarkable Business Enterprise of Modern Times.

St Albans is known the World over as the distributing centre of the famous "XL-ALL" SEEDS, which are sold at the uniform price of One Penny Per Packet. Our catalogue is gratis and post free on application, and our seeds can be obtained throughout the year.

The "XL-ALL" Seed Co. Hatfield Road, St Albans, Herts."

Walturdaw Co. catalogue, London, 1908, page 6.

"A DREAM OF TOYLAND." (No other information in this catalogue.)

The Bioscope, London, 27 February 1908. (No page number known.)

"Tommy is taken by his mother to the toyshop, where he is allowed to select a toy for himself. He chooses a mechanical motor-bus, a very fine model of the real thing. Tommy and his mother are now seen leaving the shop, the youngster showing evident delight with his present. Next, bedtime arrives and Tommy is put in his cot. He falls to sleep and soon dreams of Toyland. His vision is depicted in the next picture, which shows a public thoroughfare inhabited by toy men and women, animals, carts, motors and all kinds of vehicles, all of which move about like marionette figures in a grotesque but amusing manner. It is a veritable miniature world with the most lively scenes imaginable. Every toy operates by its own accord in a remarkable manner. At last Tommy's new toy, the motor-bus, comes upon the scene, crashes into other vehicles and there is an explosion. To sleeping Tommy it seems a reality and the moment the motor-bus explodes he jumps in his sleep with such force as to throw himself out of bed upon the floor. This abrupt termination of his vision serves to awaken him, and he is now seen sitting half dazed on the bedroom floor, rubbing his eyes. Mother enters and puts him back into bed again. The subject has been produced at great cost, involving a great amount of apparatus to stage. It is thoroughly well worked out and forms the most fascinating spectacle it is possible to conceive for children. Order at once."

The Kinematograph and Lantern Weekly, London, 27 February 1908, page 287.

"Review of the Latest Productions. Walturdaw.

The Walturdaw Co. are putting out a very ingenious subject this week, which is sure to have a big sale. The title is DREAMS OF TOYLAND. Tommy is taken by his mother to the toy shop, where he is allowed to choose whatever toy he pleases. The shopman shows him a great variety of

mechanical toys, but the youngster's choice falls to a Mechanical motor-bus. This is packed up, and the mother with the boy is seen leaving the shop. The next scene shows mother putting Tommy to bed. Now the little fellow sleeps and in his sleep he dreams of Toyland. A large public square, surrounded with buildings, is inhabited, not by natural human beings but by figures in the form of dolls, and not by full-size vehicles but by miniature carriages, motors, etc. Clock-work figures walk and run about in toy fashion, mount the mechanical motors and go through all the movements natural to a crowd of people in a busy thoroughfare. Some of their movements, however, are most grotesque and the fact that proportions are neglected adds to the incongruity of the scene. The subject is crowded with incidents well and cleverly worked out. Undressed wooden dolls stride about in the public thoroughfare. Woollen bears move about as in life. Golliwog comes into conflict with mechanical policemen. Dolls reel as though intoxicated, whilst bicycles, carriages and even traction engines run hither and thither. Finally, a motor-bus is seen to crash into another vehicle and an explosion occurs. At this point Tommy jumps with a start in his bed, falling out of it on the floor, his vision of the explosion being responsible for this sudden awakening. Just as Toyland vanishes, Tommy appears sitting on the floor by the side of his bed rubbing his eyes and coming back to consciousness. Mother now enters the room and lifts him into his bed again."

The World's Fair, Saturday, 29 February 1908. (No page number known.)
"Walturdaw. The World's Bioscope Outfitters. Latest Top Liners.
A DREAM OF TOYLAND. Code: Toyland. The most amusing, novel, and interesting film of the season. Marvellous Tricks – Grand Quality. It will bring the House Down. Little Johnny has a number of delightful Toys, moveable and otherwise, given to him by a doting Mother. He goes to bed to dream of these. The scene changes to the Street, and we see the Toys at play – Golliwogs wrestling, Teddy Bears jumping, Toy Motor-cars skidding round dangerous corners. A Motor-bus, driven by a black doll, charges into them; all capsize, the engines burst, an explosion occurs, and the Toys are scattered to all ends of the street. And then Johnny awakes. Length, 350 feet. £8 15s. (less 33 1/3 per cent.)"

The Kinematograph and Lantern Weekly, London, February 1908, page 276.
"Walturdaw's Latest Film Subject. DREAMS OF TOYLAND. An Ideal Subject for Juvenile Audiences, Of brilliant photographic quality and very ingenious. Don't miss it or you will rob the youngsters of a treat and your programme of a draw. (...) The subject has been produced at

great cost, involving a great amount of apparatus to stage. It is thoroughly well worked out and forms the most fascinating spectacle it is possible to conceive for children. – To avoid disappointment Order at Once. – Length 350 feet. Price £8 15s. 0d."
The Herts Advertiser & St Albans Times, St Albans, 13 March 1909. (No page no.)
"PICTURE MAKING. HOW BIOSCOPE RECORDS ARE MADE.
Through Mr. A. Melbourne-Cooper, the managing director of the Alpha Trading Company, and lessee of the Picture Palace, St Albans possesses exceptional advantages for seeing the best production in animated photography, for Mr. Cooper is not alone an exhibitor, but an actual manufacturer of bioscope films, an industry in which he has been so long engaged that he can lay claims to be one of its pioneers. He is therefore competent to give reliable information as to the manner in which the pictures are made which interest spectators in many parts of the world for films made at St. Albans are extensively shipped to customers abroad. (...) For the maker of living pictures there is open an absolutely unlimited field. At St. Albans it is proposed to go back as far

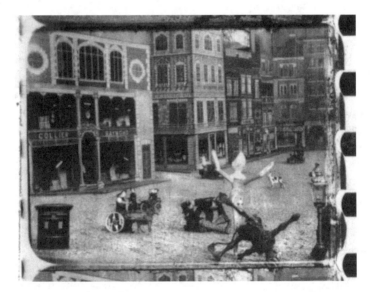

Fig. 83. A dutch doll tries to make peace in A DREAM OF TOYLAND. Cooper's right hand man and assistant animator Stanley Collier later wrote to Audrey on a sheet of paper attached to this photograph: *"Yes, I did the background, about 4 ft high. Made it up as I went along. You see the name Collier over one shop."*

as the flood for a subject! The Ark is even now in course of erection and a full complement of animals – all specially joined so as to allow of life-like attitudes – is expected to arrive before long. These pictures will be composed on the same principals as those illustrative of Toyland which meet with general approval whenever shown."

The Bioscope, London, 8 September 1910, page 39:

"Walturdaw. DREAM OF TOYLAND, Trick, 300 feet, price 1½."

The Cinema, London, 19 March 1913, page no. 47:

"THE KINEMA INDUSTRIES, LTD. A CHAT WITH MR. MELBOURNE COOPER.

(...) You may remember 'A DREAM OF TOYLAND', 'GRANDFATHER'S FORTY WINKS', and 'THE OLD TOYMAKER OF PENNY TOWN'. These I produced about five years ago."

Complementary sources

Gifford-1968 (page 28), **1973, 1978** (page 70), **1986, 2000:** "01841\01764 – February 1908, (350). DREAMS OF TOYLAND, Alpha Trading Co. (Walturdaw). D:S: Arthur Cooper. Trick. Boy dreams toys come to life: a motor-bus explodes."

Gifford-1987, page 11: "1908, (350). DREAMS OF TOYLAND, Alpha Trading Company – Walturdaw. P:D:S:A Arthur Cooper. Animated toys.

(Synopsis is quoted from the Walturdaw advertisement in *The Bioscope*, 27 February 1908) Released February 1908; print preserved in the National Film Archive."

National Film Archive Catalogue: Silent Fiction Film 1895-1930, London BFI, 1966, page 85:

"DREAMS OF TOYLAND. [F.651] Credits: p.c. Alpha; p. Arthur Melbourne-Cooper. Puppet: A child is taken to a toy shop by his mother where she buys him a mechanical motor-bus. That night the child dreams that he is in toyland (330 ft.)."

"2303 DREAMS OF TOYLAND [a] In the Land of Nod \\ PC: Alpha \\ D: Cooper, Arthur Melbourne \\ ARCH: LON." (**Ronald S. Magliozzi, 1988.**)[N78]

Publications

"Arthur Melbourne-Cooper afterwards became celebrated through his Alpha Studios and his animated model films which included the famous 'DREAM OF TOYLAND' of which 300 copies were sold and exhibited in the USA, and others to Sydney, Australia, and Barcelona, Spain." (**W.J. Collins, *Kinematograph Weekly*, 3 May 1956.**)[N79]

"Many local boys and girls, both from St Albans and the neighbouring villages, took part in my father's films – some of which still survive. It

would be interesting to know whether the following local 'stars' of yester-year still remember? The little girl [*sic*] in DREAM OF TOYLAND – which became an international success; the little WILLIE GOODCHILD who visited his Auntie; McNAB – THE MAD POET; the young bride of Park Street in TRAGIC WEDDING; THE HIGHWAYMAN who so nearly came to grief on the old lane near Potters Bar and that comic character of a policeman (who fell into real trouble) in MOTOR PIRATE – that tank-like creation which so terrified the peaceful villages of Hertfordshore." (**Audrey Wadowska,** *The St Albans and District Gazette,* **1957.**)[N80]

"**Late Honour**. It is generally accepted that the 'father' of the animated cartoon was Frenchman Emile Cohl, whose short 'Felix' cartoon strips started to make their appearance after the turn of the century. He was not. And an exhibition at St Albans proves it. For the exhibition was to depict St Albans's contribution to the film industry. And one of the organizers is the daughter of the man who did. He is Mr Arthur Melbourne-Cooper, retired 86-year-old pioneer, who now lives near Cambridge.

The daughter produced documents and 'stills' concerning the two earliest Melbourne-Cooper cartoons. One was a matchstick animation produced for advertising purposes during the Boer War in 1899. It clearly preceded Cohl's work by several years. The other was the famous 'Dream of Toyland' – the type of Cooper cartoon which many modern cinema-goers considered the latest technique. Both were produced at St Albans, where Mr Melbourne-Cooper ran one of the first cinemas in Britain. He was also responsible for the sloping floors we know today the world over. Mr Melbourne-Cooper's modesty is such that only a careful examination of the documents revealed that cartoon honours should go to Britain, not France. He had never dreamed of countering the French claim." (*Dunedin Press,* **June 1957.**)[N81]

"Yet another innovation of Mr. Melbourne-Cooper's was the use of match-sticks, toys and dolls in the making of 'animated cartoon' films – forerunners of many modern films made on the same principle. Among the most successful of these were DREAMS OF TOYLAND, IN THE LAND OF NOD, TEN LITTLE NIGGER BOYS, THE CATS' FOOTBALL MATCH and CINDERELLA – for which he had to grow his own pumpkin. (**Joe Curtis,** *Herts Countryside,* **summer 1960.**)[N82]

"The son of a professional photographer, he entered the film industry in 1892 with Birt Acres, and claimed to be the first person to produce an animated film – one made for Bryant & May's matches during the Boer War (...), and in 1907 his famous film DREAM OF TOYLAND was taken to America, where over 300 copies were sold. This is believed to be the first

film of the 'stop and start' Walt Disney type, and also had a large circulation in Spain and Australia." (*The Times,* **7 December 1961.**)[N83]

"His productions include some interesting examples of animation: a matchstick film made for Bryant & May during the Boer War (1899-1900) and DREAM OF TOYLAND, which enjoyed success in countries other than Britain – over 300 copies were sold in the U.S.A. His daughter Mrs. Audrey Wadowska, describes how 'from 1925 until his retirement about 1940, he was in Blackpool producing animated cartoon films for advertising on which all the family were engaged in various ways, drawing developing, printing, etc'." (**Obituary Society for Film History Research,** *Newsletter* **1962.**)[N84]

"DREAMS IN TOYLAND is a particularly fine little film in which a child's toys come to life. One of Melbourne-Cooper's assistants, Stan Collier, was responsible for the work of making the toys and the toy village. Over 300 copies of this film were printed and distributed as far afield as the USA. In later life, from 1925 until 1940, when he retired, Melbourne-Cooper still kept up his interest in animated films, making advertising films in Blackpool." (**Anthony Slide,** *Flickers,* **summer 1967.**)[N85]

"In 1907 he produced the ambitious DREAM OF TOYLAND, a fully animated film employing toy figures and animals, which, together with miniature cars and a motor-bus, moved to and fro in a street scene specially constructed at the Alpha studios. With this film Melbourne-Cooper not only took a giant step forward in film making, he also produced his own personal masterpiece. The film was sold worldwide, at least 76 copies being exported to America." (**Gordon Hansford, 1973.**)[N86]

"In 1908 Arthur Melbourne-Cooper, an Englishman, produced a film using live actors and trick-film techniques called DREAMS OF TOYLAND. Children's toys were animated to produce what may have been the earliest example of puppet animation. Cooper's NOAH'S ARK, also 1908, used similar techniques." (**L. Bruce Holman, 1975.**)[N87]

"Disney and to a lesser extent other American animators have perhaps dominated the cinema over the years, but at the same time a strong British tradition of cartoon making has been built up to flourish occasionally on British screens. And fortunately, the National Film Archive has taken steps during its 43 years existence to collect and preserve numerous examples from every decade. What follows is a small, but I hope a choice sampling from the archive's remarkable collection of British animated films from the beginning of the century up to 1940. The first animated films usually took the form of lightning artists doing simple sketches for the camera or crude stick men drawn

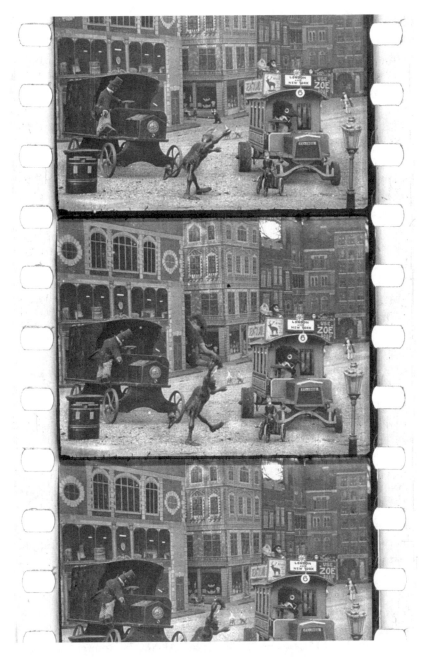

Fig. 84. A monkey acting as traffic policeman creates even more chaos in
A DREAM OF TOYLAND. A young assistant animator, moving an object, can be
seen between the shops in a single frame.

directly onto strips of film. At the same time the possibilities of stop motion puppetry was discovered, an early example of which was DREAMS OF TOYLAND, made in 1908 by a famous British film pioneer Arthur Melbourne-Cooper. In this lively and inventive little production a small boy is having dreams about all the toys he has bought that day in a toy shop."
(Clyde Jeavons, 1978, T184.) [N88]

"Melbourne-Cooper made two charming films featuring animated toys, NOAH'S ARK (GB 08) and DREAMS OF TOYLAND (GB 08). Strutting teddy bears were featured in the latter with particularly engaging effect."
(Patrick Robertson, 1980, 1985, 1988, 1991.) [N89]

"DREAM OF TOYLAND (1907), an early British production by St. Albans pioneer Arthur Melbourne-Cooper in which a small boy dreams that his toys come to life. One of the earliest and most intricate examples of puppet animation." **(David Wyatt, Stephen Herbert, 1981.)** [N90]

"...AUX JOUETS ANIMÉS. En 1907, il réalise son film d'animation le plus connu, DREAM OF TOYLAND. Audrey Wadowska raconte: 'Il y a ce petit garçon qui achète tous ces jouets, ou sa mère les achète pour lui. De retour à la maison, on le met au lit et il rêve que les jouets s'animent. Bien que ce ne soit pas le premier film de marionnettes de mon père, c'était à l'époque son projet le plus ambitieux... Le décor avec toutes les boutiques a été peint à l'huile sur le toile et on peut noter que les noms aux devantures sont ceux des employés de la société Alpha... Un des collaborateurs de mon père m'a raconté que tous les jouets étaient maintenus en position à l'aide d'épingles à chapeau ou de punaises. On les faisait bouger de deux centimètres à la fois en plan éloigné et d'un centimètre lorsque'ils passaient devant la caméra...'

Melbourne-Cooper a réalisé de nombreux autres films d'animation, dont L'ARCHE DE NOÉ et un CENDRILLON de 300 mètres en 1912, qui n'a pas été retrouvé. Il était en outre célèbre pour ses comédies, des films de trucages et ses documentaires, en plus de jouer un rôle important comme pionnier de l'exploitation cinématographique en Grande-Bretagne."

"...TO ANIMATED TOYS. In 1907, he made his best-known animation picture, DREAM OF TOYLAND. His daughter, Audrey Wadowska, talks about it: 'This idea is that the little boy buys all this toys, or his mother buys them, and he goes home, is put to bed, and he dreams that they all come to life. Though not the first animated puppet film father made, it was up to this time, his most ambitious achievement... The shops were painted in oil on flats and it's rather interesting as the names on the shop

fronts are of the people who worked for the Alpha Company... I met a man who was working on this film and he told me that all these toys were secured with hatpins, drawing pins and all sorts of devices to keep them in position. They were moved... an inch in the distance, and half an inch when they came in front of the camera.'

Melbourne-Cooper made numerous other animation pictures, among them NOAH'S ARK and CINDERELLA, a 1000 feet film released in 1912, and which has not yet been found. He was also well known for his comedies, his trick films and his documentaries; besides his work as a producer, he played an important part in pioneering film exhibition in Great Britain." **(JICA 81, Festival d'Annecy 1981.)** [N91]

"...his most acclaimed work – DREAM OF TOYLAND. He used stop-frame photography of dolls and toys to make a sophisticated animated film which fascinated his early audiences." **(Stuart Morrison, 1982.)** [N92]

"Early Trick Photography. Arthur Melbourne-Cooper had made one of the earliest known British examples of animation (and probably commercials) when in 1899 he made a film for Bryant & May which in effect was an appeal for funds to supply the troops in South Africa – not for ammunition, food or clothing ... matches – something the Ministry seemed to have overlooked. Some years later Arthur Melbourne-Cooper made two delightful films, featuring animated toys. THE TALE OF THE ARK, 1909, and DREAMS OF TOYLAND, 1908." **(Patricia Warren, 1984.)** [N93]

"By this time, Alpha Studios were producing almost a film a day including documentaries on fishing boats and the Royal Mint, short comedies, animated cartoons, almost everything upon which the cinema industry of today is based. His DREAM OF TOYLAND, employing dolls, toy animals, miniature cars and buses in a street set built in his studios, sold well over three hundred copies, including more than seventy to America. In 1908 his business was earning a lot of money and he was able to fulfil the final part of his early ambitions (...) the Alpha Picture Palace – the first British picture palace to have a sloping floor and separate projection booth." **(Richard Whitmore, Newbury, 1987.)** [N94]

"In 1908, he made another invaluable animated film, DREAMS OF TOYLAND, in which toys, given as presents to a child one afternoon, come alive in the child's dream. The puppets are animated with precision and delicacy, despite rotating shadows which give rise to a somewhat bizarre atmosphere (instead of artificial illumination, the animator still used sunlight and the frame-by-frame work was affected by the earth's rotation.)" **(Gianalberto Bendazzi, 1994.)** [N95]

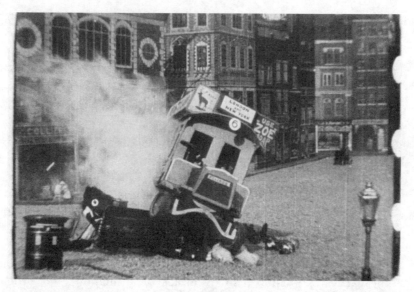

Fig. 85. The action of the monkey leads to disaster in A DREAM OF TOYLAND.

"Alpha produced trick films, animation films, and a variety of nonfiction films, often for distribution by other companies. Its engaging stop motion DREAM OF TOYLAND (1908) featured animated toys careening around a miniature replica of High Street in St Albans." (**Stephen Herbert, 2005.**) [N96]

"Amongst others, A DREAM OF TOYLAND (1907) has to be mentioned, in which a child dreams at night that the toys come to life which, in the afternoon, were given to him as a present. The little theatre of the set represents a street and everything has been made lively with care and grace." (**Giannalberto Bendazzi, *Il Sole 24 Ore*, 2005.**) [N97]

"English producer Arthur Melbourne-Cooper animated a collection of ready-made toys in a surprisingly realistic model town for his children's film A DREAM OF TOYLAND (1908)". (**Richard Rickitt, 2006.**) [N98]

Correspondence

E.G. Turner to The Evening News, Carmelite House, London EC4, 17 Nov. 1955.

"First Film Cartoon[55] 'Evening News' August 29th. A copy of your paper

55. The (shortened) publication of this letter in *The Evening News* of 22 November 1955 is in Part one, Chapter 3, par. 5.

has recently been shown to me relative to the above and in reply to your correspondent I have pleasure in giving the following particulars: – I have been in the Film Industry continuously since 1896 and in 1904 founded the Walturdaw Cinema Supply Company Ltd. We were the originators of the Film Renting Industry and consequently bought films from every Company who made them. At that time <u>America</u> looked upon England and the Continent as the main source of their supply. Mr Montague Cooper [*sic*] had a film studio at St Albans trading as the Alpha Film Company. He always submitted his products to me and we purchased quite a lot of his subjects with United Kingdom rights. In 1907 one of these subjects happened to be "A Dream of Toyland" and so far as I knew at that time, or since, this was the <u>first</u> stop and start film of the Walt Disney type made. In 1907 I booked a passage on the maiden voyage of the "Maurentania" [*sic*] which sailed on the 16th November 1907 and I took this subject and a number of others to new York. The novelty of the film mentioned created a lot of interest and I sold a lot of copies. In my own opinion Mr. Cooper was <u>first</u> photographer to create a subject of this nature and therefore the honour should go to Britain."

Mrs Audrey Wadowska to E. Lindgren, BFI, London, 25 November 1959.

"Dear Mr Lindgren. Relative to my conversation with Mr Grenfell, in connection with my father's visit to Aston Clinton on July 17th., when he was able to identify several of the items shown to him on the Editola, this will confirm the following Alpha productions (...) previously identified:

(...) 'Dream of Toyland' (Not complete), 'Noah's Ark'."

Mrs Audrey Wadowska to Mr Colin Ford, Deputy Curator, BFI, London, 16 February 1970.

"Dear Mr Ford, I have at last managed to prepare the list of identified films which you asked me for, several months ago now! I must apologise for the delay, and though I cannot guarantee there are no omissions, I do trust you will find it useful. I would also like to take this opportunity of expressing my sincere thanks to you and your colleagues for all their help and co-operation on my behalf over the passing years. It has been a slow and often frustrating task, due mainly to the early film makers practice of copying, and the frequent replacement of original titles. And not least, to my father's own peculiar methods of business in producing his films for 'wholesale trade only'. But I feel sure it has not been a waste of effort. (...)

(List 1.) The following items were personally identified: A. Melbourne-

Cooper. (...) DREAMS OF TOYLAND. (List 2.) [56] The following items have been identified, one way or another as films produced under the direction of Arthur Melbourne-Cooper. (...) DREAMS OF TOYLAND... (print is) not complete."

Recorded interviews

"One of the Lavers, not Stuart, was it Eric? – remembers taking part in that as a young boy. He lives in Watford now." (**Audrey Wadowska with Reginald Shirtcliffe, Hadley, St Albans, Summer 1964, T042.**)

"Audrey Wadowska: 'On that bus in A DREAM OF TOYLAND, it says: Zoe's Soap'. Stanley Collier: 'Oh, yes, I was very proud of her in those days. That is why I called everything Zoe. I called my motorbike Zoe, painted it on the tank. That was years before I met my wife. (...) The girl's name was Zoe Raymond.'" (**Audrey Wadowska with Stanley Collier, Aldeburgh, August 1965, T124.**)

"(The shop facades) were painted by a young man who was pretty well known here Stan Collier, who painted on flats and you will see (...) his name is on this shop front, 'Collier'. And 'Raymond' who was another assistant and 'A.M. Cooper' appears on the other shop front. And some of the toys were purchased, but this little wheel arrangement and the buses were made here, hand-made. And it's done on a table top of course in the open air. And they were dependent on the weather, and it took months to do. And I have met people in St Albans who remember seeing that being done. And the dolls and that were fixed into position with hat-pins and other pins." (**Audrey Wadowska, lecture "Herts to Hollywood", St Albans Film Society, 31 March 1966, T101.**)

"A DREAM OF TOYLAND appears in the British catalogues in March 1908, but Turner took them on the maiden voyage of the Mauretania. He recalled that in his letter published in the *Evening News*, and we checked that up, and the Mauretania sailed in November 1907. We know it took a long time to make, and it was made during fine weather, because he had to wait for sunlight. [57] The second thing is, he advertised XL-All Seeds. That folded up in 1907, because a longer established seed company took an injunction against Allseeds. So we often wondered why advertise a defunct company, so we assume it could have been

56. From the list of films that were personally identified by Cooper when they were screened to him at Aston Clinton.

57. Cooper only had electric light at his disposal when, in 1908, he opened his Alpha Picture Palace, which was the first building with electricity in St Albans. His next animation pictures were made in the basement.

Fig. 86. The end of a nightmare in A DREAM OF TOYLAND.

made, or at least started on in 1906. See? It was not made in a few weeks or a few months. They had to make all those toys. (...) This is St Peter's Street, now Marks and Spencer[58] stands on that site. This is Ruby Vivian. That little boy is Charles Lavers. And this is (Frank) Hawkins Clarke. He is the man I was telling you about with money in the business." (**Audrey Wadowska to Tjitte de Vries, London, 26 December 1976**, T075.)

"Father had a hundred pounds in this XL-All Seeds (of J. Rowntree), that was the trade name. And in DREAM OF TOYLAND, he advertises it on the toy bus. You see the bus[59] coming in front of the camera and you see: XL-All Seeds – St Albans. But they packed up in 1906.[60] So it must have been at least 1906. Because Ryder took an injunction against them. Rowntree's solicitors advised them to fold up rather than go to the courts. So that folded up." (**Audrey Wadowska to Tjitte de Vries, London, 15 April 1977**, T072.)

58. Not Marks & Spencer but, until the end of 2008, it was Woolworth.

59. Not on the bus but on the white side of a little steam driven van.

60. Apparently, the XL-All Seeds business packed up in 1907. Audrey confuses the dates with her suggestion that the production of A DREAM OF TOYLAND started in 1906. (It started in the fall of 1907.)

"You know that black doll, they were new, original in those days in the
DREAM OF TOYLAND. You remember the golliwog is driving the motor-
bus." (**Audrey Wadowska to Tjitte de Vries, London, 31 March 1978,**
T020.)

"E.G. Turner of Walturdaw, when he came over to our house in
Chiswick, he said they looked upon it as their right. He said you bought
them like a dress, you could do what you liked with them, you could cut
the sleeves off it if you wanted it. It was your property. And even A
DREAM OF TOYLAND, he chopped the end off and put another title on it
of his own invention and sold it as two separate films. (...) For the
showman did not want long films." (**Audrey Wadowska to Tjitte de
Vries, London, 16 August 1978,** T022.)

Audrey Wadowska: "You see, they date that from the publication in the
Biograph, eh, in the Kine, but that is 1909, but Turner told us he took 74
copies of it to America first on the maiden voyage of the *Mauretania*.
And that sailed on November 11th, because I wrote to the Cunard
people, 1907.[61] So it was already made by that time. So he started that
early 1907. And I'll tell some other thing, that he started it at least in
1906, because in it you see an advertisement for XL-All Seeds. On that
motor bicycle. Apparently, Father plus Rowntree started up a seed
business with offices (opposite?) Ryder who was a famous seed
merchant in those days. And Ryder rather took an injunction out
against them, and as that was going to cost them a lot of money their
solicitors advised them to fold it up. And in 1907 that had already been
folded up, and he would hardly advertise XL-All Seeds in 1907 if that
did not exist anymore. That makes me to think that this film at least
started in 1906.

Tjitte de Vries: He started it late 1906, November, December 1906?

Audrey: Some scenes, I would say, because Jessie Collier had to do all
these paintings. And toys had to be made and that took time, and he
also said, and that is on Ernest Lindgren's recording, he says how it was
made. See, he had to wait for the light, because it was done in the open
air. And if it was dark or dull, the scenery, he said, was kept out of the
back, and when the light was suitable, out it come again. So it might
have been a whole year making that film in the end. In stages.

Tjitte: At the same time he had to keep all these toys in the exact place.
That seems to me rather difficult. Never to touch, even if a mouse would
run over the scene and toys were moved, the shot would be ruined.

61. The maiden voyage of the *Mauretania* was on 16 November 1907.

Audrey: They were pinned, with safety and hat pins. Maybe he covered it up. There are different scenes in it, and our version is not complete. Why not spray out that advertisement for XL-All Seeds, that is on that bus? It is not hard the advertising for an extinct firm. *Tjitte:* He made it during the day? *Audrey:* Oh, yes. *Tjitte:* When was the injunction taken out? *Audrey:* 1907, mid 1907, I believe. *Tjitte:* So he could have made the film April or May 1907." (**Audrey Wadowska to Tjitte de Vries, London, 18 August 1978,** T026.)

"In the indexing department (of the BFI), they say that DREAM OF TOYLAND's secondary title is IN THE LAND OF NOD, but it is not! It is another film." (**Audrey Wadowska to Tjitte de Vries, London, 19 August 1978,** T028.)

"He always got his toys from Hamleys. Some of them were specially jointed for him and others were made. For DREAM OF TOYLAND, they made this fire engine and that sort of thing." (**Audrey Wadowska to Kenneth Clark, London, 24 October 1978,** T197.)

David Cleveland: "The National Film Archive has NOAH'S ARK as Alpha, 1909, Arthur Melbourne-Cooper, Director. They have DREAM OF TOYLAND, Alpha, Walturdaw, also IN THE LAND OF NOD. *Audrey Wadowska:* That is not right, and the date is 1907, not 1908. *David:* DREAMS OF TOYLAND? *Audrey:* That is Walturdaw's title. There is only one dream. *Jan Wadowski:* Father's title is A DREAM OF TOYLAND. *David:* Date? *Audrey:* 1907. E.G. Turner told us, he took it on the maiden voyage of the Mauretania. (...) He wrote to the *Evening News*, I think it was in the Fifties. You remember, they had an exhibition, the Observer Exhibition, 1956? There was some correspondence in the *Evening News* about that. And he wrote to us and he came here and he told us, he took it to America before it was released in this country. He bought the film, 74 copies. *Jan:* 75 copies. (...) *Audrey:* And we went into that, and that was in November 1907, it was the 11th. But that advertisement you showed me appeared in *The Bioscope* or something. *David:* 1908. Right, 75 copies to America. Now besides 75 copies going to America, he sold it to Walturdaw, did he sell it to anyone else?

Audrey: Walturdaw was his agent for it. But Walturdaw could have sold it to anyone. *David:* Did they buy it outright? Did they make their own negative? *Audrey:* I don't know. *Jan:* They could have. They copied, father had proof of it. *David:* Besides 75 copies that went to America, copies went elsewhere?

Audrey: Yes. They went to Germany. A Mr Greenbaum was his German agent. And Rossi his Italian agent, Herringdon Australian, and Olsson

– is it Norway or Denmark?[62] Norwegian, I believe. And the man in Barcelona.[63] – And of course Pathé did a lot of copying. *David:* And issued it under their own? *Audrey:* Yes. (...) *David:* So one film distributor would buy one copy, dupe this and sell them? *Audrey:* I suppose he would make a new negative. It was accepted practice. You could hardly do anything about it. It was accepted practice to sell your films outright. What happened afterwards, Turner told us, they bought it.

David: And all film makers in this country might do that? *Audrey:* Yes. And Mr Turner told us, it was their property. He said: you buy that dress and you want to cut the sleeves out, nothing will stop you. And they treated films like that. And very often they used to chop them up into two sections and even three sections and add a title of their own. *David:* To their own making? *Audrey:* Yes, A DREAM OF TOYLAND as we have is not complete. They cut the last piece off because the showmen didn't want long films. They used to cut them down to 400, 350 feet. And then of course, the other bit wasn't always the end, sometimes it was the beginning, sometimes a bit out of the middle. And they would put a new title on it, and sell it as a different film. That was accepted practice. But when the KMA was formed in 1906, that was really to stop this piracy. That was the Kinematograph Manufacturers Association. There were about half a dozen members, Father was one." (**Audrey and Jan Wadowski to David Cleveland, London, 11 October 1979**, T419.)

"He gave a lot of these toys to the hospital for the sick children, when he left St Albans." (**Audrey Wadowska to Tjitte de Vries, London, 28 May 1981**, T057.)

"DREAM OF TOYLAND, this is young Lavers, Eric Lavers. This is Hawkins Clarke. Now, he used to boast to father that he was 9th in succession to Judge Clark, and he was known as The Hanging Judge. (...) He (Hawkins Clarke) had 400 pounds in the Alpha Company. (...) The explosion was done with gunpowder or gun-cotton or something. It is the end of the dream." (**Audrey Wadowska to Tjitte de Vries, London, 29 May 1981**, T065.)

Unpublished manuscripts

"Probably a more notable achievement was 'A DREAM OF TOYLAND'

62. Olsson of Nordisk was in Copenhagen, Denmark, where in the 1960s a copy of GRANDMA'S READING GLASS was discovered.
63. Cooper used to call the buyers/distributors of his moving pictures 'agents'.

Fig. 87. The comfort of a mother in A DREAM OF TOYLAND.

which he made in 1907. In this he used toys made with special joints and again shot the film one frame at a time. Emile Cohl of France is generally regarded as the creator of the first popular film cartoon – his character Fantioche appeared in 1908, but Melbourne-Cooper's Toyland film should not be forgotten. Till recently authorities on the film doubted whether in fact he could have succeeded in making such a film so early. But a year ago Mr. E.G. Turner (of Walturdaw) came forward to say that he took the film to America on the first voyage of the old 'Mauretania', and the Cunard records show that this began on the 16th November 1907." (**Arthur Swinson, 1956.**)[N99]

"Arthur Melbourne-Cooper, whose ingenious puppet cartoon film A DREAM OF TOYLAND, manufactured at the Alpha Trading Company in St Albans entirely from models and dolls, exported in quantity to America on the maiden voyage of the 'Mauretania' in 1907, the film being completed a few months prior to the sailing." (**John Grisdale, 1960.**)[N100]

"In 1908, Cooper made an animated film of some brilliance. It was called DREAM OF TOYLAND and nothing like it had been done before. It is

almost certainly the world's first animated puppet film. It was a unique and immense success selling over 300 copies, 76 of which were exported to the US. There is an introduction and conclusion in live-action but the main section of the film is fully animated using children's toys and dolls." (**Luke Dixon, 1977.**) [N101]

"Melbourne-Cooper's best known film, DREAM OF TOYLAND (Feb. 1908), took more than three months to make. The opening live-action scenes begin in a genuine toyshop[64] in St Peter's Street as it was then. The site is now occupied by Marks & Spencer.[65] Audrey Wadowska takes up the story: 'A woman and her young son enter the toyshop and ask to see some toys. The shopkeeper puts various toys on the counter, mother buys some for her son. They go home, the boy is put to bed, and he dreams that all his toys come to life. Originally, the film ran to 500 ft, but the distributing agents, Walturdaw, considered it to be too long. They cut several feet out of the middle section, added a new title of their own and sold it as a separate film. This was not unusual in those days.

In the dream sequence, the shops were painted in oils on 'flats', and they are interesting as the names on the shop fronts are the names of people who worked on the film. You can see Raymond there, Collier, is on the left, Cooper is on the middle one. The symbol of the County of Hertfordshire – the Hart – is on the left of the bus. One of the advertisements on the bus reads 'Use Zoe's Soap'. Zoe was Stan Collier's girlfriend at this time. There is a rather ingenuous self-advertisement on a van: 'XL-All Seeds St Albans'. At this time father had shares in the Rowntrees family seed business. I met a man who worked on this film, and he told me that all the toys were secured with hatpins, drawing pins, and all sorts of devices to keep them in position.

Friends and neighbours were persuaded to assist, each responsible for the animation of one toy. Even so, it took several days to complete the film, which is the reason the cast shadows are seen to move across the set several times during the action. But it did not prevent the film from becoming extremely popular with the patrons, and a best-seller into the bargain. In total, Alpha sold 300 copies. In fact, E.G. Turner journeyed to New York on the Mauretania's maiden voyage, and sold 76 copies of the film while there'." (**Kenneth Clark, 2007.**) [N102]

64. A barbershop selling also fancy goods.
65. By Woolworth until December 2008.

Editorial

Three months, as suggested by people interviewed by Audrey Wadowska, even six weeks, was a very long production time in those years when a film maker normally would make a film in one or two days.

In several interviews Cooper or Audrey give different figures for the number of copies that were made. If Cooper indeed printed 300 copies, it must have been a great wear and tear on the original negative with its splices.

Walterdaw offered the picture for a price of £8 15s. Cooper possibly made a turnover of £1200 or more. The next year, at the London Road, he opened a completely refurbished Polytechnic as his Alpha Picture Palace (for many years still known by locals as "the old Poly"), and he moved his Alpha studios to premises with more studio space, dressing and laboratory rooms nearby at Alma Road.

A DREAM OF TOYLAND was shown on BBC TV, "Tonight" – Tuesday, 15 July 1958. It was screened 21 October 1977 at the National Film Theatre in a programme dedicated to Arthur Melbourne-Cooper. It was shown on BBC1, "A Look at the Past – Movie Milestones", 19 January 1978. It was screened at the Film International Festival of Rotterdam in January 1979, and at the Cambridge Animation Festival, 6-16 November 1979, and at several other festivals, among them Gent, Belgium, June/July 1980. These are just some examples of public screenings that we know of.

13. In the Land of Nod ****, 1908, 365 ft., running time 6.05 min.
A.k.a. GRANDFATHER'S FORTY WINKS, FATHER'S FORTY WINKS, GRAN'PA'S [sic] FORTY WINKS and GRANDPA'S FORTY WINKS.
Live-action and stop-motion animation.
Reissue GRANDPA'S FORTY WINKS, Cosmopolitan Films, 8 Jan. 1910 (330 ft).
Reissue FATHER'S FORTY WINKS, Butcher, 23 June 1912 (330 ft).

Credits

Directed and animated by Arthur Melbourne-Cooper. Production Alpha Trading Company. Studios Bedford Park, Beaconsfield Road, and basement Alpha Picture Palace, London Road, St Albans. Assistant animators unknown.

Synopsis

The animated part has three sets and four scenes. A father dreams that

his sons' toys and dolls come to life. A house catches fire, the police ring for the fire engine and teddy bears come to the rescue of the residents. The father is awakened by the water squirted from the toy fire engine controlled by his sons.

Primary source – Arthur Melbourne-Cooper

The Cinema, London, 19 March 1913, page 47. "The Kinema Industries, Ltd. 'A Chat with Mr. Melbourne-Cooper.'

I have been in the cinema world fifteen years, both in the manufacture of films and in the management of theatres. You may remember A DREAM OF TOYLAND, GRANDFATHER'S FORTY WINKS, and THE OLD TOYMAKER OF PENNY TOWN. These I produced about five years ago."

Contemporary sources

The Kinematograph and Lantern Weekly, London, 16 April 1908, p. 497.

"In the Land of Nod is this company's latest film and much ingenuity has been applied to the making of it. First we see a sitting room. A number of children are seated at a table playing with their toys, which include a number of dolls, a model house, fire-escape and miniature

Fig. 88. The firebrigade in action in IN THE LAND OF NOD (1908).

firemen and so on. Their father is seated in a chair near and falls asleep. The toys which he has seen affect his dreams and in his imagination the tiny figures are gifted with all the qualities of living beings. First a drawing room scene is presented in which the dolls, moving with a stiff gait, greet each other and behave exactly like human beings. Afterwards we are shown a scene on the lawn in front of this house and this is one of the cleverest of the subject. Though the figures are real dolls of the ordinary size, and the house could easily be placed on an ordinary table, the effect is exactly as if some clever actors were masquerading as dolls on the lawn in front of a real residence. This house catches alight and some of the dolls strut off to get the fire-engine, another good scene in which a street with shopfronts is shewn, being introduced at this stage. The fire-engine draws up in front of the house and soon water is being poured into the window in the approved style, while one of the figures vigorously applies his energies to a miniature pump in the foreground. We can heartily recommend an inspection of this film, which is one of the most ingenious we have seen for many months."

The Kinematograph and Lantern Weekly, London, 23 April 1908, p. 412. "Walturdaw's Latest Successes. IN THE LAND OF NOD. Father falls asleep in an armchair, while the children play with various toys on the table. He dreams that the various dolls come to life, and the film shows the exciting adventures which in his imagination befall them. A series of clever scenes show the dolls in a drawing room, in the street and putting out a fire which breaks out in their house. Throughout the figures move naturally, and yet it is evident that they are actual dolls, and not actors made up to resemble them. We invite inspection of this subject and are confident that everyone who sees it will vote it one of the cleverest trick subjects of the year.

Length 365 ft., Price £9 2s. 6d (less 33 1/3 per cent.)"

The Kinematograph and Lantern Weekly, London, 23 April 1908, p. 419.

"Latest Productions. Walturdaw Co., IN THE LAND OF NOD, 365 feet."

The Kinematograph & Lantern Weekly, London, 27 May 1909, p. 22. Walturdaw Ltd., High Holborn, London,

"LAND OF NOD, 365 ft, price per ft. 2½.d."

The Film House Record, London, 10 December 1910, page 302. GRAN'PA'S FORTY WINKS. (The Cosmopolitan Film Co. Ltd.) Length, 365 feet, Code, "Forwinks." Release Date, January 8th.

"This is a very clever trick picture in which the stop camera principle

has been used in a highly diverting manner, the opening scenes showing a group of children playing with their various toys while their grandfather dozes in his armchair while those which follow are taken up with his dream, coloured by what he has seen the children doing. The scene changes to the interior of a room in the doll's house which is one of the chief toys. There is a domestic squabble in progress, which is highly amusing from the realistic though stiff motions of the toy figures, the young son of the doll family being kicked out by his irate parents in vigorous fashion, and the man and wife also coming to blows. In the end the house catches a-fire, and there are some well shown street scenes, in which the exitement attending the turning out of the engine and escape is well portrayed. Several teddy bears keep the flames at the 'edifice' under as well as they can until the firemen come, and then there are thrilling escapes with the aid of the long ladder, while the engine plays its hose on the now blazing house. This effect is particularly realistic to the sleeping man, and no wonder, for he wakes to find that the children are playing a stream of water on his face from the toy engine."

The Bioscope, London, 5 January 1911, page 32.

"COSMOPOLITAN. Gran'pa's Forty Winks. This is a clever trick picture, the opening scenes showing children playing with their toys while their grandpa dozes in an armchair. Those which follow are his dream and what he has seen the children doing. The scene changes to the interior of a room in the doll's house, which is one of the chief toys. The house catches fire, and there is great excitement attending the turning out of the engine and escape. Several teddy bears keep the flames under control until the firemen arrive, and there are thrilling escapes with the aid of a long ladder. The effect is realistic for the sleeping man, and he wakes to find the children are playing a stream of water on his face from a toy engine. (Released January 8th.)"

W. Butcher & Sons Ltd., Camera House, Farringdon Avenue, E.C., catalogue, London, 1911, page 199.

"No. 182. "Father's Forty Winks". Length, about 350 ft. Code, "Winks." Price, 4d. per ft." (Synopsis is the same as in next paragraph.)

Kine Monthly Record, London, June 1912 (see Gifford).

"Pater familias, weary of replying to his boy's questions regarding their toys, falls asleep whilst they are amusing themselves. He dreams that their mechanical toys come to life and the picture illustrates such a dream. A street scene is shown, and all the usual characters are represented by mechanical figures, and their peculiar movements are of

course very funny. A large house catches fire, the police ring up the fire brigade, which duly arrives drawn by mechanical dogs. The house is blazing away, and some thrilling rescues are effected by teddy bears, etc. Considerable excitement exists, and the spectator witnesses what would be a sensational scene were it not that it is acted by mechanical characters. The drama ends by Pater familias being rudely awakened by the squirting of water from a toy engine in the hands of one of his boys."

Complementary sources

Gifford-1968 (page 29), **1973, 1978** (page 70), **1986, 2000:** "01887/01796 – In THE LAND OF NOD, April 1908 (365), *reissue:* 1910, GRANDPA'S FORTY WINKS. Alpha Trading Company (Walturdaw). P:D:S:A: Arthur Cooper. Trick. Father dreams of toy fire engine saving burning doll's house."

Gifford-1987 (page 11): "IN THE LAND OF NOD (365), 1908. Alpha Trading Company – Walturdaw. P:D:S:A: Arthur Cooper. Animated toys. Released April 1908: reissued by Cosmopolitian Films on 8 January 1911 as GRANDPA'S FORTY WINKS. Remade by Empire Films in 1912 as FATHER'S FORTY WINKS."

Gifford-1987 (page 20): "FATHER'S FORTY WINKS, (330), 1912. Empire Films-MP Sales, P: Frank Butcher, D:S:A: Arthur Cooper. Animated toys. Released 23 June 1912; remake of IN THE LAND OF NOD (1908)."

Gifford-2000: "03319 – FATHER'S FORTY WINKS, (370), June 1912. Empire Films (MP) p. Frank Butcher, d. Arthur Cooper. Fantasy. 'Father dreams his son's toys come to life'."

Publications

"Yet another innovation of Mr. Melbourne-Cooper's was the use of match-sticks, toys and dolls in the making of 'animated cartoon' films – forerunners of many modern films made on the same principle. Among the most successful of these were DREAMS OF TOYLAND, IN THE LAND OF NOD, TEN LITTLE NIGGER BOYS, THE CATS' FOOTBALL MATCH and CINDERELLA – for which he had to grow his own pumpkin." (**Joe Curtis, summer 1960.**) [N103]

Recorded interviews

"Now THE LAND OF NOD (365) is an animated film. Somebody put on as sub-title THE DREAM OF TOYLAND. And of course they swear it is one and the same film, and I told them it wasn't. I wonder what Denis Gifford says. We got a still from it, and that was called GRANDPA'S FORTY WINKS. Anyway, if not it is another animated film which father made. You see, in A DREAM OF TOYLAND a little boy falls to sleep in which the toys come to life. In GRANDPA'S FORTY WINKS, Grandpa is having the dream,

because forty winks means to nod off, you are just tired, that sort of thing." (**Audrey Wadowska to Tjitte de Vries, London, 3 January 1978,** T015.)

"Here is IN THE LAND OF NOD, which is Alpha, an animated film. In the indexing department, they say that DREAM OF TOYLAND's secondary title is IN THE LAND OF NOD, but it is not. It is another film. We have a still, or rather a set-up from it, not from the film but something that Father took." (**Audrey Wadowska to Tjitte de Vries, London, 19 August 1978,** T028.)

"GRANDPA'S FORTY WINKS, that is Father's, that is an animated film. There is a still from it with the teddy bear and the doll's house and the fire." (**Audrey Wadowska to Tjitte de Vries, London, 20 August 1978,** T031.)

Manuscripts

"GRANDPA'S 40 WINKS (animated toys)
" 40 WINKS (In the Land of Nod) Puppets
IN THE LAND OF NOD (Puppets)".

(**Audrey Wadowska, A-Z manuscript, 1981,** pages G and I.)

Editorial

Assisting in the animation were possibly Cooper's brother Herbert, one or two studio staff members and children from the neighbours.

It is possible that perhaps the live-action scenes (and not the time-consuming animation scenes) were remade for the Butcher reissue, as Gifford suggests,[66] but I don't think this to be likely.

14. The Kaleidoscope * *, 1908, 365 ft. running time 6.05 min.
A.k.a. THE WONDERFUL KALEIDOSCOPE, THE MARVELLOUS KALEIDOSCOPE.
Trick and/or (possibly flat) animation. Hand coloured.

Credits

Directed and animated by Arthur Melbourne-Cooper. Production Alpha Trading Company. Studio: Alpha Cinematograph Works, Bedford Park, Beaconsfield Road, St Albans. Assistant animator Stanley Collier.

Synopsis

The wonderful, fascinating and mysterious symmetrical movements of colours and abstract elements like in a kaleidoscopic viewer.

66. Gifford-1987: 'Remade by Empire Films in 1912.' [Italics by authors].

Publications

Walturdaw Catalogue, London, 1908. page 6.

THE KALEIDOSCOPE, 365 ft.

Recorded interviews

Audrey: "Stan Collier said, Father was always looking for some novelty. And Mother remembered Father and Stan Collier studying the kaleidoscope. Apparently Father made a film of that. I saw that listed somewhere in Urban or one of the catalogues as THE WONDERFUL KALEIDOSCOPE. I thought: I bet that is Father's. It stands to reason. He must have made hundreds of films, but he did not recall them personally every one. But we managed to piece together these things." (**Audrey Wadowska to Tjitte de Vries, London, 15 April 1977,** T072)

Audrey: "Also another thing he did at this time, it was in Parkstreet he did it, I spoke to an old lady[67] who saw it, who knew father well because she remembered him as a cyclist. And he was frequently down there with bank holiday sports. And of course the Parkstreet girls were very well known to him, and they were frequently taking part in his films. She remembered a film that was coloured and it was – you know they had lantern slides, I think it was done in those days that you would turn a handle – you saw these images which would change in shape and colour. He made a long film around 1906, 1907, Stan Collier, and Mother remembered it. *Tjitte:* Something like a kaleidoscope? *Audrey:* There is a name for it. THE KALEIDOSCOPE, that's it. And it was called THE LATE WONDER. In the 1890s he made just a very short one on cinematograph film. *Tjitte:* Called THE WONDERFUL KALEIDOSCOPE? *Audrey:* That's right. He made another version of that with many tricks, with Stan Collier around 1906. He talked about it between jobs." (**Audrey Wadowska to Tjitte de Vries, London, 3 January 1978,** T016.)

"THE KALEIDOSCOPE – now that is a trick one, Mother remembered that and Stan Collier remembered it. You know what the old kaleidoscope was. They studied that, and some tricks developed out of the kaleidoscope. It is called THE WONDERFUL KALEIDOSCOPE in one of the catalogues." (**Audrey Wadowska to Tjitte de Vries, London, 31 March 1978,** T020.)

Audrey Wadowska: "Oh, I just thought of that title, you remember A KALEIDOSCOPE. I thought it was THAT MARVELLOUS or THAT WONDERFUL

67. Audrey Wadowska interviewed Mr. and Mrs Hulks, Park Street in 1963 or 1964, but references to early film shows in Park Street of a moving picture KALEIDOSCOPE are not present on the tape (no. 36) or the cassette (our archive no. T299).

KALEIDOSCOPE. Mother remembered Stan Collier and Father studying an old kaleidoscope for hours, and they eventually made it into a trick film, and I have seen it listed as THAT WONDERFUL or THAT MARVELLOUS KALEIDOSCOPE. Actually I have seen both titles, but no description. *Tjitte de Vries:* Is it Kaleidoscope? Wonderful or Marvellous? *Audrey:* Both, depending on which distributor. Cricks maybe, or Walturdaw, maybe Butcher, because Butcher had a lot of Father's films." **(Audrey Wadowska to Tjitte de Vries, London, 19 August 1978, To28.)**

Audrey Wadowska: "What of these kaleidoscopes? She (Mrs Hulks) saw a moving picture of these coloured kaleidoscopes. I know that Mother recalled it at about 1906, and Stan Collier too, because they were looking for novelties, and Stan Collier and he worked on a film which I have seen in the catalogues called as THAT WONDERFUL KALEIDOSCOPE. I imagine that is the film that they are referring too. And of course that is a longer film, 300 feet. *Tjitte de Vries:* Hand-coloured? *Audrey:* I suppose so. They were working on this at Bedford Park, trying to working these coloured patterns. But this woman recalled seeing it when she was a little girl at this Park Street village school. *Tjitte:* This film? *Audrey:* No, not this film but an earlier version of it. In 1895, an experimental film. At the same time they saw PARK STREET SPORTS, that was a very early film. *Tjitte:* 1895? *Audrey:* Yes. And LADIES CYCLING AGAINST THE WIND. That is supposed to be a comedy, and one or two odd bits and pieces, more or less local scenes and Barnet, some trains, HADLEY TUNNEL, some of these early experiments. It had two titles, but that was later. *Tjitte:* But there was one in 1895? *Audrey:* A short 50-footer. *Tjitte:* Already coloured? *Audrey:* Yes. She estimates it about that time, 1895. *Tjitte:* And in that school on a Sunday, he showed these films in Park Street? *Audrey:* I wouldn't say on Sundays. *Tjitte:* A Sunday school treat? *Audrey:* She reckons in 1895 or 1896, but it would be one of these early experimental shows, because he used to show them in cellars and in Father's cellar to his friends and that sort of thing. A sort of unofficial. But this was supposed to be a novelty. She said: It was wonderful! And she said: they were coloured! *Tjitte:* September, October 1895? And they were coloured? *Audrey:* I suppose so. Very short, she said." **(Audrey Wadowska to Tjitte de Vries, London, 29 July 1979, To46.)**

Audrey Wadowska: "He (father) was to get married to that Park Street girl, remember, Nellie Costin? She had a squint. Her father was a Park Street butcher. He was very well known. Some of the early films, COMIC COSTUME RACES, were made there, and he used to show pictures there

at bank holidays. I met a woman (Mrs Hulks) there who remembered the KALEIDOSCOPE. Dad made a film of it. She remembered it at the Baptist sunday school there. It was hand coloured. *Ursula Messenger:* Before the Second World War most of the films were hand coloured. *Audrey:* She remembered as a child Dad giving the shows, and she remembered how nicely coloured it was, and that would have been before the Boer War." **(Audrey Wadowska with her sister Mrs Ursula Messenger, London, autumn 1980, T208.)**

"He made a lot of skits, not only with matches. He made many skits on social activities and things like that. Though, there is one called MAGICAL MATCHES, according to Gifford about 1908. They form patterns. Like those coloured discs. I remember mother and Stan Collier pouring over these things – I think of it later – Kaleidoscopes! – THE WONDERFUL KALEIDOSCOPE." **(Audrey Wadowska to Tjitte de Vries, London, 28 May 1981, T058.)**

Unpublished manuscripts

"WONDERFUL KALEIDOSCOPE."

(Audrey Wadowska's A-Z manuscript, 1981, page W.)

Editorial

Kaleidoscopes, whether as a viewer in a tube or as stroboscopic slide combinations for the magic lantern, were immensely popular in those days. Until now, we only found for this title one published source, a Walturdaw catalogue of 1908. Walturdaw did not produce films. The company was a regular purchaser of Cooper's pictures. We could find only one publication, but not of Audrey Wadowska's titles THAT WONDERFUL KALEIDOSCOPE or THAT MARVELLOUS KALEIDOSCOPE. Her recollections are strong, and indirectly confirmed by her mother's recollections and that of her father's assistant Stanley Collier. What Mrs Hulks of Park Street remembers, however, is another KALEIDOSCOPE picture. It must have been shorter if that was before the Anglo-Boer War (1899-1902). It was most probably 50 feet and made in Birt Acres's time for the Kinetoscopes.

When was THE KALEIDOSCOPE made? Audrey says: 1906, 1907. Walturdaw publishes it in their 1908 catalogue. Audrey says: Bedford Park. Cooper moved his Alpha studios in the weekend of 25 July 1908[68] to 14, Alma Road, near his newly opened Alpha Picture Palace, almost opposite at London Road. Because Audrey's mother remembered it –

68. This is clear from a collection of Cooper's letters to his fiancée Miss Kate Lacey from the Wadowski estate (now in the Arthur Melbourne-Cooper Archive of the authors).

Cooper, in 1908, was engaged to her – we accept the film was made in that year in the Bedford Park studios.

With *'possible flat animation'* we mean that possibly two-dimensional animation was applied with flat objects on a flat surface, contrary to cartoon animation which makes use of cells with drawings.

Our assumption is that coloured pieces of glass like in a kaleidoscopic tube were animated on a piece of opaque glass which was lighted underneath. Many kaleidoscope pictures were made in these years, based on the tradition of the movable magic lantern slides. We therefore assume with some certainty that Cooper played his part with Walturdaw, one of his regular purchasers, distributing it. His REEDHAM ORPHANAGE BOYS DRILL (1906) has a kaleidoscopic character, just like MAGICAL MATCHES (1908).

15. Magical Matches * * * *, 1908.

250 ft., running time 4.10 min./330 ft., 5.30 min./396 ft., 6.36 min.
A.k.a. MYSTERIOUS MATCHES, ANIMATED MATCHES, MAGIC MATCHES and A BOX OF MATCHES.
Stop-motion animation only. (Possibly also coloured.)
Reissue MAGICAL MATCHES, Urbanora, 1912 (330 ft).
Reissue A BOX OF MATCHES, Prieur, 1914 (396 ft).

Credits

Directed and animated by Arthur Melbourne-Cooper. Production Alpha Trading Company. Studio Bedford Park, Beaconsfield Road, St Albans.

Synopsis

A decorated matchbox opens, matchsticks tumble out, forming themselves into figures that perform all kinds of shapes and patterns.

Cooper reused for this picture the preluding scene of the matchbox that opens and matchsticks come out from MATCHES APPEAL.

Contemporary sources

The Bioscope, London, 29 February 1912, page 635.

"MAGICAL MATCHES, A series of astounding feats, performed by matches only which assume endless shapes with extraordinary alacrity. Length 330 ft. Released April 10th (Urbanora)."

The Bioscope, London, 4 April 1912, page xvii.

URBANORA. MAGICAL MATCHES (330 ft., released 10 April 1912.)

"A silver match-box appears on the screen, the lid opens, the matches

come out and make up wonderful figures. For instance, the matchsticks form into a group of acrobats, and afterwards shape into a series of brilliantly revolving stars, which, in turn, become a laughing sun. A man's head is formed, and other matches become pipes, one after the other flying into the man's mouth. Each one is tried and rejected, until one comes along representing a man's face, and then this particular pipe suddenly becomes the man's head, and vice versa. The matches reappear and form a horse, cart and driver, and off they go. In quick succession another man's head appears, with a cigar in his mouth. Finally, the matches fly into position as a skeleton, which, after many curious evolutions, takes its head in its arms and disappears."

The Bioscope, London, 17 December 1914 (see Gifford), Prieur, Humpty Dumpty Films, 396 ft.

"A Box of Matches. A very clever and somewhat original trick film introducing a series of prodigious feats admirably performed by a box of matchsticks. Really very ingenious and quite skilfully done."

Complementary sources

Gifford-1968 (page 29), **1973, 1978** (page 12), **1986, 1987, 2000:** "01893/01802 – April 1908, (250). Animated Matches, Alpha Trading Company (Williamson), P:D:S:A: Arthur Cooper. Animated matchsticks. Matchsticks come to life and perform various gymnastic feats. Released April 1908. Print preserved in the National Film Archive."

Gifford-1973, 1986, 1987 (page 34), **2000:** "05280/05117 – Dec. 1914, (396). A Box of Matches, Humpty Dumpty Films (Prieur).[69] Trick. Animated matches come out of their matchbox and perform stunts."

Publications

"Other 'novelties' which might be mentioned here are the cartoons, vaudeville films, and few odd silhouette and puppet films (e.g. The Doll's Revenge, Clarendon, 410 ft., released 26 February 1911; Cinderella, Butcher's 997 ft., released 15 December 1912) produced from time to time. The old short film of some well-known comic act continued to appear occasionally, as indeed it still does. An early novelty showing the emergence of cartoon animation was Urban's Magical Matches of 1912." (**Rachael Low, 1948/1973.**) [N104]

"In 1908, Cooper made another animated match film and Dreams of Toyland, Wooden Athletes and several fairy-tales adaptions released through Empire Films in 1912, the An Old Toymaker's Dream and

69. R. Prieur and Co., Ltd., 40 Gerrard Street, London-W.

LARKS IN TOYLAND, ended his career on the eve of the war." (**Donald Crafton, 1982.**) [N105]

Recorded interviews

"Is that a reissue of Father's MAGICAL MATCHES or MYSTERIOUS MATCHES? Father used his Boer War match box opening, that piece of film, and that is why we haven't got that piece of film (in front of the MATCHES APPEAL film, which was kept and found back in Coton). Because in the Boer War film (...) (he used that) in 1908 (for) MAGICAL MATCHES." (**Audrey Wadowska to Tjitte de Vries, London, 20 August 1978**, To30.)

"Now here is the MAGICAL MATCHES (reads:) 'a series of astounding feats, performed by matches only, which assume endless shapes with extraordinary alacrity'. This is MAGICAL MATCHES, but it is the same Father made around 1908." (**Audrey Wadowska to Tjitte de Vries, London, 20 April 1979**, To38.)

"It starts by a match box and the matches coming out of it and forming into figures, and they write this slogan on the wall. I got a still from it. (...) What Father did was, he reused the match box part in 1907 or 1908 for a prelude to another film called MYSTERIOUS MATCHES or something like that, and they come out of the box and form up into shapes and funny things. We haven't got that part." (**Audrey Wadowska to Antoinette Moses, London, 22 May 1979**, T191.)

"All along we've known that father made another matches film incorporating partly one that he made during the Boer War. And I discovered this. MUSICAL MATCHES, Charles Urban. In this embryonic cartoon animation short, matches emerge from a silver box, form themselves into various shapes and act brief scenes. 230 feet. That sounds like his. Why they call it MUSICAL MATCHES? Father thought it was MYSTERIOUS MATCHES, and I have seen it somewhere as MAGIC MATCHES. It was made somewhere 1908, it says here 1912, that must be a reissue. He used that scene of the matches emerging from the box and forming into shapes, and then they enact brief scenes." (**Audrey Wadowska to Tjitte de Vries, London, 30 July 1979**, T175.)

"He made a lot of skits, not only with matches. He made many skits on social activities and things like that. Though, there is one called MAGICAL MATCHES. According to Gifford about 1908. They form patterns. Like those coloured discs, I remember mother and Stan Collier pouring over these things – kaleidoscopes." (**Audrey Wadowska to Tjitte de Vries, London, 28 May 1981**, To58.)

Jan Wadowski: "We met an old man in London, and he told us and later we

asked Father, and he said it was exactly as it is. A box of matches opens and matches come out and started to walk. And of course he uses it for another film, for MAGICAL MATCHES. Because it was during coffee break, he cut it off, put it in his pocket and asked: Have you anything to put it in? Oh, a coffee tin. So they put MATCHES APPEAL in the coffee tin. *Kenneth Clark:* And forgot about it? *Jan:* And forgot it and took it from one place to another. And some day, Mrs Cooper was making some order in the kitchen and: Look, there is some old film here. That is why it was saved."
(Jan Wadowski to Kenneth Clark, St Albans, 28 February 1988, T410.)

Unpublished manuscripts

"ANIMATED MATCHES (Magical) 1908 – MAGICAL MATCHES (Animated Cartoon)"
(Audrey Wadowska, A-Z manuscript, 1981, pages A and M.)

"The film (MATCHES APPEAL) received its premiere on the screen of the Empire Music Hall early on in the war. Copies are held in the National Film Archives and in the Melbourne-Cooper Archive. These were speculative productions, not commissions, but the arrangement with Bryant & May remained the same: the company paid him one guinea (£1.05) each time one was shown to a paying audience. His daughter, Audrey, discovered the negative of the opening sequence[70] several years later, 'I found it in an old camera case,' Audrey laughed, 'I happened to shake it and heard something rattle inside. I don't think he realized he still had it!' Cooper used it again as an introduction to ANIMATED MATCHES – also known as MYSTERIOUS MATCHES – when released in 1908." **(Kenneth Clark, 2007.)** [N106]

Editorial

Magical Matches was released and reissued by the distributors in several lengths: 250, 330 and 396 feet. Was the original length 400 feet, and were the releases subsequently shortened? Or did the distributors lengthen the reissues with titles and repetitions of several sequences? This would not be difficult because of its kaleidoscopic nature.

Not long after MAGICAL MATCHES was made, Cooper moved his Alpha Cinematograph Works from Bedford Park, Beaconsfield Road, to

70. No, the opening sequence of the matchbox that opens and releases matches is still lost. Cooper indeed reused it in 1908 for MAGICAL MATCHES. In Coton, around 1950, the family discovered the actual negative of MATCHES APPEAL without the opening scene in a tin or tea caddy (not in an old camera case after Cooper's death). In 1956, Cooper donated prints to the Kodak Museum and the newly formed Johannesburg Film Archive. Later, safety negatives and prints were made.

14, Alma Road. He had just opened a new cinema, the Alpha Picture Palace, nearby at London Road. The turmoil of a removal is a believable situation for the family story that he once entered the family kitchen with a roll of negative in his hands, that of MATCHES APPEAL, from which he had removed the opening sequence, asking for a tea caddy or biscuit tin for safekeeping of the flammable film. In this way MAGICAL MATCHES obtained at the beginning the sequence of a match box from which matchsticks appear after its opening.

Audrey, in later years, says on several occasions that she found the MATCHES APPEAL negative in a camera case after her father's death. However, in 1956, prints were made from it not long after its discovery. Gifford's title ANIMATED MATCHES is less correct.

16. **Noah's Ark** * * * *, March 1909, 440 ft., running time 7.20 min. A.k.a. THE TALE OF THE ARK and LOTTIE DREAMS OF HER NOAH'S ARK.
Live-action and stop-motion animation.
Reissue LOTTIE DREAMS OF HER NOAH'S ARK, Butcher 1912, 350 ft. Restored 35mm print at the BFI National Archive, London; 35 mm and 16mm print in the Audrey and Jan Wadowski collection, East Anglian Film Archive, Norwich.

Credits
Directed and animated by Arthur Melbourne-Cooper. Production Alpha Trading Company. Studios: 14, Alma Road and basement Alpha Picture Palace, London Road, St Albans. Assistant animators unknown. Tinted versions were available.
The mother: Eleanor Nöggerath Fox (Nellie Hope), the child: Amanda Agnes Nöggerath.[71] The pigeon was animated by a hair of Mrs Kate Melbourne-Cooper.

Synopsis
A child plays with her toy ark, she falls asleep and dreams about the Bible tale of Noah who is leading the animals into the ark. She awakens to find her ark still beside her.

Full synopsis (of existing picture)
SCENE 1a. Live-action, medium shot, exterior, 27 seconds.
A garden scene, with shrubs and trees in the background. At the left a

71. Born 1 September 1906, St Albans.

face of a young woman with a grand flowery hat who is talking to a very young girl of approx. 18 months old at the right. In the middle of the scene a little playhouse with a slanting roof, two tiny windows at the left, four on the right side. It represents a Noah's Ark.

The toddler plays with little animals belonging to the ark. She is lively, lifts the roof of the ark with her head, looks at someone behind the camera, and shakes her head. There is a jump-cut in the shot.

SCENE 1b. Live-action, medium shot, 11 sec.

A so-called Dutch chair has been put in view with a white blanket on the elbow-rest on which the toddler now rests its head. She lifts her hand and then closes her eyes.

SCENE 2. Animation. Close-up of a table-top set representing a long shot, 52 sec.

The set may possibly be some four or five feet wide and perhaps four feet deep. There is a little boat with a house or shed built on the deck and a gangway with seven steps down to a grassy foreground. The backdrop shows a painted scenery of mountains and a kind of temple with pillars.

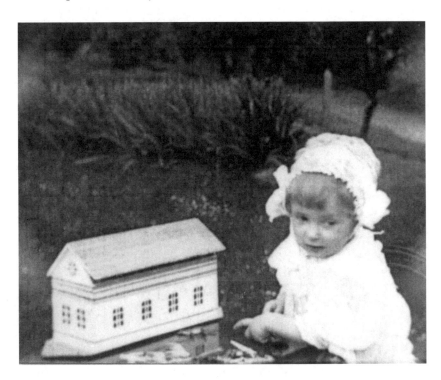

Fig. 89. Noah's Ark (1909) with Amanda Agnes Nöggerath.

The door of the house on the ark opens, and a figure in a biblical costume appears. He descends from the gangway onto the grass. A white and a grey mouse appear, who ascend the gangway into the ark.

SCENE 3. Animation. Close-up of a table-top set representing a long shot, 1.36 min.

Camera is lowered a little, mountains and temple painted on the backdrop are in a better view. Noah puts a signpost in the grass. From the right an elephant approaches. It enters the ark via the gangway. A pair of giraffes do the same and poodles, zebras, lions, geese, hyenas, deers and polar bears follow. The same with birds and two white pigeons who settle on the roof, walking up and down. They later settle on top of the open door. A giraffe looks out of the window, and an elephant teases him. A polar bear next to the open door interferes. A second bear pulls him overboard back on land and then pulls him with him on the gangway into the ark. The first bear keeps the door open for all animals to enter. A second elephant appears and enters the ark, which sometimes rolls on the water.

Finally, when all the animals and Noah's family are inside, Noah removes the signpost, takes it at first with him, but then throws it down the gangway in the water. The white pigeons go inside, one of them settles in the open window when Noah closes the door.

SCENE 4a. Live-action. Close-up of a table-top set representing a long shot, 1.06 min.

The rain is pouring down. Water is flowing through the grass. There is lightning. The ark is rolling heavily. The gangway is still out. The water is rising.

SCENE 4b. Live-action. Close-up of a table-top set representing a medium shot. 14 sec.

Different scene, no backdrops, white background. Only the ark is there. It is completely cast off in the water and floating on the waves from left to right.

SCENE 5a. Animation. Close-up of a table-top set representing a medium shot, 7 sec.

The ark is now at rest. A white pigeon flies from an open window of the ark.

SCENE 5b. Animation. Close-up of a table-top set representing a medium shot, 13 sec.

There are some branches with leaves sticking out of the quiet surface of the water. The pigeon plucks a short 'olive branch' from it and flies back.

SCENE 5c. Animation. Close-up of a table-top set representing a medium shot, 17 sec.

The pigeon arrives back at the ark, settles in the open window. Noah comes outside, the pigeon flies down to him, and Noah takes the olive branch. The water is falling. Mountains appear in the background.

SCENE 6. Live-action. Close-up of a table-top set representing a medium shot, 47 sec.

There are more and higher mountains in the background. The water is falling, and the ark is apparently stuck. A rainbow can be seen in the sky. There is some grass visible at the bottom of the screen.

SCENE 7. Animation. Close-up of a table-top set representing a long shot, 1.30 min.

Point of view is low, we are looking up to the ark, suggesting it is high on a mountain side.

The ark is now settled on solid dry, rocky ground. There is a mountain top in the background. A tiny piece of shadow of the ark can be seen on the backdrop at the right. The ark is here a little out of focus. Noah walks there. He picks up the gangway which was tucked away at the bow. He shoves it to its place, tries to put it straight, goes inside and comes back with an elephant that picks up the gangway and puts the end of it steady on a rock on the mountain-side. He disembarks, picks up a heavy rock to secure the end of the gangway. He walks away and waits for its partner. Then the two giraffes come outside, followed by the second elephant. The elephants greet each other exuberantly. All the other animals now come outside, the camels, the monkeys, and the tigers. We can just see the geese settling themselves on the banisters of the ark. (Here, the picture ends.)

Details

In the surviving print the final sequence of the awakening of the child is missing.

The titles of the copy from the Audrey and Jan Wadowski estate were most probably made by a laboratory for screening at the Cambridge Animation Film Festival in November 1979. Title: "NOAHS ARK – Made by ARTHUR MELBORNE-COOPER – 1909" [sic].

The 16mm print in the Wadowski estate is tinted. The colouring was done by Audrey and her sister Ursula. They tried to apply tinting as they remembered it from their work in the Twenties at Langford's Advertising Agency in Blackpool. They had learned tinting and colouring of films from their father when working for Langford's advertising studios in Blackpool. The first scenes in the garden are

green. The following two animation scenes are sepia coloured. The next scene of the flood is blue. The subsequent scenes are sepia again, and the last three scenes are blue-ish grey or sepia. Sometimes the colours are unstable and spotty.

I mark the animation scenes as "long shots", though technically they are close-ups of a very small set of only a couple of square feet. The intention is to let it look like medium and long shots. And they do, because the animals are rather small and taken from a distance.

From the Audrey and Jan Wadowski estate:

"National Film Archive, Tint Record No. 304.

[Noah's Ark], location No. 1743A (b)

to – 200 Tone Copper.

to – 240 Tint Blue.

to – 270 Tone Copper.

to – 349 Tone Sepia, Tint Blue."

Primary source – Arthur Melbourne-Cooper

Arthur Melbourne-Cooper to Sidney Birt Acres, Southend, 20 May 1956 (T001, tape VI, cd 1/17).

"(Talking about DUCKS FOR SALE OR RETURN.) And they thought it was a marvel. And that was with one camera turned one way, and the other one I had turned upside down, and the two ends were taken and put together. That was the first of it. The other ones of course then I did for Butcher's: CINDERELLA, THE CATS' FOOTBALL MATCH[72] in toys, that was a good scrapping one and THE 10 LITTLE NIGGER BOYS. (...) And the NOAH'S ARK, yes. That was all single picture work. They all went up in the Blitz."[73]

List of film titles in Mrs Kate Melbourne-Cooper's handwriting, authorized by Arthur Melbourne-Cooper, Coton, 1956.

"Trick: DREAM OF TOYLAND".

Contemporary sources

Herts Advertiser & St Albans Times, St Albans, 13 March 1909, page not known.

"*Picture Making. How Bioscope Records Are Made.* For the maker of living pictures there is open an absolutely unlimited field. At St. Albans it is proposed to go back as far as the flood for a subject! The Ark is even now in course of erection, and a full complement of animals – all specially joined so as to allow of life-like attitudes – is expected to arrive before

72. A.k.a. THE CATS' CUP FINAL.
73. During World War II, according to Butcher.

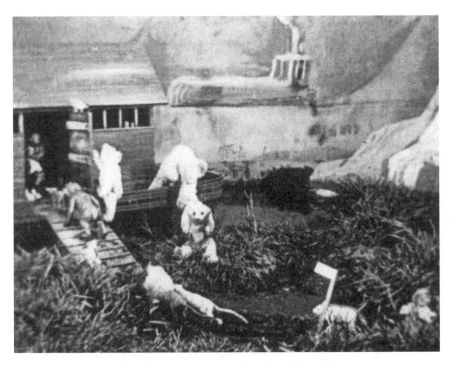

Fig. 90. The animals enter the ark in NOAH'S ARK.

long. These pictures will be composed on the same principals as those illustrative of 'TOYLAND' which meet with general approval whenever shown."

W. Butcher & Sons Ltd., Camera House, Farringdon Avenue EC, catalogue, London, 1911, page 199.

"No. 179. 'LOTTIE DREAMS OF HER NOAH'S ARK'. Lottie, tired of playing with her toys, falls asleep and dreams that her Noah's Ark and all her toys are in animation. They all enter the ark two by two, and as the rain heavily falls it rises until nothing is seen but the ark surrounded by water. The dove flies away and brings back the olive branch and the rain ceases – the rainbow appears and gradually the water subsides and her toys leave the ark. She awakens to find her box of Noah's Ark still beside her, and rubbing her eyes realizes it was only a dream. A clever and pretty picture. Length, about 350 ft. Code, 'Ark'. Price, 4d per ft."

Complementary sources

Gifford-1968 (page 88), **1973, 1986, 2000**: "02325/02193 July 1909, (440).

THE TALE OF THE ARK. Alpha Trading Co. (Cosmo),[74] D:S: Arthur Cooper. Trick. Dreams of Bible tale enacted by toys."

National Film Archive Catalogue: Silent Fiction Film 1895-1930. London BFI 1966. "NOAH'S ARK [F.674] Credits: p.c. Alpha; p. Arthur Melbourne-Cooper. Puppet: A child plays with a wooden ark and toy animals. When she falls asleep, she dreams that her toys come to life and re-enact the advent of the Flood (350ft)."

Publications

"In 1908 Arthur Melbourne-Cooper, an Englishman, produced a film using live actors and trick-film techniques called DREAMS OF TOYLAND. Children's toys were animated to produce what may have been the earliest example of puppet animation. Cooper's NOAH'S ARK, also 1908, used similar techniques." (**L. Bruce Holman, 1975.**) [N107]

"**Supporting programme: NOAH'S ARK**, 1909, G.B., Alpha. Producer/ Animation: Arthur Melbourne-Cooper. One of the very first British attempts at puppet animation. J.S. Blackton in the U.S.A. was concurrently doing similar experiments." (**Geoff Brown, Monthly Film Bulletin, June 1976.**) [N108]

"After this father made NOAH'S ARK, which is quite good. The original is coloured, and it is very pretty; but unfortunately it has not made a good 16mm print. You see all the animals go into the ark, two by two. One of the elephants playfully hustles the loiterers – typical of father's sense of humour." (**RPS lecture by Audrey Wadowska, 26 January 1977**, T128.) [N109]

"Some years later, Melbourne-Cooper made two charming films featuring animated toys, NOAH'S ARK and DREAMS OF TOYLAND." (**Patrick Robertson, Guinness, 1980, 1985, 1988, 1991.**) [N110]

"Melbourne Cooper a réalisé de nombreux autres films d'animation, dont L'ARCHE DE NOÉ et un CENDRILLON de 300 mètres en 1912, qui n'a pas été retrouvé. Il était en outre célèbre pour ses comédies, des films de trucages et ses documentaires, en plus de jouer un rôle important comme pionnier de l'exploitation cinématographique en Grande-Bretagne."

"Melbourne-Cooper made numerous other animated films, among them NOAH'S ARK and CINDERELLA, a 1000 feet film released in 1912, and which has not yet been found. He was also well-known for his comedies, his trick films and his documentaries; besides his work as a producer, he played an important part in pioneering film exhibition in

74. The Cosmopolitan Film Company Ltd., London.

Great Britain." **(JICA 81, Festival d'Annecy, 1981.)** [N111]

"Noah's beasts were the stars of the 1909 TALE OF THE ARK." **(Donald Crafton, 1982.)** [N112]

"Early Trick Photography. Arthur Melbourne-Cooper had made one of the earliest known British examples of animation (and probably commercials) when in 1899 he made a film for Bryant & May which in effect was an appeal for funds to supply the troops in South Africa – not for ammunition, food or clothing ... matches – something the Ministry seemed to have overlooked. Some years later Arthur Melbourne-Cooper made two delightful films, featuring animated toys. THE TALE OF THE ARK, 1909, and DREAMS OF TOYLAND, 1908." **(Patricia Warren, 1984.)** [N113]

"2348 NOAH'S ARK [a] \\ PC: Alpha \\ D:Cooper, Arthur Melbourne \\ Arch: LON" **(Ronald S. Magliozzi, 1988)** [N114]

"Other films by Cooper include NOAH'S ARK (1906), CINDERELLA (1912), WOODEN ATHLETES (1912) and THE TOYMAKER'S DREAM (1913)." **(Giannalberto Bendazzi, 1994.)** [N115]

Correspondence

Mrs Audrey Wadowska to E. Lindgren, Curator Britsh Film Institute, London, 25 November 1959.

'Dear Mr Lindgren. Relative to my conversation with Mr Grenfell, in connection with my father's visit to Aston Clinton on July 17th., when he was able to identify several of the items shown to him on the Editola, this will confirm the following Alpha productions (...) previously identified:

(...) 'DREAM OF TOYLAND' (Not complete), 'NOAH'S ARK'."

Mrs Audrey Wadowska to Colin Ford, Deputy Curator British Film Institute, London, 16 February 1970.

"Dear Mr Ford, I have at last managed to prepare the list of identified films which you asked me for, several months ago now! I must apologise for the delay, and though I cannot guarantee there are no omissions, I do trust you will find it useful. I would also like to take this opportunity of expressing my sincere thanks to you and your colleagues for all their help and co-operation on my behalf over the passing years. It has been a slow and often frustrating task, due mainly to the early film makers practice of copying, and the frequent replacement of original titles. And not least, to my father's own peculiar methods of business in producing his films for 'wholesale trade only'. But I feel sure it has not been a waste of effort. (...) (List 1.) The following items were personally identified: A. Melbourne-

Cooper. (...) NOAH'S ARK.

(List 2.)[75] The following items have been identified, one way or another as films produced under the direction of Arthur Melbourne-Cooper. (...) NOAH'S ARK."

Recorded interviews

"There is a rain of 40 days and 40 nights. Well, in that scene, for a whole minute, it feels just like 40 days and nights. I myself think it should be cut there. People who don't know NOAH'S ARK wonder why on earth they have to look at that scene all the time. There are no captions or explanatory notes or anything." (**Audrey Wadowska to Tjitte de Vries, London, 27 December 1976, To76.**)

"*Audrey Wadowska* (during a screening of NOAH'S ARK): This girl here, what you can see of her, is supposed to be Nellie Hope, Mrs Nöggerath. And that is, we understood, one of her children. This was made in 1909, and that does not tally with Geoff Donaldson's[76] research. Anton Nöggerath[77] was supposed to have returned to Holland by this time. In 1908, he says, his father died.[N116] And then again, how does Dave Aylott's recollection tally into this. He[78] formed (with Anton Nöggerath) the St Albans Cinematograph Company in 1910. I think this is the scene that is taken in the bath. There is a sign post there that says: Noah's Ark. *Tjitte de Vries*: So, you could not use the bathroom for a couple of weeks? *Audrey:* According to mother, she was very annoyed. And this is the part Charles Urban used for his geological film. (...) This is the long part of the 40 days and 40 nights of rain. There is the lightning. There is running water, it is not a mirror. It is suppose to be stormy here. They are bashed about. There is my colours. The whole thing was coloured, but the dyes have faded. This is that bath scene and that is supposed to be the olive branch. There is the dove. That floats around the ark. That is my mother's hair. After the 40 days and nights the storm stops, and they come out the ark again. I think this is the bath scene, because you can see the white background. There should be a rainbow. There is a bit cut out, I think. Something shoots

75. From the list of films that were personally identified by Cooper when they were screened to him at Aston Clinton.

76. Australian-Dutch film historian, Geoffrey N. Donaldson.

77. More about Nöggerath in Part One, footnote 70.

78. Dave Aylott, actor, had a rep company and played regularly with his actors in Alpha pictures. He planned a production company with Anton Nöggerath Jr. He later made his fortune manufacturing false eye lashes. Ms. *From Flicker Alley to Wardour Street*, Dave Aylott, 1949.

up there. Father called it NOAH'S ARK, but some of the distributors called it THE STORY OF THE ARK." (**Audrey Wadowska to Tjitte de Vries, London, 27 December 1976**, T 076.)

"Father saw several films (at the National Film Archive at Aston Clinton). I think they showed him 'Rescued by Rover'. He used to talk about LITTLE DOCTOR, but they didn't show him that. Harold Brown asked him a few questions, and he told his little reminiscences and things like that which they thought were funny. (...) I remember that they showed him something, I think it was NOAH'S ARK. It wasn't THE DREAM OF TOYLAND. Yes, it was NOAH'S ARK. I remember Mother was there. And the little girl was there in NOAH'S ARK, and she said: "Oh, that looks like you." And Father says: No, that was not me, I wasn't thought of at this time. That was Nöggerath's child. You see, that was made in 1909, I was not born until late in 1909, and this was early 1909."

"Ernest Lindgren was the curator, but it would be the cataloguer at the time. What was his name? David Grenfell, I think. He said to me: That can't be your father's film, it is made in 1917. And I said: well it wasn't, you know. It was made in 1909. Oh no! It wasn't. 1917!

Then I looked in the indexing files, and I saw they got it down as 1913. And then I started to go at the *Herts Advertiser* to see if they had anything reported, when the cinema opened and that sort of thing. And I read that in 1909, just before they were married – they were married in February on mother's birthday, the 17th of February 1909 – and it was before that, that father was interviewed by the chief reporter,[79] who later became editor and who was the father of the girl who worked there for years, she is about to retire now, she is an institution in the place[80] – the *Herts Advertiser or St Alban's Post* as it was called in those days. And it said there that they were welcomed by Mr Melbourne-Cooper who showed them the Alpha Picture Palace which got a studio underground, under the Palace and in course of production was the story of the ark and all the toys were there." (**Audrey Wadowska to Tjitte de Vries, London, 1 June 1978**, T062)

"In Father's days, Anton Nöggerath lived on the Sandridge Road in a terraced place which we have photographed and sent to Geoff Donaldson. And he had one or two children born in St Albans. Of course they are supposed to be in films. And according to Father Nöggerath's

79. *Herts Advertiser and St Albans Times.* 13 March 1909, 'How Bioscope Records are Made'.
80. Beryl Carrington, reporter of the *Herts Advertiser.*

wife, that was Nellie Hope, she was an actress, and she and one of her daughters are in NOAH'S ARK. (...) Someone is directing the child, and it looks that it is possibly her daughter. And she is telling to do this and the other, and you can just see a piece of her face, but it looks obvious she is not supposed to be in the picture. Father always used to say, that is Nellie Hope." (**Audrey Wadowska to Tjitte de Vries, London, 12 April 1979**, T040.)

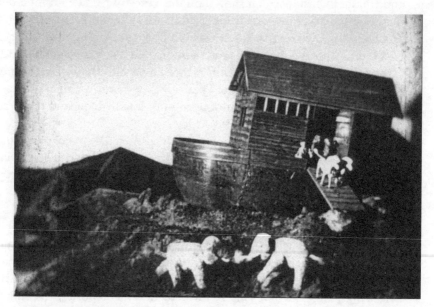

Fig. 91. With the ark on dry land, the animals are leaving in NOAH'S ARK.

Audrey Wadowska (studying Urban Catalogue 1909. C938): "ANIMAL KINGDOM, I believe these are compilations. Here, NOAH'S ARK. *Tjitte de Vries:* He (Urban) took that first bit for a title of a series 'OUR FARMYARD FRIENDS'. He cut it off to use it for something else. *Audrey:* Yes, I remember that. *Tjitte:* That is cheating on someone's copyrights. *Audrey:* But there were no copyrights. Then he gives 'OUR FARMYARD FRIENDS', and some of these are taken at the Wagon & Horses. Some chickens were Father's chickens, some other animals were Wagon & Horses. Old films, all dug up and stuck together, compiled in a series." (**Audrey Wadowska to Tjitte de Vries, London, 13 April 1979**, T036.)

"*David Cleveland:* NOAH'S ARK was made in? *Audrey Wadowska:* March 1909. *David:* Yes, the BFI says 1909, and they credit it to Alpha and

Arthur Melbourne-Cooper. Now that was sold as well? *Audrey:* Yes, that was re-titled in 1912 or 1913 by Butcher which was sold as an Empire film, for that was their firm, as LOTTIE's NOAH's ARK. (...) In 1908 he took over (the Polytechnique) and the whole building converted into a Picture Palace, and then he sloped the floor. And he used the underground that used to be a billiard room. He converted that into an indoor studio. And that was where some of the scenes of NOAH's ARK were taken. (...) He used arc lights. He always reckoned he was the first to have arc lights." (**Audrey Wadowska to David Cleveland, London, 11 October 1979**, T407/T419.)

"*Ursula Messenger:* We had toys when we were kids. Aud had an elephant. I know because the trunk always used to stick in her eyes. I remember that. I had a cat, I used to sleep with it. Ken had a rabbit, and they were all used in dad's films. *Jan Wadowski:* They were in NOAH's ARK. *Tjitte de Vries:* (Your mother) also helped with animation? *Ursula:* Yes, Mother made something out of a lamp shade. Mother was blond then, and her hair was used. *Jan:* The flying bird in Noah's Ark. *Tjitte:* Did your mother like film making? *Ursula:* Mother said it was a precarious way of living what Mother did not really like. She had three children to take care of." (**Mrs Ursula Messenger, Jan Wadowski to Tjitte de Vries, Felpham, Bognor Regis, 24 July 1983**, T206.)

Unpublished manuscripts

"Subsequently Cooper was to make a number of this type of film including NOAH's ARK, CINDERELLA, THE TOYMAKER'S DREAM and others. which proved very popular at the time and were most laborious to produce, every item of the set having to be animated by hand for the one frame, one picture technique." (**John Grisdale, 1960.**)[N117]

"NOAH's ARK made the following year in 1909 and of nearly the same length (350 feet) had added sophistications. The framing of the animated scenes within live-action was repeated. This time the film opens with a mother and daughter, the girl dozing off to sleep beside her toy ark and dreaming that the biblical story is enacted by her toys. The mother and daughter were the English wife and child of Anton Nöggerath, the Dutch film pioneer. Nöggerath learnt his trade at the Alpha studios as a result of which Cooper is probably better known today in Holland than in Britain. Unlike DREAM OF TOYLAND though, NOAH's ARK was made indoors in the studio at the new St Albans Picture Palace. It was also tinted in a variety of shades which changed from scene to scene. The later film also had the benefit of a clear, strong,

if predictable, story line, lacked the violence of DREAM OF TOYLAND together with the grotesqueness of many of that film's characters, and had the added touch of gentle humour.

The landscapes within which the ark is set were very well constructed and the water sequences well controlled. The animated section begins with a shot of the ark in the countryside. Noah comes out and down the gangway to collect the animals. The mice come first and then the elephants, one of whom is clearly none too keen at the thought of being cooped up in a little ark, having to be forced aboard by its mate. The elephant's continual attempts to escape do much to lighten the atmosphere of the film. Then come giraffes and dozens of other animals in pairs. Eventually with all aboard Noah closes the door, and the rain begins to fall. There are violent flashes of lightning (how Cooper effected these we do not know),[81] and the ark begins to float. After a while the rains cease, and Noah sends out a dove which flies (suspended according to Cooper on one of his wife's long blonde hairs) to collect an olive twig. The water subsides, the rainbow appears, and Noah emerges from the ark to drag the gangway into place. First off is the elephant, and he puts a boulder on the end of the gangway to hold it steady. The rest of the animals stream off to end the film. A considerably more polished film than its predecessor and one where Cooper is putting the technique of animation to good use rather than just playing with the toys as he had done in DREAM OF TOYLAND." **(Luke Dixon, 1977.)** [N118]

"Among his animated toys films, the dream sequence scenario enjoyed the greatest popularity. In THE ENCHANTED TOYMAKER a good fairy appears before a busy toymaker and then causes the toys to come to life by exercising her magic. The toys march into NOAH'S ARK, and the flood waters rise. Noah releases a dove who returns with a leafy twig. Many people were employed to animate the various dolls and animals over a period of two months, during which at no small inconvenience, Cooper filmed the entire event in his domestic bathtub where, with tap and bath-plug, he had complete control of the flood waters. Suspension of the dove during the flying sequences gave him trouble at first when fine thread, fishermans line, thin wire, all showed up on film. Eventually, he remembered his earlier solution to flying football and cricket balls, and

81. The lightning bolt came flashing down in four consecutive frames, drawn as white streaks (black in the negative) on the back drop representing the grey sky, touching the Ark in the fourth frame.

the problem was solved with the aid of a couple of fine hairs from his wife's head." (**Kenneth Clark, 2007.**) [N119]

Editorial

Gifford, erroneously, gives the title NOAH'S ARK as an alternative to THE FAIRY GODMOTHER (1906). NOAH'S ARK should not be confused either with THE ENCHANTED TOYMAKER (1904), which also features a Noah's ark. Charles Urban, in his Urban Trading Co. catalogues of 1906 and 1909, advertises a NOAH'S ARK, 2116*, 75 feet, as a section to proceed his "Animal Kingdom" series of live-action scenes of animals. This was the animation sequence cut from THE FAIRY GODMOTHER (1906).

NOAH'S ARK was shown June 1976 on a puppet animation programme at the National Film Theater; and on 21 October 1977 at the NFT in a programme dedicated to Arthur Melbourne-Cooper.

It was shown at several festivals, among them Camden Festival, September 1973; at the Film International Festival Rotterdam, January 1979; and at the Cambridge Animation Festival in November 1979. The British Council included it in 1985 in a film animation package "The Highlights of British Animation 1899-1974" on 16mm and video. The Australian Film Institute screened it in 1986 as part of an animation package in a number of cities. These are just some examples of public screenings that we know of.

What is the name of the little Nöggerath girl that plays in NOAH'S ARK? From the Australian-Dutch film historian Geoffrey N. Donaldson we know that Anton Nöggerath Junior [82] had five children, Antoinette (1901), Franz Anton (1903), Sidney Eric (1905), Amanda Agnes (1906) and Cecil Francis (1909), the first three born in London, the last two in St Albans. Considering her age of 18 months, the toddler falling asleep next to her ark is Amanda Agnes.

Cooper used the Noah's Ark subject several times in his animation pictures. A Noah's Ark with all its animals was a popular toy in those days. The famous shop of Hamleys in London called itself 'Noah's Ark'.

GRANDPA'S FORTY WINKS, 1910, 330 ft.
Reissue by Cosmo of IN THE LAND OF NOD, 1907 (365 ft).

DREAM OF TOYLAND, 1910, 300 ft.
Reissue by Walturdaw of A DREAM OF TOYLAND, 1908 (350 ft).

82. More about Nöggerath in Part One, footnote 70.

17. The Toymaker's Dream * * * *, 1910, 420 ft.,
running time 7 min.
A.k.a. THE OLD TOYMAKER'S[83] DREAM and THE OLD TOYMAKER OF
PENNY TOWN.
Live-action and stop-motion animation.
Reissue in 1911, 1912 and 1913 as (AN) OLD TOYMAKER'S DREAM
by Butcher's Empire Pictures, 350 ft, 315 ft. and 325 ft.

Credits
Directed and animated by Arthur Melbourne-Cooper. Production
Alpha Trading Company. Studios: 14, Alma Road and basement Picture
Palace, London Road, St Albans. Design (probably) Stanley Collier.
Assistant animators were Herbert Cooper, other studio staff members,
and children of the neighbours: the Massey and Barnes families. The
boy, played by Eric Lavers, was paid 6p.

Synopsis
A toymaker's son gives his father a model aeroplane to repair. The father
falls asleep and dreams that toys and dolls come to life and aeroplanes
are circling around St Paul's Cathedral. One of the aeroplanes crashes in
a jungle, is threatened by animals and meets with curious natives.

Primary source – Arthur Melbourne-Cooper
The Cinema, London, 19 March 1913 (page 47):
"The Kinema Industries, Ltd. A Chat with Mr. Melbourne-Cooper. 'You
may remember A DREAM OF TOYLAND, GRANDFATHER'S FORTY WINKS,
and THE OLD TOYMAKER OF PENNY TOWN. These I produced about five
years ago'."
**List of film titles in Mrs Kate Melbourne-Cooper's handwriting,
authorized by Arthur Melbourne-Cooper, Coton, 1956.**
"Trick: TOYMAKER'S DREAM."
**Arthur Melbourne-Cooper during family Christmas meeting,
Clapham, 26 December 1956,** (T003, tape III, cd 2/17).
Audrey Wadowska: "Then there was THE TOYMAKER'S DREAM? *Arthur
Melbourne-Cooper:* There was an old man, the toys came in, came alive
and were playing about. (...) *Audrey:* In THE TOYMAKER'S DREAM the star
only got sixpence, and he had to go and pay to see himself. *Cooper:* THE
TOYMAKER'S DREAM was different. Of course, he had. Money was scarce
in those days."

83. Because all the contemporary advertisements give 'toymaker', we have consequently
followed this spelling, even though the modern OED can not find it as such.

Contemporary sources

Film House Record, London, 15 October 1910, page 242.

"THE TOYMAKER'S DREAM, (T.F.C. Film – Tyler Film Co., Ltd.) Length, 420 feet. Code, 'Toy.' Release Date, October 30th.

'A fine example of 'stop-camera' work, this subject will also make an appeal by the humorous manner in which the action of the toy figures miraculously endowed with life are made to satirise some of the features of the life of today. An old toymaker is seen at his bench, at which, shortly after his young son has given him a model of an aeroplane, he falls asleep, and in imagination sees the various toys he has made become imbued with life and reality. The dream is greatly influenced by the aeroplane which the boy has given him, for in the first scene, in which a very realistic street scene is shown in which the toy figures move jerkily into and out of a row of toy shops, a 'Daily Mail' motor van passes along, with a placard offering £10,000 for a flight. Incidentally a dog falls a victim to the rushing motor-car, and the pedestrians dodge it by the smallest fraction of an inch in a startling fashion.

His fancy still running on flight, the dreaming Toymaker in imagination witnesses the start from Wormwood Scrubs of the flying machines which have entered for the £10,000 prize. – A good scene in which quite a realistic effect is obtained as the machines are seen in flight over the country. They are followed to St.Paul's, where there is an exciting picture of three flyers at one time circling the dome and in and out the towers in a hair-raising manner.

At night time one of the machines descends in a distant jungle, and after narrowly escaping the attention of various wild animals, the car is surrounded by a group of curious natives, whom he only escapes by again rising into the air, and at this interesting stage the old man is awakened from his vision."

W. Butcher & Sons Ltd., Camera House, Farringdon Avenue EC, catalogue, London, 1911, page 199.

"Trick and Humorous Subjects. No. 181. 'AN OLD TOYMAKER'S DREAM'. Another picture taken of mechanical toys in animation. The old toymaker falls asleep weary of endeavouring to sell his toys, and as he sleeps he dreams that his varied assortment of children's toys and novelties are real. The picture shows them working with all the quaint movements familiar to such a picture, making the subject extremely amusing to children and even to an adult audience. Length, about 350 ft. Code, 'Dream'. Price, 4d. per ft."

The Bioscope, London, 8 February 1912, page 346.

"Empire Pictures. Advance copies showing at the Cosmopolitan Film Co., Film House, Gerrard Street. W., – W. Butcher & Sons, Ltd.

Released May 18th. AN OLD TOYMAKER'S DREAM. An old street toymaker dreams that his mechanical figures live and we see an extremely clever representation of his dream – enacted entirely with mechanical toys. No. 181. Code 'Dream'. Length 315 ft. Price £5 5 0."

Supplement to The Kinematograph and Lantern Weekly, London, 1 May 1913, page xxxi.

"Empire. Agents – M.P. Sales Agency,[84] – 86, Wardour Street, W. OLD TOYMAKER'S DREAM (Tk). – The old toymaker falls asleep and dreams that his toys come to life. He sees many funny scenes in the streets of Toy Town, and a big aeroplane race across country, round St. Paul's and on to cannibal island. Released June 16th, length 325 ft."

Complementary sources

Gifford-1968 (page 29), **1973, 1978** (page 70), **1986, 2000:** "02797/02652 – October 1910, (420), THE TOYMAKER'S DREAM, Alpha Trading Co. (Tyler) D:S: Arthur Cooper. Trick. Toymaker dreams of toy aeroplanes crashing."

Gifford-1987 (page 16): "1910. THE TOYMAKER'S DREAM (420). Alpha Trading Company – Tyler Films. P:D:S:A: Arthur Cooper. Animated Toys. Old toymaker falls asleep on the job and dreams that his toys come to life. Two toy airplanes crash into each other. 'A very clever trick film and a good advertisement for the Daily Mail.' (*Bioscope,* 27 October 1910.) Released 30 October 1910. Remade as THE OLD TOYMAKER'S DREAM (1913)."

Gifford-1973, 1986, 2000: "04059/03905 – April 1913, (311), AN OLD TOYMAKER'S DREAM, Empire Films (M.P.), D:S: Arthur Cooper. Trick. Old toymaker dreams toys come to life."

Gifford-1987 (page 23): "June 1913, (325), THE OLD TOYMAKER'S DREAM, Empire Films – M.P. Sales. P: Frank Butcher, D:S:A: Arthur Cooper. Animated Toys. 'The old toymaker falls asleep and dreams that his toys come to life. He sees many funny scenes in the streets of Toy Town, and a big aeroplane race across country, round St. Paul's, and onto a cannibal island.' (*Kine Monthly Film Record,* June 1913.) Released 16 June 1913."

Herbert Birett-1991:[N120] "14310 DER TRAUM DES SPIELWARENFABRIKANTEN, [1910] T10 THE TOYMAKER'S DREAM, LRE Cooper, Arthur ABU Cooper,

84. Frank Butcher's Moving Pictures Sales Agency.

Arthur SAN Trickfilm INH Flugzeuge verunglücken. VUP 2.12.1910.
SPA Gifford 2797, PRO Tyler; 118 m/124.50."

Publications

"In 1908, Cooper made another animated match film and DREAMS OF
TOYLAND, WOODEN ATHLETES and several fairy-tales adaptions released
through Empire Films in 1912, the AN OLD TOYMAKER'S DREAM and
LARKS IN TOYLAND, ended his career on the eve of the war." (**Donald
Crafton, 1982.**) [N121]

"Other films by Cooper include NOAH'S ARK (1906), CINDERELLA (1912),
WOODEN ATHLETES (1912) and THE TOYMAKER'S DREAM (1913)."
(**Giannalberto Bendazzi, 1994.**) [N122]

Correspondence

**Letter of Eric Lavers to Mrs Audrey Wadowska, Watford, 1975 (?)
(T207).**

"One thing I do remember vividly is I took part and acted in a film for
the next-door people, as I called them, and the Film was actually shown
some long time after it had been taken, at the Poly Cinema, St Albans,
for three nights. As I had a 'star' part I attended the Poly on each of these
three days to the great detriment of my meager pocket money! The
name of the film was THE TOYMAKER'S DREAM."

Recorded interviews

Audrey Wadowska: "These are extracts from personal reminiscences.
Tjitte de Vries (reads Audrey's notes): (Eric Lavers) took part in a film
which was later shown at the Poly cinema for three nights. As he had a
'star' part he went to all three performances. His part was small in that.
He entered a toymaker's repair shop to ask him to repair a toy. He drops
off to sleep and his toys all come to life. Then he returns to wake the old
man up. He was paid the magnificent sum of 6d[85] for this. *Audrey:* That
was Eric Lavers, we got a letter from him. He was a Watford man, a
horrible man. He was the one who said: much water has flown under
the bridge since then." (**Audrey Wadowska to Tjitte de Vries, London,
19 August 1978,** T028.)

Ken Clark: "So that is also live-action and animation? *Audrey Wadowska:*
Many of them were. Like THE OLD TOYMAKER'S DREAM. He dreams that
his toys come into action. And the aeroplanes travel all around St.
Paul's. All done in models, made in 1910, the time when whats-his-
name made the first flight, the Daily Mail flight from London to

85. This 'magnificent sum' would have allowed Eric Lavers three visits to the cinema in the
cheapest seats.

Manchester. (...) THE OLD TOYMAKER'S DREAM, that was made in 1910, because we know the old fellow who is in that film. " (**Audrey Wadowska to Kenneth Clark, London, 24 October 1978,** T197.)

"AN OLD TOYMAKER'S DREAM made in 1910, because we met the boy who took part in that. He recalled going into the shop and waiting for the toymaker." (**Audrey Wadowska to Tjitte de Vries, London, 20 April 1979,** T037.)

Unpublished manuscripts

"It can only be assumed that a temporary financial embarrassment provoked the following 'dig' from a Mr. E.W. Lavers:

'One thing I remember vividly is I took part and acted in a film for the next-door people, as I called them, and the film was actually shown some long time after it had been taken, at the Poly Cinema, St Albans, for three nights. As I had a 'star' part I attended the Poly on each of these three nights to the great detriment of my meager pocket money.

The name of the film was THE TOYMAKER'S DREAM, and the whole length of the film was taken up by an old toymaker dreaming that his toys came to life and had a romance. My part was small in that I entered the old fellow's repair shop asking him to repair a toy. He drops off to sleep and his toys come to life and then I return and wake him up. As a matter of interest, my fee for this service was the magnificent sum of 6d. I wonder what the film stars of today would think'." (**John Grisdale, 1960.**) [N123]

"Films made from animated toys and often satirising topical events continued to engage Melbourne-Cooper's ingenuity at this period, and a typical example was THE TOYMAKER'S DREAM, a fine specimen of 'stop-start' camera work. In the spring of 1910 the Daily Mail newspaper offered a prize of £10,000 to the aviator who could pilot an aircraft from London to Manchester in one day, which contest was won by the brilliant French airman M. Louis Paulhan who flew the 185 miles in 4 hours 12 minutes, an amazing feat that left the world breathless with astonishment. Always on the look-out for new themes for his films Melbourne-Cooper took this event as his inspiration for THE TOYMAKER'S DREAM with fascinating results. (...) As reported in *The Film House Record* of October 15th, 1910, 'This was a fine example of the new and ingenious technique, and the manner in which the toy figures are miraculously endowed with life to satirise some of the features of life today is extremely humorous.' The film's length was 420 feet." (**John Grisdale, 1960.**) [N124]

"OLD TOYMAKER'S DREAM

OLD TOYMAKER OF PENNY TOWN (Puppets)."

(**Audrey Wadowska, A-Z manuscript, 1981,** page O.)

Editorial

Butcher reissued it as (An) Old Toymaker's Dream several times in different shorter lengths. In 1911 it is 350 ft., in 1912 it is 315 ft., and in 1913 it is 325 ft.

Gifford-2000: "June 1904: The Enchanted Toymaker (190), *also*: The Old Toymaker's Dream, Alpha Trading Co. (Paul), d: Arthur Cooper. Trick. Old man dreams fairy enlarges his Noah's Ark and toy animals enter it." Gifford clearly confuses two different pictures.

18. Oxford Street Up-to-Date * *, 1910, 350 ft.,
running time 5.40 min. Stop-motion animation only.

Credits

Directed and animated by Arthur Melbourne-Cooper. Production Alpha Trading Company. Studios: basement Alpha Picture Palace, London Road, St Albans. Design (probably) Stanley Collier. Assistant animators were most probably children of the neighbours, the Massey, Lavers and Barnes families.

Synopsis

A model of Oxford Street with busy traffic of cars, cabs and pedestrians "represented by mechanical toys".

Contemporary sources

W. Butcher & Sons Ltd., Camera House, Farringdon Avenue EC, catalogue, London, 1911, page 199.

"Trick and Humorous Subjects. Oxford Street up-to-date.

A model of Oxford Street with all the 'buses, cabs and pedestrians represented by mechanical toys. The lightning rapidity of motion is very amusing, whilst the extraordinary movements and situations created with the toys in animation is so remarkably clever that one asks 'How is it done?' Length, about 350 ft. Code, 'Uptodate'. Price, 4d. per ft."

Recorded interviews

Audrey Wadowska: "And this Oxford Street up-to-date. *Ken Clark* (reads): Model of Oxford Street, represented by mechanical toys again almost as if to say how the films were made." (**Audrey Wadowska to Kenneth Clark, London, 24 October 1978,** T197.)

Audrey Wadowska: "Butcher's employed Father or commissioned Father and built him a studio for its purpose or converted the studio because there were large grounds. Today, it is Manor Park, it is a big house and has a public garden behind it. Well, in Father's day it belonged to Butcher's.

And Father made these Empire animated films there. But at the same time he was the genial manager of the Harrow Picture Drome. *David Cleveland:* Was he? He was the manager of a cinema and at the same time working for Butcher's, doing animated films? But they would be turned out as Butcher's films, no reference to Melbourne-Cooper at all. *Audrey:* No, oh no. But you will see in the Butcher films some reissues, like I said, one is LOTTIE'S DREAM OF TOYLAND. One is OXFORD STREET UP-TO-DATE. All done with toys. And the odd thing is, it said: completely with mechanical toys. But they weren't mechanical." (**Audrey Wadowska to David Cleveland, London, 11 October 1979,** T407.)

"And then there was OXFORD STREET UP-TO-DATE, that comes under Butcher's animated films. I don't know much about it but I got it listed." (**Audrey Wadowska to Tjitte de Vries, London, 28 May 1981,** T057.)

Unpublished manuscripts

"OXFORD STREET UP-TO-DATE (animated toys). OXFORD STREET UP-TO-DATE (puppets)." (**Audrey Wadowska's A-Z manuscript, 1981,** page O.)

"As well as his live-action comedies and dramas, three animated toy films were released in 1910: OLD TOYMAKER OF PENNYTOWN, OXFORD STREET UP-TO-DATE, and THE CAT'S CUP FINAL." (**Kenneth Clark, 2007.**) [N125]

Editorial

The only convincing indicator that this is an animation picture made by Cooper is the publication in Butcher's catalogue of 1911. We gave this film a hesitant second star because of some indirect indicators. Cooper was fond of busy traffic. One of the first pictures he made for Acres was TRAFFIC ON WESTMINSTER BRIDGE (1895). The animation in A DREAM OF TOYLAND (1907) consists for a great deal of heavy traffic. His little masterpiece ROAD HOGS IN TOYLAND (1911) for Butcher is a demonstration how speedy traffic destroys rustic country scenes.

OXFORD STREET UP-TO-DATE is with its more than 5 ½ minutes running time quite a long animation picture. Cooper was a cinematographer who had the patience to make it. Frank Butcher's synopsis mentions that 'the lightning rapidity of motion is very amusing', which tallies with Cooper's sense of humour, present in almost all of his pictures. Butcher recommends: 'The (...) animation is so remarkably clever that one asks 'How is it done?'. The specific mention of cleverness and the question 'How is it done' are other indirect indicators for someone like Cooper to be the maker of this animation picture.

Audrey Wadowska mentions the title in three different interviews, creating a negative indicator by suggesting that this picture was made

in Butcher's Manor Park studio. Audrey is not correct here. Cooper still made two other animation pictures, THE CATS' CUP FINAL (1910) and TOPSY'S DREAM OF TOYLAND (1911), in the basement studios of his Alpha Picture Palace in St Albans where he had electric light available. This light enabled him to do the animation in the evenings or at any moment that suited him, for instance on rainy days. He moved with his family to 26, Manor Park in Lee in the second half of 1911, and made there for Frank Butcher ROAD HOGS IN TOYLAND (1911), as the first of a series of animation pictures for Empire Films.

19. **The Cats' Cup Final** * * * *, 1910, 360 ft., running time 6 min.
A.k.a. THE CATS' FOOTBALL MATCH.
Stop-motion animation only.
Reissue THE CATS' CUP FINAL, Butcher's Empire Films, November 1912.

Credits
Directed and animated by Arthur Melbourne-Cooper. Production Alpha Trading Company. Studio: basement Alpha Picture Palace, London Road, St Albans. Assistant animators studio staff members Stanley Collier, Herbert Cooper, and others.

Synopsis
Toy cats play a football match. Several injured players are carried off to safety on wheelbarrows by monkeys.

Details
The tabby cats were specially made with adapted joints for this production by the famous toyshop of Hamleys, Regent Street, London.
Originally, Cooper wanted to make THE CATS' CUP FINAL as cartoon animation. He asked in vain first illustrator Harry Furniss and later cat painter Louis Wain to make the drawings. Wain asked £1000 to start with.

Primary source – Arthur Melbourne-Cooper
List of film titles in Mrs Kate Melbourne-Cooper's handwriting authorized by Arthur Melbourne-Cooper, Coton, 1956 (T441).
"Trick: CATS FOOTBALL MATCH."
Arthur Melbourne-Cooper to Sidney Birt Acres, Southend, 20 May 1956 (T001, tape VI, cd 1/17).
"The other ones, of course, then I did for Butcher's: CINDERELLA, THE CATS' FOOTBALL MATCH in toys, that was a good scrapping one, and THE

TEN LITTLE NIGGER BOYS. (...) And the NOAH'S ARK, yes. That was all single picture work. They all went up in the Blitz."[86]

Arthur Melbourne-Cooper to Stanley Collier, Aldeburgh, 20 July 1958 (T090, tape X, cd 4/17).

Cooper: "The funniest thing was, when I was doing THE CATS' FOOTBALL MATCH, I went up to Hamleys and I bought some tabby cats for playing football, the same as what you see today. And they all got bellows inside, they used to cry in there when their box opened. They put it in a big cardboard box. I put it in the seats to come down. I sat there. Two or three old ladies sitting opposite me. And I moved this box and the cats inside meowed! And they said (whispering): He has cats in there. They stared at me. So I put the box down, and the cats did another cry out. And they sat there gazing at me. So I opened the box and showed them what was in them. I had no cats in the box. *Stanley Collier:* How dare you treat a poor old pussy cat. *Cooper:* They gave a very natural sort of meow. (...) It was a terrible meowing they set in. They were on the point of calling the guard,[87] I think."

Arthur Melbourne-Cooper to John Grisdale, Coton, March 1960 (T043, tape IV, cd 9a/17, cd 9b/17).

"I went to see Louis Wain,[88] went to see him to make animated films, but he wanted too much money. I looked for someone to drawing THE CATS' CUP FINAL and wanted to engage Louis Wain, 1910, but he wanted 1000 pounds down to start it. But I would always find a way doing the job, so I used puppets. I bought the cats from Hamleys in London. I used to squeeze on my way back the package in which they were and ladies would think I had real cats in there. I needed chaps to do the work, and if it was not right, I would brake it up and do it all over again. Football playing cats, finished up with a monkey pushing a barrow carrying off the injured cat-players. One had a stomach ripped open. Before that I tried to get Harry Furniss on the job, a Punch illustrator, but he saw no future in it.[89] With someone who would draw illustrations for me I would

86. During World War II, according to Butcher.
87. According to film historian David Cleveland they had guards in those days on the train.
88. Louis Wain was a famous illustrator and painter of cats. He lived in Kilburn in a house with dozens of cats. He died in Napsbury Hospital, a mental institution, just outside St Albans.
89. Illustrators shrank from the great number of drawings necessary to make an animated cartoon picture. In 1924, when Cooper moved to Langfords Advertising Agency in Blackpool, he had many arguments with the illustrators about the number of drawings needed for the advertising cartoon pictures he was producing there.

have followed a procedure like this: take for instance an earthquake, have it outlined, wash the rest away, and in reversal it would come again. I would have used a double reversal camera, to do the filling in, and 'washing' out, paint the picture out in white till the outline, and in reversal it would seem as if all came to pieces."

Complementary sources

Gifford-1968 (page 29), **1973, 1978** (page 70), **1986, 2000**: "03646/03500 – October 1912, (360). THE CATS' CUP FINAL, Empire Films (MP), D:S: Arthur Cooper. Trick. Toy cats play football match."

Gifford-1987 (page 19): "1912 (360). THE CATS' CUP FINAL, Empire Films – M.P. Sales. P: Frank Butcher, D:S:A: Arthur Cooper. Animated toys. 'An ingenious trick film.' (*Kine Monthly Film Record,* November 1912.) Toy cats play a football match. Released 3 November 1912."

Publications

"Yet another innovation of Mr. Melbourne-Cooper's was the use of match-sticks, toys and dolls in the making of 'animated cartoon' films – forerunners of many modern films made on the same principle. Among the most successful of these were DREAMS OF TOYLAND, IN THE LAND OF NOD, TEN LITTLE NIGGER BOYS, THE CATS' FOOTBALL MATCH and CINDERELLA – for which he had to grow his own pumpkin." (**Joe Curtis,** ***Herts Countryside,*** **summer 1960.**) [N126]

Recorded interviews

Audrey Wadowska: "What did George Maynard do? *Wally Colegate:*[90] I saw him making the Dolly films,[91] you know, football, CATS' CUP FINAL, wasn't it? *Audrey:* On his own? *Colegate:* No, your father! Oh no, no. *Audrey:* Jackey remembers that one, and the other one has to do with the circus. I found no references of that. GOING TO THE CIRCUS. Didn't dad gave Mavis[92] a lyon? *Colegate:* That's right, I can remember that well. Mavis had some trouble in her life." (**Audrey Wadowska to Wally Colegate, London, August 1972,** T195.)

Audrey Wadowska: "There is something funny about the word cartoon films. Emile Cohl is the first cartoon film. It is animation. But Father is puppet animation, but it is still animation. *Jan Wadowski:* He asked

90. Actor, husband of actress Jackeydawra Melford.
91. i.e. THE HUMPTY DUMPTY CIRCUS, a.k.a. THE DOLL'S CIRCUS or GOING TO THE CIRCUS. H. Maynard, son of the sweets manufacturer, in a letter to the Kinematograph Weekly of 13 November 1947, confirms his assistance to this and other animation pictures made by Cooper.
92. Actress Mavis Melford, sister of Jackeydawra Melford.

Harry Furniss to make drawings. *David Cleveland:* What year was this? *Audrey:* About 1907, 1908. After DREAM OF TOYLAND. *Cleveland:* Some time after his original animation. He abandoned it? *Audrey:* He couldn't get anybody do the drawings. Furniss said, there was no future in it, and later I read that he went to America. Later, when he went to do THE CAT'S FOOTBALL MATCH he tried to get Louis Wain to do it, the famous cat artist, but he wanted 2000 pounds.[93] Father did not have that sort of money. So he did that with puppets. *Jan:* (Shows a book of Louis Wain)." **(Audrey and Jan Wadowski to David Cleveland, London, 19 December 1977, T420.)**

Audrey Wadowska: "THE CATS' CUP FINAL, he made that at St Albans. *Peter Colman:* Animation as well? *Audrey:* Yes, and it is reported in the paper, the *Herts Advertiser*. Peter Green wrote previously about me. (...) In this week's paper, he mentions THE CATS' CUP FINAL. Father tried to get Louis Wain to draw the cats, because Wain was famous in those days. He visited him in Kilburn. He said, he had dozens, hundreds of cats in all shapes and sizes, he was surrounded by cats. But in my view, his drawings are very good. I have seen some of them. They are very lifelike. They have that comic-like which just suited father's CATS' CUP FINAL. But he wanted a £1000 before he put a pen to paper. That was a lot of money in those days. Then he tried Harry Furniss on the job. But he saw no future in animation at all. But I read in *The Bioscope*, by 1912 he has gone to America to make animated films for Edison. When Father wanted him in 1908, there was no future in it." **(Audrey Wadowska to student Peter Colman, London, 27 January 1978, T185.)**

Audrey Wadowska: "THE TOYMAKERS DREAM and THE CATS' CUP FINAL, those were made in St Albans. And GOING TO THE CIRCUS[94] is possibly on Butcher's list. But Jackey[95] and her sister remember going to Warwick Court, seeing Father working on that hair. He may not have made all of them there, but it was made for Butcher. *Tjitte de Vries:* Warwick Court was...? *Audrey:* Kinema Industries in those days. He had an indoor studio, but not a staged studio floor. When he wanted a staged production, he hired through Theo Bouwmeester the Pathé Studio in Great Portland Street, which is not far from Warwick Court of course." **(Audrey Wadowska to Tjitte de Vries, London, 15 August 1979, T061.)**

93. Cooper himself, and Audrey somewhere else, say £1000.
94. i.e. THE HUMPTY DUMPTY CIRCUS.
95. Jackeydawra and sister Mavis Melford, actresses, daughters of actor Mark Melford. It is unclear what Audrey means. THE CATS' CUP FINAL was made in St Albans.

Fig. 92. From 1912 till 1915, 4 and 5, Warwick Court, High
Holborn in London, was Arthur Melbourne-Cooper's Kinema
Industries offices with laboratories in the basement.

Audrey: "Harry Furniss saw no future in it, but I read that he in 1912
went to America to work for Edison. *Ursula Messenger:* Oh, eh, CAT'S
FOOTBALL MATCH. *Audrey:* Yes, Dad asked Louis Wain. He had
hundreds of cats. He died in Napsbury hospital. I went to see a man
who had a lot of his drawings. But Wain wanted £1000 so dad did it with
toy cats. *Ursula:* From Hamleys, yes. *Audrey:* Sometimes it was called
THE CATS' FOOTBALL MATCH, or THE CATS' CUP FINAL. Jackeydawra
said, she never laughed so hard." (**Audrey Wadowska to her sister
Ursula Messenger, London, Autumn 1980,** T208.)
"Father tried to get him (Harry Furniss) to do the drawings for his
animated films before 1910. But he saw no future in that, he wouldn't
touch it. But I read in *the Bioscope* in 1914, he went to America and was
working for Edison! So he changed his mind. Then a lot of them did. A
lot of people wouldn't touch film, even the actors and actresses. The
Dare Sisters, Father wrote to the Dare Sisters and asked them whether
they would take part in some film. Oh, no! That would spoil their
reputation. Their faces would be seen on the cinema screen. (...) Louis
Wain – Father tried to get him to draw the cats, because he was a cat
artist, he lived out at Kilburn, he was a bit of a mad man, he finished up
in Napsbury Mental Hospital near Park Street. And he died there.
 There was a piece in a local paper about a man who remembered him,
who worked there, in the *Herts Advertiser*. And I went to see him. And

apparently he got quite a lot of Louis Wain drawings. And of course he said, he was stark staring mad. Anyway, when father went to see him in some flat in Kilburn, he had hundreds of cats all over the place. Mind you, his drawings are very good, lifelike. And we did have one on a postcard, that when you pressed it was: Meow. I have seen drawings of him. He is very good. But he wanted a thousand pounds before he put a pen to paper. Of course father did not have that sort of money in those days. But THE CATS' CUP FINAL or THE CATS' FOOTBALL MATCH, those are the two titles, would have been good, I imagine. He did it with these toys, before 1910. And Jackey went with her father to see it at a place in London, and she said: they didn't stop laughing from beginning to end. And even her father laughed, and it took something to make him laugh. Funny thing is, some of these comedians are misers. Anyway, she said, it was a wonderful film, and it finished out with a set-to at the end, the cats were scratching each other, and one was open down the stomach and was carted off in a toy wheelbarrow. The funniest film, she said, she had ever seen. I would love to have that. Toy cats, he bought them from Hamleys, and they meowed. And it was made at St Albans, because he recalled that he got them packed in a box and as he was travelling on the train to St Albans, about Radlett two ladies got on, and Father put his arm on the box, and there it was: Meow! And these old ladies looked at him and threatened almost to report him to the RSPCA because he got cats in that box. And he opened the box to show them that they were toys. Of course, mind you he did that purposely, just for the joke." **(Audrey Wadowska to Tjitte de Vries, London, 17 April 1981,** To53.**)**

"THE CATS' CUP FINAL is an Urban film. Made before 1912, because it was made at St Albans." **(Audrey Wadowska to Tjitte de Vries, London, 19 April 1981,** To55.**)**

"He made (...) THE CATS' CUP FINAL or THE CATS' FOOTBALL MATCH, under those two titles. And according to Jackey it was the funniest film she had ever seen. (...) They were toy cats. He wanted that artist, what's his name, Harry Furniss, no, not that one, Louis Wain for that one, the cat artist. He wanted too much money. So he got toys for it." **(Audrey Wadowska to Tjitte de Vries, London, 28 May 1981,** To57.**)**

Unpublished manuscripts

"In order to produce the animated models film CATS' FOOTBALL MATCH with realistic sound effects, it had been found necessary to purchase toy cats with artificial meows as near to the real cat cry as possible. These model cats were bought from Hamleys, a toy specialist in London." **(John Grisdale, 1960.)** [N127]

"Cat's Cup Final (puppets), 1910."
(**Audrey Wadowska, A-Z manuscript, 1981,** page C.)
"An idea for a film titled The Cats' Cup Final prompted Arthur to approach Harry Furniss, but he refused point-blank to make an animated drawing film, holding the opinion that he could see no future for the medium. Next, Arthur approached Louis Wain in his Kilburn home with the suggestion the artist might like to animate his famous cats in cartoon form. At first, Wain was enthusiastic and produced many preliminary drawings but, when he realized how many more would be required, he asked for an advance of £1000. Cooper was not willing to agree to that, and was momentarily tempted to abandon the venture. Instead, he shrugged off his disappointment and proceeded to make the film in his usual fashion. In fact, it had been because so many drawings were needed in the making of an animated cartoon film that Arthur chose to animate toys in the first place." (**Kenneth Clark, 2007.**) [N128]

Editorial

Apparently, Cooper planned to do something new. He had an idea for a spoof on the popular game of football with two teams of cats playing a cup final. He wanted to make a cartoon animation of it and not puppet animation. He approached two famous artists, the painter of cat pictures Louis Wain, and *Punch* magazine cartoonist Harry Furniss. When they realised how many drawings were necessary for each minute of film, 480 to 600, they were not quite eager.

Louis Wain (1860-1939) painted and drew very humorous humanizing drawings and remarkable artistic paintings of cats. No wonder that Cooper approached him, but Wain, apparently realising the amount of work and always being short of money, asked seriously for the sum of £1000 in advance. However, in 1917, film maker H.D. Wood asked him to make cartoon animations. Film maker George Pearson helped him, but the cinema success was not great, and the venture was abandoned, and only a fragment seemed to have survived.[N129]

Harry Furniss (1854-1925) made more than 2,600 drawings for *Punch* magazine. In 1912, according to *The Bioscope*, Furniss went to America where he, in 1914, made the first cartoon picture for Edison.

The Toymaker's Dream, Tyler Film Co. Ltd., 1910, 420 ft.
Reissue of The Toymaker's Dream, 1910 (420 ft).

Dollyland, 1911, 80 ft.
Reissue by Butcher's Empire Films of Dolly's Toys, 1901 (80 ft).

20. Topsy's Dream (of Toyland)*, 1911, 350 (?) ft.,
running time 5.50 min.
Live-action and stop-motion animation.
A.k.a. Topsy's Dream of Toyland

Credits

Directed and animated by Arthur Melbourne-Cooper. Production
Alpha Trading Company. Studios: 14, Alma Road and basement Alpha
Picture Palace, London Road, St Albans.

The policeman is played by Bob Wilmott who, from 1910-1914, was a
uniformed commissionaire of the Alpha Picture Palace, St Albans.

Synopsis

A little girl falls asleep on a bench on the Thames embankment,
dreaming of Toyland where all the dolls are alive. A policeman wakes
her when snow starts to fall.

Contemporary sources

The Bioscope, London, 12 December 1912, page 858.
"Book These Extra Attractions. Topsy's Dream, Dec. 19th. 4.0.0, Jan. 6th,
2.10.0, Jan. 9th. 2.5.0, Jan 13th. 2.5.0. The London & County Film Service,
104, Wardour Street, W."

Recorded interviews

"*Bob Wilmott:* We took a bit of a picture downstairs, called Topsy's
Dream Of Toyland. Well, I picked up a girl supposed to be on the
Thames Embankment, picked up one of these waif and stray little girls,
you know, and it was snowing like, they were throwing white stuff
down from the top when I was lifting her up. It was called Topsy's
Dream Of Toyland, silent of course. *Audrey Wadowska:* It wasn't made
with dolls?

Wilmott: A little girl, some little girl, you know. I just went and picked
her up. I was dressed up like a policeman when I picked her up, just like
a policeman I was. It was Old Streaky's policeman's uniform I had.
Audrey: I never heard of it, must look it up. *Wilmott:* It was between 1910
and 1914, that is what I am talking about." (**Bob Wilmott to Audrey
Wadowska, St Albans, 1963,** T294.)[96]

"I am listening to a tape recording which was made in St Albans with an
old man there. He says he remembers taking part in Topsy's Dream Of
Toyland. Now I have seen that somewhere, but I didn't connect it with
an Alpha title. He says he was in it, and that was made in St Albans. So

96. Interview by Audrey Wadowska with Bob Wilmott and his sister Mrs Argent, St Albans.

that is another one to put on the list." (**Audrey Wadowska to Tjitte de Vries, London, 16 August 1978,** T022.)

"Ah! Topsy's Dream Of Toyland, that's it, yes! This man in St Albans remembers that. That was taken in 1910/1911. That was Bob Wilmott. I have never connected that with Father. And he said, he took the part of a policeman. Apparently, a little girl is away for something. She is supposed to be on the Thames Embankment, and a policeman goes and wakes her up and the snow is falling down, and he was the policeman. And he said, the snow was made of paper. It is quite long. So, not so late, 1911. That is Father's!" (**Audrey Wadowska to Tjitte de Vries, London, 20 August 1978,** T031.)

"I haven't seen anybody suggesting this is an Alpha, but in St Albans there is a man, dead now, he worked for Father, he was the Picture Palace's first uniformed commissionaire, and he recalled – Jasiek and I went to see him – Topsy's Dream Of Toyland, made in 1910. This is 1913,[97] and I suppose it appears here, because Cricks & Martin – Bob Wilmot, that was his name. He was the policeman. The story opens with a little girl, supposed to be on the London embankment, lying down on a seat. (...) And it is snowing fast, because I asked him whether they had to wait for the snow, but he said: No, it was papers they spread out." (**Audrey Wadowska to Tjitte de Vries, London, 20 April 1979,** T038.)

"He made that about 1910. (...) It was not completely animation. This man took part of a policeman and Topsy is asleep on the embankment, supposed to be on a public sitting, and he has to wake her up, because she is dreaming she is in Toyland. It was made in St Albans, could be for Cricks and Martin. Or Walturdaw or Urban." (**Audrey Wadowska to Tjitte de Vries, London, 19 April 1981,** T055.)

Unpublished manuscripts

"Topsy's Dream of Toyland (1910)"

(**Audrey Wadowska, A-Z manuscript, 1981,** page T.)

Editorial

Gifford-1973, 1986: "03263 – December 1911, Topsy's Dream of Toyland, 1050 ft. 'Cricks & Martin, D/S A.E. Coleby, with Dorothy St John, Edwin J. Collins. Fantasy. Waif faints and dreams she weds Prince; on waking she is adopted by rich man'."

This apparently is not animation but a different live-action picture. Gifford, in his 2000 edition, omits this title. Cricks & Martin advertises

97. *The Bioscope*, 2 October 1913.

this lengthy production from 1911 till 1913. Could Alpha's production have been released under a different title?

Bob Wilmott, who was a uniformed doorman of the Alpha Picture Palace, remembers this picture with satisfying details on the basis of which Audrey assumes that it must have been made by her father. Wilmott's story is strong enough to grant this title one star.

The Bioscope advertises it as TOPSY'S DREAM. To distinguish it from Cricks & Martin's live-action picture, we put OF TOYLAND between brackets. This most probably was Cooper's last animation production in the basement of the Alpha Picture Palace in St Albans. Not long after that, the family moved to Manor Park, Lee, where Cooper made a number of animation pictures for Fred Butcher's Empire Pictures.

21. **Road Hogs in Toyland** * * * *, 1911, 330 ft.,
running time 5.30 min. A.k.a. ROAD HOGS IN MOGGYLAND.[98]
Stop-motion animation.
16mm print in the Audrey and Jan Wadowski collection, copy from the John Huntley Film Archives, now in the East Anglian Film Archive, Norwich; 16mm print in the Tjitte de Vries/Ati Mul Collection, Rotterdam, Netherlands.

Credits
Directed and animated by Arthur Melbourne-Cooper as his first picture for Butcher's Empire Pictures. Producer Frank Butcher of W. Butcher and Sons Ltd. Butcher's studio at 42a, Manor Park, Lee. Assistant animator Henry Maynard.

Synopsis
There are toys and dolls in all sorts and sizes in a remarkable number of scenes. There is a race of motor cars – the Road Hogs – creating devastating scenes in Toyland. There is much consternation in several toy villages, but the cars are rushing on over bridges, and down steep hills. The race ends with the disastrous collision of two racing cars which are thrown up high in the air.

Full synopsis (of existing picture)
ORIGINAL TITLE SCENE (1½ sec.). Surrounded by arts and crafts decorations, there is the following title:
"ROAD HOGS IN TOYLAND. A story enacted entirely by mechanical

98. Moggy: slang for cat.

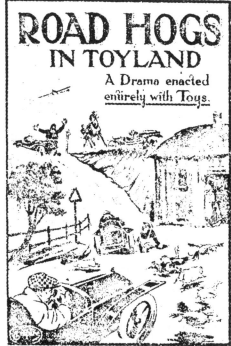
Fig. 93. ROAD HOGS IN TOYLAND (1911), Butcher's advertisement in *The Bioscope*.

toys. W. Butcher & Sons Ltd." And in a separate graceful frame with sun beams as background: "Empire".

SCENE 1. Big close-up of table-top scene representing a long shot, 65 seconds.

At the right is a house of two storeys, apparently an inn. There is a road in the centre. Painted on the backdrop are houses.

A toy donkey kicks backwards at a figure who apparently was thrown off. A racing-car with the number 4 on it is parked in front of the house at the right. A servant girl in a white apron accompanied by a goose is standing in front of it. Another racing-car approaches from the front of the screen. It has a 2 on it. From the left racing-car number 5 approaches. Between them a small motorcar makes its way.

The donkey kicks the man another time. Both disappear at the left. The three racing-cars are now parked in front of the inn. The drivers enter the inn.

A chair comes into view from the left. It is carried by a figure with striped stockings and a funny headgear. He is followed by a female in a short skirt with a wide pettycoat. She assists in carrying another chair. With stiff legs she mounts a chair and makes a bow to an invisible audience. A couple of little clowns appear in the foreground of which one makes a head stand. The female now stands on the back of the chair making equilibristic exercises. A man with a flock of geese stops to gaze at the equilibriste who makes rotations on the back of the chair, almost making a head stand. She descends from the chair.

The drivers appear from the inn and get in their racing-cars. The geese climb on the chair to imitate the girl. She lifts up a goose and swings it around. The three racing-cars drive around the chair to the front. They are in each other's way and in that of the geese and a chicken. The girl waves them good-bye. The scene is now empty. There is only a chair with one goose left on the road.

SCENE 2. Big close-up of table-top scene representing a long shot. 63 seconds.

The scene shows a viaduct over a road and a small canal in which floats a boat with white sails. There is a steep road at the left leading downwards from the viaduct to the foreground. In the centre is a flower-bed. A puppet in a black dress and black hat is waiting there. Behind her is a female in white, a nurse-maid, with a pram. She walks to the right, then to the left around the woman in black, and finally walks to the right again away from the woman.

From the left a gentleman in black appears. He has a high hat. He walks

towards the woman in black. He takes off his hat and makes a bow. The woman steps back. He wants to kiss her. Her hat falls off. She pushes him away. Another gentleman appears wearing a grey coat. He makes an outcry with his arms. From the right a boy in sailor suit enters to watch what is going on. The man in grey has a cane, and he hits the man in black on his head. The man falls on the ground and receives two more hits. The lady lifts up her skirts and walks towards us. The man in black receives yet another hit. The boy watches. The lady in black walks to the right almost out of the scene, and then goes to the left. Her face is out of focus. The man in grey is still very busy finishing off the man in black. The white boat in the canal sails away.

The man in black tries with great difficulty to get up. The boy picks up the high hat.

Racing-car 3 can be seen on the high viaduct. The man in black is just in time to step away from the downwards racing vehicle, which turns around the flower-bed, passes under the viaduct and disappears in the back. Racing-car 4 follows the same route. Racing-car 3 hits the white fence of the sloping road, damaging it. Racing-car 2 hits the damaged fence and rolls downwards over the now completely devastated fence. It stops, drives back and then forward to the front, goes around the flower-bed and underneath the viaduct to disappear at the back. The little white sailing boat returns.

SCENE 3. Big close-up of table-top scene representing a long shot, 1.26 min. There is a little white house at the left. In the centre is a country-road, and in the foreground a whimsical horse with a clown as rider. The horse bows and throws the rider off. Someone in the background is rolling two beer barrels to the right of the scene. The horse kicks at the rider, the rider kicks at the sitting horse. Both fall over, the horse pursues the rider and sits on top of him. It jumps a couple of times with its behind up and down on the man. The clown tries to saddle the horse again.

A plump policeman arrives from the right. He gestures to the horse and its rider, but the horse kicks the policeman away who is rolling away over the road. Horseman and horse disappear at the left from the scene. The policeman is rolling to the back. A donkeycart rides from right to left. Outside the white house a man is waving to three or four racing-cars which are arriving. The man is standing in the middle of the road and is hit by one of the cars. The policeman tries to help him. Racing-car 5 rolls over, number 3 rides over the car, 2 and 4 drive around it.

The policeman helps the man to his feet. Together they lift the car upon its wheels. The policeman stumbles over the driver who is lying on the road. The man pushes the racing-car to the front and pushes also the policeman with the driver out of sight. The scene is now empty.

SCENE 4. Big close-up of table-top scene representing a long shot, 64 seconds.

A rural scene. There is a hill at the right with a cottage and a farmer's wife in a long frock with a poodle, a donkey and chickens.

There is a hill at the left. From the left our unfortunate horseman arrives on his horse with its stiff legs. He disappears out of view on the right. It is a gravel-road with fences at both sides. In the distance a racing-car appears. In the foreground a poodle crosses the road. The woman goes after it. The poodle settles itself in the middle of the road and gets run over by racing-car 3. The woman and a Dutch doll raise an outcry. Racing-car 4 is followed by number 2. A chicken, flying from one side of the road to the other, is run over. A wheel of racing-car 2 comes off, and the driver falls out of the car.

From the left a giant with enormous big shoes appears. He almost touches top as well as bottom of the screen. The driver in his long coat spreads his arms in despair, asks the giant something and points to his car. The giant nods, walks towards the car and lifts it up. The driver puts the lost wheel back on.

The woman in her long frock and the Dutch doll are watching the scene. The driver starts the engine with the cranking handle. The giant lifts him up and puts him in his seat. They shake hands. The driver moves the car a little to the back, then gets in forward gear and drives away, while the giant, the little woman and the Dutch doll wave good-bye.

SCENE 5. Big close-up of table-top scene representing a long shot, 29 seconds.

To left and right are back gardens of houses. There is a fence at the left and a parked horse cart with its beams up at the right of the road.

In the distance racing-cars are arriving. There is a small motor-car driving to the front and crossing the road. Racing-car number 2 tries to avoid the motorcar but hits it. The racing-car driver stops, but the driver of the small car is so angry, he bumps hard into number 2 several times. Racing-car 4 arrives, followed by number 5. Number 3 hits the parked horse cart and damages it. The giant arrives to look what happened to the horse cart. One wheel came off, taken away by one of the racing-drivers. A little clown appears. From the left a donkey appears. It kicks the little clown out of sight.

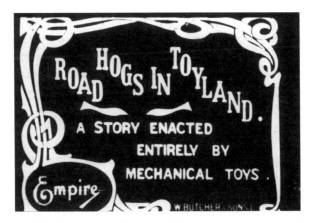

Fig. 94. ROAD HOGS IN TOYLAND, Butcher's art-nouveau title.

SCENE 6. Big close-up of a table-top scene representing a long shot, 21 seconds.

A rural scene. Trees in the background, a white house at the left and a house at the right.

Three racing-cars appear from different sides. Number 2 and number 5 are in a head-on collision. They bump each other high up on their backs and then both fall down. They now lie on top of one another. The drivers are lying on the road.

From the background, number 3 arrives and stops. Number 4 approaches from the back. Something that looks like a flying machine becomes visible. It has a rotating propeller in front and is landing.

A final title: THE END.

Details

The titles of the copy from the Audrey and Jan Wadowski estate were, most probably, made for the screening of this film at the Cambridge Animation Film Festival in September 1979. Title: "ROAD HOG IN TOYLAND – Made by ARTHUR MELBORNE-COOPER – 1911" [sic]. After this title there are still some frames of the original title left.

Surviving film does not have the complete final sequence of the rescue by an aeroplane.

Contemporary sources

The Kinematograph & Lantern Weekly, London, 23 November 1911, page 136.[99]

99. A full page advertisement.

"Empire Pictures. Released December 16th. ROAD HOGS IN TOYLAND (A Story enacted entirely with Mechanical Toys.) Just a picture for children's matinees, etc., during the festive season. A clever film that will also please and bewilder all your patrons. See that this is in one of your programmes. No. 171. Length 330 feet. Price £5 10 0. Advance Copy of the above now showing at the Cosmopolitan Film Company, Film House, Gerrard Street, W. – W. Butcher & Sons, Ltd. The Showman's Headquarters for Everything Appertaining to Cinematography."
The Bioscope, London, 7 December 1911, page 676.[100]
"Empire Pictures. Advance Copies showing at the Cosmopolitan Film Company, Film House, Gerrard Street, W. Released December 16th.

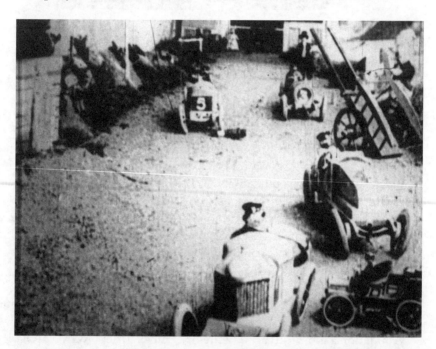

Fig. 95. ROAD HOGS IN TOYLAND, racing cars upsetting a serene countryside.

ROAD HOGS IN TOYLAND. A Story enacted entirely with Mechanical Toys. Have you seen the advance copy? You will want it for the festive season. All the youngsters' pet toys in animation. It will make them scream with delight, and will bewilder their parents. All the renting houses are

100. Full page advertisement with the poster, illustrating racing motor cars.

buying. Book it early from your renter.

Splendid original poster. No. 171, length 330 ft. code 'Toys'. Price £5 10s. Synopsis on application.

W. Butcher & Sons, Ltd. Headquarters for everything pertaining to Cinematography. Camera House, Farringdon Avenue, London EC."

W. Butcher & Sons, Ltd., Empire Films catalogue, London, 1911, page 199.

"Trick and Humorous Subjects. No. 171. 'ROAD HOGS IN TOYLAND'.

The picture enacts a series of incidents in Toyland, showing the ruthless devastation following in the path of the "Road-hog" on motor cars, on horse-back, and on foot on the public highway. The motor car is predominant, and many of these are depicted travelling at a terrific speed, causing consternation in the miniature toy villages, where sensational hairbreadth escapes occur.

Serious mishaps take place as the cars rush on in their mad career; over bridges, down steep hills, they dash through everything in their way, with the disastrous result of two high-speed cars colliding and being thrown high in the air, falling back to earth a shapeless mass. An aeroplane hovering in the distance dashes to the rescue of the occupants. A sensational drama, if it were not a screaming farce, all the characters being mechanical toys specially made for the purpose. The principal features of the nursery are introduced, and the peculiarly life-like movements of the characters will amuse the children, and bewilder the parents.

Length, 330 ft. Code, 'Toys'. Price, £5 10 0."

Complementary sources

Gifford-1968 (page 29), **1978** (page 70), **1987** (page 18): "ROAD HOGS IN TOYLAND, 1911 (330). Empire Films – Butcher. P: Frank Butcher, D:S:A: Arthur Cooper. Animated Toys. 'A story enacted entirely with mechanical toys. A picture that will please the youngsters. All their pet characters introduced.' (Advertisement *Bioscope*, 30 November 1911.) 'All the youngsters' pet toys in animation, it will make them scream with delight, and will bewilder their parents.' (Advertisement *Bioscope*, 7 December 1911.) 'A smart little film which should prove very popular'." (*Bioscope*, 23 November 1911.) Released 16 December 1911."

Publications

"There was one name that I did not see mentioned, *i.e.*, Melbourne Cooper, who, at that time, was producing trick toy films in a basement at 4 and 5, Warwick Court, Holborn. After leaving Chas. Urban, I went

to work for him and assisted on DOLLS' CIRCUS,[101] ROAD HOGS IN TOYLAND, BABY'S DREAM,[102] and many others.

Using a specially geared Prestwich camera, two mercury-vapour tubes and a table top for a stage, Melbourne Cooper, would work all day and far into the night making his beloved models and toys come to life on the screen. He made everything himself except the dolls, which he purchased from Hamleys. He showed unlimited patience in handling these, as of course, all these films were one picture one turn. We took four to five weeks to produce one film of 400 ft., and Messrs. Prieur, of Gerrard Street, handled them, and most of them were great successes.

I have seen many celebrities of stage and screen down in that basement watching him at work, including Chas. Urban, Smith, Paul, Moy, Newman, and many others who have now passed over. The tricks I learnt from him stand me in stead to-day, even though we have advanced so wonderfully, and I think I can safely say that Melbourne Cooper was the pioneer of what we term to-day 'special effects'." **Henry Maynard, letter in Kinematograph Weekly, London, 13 November 1947,** (no page no. known).

"2406, ROAD HOGS IN TOYLAND \\ PC: Empire \\ ARCH: LON". **(Ronald S. Magliozzi, 1988.)** [N130]

Recorded interviews

"We gave four films to John Huntley[103] in exchange for ROAD HOGS IN TOYLAND. We did not want those films, we thought they were all Cricks (& Martins)." (**Audrey Wadowska to Tjitte de Vries, London, 19 August 1978,** T029.)

"We got ROAD HOGS IN TOYLAND. You know, what I cannot understand, in that advertisement of CINDERELLA too, it says: enacted entirely with mechanical toys. When I told Jackeydawra Melford that, she said: 'What a lie! They were not mechanical. They were moved hand by hand.' I suppose that is the selling line." (**Audrey Wadowska to Tjitte de Vries, London, 20 August 1978,** T031.)

Audrey Wadowska: "(Antoinette Moses) asked me to send her stills for their publishing a programme.[104] They have a 46 page programme. I sent them to her by registered post. She got them, and she tells me some of

101. Alternative title for THE HUMPTY DUMPTY CIRICUS (1914).
102. What Maynard most probably meant is LARKS IN TOYLAND (1913).
103. Film historian, collector and lecturer.
104. For the Cambridge Animation Festival, 9-16 November 1979.

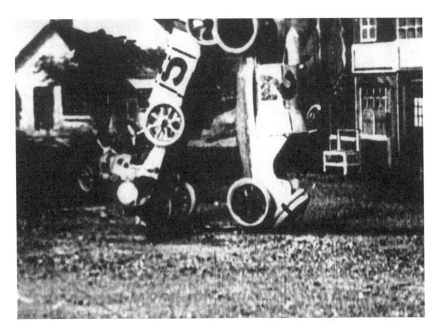

Fig. 96. ROAD HOGS IN TOYLAND, the finish.

them are on display in Hepworth's in Cambridge. (...) She wants all that we have of father's animation films. The NFA will get them 35mm prints if we agree. The two films they haven't got are MATCHES and ROAD HOGS IN TOYLAND. We got the 16mm print. I don't like it, Tjitte thinks it is clever, but I don't think much of it. Anyway, she wants everything we have of father's. She is still undecided about the music." (**Audrey Wadowska to David Cleveland, London, 11 October 1979,** T419.)

"That (photograph) is from the animated film ROAD HOGS IN TOYLAND. Made in 1912, I believe, Kinema Industries, Butcher's Empire, 1911, 1912. He made it at Butcher's, Lee, between Blackheath and Lewisham. His offices were in (Warwick Court). After this period he started Kinema Industries, under the trade name of Heron." (**Audrey Wadowska to Tjitte de Vries, London, 17 April 1981,** T048)

"That (photograph) is ROAD HOGS IN TOYLAND, the same old horse that appeared in DREAM OF TOYLAND but now years later, 1911." (**Audrey Wadowska to Tjitte de Vries, London, 28 May 1981,** T057.)

Audrey Wadowska: "They say of CINDERELLA and of ROAD HOGS, it is done with mechanical toys! Anyway, he bought some of them for ROAD

HOGS. *Tjitte de Vries:* This would be a nice thing to tell at Annecy,[105] that even the trade did not understand the frame-by-frame technique so they advertised it as done with mechanical toys. *Audrey*: I could take stills with me." (**Audrey Wadowska to Tjitte de Vries, London, 29 May 1981,** T065.)

Unpublished manuscripts

"After he left St Albans Cooper worked for a while for W. Butcher and Son making some of their "Empire" films. For Butcher Cooper made nothing but puppet films, turning them out as quickly as he had once made live-action films. It would probably not be wrong to assume that most of these films were undistinguished. ROAD HOGS IN TOYLAND (c. 1911/12) was said on the titles to be "enacted entirely by mechanical toys", though it was made by stop-frame animation. All the elements of DREAM OF TOYLAND are there, though with a larger number of scenes and a great deal more violence, with fights, crashes and road accidents. There are many sports cars in the film and a multitude of other toys. There is no story line but again a mere series of incidents. There is one interesting shot however when, with the camera at a very low angle a car pushing a policeman in front of it drives straight towards the lens." (**Luke Dixon, 1977.**)[N131]

Editorial

During 1911 and 1912, Cooper produced a number of animation pictures for Butcher at their studio at Manor Park, Lee. The Cooper family lived next to the studio at no. 26. With his puppet satire ROAD HOGS IN TOYLAND, Cooper is poking fun at motor car races on public roads which were a fashion in those years.

It is a pity that in the surviving print, originally from the John Huntley Collection, not much is left from the second half of the final scene in which an aeroplane comes to the rescue.

AN OLD TOYMAKER'S DREAM, Butcher's Empire Pictures, 1911, 325 ft. Reissue of THE TOYMAKER'S DREAM, 1910 (420 ft).

LOTTIE DREAMS OF HER NOAH'S ARK, 1912, 350 ft. Reissue by Butcher's Empire Pictures of NOAH'S ARK, 1909 (440 ft).

105. Audrey Wadowska, that year, was invited by the Annecy Animation Film Festival, France, to present her father's animation pictures.

22. Sports in Moggyland[106] *, 1912, 340 ft., running time 5.40 min.
A.k.a. THE WOODEN ATHLETES (see Editorial below).
Stop-motion animation only.

Credits
Directed and animated by Arthur Melbourne-Cooper possibly at Butcher's film studio, 42a, Manor Park, Lee, for Butcher's Empire Pictures. Producer Frank Butcher.

Synopsis
All kind of circus animals, monkeys, dogs, even beetles and fleas, and a company of Dutch dolls[107] perform a range of athletic and circus acts including high wire cycling.

Contemporary sources
The Bioscope, London, 5 September 1912, page 749.
"SPORTS IN MOGGYLAND. When witnessing the antics of performing birds and animals, whether monkeys, dogs, cats, canaries, parroquets, or even beetles and fleas, one is first of all struck by surprise at the seeming intelligence of the performers, which merges into envious admiration of the extraordinary patience which must have been exercised by the instructor who is responsible for their efforts. But the patience displayed by the trainer of the lower animal kingdom sinks into absolute insignificance compared with what must be requisite in order to bring a company of Dutch dolls to such a pitch of perfection as is evinced by the participators in the SPORTS OF MOGGYLAND. For it is quite impossible, after seeing them, to believe that these puppets are not endowed with an intelligence which enables them fully to appreciate and enjoy the antics they engage in. They drill with the precision and enthusiasm of Boy Scouts; they leap hurdles, negotiate the giant's stride, and engage in desperate tournaments which would be almost too sensational in point of danger were it not for the comforting reflection that nothing really matters much, as in the constantly occurring event of total dismemberment they show a marvellous aptitude for getting themselves joined together again. Their facial expression is of such uniquely uniform quality as to induce the belief that many of our

106. Moggy is not only slang for a cat, a moggy is also a heavily painted doll. When Audrey asked her father: "What is a moggy?" he told her: "You are a moggy," because she used make-up.
107. Dutch dolls – very popular with children: wooden, mainly undressed, dolls with movable joined limbs, or movable stiff limbs.

English actors have modelled themselves after their methods; and in one great essential they can teach a valuable lesson to Cinematograph actors, for they place no reliance whatever on the spoken word. Everything is expressed by the simplest pantomime. This is a film which will cause intense delight to all the children; and all well-regulated parents, after seeing this excellent film, will treat their children's dolls with vastly increased respect, for the Cosmopolitan Film Company has shown us what they are capable of when roused. (Cosmopolitan Film Company, Limited. Released September 19th. Length 340 ft.) "

Complementary sources

Gifford-1973, 1986, 2000: "03594/03448 – SPORTS IN MOGGYLAND, September 1912 (340). Diamond Films[108] (Cosmo). Trick. Wooden toys hold sports gala."

Gifford-1987 (page 19): "SPORTS IN MOGGYLAND, 1912 (340). Diamond Films – Cosmopolitan. Animated Toys. Released September 1912."

Correspondence

Mrs Audrey Wadowska to E. Lindgren, BFI, London, 25 November 1959. "Dear Mr Lindgren. Relative to my conversation with Mr Grenfell, in connection with my father's visit to Aston Clinton on July 17th., when he was able to identify several of the items shown to him on the Editola, this will confirm the following Alpha productions (...) previously identified·

(...) 'THE WOODEN ATHLETES' ... Not his production."

Recorded interviews

"That is the one, SPORTS IN MOGGYLAND (*The Bioscope*, September 5, 1912), that is Father's. (Reading:) 'Which merges into envious admiration of the extraordinary patience which must have been exercised by the instructor who is responsible for the efforts but the patience displayed by the trainer of the lower animal kingdom sinks into absolute insignificance compared with what much be requisite in order to bring a company of Dutch dolls to such a pitch of perfection as is evidenced by the participants in the SPORTS IN MOGGYLAND. (..) For the Cosmopolitan Company has shown us what they are capable of when roused. Released September 19th, length 340 feet'." (**Audrey Wadowska to Tjitte de Vries, London, 20 August 1978,** T030.)

"Now, SPORTS IN MOGGYLAND, there is a long story about it. I wanted a still from it. At the BFI they told me, they have discontinued that service.

108. A production company belonging to "many other firms which have left little trace" – according to Rachael Low, *The History of the British Film 1906-1914*, (London, 1948-1973).

This is a part synopsis (*The Bioscope*), September 1912. This is THE WOODEN ATHLETES. We got this one, and I am not so sure whether it is Father's title, because it is an athletic performance by Dutch dolls. And Father described this one. Though Father described the action I don't remember this title." (**Audrey Wadowska to Kenneth Clark, London, 24 October 1978,** T197.)

"Yesterday, at the anniversary exhibition of 200 Years Derby at the Royal Academy, you could buy Dutch dolls at a penny each. In the 1800s, it was the custom to wear one of these in your hat when you went to the Derby." (**Audrey Wadowska to Tjitte de Vries, London, 13 April 1979,** T036.)

"Yes, THE WOODEN ATHLETES is not his title. In fact what's on the film is a wooden athlete. It is part of SPORTS IN MOGGYLAND, Father's title. It is not a complete film." [109] (**Audrey Wadowska to Tjitte de Vries, London, 17 April 1981,** T053.)

"And SPORTS IN MOGGYLAND. We believe that THE WOODEN ATHLETE is not his title, but it is a part of SPORTS IN MOGGYLAND." (**Audrey Wadowska to Tjitte de Vries, London, 28 May 1981,** T057.)

Unpublished manuscripts

"SPORTS IN MOGGYLAND (an/Toys) 1911"

(**Audrey Wadowska, A-Z manuscript, 1981,** page S.)

Editorial

Audrey, in a letter of 25 November 1959, writes to Ernest Lindgren that her father had seen THE WOODEN ATHLETES in Aston Clinton, and identified it as NOT his production. See THE WOODEN ATHLETES in Chapter 8 - *Possibles and (Im)probables*. But nevertheless Audrey confuses SPORTS IN MOGGYLAND with THE WOODEN ATHLETES, running time also some 5½ minutes, assuming that it is a part taken from it. This could be the case, but the length of both pictures (THE WOODEN ATHLETES is 330 ft., and a combination would make a rather long picture of 670 ft.) as well as the story lines (describing two un-matching stories: athletic performances and an acrobatic show) make this not obvious. Audrey and Jan Wadowski had in their film collection a 16mm print of THE WOODEN ATHLETES from the NFA. Watching this film many times, we both have serious doubts whether this indeed was made by Cooper. If so, then it must have been a "quicky". Compared with even MATCHES APPEAL, his first demonstrable stop-motion animation in which the figures are constantly moving and bending their legs, knees, arms and elbows, the animation in WOODEN ATHLETES is very basic and simple,

109. Note Audrey Wadowska: C.U(rban), *The Bioscope*, May 9, 1912, supplement page XIV.

almost crude. When the patrons are entering the showman's booth, the figures are shoved two or three frames per second, a pure form of slide-animation. The background of the performances is very bare, and the animation in particular of the last act, which is flat paper animation – the tightrope dancer who comes down in pieces – can be called primitive. Cooper already did the same kind of stunt in Animated Matches Playing Volleybal when a player jumps so fast and high to a ball that only his body with his arms shoots up and his legs are left behind.

Compared with the sophistication of A Dream of Toyland, Noah's Ark and Road Hogs in Toyland, the whole of the production – production values, direction and animation together – of The Wooden Athletes does not stand up at all with his former animation work. We therefore put The Wooden Athletes in our chapter *Possibles and (Im)probables* even though Gifford (this title entry appears only in his 1987 publication) credits Arthur Cooper for this picture.

In interviews with us and with Ken Clark, Audrey Wadowska was adamant that her father in 1911 or 1912 made a Sports in Moggyland, and we therefore think that Cooper can be credited with this title. Gifford credits an unknown production company, Diamond Films, for it. Have the production companies become mixed up, the rather unknown Diamond Films and Butcher? (Distributor Cosmopolitan Film Company Ltd, in 1910, reissued Cooper's In the Land of Nod (1908) under the title Grandpa's Forty Winks.)

The story line of Sports in Moggyland as given in *The Bioscope* follows a pattern that matches Cooper's style of story telling in his animation work. Considering all these arguments and Audrey Wadowska's conviction about the title Sports in Moggyland, it therefore deserves at least one star, but with the restriction as Audrey Wadowska never hesitated to remark in her interviews with us: "More research is necessary".

Audrey makes the confusion even greater by suggesting that Going to the Circus is an alternative title for The Wooden Athletes[110] in which indeed patrons are visiting something which can, with much goodwill, be considered to be a circus performance. However, Going to the Circus is an alternative trade title for The Humpty Dumpty Circus.

110. Audrey Wadowska to Tjitte de Vries during projection of The Wooden Athletes, 27 December 1976, T076. See also The Wooden Athletes in the chapter Possibles and (Im)probables.

23. Ten Little Nigger Boys * * * *, 1912, 380 ft.,
running time 6.20 min. Stop-motion animation only.

Credits
Directed and animated by Arthur Melbourne-Cooper at Butcher's film studios, 42a, Manor Park, Lee, for Butcher's Empire Pictures. Producer Frank Butcher. Assistant animators unknown.

Synopsis
The film is based on the popular nursery rhyme in which ten little nigger boys disappear successively through a too plentiful dinner, a police trap, a monstrous fish, an accident while dropping sticks, a hive of bees, a shell, a tree, a lion and a gun after which the survivor shrivels up in the sun.

Details
"Ten Little Nigger Boys" was one of many series of coloured glass slides (3¼" by 3¼") for magic lanterns produced under the trademark Primus by Butcher & Sons. This one was a series of 8 slides in a box as part 515 of the Junior Lecturers Series A, with the lines of the nursery rhyme at the top of the drawings on the slides (see editorial).

Primary source – Arthur Melbourne-Cooper
Arthur Melbourne-Cooper to Sidney Birt Acres, Southend, 20 May 1956 (T001, tape VI, cd 1/17).
"The other ones of course then I did for Butcher's: CINDERELLA, THE CATS' FOOTBALL MATCH in toys, that was a good scrapping one, and the TEN LITTLE NIGGER BOYS."
List of film titles in Mrs Kate Melbourne-Cooper's handwriting authorized by Arthur Melbourne-Cooper, Coton, 1956:
"Trick 1913 for Butchers (approx. 1913) 10 LITTLE NIGGER BOYS".

Complementary sources
Gifford-1973, 1986, 2000: "03831/03678 – TEN LITTLE NIGGER BOYS, December 1912, (380). Empire Films (M.P.) D:S: Arthur Cooper. Trick. Nursery rhyme enacted by toys."
Gifford-1987 (page 21): "1912, (380). TEN LITTLE NIGGER BOYS, Empire Films – M.P. Sales. P: Frank Butcher, D:S:A: Arthur Cooper. Animated Toys. 'An up-to-date version of the old nursery rhyme enacted entirely by mechanical toys. A too plentiful dinner, a police trap, a monstrous fish, an accident while dropping sticks, a hive of bees, a shell, a tree, a lion and a gun, successively account for the nigger boys, the survivor shriveling up in the sun. The tricks are performed with unusual cleverness.' (*Bioscope*, 23 January 1913.) Released December 1912."

Publications

"Yet another innovation of Mr. Melbourne-Cooper's was the use of match-sticks, toys and dolls in the making of 'animated cartoon' films – forerunners of many modern films made on the same principle. Among the most successful of these were DREAMS OF TOYLAND, IN THE LAND OF NOD, TEN LITTLE NIGGER BOYS, THE CATS' FOOTBALL MATCH and CINDERELLA – for which he had to grow his own pumpkin." (**Joe Curtis,** ***Herts Countryside*, summer 1960.**) [N132]

Recorded interviews

"And then TEN LITTLE NIGGER BOYS is an interesting one, too. Because he has been asked how he managed to get the last nigger boy, because if you remember the story it is: one little nigger boy, two little nigger boys, and in the end there is none. He used to say to get over that problem, he soaked the last one in methylated spirits and put a match to it, and the camera did not pick up the flames. (...) And you actually saw this nigger boy shrivel, he disintegrates but you did'nt see the flames because the methylated spirits didn't register on the film. (...) And also TEN LITTLE NIGGER BOYS, there is a still from that. My aunt around the time of her death, had one of these little nigger boys, and when she died her landlady gave it away on a jumble sale." (**Audrey Wadowska to Tjitte de Vries, London, 27 December 1976,** To76.)

"I have seen it myself, a 4-page, bigger than that, 4 sections, when you open it, it is Empire Film, TEN LITTLE NIGGER BOYS with a still of it, and GOING TO THE CIRCUS that Jackey remembered Father making it because Father gave her sister Mabel[111] a lyon, and the DREAM OF TOYLAND re-issue. And THE CATS CUP FINAL. I remember seeing TEN LITTLE NIGGER BOYS. What has he (Denis Gifford) done with it? I have seen it. He must have more, maybe from (John) Barnes?" (**Audrey Wadowska to Tjitte de Vries, London, 4 August 1978,** T177.)

"Can you imagine Father's humour in that. He made a lot like that. There was TEN LITTLE NIGGER BOYS. (...) During 1911, Father was commissioned by Butcher's, in Lee, near Lewisham, just near Blackheath, because Father left St Albans. It was 1912 actually, and during this time he became managing director of Harrow Picture Palace during the evening, and during the day he turned out these animated cartoon films for Butcher's." (**Audrey Wadowska to Kenneth Clark, London, 24 October 1978,** T197.)

111. Mavis Melford, actress, sister of Jackeydawra, both daughters of actor Mark Melford.

"Aunt Bertha had two of the black nigger boys. Gifford got a pamphlet, a piece of paper, published by Butcher. (...) When I met Aunt Bertha she had two, I did not have the sense to ask her for them. When she was going to the old folk's home she gave them to this woman. When I asked her for them she said she had given them away to a hospital. Well, I could not go to the hospital and ask them back, could I?" (**Audrey Wadowska to Tjitte de Vries, London, 15 August 1979,** T061.)

"When I visited auntie Bertha when she was in this old folk's home (in Southend), she had a black doll from the Ten Little Nigger Boys, but I was just too late, she had given it to some child." (**Audrey Wadowska to her sister Ursula Messenger, London, Autumn 1980,** T208.)

"*Ken Clark:* Golliwog, what is this golliwog? *Jan Wadowski:* Golliwog[112] is made from wood, I have a picture which I will show you. *Ken Clark:* Here is Ten Little Nigger Boys. That is the one you are referring to? *Jan Wadowski:* No, that is Wooden Athletes. I think they were sort of Dutch." (**Kenneth Clark interviews Jan Wadowski, St Albans, 21 February 1988,** T410.)

Editorial

Ten little nigger boys sat down to dine;
One choked his little self, and then there were nine.
Nine little nigger boys sat up very late;
One overslept himself, and then there were eight.
Eight little nigger boys travelling in Devon;
One said he'd stay there, and then there were seven.
Seven little nigger boys chopping up sticks;
One chopped himself in half, and then there were six.
Six little nigger boys playing with a hive;
A bumble-bee stung one, and then there were five.
Five little nigger boys going in for law;
One got into chancery, and then there were four.
Four little nigger boys going out to sea;
A red herring swallowed one, and then there were three.
Three little nigger boys walking in the Zoo;
A big bear hugged one, and then there were two.
Two little nigger boys sitting in the sun;
One got frizzled up, and then there was one.

112. A golliwog is a black rag doll. The bus in A Dream of Toyland is driven by a golliwog. Golliwogs were very popular with children in those days. Dolls made of wood were called Dutch dolls. And a heavily painted doll was called a 'moggy'.

One little nigger boy living all alone;
He got married, and then there were none.
A century ago, this very popular nursery rhyme was known by heart by
many people, young and old, white and black.[113]

FATHER'S FORTY WINKS, 1912, 330 ft.
Reissue by Butcher's Empire Pictures of IN THE LAND OF NOD, 1907 (365 ft).

MAGICAL MATCHES, 1912, 330 ft.
Reissue by the Urban Trading Company of MAGICAL MATCHES, 1908
(250 ft). Probably lengthened by titles and/or duplication of several
kaleidoscopic scenes.

24. Old Mother Hubbard *** , 1912, 410 ft., running time 6.50 min.
 Stop-motion animation only.

Credits
Directed and animated by Arthur Melbourne-Cooper at the Butcher's
film studio, 42a, Manor Park, Lee, for Butcher's Empire Pictures.
Producer Frank Butcher. Assistant animators unknown.

Synopsis
The traditional nursery rhyme of Old Mother Hubbard, her dog and her
cupboard is enacted by dolls.

Details
"Old Mother Hubbard" was one of many series of coloured glass slides
(3¼" by 3¼") for magic lanterns produced under the trademark Primus
by Butcher & Sons. This one was a series of 8 slides in a box as part 513
of the Junior Lecturers Series A, with the lines of the nursery rhyme (see
editorial) at the top of the drawings on the slides. There were also magic
lantern glass strips of this nursery rhyme of a smaller size (6 1/8" by
1 3/8") with each strip containing four illustrations.

Complementary sources
Gifford 1973, 1978 (page 70), **1986, 2000**: "03733/03588 – November
1912 (410). OLD MOTHER HUBBARD, Empire Films (MP). D:S: Arthur
Cooper. Trick. Nursery rhyme enacted by toys."

113. In 1939, Agatha Christie wrote a detective novel *Ten Little Niggers* (100 million copies),
filmed by René Clair as *And Then There Were None* (1945). It ran for many years as a play in
London's West End, because of its racist connotations retitled as *Ten Little Indians*.

Gifford-1987 (page 21): "1912 (410). OLD MOTHER HUBBARD, Empire Films – M.P. Sales. P: Frank Butcher, D:S:A: Arthur Cooper. Animated Toys. Traditional nursery rhyme of Mother Hubbard, her dog and her cupboard. Released 24 November 1912. Not reviewed."

Recorded interviews

"This NURSERY RHYMES[114] is that animated? He did a MOTHER HUBBARD." (**Audrey Wadowska to Tjitte de Vries, London, 31 March 1978,** T021.)

"OLD MOTHER HUBBARD is Father's Empire series again.(...) That was made about 1912." (**Audrey Wadowska to Tjitte de Vries, London, 19 April 1981,** T055.)

Unpublished manuscripts

"OLD MOTHER HUBBARD (puppets)."

(**Audrey Wadowska, A-Z manuscript, 1981,** page O.)

Editorial

Old Mother Hubbard went to the cupboard,
To get her poor dog a bone;
But when she got there the cupboard was bare,
And so the poor dog had none.
She went to the barber's to buy him a wig;
When she came back he was dancing a jig.
"Oh, you dear merry Grig! how nicely you're prancingl"
Then she held up the wig, and he began dancing.
She went to the fruiterers to buy him some fruit;
When she came back he was playing the flute.
"Oh, you musical dog! you surely can speak:
Come sing me a song"– and he set up a squeak.
The dog he cut capers and turned out his toes;
'Twill soon cure the vapours he such attitude shows.
The dame made a curtsey, the dog made a bow;
The dame said, "Your servant"; the dog said, "Bow-wow!"

Even though Audrey Wadowska knew little about OLD MOTHER HUBBARD, we appointed three stars because there is hardly any doubt that Cooper made this animation picture for Butcher's Empire Films. Gifford is clear about this in all his editions, and it stands in Butcher's tradition of illustrated nursery rhymes on magic lantern glass slides.

114. Urban catalogue, 1905, page 314, 600 ft. This was a live-action picture of several nursery rhymes.

25. Cinderella * * * *, 1912, 997 ft., running time 16.37 min.
 Stop-motion animation only.

Credits

Directed and animated by Arthur Melbourne-Cooper at Butcher's film studio, 42a, Manor Park, Lee, for Butcher's Empire Pictures. Producer Frank Butcher. Assistant animators unknown. Dolls by Hamleys, Regent Street London. Dresses: Mrs Kate Melbourne-Cooper. Coloured.

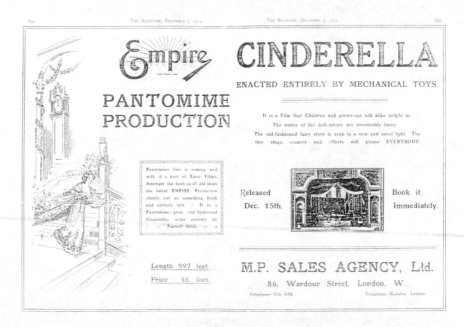

Fig. 97. CINDERELLA, double spread in *The Bioscope*, 5 December 1912.

Synopsis

A fairy godmother takes care that step-sister Cinderella also can go to the ball where she dances with the Prince. Leaving the ballroom she loses one of her shoes, which enables the lovelorn Prince to trace her and raise her from her lowly kitchen duties.

Details

The popular fairy tale of Cinderella is completely enacted by dolls. Cooper's longest animated puppet picture, also for its time a rather long film.

Primary source – Arthur Melbourne-Cooper

Arthur Melbourne-Cooper to Sidney Birt Acres, Southend, 20 May 1956 (T001, tape VI, cd 1/17).

"The other ones of course then I did for Butcher's: CINDERELLA, THE CATS' FOOTBALL MATCH, in toys, that was a good scrapping one, and the TEN LITTLE NIGGER BOYS. And the NOAH'S ARK, yes. That was all single picture work. They all went up in the Blitz."[115]

List of film titles in Mrs Kate Melbourne-Cooper's handwriting authorized by Arthur Melbourne-Cooper, Coton, 1956:

"Trick (Approx. 1913) CINDERELLA."

Contemporary sources

The Bioscope, London, 5 December 1912, pages 692-693.[116]

"Empire Pantomime Productions. Pantomime time is coming, and with it a host of Xmas films. Amongst the hash-up of old ideas the latest Empire Production stands out as something fresh and entirely new. It is a Pantomime – good, old-fashioned CINDERELLA, acted entirely by Nursery Dolls.

CINDERELLA, enacted entirely by Mechanical Toys. It is a Film that Children and grown-ups will alike delight in. The antics of the doll-actors are irresistibly funny. The old-fashioned fairy story is seen in a new and novel light. The tiny stage, scenery and effects will please EVERYBODY. Book it immediately."

The Bioscope, London, 12 December 1912, page 858.

"Book These Extra Attractions. Please your Patrons, all three-day bookings. CINDERELLA. Jan. 6th, 3.0.0, Jan. 9th. 3.0.0, Jan 13th. 2.10.0, Jan. 16th. 2.5.0. The London & County Film Service, 104, Wardour Street, W."

Complementary sources

Gifford-1973, 1978 (page 70), **1986, 2000**: "03734/03589 – November 1912, (997). CINDERELLA, Empire Films (MP), D:S: Arthur Cooper. Trick. Fairy story enacted by toys."

Gifford-1987 (page 21): "1912, (997). CINDERELLA, Empire Films – M.P. Sales. P: Frank Butcher, D:S:A: Arthur Cooper. Animated toys. "This film represents the well-known story of CINDERELLA, the various parts being taken by nursery dolls." (*Kinema Monthly Film Record*, December 1912.)"

Publications

"Yet another innovation of Mr. Melbourne-Cooper's was the use of match-sticks, toys and dolls in the making of 'animated cartoon' films –

115. During World War II, according to Butcher.
116. Full page double spread illustrated with photograph and drawing.

forerunners of many modern films made on the same principle. Among the most successful of these were DREAMS OF TOYLAND, IN THE LAND OF NOD, TEN LITTLE NIGGER BOYS, THE CATS' FOOTBALL MATCH and CINDERELLA – for which he had to grow his own pumpkin." **(Joe Curtis, Herts Countryside, Summer 1960.)** [N133]

"Other 'novelties' which might be mentioned here are the cartoons, vaudeville films, and few odd silhouette and puppet films (e.g. THE DOLL'S REVENGE, Clarendon, 410 ft., released 26 February 1911; CINDERELLA, Butcher's 997 ft., released 15 December 1912) produced from time to time. The old short film of some well-known comic act continued to appear occasionally, as indeed it still does. An early novelty showing the emergence of cartoon animation was Urban's MAGICAL MATCHES of 1912." **(Rachael Low, 1948/1973.)** [N134]

"Another animated puppet film was CINDERELLA, made in 1912 and 999ft in length, which was quite long in those days for an animated film, but we haven't got that, unfortunately. Mother dressed Cinderella in her gowns, and the drapery on the stairs which she comes down was made from, you know, in those days they used to have silk shades around the gas mantles with glass beaded fringes. And he made her coach by cutting it out of cardboard, and mounting a very big enlarged photograph of the Lord Mayor's coach onto it. And he had to grow his own pumpkin, at that!" **(RPS lecture by Audrey Wadowska, London, 26 January 1977, T128.)** [N135]

"Melbourne Cooper a réalisé de nombreux autres films d'animation, dont L'ARCHE DE NOÉ et un CENDRILLON de 300 mètres en 1912, qui n'a pas été retrouvé. Il était en outre célèbre pour ses comédies, des films de trucages et ses documentaires, en plus de jouer un rôle important comme pionnier de l'exploitation cinématographique en Grande-Bretagne."

"Melbourne-Cooper made numerous other animated films, among them NOAH'S ARK and CINDERELLA, a 1000 feet film released in 1912, and which has not yet been found. He was also well known for his comedies, his trick films and his documentaries; besides his work as a producer, he played an important part in pioneering film exhibition in Great Britain." **(JICA 81, Festival d'Annecy, 1981.)** [N136]

"Other films by Cooper include NOAH'S ARK (1906), CINDERELLA (1912), WOODEN ATHLETES (1912) and THE TOYMAKER'S DREAM (1913)." **(Giannalberto Bendazzi, 1994.)** [N137]

Correspondence

David Cleveland to Tjitte de Vries, Manningtree, 25 April 2007.
"So, to answer your question, CINDERELLA at 999 ft. should have lasted

on the screen at 16 frames per second about 16 minutes. But I expect it got turned through the projector a bit faster."

Recorded interviews

"Even in the old days, he made CINDERELLA – Jackey Melford[117] remembers seeing him doing it and making the coach. She says it was a beautiful thing. He made the whole complete set. We have a still of it. And Cinderella's dress was made by mother from lace, we still got it, which he brought back from a Paris Convention, and what was then very fashionable, you had these silk lamp shades with crystal beads, a fringe on that. He had that draped around the back of the steps." (**Audrey Wadowska to Jim Schofield, Blackpool, 1963,** T094.)

"They did not get my father to agree to go bankrupt.[118] And I suppose he would have saved himself, but you see, Mother was too shocked. She would not have it, and he wanted to pay up his debts, and he did. And he freed himself that way. But Mr Dawson[119] wanted him to remain on to the Picture Palaces as his manager. But Father said, he wasn't going to have that. If he couldn't be boss in his own Picture Palaces, he wanted to be left out. But he hung on at his address at Alma Road till about some time during 1912. During that period he was commissioned by Butcher to make animation films. They used to make cameras and things, but they used to buy Father's films too. That was another agent, and they published catalogues. And he turned out ever so many animation films, including the famous one of CINDERELLA which came out for Christmas 1912 . That was 999 feet. Very long. For that he was growing his own pumpkin which was stolen." (**Audrey Wadowska to Tjitte de Vries, London, 26 December 1976,** T074.)

"He actually made some of these toys, not all of them. And in CINDERELLA, he bought the magnificent, what people used to call a princess doll in those days, and mother dressed her. And her dress was made out of some beautiful lace which he brought back in 1909 when he went to the Paris Convention, for her to wear on her dress. And on the balustrade, in that famous scene where she comes down the steps into the ball, we have an original still photograph of that, but it is also published in *The Bioscope*, a reproduction of it. But we have it. It has been folded with a crack at one side.

117. Actress Jackeydawra Melford, daughter of actor Mark Melford.

118. After the failure of going public with his cinemas, the Alpha Picture Palaces.

119. Dawson – with Walker and Turner – formed the 'daw' in Walturdaw Trading Company Ltd.

In those days, they had gas mantles with a circular shade, and it was red silk with a crystal beaded fringe, that was draped over the back of the steps. So you can see how big it was. It was just about the width of a gas mantle. He made the stairs himself. He grew the pumpkin himself, and the coach in which Cinderella drives in, he made out of cardboard himself. He copied it more or less from the Queen's coach. He had a big photograph of this royal coach and a big blow-up which he mounted on this, the base, to let it look like the real thing. According to Jackey Melford it was magnificent. That was according to Butcher's catalogue 999 feet. I often wondered why they didn't add another foot and call it a thousand feet. Anyway, it was very long for that period. That was 1912. But nobody got that. I would love to have that." (**Audrey Wadowska to Tjitte de Vries, London, 27 December 1976,** T076.)
"We went to London then. He was for a time manager of the Hippodrome at Harrow for less than a year. He put that on its feet. And during this time he worked for Butcher's on making puppet films. He turned them out like hot cakes, because they were very popular. CINDERELLA was a very important one, 999 feet. That was very long for an animated film in those days. Supposed to be very marvellous." (**Audrey Wadowska to Peter Colman, London, 27 January 1978,** T185.)
"We got ROAD HOGS. You know, what I cannot understand in that advertisement of CINDERELLA too: it says enacted entirely with mechanical toys. When I told Jackeydawra that, she said: 'What a lie! They were not mechanical, they were moved hand by hand.' I suppose that is the selling line." (**Audrey Wadowska to Tjitte de Vries, London, 20 August 1978,** T031.)
"They were usually made before Christmas, but some of them were made months beforehand. They saved them up for Christmas. (...) Mother dressed Cinderella and the main dolls. I think Father bought the dolls. (...) Some of them were especially jointed. He always got his toys from Hamleys. Some of them were specially jointed for him and others were made. For DREAM OF TOYLAND, they made this fire engine and that sort of thing. And he used painted backdrops, which he painted himself. Father went to Paris in 1909 to that famous Congress, and he brought home for Mother French lace – we still got that somewhere – and Mother made Cinderella's train from that. The pumpkin, he had to grow himself, and somebody pinched it. Cinderella's coach was particularly interesting. Because he made a mock-up of that and I have been told by the person who saw him working on it, that it was perfect in everyday detail. How he did it? He got a photograph of Lord Mayor's coach and

made a big blow-up. The toys were about 6 inches. (...) He mounted this photograph of the Lord Mayor's coach round the shell, and it had wheels. He was very clever with carpentry and that. He always was till the end of his life." (**Audrey Wadowska to Kenneth Clark, London, 24 October 1978,** T197.)

David Cleveland: "How long did he stay with Butcher's? *Audrey Wadowska:* Till 1912. He made CINDERELLA there. That was a very ambitious film. That was 999 feet. Which was very long in those days for animated films, and I only wish we got it. Mother made the dolls' clothes, and he grew his own pumpkin. We know the story with all these things. And I don't know if that was the last film or not, but then he started Kinema Industries, and of course Father had no money. *Cleveland:* Who started it? *Audrey:* Father did, with a man called Andrew Heron. *Cleveland:* While still working for Butcher's? *Audrey:* Yes, but then he left Butcher's and went to Warwick Court, exactly where he had started with Charles Urban, (numbers) 4 and 5." (**Audrey Wadowska to David Cleveland, London, 11 October 1979,** T407.)

"And of course, the most important of Father's animated films is CINDERELLA. Some archive may have it. He sold them abroad. This one is almost 1000 feet long, 999 feet! (...) In *The Bioscope* and *Kinema and Lantern* they published a two-page spread advertisement of CINDERELLA in colour." (**Audrey Wadowska to Tjitte de Vries, London, 19 April 1981,** T055.)

Unpublished manuscripts

"Subsequently Melbourne-Cooper made a number of this type of film, including NOAH'S ARK, CINDERELLA, THE TOYMAKER'S DREAM, and others which proved very popular at the time, especially when served up as Christmas fare, but were most laborious to produce, every item of the set having to be animated by hand for the one frame, one picture technique. This invention sets the seal on Melbourne-Cooper's flair for innovations that became the forerunners of many new techniques in the industry. Invariably staged in the garden adjoining the Alpha studios,[120] although most of the models and dolls used were purchased from a model-maker in London, many were made by the Melbourne-Cooper family and all kinds of clever devices invented to support and motivate them while filming, such as hat-pins through the centre of figures, and the long fair hair of Mrs Cooper to animate the limbs and joints of dolls.

120. This is not correct. CINDERELLA was made in the Butcher studios, 42a, Manor Park, Lee. The dolls were purchased at Hamleys Toyshop, London.

The six inch or so wooden dolls would usually cost in the region of 4/6 each,[121] and these would be dressed with consummate artistry by Mrs Cooper and a local hairdresser. Cheaper dolls were used for subsidiary roles, such as dancers in the ballroom sequence – Cinderella being in a special transformation scene of a sudden replacement by another doll. In this delightfully elegant and spectacular puppet film Melbourne-Cooper himself made the model coach from cardboard upon which had been pasted a large photograph of the Lord Mayor's state coach of sumptuous design and ornamentation. He also grew his own pumpkin, which was subsequently pinched." (**John Grisdale, 1960.**)[N138]

"15 December 1912 Butcher's released their CINDERELLA, a 997 feet animated puppet film made by Cooper. It was probably his masterpiece (certainly it was a favourite of his) in that kind of work, but no print has survived for us to tell. All we have is a small still from the film. By 1914 the animated film, using both puppets and drawings, was a regular part of international film output, and *The Kinematograph Year Book* for 1915 was able to record that cartoon films at least were "now coming from any-where, everywhere and nowhere in particular." (**Luke Dixon, 1977.**)[N139]

"Some years earlier, when the British Mutoscope and Biograph Company had sent Arthur to Paris to film the 1905 Great Exhibition, he had bought a beautiful French lace collar as a present for his wife. Now that he planned to make CINDERELLA (1912), his wife skilfully transformed the collar into a train for Cinderella's dress. Arthur had already grown a servicable pumpkin, and constructed suitable transport to carry Cinderella to the ball by enlarging a photograph of the Lord Mayor's coach proportionate in size to Cinderella – who was six inches tall – then cut it out, added solid wheels and the remaining three-dimensional embellishments.

The remainder of the dolls used in the production came from Hamleys, the famous London toyshop, some being specially jointed for him. As was quite usual in those days, he completed the film months before its review appeared in *The Bioscope*, 5 December 1912. (Charles Urban admitted to keeping films on the shelf for periods of up to two years before listing their availability in his catalogue.)" (**Kenneth Clark, manuscript 2007.**)[N140]

Editorial

Unfortunately, this picture, of which Cooper was rather proud, did not survive. With 1000 feet it was the longest stop-motion puppet picture

121. In today's currency this would be 22$^{1}/_{2}$ pence.

Cooper made. It demonstrates that, perhaps not the distributors, but the audiences were accepting and enjoying longer movies. Cooper kept a black and white photograph of the set with the dolls in position, which Audrey later had coloured. On the back of this photograph it says: "Joseph Hope – 'Pinct' – June 18th, 1977".

THE CATS' CUP FINAL, Butcher's Empire Pictures, October 1912, 360 ft. Reissue of THE CATS' CUP FINAL, 1910 (360 ft).

DOLLY'S DOINGS, Walturdaw, 1913-1914, 500 ft. Animated Toy Comedies. Most probably a reissue of DOINGS IN DOLLYLAND, 1905 (375 ft), lengthened with titles.

26. Larks in Toyland * * *, 1913, 496/516 ft.
Running time 8.16/8.36 min.
Stop-motion animation only.

Credits
Directed and animated by Arthur Melbourne-Cooper for Butcher's Empire Pictures in the basement studio of 4 and 5, Warwick Court, High Holborn, W.C. Production Kinema Industries Ltd., assistant animator Henry Maynard.

Synopsis
Puppets are the actors and actresses in a world of animated toys full of larks.

Contemporary sources
Supplement to the M.P. Offered List and Buyer and Seller, London, 22 November 1913. (No page no.)
"Christmas. All the points of Ideal Christmas Films are found in (...) *Empire* – LARKS IN TOYLAND, 516 ft. Released Dec. 25th.
They are New and Up-to-Date. The Dramas are truly pathetic, with Bright, Seasonable Happy Endings. The LARKS IN TOYLAND are Real, Riotous Larks. The Films will please Kiddies and Grown-ups alike. The Billing Matter is absolutely First-Class.
Sole agents Davison's Film Sales Agency (T.H. Davison, Late M.P. Sales Agencies). 18, Charing Cross, WC. The Films the Public Want."
Supplement to The Bioscope, London, 18 December 1913, page xxxiii.
"Film Releases. This Week, Next Week and the Week After. Dec. 14th to Jan. 3rd. – Empire: LARKS IN TOYLAND, Comedy. 516 ft. released Dec. 25th."

Complementary sources

Gifford-1968 (page 29), **1973, 1978** (page 70), **1986, 2000**: "04491/04328 –
December 1913 (496). (U)[122] Larks in Toyland, Empire Films (DFSA),[123]
D:S: Arthur Cooper. Trick. Animated toys."

Gifford-1987 (page 25): "1913 (496). Larks in Toyland, Empire Films –
Davison. P: Frank Butcher, D:S:A: Arthur Cooper. Animated Toys. 'A
cleverly contrived comic with real dolls as the artistes and toys galore to
appeal to the kiddies.' (*Bioscope*, 11 December 1913.) Released 25
December 1913."

Publications

"There was one name that I did not see mentioned, *i.e.*, Melbourne
Cooper, who, at that time, was producing trick toy films in a basement
at 4 and 5, Warwick Court, Holborn. After leaving Chas. Urban, I went
to work for him and assisted on Dolls' Circus,[124] Road Hogs in
Toyland, Baby's Dream,[125] and many others." (**Henry Maynard, letter
in *Kinematograph Weekly*, London, 13 November 1947.)**[126]

"In 1908, Cooper made another animated match film and Dreams of
Toyland, Wooden Athletes and several fairy-tales adaptions released
through Empire Films in 1912, the An Old Toymaker's Dream and
Larks in Toyland, ended his career on the eve of the war." (**Donald
Crafton, 1982.)**[N141]

Recorded Interviews

"I noticed another animated film Father made, Larks in Toyland. (...)
But anyway, this is what it is about: Larks in Toyland, an animated
film for Butcher. (...) There we are, Larks in Toyland,[127] 'New and Up-
to-Date'. The Larks in Toyland are real, riotous Larks. Will please
Kiddies and Grown-ups alike (...).' We were living there, – actually
Butcher's studio grounds were at the bottom of our garden." (**Audrey
Wadowska to Tjitte de Vries, London, 20 August 1978.** To30.)

Editorial

Where did Cooper make this picture? In the Butcher studios at Manor
Park right at the bottom of the Cooper family's own garden at no. 26? Or

122. Universal Film Co., Ltd., 5, Denmark Street, W.C.
123. T.H. Davison's Film Sales Agency, (late M.P. Sales Agency) 18, Charing Cross Road,
London-WC.
124. Alternative title for The Humpty Dumpty Ciricus (1914).
125. What Maynard most probably meant is Larks in Toyland (1913).
126. For Maynard's complete letter, see 19. Road Hogs in Toyland (1911).
127. M.P. [Motion Pictures] Offered List, November 22, 1913.

in the studios in the basement at 4 and 5 Warwick Court, High Holborn, London?

During 1912/1913, Cooper, with financier Andrew Heron, established two new companies, Heron Films Ltd (for making dramas with actor Mark Melford) and Kinema Industries Ltd, both with offices at 4 and 5, Warwick Court, High Holborn, where the basement contained studio space and film laboratories.

We therefore assume that Cooper's Kinema Industries produced LARKS IN TOYLAND for Butcher's Empire Films, because Frank Butcher's distribution outlet M.P. Sales has gone over into Davison's Film Sales Agency.

The published letter of Henry Maynard, son of the family of the Maynard Sweets company, is rather convincing about this.

OLD TOYMAKER'S DREAM, Empire Agents – Moving Pictures (M.P.) Sales Agency, 1913, 325 ft.
Reissue of THE TOYMAKER'S DREAM, 1910 (420 ft).

27. Lively Garden Produce **, 1914, 300 ft., running time 5 min.
Stop-motion animation.

Credits

Directed and animated by Arthur Melbourne-Cooper. Production Kinema Industries Ltd. Studio: basement film studio of 4 and 5, Warwick Court, High Holborn. Assistant animators unknown.

Synopsis

Several kinds of fruits and vegetables are animated, performing all kinds of stunts.

Contemporary sources

The Kinematograph and Lantern Weekly, Supplement, London, 9 July 1914.

"ALPHA FILMS. Agents: R. Prieur and Co., Ltd., 40 Gerrard Street, W. LIVELY GARDEN PRODUCE (Tk)[128] – A lively little trick film, depicting the capers of several kinds of fruits and vegetables. Released August 20th, length 300 ft."

The Bioscope, Supplement 20 August 1914.

128. Tk. = Trick film.

Fig. 98. Keen gardener Melbourne-Cooper shows his produce to Kodak Museum's Brian Coe.

"R. Prieur & Co, Ltd., 40, Gerrard Street, W., Gerrard 9115, Enerphone, London. ALPHA, LIVELY GARDEN PRODUCE, 300 feet, date 20 August."

Recorded interviews

Tjitte de Vries: "When did Langford folded up? *Audrey Wadowska:* I don't know exactly. It was still going when I left. It would be beginning of the war, I would say. *Tjitte:* 1940? *Audrey:* Around that time. *Tjitte:* Your father was over 65 when Langford closed? *Audrey:* He then came down to Cambridge, to live at Shelford. *Tjitte:* Why go to Cambridge? *Audrey:* Because mother's family lived there. They were alive then, and they had their own cottage. And he rented – you see, there is a big house on the Newton Road there, it got stables and all that sort of thing. And there was an old lady living in it, who had a son and a daughter. The son went to India during the war with his wife and left the old lady alone in this big house. She wanted somebody there for company. So Father and Mother had practically the whole of the house, and Father had the use of the garden, to grow sweet peas. He used to pack them up in bunches and sell them thruppence a piece and sell them at Cambridge market. He did not stand there and sell them, but he sold them in bulk to a buyer. He used

to like sweet peas. Sweet peas and pansies I think, were his favourite flowers. Anyway he used to grow vegetables and things. He had an allotment. He was retired." (**Audrey Wadowska to Tjitte de Vries, London, 17 April 1981,** T053.)

Tjitte: "In 1918, you came from Dunstable. You were disappointed about Lancaster Road (Eastwood, near Southend)? Because in your days it was just a mud track? *Ursula:* Yes. *Tjitte:* The house was called – ? *Ursula:* Barrybrow. *Tjitte:* It was not too long a distance from Raleigh Road? *Ursula:* No, it wasn't very far. *Tjitte:* It had half an acre, you told us. That is where he kept his chickens? *Ursula:* No, he kept his chickens across the road. *Tjitte:* Did he take his chickens over from someone? Or did he breed them himself? *Ursula:* He bred them himself because I can remember him turning over the eggs. *Tjitte:* He had an incubator? *Ursula:* Yes. There was a very big orchard. A quarter of an acre or half an acre, I don't know. *Tjitte:* Apples, pears? *Ursula:* Yes, plants. And poplars on the side to keep the wind out. It was not a full acre. We had our own little garden there. We grew vegetables. Lettuce, cabbages, carrots. *Tjitte:* You must have lived there quite a while, a couple of years, for keeping up that garden. *Ursula:* Aud and I had scarlet fever there. Ken didn't. It was quite serious." (**Ursula Messenger to Tjitte de Vries, Felpham, Bognor Regis, 20 July 2003,** T172.)

Unpublished manuscripts

"Lively Garden Produce"

(**Audrey Wadowska, A-Z manuscript, 1981,** page L.)

Editorial

From interviews with Cooper's children it is clear that their father was a keen gardener. There are several anecdotes about the big garden he had on the studio grounds at Bedford Park. There are photographs where Cooper stands as a proud gardener between his vegetable beds. Above, we picked at random from all the interviews two examples that testify of Cooper's love for gardening.

There are three notes from Audrey. The first (our archive number N131) mentions the title Lively Garden produce. The second is the title she wrote down in her A-Z manuscript in which she, in the last couple of months of her life, wrote down as many titles as she was certain of could be credited to her father. The third one is a clear scribble in her handwriting in the margin of a page from *Kinematograph and Lantern Weekly* at Prieur's advertorial: "Reissue". But was it a reissue? That is a possibility. However, we didn't find any indicator before 1914 that he

made anything that could be construed as an animation picture with vegetables.

The notification by Prieur is a clear announcement of an Alpha trick picture. Cooper had many of his films from old stock distributed by Prieur. The note Tk. at the title makes it clear that it is an animation or trick picture as Cooper himself called them.

Cooper grew vegetables in their garden at 26 Manor Park, Lee, where he, for instance, grew the giant pumpkin for his puppet picture CINDERELLA, his last film produced by Frank Butcher to be distributed by Butcher's M.P. Sales. We assume that LIVELY GARDEN PRODUCE was still made when the family lived at 26, Manor Park. Could Cooper, for the last time, have used Frank Butcher's studio building behind their house? Or did he take his vegetables and fruits to the downstairs studio at Warwick Court in High Holborn? How long would fresh garden produce have lasted under the two mercury-vapour tubes? Or would he have used clay figures or imitation vegetables made of fabric?

Notwithstanding the shortage of information, we afford this picture a second star, remembering the stories of Cooper's daughters Audrey and Ursula that their father was a keen gardener, even, after 1918, for a short time managing a greenhouse when the Cooper family lived at Lancaster Road in Eastwood, Surrey. It is very likely that he made at one time in his career an animation picture with his favourite subjects as leading characters.

28. The Humpty Dumpty Circus ***, 1914, 448 ft.,
running time 7.28 min. Stop-motion animation only.
A.k.a. THE DOLLS' CIRCUS and GOING TO THE CIRCUS.

Credits
Directed and animated by Arthur Melbourne-Cooper. Production Kinema Industries Ltd. for Acme Films. Studio: basement studio of 4 and 5, Warwick Court, High Holborn, W.C. Production Kinema Industries Ltd. Assistant animator Henry Maynard. Distributed by R. Prieur and Co. Ltd.

Synopsis
Animated dolls are going to the circus where clowns, lions, tigers and other animals are performing as if the toys from the well-known Schoenhut's Humpty-Dumpty Circus box have come to life.

Contemporary sources

Kinematograph Monthly Film Record, London, December 1914 (page 75).

"Acme Films. Agents – R. Prieur[129] and Co., Ltd., 40 Gerard Street, W. DOLLS' CIRCUS, THE (Tk). – This depicts the capers of a number of dolls. Released Dec. 7th, length 500 ft."

Complementary sources

Gifford-1973, 1986, 2000: "05096/04933 – THE HUMPTY DUMPTY CIRCUS, October 1914, (448). Humpty Dumpty (Prieur). Trick. Animated dolls perform in circus."

Gifford-1987 (page 19): "THE HUMPTY DUMPTY CIRCUS, 1914, (448). Humpty Dumpty Film – R. Prieur. Animated toys. Wooden dolls come to life and perform circus stunts. Released October 1914."

Gifford-1987 (page 33): "THE DOLL'S CIRCUS [sic], 1914 (500). Goblin Films – R. Prieur. Animated toys. Dolls give a circus performance. Listed in *Bioscope*, 26 November 1914; released 7 December 1914. Not reviewed."

Publications

"There was one name that I did not see mentioned, *i.e.*, Melbourne Cooper, who, at that time, was producing trick toy films in a basement at 4 and 5, Warwick Court, Holborn. After leaving Chas. Urban, I went to work for him and assisted on DOLLS' CIRCUS,[130] ROAD HOGS IN TOYLAND, BABY'S DREAM,[131] and many others. (...) We took four to five weeks to produce one film of 400 ft. Messrs. Prieur, of Gerrard Street, handled them; most of them were great successes." (**Henry Maynard, letter in Kinematograph Weekly, London, 13 November 1947.)**[132]

"As cameraman, producer and director, Arthur Melbourne-Cooper, for many years, worked in the world of cinematography, and added to his bulky filmography at least some twenty other short films produced with his animation technique, dating from the year 1901 (*DOLLY'S TOYS*) until 1914 (*HUMPTY DUMPTY CIRCUS*)." (**Giannalberto Bendazzi, *Il Sole 24 Ore*, 2005.)** [N142]

129. From approx. 1911/1912 till 1915 Prieur became Cooper's 'agent' (sales agent and rental distributor) for his old Alpha stock and reissues. – R. Prieur and Co., Ltd., 40, Gerrard Street, London-W. This is confirmed in Henry Maynards letter to *Kinematograph Weekly*.
130. Alternative title for THE HUMPTY DUMPTY CIRICUS (1914).
131. What Maynard most probably meant is LARKS IN TOYLAND (1913).
132. For Maynard's complete letter, see 19. ROAD HOGS IN TOYLAND (1911).

Recorded interviews

Audrey Wadowska: "What did George Maynard[133] do? *Wally Colegate:*[134] I saw him as making the Dolly films, you know, football, CATS' CUP FINAL, wasn't it? *Audrey:* On his own? *Colegate:* No, your father did it. – Oh no, no. *Audrey:* Jackey remembers that one, and the other one has to do with the CIRCUS. I found no references of that. GOING TO THE CIRCUS. Didn't Dad give Mavis a lyon? *Colegate:* That's right, I can remember that well. Mavis had some trouble in her life." (**Wallace Colegate to Audrey Wadowska, London, August 1972,** T195.)

"Made for Butcher? Yes, at Warwick Court. I forget the exact title, GOING TO THE CIRCUS or something. She[135] [Jackeydawra Melford] recalled it because she and her sister Mavis watched him doing it. And in fact, Mavis wanted a lion, and father gave her this lion. It was a circus performance of animals and apparently you saw a crowd of dolls going along in cars to the circus and then you saw this circus performance, animated tigers and lions and other circus animals, but we haven't got that. Denis Gifford, I was telling you about, he has these four sheets and a still from the scene where they are going to the circus. On it is a white patch like a flag saying 'To The Circus'. I have seen it myself. Whether he still got it, I don't know." (**Audrey Wadowska to Tjitte de Vries, London, 27 December 1976,** T076.)

"Jackey remembers that circus film, and nobody actually seems to remember the exact title, but Denis Gifford now has this folded poster (...) and you see a notice up there: 'To The Circus'. It is animated, and you see a circus of dolls. It was on the same page as TEN LITTLE NIGGER BOYS which is father's film taken for Butcher's Empire Films, but it might not be listed as an Empire film because he also sold it to Universal then, I saw it in the Universal catalogues. But Jackey remembers that, it is a circus performance of dolls and animals and lions, because father gave Jackey's sister (Mavis) one of the lions that he used for this. Denis Gifford had this folder with a still of it, but he was not telling me. But I saw it years ago, he showed it to me." (**Audrey Wadowska to Tjitte de Vries, London, 31 March 1978,** T020.)

"There is also the one with the box with the toy soldiers that come to life. I haven't found the title of that one yet. Nor the CIRCUS one that

133. Audrey meant Henry Maynard, called by Cooper: Young Maynard.
134. Wallace Colegate, actor and husband of actress Jackeydawra Melford, whose sister was Mavis Melford.
135. Actress Jackeydawra Melford, daughter of actor Mark Melford.

Jackeydawra remembers. Being made in Warwick Court, Kinema Industries." (**Audrey Wadowska to Tjitte de Vries, London, 19 August 1978,** T029)

"The other one is later, because Jackey, eh, it is not a toy miniature circus, but the subject is where toys go to the circus and sit down and on the stage animals perform and that is Jackey's recollection. And first of all you see all these dolls going off to the circus, and they go to the circus, and I have seen that." (**Audrey Wadowska to Tjitte de Vries, London, 20 August 1978,** T030.)

"HUMPTY DUMPTY is not here (in Gifford at the year 1913), but I remember father saying it. I think the distributors decide on the length. There is one we cannot find the synopsis of, but we remember it well because father gave Jackeydawra Melford and her sister (Mavis) the toys, and it deals with a circus. Dolls are seen going to the circus, and these animals perform on a stage. There is a lion. Father gave them these toys. We called it, at least I call it THE DOLLS' CIRCUS, but I don't know the correct title. She remembered it and that it was made in 1913." (**Audrey Wadowska to Kenneth Clark, London, 24 October 1978,** T197.)

"What have I got here: Gifford equals THE DOLLS' CIRCUS? Well, Jackey and her sister remember father making that, and I think that is the one of the four-folded page Denis Gifford showed us many years ago. That had a still from the LITTLE NIGGER BOYS and THE DOLLS' CIRCUS, because I remember seeing it like it does in THE WOODEN ATHLETES for instance. The dolls come down sitting to a circus, and lions and tigers enact, and nobody seems to know the actual title of it, and it says on an arrow, like it does in NOAH'S ARK, a little notice, instead of 'To The Ark' it says 'To The Circus' and Denis Gifford has got that, but he is not giving it to us." (**Audrey Wadowska to Tjitte de Vries, London, 20 April 1979,** T038.)

Audrey Wadowska (remembering a leaflet when visiting Denis Gifford): "I have seen with my own eyes a four-page, bigger than that, four sections, when you open it, it is Empire Film, TEN LITTLE NIGGER BOYS with a still of it, and GOING TO THE CIRCUS that Jackey remembered father making it because father gave her sister Mabel a lyon – and the DREAM OF TOYLAND-re-issue." (**Audrey Wadowska to Tjitte de Vries, London, 4 August 1979,** T177.)

"GOING TO THE CIRCUS is possibly on Butcher's list. But Jackey and her sister remember going to Warwick Court, seeing father working on that there. He may not have made all of them there, but it was made for

Butcher. Warwick Court was Kinema Industries Ltd. in those days. He had an indoor studio, but not a staged studio floor. When he wanted a staged production, he hired through Bouwmeester Pathé Studio in Great Portland Street which is not far from Warwick Court of course, and Rosenthal('s studio at Croydon). I believe Barker did take over Warwick. Barker moved into Ealing. (...) He made his animated films there (Butcher's studio, Manor Park), and he did his developing there. He continued to make animation pictures for Kinema Industries[136] because Jackey remembered him there making this circus one, GOING TO THE CIRCUS, with dolls. There is a still with a crowd of dolls representing the public entering a circus ring or tent with a stage, and all these circus people enact their bits and pieces. Something like the WOODEN ATHLETES." (**Audrey Wadowska to Tjitte de Vries, London, 15 August 1979,** T061.)

"She (Jackeydawra Melford) saw him making several (animation pictures) at Warwick Court for Kinema Industries, among them that DOLLS' CIRCUS. She is not quite sure of that name, but it was a circus performance by dolls and animals." (**Audrey Wadowska to Tjitte de Vries, London, 19 April 1981,** T055.)

"A VISIT TO THE CIRCUS, it shows a circus performance of animals and things. Jackey remembered it, because Father gave her sister a lion which appeared in it." (**Audrey Wadowska to Tjitte de Vries, London, 28 May 1981,** T057.)

Unpublished manuscripts

"DOLL'S CIRCUS [*sic*](actual title unknown)."

(**Audrey Wadowska, A-Z manuscript, 1981,** page D.)

Editorial

Humpty Dumpty sat on a wall,
Humpty Dumpty had a great fall;
All the King's horses and all the King's men
Couldn't put Humpty Dumpty in his place again.

It stands to reason that Cooper was inspired by the famous box of toys, the *'Schoenhut's Humpty-Dumpty Circus, The Toy Wonder, 10,001 New Tricks, Unbreakable Jointed Figures'*, which the American Schoenhut Company had produced since 1903. The circus contained a clown, a donkey, an elephant and other animals together with chairs, ladders and barrels. The circus was named after a famous British clown who called himself Humpty Dumpty.

136. Apparently after the end of his commission from or contract with Frank Butcher.

The name Humpty Dumpty had been used since the 15th century for obese persons, but in the 17th century also for big cannons. Humpty Dumpty as an egg-like figure became famous world-wide from the illustration in Lewis Carroll's *'Alice through the looking glass'*.

Actress Jackeydawra Melford told Audrey Wadowska that Cooper made an animation picture with dolls about a circus performance in the basement studio of 4 and 5, Warwick Court, High Holborn, the offices of his Kinema Industries Ltd. and Heron Films Ltd.

Henry Maynard, assistant animator on a number of animation pictures, mentions DOLLS' CIRCUS [*sic*] (1914). Although the evidence of Jackeydawra Melford is very strong, it comes to us via a third party, Audrey Wadowska, but the evidence of Maynard is strong enough as an indicator for a third star.

Because R. Prieur was Cooper's agent for the distribution of his Alpha pictures, he possibly took THE HUMPTY DUMPTY CIRCUS as the start of a Humpty Dumpty series of animation pictures followed by A BOX OF MATCHES, a 1914 reissue of MAGICAL MATCHES (1908), and other titles, like HUMPTY DUMPTY R.A. (1915) for which we have no indicators that Cooper had anything to do with it.

Audrey Wadowska confuses GOING TO THE CIRCUS, the alternative title for THE HUMPTY DUMPTY CIRCUS with THE WOODEN ATHLETES, which is also animation but not made by Cooper.

Cooper's THE HUMPTY DUMPTY CIRCUS (1914) should not be confused with J. Stuart Blackton and Albert E. Smith's (Vitagraph) animation picture HUMPTY DUMPTY CIRCUS (1908).

A BOX OF MATCHES, 1914, 396 ft., running time 6.36 min.
Reissue of MAGICAL MATCHES, 1908 (250 ft). Humpty Dumpty Films – R. Prieur. Probably lengthened with the duplication of several kaleidoscopic scenes.

CHAPTER 7

The Langford Period 1925-1940
Eight Cinema Advertisements

29. **Swiss Rolls** * * *, 1925, presumably 80 ft.,
running time approx. 50 seconds.
Cartoon Animation. A.k.a. DERBYSHIRE (?) SWISS ROLLS.[137]

Credits

Directed by Arthur Melbourne-Cooper. Production Animads Film Publicity, Langford & Co. Ltd., at the Animads studio, 72a, Cookson Street, Blackpool. Drawings and animation by Frank Ball, lettering Audrey Cooper.

Synopsis

Bakers demonstrate the way in which delicious sponge cake rolls are baked.

137. Swiss roll is a type of sponge cake baked in a very shallow rectangular baking tray, and then filled with jam, cream, marmalade or chocolate, rolled up and served in circular slices.

Fig. 100. Swiss Rolls Roly Poly.

Fig. 101. Swiss Rolls jam pudding.

The origin of the term 'Swiss' is unclear. Mrs Isabella Beeton, in her 1899 edition of *The Book of Household Management*, publishes as recipe 1790 'Roly-Poly Jam Pudding' made with a light suet crust and any type of jam rolled tightly into it, the illustrations of which resembles precisely these Swiss rolls.

Fig. 99. SWISS ROLLS (1925), Frank Ball's story board.

Details

A story board sketch by artist Frank Ball of Langford survived.

Recorded interviews

Kenneth Melbourne-Cooper: "Facts are bringing this back, like you just mentioned Gladhill. *Audrey Wadowska:* There was another one Jim Schofield remembered, SWISS ROLLS. We got a photo, maybe Swiss Rolls was something new. For whom was that made? *Ken:* My guess would be Green's, because it was very popular, made down Maidstone way, Dover perhaps. *Audrey:* Not Blackpool? *Ken:* I don't think so, I think it was the mixture. I don't think it was the roll. Green's jelly's and that sort of thing." (**Audrey Wadowska with her brother Kenneth Melbourne-Cooper, London, 24 October 1973,** T304.)

Ursula Messenger: "And that SWISS ROLLS, I can't remember the name of that one, but I know that there was Derbyshire in Cookson's [Street studio]. It could be one of them. It might have been some one with Mr English at Sheffield." (**Family discussion Audrey and Jan Wadowski, Ursula Messenger, London, August 1975,** T207.)

Audrey Wadowska: "They went all over the country. What I can remember, there was GLADHILL'S TILLS, PADDY FLAHERTY WHISKY, CLIFTON CHOCOLATES, CHURCHMAN'S CIGARETTES, and one we got a

still from, SWISS ROLLS. (...) *Kenneth Clark:* Animated ads for SWISS ROLLS? *Audrey:* Supposed to be something quite new in the baker's line in those days. None of us can remember whose. *Clark:* These were key drawings, these were used for Animads? *Audrey:* Yes." (**Audrey Wadowska to Kenneth Clark, London, 24 October 1978,** T197/198.)

Audrey Wadowska: "I remember the SWISS ROLLS one. That was a new thing, these Swiss rolls from the local bakery. It was a Blackpool bakery, wasn't it, Con? *Ursula (Con) Messenger:* On the other hand, a Mr England had this place in Leeds. *Audrey* (showing the drawings of Frank Ball): This artist could not get on with Father, he didn't understand the animation technique. He could not understand why you needed several drawings to get the movement of an arm. It bored him, and they quarrelled. *Ursula:* They were used to do it just for the one slide. *Audrey:* Anyway Father had difficulties with this artist, and he was quite well-known. But the bosses let Father get on with it, because they knew he was reliable. He had a free hand. The only thing is he used to annoy Mother, and he had a car, and we never knew when we would get home. We did not want to leave him behind, because we were driving as well in those days. As Jim Schofield says, he sometimes would work all day and all night, and he never ate while working. And Mother would prepare a meal for 6 or 8 o'clock, and we wouldn't turn up. We never got overtime. (...) *Ursula:* I do remember a loaf of bread. I thought it was Derbyshire, but that is a big firm in Blackpool, but according to Jim Schofield it is MOORES BREAD. I can remember this loaf and I can see this loaf standing there and all of a sudden it all wrapped up." (**Audrey Wadowska and Ursula Messenger to Tjitte de Vries, London, 14 April 1979,** T078.)

Audrey Wadowska: (Looking at Frank Ball's story board.) "That is a Blackpool one. And it is for SWISS ROLLS. One of the artists made that, Frank Ball. He was head artist. They had several artists. That is just a reproduction of some of his drawings, and we made an animated moving picture of it. Nicely sugared, and that sort of thing. *Tjitte de Vries:* This was a design for an animation picture? *Audrey:* Yes." (**Audrey Wadowska to Tjitte de Vries, London, 29 May 1981,** T065.)

Tjitte de Vries: "CLIFTON CHOCOLATES, you told us about. And the SWISS ROLLS, and that Derbyshire? Derbyshire Rolls? *Ursula Messenger:* Yes, I remember something like that. Could be Derbyshire. She (Audrey) would know, because she did the lettering for it." (**Mrs Ursula Messenger to Tjitte de Vries, Rotterdam, 7 May 2005,** T396.)

Editorial

In 1925, Melbourne-Cooper moved from Southend to Blackpool to become artistic manager of Animads Film Publicity, a department of Langford & Co. Ltd. Advertising Agency, Blackpool. In a studio at 72a, Cookson Street, after approx. 1930 in premises at New Preston Road, he installed his own stop-motion camera above an animation desk with pins and a glass plate for the execution of cartoon advertisements applying drawings on celluloid sheets.

Cooper first lived in Blackpool as a lodger until he found a house for the family, *Krahnholm* at Carleton, Poulton-le-Fylde. The family moved there in the second week of May, 1926, during the general strike, with the result that they had to wait for some time before the furniture arrived.

All three of Cooper's children, Audrey, Ursula and Kenneth, for a shorter or longer period, assisted him in the production of animated advertising films and glass slides for the cinemas. Audrey became a renowned letterer, Ursula an experienced colouring artist and Ken a printer's block maker. They shared their recollections with the authors. The titles of several animated advertising films were still remembered by the three of them, and also by their former employer, Langford's managing director Jim Schofield.

Apparently, Swiss Rolls, as a jam filled sponge cake, was marketed as a new commodity brand. One finds it today as 'Swiss rolls' in the cookery books. The Cooper children all remembered the Swiss Rolls advertising film. There was no doubt that Cooper made it. We did not find indicators from other sources, therefore only three stars.

Swiss Rolls, most probably, is the first animated advertising picture in the British cinemas.

There is a note in Audrey's handwriting on the back of a photograph of Frank Ball's story-board: *"Drawings for advertising film for Swiss Rolls (1925)"*. Most of the dates and lengths of the Langford advertising films are estimates. We assume that, after 1929, there was scarcely any demand for animated advertising pictures which were time-consuming to produce and expensive for cinema screening. We therefore date the Langford Animads pictures of which we have no dates as made mainly between 1925 and 1930.

30. **Clifton Chocolates** * * * *, 1926, presumably 80 ft.,
running time 60 seconds.
Puppet animation concluded with a live-action pay-off.
Five short 35mm film strips survived with different scenes, in
total 39 neg. frames, 9 positive frames, now in the Arthur
Melbourne-Cooper Archive of the authors. Kodak dating marks
are from 1926.

Credits

Directed and animated by Arthur Melbourne-Cooper. Production
Animads Film Publicity, Langford & Co. Ltd., at the Animads studio,
72a, Cookson Street, Blackpool. Set design by Jack Brownbridge. Both
Cooper's daughters Audrey and Ursula were involved in the animation
of the dolls. Ursula appeared in the live-action close-up, Audrey
designed the lettering.

Synopsis

Romeo and Juliet (or Harlequin and Colombine) experience some
romantic troubles. A soldier intervenes, and a box of Clifton chocolates

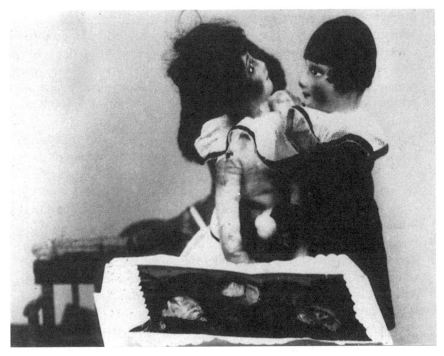

Fig. 102. CLIFTON CHOCOLATES - Romeo and Julia (1926).

brings the solution: the couple embrace each other. The film ends with a pay-off: an emblematic shot of Ursula Melbourne-Cooper who, through a dark curtain, offers the cinema audience an open box of Clifton chocolates followed by the text "Every girl truly loves The Best Chocolates".

Details
Surving strips of film (now in the Arthur Melbourne-Cooper Archive of the authors):
– two strips of negative 35mm film with two kissing puppets in a close medium shot and a box of chocolates in the foreground.
– one strip of positive 35mm film with Ursula Melbourne-Cooper showing a box of Clifton Chocolates;
– one strip of positive 35mm film with the concluding text "EVERY GIRL TRULY LOVES *THE BEST* CHOCOLATES";
– one strip of positive 35mm film with two puppets courting and a soldier in medium shot.

Publications
"In later life, from 1925 until 1940 when he retired, Melbourne-Cooper still kept up his interest in animated films, making advertising films in Blackpool." (**Anthony Slide, summer 1967.**) [N143]

"But by then (1911) the Alpha Company had run into financial difficulties, and Father had established Kinema Industries, financed by Andrew Heron with offices at Warwick Court in London – the same premises which he knew so well from the earliest days of his long and intimate association with Charles Urban. At the outbreak of the War in 1914, he was sent to Woolwich on a training course and became a government Inspector of Ammunition stationed at Luton. Then in 1925 he went to Blackpool, producing animated cartoon films for advertising, on which all the family were engaged. Retiring in 1940, he settled down at Cambridge, where he died in November 1961 in his eighty-eighth year." (**RPS lecture of Audrey Wadowska, London, 26 January 1977,** T128.) [N144]

Recorded interviews
Audrey Wadowska: "I don't remember this story (looking at a still from CLIFTON CHOCOLATES), a Harlequin and a Columbine? *Jim Schofield:*[138] And a soldier comes in. *Audrey:* What does he do? *Schofield:* Well, he brings the box of chocolates in whereupon the soldier, or the Harlequin or Columbine disappears backwards over that balustrade business over

138. Retired managing director of Langford & Co Ltd, advertising agency at Blackpool.

there. That was roughly the story. *Audrey:* How many feet, how long did they last? Two or three minutes, I suppose. *Schofield:* I can't remember, 16 frames to a second? A 100 feet, I suppose. And this lettering was run in, letter by letter on celluloid, though some of the things, I think, you did on the actual frame." (**Audrey Wadowska interviews Jim Schofield, Blackpool, 1963,** T094.)

Audrey Wadowska: "And there is also that Blackpool business. That is historical now. Apparently, we were among the first to make animated cartoon films for advertising. But I don't remember much about it.

Kenneth Melbourne-Cooper: I do. I was in it when the old man was there. He built the dark room and had a tank made for dipping the film in. You know when he was in the garden and the racks for drying, well, he had those racks made and the tanks about this side, vertical, and he used to dip them in. Somebody made them out of oak or something, and they kept splitting, and they kept damn well leaking. He had bitumen inside which seems to stop the leaking but it wore off and distorted, a right flop they were. But there we had four big pillars put up, with a rack on, and beams across. The camera was held on the top. And the first film that we made there was done on celluloid sheets, drawing after drawing on pins, on register pins. But I just can't remember whether it was animals, or what, I can't remember what was on the films. But I can remember the CLIFTON CHOCOLATES one. He made the Clifton one up in Cookson Street, before we went to Preston New Road. That was done right up on the top floor above Arkley's Garage. We had the same type of wooden thing there. And I was the one who did these three turns, three turns, there were puppets, they were hanging on strings, there was a little settee, I remember. There was a like lady puppet and a male puppet that sat there making love, and somebody comes there over the back, looked over with a box of Clifton Chocolates, and you see the girl leaves him going to the bloke with the chocolates.

Audrey: Anyway, Con was in there (in CLIFTON CHOCOLATES), because we got a little clip of that, her face is there looking over that box of chocolates. We also got a clip of these toys. But I do not particularly remember Preston Road. But there is also another one, PADDY FLAHERTY WHISKEY and GLADHILL'S TILLS.

Ken: I remember GLADHILL'S TILLS, that was made in my time. Gladhill was a Sheffield Company. *Audrey:* Perhaps I could see them. *Ken:* You might, the same as Clifton's, they were taken over by Barker & Dobson's. I always wondered whether Barker & Dobson still got it. If they do it

Fig. 103. The 'pay-off': Ursula Messenger offers the cinema audience a box of chocolates in CLIFTON CHOCOLATES (1926).

must be in tins. Liverpool got badly blitzed in the war. But it might be interesting, it may have escaped. If they still got it, I could come over and fetch it.

Audrey: Personal contact is always better than writing. When I went to Sheffield they were so helpful. They were there to meet me, the Mottershaws, they had scrap books and catalogues. Father sold films to them. *Ken:* Father made more than one film for Clifton, whether the negatives or the positives are still there at Liverpool, as long as you get hold of them. They were showing in Blackpool the Clifton ones, as I remember." (**Kenneth Melbourne-Cooper to Audrey Wadowska, London, 24 October 1973,** T304.)

Kenneth Clark: "The films consisted of just short local adverts or were they national adverts? *Audrey Wadowska:* Well, they went all over the country but what I can remember, a lot of them were – I mean there was GLADHILL'S TILLS, PADDY FLAHERTY WHISKEY, CLIFTON CHOCOLATES, CHURCHMAN'S CIGARETTES, and one we got a still from that, SWISS ROLLS, that shows a different movement on this. (...) And there was CLIFTON CHOCOLATES, that was done in puppets. We should never forget that, just to show how mean people are. We were given a box of chocolates to be filmed. Father's idea was to have these puppets, Harlequin and Columbine, courting and kissing and spooning in the garden, and he presents her a box of Clifton chocolates, and my sister Ursula assisted my father on this particular one. And it took weeks to make. We ate them, divided these chocolates between us. And the Clifton people came along, they wanted the box back! So we went around and gave a shilling each to reimburse them for the eaten chocolates. *Clark:* Can you date that particular film? *Audrey:* Not exactly. I would say about 1926 or 1927." (**Audrey Wadowska to Kenneth Clark, London, 24 October 1978,** T197.)

Ursula Messenger: "And then there is the famous story of the chocolates. *Audrey Wadowska:* They wanted a film, an animated film for the wonderful Clifton chocolates. *Ursula:* They were a local firm, not very far away. *Audrey:* They delivered this beautiful box of chocolates to do the job. We had it for several weeks. It took quite a time to make. They were pretty stale when it was finished. Then one of the staff thought, well, and the box went round, and we had all one each. But shortly afterwards we were sent the bill. We had to pay for this old box of chocolates! And it worked out about a shilling each. *Ursula:* That was a lot of money in those days. *Audrey:* And we had to send a shilling from our wages to Clifton to make up for the box of chocolates. *Ursula:* I had

to hold up the box with chocolates. *Audrey:* Father did some Harlequin and Columbine. *Ursula:* That must have taken some time because dad had these dolls, I remember they had to sit on a seat and we had to move them, Pierrot and Pierrette, wasn't it? *Audrey:* Something like that. They were courting and eventually she was presented with a box of Clifton chocolates. And Con, you had your face through a velvet hole. *Ursula:* That must have been a close-up, my face through black velvet and just with my hands and a white box like this. I was supposed to smile. *Audrey:* We got a cut-off of that." (**Audrey Wadowska and Ursula Messenger to Tjitte de Vries, London, 14 April 1979,** To78.)

"We did that one for CLIFTON CHOCOLATES in Blackpool, Cookson Street, above the garage. We did one or two. We nearly set the studio on fire at one time. They put some big arc lamps on. But the wire was too light. It heated up like a fire, and it went sshhh, like that, and it left a burn mark all over the floor when it came down. (...) He had these wooden development tanks made, about that wide, with racks with pins on them, so he could wind films on a donkey. And he had these tanks that would leak, a big problem. It was made from a wrong type of wood. The films were made on celluloid to make the movement. It was frame-by-frame. We used fluorescent tubes, they were high enough for the ultraviolet. There were problems to get it clicking. The camera might have been a Williamson, a rather square one, but he played around with Debries." (**Kenneth Melbourne-Cooper to Tjitte de Vries, Burnley, 2 August 1983,** To88.)

Jan Wadowski: "There is another question I want to ask you. Which firm has been advertising which film, and which firm has taken over. Do you know the addresses? *Kenneth Melbourne-Cooper:* Well, Con could answer this, because she went and worked for them, I think. It was Dawson and somebody else. They had a little place in Burley Street in Blackpool, they were like the opposition to us. And they moved down to London. Whether Rank took over I don't know. They seemed to go down to London and made a name in advertising. They were in Wardour Street.

Jan: Which advertising firm still exists? But what about the films, have they still the copies. *Ken:* Oh, yes, the CLIFTON CHOCOLATES film. That company was taken over by Barker and Dobson's. Liverpool got badly blitzed during the war. Whether they survived? One should go and see. They could possibly still have a film. *Jan:* Or they took the film over to the advertiser? *Ken:* Langford had options on the screens. They had

contacts with people to show films. Whether they sold it outright and passed it on to them? But I can't think they got it showing without going through an agency. There must be an agency that handled the film. Langford made the films, more like under the instructions from the CLIFTON CHOCOLATES people. I have seen it shown in the cinemas in my time.

Jan: They advertised probably in several cinemas and made several copies. *Ken:* I would say so. *Jan:* Or one copy from one place to another? *Ken:* I would say more copies. *Jan:* They had to pay the cinemas to show them. *Ken:* Oh yes, they used to sign them up on contracts. Say, like the Grand Theatre would be signed up for 12 months for Langford slides only. Because I can remember them talking sometime, saying they lost cinema so-and-so. The competition offered more money. *Jan:* Barker and Dobson still exist in Liverpool? *Ken:* Oh, yes, they still exist, though they are having a hard time right now. It is a big company, they lost about 5 million last year or the year before. I don't know how many films Father made. I was not that interested. I had my motorbike and my friends. It was just a job to me." (**Kenneth Melbourne-Cooper to his brother-in-law Jan Wadowski, St Albans, 17 May 1984,** T210.)

Tjitte de Vries: "These are also advertising films, puppet films for chocolates? *Ursula Messenger:* Yes, CLIFTON CHOCOLATES. They sent a box for the film. I got my head through a black velvet thing. These were toys that dad made. They wanted the box back, and we each had to pay a shilling for eating the chocolates." (**Ursula Messenger to Tjitte de Vries, Felpham, Bognor Regis, 23 October 2000,** T137.)

Editorial

Most of the dates and lengths of the Langford advertising films are our assumptions. Audrey wrote on the back of a print of a Clifton film strip: *"Film Strip from advertising film for Clifton Chocolates 1926".*

Former Langford manager Jim Schofield says in one of his interviews to Audrey that the Clifton film could have been 100 feet. This is approx. 1.00 minute screening time, which is very long. Even our estimate of 60 seconds is perhaps too long. We are rather certain that the Clifton picture was one of the first animation advertisements Cooper made for the cinemas. As a kind of try-out such a length could be explainable.

31. Paddy Flaherty Whiskey * * *, 1925-1930, presumably 40 ft., running time 30 seconds. Combined object and cartoon animation.

Credits

Directed and animated by Arthur Melbourne-Cooper. Production Animads Film Publicity, Langford & Co. Ltd., at the Animads studio, 72a, Cookson Street, Blackpool. Drawings Frank Ball. Assistant animators Audrey and Ursula Melbourne-Cooper. Lettering Audrey Melbourne-Cooper.

Synopsis

Animation of lettering and a whiskey bottle with the labels "Corn Distilleries Old Irish Whiskey" and "PADDY FLAHERTY". The lettering forms the following text: "Say 'Paddy', the best thing, next time you order." Emblem: "Animads Film Publicity."

Details

One strip of negative 35mm film with eight frames survived with a bottle and the text *"Say 'Paddy' the best thing next time you order"* – followed by the Animads trademark (now in the Arthur Melbourne-Cooper Archive of the authors).

Recorded interviews

Audrey Wadowska: "He liked farming and chickens and all that. (...) I think Blackpool was the only place where he did not have any chickens. He loved his gardens. Always had a nice garden. (Showing stills.) GLADHILL'S TILLS, I think. *Jim Schofield:* Yes, that is another one. PADDY FLAHERTY WHISKEY I can remember something about that now. GLADHILL'S TILLS, I do remember. *Audrey:* I think he said it had something to do with clean milk. They couldn't remember the title. But my father did remember this dirt getting into milk in one of the scenes." (**Audrey Wadowska with Jim Schofield, Blackpool, 1963, T094.**)

Audrey: "Anyway, Con was in there (CLIFTON CHOCOLATES) because we got a little clip of that, her face is there looking over that box of chocolates. We also got a clip of these toys. But I do not particularly remember Preston Road. But there is also another one, PADDY FLAHERTY WHISKEY and GLADHILL'S TILLS." (**Audrey Wadowska with her brother Kenneth Melbourne-Cooper, London, 24 October 1973, T304.**)

"We did PADDY FLAHERTY WHISKEY, Irish whiskey, I don't remember what the animation was about." (**Audrey Wadowska and Ursula Messenger to Tjitte de Vries, London, 14 April 1979, T078.**)

Editorial

The lettering of the titles of many early films was done by Cooper himself. A couple of boxes with the letters he used were still in the estate of Audrey and Jan Wadowski. Even though Cooper kept a short strip of film with the Paddy whiskey bottle, we would have preferred one or two more indicators to afford it a fourth star.

Most of the dates and lengths of the Langford advertising films are our suppositions. We assume that, after 1929, there was no demand anymore for animated advertising pictures as they were time-consuming to produce and expensive for cinema screening. We therefore date the Langford Animads pictures for which we have no dates as made between 1925 and 1930.

32. Gladhill's Tills * * * *, 1925-1930, presumably 50 ft.,
 running time approx. 35 seconds. Cartoon animation.

Credits

Directed and animated by Arthur Melbourne-Cooper. Production Animads Film Publicity, Langford & Co. Ltd., at the Animads studio, 72a, Cookson Street, Blackpool. Camera Kenneth Melbourne-Cooper, set design Jack Brownbridge, drawings Frank Ball, artist letterer Audrey Melbourne-Cooper.

Synopsis

Gladhill's advanced cash registers with the new facility to print receipts after receiving payment are going around the world.

Details

A short strip of 35mm neg. film survived with 7 frames, now in the Arthur Melbourne-Cooper Archive of the authors.

Recorded interviews

Audrey Wadowska: (showing stills.) "Gladhill's Tills, I think. *Jim Schofield:* Yes, that is another one. Paddy Flaherty Whisky, I can remember something about that now. Gladhill's Tills, I do remember." (**Audrey Wadowska with Jim Schofield, Blackpool, 1963**, T094.)

Audrey Wadowska: "Anyway, Con (Ursula) was in there (Clifton Chocolates) because we got a little clip of that, her face is there looking over that box of chocolates. We also got a clip of these toys. But I do not particularly remember Preston Road. But there is also another one, Paddy Flaherty Whiskey and Gladhill's Tills. *Kenneth Melbourne-Cooper:* I remember Gladhill's Tills, that was made in my time.

Fig. 104. Family scene shortly after removal from Carleton near Blackpool to Little Shelford near Cambridge. Left to right: Arthur Melbourne-Cooper, his son Kenneth, grandmother Mrs. Lacey, Ken's daughters Susan and Angela, Mrs Kate Melbourne-Cooper, and behind her Ken's wife Mary. Ken was the only one of Arthur's children to give him grandchildren.

Gladhill was a Sheffield company. *Audrey:* Perhaps I could see them? (...) *Ken:* That Gladhills one, I can't remember what was it? *Audrey:* GLADHILL'S TILLS THE WORLD, wasn't it? *Ken:* I wonder if that was on celluloid, pin registered. *Audrey:* How was it done?
Ken: Celluloid, clear celluloid. *Audrey:* Flat on the table? *Ken:* Just like Mrs Doodah. *Audrey:* Oh, yes, Lotte Reiniger. *Ken:* We had light underneath. He had Hewitts, the early ones of the mercury-vapoured tubes, two long Hewitts, and they gave him no end on it, and they had magnetical starters, tick, tick, a long time before warming up, clattering away before they started. I don't know if Frank Ball did the drawings for it. *Audrey:* Yes, he did. *Ken:* Did he do a lot? *Audrey:* Yes. He was always at loggerheads with Dad, because he just couldn't understand why he had to make so many drawings.
Ken: Once you get the sequence of it, they can reprint, reprint and with two walks you can walk a mile. Lotte (Reiniger) did that a lot, cut out and put it back. She didn't do it continuously, Lotte was just repeat after

repeat. She might have moved the background, but she only did the complete walk and not every time for any walk. It was just repeat after repeat. Double projection. *Audrey:* But that was done on celluloid, and the camera was mounted above. *Ken:* On rails and it would go up and down, height according to the size of the picture. I don't know whether we had steps-up or what. Chrissie, they had a lot of sets made, didn't they, with Geoff Ball. And Jack Brownbridge – . *Audrey:* That's right, Brownbridge. *Ken:* He painted some of the sets, didn't he? One set was a little old bay window thing, like The Old Shoppey. What was that done for? I don't know if that was a trick film, or what? *Audrey:* Pecary was there at the time. Doesn't she remember? *Ken:* Facts are bringing this back, like you just mentioned Gladhill. *Audrey:* There was another one Jim Schofield remembered, SWISS ROLLS. We got a photo, maybe Swiss Rolls was something new." (**Audrey Wadowska with her brother Kenneth Melbourne-Cooper, London, 24 October 1973,** T304.)

Ursula Messenger: "I think Jim Schofield, I think he'll remember GLADHILL'S TILLS. CLIFTON CHOCOLATES. *Audrey Wadowska:* PAD O'FLAHERTY'S[139] WHISKEY. He remembered Dad making that thing of wire and cotton wool. I remember GLADHILL'S TILLS TILL THE WORLD. And you were in CLIFTON CHOCOLATES. Jack Brownbridge told me he had a slide that I did, he was going to look it up.

Ursula: They can't all have disappeared. *Audrey:* Where did they go? The advertiser did not own the slide? *Ursula:* They used to come back at Langfords. I remember seeing them coming in. *Audrey:* What happened to the films when the advertiser stopped paying for them? They went back to Langfords? I wonder. If I had time I'd write to the advertisers, like Gladhill. I am afraid they were chucked out as old rubbish. These old slides would be interesting now. *Ursula:* I remember they were numbered to know which to show first, not to repeat the same design, or not two garages after one another. You had to be careful. And that certain designs went to certain cinemas. *Audrey:* The same with daffodils, the seasonable things, or great events."

(**Cooper family discussion: Audrey and Jan Wadowski, sister Ursula (Con) Messenger, London, August 1975,** T207.)

"And then we did GLADHILL'S TILLS. Well, I did as far as finding out that there was a Gladhill making tills up in Scotland."
(**Audrey Wadowska with Kenneth Clark, London, 24 October 1978,** T198.)

139. Paddy Flaherty.

"I remember GLADHILL'S TILLS. Gladhill till the world, I don't know what it was about. They made cash registers, and I remember these tills going around the world."
(**Audrey Wadowska and her sister Ursula Messenger to Tjitte de Vries, London, 14 April 1979, T078.**)

Audrey Wadowska: "Well, Clifton's, in the Twenties we made that famous chocolate film, CLIFTON CHCOLATES, you know that story. Apparently they were a Manchester firm. *Tjitte de Vries:* You had to bring the box back but had it eaten up. *Audrey:* Yes. And we made a film for Gladhill, GLADHILL'S TILLS. And I remember it was called GLADHILL'S TILL THE WORLD. And they had a trade mark." (**Audrey Wadowska to Tjitte de Vries, London, 4 August 1979, T177.**)

"We did one for GLADHILL'S TILLS, that is in Huddersfield. It was done on celluloid in sheets, one on top of the other. It was to do with money tills. It was one of those advanced tills." (**Kenneth Melbourne-Cooper to Tjitte de Vries, Burnley, 2 August 1983, T088.**)

"This was before Walt Disney was thought of. I can always remember, we did one for GLADHILL'S TILLS. On the tills of those days was one with a roll of paper and it wrote in how much, which was the latest thing. That was Gladhill's Tills of Huddersfield." (**Kenneth Melbourne-Cooper to Jan Wadowski about his Langford period, St Albans, 17 May 1984, T210.**)

Ursula Messenger: "I don't know much about the advertisers. Being in the colouring department we had to go up a ladder to a floor where Dad was. Downstairs was were the artists were. And through there things came to the office. *Tjitte de Vries:* GLADHILL'S TILLS? The tills are the things you have in a shop to keep your money in. *Ursula:* Yes, I remember that one. That was a film. Audrey would know about it because she did the writing. She was a letterer." (**Ursula Messenger to Tjitte de Vries, Rotterdam, 7 May 2005, T396.**)

Editorial

The attraction of the new brand of tills was that, after receiving the customer's payment, a receipt could be printed on a narrow roll of paper, which was quite a novelty. The Cooper children as well as their former boss Jim Schofield, they all remembered the GLADHILL'S TILLS advertising film. There was no doubt at all that Cooper made it.

Most of the dates and lengths of the Langford advertising films are our suppositions. We assume that, after 1929, there was scarcely any demand anymore for animated advertising pictures, which were time-consuming to produce and expensive for cinema screening. We

therefore date the Langford Animads pictures for which we have no dates as made between 1925 and 1930.

33. **Churchman's Cigarettes** * *, 1925-1930, presumably 80 ft., running time approx. 35 seconds. Animation technique unknown.

Credits

Directed and animated by Arthur Melbourne-Cooper. Production Animads Film Publicity, Langford & Co. Ltd., at the Animads studio, 72a, Cookson Street, Blackpool. No further credits known.

Synopsis

Animated advertising picture to promote CHURCHMAN'S CIGARETTES in the cinemas for W.A. & A.C. Churchman, factory in Ipswich until late 1980s, issued by the Imperial Tobacco Co. of Great Britain & Ireland, Ltd. Details unknown.

Recorded interviews

Kenneth Melbourne-Cooper: "See, Dad went up to Blackpool before we went there. *Audrey Wadowska:* That was 1925. Do you remember whether he answered an advertisement in the *Kine Weekly*, or whether he put an advertisement in himself? *Ken:* I have no idea. I remember helping him, we were doing photography in Thundersley in those sheds in the garden. He was making things for CHURCHMAN'S CIGARETTES, little pictures, genuine bromide print. I can remember them going out. I think they were at Ipswich or Norwich, Churchman's Cigarette people there. And they took a set – he got a set of churches, or cathedrals or what. And the order was so big, he couldn't print them, and there was Thundersley or Westcliff,[140] along there somewhere, there used to be commercial printing, and they were done in a roll, they were going in 20 a packet. They were genuine photographs, small ones." **(Audrey Wadowska with Kenneth Melbourne-Cooper, London, 24 October 1973,** T304.)

Audrey Wadowska: "He [Jim Schofield][141] remembered Dad taking photographs for Churchman's cigarette cards. When I was on Camden market they had a whole roll of cigarette cards, and they said that Churchman stopped publishing in the 30s. They hadn't got any black

140. According to Ursula Messenger the Churchman's Cigarette church pictures could have been printed by a firm in Basildon.

141. Retired managing director of Langford & Co., Ltd, advertising agency at Blackpool.

and white photographs of churches. *Ursula Messenger:* I remember Dad took quite some photographs of churches. He did a lot of photographs too. I remember him taking that old church looking out over five counties. Jim Schofield would be the person to remember Dad making these films." (**Family discussion – Audrey and Jan Wadowski, Ursula Messenger, London, August 1975,** T207.)

"They then started The Veterans. He should have become a veteran. But Mother objected, she wanted him to break from film. So he takes up still photography, and he goes around taking photographs of babies and people who want their portrait taken and local views. The same thing that Uncle Bert and he did – I didn't tell you yet but I will later – these local views. And amongst other things, one of the most important things is – my brother reminded me about it – he had a hand in it – he took views – as you know, packets of cigarettes, CHURCHMAN's had cards in them. He started photographing views of various churches and views and developed them and printed them for Churchman's. I have been searching all around Portobello market searching for these. They got any amount of ancient cigarette cards but not Churchman's. My brother suggested to write to Churchman's, but I reckon they have been taken over by now." (**Audrey Wadowsk to Tjitte de Vries, London, 26 December 1976,** T074.)

"They went all over the country. What I can remember – there was GLADHILL's TILLS, PADDY FLAHERTY WHISKY, CLIFTON CHOCOLATES, CHURCHMAN's CIGARETTES, and one we got a still from, SWISS ROLLS." (**Audrey Wadowska to Kenneth Clark, London, 24 October 1978,** T197.)

David Cleveland: "What did your father do in Southend? *Audrey Wadowska:* Well, he set himself up then as a local photographer, and he used to take portraits and views. And amongst other things he made sets of – one particular I remember and my brother remembered it too – but some things we don't even remember – but he made a set of photographic cigarette cards for Churchman's Cigarettes. And I have been searching for those in these cigarette, eh – Can't find them. And Churchman's don't exist anymore, they amalgamated with somebody. I haven't got around that. *Cleveland:* I thought they had a factory at Ipswich. So he did that? And then he went to Blackpool, and he started to build up again? *Audrey:* Yes, he bought himself a camera. And I haven't discovered to this day whether he answered an advertisement or whether he advertised. I have an idea he would have advertised in the *Kinematograph Weekly.* He used to be subscribed to that, because we had bundles and bundles of that which we burned. And he went up

before us, in the winter of 1924/1925. And he was there over a year on his own, and the idea was to make animated films for advertising. *Cleveland:* He went in 1924, and he was able somehow to set up a little studio there, wasn't it? *Audrey:* Well, he worked for – no, he was employed by Langford and Company. *Cleveland:* The slides? *Audrey:* The slide makers." (**Audrey Wadowska to David Cleveland, London, 11 October 1979,** T407.)

"Langford's trade mark was Animads. I remember him making the CLEAN MILK (CAMPAIGN). I remember making PADDY FLAHERTY WHISKEY, GLADHILL'S TILLS, CHURCHMAN'S CIGARETTES, and of course CLIFTON CHOCOLATES. We made one or two but not enough to keep us as a family in full time employment, so in between times we did lantern slides." (**Audrey Wadowska to Tjitte de Vries, London, 17 April 1981,** T053.)

Editorial

Cooper had old connections with W.A. & A.C. Churchman. After World War I, Cooper was a seasonal photographer in Southend-on-Sea, later living in Thundersley, and made hundreds of photographs of local churches for Churchman's Cigarettes organised in series of 50 cigarette cards for each county. There are convincing indicators for two stars, but unfortunately no more. The Churchman's churches cigarette cards are much wanted collector's items. We had no success in our efforts trying to find existing copies of the film.

Most of the dates and lengths of the Langford advertising films are our suppositions. We think that, after 1929, there was scarcely any demand anymore for animated advertising pictures which were time-consuming to produce and expensive for cinema screening. We therefore date the Langford Animads pictures for which we have no dates as made between 1925 and 1930.

34. Clean Milk Campaign * * *, 1927, 80 ft., presumably 60 seconds.

Stop-motion animation of objects combined with cartoon and lettering animation.

Credits

Directed and animated by Arthur Melbourne-Cooper. Production Animads Film Publicity, Langford & Co. Ltd., at the Animads studio, 72a, Cookson Street, Blackpool. Camera Kenneth Melbourne-Cooper,

set design Jack Brownbridge, drawings Frank Ball, lettering Audrey Melbourne-Cooper.

Synopsis

Under a magnifying glass, microbes or bacilli are seen doing their dirty work. A demure cow in drawings can also be seen.

Details

This most probably was a commission of the Clean Milk Campaign by Wilfred Buckley and his Clean Milk Movement to improve the quality of milk and promote the consumption of pasteurized milk. A strip of 35mm film with nine frames survived with a drawing of a cow and animated lettering: "This is demure" (now in the Arthur Melbourne-Cooper Archive of the authors).

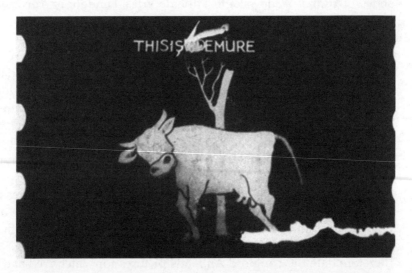

Fig. 105. CLEAN MILK CAMPAIGN (1925-1930). A demure cow.

Publications

"My sister used to colour the slides, I designed them, and my brother made the pictures. We worked as a family group, with Father in charge. In those days they used to handcolour films, and we appear in them ourselves. My father had dolls that he animated. He was very clever with it. He made nasty looking insects with cotton wool and used them, blown up and very frightening, for an advertising film we made on the importance of clean milk." (**Audrey Wadowska to Ronald Riggs, Herts Advertiser, St Albans, 28 June 1974.**)[N145]

Recorded interviews

Audrey Wadowska: "I think he said it had something to do with Clean Milk. They couldn't remember the title. But my father did remember this dirt getting into milk in one of the scenes. *Jim Schofield:* You are quite right. He had a little microbe made part of cotton wool stuff and things on it. He had it made out of wire, supposed to get into it, in the milk. Something like that about it, this thing that got into the milk." (**Audrey Wadowska to Jim Schofield, Blackpool, 1963,** T094.)

"One Jim Schofield particularly remembered was Clean Milk, with dad making his own little insects with cotton wool and all these insects which were in the milk." (**Audrey Wadowska and Kenneth Melbourne-Cooper, London, 24 October 1973,** T304.)

Audrey Wadowska: "These Cheese Mites – father made one called Cheese Mites, but I don't think it had to do with lilliputians. I think it was done with his favourite idea of hand-made bugs, made of wire and cotton wool, enlarged through the magnifying glass. *Tjitte de Vries:* Animated? *Audrey:* Yes. Stan Collier[142] recalled that. It was an early one. You saw the cheese, crawling with bugs and then he enlarged it – the interpolated type, I suppose. You saw these ghastly cheese mites which he made himself. Same as Blackpool for milk, Clean Milk Campaign. He made bugs and things himself with wire and cotton wool." (**Audrey Wadowska to Tjitte de Vries, London, 31 March 1978,** T019.)

Audrey Wadowska: "When we were in Blackpool, we had to make a film in those days for a Clean Milk Campaign. And he made an enlargement through magnifying glass idea, like he did many years ago for Grandma's Reading Glass, insects in milk. He made that with wire and cotton wool. He made them himself. *Kenneth Clark:* There was a series of films about that time, because they were pushing milk. (...) The Milk Board says all their archive was destroyed during the war. *Audrey:* We got some (film strips) with a cow on it. This cow has something to do with Clean Milk, I think. The cow moves its legs and moves its head, and you can see the animation on the title." (**Audrey Wadowska to Kenneth Clark, London, 24 October 1978,** T197/198.)

Audrey Wadowska: "And he made bugs out of wire and cotton wool. That was the Clean Milk Campaign. He made his own bugs. *Ursula Messenger:* Horrible looking germs. It was a campaign. *Audrey:* Some

142. Cooper's assistant at that time.

special firm. *Ursula:* In those days, we used to go to a farm with a jug."
(**Audrey Wadowska and Ursula Messenger to Tjitte de Vries, London,
14 April 1979,** T078.)

"In 1927, there was a CLEAN MILK advertisement. It was made for
Howard's Dairy. I have forgotten that. That was shown at the Kursaal at
Southend, because I met a man who made it. But we made it in
Blackpool. On this CLEAN MILK father made his own bugs with wire
and cotton wool, and all these bugs caught about in the milk. And there
was a campaign to clean up milk." (**Audrey Wadowska to Tjitte de
Vries, London, 17 April 1981,** T053.)

Editorial

The Hampshire County Council in their series Hampshire Papers
published an interesting paper by Philip Sheail, "Wilfred Buckley of
Moundsmere and the Clean Milk Campaign" (May 25, 2003). The
Cooper children as well as their former boss Jim Schofield, they all
remembered the CLEAN MILK CAMPAIGN advertising film. There is no
doubt that Cooper made it. Most of the dates and lengths of the
Langford advertising films are our suppositions.

35. Moores Bread * *, 1925-1930, presumably 50 ft ,
 running time approx. 35 sec. Possibly stop-motion animation.

Credits

Directed and animated by Arthur Melbourne-Cooper. Production
Animads Film Publicity, Langford & Co. Ltd., at the Animads studio,
72a, Cookson Street, Blackpool. Assistant animator Audrey Melbourne-
Cooper.

Synopsis

Microbes are animated going into a bread in order to promote the
healthier wholemeal bread of Moores Bakeries. No further details
known.

Recorded interviews

Jim Schofield: "And also there was something about MOORES BREAD too,
in which a microbe got into. I think at that time (it had) to do with
producing rough bread[143] that was just getting out. And Moores was one
of the few who were coming out with rough bread. *Audrey Wadowska:* I
remember at Langford House helping him with the films, and I can see

143. Wholemeal bread.

myself now, doing all these movements one by one, movement by movement. *Schofield:* He used to do most of that film work at night time, he used to stay on at night time." (**Audrey Wadowska with Jim Schofield, Blackpool, 1963,** T094.)

"Here is another one that Collier recalled as being very funny. You know that one, CHEESE MITES, he told that Father made one called CHEESE MITES, and there were maggots, hand made. They were enlarged. We did a similar thing in Blackpool, and the maggots were in bread this time. Black bread came into being this time, supposed to keep the maggots, or insects out. He did the same thing, and made his own maggots out of wire and cotton wool." (**Audrey Wadowska to Tjitte de Vries, London, 13 April 1979,** T035.)

Ursula Messenger: "I do remember a loaf of bread. I thought it was Derbyshire, but that is a big firm in Blackpool, but according to Jim Schofield it is MOORES BREAD. I can remember this loaf, and I can see this loaf standing there, and all of a sudden it all wrapped up." (**Audrey Wadowska and Ursula Messenger to Tjitte de Vries, London, 14 April 1979,** T078.)

Editorial

It was the time of healthy bread and clean milk. Langford manager Jim Schofield, Audrey and her sister Ursula remembered MOORES BREAD with the particulars of the animated microbe becoming enlarged – a repetition of what Cooper had done in PROFESSOR BUNKUM'S PERFORMING FLEA (1907). This 'repeat performance' affords it a second star. (Moores Bread still exists in Australia.)

Most of the dates and lengths of the Langford advertising films are our suppositions. We assume that after 1929 there was scarcely any demand anymore for animated advertising pictures, which were time-consuming to produce and expensive for cinema screening. We therefore date the Langford Animads pictures for which we have no dates as made between 1925 and 1930.

36. Gladhill's Clocking-in Clock *, 1925-1930,
presumably 50 ft., running time approx. 35 sec.
Cartoon animation.

Credits

Directed and animated by Arthur Melbourne-Cooper. Production Animads Film Publicity, Langford & Co. Ltd., at the Animads studio,

72a, Cookson Street, Blackpool. Camera Kenneth Melbourne-Cooper. Drawings (probably) Frank Ball.

Synopsis

The film shows a big dial with holes and numbers which can be pushed in by employees entering or leaving the premises. No further details known.

Recorded interviews

Audrey Wadowska: "Anyway, Con (Ursula) was in there (CLIFTON CHOCOLATES) because we got a little clip of that, her face is there looking over that box of chocolates. We also got a clip of these toys. But I do not particularly remember Preston Road. But there is also another one, PADDY FLAHERTY WHISKEY and GLADHILL'S TILLS. *Kenneth Melbourne-Cooper:* I remember GLADHILL'S TILLS, that was made in my time. Gladhill was a Sheffield company. *Audrey:* Perhaps I could see them? *Ken:* You might, the same as Clifton's, they were taken over by Barker & Dobson's. I always wondered whether Barker & Dobson still got it. If they do it must be in tins. Liverpool got badly blitzed in the war. (...) *Ken:* That Gladhills one, I can't remember what was it? *Audrey:* GLADHILL'S TILLS THE WORLD, wasn't it? *Ken:* I wonder if that was on celluloid, pin registered. *Audrey:* How was it done? *Ken:* Celluloid, clear celluloid. *Audrey:* Flat on the table? *Ken:* Just like Mrs Doodah. *Audrey:* Oh, yes, Lotte Reiniger. *Ken:* We had light underneath. He had Hewitts, the early ones of the mercury-vapoured tubes, two long Hewitts. (**Kenneth Melbourne-Cooper to Audrey Wadowska, London, 24 October 1973, T304.**)

Audrey Wadowska: "Well, Clifton's, in the Twenties we made that famous chocolate film, CLIFTON CHCOLATES, you know that story. Apparently they were a Manchester firm. *Tjitte de Vries:* You had to bring the box back but had it eaten up. *Audrey:* Yes. And we made a film for Gladhill, GLADHILL'S TILLS. And I remember it was called GLADHILL'S TILL THE WORLD. And they had a trade mark." (**Audrey Wadowska to Tjitte de Vries, London, 4 August 1979, T177.**)

"We did one for GLADHILL'S TILLS, that is in Huddersfield. It was done on celluloid in sheets, one on top of the other. It was to do with money tills. It was one of those advanced tills." (**Kenneth Melbourne-Cooper to Tjitte de Vries, Burnley, 2 August 1983, T088.**)

"That was Gladhill's Tills of Huddersfield. And we also did one for them that was a CLOCKING-IN CLOCK. And if I remember rightly it had a big dial and holes in it, and you had a number, and you put it up and pushed it. I don't think it had a card, just a big wheel with all these

holes, saying: you are number 10. When you went in, in the morning, you brought this finger around and pushed it in number 10 hole and it clocked you in. I remember that one. We kept making these things, but the Depression came in, was that 1929, 1931? That stopped it." (**Kenneth Melbourne-Cooper to Jan Wadowski, St Albans, 17 May 1984,** T210.)

Editorial

Kenneth Cooper's recollection is the only indicator we have. Because of the strength and details of the recollection – Ken's memories have been reliable – we felt that we could afford it one star, also because Cooper and his Animads company made an earlier advertising animation picture for the famous Gladhill company with its revolutionary automaton machines. However, it is as Audrey regularly used to say: "More research would be very welcome."

Most of the dates and lengths of the Langford advertising films are our suppositions. We think that, after 1929, there was scarcely any demand anymore for animated advertising pictures, which were time-consuming to produce and expensive for cinema screening. We therefore date the Langford Animads pictures for which we have no dates as made between 1925 and 1930.

CHAPTER 8

Possibles and (Im)probables

(277.) Rival Cyclists or: Flues's Tyres*, 1897, approx. 50 ft., running time 50 sec. A.k.a. Pneumatic Tyres.
Advertisement. Live-action with possible trick or animation.

Credits

Directed by Arthur Melbourne-Cooper. Independent production, probably filmed at Ridge Hill.

Two young men and a young woman unknown.

Synopsis

Young man takes the sister of another young man out on a bicycle ride. One of them gets a flat tyre, which the young man repairs with humorous incidents.

Details

This picture was shown together with possibly one or two other commercials and several short comedies in January 1898 at the St Albans Trade Fair.

Publications

"St Albans Trade Exhibition at Drill Hall. January 25 – February 4. Side shows were very good. First came the cinematograph, which was greatly enjoyed, a good number assembled to see the pictures. Then there was the phonograph, which was manipulated by Mr Pritchell of Manchester. Mr Wix attended Cadbury's Cocoa stall. Mr Doogood, Alfred Bird & Sons Custard Powder stall. Mr Holder's stall demonstrated the making of both White and Brown Bread with his machinery.

Demonstrations in the Art of Hairdressing were watched with interest. Not only were we reminded of the 'Art' of hair dressing, but the art of Advertising, particularly so when watching what are popularly called 'Animated Pictures'. These dealt with various things. Some of the subjects were comic, but a great many of the 'bits' thrown

on the screen by the Cinematograph had reference to somebody's tyres, or somebody's Special Invention. It was all very interesting. Whilst noting the movements of a young man, who, on a cycle journey, had very considerately taken charge of another fellow's sister, one was apt to forget that the lesson he gave us of pneumatic tyre repairing was another illustration of the sweet uses of advertisement. This is where the 'Art' comes in! It was also, hereabouts, that a seat burdened with the weight and all-round substantiality of the 'Herts Advertiser' positively gave way, and let us down in the most rough and ready manner!! An account will be forwarded to the Syndicate in respect of providing an 'extra' and most entertaining item!!" (**Herts Advertiser & St Albans Times – January 29th, 1898.**)

Recorded interviews

Audrey Wadowska: "St Albans Trade Exhibition at Drill Hall. *Herts Advertiser*, January 29th, 1898. The first trade exhibition. There, Father gave an exhibition of his animated pictures. And among them were sorts of advertisements, it was reported in the *Herts Advertiser*: What a clever way the cinematograph, they entertain you and advertise at the same time. Something to that effect. And one was FLUES's TYRES, bicycle tyres. Apparently cyclists, a couple, are on the road, and they have a puncture and of course some ad comes into it to advertise: use Flues's Tyres.

And another one is that one we saw at Brighton.[144] Up till now it was supposed to be Bamforth advertising, I forget now, who, they said it was Bamforth or Williamson, when we were at Brighton? Anyway it is that thing: STOLEN MILK. A couple of tramps go up to something and it got Nestle's Milk on it. They steal that, have a swig of that and off they go. That was shown then. Therefore it must have been made before January 1898. And another that was shown there, was PAPER TEARING. And another one was a local firm, actual it was mother's employer, though at the time she was not working there: HOLDER'S BAKERY, bread making by a modern process at the time. And there was PILLOW FIGHT, and one or two other bits and pieces. So you see, Bamforth did not make Nestle's STOLEN MILK, nor PAPER TEARING, if you come across it." (**Audrey Wadowska to Tjitte de Vries, London, 19 August 1978,** T028.)

Tjitte de Vries: "FLUES's TYRES – RIVAL CYCLISTS. What is that? *Audrey Wadowska:* That was shown on that Trade Fair. *Tjitte:* Flues is a brand? *Audrey:* Yes, a funny name but it is reported in the *Hert's Advertiser*. They

144. FIAF Congress 'Cinema 1900-1906', Brighton, 1978.

say you look at an entertainment film not realising it is an advertising film. It was made before the Trade Fair. It might have been 1897, 1898. It was shown on the Trades Fair. That was January till February 1898, so they could be made earlier. Flues's Tyres and Bread Making at Holder's Bakery, where mother worked. And Paper Tearing, one or two other short comics. And Nestle's Milk. That is called The Stolen Milk. There are two tramps sitting on a box marked Nestle's, and they steal milk and swallow it. It might be an advertising film, it just might be accidental on a Nestle's milk box. *Tjitte:* But has it been reported that he showed there these films? *Audrey:* Yes. He said that to Ernest Lindgren." (**Audrey Wadowska to Tjitte de Vries, London, 4 August 1979,** T177.)

Jan Wadowski: "Advertising, I am sure for example, (motor) car's tyres, that was Colliers advertising. I have a photograph from drawings. That was animated. Just this one, *Herts Advertiser*, January 29, 1898. Just read. *Kenneth Clark:* 'St Albans Trade Exhibition, Drill Hall, January 25th-February 4th. Side shows were very good. First came the cinematograph which was greatly enjoyed. A great number assembled to see the pictures.'

We cut down where it reads: 'Demonstrations in the art of hair dressing were watched with interest. Not only were we reminded of the art of hair dressing but the art of advertising, particularly so when watching what is popularly called animated pictures. These dealt with various things. Some of the subjects were comic, but a great many of the bits thrown on the screen by the cinematograph had reference to somebody's tyres, somebody's special invention. All very interesting whilst noting the movements of a young man who on a cycle journey had very considerately taken charge of another fellow's sister, one was apt to forget that the lesson he gave us in pneumatic tyre repairing was another illustration of the sweet uses of advertisement. This is where the art comes in. It was also here about that the seat burdened with the weight and alround substantiality of *Herts Advertiser* positively gave way and let us down in the most rough and ready manner.'

Jan Wadowski: What happened, in the newspaper they even give it not a title. They just go it over generally. *Ken Clark:* You think that the tyre advertisement was in fact animated? Animated in part, if not in whole? *Jan Wadowski:* No, not in whole. What Father told me, it was Collier who put the drawing in it. My idea now is to go and find the actual programme. The date –. *Ken Clark:* May 27, 1896. *Jan Wadowski:* St

Albans. There was an exhibition, agricultural, in a big area. *Ken Clark:* (Reads:) 'In the same building, several local and other firms exhibit scientific and musical instruments, photographs – '." **(Jan Wadowski to Kenneth Clark, St Albans, 21 February 1988, T409.)**

Unpublished manuscripts

Arthur Lomas: "I like to read to you here this piece that was in the *Herts Advertiser*. It is the first trades exhibition held at the Drill Hall here in St Albans, and it is January 1898. And among other things it says:

'Demonstrations in the art of hairdressing were watched with interest. Not only were we reminded of the art of hairdressing but the art of advertising particularly so when watching what are popularly called "animated pictures". These dealt with various things. Some of the subjects were comic, but a great many of the bits thrown on the screen by the cinematograph had reference to somebody's tyres or somebody's special inventions'.

Well, we know the tyres were Dunlop's and the special invention was something else by the Collier family because he was an inventor of different things." **(Lecture Arthur Lomas, St Albans Film Society, 31 March 1966, T101.)**

"Another commercial advertising somebody's pneumatic tyres, was shown at a trade exhibition held in St. Albans Drill Hall from Jan. 25th to Feb. 4th,1898. The *Herts Advertiser* reported: 'First came the cinematograph which was greatly enjoyed, a great number assembled to see the pictures ... what were popularly called 'animated pictures'.

The journalistic use of the phrase 'animated pictures' does not positively identify any early film as being a stop-motion, single-frame, hand-animated drawing or model film; it was merely another way of saying 'pictures that moved'. To add to the confusion, people sometimes called a comical event performed by live actors a 'cartoon'. In conversation, both Cooper and his daughter Audrey described animated toy sequences in his live-action films as 'cartoons'. And of course, then as now, preliminary sketches by Raphael, Da Vinci, the Carracci brothers, and stained glass window designers are called 'cartoons'." **(Kenneth Clark, 2007.)**[N146]

Editorial

We assume that this was an independent production, but possibly still printed and developed in the workshop of Birt Acres, 45 Salisbury Road at Barnet. It was possibly filmed at Ridge Hill where Cooper made more pictures and where he knew several young ladies and young men who appeared in them.

The only primary source we have is the write-up in the *Herts Advertiser*. Then there is secondary but confusing information from Audrey and Jan Wadowski, based on what Cooper told them. The newspaper report is not clear. The cinematograph showed pictures in the Drill Hall on the occasion of the Trade Fair which lasted for ten days from 25 January till 4 February 1898. Jan Wadowski refers to an earlier exhibition, an agricultural exhibition on 27 May 1896. Let us forget about this one. Let us look at the trade fair of 1898. If films were shown there specifically for this exhibition, they must have been made in 1897. Short comedies could have been made even earlier. Most probably Cooper showed his success picture Ducks on Sale or Return, as well as other comedies.

Audrey mentions several titles: Flues's Tyres (1897/1898), Bread Making at Holder's Bakery (1897), Paper Tearing, and Nestle's Milk, also called (The) Stolen Milk (1897), as moving pictures shown by her father at the exhibition.

Therefore, on the basis of what we know from the newspaper report, we may be sure that a picture was shown concerning pneumatic tyres, in which a young man and his sister, and another young man are appearing. We assume that the second, gallant young man is trying in a humourous way to deal with the disaster of a flat tyre.

Twice, Audrey in her notes, refers to it as 'Flues's Tyres'. But a couple of times they were mentioned to us as 'Collier's Tyres' or 'Collier's New Invention'. There is even a photographic reproduction of a cut-through of what is labeled as 'Collier's Tyre'. Has this new invention of a non-pneumatic tyre to do with the moving picture that was shown in 1898? Or was it another picture, a second one dealing with tyres? Tyres were a tremendously popular subject when bicycles came in vogue, because roads, not especially fit for riding on them, often caused a punctured tyre. Cooper himself was an ardent cyclist, taking his camera with him when he cycled all the way down to Brighton, and even participating for a day or so in a seven-day cycling race at the Crystal Palace.

Did one or more of these pictures contain some form of animation or trick work? We are not at all sure about it. We gave it one star, because it is certain that at least a moving picture of this kind was shown at the trade exhibition in St Albans in 1898, and we are convinced that Cooper made it.

(242.) Collier's Tyres or: Collier's New Invention *, 1897,

approx. 50 ft. running time 50 sec. A.k.a. REILLOC TYRES
Advertisement. Live-action with possible animation or trick film
insert.

Credits

Directed by Arthur Melbourne-Cooper. Independent production.
Assistent Stanley Collier. Most probably filmed at St Albans.

Synopsis

The qualities of a newly invented non-puncture tyre for automobiles are
displayed.

Details

This picture was shown together with possibly one or two other
commercials and several short comedies in January 1898 at the St
Albans Trade Fair.

Publications

"St Albans Trade Exhibition at Drill Hall. January 25 – February 4. Side
shows were very good. First came the cinematograph, which was greatly
enjoyed, a good number assembled to see the pictures. Then there was
the phonograph, which was manipulated by Mr Pritchell of Manchester.
Mr Wix attended Cadbury's Cocoa stall. Mr Doogood, Alfred Bird &
Sons Custard Powder stall. Mr Holder's stall demonstrated the making
of both White and Brown Bread with his machinery.
Demonstrations in the Art of Hairdressing were watched with interest.
Not only were we reminded of the 'Art' of hair dressing, but the art of
Advertising, particularly so when watching what are popularly called
'Animated Pictures'. These dealt with various things. Some of the
subjects were comic, but a great many of the 'bits' thrown on the screen
by the Cinematograph had reference to somebody's tyres, or
somebody's Special Invention. It was all very interesting. Whilst noting
the movements of a young man, who, on a cycle journey, had very
considerately taken charge of another fellow's sister, one was apt to
forget that the lesson he gave us of pneumatic tyre repairing, was
another illustration of the sweet uses of advertisement. This is where the
'Art' comes in! It was also, hereabouts, that a seat burdened with the
weight and all-round substantiality of the 'Herts Advertiser' positively
gave way, and let us down in the most rough and ready manner!! An
account will be forwarded to the Syndicate in respect of providing an
'extra' and most entertaining item!!" (**Herts Advertiser & St Albans
Times – January 29th, 1898.**)

Recorded interviews

Jan Wadowski: "Advertising, I am sure for example, (motor) car's tyres, that was Colliers advertising. I have a photograph from drawings. That was animated. Just this one, *Herts Advertiser*, January 29, 1898. Just read. *Kenneth Clark:* 'St Albans Trade Exhibition, Drill Hall, January 25th-February 4th. Side shows were very good. First came the cinematograph which was greatly enjoyed. A great number assembled to see the pictures.' We cut down to where it reads: 'Demonstrations in the art of hair dressing were watched with interest. Not only were we reminded of the art of hair dressing but the art of advertising, particularly so when watching what is popularly called animated pictures. These dealt with various things. Some of the subjects were comic, but a great many of the bits thrown on the screen by the cinematograph had reference to somebody's tyres, somebody's special invention.'

Jan Wadowski: What happened, in the newspaper they even give it not a title. They just go over it generally. *Ken Clark:* You think that the tyre advertisement was in fact animated? Animated in part, if not in whole? *Jan Wadowski:* No, not in whole. What Father told me, it was Collier who put the drawing in it." (**Jan Wadowski to Kenneth Clark, St Albans, 21 February 1988,** T409.)

Unpublished manuscripts

Arthur Lomas: "I like to read to you here this piece that was in the *Herts Advertiser*. It is the first trades exhibition held at the Drill Hall here in St Albans, and it is January 1898. And among other things it says:

'Demonstrations in the art of hairdressing were watched with interest. Not only were we reminded of the art of hairdressing but the art of advertising particularly so when watching what are popularly called "animated pictures". These dealt with various things. Some of the subjects were comic, but a great many of the bits thrown on the screen by the cinematograph had reference to somebody's tyres or somebody's special inventions'.

Well, we know the tyres were Dunlop's, and the special invention was something else by the Collier family because he was an inventor of different things.

'It was all very interesting. Whilst noting the movements of a young man who on a cycle journey had very considerately taken charge of another fellow's sister, one was apt to forget that the lesson he gave her asked 'of pneumatic tyre repairing' was another illustration of the sweet usage of the advertisement. This is where the art came in. It was also hereabouts that a seat burdened with the weight and all round

substantiality of the *Herts Advertiser* positively gave way and let us down in the most rough and ready manner and an account will be forwarded to the syndicate in respect of providing an extra and most entertaining item!" **(Lecture Arthur Lomas, St Albans Film Society, 31 March 1966, T101.)**
"Another commercial advertising somebody's pneumatic tyres, was shown at a trade exhibition held in St. Albans Drill Hall from Jan. 25th to Feb. 4th,1898. The *Herts Advertiser* reported: 'First came the cinematograph which was greatly enjoyed, a great number assembled to see the pictures ... what were popularly called 'animated pictures'.

The journalistic use of the phrase 'animated pictures' does not positively identify any early film as being a stop-motion, single-frame, hand-animated drawing or model film; it was merely another way of saying 'pictures that moved'. To add to the confusion, people sometimes called a comical event performed by live actors a 'cartoon'. In conversation, both Cooper and his daughter Audrey described animated toy sequences in his live-action films as 'cartoons'. And of course, then as now, preliminary sketches by Raphael, De Vinci, the Carracci brothers, and stained glass window designers are called 'cartoons'." **(Kenneth Clark, 2007.)** [N147]

Editorial

Cooper and Stanley Collier, called 'Skats' by his boss, were close friends. The Alpha Trading Company issued two different picture postcards of the Reilloc Tyres, the anti-puncture tyre invented by Stan's father. The *Herts Advertiser & St Albans Times* mentions this new invention as being shown by the Cinematograph, and both Audrey and her husband Jan on different locations suggest that it could have been partly animated. The illustrations of the two picture postcards could have been used in the moving picture. We are not at all sure if there were interpolated scenes, and if they were animated or made with trick camera work. The only thing we are sure of is that Cooper, assisted by Stan Collier, made an advertising picture for a tyre invented by Collier Senior.

Toy Shop, 1898, 60 ft., running time 60 seconds.
Trick film? Or only live-action?
Synopsis
The interior of the famous toyshop of Hamleys, London. A lot of mechanical toys are moving about. Shoppers enter and are demonstrated the various toys.

Contemporary sources

Animatograph Films R.W. Paul, catalogue, London, 1898, page 12.

"Comic and Dramatic Films. 60 feet long, at £2 5s. each. 20m., Mk. 45. Fcs. 56.

Toy-Shop – *Puppenfee* – *Jouets*. 'The interior of Hamleys Toyshop, crowded with mechanical figures in motion. Purchasers enter, and are shown the various animals and models'."

Recorded interviews

"Toy-shop is Father's, but I can't prove that. He bought toys from Hamleys, they were at High Holborn at the time. I had wondered whether Father made this one, because he bought his toys there." (**Audrey Wadowska to Tjitte de Vries, London, January 3, 1978,** To16.)

Editorial

Further details unknown. It is quite clear to us that Cooper had probably not much to do with this picture. It is apparently not an animation picture, but a documentary or advertising short for Hamleys Toyshop at Regent Street or High Holborn, where Cooper happened to buy the toys for his puppet pictures.

(051.) **Anatomy Man**, 1902-1914.

Object animation of book illustrations.

Synopsis

The detailed pictures from *Philips' Popular Mannikin*, edited by W.S. Furneaux, of the anatomical details of a human being are animated.

Editorial

In the estate of Audrey and Jan Wadowski, we found a book in octavo format, *"Philips' Popular Mannikin" edited W.S. Furneaux, price 3/6 net. London: George Philip & Son, Limited, 32, Fleet Street, E.C.* with three detailed anatomical illustrations of a human being, of which the several parts of limbs, entrails, bowels and intestines can be removed. The pages were separated from the spine, and the book clearly had been used.

According to Audrey Wadowska, her father had used this for an animated picture, Anatomy Man, as part of another picture or as an independent production.

No further details known.

Dreamland Adventures, 1907, 540 ft., running time 9 min.
A.k.a. TWEENY, THE DOLL THAT GREW UP.
Live-action trick film.

Synopsis
Children in the nursery fall asleep. Their dolls take them on an adventurous trip in a submarine through the ocean and to the North Pole. They arrive back home on an iceberg which is melted down with a fire by their parents.

Contemporary sources
Urban Trading Co., Catalogue, London, 1907, page 20.

"2024 DREAMLAND ADVENTURES or TWEENIE, THE DOLL THAT GREW UP. This unique and beautiful magic and mystery subject will enthral children of all ages from six to sixty.

Scenes of delightful ocean-bed travel, as viewed from a sub-marine boat, where wonderful sea monsters disport amid natural surroundings of coral grotto, ocean garden and forest, are only equalled by the beauties of the frozen North with its icebergs, ice-bound vessels, and the thrilling scenes of an aerial voyage through cloud and space in an airship. Unique charm, novelty and beauty in every inch of film."

The Kinematograph and the Lantern Weekly, London, 25 Dec. 1907, page 67.

"Though described as a Christmas subject, the Urban-Eclipse DREAMLAND ADVENTURES is a film which we can imagine showmen of every class welcoming with open arms at any time of the year. At the same time, its atmosphere of mirth and mystery make its debut at this period particularly opportune, and we venture to predict that few Christmas bills will be found lacking it. We know of one showman whom hard fate has compelled to vacate his usual hall for a season, and this gentleman says he regrets the circumstance twice as much since he has seen this subject. Other showmen who know from personal experience how difficult it is to raise enthusiasm in the breast of a person who sees some dozens of films a week, will appreciate this testimony at the proper value.

The film has as subtitle TWEENIE, THE DOLL THAT GREW UP and the doll, with a Golliwog which also comes to life, plays an important and amusing part in the subject. In the first scene, in the childrens' nursery, after the youngsters are safely asleep, the tiny doll is observed to raise herself jerkily to an upright position on the floor and then gradually increase in size until she is only recognisable from a well grown girl by

the peculiar automaton-like movements of her limbs. Joined by the Golliwog, she then wakes the children – a boy and a girl – and still with her grotesque jerky gait leads them into the street. Here a toy motor which the boy is carrying is rapidly, through her instrumentality, converted into a real car, in which the party drive to the side of the sea, where the motor vanishes. One of the children is playing with a toy submarine in the water, and this also rapidly changes into the real article. The children enter and set out in search of adventure. A view is given of the interior of the submarine and of the children looking in turn through a port-hole, and the views given at this stage and later from the airship are to our mind easily the best of a subject which is particularly novel throughout. The submarine rises somewhere in the vicinity of the North Pole, and here an amusing encounter occurs with a realistic polar bear, whose attentions are so close that recourse is taken of the doll's magic powers once more. She transforms a toy airship into a real one, and the party sails away with Bruin hanging on the grappling iron, whence he presently falls to be transfixed by an ice pinnacle. There follows at this stage some further delightful panoramic glimpses of the variety previously alluded to. One could easily believe that this section of the subject had been taken in the arctic circle. A wrecked ship, surrounded by the ice is seen, and a sunrise effect on the ice is also illustrated with great effect, and at last the journey terminates at the home of the Frost King, a person who opens his huge mouth and takes the expedition at a gulp, to eject them embedded in an iceberg and blow them homewards over the ice. The iceberg travels quickly and arrives in the garden at home. The astonished parents build a fire underneath the ice, and it gradually thaws, the children stepping out with the doll and golliwog, restored to their usual size, in their arms. We can find no higher praise for this subject than to say that it carries out with perfect success in picture form just such a delightfully fanciful story as J. M. Barrie writes with such skill."

The Kinematograph and Lantern Weekly, London, 2 January 1908, page 3.

"Great Urban-Eclipse Successes. All winners.

DREAMLAND ADVENTURES, or TWEENIE, THE DOLL THAT GREW UP. A beautiful and unique humour, magic and mystery subject. Ocean, ice and cloud wonders. Astounding situations, perfectly staged and enacted. Charm, novelty and laughter in every inch of film. No. 2024. Code 'Dreams'. Length 540 feet. Price £9 0 0 .

The Charles Urban Trading, Ltd. Chief offices: 48, Rupert St., Shaftesbury Avenue, London, W."

The Kinematograph & Lantern Weekly, London, 23 November 1911, page 189.

"Cross's Pictures Ltd., 12 Macclesfield Street, Shaftesbury Avenue, London, W.

Christmas Films. DREAMLAND ADVENTURES, tinted, 540 ft. approx 1/-."

Complementary sources

Gifford-1973, 1986, 2000: "01691/01637 – DREAMLAND ADVENTURES, July 1907 (540). Urban Trading Co. D: W.R. Booth. Fantasy. Doll and golliwog take children to Arctic in airship."

Publications

"2274 DREAMLAND ADVENTURES \\ PC: Urban \\ D: Booth, Walter R. \\ ARCH:STO." **(Ronald S. Magliozzi, 1988.)** [N148]

Recorded interviews

"DREAMLAND ADVENTURES is his, yes. I have a question mark here." **(Audrey Wadowska to Tjitte de Vries, London, 31 March 1978,** T021.)

"This is DREAMLAND ADVENTURES, or this is TWEENY, THE DOLL THAT GREW UP. It is necessary to go into that and to discover whether it is a foreign film or Alpha. It might be American. We must study that one." **(Audrey Wadowska to Tjitte de Vries, London, 16 August 1978,** T022.)

"DREAMLAND ADVENTURES, sure it is not Father's. Has an idea it is American, very similar story line, sometimes even the titles are the same. You have to see them." **(Audrey Wadowska to Tjitte de Vries, London, 17 August 1978,** T181.)

"Here is DREAMLAND ADVENTURES, that is Father's. I believe the Americans made one, same title. (Reads from an Urban advertisement:) 'A beautiful and unique humour, magic and mystery subject. Astounding scenes.' I wonder. We'll put a question mark at that." **(Audrey Wadowska to Tjitte de Vries, London, 19 August 1978,** T027.)

Audrey Wadowska: "And TWEENIE, THE DOLL THAT GREW UP. Is this an animated film? (Reads from *Kinematograph and the Lantern Weekly*:) 'In the first scene in the children's nursery the tiny doll is observed to raise herself jerkily to an upright position on the floor and then gradually increases in size until she is only recognisable from a well grown girl by the peculiar automation-like movements of her limbs. Joined by the golliwog, she then wakes the children.' Yes, that is his. Golliwogs were a new toy in those days. And he got his from Hamleys the toymakers. He used to get his toys from them, except those he

made himself. I don't think anybody else is making animated golliwogs at this time. *Tjitte de Vries:* It is very early, 1907, it could very well be your father's. *Audrey:* Yes, it could be. So that is DREAMLAND ADVENTURES, subtitle TWEENIE, THE DOLL THAT GREW UP. *Tjitte:* That description makes you sure? *Audrey:* Oh, yes, I should give Ken Clark a note of this." (**Audrey Wadowska to Tjitte de Vries, London, 19 August 1978,** T028.)

Audrey Wadowska: "Great Urban Successes. These are all Father's. DREAMLAND ADVENTURES, that has a golliwog in it. (...) *Tjitte de Vries:* This is DOLLS IN DREAMLAND.[145] (Reads:) 'A pretty little girl is seen bidding her dollies goodnight. Her eyes are soon closed, and the dolls scamper off to Dreamland, where they hold High Carnival. A Teddy Bear acting as master of ceremonies.' What is it, Audrey? Here a bed with the little girl, there the toys. *Audrey:* I think it is Father's, I won't be surprised. Maybe that's the one Father couldn't remember the title of. There is also the one with the BOX OF TOY SOLDIERS that come to life. I haven't found the title of that one yet. Nor the CIRCUS one that Jackeydawra remembers. Being made in Warwick Court, Kinema Industries. *Tjitte:* The box with the toy soldiers, that could be in this one? *Audrey:* Could it? I understood Father said it was a boy. A boy's box with toy soldiers, he said, came to life. I wouldn't be surprised if that's not his. It might not be British. But animated dolls, I am sure, it is his. It might have been called DREAMLAND ADVENTURES, because that is one of Father's titles, It might be that. I would not like to touch these things until I have more evidence." (**Audrey Wadowska to Tjitte de Vries, London, 19 August 1978,** T029.)

"(Cross's Pictures Ltd., Bargain Films, 1911) DREAMLAND ADVENTURES, 540 feet, that might be Father's. Tinted too?" (**Audrey Wadowska to Tjitte de Vries, London, 20 August 1978,** T034.)

"Now, what about DREAMLAND ADVENTURES. Somebody was telling me, that is Father's. I will go into that and let you know. It is an animated film." (**Audrey Wadowska to Kenneth Clark, London, 24 October 1978,** T199.)

Audrey Wadowska: "Father went to Warwick Pageant of King Clark. There is a film called DREAMLAND ADVENTURES, animated dolls, and it is also called TWEENIE, THE DOLL THAT GREW UP. *Tjitte de Vries:* Is that

145. Kemp Niver, *AM&B, Bulletin 100,* June 8, 1907. DOLLS IN DREAMLAND, A Delightful Fantasy in Motion Pictures By the Biograph, length 752 feet, price 12 cents per foot, No. 3294, code word 'Reunaio'.

the same film? *Audrey:* Yes. Is that Father's? Might be another than The Dream of Toyland." (**Audrey Wadowska to Tjitte de Vries, London, 20 April 1979,** T037.)

Tjitte de Vries: "Dreamland Adventures, and A Night in Dreamland, two different films? *Audrey Wadowska:* No, the same film. Dreamland Adventures yes, now, I believe – wait, do they say it is American? *Tjitte:* A Night in Dreamland, a fairy fantasy, *Kine Weekly* 1907, two kiddies are brought to bed by their parents and dream they are off to the North pole. Dec. 25. Dreamland Adventures is a Walturdaw special Christmas toy picture. *Audrey:* That will be Father's. *Tjitte:* The first one is 500 feet, a novel and original Christmas picture. 1907. *Audrey:* About the same year as Dream of Toyland. *Tjitte:* First scene shows kiddies asleep in the nursery. (Reads synopsis) Looks like a Peter Pan film. *Audrey:* It is animated. Very similar as Dream of Toyland. Instead of a boy brought to bed it is a girl, and they dream their toys come to life. *Tjitte:* You got here: Alpha WB. *Audrey:* Walter Booth. *Tjitte:* Why? *Audrey:* I think he was working on the job. Father had assistants by this time, he didn't do anything completely on his own." (**Audrey Wadowska to Tjitte de Vries, London, 30 July 1979,** T175.)

Editorial

Although Audrey Wadowska mentions Dreamland Adventures more than ten times in her interviews with us, she also admits that, "I have to go into that".

We, in our turn, are not at all convinced that this is an animation picture. From the synopses we conclude that it is a live-action trick picture, in the manner of Georges Méliès. Dolls, toy submarine, toy vehicles, etc. emerge in real size. Audrey Wadowska is even confused with Biograph's Dolls in Dreamland, though elsewhere she is aware of an American production. Gifford, labelling it 'fantasy', credits without question mark Walter Booth for Dreamland Adventures. But did Booth deal directly with Charles Urban, to whom Cooper regularly sold Alpha productions? Where did Booth make it? At the Alpha studios or at Paul's? He only later had his own studio at Isleworth.[146]

146. See about Walter Booth: footnote 50 in Part One.

Dolls in Dreamland, 1907, 752 ft., running time 12.32 min.

Puppet animation and live-action.

Complementary sources

American Film Institute Catalog, 1893-1910, **Metuchen, 1995,** page 276. "American Mutoscope and Biograph Co. *Dist* American Mutoscope and Biograph Co. *Rel date* 8 June 1907. *Prod* 22-23 Mar 1907. b&w; 752 ft. [code no.: 3294; code name: Reunaio; source BIOB1]. *Cam* F.A. Dobson. Location New York City studio NY."

Publications

Kemp Niver, *Biograph Bulletins 1896-1908*, **Los Angeles, 1971,** page 296.

"Form no. 1265. Bulletin No. 100, June 8, 1907. A Delightful Fantasy in Motion Pictures By the Biograph. Length, 752 feet; price 12 cents per foot.

Here is presented a production that is as unique as it is novel. A pretty little girl, aweary after her day's play in the nursery, is seen bidding her Dollies goodnight and going to bed. Her eyes are soon closed in sleep, and the Dolls, of which there are quite a score, scamper off to Dreamland, where they hold high carnival, Teddy Bear acting as master of ceremonies. A luncheon is served by Teddy Bear to the now animated Dolls, after which each gives a dance peculiar to their character. The warning that dawn is approaching is given, and they all toddle back to the nursery to greet Little Mother when she wakes. While this film appeals particularly to the little folk, it is also highly amusing to the grown-ups on account of its many mysterious and comic incidents. No. 3294. Code word – Reunaio."

Recorded interviews

Tjitte: "This is DOLLS IN DREAMLAND. [Reads from Kemp Niver:] 'A pretty little girl is seen bidding her dollies goodnight. Her eyes are soon closed and the dolls scamper off to Dreamland, where they hold High Carnival. A Teddy Bear acting as master of ceremonies.' What is it, Audrey? Here a bed with the little girl, there the toys? *Audrey:* I think it is Father's, I won't be surprised. Maybe that's the one Father couldn't remember the title of. There is also the one with the box with the toy soldiers that come to life. I haven't found the title of that one yet. Nor the circus one that Jackeydawra [Melford] remembers. Being made in Warwick Court, Kinema Industries. *Tjitte:* The box with the toy soldiers, that could be in this one? *Audrey:* Could it? I understood Father said it was a boy. A boy's box with toy soldiers, he said, came to life. I wouldn't be surprised if

that's not his. It might not be British. But animated dolls, I am sure, it is his. It might have been called DREAMLAND ADVENTURES,[147] because that is one of father's titles, It might be that. I would not like to touch these things until I have more evidence." (**Audrey Wadowska to Tjitte de Vries, London, 19 August 1978,** T029.)

Editorial

This is definitely not a film by Cooper but by F.A. Dobson for the American Mutoscope and Biograph company in New York.

The Little Fairy, 1908, 470 ft., running time 6.50 min.

Live-action and animation, possibly combined with trick scenes.

Credits

Acted by boy and girl, actor and actress. Distributed by Walturdaw.

Synopsis

Poor boy and rich girl meet in the street, and become friends. She gives him a toy egg. When he is asleep, he dreams that little animals come out of the egg to play around. Girl's parents agree in the end in the friendship.

Contemporary sources

Walturdaw in **The Kinematograph and Lantern Weekly,** London, 9 July 1908.

"THE LITTLE FAIRY. Two tiny children meet in the street and become fast friends. One is the daughter of wealthy parents, the other the son of a poor couple. The rich little girl later meets the boy as she is coming out from a toy shop, laden with good things, and gives him a big egg, and when he is asleep at night he, in imagination, sees this open and let out first a number of pretty chicks and two rabbits, which play about in pretty style. The youngster awakes as the girl enters his room with her parents, whom she has persuaded to befriend her comrade. **Length 470 ft. Price £11 5s (less 33½ p.c.)**"

Recorded interviews

Audrey Wadowska (going through catalogues and old notes): "Now THE LITTLE FAIRY, this is the big egg thing. He made it around Easter time. A poor boy and a rich girl, they go to a toy shop and she gives him a big egg. And he dreams that chicks and rabbits come out of the egg and play around. But I don't know if it is done with toys or the real things.

147. This is probably a live-action trick film, according to Gifford made by Walter Booth.

Otherwise that is another animated one. We ought to find out. Do you think it sounds animated, do you? *Tjitte de Vries:* Yes, but it gives not many clues." (**Audrey Wadowska to Tjitte de Vries, London, 19 August 1978**, T028.)

Tjitte de Vries: "THE LITTLE FAIRY. *Audrey Wadowska:* Yes, Father made one. *Tjitte* (reading the synopsis from the Walturdaw advertisement): THE LITTLE FAIRY, it is acted by children, and there is a piece of animation in between. July 1908. When he is asleep at night he, in his imagination, sees this open and let out first a number of pretty chicks and then two rabbits which play about. I think that is an animation bit, like DREAM OF TOYLAND. *Audrey:* It could be." (**Audrey Wadowska to Tjitte de Vries, London, 1 January 1982**, T085.)

Editorial

This film is a mystery. Walturdaw has a full page in *The Kinematograph and Lantern Weekly* advertising four films with THE LITTLE FAIRY as the third one, with a precise synopsis which tells it all. A typical Victorian little drama in the spirit of Hesba Stretton. Audrey Wadowska mentioned it twice, but it is clear that she only saw this Walturdaw advertisement. The mystery, however, is that we could not find this film anywhere else, not in Gifford and not in the American Film Catalog. Cooper could have made it, someone else could, or it could have been an import. This last possibility is plausible considering the steep price of £11 5s. It might contain an animation scene with toys, but this could also have been a 'farm yard friends' kind of scene.

Kiddies Dream, 1910, 455 ft., running time 7.30 min.

Live-action and animation, possibly combined with trick scenes.

Synopsis

Christmas Eve, children are put to bed and in their dreams their Christmas presents come to life. When they wake up, they find the toys from their dream waiting for them.

Details

Notes Audrey from Film House Record, London, 1910:

"KIDDIES DREAM. It's Christmas Eve – After putting the children to bed, the parents go out to buy some toys for them. They dream Fairies descend the chimney and dance merrily round the Christmas tree. Their parents return and softly put the toys into their room. This is very well taken, and lovely scenes follow as the toys come to life. One present is a

miniature theatre, and, the curtain rising, the deck of a ship is disclosed containing several figures. Soon a vivid lightning flash is seen; the sea rises, waves dash over the vessel and it finally sinks, while the crew take to a raft. Other clever effects are obtained by the aid of a box of soldiers in uniforms of all the chief nations, which go through manoeuvres peculiar to their country. In the morning when the children wake up it is to find the toys of their dreams waiting for them."
Length —-. (Nov. 1910.)

Contemporary sources

The Film House Record, London, 26 November (1910), page 280.
THE KIDDIES' DREAM. (Milano Film – The Cosmopolitan Film Co., Ltd.,) Length 455 feet. Code, "Kidream." Release Date, December 18th.
"A dainty little subject specially issued for, and appropriate to, the Christmas season, but which can be shown at any time, and containing some particularly pretty trick effects. After two youngsters have been put to bed on Christmas Eve the parents go out, and are seen buying numerous toys calculated to bring joy to the heart of youth. Meanwhile the children are visited by a dream, in which they see a number of daintily dressed Christmas fairies descend the chimney and dance merrily round a Christmas tree. On the parents' return they softly place the toys in the room and retire, and then follow a series of particularly well-taken scenes, in which to the children's fancies the various toys and figures come to life. One of the presents is a miniature theatre, and, the curtain rising, the deck of a ship is disclosed, containing several figures. Soon a vivid lightning flash is seen, the sea rises, waves dash over the vessel, and it finally sinks beneath the waters, while the crew take to a raft. Other clever effects are obtained by the aid of a box of soldiers in the uniforms of all the chief nations, which go through manoeuvres peculiar to their country. In the morning, when the children wake, it is to find the toys of their dreams waiting for them."

Unpublished manuscript

"Another Melbourne-Cooper production working on the same technique of animated puppets was a film entitled KIDDIES DREAM, manufactured in 1910. This delightful Christmas fantasy is yet another colourful example of his unique pioneering capacity to originate and exploit a new medium of cinematograph entertainment. (...) [See synopsis above.] Characteristic of most of Melbourne-Cooper's fantasy films of this type was a flamboyancy of thought and design that made this film maker's work attractive and popular to patrons of all ages."
(John Grisdale, 1960.) [N149]

Editorial

This film is possibly a combination of live-action and puppet animation, and it could very well have been made by Cooper. It is in his spirit, but the only indicator we found was the review in Film House Record which was almost verbally used by John Grisdale. Audrey Wadowska in all her recorded interviews never mentions this title, though she is looking for a BOY'S BOX OF SOLDIERS, the synopsis of which tallies with one of the scenes in this film. How did Grisdale know that he could credit Cooper for it? Did Cooper tell him? Or did Audrey Wadowska tell him so? All in all, we were only able to deem it half a star and that is not enough. Again, we repeat what Audrey Wadowska so many times used to say: more research is necessary.

It is curious that Gifford does not have this film, but The Film House Record shows the solution: it mentions that it is distributed by Milano Film and imported by the Cosmopolitan Film Company. There goes even that half star.

Little Red Riding Hood, 1910-1913, —- ft.

Type of picture not known. A.k.a. RED RIDING HOOD

Synopsis

The well-known fairy tale.

Complementary sources

The M.P. Offered List,[148] London, 22 November 1913, page 392.
"B.B. Pictures, Ltd. (London), 26, Litchfield Street, W.C.
Pantomimes and Christmas Dramas, T3352a RED RIDING HOOD, length 500, maker C&M."

Recorded interviews

"Yes, he made a RED RIDING HOOD." (**Audrey Wadowska to Tjitte de Vries, London, 20 August 1978,** T031.)

"The Three Bears and LITTLE RED RIDING HOOD, that could be Father's. Father did make a LITTLE RED RIDING HOOD, but maybe not this one. (Essenay, 643 ft. Dec. 1912.)" (**Audrey Wadowska to Tjitte de Vries, London, 19 April 1981,** T055.)

"He made LITTLE RED RIDING HOOD. And his most ambitious one was

148. The 'M.P. Agency', at the end of 1913, was sold by Frank Butcher to F.H. Davison's Film Sales Agencies.

CINDERELLA." (**Audrey Wadowska to Tjitte de Vries, London, 28 May 1981,** T057.)

Editorial

The title is mentioned two or three times by Audrey Wadowska. There is a RED RIDING HOOD of Cricks & Martin in 1913 in an advertisement, but this film could very well be a pantomime production and not an animation picture. Without more information, Audrey Wadowska's naming the title a couple of times and the assurance "he made one" do not give enough indicators for even half a star (two doubtful indicators).

(054.) **Animated Putty**, 1911, 375 ft, running time 6.15 min.
Object animation.

Synopsis

Putty takes on various shapes.

Contemporary sources

The Kinematograph & Lantern Weekly, London, 12 January 1911, page 628.

"Kineto, Limited. Released February 2nd. ANIMATED PUTTY.

An exceedingly clever and original trick film. Quite unique in the way effects are obtained and sure to arouse the wonder and interest of any audience.

1. – A lump of putty, being used by a glazier, shows signs of animation. He claps a plant pot over it, but the putty emerges through the hole at the bottom and forms itself into all sorts of fantastic shapes.

2. – As we watch, the shapeless mass assumes the shape of an eagle's head, every detail of plumage clearly defined.

3. – Another transformation: foliage begins to appear, then buds and these in turn bursts into blossom.

4. – The putty winds itself in circles, tier upon tier, and behold, a windmill takes shape before us, and its wings *sprout* one after another, and revolve.

5. – A lady, Mephistopheles and his imps, and a small boy follow in turn, phosphorescent glowings adding to the effect.

A quaint fantasy wonderful and diverting. No. 644, Code 'Putty'. Length 375 feet.

Kineto Limited, Kinematograph Specialists. Kinemacolor Building, 80-82 Wardour Street, London W."

Walturdaw catalogue, London, 1913-1914, no page no.

"List of Films. 3. Cartoons and Trick Subjects. ANIMATED PUTTY, 300 ft."

Complementary sources

Gifford-1986: "02910 – ANIMATED PUTTY, January 1911, (375). Kineto *reissue* 1913. D: W.R. Booth. Trick. Putty models itself into shape."

Publications

"1911 – 2386 – ANIMATED PUTTY [a] \\ PC: Kineto \\D: Booth. Walter R. \\ ARCH: LON"

(Ronald S. Magliozzi, 1988.) [N150]

Recorded interviews

"Now, ANIMATED PUTTY (looking at Walturdaw catalogue), I always suspected that to be his, because it is a Kineto, and Kineto is an Urban subsidiary. They were Urban's subsidiaries, and they didn't distribute comics and that sort. And amongst them is Father's PICTURESQUE NORTH WALES and parts of his Scottish series and that ANIMATED PUTTY." (**Audrey Wadowska to Tjitte de Vries, London, 20 April 1978,** T037.)

Audrey Wadowska: "ANIMATED PUTTY, I believe that this is his. But this is a later date, isn't it, 1911. Because, you see, Kineto was a subsidiary of Urban. And they took this type of film from Urban, and specialized in this type of thing. I have an idea that this is his. (...) *Tjitte de Vries:* This is also an animated film, 1911? *Audrey:* Yes, done with putty, I believe. Kinema Industries period. No it isn't, it is before that period. He would have done that at St Albans, I suppose. He made ever so many animated films for Butcher's up there, when we were in Lewisham. It was his job. Turned them out like hot cakes." (**Audrey Wadowska to Tjitte de Vries, London, 19 August 1978,** T027/028.)

"ANIMATED PUTTY I always wondered whether that is his, because that is Kineto again. I don't remember him mentioning ANIMATED PUTTY. Apparently, this man makes figures out of putty. It might be trick work of some sort, it might be animated but I am not sure." (**Audrey Wadowska to Tjitte de Vries, London, 17 April 1981.** T053.)

"I am not so sure that ANIMATED PUTTY is not his. It is issued as a Kineto Film, they were a subsidiary of Urban, and it is quite possible that was his. But I cannot be sure. Somebody has a lump of putty – it might be his. But these other films, he mentioned them, and he recollected them very well."

(**Audrey Wadowska to Tjitte de Vries, London, 28 May 1981,** T057.)

Editorial

Even though Audrey Wadowska mentions this title four times in interviews with us, there are too many question marks as she herself

confirms. Gifford credits Walter Booth for it. Urban bought a lot of films from Alpha. So did Walturdaw. Booth worked alternately at Cooper's Alpha studios and Robert Paul's Animatograph studios.[149] Could he have sold his trick film as an independent production to both Urban and Walturdaw? No further details known.

Tragedy in Toyland, 1911, 876 ft., running time 14.16 min.
Puppet animation and live-action.

Publications
"Credits: *p.c.* Kalem. Trick: Toys in a nursery come to life. Two toy soldiers fight a duel over a doll, Miss Pru. She comes between them and is killed. Her dog Fido lies down and dies too. Finally a real dog comes into the nursery, picks up Miss Pru and carries her away. (876 ft.)." **(National Film Archive Catalogue: Silent Fiction Film 1895-1930, London, 1966.)** [N151]

"There are records of an animated toy film called TRAGEDY IN TOYLAND, in which toy soldiers fight a duel over a doll, named Miss Pru. The film was copyrighted in the United States by the Kalem company on May 17, 1911, but there is no indication of who made the film." **(L. Bruce Holman, 1975.)** [N152]

Editorial
This film is definitely not made by Cooper. The only source we could find for this film is the National Film Archive Catalogue. We could not find this title anywhere in any of Gifford's publications and neither in the American Film Institute Catalog.
NOTE.
Miss Pru is a character from the play *Love for Love* (1695) by the English playwright William Congreve (1670-1729).

149. About Walter Booth: see footnote 50 in Part One.

(158.) The Land of Nursery Rhymes***, 1912, 436 ft.,
running time 7.16 min. Live-action.

Credits

Directed by Arthur Melbourne-Cooper. Production Heron Films Limited,[150] 4 and 5, Warwick Court, High Holborn, W.C. Distributed by Universal Film Co.

Synopsis

A girl dreams that the figures from the book of nursery rhymes come to life.

Contemporary sources

The Bioscope, London, 7 November 1912, page 449.

"An extremely pretty film in which are woven all the well-known nursery rhymes – each one dissolving into the other, and forming a delightful subject for both young and old. Length 430 ft. Released December 22nd. (Universal Film Co., Limited.)"

The Bioscope, London, 12 December 1912, page 858.

"Universal Film Co., Ltd., 5, Denmark Street, W.C. Now showing. (...) THE LAND OF NURSERY RHYMES. Heron. 430 ft. Released Dec. 22nd."

Supplement to The Bioscope, London, 12 December 1912, page xxxi.

"Ethel, tired of her play, picks up her volume of nursery rhymes, and, seating herself in her chair in the nursery, falls asleep, and in her dream visits "The Land of Nursery Rhymes". Doll's house opens, and one of the dolls beckons her to follow, and leads the way through the doll's house and into the enchanted land of rhymes. She meets Jack and Jill, and witnesses their downfall, but on going to help them up they vanish. She meets Humpty Dumpty, Simple Simon, Little Jack Horner, Old King Cole, the Little Man with the Little Gun, and Miss Muffit. In each of these she again sees their various stories enacted, and as each little drama or otherwise is completed, the scene vanishes into the next. In her endeavour to catch up Miss Muffit, who runs away from a spider, she trips over a tree trunk and wakes up in the nursery, having fallen off the chair. Her mother comes in, and Ethel tells her what she has seen in her dreams. (Released December 22nd. Length 436 ft.)"

Kinematograph Monthly Film Record, London, December 1912, page 100.

150. Heron Films Ltd., established in 1912 by Arthur Melbourne-Cooper, 'cinematographer', and Andrew Heron, 'gentleman', with the aim to produce films written and played by the then famous actor Mark Melford and his company.

"Ethel picks up her volume of nursery rhymes, falls asleep, and in her dream visits 'The Land of Nursery Rhymes'. Her doll's house opens, and one of the dolls beckons her to follow, and leads the way through the doll's house and into the enchanted land of rhymes. She first of all meets Jack and Jill, and again witnesses their downfall. She meets Humpty Dumpty, Simple Simon, Little Jack Horner, Old King Cole, the Little Man with the Little Gun, and Miss Muffit. In each of these she again sees their stories enacted, and as each little drama or otherwise is completed, the scene vanishes into the next. In her endeavour to catch up Miss Muffit, who runs away from a spider, she trips over a tree trunk and wakes up in the nursery, having fallen off the chair and bumped her head."

Complementary sources

Gifford-1973, 1986, 2000: "03846/03693 – December 1912 (436). THE LAND OF NURSERY RHYMES, Heron Films (U).[151] *Reissue* : 1914. P: Andrew Heron. D:S: Mark Melford. Mark Melford [the father], Jakidawdra[152] Melford. Fantasy. Girl dreams of nursery rhyme characters."

Recorded interviews

"(Looking at an Urban catalogue:) This NURSERY RHYMES, is that animated? He did a MOTHER HUBBARD." (**Audrey Wadowska to Tjitte de Vries, London, 16 August 1978,** T021.)

Audrey Wadowska: "THE LAND OF NURSERY RHYMES,[153] that is a Butcher's, released by Universal. Is it animated? It might not be, I need to solve that one. *Tjitte de Vries:* An animated trick film? *Audrey:* Yes, according to Denis Gifford, Jackeydawra was in it. Animated yes. Anyway, it was a Christmas film." (**Audrey Wadowska to Tjitte de Vries, London, 20 August 1978,** T031.)

"IN THE LAND OF NURSERY RHYMES is Heron.[154] Yes, dissolving nursery rhymes, that's it." (**Audrey Wadowska to Tjitte de Vries, London, 20 April 1979,** T038.)

Audrey Wadowska: "There is Jackdaw Films, supposed to have Jackeydawra Melford in them. There is a whole list. I showed that to Jackey, and she said she had nothing to do with any of them, never heard of them! You really cannot rely on these distributors. They have a bunch of films and want to sell the whole pack of them. I pointed something out to her,

151. Universal Film Co., Ltd., 5, Denmark Street, W.C.
152. Correct spelling: Jackeydawra Melford.
153. *The Bioscope*, November 7, 1912, released by Universal Film Co., length 430 ft.
154. *The Bioscope*, November 7, 1912, length 430 ft., released December 22, through Universal Film Co., Ltd.

I<small>N</small> T<small>HE</small> L<small>AND</small> O<small>F</small> N<small>URSERY</small> R<small>HYMES</small> I think it was. Denis Gifford says: Jackeydawra Melford is in it, and she said: He is a bloody liar, you tell him so. What can you do? *Tjitte de Vries:* And the N<small>URSERY</small> R<small>HYMES</small>, was she in it? *Audrey:* Gifford says she was, but she denies it. *Tjitte:* Was it a Jackdaw production? *Audrey:* Heron, I suppose. *Tjitte:* Who directed N<small>URSERY</small> R<small>HYMES</small>? *Audrey:* Father! A Heron picture." (**Audrey Wadowska to Tjitte de Vries, London, 19 April 1981.**)

"And he made one too, called N<small>URSERY</small> R<small>HYMES</small>, with scenes from Humpty Dumpty and different nursery rhymes." (**Audrey Wadowska to Tjitte de Vries, London, 28 May 1981.**)

Unpublished manuscripts

"In the L<small>AND</small> <small>OF</small> N<small>URSERY</small> R<small>HYMES</small> (Puppets)."

(**Audrey Wadowska, A-Z manuscript, 1981,** page I.)

Editorial

In our interview T021 of 16 August 1978, Audrey Wadowska refers to T<small>HE</small> N<small>URSERY</small> R<small>HYMES</small>. The catalogue ' *Revised list of Bioscope Films, The Charles Urban Trading Co., Ltd.,*' of February 1905 shows on page 314 under no. 3546 T<small>HE</small> N<small>URSERY</small> R<small>HYMES</small>, 600 feet (running time 10 minutes):

"This is a long film depicting all the incidents of the nursery rhymes in the manner beloved of children who readily recognise the favourites of their nursery teaching the old favourites introduced are: (1) 'Jack and Jill' (2) 'Old Woman who lived in a Shoe' (3) 'Sing a Song o Sixpence' (4) Old Mother Hubbard' (5) 'Goosey Goosey' (6) 'Cat and the Fiddle,' &c. Each Story introduced by a title. Exhibited with great success at the children's entertainments at the Shaftesbury Theatre and elsewhere. 600 feet."

This film clearly has nothing to do with the 1912 Heron production T<small>HE</small> L<small>AND</small> <small>OF</small> N<small>URSERY</small> R<small>HYMES</small>, which is most probably not an animation picture, but live-action in the pantomime tradition.

Mark Melford was in those days a famous actor who was under contract with Cooper's Heron Films Ltd to write and produce moving picture dramas. It is unlikely that he directed animation pictures or children's pantomime productions. Was his daughter, the actress Jackeydawra Melford, playing in the live-action scenes? Jackeydawra denied to Audrey that she was in this picture.

Even though Audrey suggests it could be a Butcher production, the Universal advertisement clearly states it is produced by Heron. We are giving it three stars, considering it as a full live-action motion picture.

The synopsis of Universal Film Co. in the *Kinematograph Monthly Film Record* of December 1912 is almost the same as in *The Bioscope* of December 12, 1912.

The Wooden Athletes, [155] 1912, 330 ft., running time 5.30 min.
> Stop motion animation and/or trick picture.
> A.k.a. (incorrectly) SPORTS IN MOGGY LAND, which is an original
> title by Melbourne-Cooper and a different film.

Synopsis

The picture starts with the title "The Wooden Atheletes" [sic]. We see a coach and a coachman. He is going to the horse and leading the coach away. We then see a showman's booth with a band playing drum and pipes, and the gathering of a curious crowd. After the patrons go inside, the show can begin. Each time preceded by titles announcing their turns, wooden peg-dolls perform all kinds of athletic and acrobatic features and bow to the audience after each turn.

Fig. 106. THE WOODEN ATHLETES (1912) was not made by
Melbourne-Cooper.

Details

Analyzing this animation picture, the movements are generally taken at three frames per movement.

Complementary sources

National Film Archive Catalogue: Silent Fiction Film 1895-1930, London BFI, 1966, page 94.

155. This title should not be confused with HE WOULD BE AN ATHLETE (1907), which is a live-action picture made by Arthur Melbourne-Cooper.

"The Wooden Athletes [F726] Credits: p.c. Charles Urban. Comedy: By means of trick photography wooden peg-dolls act as acrobats and equilibrists. In a travelling showman's booth spectators watch an acrobatic display including weight lifting, a balancing act involving a dwarf and a giant peg-doll, and other feats, including dolls which walk the tightrope and jump through paper hoops (282 ft.)."

Catalogue of Viewing Copies. The National Film Archive, London 1971, page 76.

"GB. 1912. The Wooden Athletes (A.Melbourne-Cooper) [F.726] 35St. 384 ft."

Gifford-1987 (page 18): "Wooden Athletes, 1912 (330), Empire Films – M.P. Sales. P: Frank Butcher, D:S:A: Arthur Cooper. Animated Toys. A unique trick film. It consist of a troupe of acrobats and equilibrists made up of ordinary wooden dolls, and their performances are wonderful. The outside of a travelling showman's booth is first shown, and the 'band' consisting of the big drum and pipes is braying out to a gaping crowd. The boss showman is strutting up and down the front of the booth. When all the dolls have crowded in, the interior is shown, and the performance goes on. There is weight-lifting extraordinary, jumping through hoops, walking and dancing on the tightrope, and a number of other circus eccentricities. After each turn the oddities come to the front and bow to the audience.' (*Bioscope*, 9 May 1912) Released 15 May 1912. Print preserved in the National Film Archive."

Publications

"Wooden Athletes and several fairy-tale adaptations released through Empire Pictures in 1912, the An Old Toymaker's Dream and Larks in Toyland, ended his career on the eve of the war." (**Donald Crafton, 1982.**) [N153]

"Acres's young assistant at this time was Arthur Melbourne-Cooper, who used the stop-motion facility to animate matches and children's toys. (...) Friday 9th November – Wooden Athletes, Arthur Melbourne-Cooper 1912." (**Ken Clark, 1979.**) [N154]

"1912 – 2461 – Wooden Athletes, The [a] \\ PC: Urban \\ ARCH: LON". (**Ronald S. Magliozzi, 1988**) [N155]

"Other films by Cooper include Noah's Ark (1906), Cinderella (1912), Wooden Athletes (1912) and The Toymaker's Dream (1913)." (**Giannalberto Bendazzi, 1994.**) [N156]

Correspondence

Mrs Audrey Wadowska to E. Lindgren, BFI, London, 25 November 1959.

"Dear Mr Lindgren. Relative to my conversation with Mr Grenfell, in connection with my father's visit to Aston Clinton on July 17th., when he was able to identify several of the items shown to him on the Editola, this will confirm the following Alpha productions (...) previously identified:
(...) 'THE WOODEN ATHLETES' ... Not his production."
Mrs Audrey Wadowska to Mr Colin Ford, BFI, London, 16 February 1970.
"Dear Mr Ford, I have at last managed to prepare the list of identified films which you asked me for, several months ago now! I must apologise for the delay, and though I cannot guarantee there are no omissions, I do trust you will find it useful.

I would also like to take this opportunity of expressing my sincere thanks to you and your colleagues for all their help and co-operation on my behalf over the passing years. It has been a slow and often frustrating task, due mainly to the early film makers practice of copying, and the frequent replacement of original titles. And not least, to my father's own peculiar method of business in producing his films for the 'wholesale trade only'. But I feel sure it has not been a waste of effort. (...).

The following items were personally identified by Arthur Melbourne-Cooper.
(...) WOODEN ATHLETES.

The following items have been identified, one way or another, as films produced under the direction of Arthur Melbourne-Cooper.
(...) WOODEN ATHLETES."

Recorded interviews
Audrey Wadowska (during the screening of THE WOODEN ATHLETES): "These people are supposed to be at the circus, watching this. They used to call those pink dolls moggies. I asked my father once when he was talking about moggies. I said: What is a moggy? He said: you are one. Meaning a painted doll! It is not complete. It should be 400 feet long. There was quite a lengthy synopsis published in *The Bioscope*. This is the giant and the dwarf. Doing a lot of bowing. *Jan Wadowski:* They are now doing olympic gymnastics. *Audrey:* That is the end. *Tjitte de Vries:* 1911? Made for Butcher? *Audrey:* Yes, at Warwick Court. I forget the exact title, GOING TO THE CIRCUS or something." (**Audrey Wadowska and Jan Wadowski to Tjitte de Vries, London, 27 December 1976,** T076.)
"THE WOODEN ATHLETE. This must be 1911 then. Troupe of acrobats

made up of ordinary wooden dolls. Outside a travelling show. Man's booth is first shown. Band playing to crowd, when dolls have crowded in, interior is shown. There is weight lifting, jumping through hoops, walking and dancing on a tight-rope, and a number of other circus eccentricities. 6 minutes.

Yesterday, at the anniversary exhibition of 200 Years Derby at the Royal Academy, you could buy Dutch dolls at a penny each. In the 1800s, it was the custom to wear one of these in your hat when you went to the Derby." (**Audrey Wadowska to Tjitte de Vries, London, 13 April 1978,** T036)

"Now, Sports In Moggyland, there is a long story about it. I wanted a still from it. At the BFI they told me, they have discontinued that service. (...) This is a part synopsis (*The Bioscope*), September 1912. This is The Wooden Athletes. We got this one, and I am not so sure whether it is Father's title, because it is an athletic performance by Dutch dolls. And Father described this one. Though Father described the action, I don't remember this title." (**Audrey Wadowska to Kenneth Clark, London, 24 October 1978,** T197.)

David Cleveland: "The last one they (National Film Archive) got is The Wooden Athletes. What it says in there, it was made in 1912. *Audrey Wadowska:* It should be 1911 it was made. It could have been listed 1912. *Cleveland:* It was issued by Charles Urban Trading Company and written in pencil across the page is: Arthur Melbourne-Cooper, director. They got those (films) available to look at." (**Audrey Wadowska to David Cleveland, London, 11 October 1979,** T419.)

"Yes, The Wooden Athletes is not his title. In fact what's on the film is a wooden athlete. It is part of Sports In Moggyland, father's title. It is not a complete film."[156] (**Audrey Wadowska to Tjitte de Vries, London, 17 April 1981,** T053.)

"And Sports in Moggyland. We believe that The Wooden Athletes is not his title, but it is part of Sports in Moggyland." (**Audrey Wadowska to Tjitte de Vries, London, 28 May 1981,** T057.)

Unpublished manuscripts

"Wooden Athletes made at about the same time as Road Hogs is a much simpler film. Dutch dolls are seen performing on a stage to attract people in to a fair-ground show. We then see the show itself captioned as "Equilibrists – the Giant and the Dwarf – Feats of Strength". The dolls go through the novelty act routines of a variety show with acrobats,

156. Note Audrey Wadowska: C.U[rban], The Bioscope, May 9, 1912, supplement page XIV.

tightrope walkers and jumping through hoops. There are never more than two or three dolls seen at any one time and there is no scenery except for a decorated backdrop for the outside of the show and a plain one for inside. The movement of the dolls is very smooth, these wooden dolls being relatively easy to manipulate, and the only example of sick humour is when a tightrope walker jumps into the air and comes down in pieces which quickly reassemble." **(Luke Dixon, 1977.)** [N157]

Editorial

WOODEN ATHLETES looks like a bad parody on the surviving animation pictures of Cooper.

The surviving film is more or less complete according to the synopsis in *The Bioscope* of 9 May 1912. According to Audrey Wadowska, some long sequences in the beginning and possibly also at the end are missing. She believes that the surviving film forms only a part of the original SPORTS IN MOGGYLAND.

There are too many indicators against Cooper being the maker of this very simplistic picture with its simple sets and crude animation, uncomparable with the sophistication of ROAD HOGS IN TOYLAND (1911). See our editorial at no. 22. SPORTS IN MOGGYLAND.

Audrey creates even more confusion when she suggests that GOING TO THE CIRCUS is an alternative title for THE WOODEN ATHLETES in which patrons are visiting something which is without doubt a fair-ground booth. However, GOING TO THE CIRCUS is an alternative trade title for THE HUMPTY DUMPTY CIRCUS.

Most important of all, according to a letter in 1959 by Audrey to National Film Archive curator Ernest Lindgren, Cooper had seen the film on a viewer in Aston Clinton and concluded that this was NOT his production, but in a letter, eleven years later, Audrey is claiming the film for her father, apparently forgetting the first letter to Lindgren.

(052.) **Sports in Toyland**, 1914, 310 ft., running time 5.10 min.
 Puppet animation

Synopsis

Wooden dolls are playing various sports.

Complementary sources

Gifford-1973, 1986, 2000: "05191/05028 – SPORTS IN TOYLAND, November 1914, (310). Excel. D: (Stuart Kinder). Trick. Toys hold sports day and spell out 'Good Night'."

Gifford-1987 (page 32): "SPORTS IN TOYLAND, 1914, (310). Excel Films – R. Prieur. D:S:A: Stuart Kinder. Animated dolls. 'A fairly well executed trick picture showing wooden dolls at various sports. The film finishes with a 'Good Night' device and is therefore suitable for the end of a programme.' (*Bioscope*, November 12, 1914.) Released 21 December 1914."

Editorial

This could be a reissue of SPORTS IN MOGGYLAND. The 'Good Night' scene may have been added to this reissue. Apart from distributor R. Prieur, there is another possible indicator for crediting Cooper: Stuart Kinder. He was cameraman for Cooper for several years. He possibly was not the director, but cameraman and/or assistant animator. There is a possibility that this film was made under the direction of Arthur Melbourne-Cooper in the animation studios in the basement of Cooper's Kinema Industries offices, 4 and 5, Warwick Court, High Holborn, W.C. But these are all conjectures based on only two indicators.

(056.) Humpty Dumpty R.A., 1915, 525 ft., running time 8.45 min.
Combination of puppet animation and "lightning cartoons" (quick sketch artists).

Synopsis

An animated doll as quick-sketch artist is drawing cartoons of famous military men and politicians.

Complementary sources

Gifford-1973, 1986: "05409 – HUMPTY DUMPTY R.A.,[157] January 1915 (525). Humpty Dumpty Films, (Prieur). TRICK. Doll sketches Jellicoe, French, Churchill, Kitchener."

Gifford-1987 (page 36): "Humpty Dumpty R.A., 1915 (525). Humpty Dumpty Films – R. Prieur. Animated doll/lightning cartoons. 'An animated doll executed lightning cartoons of men famous at the present moment including Admiral Jellicoe, General French, Winston Churchill, Sir Edward Grey, and Lord Kitchener. The sketches might have been executed just a little nearer to the camera, but they are cleverly done, and are excellent likenesses, whilst the general idea of the film is very well carried out.' (*Bioscope* 28 January 1915.)"

Editorial

When Melbourne-Cooper was working for Birt Acres, he was the

157. Royal Academy.

cameraman for the 'lightning cartoon' sketches by Tom Merry in 1895 and 1896, made at 45, Salisbury Road, Barnet. HUMPTY DUMPTY R.A. could have been one of Cooper's last productions in the basement studios of his Kinema Industries offices, 4 and 5, Warwick Court, High Holborn W.C. 'Prieur' and 'Humpty Dumpty' as such are insufficient indicators for crediting Cooper as the maker of this film.

(057.) Quality street,* 1936 (?), 40-60 ft., approx. 35 seconds.
Animated puppets.

Credits

Directed and animated by Arthur Melbourne-Cooper. Production Animads Film Publicity, Langford & Co Ltd., Preston New Road, Blackpool. Design by Jack Brownbridge, camera Kenneth Melbourne-Cooper.

Fig. 107. QUALITY STREET - campaign in 2006. Cooper probably made a puppet animation advertisement for the British cinemas when these famous sweets were launched in 1936.

Synopsis
Camera rides in on a bay window, where curtains open to give a view
into the street where a soldier is winning the heart of a young lady by
offering her Quality Street sweets.

Recorded interviews
Kenneth Melbourne-Cooper: "He (Jack Brownbridge) painted some of the
sets, didn't he? One set was a little old bay window thing, like The Old
Shoppey. What was that done for? I don't know if that was a trick film,
or what?" (**Audrey Wadowska and her brother Kenneth Melbourne-
Cooper, London, 24 October 1973,** T304.)

"Going back to Jack Brownbridge, there is a rather funny story there. I
don't know what the set was for, but we had to get some decor of vases
and things like that. And Jim Schofield had a nice piece of Lalique glass
vase, about that big. Lalique in those days was very expensive, French
glass, very pale blue. And we wanted this on the set and Jack said to Jim:
We take great care of it. Because it was valuable, because it was a wedding
present or what. And of course, the worst happened, he drops it. Being so
blooming careful, he nursed it, keep away! And then he dropped it. That
was the last for poor Jack. He was a good artist too, Jack Brownbridge.

About that bay window we had made. I am certain it was for
something like MacIntosh's Quality Street. Something like that. I
know, he had this thing built and a bloke came in and painted it and
drop curtains made for it. And when you looked through the window,
there were these children in old-fashioned dresses. Just like
MacIntoshes. I just can't remember finishing the film." (**Kenneth
Melbourne-Cooper to Jan Wadowski, St Albans, 17 May 1984,** T210.)

Tjitte de Vries: "How many people were there? Twenty or thirty? *Ursula
Messenger:* Not more. *Tjitte:* Ken was there, you worked there? Ken was
working the camera. He was telling us about the Quality Street
picture. He remembered that this was made. Did you know that?
Ursula: No. I didn't have a lot to do with films. Aud did the lettering. I
was on the colouring side. They built a floor on the roof,[158] and there
were the three of us. I did the colouring of the slides, so I did not have
much to do with the office work.

Tjitte: What Ken said was: The wages were low, but they got a good
training. *Ursula:* Ken was right there." (**Ursula Messenger to Tjitte de
Vries, Felpham, Bognor Regis, 25 October 2006,** T445.)

158. The premises of 72a, Cookson Street, Blackpool.

Editorial

The above three interviews are the only doubtful indicators we have for this film, which could have been made by Cooper, plus the knowledge that Ken Melbourne-Cooper was the camera operator. Correspondence with Nestlé Rowntree or the Borthwick Institute for Archives in York[159] were without any result.

Fig. 108. Cinema slide design by Cooper's eldest daughter Audrey (approx. 1935).

Quality Street was promoted in 2006 as celebrating its 70th anniversary. Therefore, the advertising film could have been made in 1936, when Ken was 25 years old. Ken's story reminds us of the synopsis for CLIFTON CHOCOLATES.

159. Email replies to our letters on 2 October 2006 and 2 January 2007, respectively.

Does this film deserve a star? We just don't know. It is a pity that advertising pictures are so neglected in archives and at companies. Not only admirable and less beautiful examples of artistry have therefore disappeared into oblivion, but also instances of social history.

Notes on Part Two – Filmography

(The T before a number refers to the transcription of an audio tape or cassette.)

1. Tjitte de Vries, 'Arthur Melbourne-Cooper (1874-1961), a Documentation of sources concerning a British film pioneer', in *KINtop, Jahrbuch zur Erforschung des Frühen Films*, Frankfurt am Main (Stroemfeld/Roter Stern), Autumn 2005, pages 146-176.
2. Denis Gifford, *American Animated Films: The Silent Era, 1897-1929*, Jefferson NC and London (McFarland), 1990, page x.
3. Kenneth Clark, *More Movements in Animation. Pioneers of British Animated Films.* Manuscript, 2007. Forthcoming publication in 2010, pages 13-15.
4. Mette Peters, NIAF Tilburg, letter to the authors, 23 July 2007.
5. John Grisdale, *Portrait in Celluloid*, manuscript 1960, pages 117-120.
6. Gregory Fremont-Barnes, *The Boer War 1899-1902*, Essential Histories, Oxford (Osprey Publishing), 2003, page 76.
7. Gifford – Each time when Gifford is mentioned as the source, we omit from giving an end note. We refer to our Bibliography with its seperate section '4. Cinematography – Gifford' with seven publications. We will not refer to page numbers but instead we give Gifford's catalogue numbers of the films.
8. W.J. Collins, 'Advertising was there from the start', *Kinematograph Weekly*, 3 May 1956, page 77.
9. Gordon Hansford, *Arthur Melbourne-Cooper 1874-1961. Pioneer of the British Film Industry*, St Albans Film Society, 23 October 1973, page 3.
10. Patrick Robertson, *The Shell Book of Firsts*, London (Ebury), 1974, page 65; *The New Shell Book of Firsts*, London (Headline Book), 1994/1995, page 132.
11. Luke Dixon, 'A forgotten visionary', *Weekly Review, Barnet Press*, 29 August 1980, page 12.
12. Patrick Robertson, *The Guinness Book of Film Facts and Feats*, Enfield (Guinness), 1980, page 246; *Guinness Film Facts and Feats*, Enfield (Guinness), 1985, page 210; *The Guinness Movie Facts & Feats*, Enfield (Guinness), 1988, page 217; *The Guinness Book of Movie Facts & Feats*, New York (Abbeville), 1991, page 190.
13. Anon., 'Hommage Arthur Melbourne-Cooper', JICA 81, No. 6, *Bulletin Quotidien des Journées Internationales du Cinema D'Animation*, Festival d' Annecy, Sunday, 14 June 1981, pages 6-7.
14. Stuart Morrison, 'Arthur's magic art', *Evening-Post Echo*, 11 January 1982, page 3.
15. Richard Whitmore, 'The Forgotten Visionary', in *Of Uncommon Interest*, Bourne End (Spurbooks), 1975, pages 118-131; 'The Film Pioneer of St Albans', in *Hertfordshire Headlines*, Newbury (Countryside Books), 1987, pages 97-108.

16. Jeffrey Klenotic, 'Advertising Films' in *Encyclopedia of Early Cinema*, Richard Abel, ed., London/New York (Routledge), 2005.
17. Christopher Winn, 'Genesis of the British Film Industry', in *I Never Knew That About England*, London (Ebury), 2005, page 112.
18. Grisdale, manuscript 1960, ibid. pages. 2, 117-121.
19. Luke Dixon, *Pioneers of the British Films, the Work of Birt Acres and Arthur Melbourne-Cooper*, manuscript, Eastern Arts Association, 1977, pages 5/9-12.
20. Alan B. Acres, *Frontiersman to Film-maker*, manuscript, Southend, 2006, page 4.
21. Clark, manuscript 2007, ibid., page 6.
22. Richard Buckle, The Observer Exhibition,'*Sixty Years of Cinema*', London, 1956, page 18.
23. Collins, 1956, ibid., page 77.
24. Audrey Wadowska, 'Do you remember', in *The World's Fair*, 24 November 1956, page 3.
25. Morris Freedman, 'First Animated Cartoons', *Radio Times*, 8 March 1957.
26. Anon., 'Late Honour', in *New Zealand and Cambridge Daily News*, Dunedin Press, June 1957.
27. Anon., 'Animated Picture', *Technology*, October 1959, page 256.
28. Anon., 'Mr. A. Melbourne-Cooper, A Pioneer in the Cinema', *The Times*, obituary, Thursday, 7 December 1961.
29. Anon., 'Arthur Melbourne-Cooper', in *Newsletter No 12*, Society for Film History Research, January 1962, page 1.
30. Anthony Slide, 'A Tribute to Arthur Melbourne-Cooper', in *Flickers. The Journal of the Vintage Film Circle*, No. 25, Summer 1967, page 6.
31. Hansford, 1973, ibid., page 3.
32. Robertson, 1974, ibid., page 65; Robertson, 1994/1995, ibid., pages 132-133.
33. Anon., 'Father of Animation', *BFI Newsletter*, No. 9, January 1974.
34. Whitmore, 1975, ibid., pages 118-131.
35. Lecture by Audrey Wadowska, 'Arthur Melbourne-Cooper Motion Picture Pioneer', to the Motion Picture Group of the Royal Photographic Society, 26 January 1977, in *Film Collecting*, No. 3, Fall 1977, page 6; in No. 4, Winter 1977/78, page 7; in No. 5, Fall 1978, page 22.
36. Anon., 'Wholly Moses. Campaign Diary', Cambridge Animation festival, *Eastword*, monthly by Eastern Arts Association, 19 October 1979, page 4.
37. Anon., 'Pre-Disneyland', *The Daily Telegraph*, Friday, 9 November 1979, page 18.
38. Ken Clark, 'Early Pioneers', programme notes Cambridge Animation Festival, 9-14 Nov. 1979, in *Cambridge Animation Festival*, Arts Cinema, Cambridge, Eastern Arts Association, page 8.
39. Anon., 'Posthumous Fame for Film Pioneer', *Review and Express*, 15 November 1979, page 8.
40. Alexander Sesonske, 'The Origins of Animation', *Sight & Sound*, Summer 1980, page 186.
41. David Williams, 'How it All Began...', in *Film Making*, Vol. 18 No. 9, September 1980, page 47.
42. JICA 81, No. 6, Bulletin d' Annecy, 14 June 1981, ibid., pages 6-7.
43. Robertson, 1980, ibid. page 241; 1985, ibid., page 206; 1988, ibid., page 213; 1991, ibid., page 184.

44. Donald Crafton, *Before Mickey. The Animated Film 1898-1928*, Cambridge Mass./London (The MIT Press), 1982/1987, page 223.
45. Barry Salt, *Film Style and Technology: History and Analysis*, London (Starw.), 1983, page 72.
46. Patricia Warren, *The British Film Collection 1896-1984. A History of British Cinema in Pictures*, London (Elm Tree), 1984, page 7.
47. Elaine Burrows in *All Our Yesterdays*, Charles Barr, ed., London (BFI), 1986, pages 273-274.
48. John Halas, *Masters of Animation*, London (BBC Books), 1987, page 18.
49. Whitmore, 1987, ibid., pages 97-108.
50. Donald Crafton, *Emile Cohl, Caricature, and Film*, Princeton (Univ. Press), 1990, page 129.
51. Giannalberto Bendazzi, *Cartoons. One hundred years of cinema animation*, London (John Libbey), 1994, pages 7, 40.
52. Winn, 2005, ibid., page 112.
53. Giannalberto Bendazzi, 'Fiammiferi superstar' (Matchsticks superstar), in *Il Sole 24 Ore*, weekly cultural supplement of the daily newspaper, 14 August 2005.
54. Richard Rickitt, *Special Effects. The History and Technique*. London (Aurumpress), 2006, page 181.
55. Website BFI, National Archive, Catalogues, collections & archives, 1 July 2007.
56. Website IMDb (International Movie Database), Matches: An Appeal, 25 March 2007.
57. Major I. Scheibert, *Der Freiheitskampf der Buren* (The Fight for Freedom of the Boers), Berlin, 1902 – Supplement- und Schlußband, page 53.
58. Byron Farwell, *The Great Boer War*, New York/London (Wordsworth), 1976/1977, page 41.
59. Thomas Pakenham, *The Boer War*, London (Abacus), 1979/2004, page 210.
60. Fremont-Barnes, 2003, ibid., page 24.
61. Arthur Swinson, *Draft of Magazine Article*, 1956, page 4.
62. Grisdale, manuscript 1960, ibid., pages 2, 99, 117-120, 156-157.
63. Dixon, 1977, ibid., pages 6/14-15; Appendix D/1-4.
64. Crafton, 1982/1987, ibid., page 223.
65. Crafton, 1990, ibid. pages 129-130.
66. Bendazzi, 2005, ibid.
67. British Film Institute, website BFI *Screenonline*, film, animation, 5 May 2005.
68. Clark, manuscript 2007, ibid., pages 13-15.
69. Savada Elias, *The American Film Institute Catalog, Film Beginnings 1893 – 1910, Film Entries*, Metuchen, N.J. & London (Scarecrow), 1995, pages 30, 179, 277.
70. Crafton, 1982/1987, ibid., page 223.
71. Crafton, 1990, ibid., pages 129-130.
72. Clark, manuscript 2007, ibid., page 15.
73. Salt, 1988, ibid., page 72.
74. Crafton, 1982/1987, ibid., page 223.
75. Clark, manuscript 2007, ibid. page 15.
76. Grisdale, manuscript 1960, ibid., pages 214-216.
77. Grisdale, manuscript 1960, ibid., page 156.
78. Ronald S. Magliozzi, *Treasures from the Film Archives. A catalog of short silent fiction*

films held by the FIAF archives, Metuchen NJ & London (Scarecrow), 1988. page 143.

79. Collins, 1956, ibid., page 77.
80. Audrey Wadowska, Recollections (extract), 'When They Made Films in St Albans', *St Albans and District Gazette*, Friday, 18 January 1957.
81. Dunedin Press, 1957, ibid.
82. Joe Curtis, 'Pioneer of the film industry. Mr. Arthur Melbourne-Cooper', in *Hertfordshire Countryside*, Vol. 15, no. 57, 1960, page 28. Authorized interview.
83. Obituary *The Times*, 1961, ibid.
84. Society for Film History Research, 1962, ibid., page 1.
85. Slide, 1967, ibid., page 6.
86. Hansford, 1973, ibid., page 3.
87. L. Bruce Holman, *Puppet Animation in the Cinema. History and Technique.* New York/London (Barnes/Tantivy), 1975, pages 21, 93.
88. Clyde Jeavons, BBC-1 tv, 3rd part of series 'A Look at the Past – Movie Milestones', 19 January 1978, (T184).
89. Robertson, 1980, ibid., page 246; 1985, ibid., page 206; 1988, ibid., page 213; 1991, ibid., page 184.
90. David Wyatt, Stephen Herbert, *Fifth Animation Festival Scala Cinema*, London, 10 Jan. 1981.
91. Anon., JICA 81, Annecy, 14 June 1981, pages 6-7.
92. Morrison, 1982, ibid., page 3.
93. Warren, 1984, ibid., page 7.
94. Whitmore, 1987, ibid., page 103.
95. Bendazzi, 1994, ibid., page 40.
96. Stephen Herbert, 'Alpha Trading Company' in *Encyclopedia of Early Cinema*, Richard Abel, ed., London/New York (Routledge), 2005.
97. Bendazzi, 2005, ibid.
98. Rickitt, 2006, ibid., page 181.
99. Swinson, 1956, ibid., page 4.
100. Grisdale, manuscript 1960, ibid., pages 2, 156-159.
101. Dixon, manuscript 1977, ibid., pages 6/15 – 6/19.
102. Clark, manuscript 2007, ibid., page 16.
103. Curtis, 1960, ibid., page 28.
104. Rachael Low, *The History of the British Film 1906-1914.* London (George Allen & Unwin), 1948/1973, page 181.
105. Crafton, 1982/1987, ibid., page 223.
106. Clark, manuscript 2007, ibid., page 11.
107. Holman, 1975, ibid., pages. 21, 93.
108. Geoff Brown, 'Supporting Programmes', *Monthly Film Bulletin*, BFI, June 1976, as quoted in National Film Theatre Programme Notes, 'No Strings. Puppet Animation in the Cinema'.
109. *Film Collecting*, 1977, ibid., page 7.
110. Robertson, 1980, ibid., page 241; 1985, ibid., page 206; 1988, ibid., page 213; 1991, ibid., page 184.
111. JICA 81, Annecy, 14 June 1981, ibid., pages 6-7.
112. Crafton, 1982/1987, ibid., page 223.
113. Warren, 1984, ibid., page 7.

114. Magliozzi, 1988, ibid., page 146.
115. Bendazzi, 1994, ibid. page 41.
116. Ivo Blom, *Pionierswerk. Jean Desmet en de vroege Nederlandse filmhandel en bioscoopexploitatie (1907-1916)*, Amsterdam, 2000. Ivo Blom, *Jean Desmet and the Early Dutch Film Trade*, Amsterdam University Press, 2003. Ivo Blom, 'Chapters from the life of a camera-operator. The recollections of Anton Nöggerath – filming news and non-fiction, 1897-1908'*, in Film History, Volume 11, number 3, 1999, pp. 262-281. G. N. Donaldson, *Wie is Wie in de Nederlandse Film. Nöggerath, Franz Anton, Senior*, in Skrien, nr. 128, Zomer 1983, pages 34-36. Karel Dibbets en Frank van der Maden (ed.), *Geschiedenis van de Nederlandse Biscoop tot 1940*, Het Wereldvenster, Weesp, 1986.
117. Grisdale, manuscript, 1960, ibid., pages 157-160.
118. Dixon, manuscript, 1977, ibid., pages 6/19-6/21.
119. Clark, manuscript, 2007, ibid., page 15.
120. Herbert Birett, *Das Filmangebot in Deutschland 1895 – 1911*, München (Filmbuchverlag Winterberg), 1991, page 654.
121. Crafton, 1982/1987, ibid., page 223.
122. Bendazzi, 1994, ibid. page 41.
123. Grisdale, manuscript 1960, ibid., pages 148, 228-229.
124. Grisdale, manuscript 1960, ibid., pages 265-266.
125. Clark, manuscript 2007, ibid., page 18.
126. Curtis, 1960, ibid., page 28.
127. Grisdale, manuscript 1960, ibid., pages 223-226.
128. Clark, manuscript 2007, ibid., page 18.
129. Rodney Dale, *Louis Wain. The Man who drew Cats*, London (Chris Beetles), 1991.
130. Magliozzi, 1988, ibid., page 148.
131. Dixon, manuscript 1977, ibid., pages 6/21-6/22.
132. Curtis, 1960, iIbid., page 28.
133. Curtis, 1960, ibid., page 28.
134. Low, 1948/1973, ibid., page 181.
135. *Film Collecting*, 1977, ibid., pages 7, 10.
136. JICA 81, Annecy, 1981, ibid., pages 6-7.
137. Bendazzi, 1994, ibid., page 41.
138. Grisdale, manuscript 1960, ibid., pages 157, 160.
139. Dixon, manuscript 1977, ibid., page 6/22.
140. Clark, manuscript 2007, ibid., page 20.
141. Crafton, 1982/1987, ibid., page 223.
142. Bendazzi, 2005, ibid.
143. Slide, 1967, ibid., page 7.
144. *Film Collecting*, 1977, ibid., pages 7, 10.
145. Ronald Riggs, "The Forgotten Movie Pioneer", *Herts Advertiser*, Friday, 28 June 1974, page 9.
146. Clark, manuscript 2007, ibid, page 6.
147. Clark, manuscript 2007, page 6.
148. Magliozzi, 1988, ibid., page 142.
149. Grisdale, manuscript 1960, ibid., page 266.
150. Magliozzi, 1988, ibid., page 147.

151. Roger Holman et al., *National Film Archive Catalogue, part III, Silent Fiction Films 1895-1930*, London (BFI), 1966, page 182.
152. Holman, 1975, ibid., page 22.
153. Crafton, 1982/1987, ibid., page 223.
154. Clark, 1979, ibid. pages 8-9.
155. Magliozzi, 1988, ibid., page 152.
156. Bendazzi, 1994, ibid., page 41.
157. Dixon, manuscript 1977, ibid., page 6/22.

Appendices

Appendix I

6 Surviving Pictures
 Matches Appeal (1899)
 Animated Matches Playing Volleyball (1899)
 Animated Matches Playing Cricket (1899)
 A Dream of Toyland (1907)
 Noah's Ark (1909)
 Road Hogs in Toyland (1911)

Live-action pictures with animation inserts
 Cheese Mites (1902)
 Professor Bunkum's Performing Flea (1907)

Pictures with combined stop-motion animation and live-action
 Bird's Custard (1897)
 A Boy's Dream (1904)
 The Enchanted Toymaker (1904)
 The Fairy Godmother (1906)
 A Dream of Toyland (1907)
 In the Land of Nod (1907)
 Noah's Ark (1909)
 The Toymaker's Dream (1910)
 Topsy's Dream of Toyland (1911)
 Clifton Chocolates (1926)

The surviving films are kept at the following addresses:

Matches Appeal
35mm print from original negative at the Kodak Collection in the National Media Museum at Bradford, and in the National Film, Video and Sound Archives, Pretoria, S.A. Copy from preserved negative at the Cinémathèque Québècoise. Copies from this at the BFI National Archive, London.

Matches Appeal: Animated Matches Playing Volleyball; Animated Matches Playing Cricket
35mm prints at the Netherlands Institute of Animation Films (NIAF), Tilburg;
35mm restored negatives and positives, and 16mm prints from the Audrey and Jan Wadowski estate in the East Anglian Film Archive, Norwich;
16mm prints in the Tjitte de Vries/Ati Mul Collection, Rotterdam, Netherlands.

A Dream of Toyland
35mm original nitrate copy and restored print from the Tjitte de Vries/ Ati Mul Collection at the Netherlands Filmmuseum, Amsterdam;
restored 35 mm print at the BFI National Archive, London;
35mm negative and 16mm print from the Audrey and Jan Wadowski estate in the East Anglian Film Archive, Norwich;
35mm step-print and 16mm print in the Tjitte de Vries/Ati Mul Collection, Rotterdam, Netherlands;
16 mm print at the Netherlands Instititute of Animation Films (NIAf), Tilburg, Netherlands.

Noah's Ark
Restored 35mm print at the BFI National Archive, London;
35 mm and 16mm print from the Audrey and Jan Wadowski estate in the East Anglian Film Archive, Norwich.

Road Hogs in Toyland
16mm print in the Audrey and Jan Wadowski estate (from the John Huntley Film Archives) at the East Anglian Film Archive, Norwich;
16mm print in the Tjitte de Vries/Ati Mul Collection, Rotterdam, Netherlands.

DVDs of these films are in the Arthur Melbourne-Cooper Archive of the authors.

NOTE The late Mrs Ursula Messenger, the last survivor of the Arthur Melbourne-Cooper family and legal holder of the estate of rights and copyrights, during her life generously allowed the authors the use of moving pictures and photographs of her father and of her family in connection with their publications about her father.

Appendix 2a
A Dream of Toyland: Analysis

40 Animated Film Stars

1. Chap with top hat and chequered trousers
2. Little policeman
3. 'Dream of Toyland' motor-bus
4. Golliwog driver
5. Two geese
6. Black cab and driver
7. Little wooden dog
8. Little donkey cart
9. Very small soldier
10. Monkey with cart and milk churn
11. Tall policeman
12. Black&white horse
13. Dutch doll no. 1
14. Dutch doll no. 2
15. White bear
16. Three-wheel tractor and two-wheel trailer with chauffeur and madam
17. Black Royal Mail van
18. Woman with pram
19. Man in black suit and cap
20. Chinaman with rickshaw
21. Tall Dutch doll
22. Antique motorcar with two persons
23. Antique white car with driver
24. Donkey cart with girl and ponytail
25. Taller horse
26. Drunken horse rider
27, 28, 29 and 30. Four passengers on upper deck of motor-bus

31. Dutch doll with pram
32. Golliwog policeman
33. Chinese busker with drum
34. Horse cart
35. Little sailor man
36. Steam driven white "XL-All Seeds" van
37. Princess doll
38. Horse cab
39. Steam locomotive
40. Family of five Dutch dolls

Most of the toys were given to the children's ward of St Albans Hospital.

Same Film: Two Different Copies

We studied two different copies of A DREAM OF TOYLAND. The first is the nitrate copy from our own collection which we donated to the Netherlands Filmmuseum ten years ago for reasons of preservation. We call this "our copy" in distinction from the copy of the Audrey Wadowska collection, which is a step-up print from a dupe negative of a print from the BFI National Archive, wrongly titled IN THE LAND OF NOD. We call this the "BFI copy". Both films are 100 meters (330 ft) in length, at 24 fps lasting 3 minutes 40 seconds, and at 16 fps lasting 5 minutes 30 seconds.

Our copy contains 9 physical splices: 4 tape splices, 5 wet splices, and 2 reparations of perforations. Three tape and two wet splices are in action scenes, and are clearly splices to repair wear and tear. That leaves 3 physical wet splices, and one questionable tape splice. The first strong wet splice connects the title with the first scene of the film. A second wet splice connects the fourth live-action scene with the animation sequence. A third dirty wet splice is a repair at 1/3rd or 40 seconds into the animation. A tape splice at 53 seconds or half-way in the animation sequence could very well be a repair of an old splice. More about this splice later.

Appendix 2c makes an effort to analyse the animation sequence. We wanted to make an estimation of the time periods in which the animation was done. Sunny and non-sunny periods were counted. A great number of clear, thin, white negative splices were counted in both copies.

In our copy we came across the 2 physical splices mentioned above, one wet splice, and some frames later one tape splice. The tape splice was preceded by two clear, thin, white negative splice lines. Besides a white, but

dirty negative repair splice, we also counted 23 nice, clean, small, white negative splices. (These clean white splice lines are not visible in the projection.)

Even though the animation sequence of the BFI copy shows the same 23 white negative splices, it differs in some other places from ours. The first is when scene 4, the bedroom scene, is connected with the animation sequence. After the connecting wet splice our copy shows a white negative splice some frames later, and a jump when two dolls approach each other to start a fight. The BFI copy starts the fight at once with the frame after our jump. Our first frames are missing here.

The second difference is at one-third into the animation where our copy has a dirty physical wet splice with several frames missing. The camera has now visibly a slightly different position and the objects, notably the white bear and the pillar box seem to have moved to the left. The BFI copy shows only a white negative splice and no frames missing, but the change of camera position is the same.

The third difference between the BFI copy and ours happens half-way along the sequence at the beginning of the fifth animation session, when the black Royal Mail van with a Dutch doll at the wheel is driving to the left, with geese, a little China man, a horse and its rider, a policeman, a princess doll and a little wagon-and-horse on the foreground.

There is in our version the dirty tape splice, mentioned above. But this splice is followed by a perceptible jump: the Royal Mail van leaps backwards, and so do the other objects. The camera is moved to the right, the pillar box to the left. The repeated frames are the same as the 8 preceding frames, as if these were copied and joined together, although the light is now brighter. And the BFI copy? There is no physical tape or wet splice here. After the two preceding clean white negative splice lines, there is no jump back or repetition of frames.

Are there more differences between our copy and the BFI one besides these three obvious ones?

Both versions, after the different titles, start with the same frames when the actress and the boy are walking down St Peter's Street in St Albans towards the camera with a cyclist in the background parking his bike with its peddle against the curb. The BFI copy shows two negative splices in the shopping scene, our copy has three negative splices. The BFI copy contains a very dirty splice (a repair splice in the negative?) connecting the second exterior scene to the bedroom scene, as if the connecting frame has not been scraped clean enough: in a very bleak frame the shop fronts can still be seen through the bed in the bedroom. In our copy this splice also contains dirt,

but the splice is much better and does not show double images in a bleak frame. Our splice is not physical.

The bedroom scene in which the boy is put to bed contains in our copy a negative splice which is not in the BFI copy. When the actress tucks the boy in, both copies have the same negative splice.

The first live-action scene after the animation sequence is of the burning motor-bus. Although the scene is connected on the negative with the animation sequence, both copies have a physical wet splice some seconds later. However, the BFI copy has an extra splice, and the burning of the bus is partly repeated, lasting twice as long as in our copy: 8 seconds against 4 seconds (both at 24 fps). Next, the BFI copy has a dirty black splice connecting the burning motor-bus shot with the shot of the weeping little boy sitting next to his bed. Our copy connects the shots with a thin white negative splice. The BFI copy ends with the actress kneeling down and taking the boy in her arms. Our copy is 7 seconds longer: the woman lifts the boy, intending to put him back in bed. When she lifts him, our copy ends with a dirty splice.

Appendix 2b
Scene Lengths of A Dream
of Toyland

From original nitrate copy at the Netherlands Filmmuseum: Count of
physical splices.

Scene:	Frames: (consec.)	Secs.: at 24 fps	Meters: (consec.)	Feet: (consec.)	Notes:
Original title	75	0.03.02	1.30	4.10	Title ends with strong physical **wet splice** to assemble it with next shot.
Scene 1: Exterior live-action St Peter's street	296	0.12.08	5.50	18.08	Frame counter at 117 (42 frames into the scene): a repair **tape splice** where 2 frames are partially damaged and dirty at right side.
Scene 2: Interior live-action shop	1560	1.05.00	29.58	97.08	(**Note**: no physical splice connects scene 1 with scene 2. There is a professional thin white negative splice assembling them.) At 373 frames: repair of perforations.
Scene 3: Exterior same street	1658	1.09.02	31.42	103.10	(**Note**: as before a thin white negative splice connects scene 2 with scene 3.)
Scene 4: Interior bedroom	2133	1.28.22	40.55	133.05	(**Note**: as before a thin white negative splice connects scene 3 with scene 4.) At 1938 frames repair of perforations.

Scene:	Frames: (consec.)	Secs.: at 24 fps	Meters: (consec.)	Feet: (consec.)	Notes:
Scene 5: Animation sequence	4863	3.22.15	92.40	303.15	At 2134 frames strong physical **wet splice** covered with black ink half way black fade-over which assembles scene 4 with animation sequence. At 3088 frames, physical **wet splice,** blackened with ink, frames missing. At 3370 and 3380 frames: white negative splices. At 3393 frames a repair **tape splice,** approx. half way along animation sequence. 8 preceding frames are repeated. (Possible repair of a wet splice?) At 3416 frames a repair **tape splice**
Scene 6: Close-up live-action burning toys	4964	3.26.20	94.50	310.04	(**Note**: a thin white negative splice connects scene 5 with scene 6.) At 4941 frames a strong physical repair **wet splice.**
Scene 7: Interior live-action bedroom. Scene ends incomplete	5267	3.39.11	100.3	329.03	(**Note**: a thin white negative splice connects scene 6 with scene 7.) At 5185 frames a repair **tape splice;** at 5229 frames dirty but strong **wet splice,** both in the action with loss of frames. (There are no end titles.)

Total of 5 wet splices, 4 tape splices, and 2 perforation reparations.

Appendix 2c
Animation Sessions in 8 Possible
Day Periods

23 Negative Splices, 6 Frames with Animators at Work

No. of seconds	Total	No. of frames	Description of scene. (Total frame count of the film: 5267. Frame counter of the animation sequence starts at 2134; ends at 4863.) Count in seconds is at 24 fps. (At 16 fps 2.52 minutes.)
	(2134)		=First possible day period with animation sessions- 10 seconds=
0.00-0.10	10	0	0.00: Strong **wet splice** between fade-out and fade-in from sleeping boy to first animation.
			After the fade-in the lighting is equal and rather grey.
			0.01: Man in high hat and a policeman walk to each other. Clear **white splice** with a jump, some missing frames: man and policeman have lept to the right and start a fight.
			0.02: A motor-bus arrives from the side-street. More objects enter the scene.
			0.05: In general during this session: clear sunlight from the right. Sun gradually turns to the middle. Objects give clear shadow on the ground.
			0.06: A fine **white splice**.
		177	0.07: From the far right a black Royal Mail van arrives.
		209	0.08: =(01)= *Bert Cooper's upper body is visible in one frame animating an object.*
			Clear, clean **white splice**. Sun comes from the middle. Policeman (left) tries to put a little soldier doll in a pillar-box. 10 to 12 objects are animated.
		212	0.09: A monkey is in the middle of the scene, Dutch dolls are at the front, geese at the left, 18 objects in animation.

No. of seconds	Total	No. of frames	Description of scene. (Total frame count of the film: 5267. Frame counter of the animation sequence starts at 2134; ends at 4863.) Count in seconds is at 24 fps. (At 16 fps 2.52 minutes.)
0.10-0.27	17		=SECOND POSSIBLE DAY PERIOD WITH ANIMATION SESSIONS-17 SECONDS= 0.10: Sun jumps back to the right. New animation session. 0.12: The sun jumps to the middle and shines full on the shops. 0.13: Dirty repair **splice** in negative, frame is out of focus. A Dutch doll in front, next to a girl with ponytail in a donkey-cart at the right. Also a big Dutch doll, behind her the motor-bus. Much traffic. 0.15: Sun is at the left. Shadows become much longer and then disappear. 0.16: Sun disappears, but is after a few frames at the left. Long shadows. In the following seconds: at one point shadows and sunbeams on the shop front in the side street seem to repeat themselves two or three times, confirmed by the shadow of the Dutch doll walking towards the camera. 14 animated objects. 0.17: A perfect clean **white splice**. No sun. Next frame full sun from the left. The girl in the donkey-cart is at the left. The other objects move to the left as well. 0.20: Shadow of a boy in the side-street is visible on one frame. 0.22: Long shadows from left to right becoming even longer, indicating they have worked all day. 0.23: Perfect **white splice**. Long dark shadows cover the set, indicating low sun, late afternoon. Royal Mail van and motor-bus are in the centre of the set. Little Dutch doll in front. Girl in donkey-cart is vanishing to the right. 0.26: =(2)= *Upper body of a boy appears in a single frame in the side-street animating an object.* Light is equal and vaguely grey.
		510	
		658	
0.27-0.38	11	672	=THIRD POSSIBLE DAY PERIOD WITH ANIMATION SESSIONS-11 SECONDS= 0.27: **White splice**: frame out of focus, no action jumps. The Royal Mail van is at the foreground left, the motorbus is at the right, and the monkey is cautioning a little car in front of the bus.

No. of seconds	Total	No. of frames	Description of scene. (Total frame count of the film: 5267. Frame counter of the animation sequence starts at 2134; ends at 4863.) Count in seconds is at 24 fps. (At 16 fps 2.52 minutes.)
		797	0.28: **White splice**. The light is clear but diffuse; animation resumed on another day? 0.32: **White splice**. The light is different again but clear. One can observe a short reflection of the sun from centre or west, and of bare tree branches in the windows of the motor-bus. The bus fills the whole screen when going to the right. A white bear on top tries to remove the monkey who wants to get on. 14 animated objects. 0.38: **White splice**. The set looks lighter. The motor-bus drives to the back. The bear is thrown from the bus. Many small objects are moving about.
0.38-0.51	13	955 964 1083	=FOURTH POSSIBLE DAY PERIOD WITH ANIMATION SESSIONS- 13 SECONDS= 0.38: There is a dirty physical **wet splice** blackened with ink, some frames are missing, and a clear jump. Pale sunlight from the right. Apparently a new animation session. Horse, motor-bus, pillar-box and bear are in slightly different positions to the left. Golliwog policeman enters the set, and is threatened by the bear. 0.39: =(3)= *Stan Collier's upper body is in a single frame in full view from the right animating the geese.* Sunlight gives comparative clear shadows. 0.42: **White splice**. A little black cab is at the left. The white bear carries the golliwog above his head. A horse fights with dolls. The bus is driving to the side-street. The sun is in the middle, shadows are sliding to the right. 0.43: =(4)= *A single frame shows the hand of a boy in the side street.* The bear has pushed the golliwog policeman to the ground. The horse has the other policeman in his mouth. The drunken man is still there lying down. 0.44: The light changed into diffuse grey. Apparently a cloudy day with spotty short shadows straight below the objects. 12 animated objects. 0.48: **White splice**. The white bear still fights with golliwog, also the horse and its rider. From the right the Royal Mail van enters the scene. Short moments of sun

No. of seconds	Total	No. of frames	Description of scene. (Total frame count of the film: 5267. Frame counter of the animation sequence starts at 2134; ends at 4863.) Count in seconds is at 24 fps. (At 16 fps 2.52 minutes.)
			streaks from the left on shop front in side street. 0.49: **White splice**. The light becomes greyish and is changing several times. The Royal Mail van with a Dutch doll at the wheel drives to the left. In the foreground are geese, a little China man, a horse and rider, a policeman, a princess doll and a little wagon-and-horse.
0.51-1.03	12	1236	=FIFTH POSSIBLE DAY PERIOD WITH ANIMATION SESSIONS-12 SECONDS= 0.52: Dirty physical **wet splice** in our print, and jump: the Royal Mail van leaps backwards. The set is lighter. The camera moved to the right, the pillar-box at the left and the shops are in slightly different positions. The frames repeat exactly the preceding 8 frames as if the animation was repeated. Two geese shall attack the drunken man.
		1283	0.53: A repair **tape splice** in the copy causes two frames to be out of focus. Light is still diffuse. 0.55: The golliwog policeman enters the scene. From the right a white XL-Allseeds van enters from the back. The policeman picks up a goose, other one attacks him. Clear sunlight comes from left causing long shadows. 10 animated objects. 0.58: Sunstreaks are on the shop front in the side street. There is a big shadow from the left to the right side of the set. 1.00: The monkey takes the other goose with him. Long shadows. 1.01: **White splice**. Motor-bus enters from the side-street.
1.03-1.23	20		=SIXTH POSSIBLE DAY PERIOD WITH ANIMATION SESSIONS-20 SECONDS= 1.03: **White splice**. Alternating grey light in general. There is a jump, the camera is slightly moved to the right, the pillar-box is now to the left. Obviously, a new animation session. A vague sun shines from the right with very diffuse light. XL-Allseeds van drives from

No. of seconds	Total	No. of frames	Description of scene. (Total frame count of the film: 5267. Frame counter of the animation sequence starts at 2134; ends at 4863.) Count in seconds is at 24 fps. (At 16 fps 2.52 minutes.)
		1855 1888 2052	the centre to the left. At the right of it appears a little wagon-and-horse. The princess doll gets out of the XL-Allseeds van which produces smoke from its funnel. The policeman puts her on the milk-van pushed by the monkey. The motor-bus disappears at the back. 1.06: **White splice** causes frame out-of-focus. XL-Allseeds van appears from the side-street. Light is diffuse and shadowless. Royal Mail van comes from the left. 1.11: =(5)= *A single frame with head and arm of Bert Cooper at the right animating the black Royal Mail van.* A Dutch doll pulls at the princess doll in a hand cart. 1.13: =(6)= *A single frame with shoulder and arm of Bert Cooper who, from the right, animates the Royal Mail van.* 1.15: **White splice.** Monkey and policeman are fighting in the foreground. A man with cap is tumbling about. 1.17: **White splice.** A jump in animation. Royal Mail van comes from the back. A large Dutch doll enters.
1.23-1.37	14		=SEVENTH POSSIBLE DAY PERIOD WITH ANIMATION SESSIONS-14 SECONDS= 1.23: Nice **white splice.** The sun gives clear light from the right. The Dutch doll dances with monkey and policeman celebrating the end of their fight. The Royal Mail van comes from the right towards them and runs over the drunkard. 1.25: The sun shines from the right. The white bear enters on a steam engine. 1.26: **White splice.** The light changes, shadows are vague. Dutch doll walks to the right, monkey goes to the left. There is much traffic. Neutral grey light. Two figures are tumbling over each other for a long time. 1.32: The white bear and the monkey defy each other. Sun is at the left, making long shadows. 1.34: Filtered vague sunlight from the left. Gliding shadows on the side-street shop front. Long shadows

No. of seconds	Total	No. of frames	Description of scene. (Total frame count of the film: 5267. Frame counter of the animation sequence starts at 2134; ends at 4863.) Count in seconds is at 24 fps. (At 16 fps 2.52 minutes.)
			from the left, apparently late in the afternoon. The monkey challenges the white bear in its steam engine.
1.37-1.54	17	2730 (4863)	=EIGHT POSSIBLE DAY PERIOD WITH ANIMATION SESSIONS- 17 SECONDS= 1.37: **White splice**. Grey diffuse light. The monkey looks behind him to the white bear who hits him with a locomotive. In the centre is a little horse running around. 1.40: Grey light, sometimes some filtered sunlight from the right. 1.43: Clear and grey light alternate, sunlight from the right. 17 objects. 1.47: Sun is at the left. Dutch doll places traffic sign in centre foreground. 1.50: White bear runs with his locomotive over the traffic sign and collides with the motor-bus, ending up underneath both vehicles. The golliwog driver falls out of the bus, the other passengers too.
1.54-1.58	4	2830 (4964)	1.54: **White splice** onto live-action scene. The motor-bus is on fire, smoke comes out of it. Scene is being filled with white smoke. 1.58: **White splice** into white sheets of the little boy's bed.
TOTAL	1.58		25 splices. 6 single frames with animators in view.

At the start in this print: 1 physical wet splice. Half-way this print: 1 physical wet splice & 1 physical tape splice; visible negative splices: 1 dirty white splice (negative repair); 23 white editing splices.

Animation sessions: four times of 1 second; four times of 2 seconds; three times of 3 seconds; five times of 4 seconds; one time of 5 seconds; four times of 6 seconds; and one time each of 8, 9, 11 and 16 seconds.

Appendix 3
More than 300 Films
made by Cooper

Preliminary list of films made by Arthur Melbourne-Cooper based on:
- 17 tape recorded interviews with Arthur Melbourne-Cooper,
- seven publications by Denis Gifford,
- handwritten list of films by Mrs Kate Melbourne-Cooper authorized by her husband,
- Alpha advertisement in *Kinematograph and Lantern Weekly*, 5 March 1908,
- Alpha Cinematograph Catalogue of films.
- The American Film Institute Catalogue.
- manuscript *Portrait in Celluloid* by Cooper's biographer John Grisdale.

1895
Arrest of a Pickpocket
(Study in) Black and White (Washing)
Carpenter's Lunch, a.k.a. Carpenter's Meal Time
Ladies Cycling Against the Wind
Spilt Milk
Twins Tea Party

1896
Barnet (Horse) Fair
Barnet Local Militia
Brighton Beach
Changing the Guard
Children Quarrelling
Children Playing
Comic Sports at Park Street
Frogmore Sports
Girls Crossing Pontoon Bridge at Henley

Golfing Extraordinary
Hyde Park Cycling
Keen's Mustard
Launch of the Daily Mail
Little Bread Winner, The
Maypole Dance
Our Farmyard Friends
Penny Steamer Passing Westminster Pier
Pettycoat Lane on Sunday Morning
Picking up Mails at 60 Miles per Hour at New Barnet
Pierrot and Pierrette
Pillow Fight
Platt Betts Bicycle Race
Rush Hour at London Bridge
Six Day Cycling Race at Crystal Palace
Stockton-on-Tees, Felling a Chimney
Under the Clock of Westminster

Visit to the Zoo, A
X-Ray Fiend, The

1897

Bird's Custard
Charge of the Queen's Lancers on
 Salisbury Plains
Charge of the 17th Lancers at
 Aldershot
Collier's Tyres New Invention
Dollie's (Dorothy's) Wedding Cake
Ducks for Sale or Return
Dunlop's Pneumatic Tyres
Father Goes Fishing
Holder's Bakery
Ungallant Lover, The
Washing (Bathing) the Baby
Workers Leaving Vickers' Factory
 (1897 ?)

1898

Dancing at the Crystal Palace
Donkey Ride at Hasting Sands
 (1898?)
Falling of a Monarch, The (1898?)
Fireworks at Crystal Palace
High Diving at Tunbridge Wells
High Diving for Girls at Tunbridge
 Wells
In the Good Old Times
Magic Apple, The
Pancake Race (1898?)
Semi-Final Southampton-Sheffield
 United FC, 19 March 1898
Village Blacksmith in Dumb Motion,
 The
W.C. Grace Leaves Lord's
Water Polo at Tunbridge Wells

1899

Animated Matches Playing Cricket
Animated Matches Playing Volleyball
At Last That Awful Tooth
Briton versus Boer (Boer versus
 Briton)
Burning of Kruger's Effigy on Hadley
 Green

Charge of the 12th Lancers
High Life below Stairs
Leaving for the Boer War at
 Southampton
Matches Appeal
Soldier, Policeman and Cook
Southwark's Fire Brigade Turn-out
The Fireman's Snapshot
Trawlers Ahoy
Waltzing on the Lawn at Crystal
 Palace

1900

Car Ride (1900?)
Castle of Bricks, The
City Imperial Volunteers Marching
CIVs Boarding SS Garth Castle
Dame Clara Butt
Dan Leno's Cricket Match
Edna May in front of Her Mirror
Farmer Giles Goes to Market
Farmer Giles and His Portrait
Folkestone Military Tournament
Grandma's Reading Glass
It's No Use Crying over Spilt Milk
Little Doctor, The
Madame Cassavetti Putting on Her
 Jewelry
Netley Hospital
Night of Horror, A (1900?)
Panorama from a Steam Crane
Rifle Brigade Driving in an Enemy's
 Outpost
Shipwreck (The August) in a Gale, 15
 Feb. 1900
Sleep-all-Day Fire Brigade (1900?)
Snapshot Fiend, The- (1900?)
Soldiers Returning at Southampton
 from Boer War
Terrible Row in the Farmyard
What the Farmer Saw
Wild Man of Borneo, The

1901

Beer Barrels on the Loose (1901?)
(Lively) Cock Fight, A
Dolly's Toys

Queen Victoria's Funeral
Return of the City Imperial
 Volunteers

1902

Blind Man's Bluff
Boer War Troops Marching Past Lord
 Roberts
Cheese Mites
Coronation of Edward VII taken from
 the Canadian Arch
The Magic Syringe

1903

Bill Sykes Up-to-Date
Boy's Dream, A
Chatsworth Garden Party, 5 Feb. 1903
City and Suburban, The
Grand National, The
Great Yarmouth Herring Fishery
Launch of Sir Thomas Lipton's
 Shamrock III at Dumbarton, 17
 March 1903
Lincolnshire Handicap, The
National Lifeboat Demonstration at St
 Albans
Opening of Kew Bridge, (The King at)
 20 May 1903

1904

Blacksmith's Daughter, The
Enchanted Toymaker, The
Fat Boy of Peckham, The
Held to Ransom
Motor Valet, The
Motor Highway Man, The
Off for the Holidays
Smallest Railway in the World, The
Tramps in Clover
When the Cat's Away
Willie, Tim and the Motor Car

1905

Abbey Church Lad's Brigade
Bread Making by Machinery/The
 Staff of Life
Death of the Iron Horse

Doings in Dollyland
Ducking Stool, The
Empire's Money Maker, The/A Visit
 to the Royal Mint
Grandfather's Tormentors
His Washing Day
Life and Death of an Iron Horse, The
MacNab's Visit to London
Oh That Molar
Resurrection of Ramases (1905?)
Soapy Soup
St Albans Pageant
What Is It Master Likes So Much
Who's to Blame
Wonderful Hair Restorer, The

1906

Bonnie Scotland (1906?)
Catching Story, A
Deer Stalking
Eagle's Nest, The
Fairy Godmother, The
General Booth at Salvation Army
Guinea Entertainer, The
Happy Man, The
King Haakon's Coronation
Mad Poet, The
Motor Valet, The
Motor Pirate, The
Optician's Apprentice, The (1906?)
Picturesque North Wales series
Policeman's Love Affair, The
Rescued in Mid-Air
Resurrection of Ramases, The (1906?)
Robbing His Majesty's Mails
Scottish Herring Fishery at Great
 Yarmouth
Slippery Visitor, A
Target Practice
Visit to a Spiritualist, A
Willie Goodchild Visits His Aunt
Wreck of HMS Montague
Youth Regained

1907

Anarchist and His Dog, The
Animated Pillar Box, The

Bad Sixpence, The
Belles of Killarney, The
Between One and Two A.M.
Boy's Half Holiday, A
Butter Making
Dream of Toyland, A
English Husbands and Irish Wives
Her (Lottie's) (First) Pancake(s)
He Would Be an Athlete
His Saturday Wages
In Quest of Health
Leefoss Waterfalls (1907?)
Little Nell and Burglar Bill
London to Killarney
Luck of Life, The
Ora Pro Nobis
Poet's Bid for Fame, The
Professor Bunkum's Performing Flea
Reedham Orphanage Boys Fancy
 Drill
Reedham Orphanage Girls Fancy
 Drill
Seen at the Chiropodist
Spring Cleaning
Sunday's Dinner
When Women Rule the World
When Mistress Took Her Holiday
Wily Fiddler, The-
Woes of a Married Man, The

1908

Billie's Bugle
Boulter's Lock on Ascot Sunday
Cheekiest Man on Earth, The
Curate's Honeymoon, The
For An Old Love's Sake
Grandpa's Pension Day
Green's Goose
Hatching a Chicken in an Incubator
Hop Picking in Kent
In the Land of Nod
It's Just My Luck
Kaleidoscope, The
Little Stranger, The
Magical Matches
Matches Made in England
Oh Those Boys

Pair of Antique Vases, A
Plumber and the Lunatic, The
Tommy's Visit to His Aunt
Wreck of HMS Gladiator in the
 Solent, The, 25 April 1908

1909

Hastings Military Manoeuvres
Little Nell the Drunkard's Child
Noah's Ark
Sculptor's Dream, A

1910

Cats Cup Final, a.k.a. Cats Football
 Match
King Edward VII's Funeral from
 Edgeware Road, 20 May 1910
Oxford Street Up-to-Date
Toymaker's Dream, The

1911

King George V Coronation, 22 June
 1911
Road Hogs in Toyland
Topsy's Dream

1912

Blowing Bubbles
Cinderella
Courtier Caught, The
Day's Sport, A
Herncrake Witch, The
His First Sovereign
Land of the Nursery Rhymes, The
Life of a Racing Pidgeon, The
Manufacture of Walking Sticks, The
Mr Swanker Goes Shooting
Old Mother Hubbard
Saw Milling Industry, The
Sports in Moggyland
Ten Little Nigger Boys

1913

Beautiful Wales
Bottled Courage
Flying from Justice
Incorrigibles, The

Larks in Toyland
Lifeboat Rescue, A
Milling the Militants
Otter Hunting
Pat's Idea
Suffragette Derby
Trip on the River Medway, A

1914

Alone I Did It
Bill Wants British Washing
Bill's Return to Pictures
Construction of a Lifeboat
How to Make £2000
Humpty Dumpty Circus, The
Inn on the Heath, The

Lively Garden Produce
Man's Crossroads, A
One Up On Father
Tricked by His Pal
White Hope on Championship, The

1925-1930

Swiss Rolls, 1925
Clifton Chocolates, 1926
Clean Milk Campaign,1927
Churchman's Cigarettes, 1925-1930
Gladhill's Tills, 1925-1930
Gladhill's Clock-in Clock, 1925-1930
Moores Bread, 1925-1930
Paddy Flaherty Whiskey, 1925-1930

Appendix 4

17 Arthur Melbourne-Cooper

Audio Tapes Plus One[1]

Cooper mentions 282 times a film made by him: 173 different titles.

Reel 1 Visit to Sidney Birt Acres, Southend
Date recording: Sunday, 20 May 1956.
Location: Southend-on-Sea.
Persons: Arthur Melbourne-Cooper, Mrs Kate Melbourne-Cooper, Sidney Birt Acres (son of Birt Acres), Mrs Phyllis Birt Acres, Alan Acres, Doreen Acres (their son and daughter), Audrey Wadowska (daughter of Mrs and Mr Melbourne-Cooper).
Subjects: Birt Acres, R.W. Paul, Biograph, E.G. Turner, Kinetic Camera, Biograph, Mutoscope, Empire Theatre, Old Polytechnic, Picture Palace, animation technique, Wellington, Elliot's, Friese-Green, Walter Gibbons
Films: (25 titles mentioned): Derby 1895, Suffragette Derby 1913, Derby 1896, Picking up the Mails, Going through Hadley Tunnel, Spilt Milk, Henley Regatta 1895, Launch of the Albion, Coronation of King Edward VII, Queen Victoria's Funeral, London to Killarney, Grand National (1903 same evening shown at the Empire), Lincolnshire Handicap (1903 same evening shown at the Empire), Dream of Toyland, Matches Appeal, Ducks for Sale or Return, Cinderella, Cats Cup Final, Ten Little Nigger Boys, Noah's Ark, Motor Pirate, Resurrection of Ramases, The Magic Syringe, Birds Custard, Haycart crossing Hadley Green.

1. These tapes from the Audrey and Jan Wadowski estate plus copies on audio cassettes are now in the Arthur Melbourne-Cooper Archive of Tjitte de Vries and Ati Mul. Copies on cassette of a number of these tapes have been donated to the East Anglian Film Archive. All seventeen tapes are digitized on CD.

Original number:[2] Tape VI and 47; our file number[3] T001. Cd 1/17. Length: 50 min.

Reel 2 Christmas Family Meeting, Clapham
Date recording: Wednesday, 26 December 1956.
Location: Clapham.
Persons: Arthur Melbourne-Cooper, Mrs Kate Melbourne-Cooper, Bob and Ursula (daughter) Messenger, Audrey Wadowska and husband Jan Wadowski, Kenneth Melbourne-Cooper (youngest son), his wife Mary and children (two young daughters, Angela and Susan).
Subjects: Animated pictures, horror films, export, suffragettes, Stanley Collier, Ramona stencilling, Mrs Pankhurst, Jackeydawra Melford, Charles Urban.
Films (40 titles mentioned): Dream of Toyland, When the Cat's Away, Boy's Half Holiday, Cats' Cup Final (a.k.a. Cats' Football Match), Motor Valet, Oh That Molar, When Women Rule(d) the World, Little Stranger, Grandpa's Pension Day, Good Old Times, Village Fire Brigade, Resurrection of Ramases, Held to Ransom, Robbing His Majesty's Mails, Mad Poet, MacNab's Visit to London, In Quest of Health, Motor Pirate, Leaving for the Boer War, Charge of the 17th Lancers, Queen Victoria's Funeral, Coronation of King Edward VII, Launch of Sir Thomas Lipton's Shamrock at Dunbarton, Steelworks, Stockton-on-Tees, Bird's Custard, Keen's Mustard, Launch of the Albion, Animated Matches, Chatsworth House Party 1903, Grand National (same night), City and Suburban (1903), Lincolnshire Handicap (1903 won by Norton), Night of Horror, In the Good Old Times, Ducking Stool, Toymaker's Dream, The Trapper Trapped, The Silver King, King Haakon's Coronation.
Original number: Tape III; our file number T003. Cd 2/17. Length: 35 min.

Reel 3 BBC interview by Ernest Lindgren
Date recording: 11 July 1958.
Location: BBC radio, Broadcasting House, London. What's on Today.
Persons: Arthur Melbourne-Cooper; interviewed by Ernest Lindgren, curator National Film Archive; Audrey Wadowska (in the background).
Subjects: Birt Acres, celluloid, Kodak, Alpha, Picture Palace, animated films, *The Daily Telegraph*, Tunbridge Wells.

2. Original number is the number given by Audrey and Jan Wadowski.
3. 'Our file number' is the number given by us in our archive after copying the tapes to cassettes and digitizing them to CDs.

Films (9 titles mentioned): Matches Appeal, High Diving at Tunbridge Wells, Coronation of King Edward VII, Lincolnshire Handicap 1903 (same evening screened at the Empire Theatre, Leicester Square, London), Grand National 1903 (same evening screened at the Empire Theatre), Prince of Wales Opening the Cardiff Exhibition, Ducks for Sale or Return, Dream of Toyland, Return of the City Imperial Volunteers.
Original number: Tape XII; our file number T002. Cd 3/17. Length: 20 min.

Reel 4 Visit to Stan Collier, Aldeburgh (part 1/2)
Date recording: 20 July 1958.
Location: Aldeburgh, Suffolk.
Persons: Arthur Melbourne-Cooper, Stan Collier, Mrs Kate Melbourne-Cooper, Audrey and Jan Wadowski, Bob and Ursula Messenger.
Subjects: Hales' Tours, Old Poly, gas light, pipe smoking, meowing cats, Ernie Baker, Clark's Motor Cycle shop.
Films (14 titles mentioned): Dream of Toyland, Motor Pirate, London to Killarney, English Husbands and Irish Wives, Cat's Football Match, Sheffield, workers leaving factories, Squire Tightfist, Sergeant Brue, Dream of Toyland (Toy Town), Held to Ransom, Resurrection of Ramases, Curate's Honeymoon, Hale's Tours, Noah's Ark.
Original number: Tape X; our file number T090. Cd 4/17. Length: 60 min.

Reel 5 Visit to Stan Collier, Aldeburgh (part 2/2)
Date recording: 20 July 1958.
Location: Aldeburgh, Suffolk.
Persons: Arthur Melbourne-Cooper, Stan Collier, Mrs Kate Melbourne-Cooper, Audrey and Jan Wadowski, Bob and Ursula Messenger.
Subjects: Gorehambury, Lord Grimston, Brighton.
Films (3 titles mentioned): London to Brighton Walking Race, Motor Pirate, Robbing His Majesty's Mails.
Original number: Tape XI-B; our file number T091. Cd 5/17. Length: 60 min.

Reel 6 Cooper interviewed by Audrey Wadowska, Coton
Date recording: 20 July (?) 1958. Before (or after) visit to Collier (recorder test?)
Location: Lantern Cottage, Coton (near Cambridge).
Persons: Arthur Melbourne-Cooper, Audrey Wadowska.
Subjects: Southampton, CIV's, Boer War, Tunbridge Wells, railway carriage as dark room with milk churn.

Films (8 titles mentioned): High Diving at Tunbridge Wells, Water Polo at Tunbridge Wells, In Quest of Health, Soldiers Returning at Southampton from Boer War, Netley Hospital, Suffragette Derby of 1913, Boys Half Holiday, Grand National 1903.
Original number: Tape XI-A; our file number T050. Cd. 6/17. Length 10 min.

Reel 7 Cooper interviewed by Audrey Wadowska, Coton
Date recording: 1959 (before or early 1959).
Location: Lantern Cottage, Coton (near Cambridge).
Persons: Arthur Melbourne-Cooper, Audrey Wadowska.
Subjects: Biograph, Coronation, Mrs Chapman, Birt Acres, R.W. Paul, Warwick Trading Co., Joe Rosenthal, Anton Nöggerath Jr., Paris, Mutoscopes, Tunbridge Wells, Norman Whitton, colour films, Hepworth, Kinema Colour, Rosie Rosenthal, Jessie Forde, Empire Theatre, Dr Dobbs, Bartolli & Tate, the Polytechnique, Billy Jeapes, Harold Jeapes, Brixton, Moy cameras.
Films (12 titles mentioned): Coronation (from Canadian Arch), Madame Cassavetti Putting on Her Jewelry, Dame Clara Butt, Edna May in front of Her Mirror, School Children Leaving School (at Barnet?), Gardener and the Hose, Man with a Caravan, Belles of Killarney, Short Sighted Cyclist, Chatsworth House, Our Village Fire Brigade, Brighton (first trip).
Original number: Tape II-A; our file number T005. Cd 7/17. Length: 64 min.

Reel 8 Family Meeting for Cooper's birthday, Coton
Date recording: 15 April 1959.
Location: Lantern Cottage, Coton (near Cambridge).
Persons: Arthur Melbourne-Cooper, Mrs Kate Melbourne-Cooper, Audrey Wadowska, Ken Melbourne-Cooper, Jan Wadowski.
Subjects: Ivy Close, Ronald Neames, Alpha pictures, Gordon Selfridge, Letty (Blanche) Forsythe, Billy Jeapes, Salvation Army, Marshalswick Farm, Lord Grimston's camera, Kate O'Connor, 40,000 negatives of Thomas, Warwick Villa, sister Agnes.
Films (5 titles mentioned): London to Killarney, Irish Wives and English Husbands, Trips in Killarney, Spilt Milk, Brighton Beach.
Original number: Tape IX; our file number T009. Cd 8/17. Length: 64 min.

Reel 9 John Grisdale interviews Cooper, Coton (part 1/2)
Date recording: Early March 1960.
Location: Lantern Cottage, Coton (near Cambridge).
Persons: Arthur Melbourne-Cooper, John Grisdale, Audrey Wadowska.

Subjects: Alpha films, Birt Acres, R.W. Paul, Dave Aylott, Louis Wain.
Films (17 titles mentioned): High Diving at Tunbridge Wells, Motor Pirate, Optician's Apprentice, At the Chiropodist, At Last That Awful Tooth, MacNab's Visit to London, When Women Ruled the World, Ora Pro Nobis, Resurrection of Ramases, Night of Horror, Professor Bunkum's Performing Flea, Little Stranger, Coronation (from Canadian Arch), Held to Ransom, Cats' Cup Final, Our Village Fire Brigade, What the Farmer Saw.
Original number: Tape IV; our file number T043. Cd 9a/17 (cd4); cd 9b/17 (cd5). Length: 2 x 44 min.

Reel 10 John Grisdale interviews Cooper, Coton (part 2/2)
Date recording: Early March 1960.
Location: Lantern Cottage, Coton (near Cambridge).
Persons: Arthur Melbourne-Cooper, John Grisdale, Audrey Wadowska.
Subjects: Alpha films, Mrs Chapman, Birt Acres' camera, R.W. Paul, Victor Cavendish, Chatsworth, Billy Jeapes, brother Bert, Biograph, Koopman, Smedley.
Films (6 titles mentioned): Opening of Kew Bridge, Chatsworth Garden Party, Grand National (1903), City Suburban, Suffragette Derby of 1903, Coronation (Canadian Arch).
Original number: Tape V; our file number T044. Cd 10/17. Length: 46 min.

Reel 11 John Grisdale interviews Cooper, Coton (part 1/2)
Date recording: July 1960.
Location: Lantern Cottage, Coton (near Cambridge).
Persons: Arthur Melbourne-Cooper, Mrs Kate Melbourne-Cooper, John Grisdale, Mrs Grisdale, Audrey Wadowska.
Subjects: Salvation Army, family Cooper, Thomas Cooper, grandmother Rebecca, Clock Tower fountain, PC Pike, Acres camera, Alpha films, Birt Acres, R.W. Paul, Grimston's big camera, Abbey photographs, Ernie Baker, George Munroe.
Films (17 titles mentioned): Washing the Baby, Resurrection of Ramases, Pillow Fight, The Bookmaker, Shoeing the Horse, Study in Black and White, Spider on a Web, Blowfly Drinking, Dollie's Wedding (Birthday) Cake, Giles' Visit to London, London to Killarney, High Diving at Tunbridge Wells, Water Polo, Fireworks at the Crystal Palace, Curate's Honeymoon, Our Farmyard Friends, Spilt Milk.
Original number: Tape I-A; our file number T095. Cd 11a/17 (cd1), length 76 min.; cd 11b/17 (cd2), length: 21 min.

Reel 12 John Grisdale interviews Cooper, Coton (part 2/2)
Date recording: July 1960.
Location: Lantern Cottage, Coton (near Cambridge).
Persons: Arthur Melbourne-Cooper, Mrs Melbourne-Cooper, John Grisdale, Mrs Grisdale, Audrey Wadowska.
Subjects: Bedford Park, Birt Acres, Hepworth, Alpha, Christmas Show, Jessamin Forde, Maynard, pageant, Norman Reckitt, Sir Thomas Lipton, Joe Anderson.
Film (12 titles mentioned): Two Old Maids and a Bull, In Quest of Health, Grandpa's Pension Day, What the Farmer Saw, Black and White Washing, Willie Goodchilds Visits His Auntie, London to Killarney, St Albans Pageant of 1908, Oxford Pageant, Launch of the Shamrock III, Wreck of HMS Montague, Sculptor's Dream.
Original number: Tape I-B; our file number T096. Cd 12/17 (cd3). Length: 68 min.

Reel 13 Bert Barker of the British Fairground Society visits Cooper, Chiswick (part 1/2)
Date recording: Summer 1960. (Aug.)
Location: 100, Wavendon Avenue, Chiswick, London.
Persons: Arthur Melbourne-Cooper, Mrs Kate Melbourne-Cooper at 100 Wavendon Avenue, Chiswick, home of Jan and Audrey Wadowska, visited by Bert Barker, hon. secr. British Fairground Society; Mrs Barker, Mrs Ursula Messenger.
Subjects: Fair-grounds, snapshot camera, Hepworth, Coronation, Canadian Arch, Stockton-on-Tees, his first bicycle, Biograph, Mutoscopes, Sheffield summons, What the Butler Saw, Hales Tours, Mrs Chapman, Picture Palace, Notts Goose Fair.
Films (21 titles mentioned): Rush Hour at London Bridge, Henley Regatta (1896), Derby (1896), Coronation (from Canadian Arch), What the Farmer Saw, Fat Boy of Peckham, Wild Man of Borneo, The Untamed Shrew, Hale's Tours, Stockton-on-Tees: Felling a Chimney, Cup Final (Football Match) Southampton, Seven-Day Bicycle Race at Crystal Palace, Fireworks at Crystal Palace, Waltzing at Crystal Palace, Spilt Milk, (Lively) Cock Fight, Farmyard Quarrels, Scenes at a Farmyard, Falling of a Monarch, Picture (Study) in Black and White, Professor Bunkum's Performing Flea.
Original number: Tape XIII; our file number T006a. Cd 13a/17 (cd 1/3); cd 13b/17 (cd 2/3). Length: 80 min.

Reel 14 Bert Barker of the British Fairground Society visits Cooper, Chiswick (part 2/2)
Date recording: Summer 1960 (Aug.)
Location: 100 Wavendon Avenue, Chiswick, London.
Persons: Arthur Melbourne-Cooper, Mrs Kate Melbourne-Cooper at 100 Wavendon Avenue, Chiswick, home of Jan and Audrey Wadowska, visited by Bert Barker, hon. secr. British Fairground Society; Mrs Barker, Mrs Ursula Messenger.
Subjects: The Fall of Troy, Charles Thurston, carbide light, Lord Grimston, chucker-out, Pathé robbery of Cooper's Motor Pirate.
Films: (12 titles mentioned): Cavalry Scene, Family Scenes, Washing the Baby, Baby's Toilet, The Little Stranger, The Wild Man from Borneo, Architect's Apprentice, Two Chinamen, Mesher and Nurse Maid, The Optician's Apprentice, The Resurrection of Ramases, The Motor Pirate.
Original number: Tape XIV; our file number T006b. Cd 14/17 (cd 3/3). Length: 50 min.

Reel 15 Cooper interviewed by Audrey Wadowska, Coton
Date recording: August 1960.
Location: Lantern Cottage, Coton (near Cambridge).
Persons: Arthur Melbourne-Cooper, Audrey Wadowska.
Subjects: Thomas Cooper, Birt Acres' start, Bertha Randall, announcing films, girl under train trick, mail trains, upside down camera, going through old catalogues, Cooper dictating what to write and what not to write.
Films (25 titles mentioned): The Village Blacksmith, The Village Blacksmith in Dumb Motion, Barnet Local Militia, Scenes at Barnet Fair, Ladies Cycling against the Wind, Pillow Fight, Changing the Guard, Westminster Penny Steamer, Under the Clock of Westminster, Picking up the Mails at 60 Miles per Hour, When Lovers Fall Out, Train Coming out of Hadley Tunnel, Charge of the 17th Lancers, London to Killarney, Britain versus Boer, What the Farmer Saw, High Diving at Tunbridge Wells, Water Polo at Tunbridge Wells, The King Opening Kew Bridge, Fireworks Display at Crystal Palace, Held to Ransom, Spilt Milk, Resurrection of Ramases, Shoeing a Horse, Children Playing.
Original number: Tape XV; our file number T047. Cd 15/17. Length: 37 min.

Reel 16 Cooper interviewed by Audrey Wadowska, Coton
Date recording: 2 September 1960.
Location: Lantern Cottage, Coton (near Cambridge).
Persons: Arthur Melbourne-Cooper, Audrey Wadowska.
Subjects: Grandma's Reading Glass, Grisdale ms., Cooper's history career and films, Birt Acres, R.W. Paul, films at fair-grounds, Jessamin Forde, Cooper's marriage, Letchworth fires, man trying to stop sheep, parson and praying donkey on Hastings sands, snapshots of Abbey, 45 Salisbury Road, Crystal Palace, Cardiff Exhibition, Dick Cash, Henley Regatta: enjoy yourself, Friese-Greene, Charlie Moores, Warwick developing Boer War films, Doctor Dobbs, Norma Lavers, Butcher's, Kinema Industries, poultry farming at Eastwood.
Films (37 titles mentioned): Ducks for Sale or Return, The House of Bricks, Picking up the Mails, Rough Sea at Dover, The Cat's Path, An Eagle's Nest (Searching for), Deer Stalking, Bathing the Baby (Washing the Baby?), Carpenter and the Sweep, Carpenter's Lunch (Carpenter's Meal Time), Miller and Sweep, His Saturday Wages, Stopping the Sheep, Father Buys a Donkey, Waltzing on the Lawn at Crystal Palace, Fireworks at Crystal Palace, Seven Days Cycling Race (at Crystal Palace), Derby of 1895, What the Farmer Saw, Dream of Toyland, Motor Pirate, Pancake Race, Grandma's Reading Glass, Water Polo at Tunbridge Wells, High Diving at Tunbridge Wells, Bonnie Scotland, London to Killarney, In the Good Old Times, Fire Brigade Turn-out, Spilt Milk, Study in Black and White, Mother's Washing Day, Village Racing (Sack Racing), Comic Sports at Park Street, Britain versus Boer, The City Imperial Volunteers (CIVs), Resurrection of Ramases, In Quest of Health.
Original number: Tape VIII; our file number T068. Cd 16/17. Length: 73 min.

Reel 17 Cooper interviewed by Audrey Wadowska, Coton
Date recording: Easter 1961.
Location: Lantern Cottage, Coton (near Cambridge).
Persons: Audrey Wadowska, Arthur Melbourne-Cooper.
Subjects: Hales Tours, Killarney, Alpha, career, fair-grounds, Billy Jeapes, Free Masons, Brides First Night.
Films (19 titles mentioned): London to Killarney, Hale's Tours, Study in Black and White, Pancake Races, Sack Racing, Grandpa's Pension Day, Our Village Fire Brigade, Mayday, Morris Dancing, Dancing at the Crystal Palace, What the Farmer Saw, Jack's Day Ashore, Life and Death of an Iron Horse, Father Buys a Donkey, Hanging out the Clothes, London to

Killarney, Butter Making, Belles of Killarney, Bonnie Scotland.
Original number: Tape VII side B; our file number T007. Cd 17/17. Length: 32 min.

(Plus a reel with an interview by John Grisdale with Alpha actor Roger Pamphilon made during the same time as his interviews with Arthur Melbourne-Cooper.)

Reel 18 John Grisdale interviews Roger Pamphilon, Luton
Date recording: 2 September 1960.
Location: Beachwood Green, Luton, Beds.
Persons: John Grisdale, Mrs Grisdale, Roger ("Pam") Pamphilon, child actor in Alpha Pictures (later draper).
Subjects: Boy star in 50 films, Snowman, Picture Palace, making film joins, Cadbury's melted chocolate in Letchworth, Stanley Collier, Bert Cooper in WW-I.
Films: (5 titles mentioned by Pamphilon/Grisdale): Motor Pirate, Grandpa's Pension Day, Opening of Kew Bridge, London to Killarney, On Front of a Steam Engine.
Original number: Tape VII side A; our file number T004. Length: 32 min.

Bibliography

*"If we have seen further, it is by
standing on the shoulders of giants."*
With reference to Sir Isaac Newton.

Account of Sources

I. Publications

Anon., 'How Bioscope Records Are Made', in *Herts Advertiser & St Albans Times*, 13 March 1909.

Anon., 'Late Honour', in *New Zealand and Cambridge Daily News*, Dunedin Press, June 1957.

Anon., 'Animated Picture', *Technology*, October 1959.

Anon., 'Mr. A. Melbourne-Cooper, A Pioneer in the Cinema', *The Times*, Thursday, 7 December 1961.

Anon., 'Arthur Melbourne-Cooper', in *Newsletter No 12*, Society for Film History Research, January 1962.

Anon., 'Father of Animation'. in *BFI-Newsletter*, no. 9, January 1974.

Anon., 'Wholly Moses. Campaign Diary', Cambridge Animation festival, in *"Eastword"*, Eastern Arts Association, 19 October 1979.

Anon., 'Pre-Disneyland', *The Daily Telegraph*, Friday, 9 November 1979.

Anon., 'Posthumous Fame for Film Pioneer', *Review and Express*, Thursday, 15 November 1979.

Anon., 'Hommage Arthur Melbourne-Cooper', in *JICA 81, Bulletin Quotidien des Journées Internationales du Cinema D'Animation*, No. 6, Festival d' Annecy, Sunday, 14 June 1981.

Aubert, Michelle, et al, *The Will Day Historical Collection of Cinematograph & Moving Picture Equipment*, Paris, ("1895", No. hors-série, Ass. Française de Recherche sur L'Histoire du Cinéma), Octobre 1997.

Bendazzi, Giannalberto, 'Fiammiferi superstar' (Matchsticks superstar),[4] in *Il Sole 24 Ore*, weekly cultural supplement of the daily newspaper, 14 August 2005.

4. Translation thanks to Fr Nico van der Drift osb

Burrows, Elaine, 'Live Action. A Brief History of British Animation', in *All Our Yesterdays*, Charles Barr (ed.), BFI Publishing, London 1986

Blom, Ivo, 'Chapters from the life of a camera-operator. The recollections of Anton Nöggerath filming news and non-fiction, 1897-1908', in *Film History*, Volume 11, no. 3, 1999, pp. 262-281.

Brown, Geoff, 'Supporting Programmes', *Monthly Film Bulletin*, BFI, June 1976, as quoted in National Film Theatre Programme Notes, 'No Strings. Puppet Animation in the Cinema'.

Clark, Ken, 'Early Pioneers', in *Cambridge Animation Festival November 9th-14th*, Arts Cinema, Cambridge, Eastern Arts Association, 1979.

Coe, Brian, 'Appreciation of the Origins of Cinematography', in *British Kinematography*, Vol. 27, No. 6, December, 1955.

Collins, W.J., (dir. Pearl, Dean and Youngers) 'Advertising was there from the very start', in *Kinematograph Weekly*, 3 May 1956.

Collins, W.J., (dir. Pearl & Dean Ltd), 'Advertising was in at the beginning', in *Supplement to World's Press News*, 11 May 1956.

Crangle, Richard, 'Actuality and Life. Early Film and the Illustrated Magazine in Britain', in *Cinema at the Turn of the Century*, Éditions Nota bene/Payot, Quebec/Lausanne, 1999.

Curtis, Joe, 'Pioneer of the film industry. Mr. Arthur Melbourne-Cooper', in *Hertfordshire Countryside*, Vol. 15, no. 57, 1960.

Dixon, Luke, 'Taking off for the stars', in *Weekly Review, Barnet Press*, 25 July 1980.

Dixon, Luke, 'A forgotten visionary', in *Weekly Review, Barnet Press*, 29 August 1980.

Donaldson, G.N., 'Wie is Wie in de Nederlandse Film (Who is Who in Dutch Film). Nöggerath, Franz Anton, Senior', in *Skrien*, no. 128, Zomer 1983, pp. 34-36.

Field, Bill, 'The unsung pioneers of the world of celluloid', in *Barnet Press*, 24 Sept. 1965.

Freedman, Morris, 'First Animated Cartoons', *Radio Times*, 8 March 1957.

Hansford, Gordon, 'Arthur Melbourne-Cooper 1874-1961. Pioneer of the British Film Industry', *St Albans Film Society*, 23 October 1973.

Maynard, H., 'An Employee of Charles Urban Recalls "The Old Days", in *Kinematograph Weekly*, 13 November 1947.

Morrison, Stuart, 'Arthur's magic art', in *Evening-Post Echo*, 11 January 1982.

Riggs, Ronald, 'The Forgotten Movie Pioneer', *Herts Advertiser*, 28 June 1974.

Slide, Anthony, 'A Tribute to Arthur Melbourne-Cooper', in *Flickers The Journal of the Vintage Film Circle*, No. 25, Summer 1967.

Sesonske, Alexander, 'The Origins of Animation', in *Sight & Sound*, Summer 1980.

Turner, E.G., 'First film cartoon', in: *Evening News*, 17 November 1955.

Vooys, Is. P. de, 'De Kinematograaf in de Litteratuur'. *Bew.*, Jan. 1910.

Vries, Tjitte de, 'Pionier maakte duizend films: Arthur Melbourne-Cooper', *Het Vrije Volk*, 16 September 1974.

Vries, Tjitte de, 'Sound-on-Disc Films 1900-1929 and the Possibilities of Video Transfer', in *Cinema 1900/1906. An Analytical Study*, Brussels (FIAF), 1982.

Vries, Tjitte de, 'George Albert Smith ontmaskerd: naar een ontmythologisering van de Engelse filmgeschiedenis', in *Skrien* 148, 1986.

Vries, Tjitte de, 'Gevecht om 'première' van de filmpioniers: Frans, Brits, Amerikaans of Duits, in *Het Vrije Volk*, 22 February 1987.

Vries, Tjitte de, 'Arthur Melbourne-Cooper, film pioneer: wronged by film history', in

KINtop, Jahrbuch zur Erforschung des Frühen Films, Frankfurt am Main (Stroemfeld/Roter Stern), 1994.

Vries, Tjitte de, 'Animated Matches of 1899 still in existence', *Alpha Tidings,* Vol. I, no. 5, December 1998.

Vries, Tjitte de, 'The case for Melbourne-Cooper', in *Film History,* Vol. 12, No. 3, Eastleigh (John Libbey), 2000.

Vries, Tjitte de, 'Arthur Melbourne-Cooper (1874-1961), a Documentation of sources concerning a British film pioneer', in *KINtop, Jahrbuch zur Erforschung des Frühen Films,* Frankfurt am Main (Stroemfeld/Roter Stern), Autumn 2005.

Vries, Tjitte de, 'Arthur Melbourne-Cooper (1874-1961), British film pioneer, pioneer of stop-motion pictures', lecture, *Netherlands Institute of Animation Films (NIAf),* Tilburg, 21 September 2005.

Wadowska, Audrey, 'Do you remember', in *The World's Fair,* Saturday, 24 Nov. 1956.

Wadowska, Audrey, Recollections (extract), 'When They Made Films in St Albans', *St Albans and District Gazette,* Friday, 18 January 1957.

Wadowska, Audrey, 'The oldest purpose-built cinema', in *Hertfordshire Countryside,* vol. 25, no 135, 1970.

Wadowska, Audrey, Arthur Melbourne-Cooper Motion Picture Pioneer', lecture to the Motion Picture Group of the Royal Photographic Society, January 26, 1977, published in *Film Collecting,* No. 3, Fall 1977; No. 4, Winter 1977/78; No. 5, Fall 1978.

Wadowska, Audrey, 'Arthur Melbourne-Cooper: Motion picture pioneer', in *Film Collecting,* no. 3, August 1977.

Wadowska, Audrey, and Tjitte de Vries, 'The Films of Arthur Melbourne-Cooper', in *Cinema 1900/1906. An Analytical Study,* Brussels (FIAF), 1982.

Wheeler, Anne, and Tony Stevens, 'Arthur Melbourne-Cooper', in *Around St Albans,* Stroud (Tempus), 2001.

Williams, David, 'How it all began...', *Film Making,* Vol. 18, no. 9, September 1980.

Wyatt, David, Stephen Herbert, *Fifth Animation Festival Scala Cinema,* London, 10 January 1981.

2. Cinematography – Animation

Bendazzi, Giannalberto, *Cartoons. One hundred years of cinema animation,* London (John Libbey), 1994.

Bocek, Jaroslav, *Jiri Trnka, Artist and Puppetmaker,* London (Paul Hamlyn), 1963.

Crafton, Donald, *Before Mickey. The Animated Film 1898-1928,* Cambridge Mass./London (The MIT Press), 1982/1987.

Crafton, Donald, *Emile Cohl, Caricature, and Film,* Princeton (University Press), 1990.

Dale, Rodney, *Louis Wain. The Man who drew Cats,* London (Chris Beetles), 1991.

Halas, John and Roger Manvell, *The Technique of Film Animation,* London (Focal Press), 1987.

Halas, John, *Masters of Animation,* London (BBC Books), 1987.

Heraldson, Donald, *Creators of Life, a History of Animation,* New York/London (Drake), 1975.

Holman, L. Bruce, *Puppet Animation in the Cinema. History and Technique,* New York/London (Barnes/Tantivy), 1975.

Rich, Ruby, Marcin Gizycki, Jayne Pilling, Ruth Baumgarten, *Starewicz 1882-1965,* Edinburgh (37th Edinburgh Film Festival), 1983.

Robinson, David, *Masterpieces of Animation 1833-1908*. Griffithiana. Pordenone (La Cineteca del Friuli), 1991.

Vries, Tjitte de, and Ati Mul. *Joop Geesink, Poppenfilmproducent*, Rotterdam (Kersten Realisaties), 1984.

Vries, Tjitte de, *Tien jaar Holland Animation. Rembrandt's filmende erfgenamen*, Rotterdam (Kersten Realisaties), 1983.

3. Cinematography – Relevant Sources

Abel, Richard, ed., *Encyclopedia of Early Cinema*, London/New York (Routledge), 2005.

Armes, Roy, *A Critical History of British Cinema*, London (Secker & Warburg), 1978.

Barr, Charles, ed., *All Our Yesterdays, 90 Years of British Cinema*, London (BFI Publishing), 1986.

Blom, Ivo, *Pionierswerk. Jean Desmet en de vroege Nederlandse filmhandel en bioscoopexploitatie (1907-1916)*, Amsterdam (private), 2000.

Blom, Ivo, *Jean Desmet and the Early Dutch Film Trade*, Amsterdam (University Press), 2003.

Buckle, Richard, *The Observer Film Exhibition, Sixty Years of Cinema*, London (Observer), 1956.

Carrière, Jean-Claude, *The Secret Language of Film*, London (Faber and Faber), 1995.

Coe, Brian, *The History of Movie Photography*, London, (Ash & Grant), 1981;

Cook, Olive, *Movement in Two Dimensions*, London (Hutchinson), 1963.

Hazell, Frank, 'The Diamond Jubilee Diary 1896-1956', *Kinematograph Weekly*, London, 3 May 1956.

Hecht, Hermann, Ann Hecht, ed., *Pre-Cinema History*, London, (BFI/Bowker, Sauer), 1993;

Hendricks, Gordon, *Origins of the American Film*, New York (Arno Press & The New York Times), 1972.

Herbert, Stephen, and Luke McKernan, *Who's Who of Victorian Cinema*, London (BFI Publishing), 1996.

Holman, Roger, ed. *Cinema 1900/1906. An Analytical Study by the National Film Archive (London) and the International Federation of Film Archives*, Brussels (FIAF), 1982.

Hopwood, Henry V., *Living Pictures. Their History, Photo-Production and Practical Working*, London, (Opticians & Photographic Trades Review), 1899/New York (Arno Press & The New York Times), 1970.

Kessler, Frank, *Het idee van vooruitgang in de mediageschiedschrijving* (The idea of progress in media historiography), Utrecht (Utrecht University), 2002.

Kuhn, Annette, and Sarah Street, ed. 'Audiences and Reception in Britain', *Journal of Popular British Cinema*, Trowbridge (Flicks Books), 1999.

Lange-Fuchs, Hauke, *Birt Acres, der Erste Schleswig-Holsteinische Film Pionier*, Kiel (Walter G. Mühlau), 1987.

Lange-Fuchs, Hauke, *Der Kaiser, der Kanal und die Kinematographie*, Schleswig (Landesarchiv Schleswig-Holstein), 1995.

Liesegang, Franz Paul, Hermann Hecht, ed., *Dates and Sources. A contribution to the history of the art of projection and to cinematography*, London (Magic Lantern Society), 1986;

Low, Rachel, *The History of the British Film 1906-1914*, London (Allen & Unwin), 1948/1973.

March Hunnings, Neville, *Cinema Studies, Volume I + II*, London (Society for Film History Research), 1960-1967.

Malthête-Méliès, Madeleine, *Méliès. L'Enchanteur*, Paris (Hachette), 1973.

Mannoni, Laurent, et al, *Light and Movement. Incunabula of the Motion Picture*, Pordenone (Le Giornate del Cinema Muto), 1995.

Mitry, Jean, *Esthétique et psychologie du cinéma*, Vol. 1, Paris (Éditions Universitaires), 1965.

Mitry, Jean, *Histoire du Cinéma, I. 1895-1914*, Paris (Éditions Universitaires), 1967.

Remise, Jac, et al, *Magie Lumineuse*; Tours (Balland), 1979.

Robertson, Patrick, *The Shell Book of Firsts*, London (Ebury & Michael Joseph), 1974.

Robertson, Patrick, *The New Shell Book of Firsts*, London (Headline Book), 1994/1995.

Robertson, Patrick, *The Guinness Book of Film Facts and Feats*, Enfield (Guinness), 1980.

Robertson, Patrick, *Guiness Film Facts and Feats*, Enfield (Guinness), 1985.

Robertson, Patrick, *The Guinness Book of Movie Facts and Feats*, Enfield (Guinness), 1988.

Robertson, Patrick, *The Guinness Book of Movie Facts & Feats*, New York (Abbeville), 1991.

Rossell, Deac, *Living Pictures. The Origins of the Movies*, Albany (State University of NY Press), 1998.

Sadoul, Georges, *Histoire du Cinéma*, Paris (Librarie Flammarion), 1962.

Sadoul, Georges, *Histoire du Cinéma Mondial, des origins a nos Jours*, Paris (Flammarion), 1949/1974.

Sadoul, Georges, *Histoire Générale du Cinéma, II, Les Pionniers du Cinéma (de Méliès à Pathé) 1897-1909*, Paris (Les Éditions DeNoël), 1947.

Sadoul, Georges, *British Creators of Film Technique, British Scenario Writers, the creators of the language of D.W. Griffith, G.A. Smith, Alfred Collins and some others*, London (BFI), 1948.

Salt, Barry, *Film Style and Technology: History and Analysis*, London (Starword), 1983.

Spehr, Paul C., *The Movies Begin. Making Movies in New Jersey 1887-1920*, Newark NJ (Newark Museum), 1977.

Tibbets, John C., ed., *Introduction to the Photoplay*, Shawnee Mission, Kansas (National Film Society Inc.), 1977.

Toulet, Emmanuelle, *Cinema is 100 years old*, London (Thames and Hudson), 1995.

Warren, Patricia, *The British Film Collection 1896-1984. A History of the British Cinema in Pictures*, London (Elm Tree Books), 1984.

Whitmore, Richard, *Of Uncommon Interest*, Bourne End (Spurbooks), 1975.

Whitmore, Richard, *Hertfordshire Headlines*, Newbury (Countryside Books), 1987.

Winn, Christopher, *I Never Knew That About England*, London (Ebury Press), 2005.

4. Cinematography – Gifford

Denis Gifford, *British Cinema, an Illustrated Guide*, London/New York (Zwemmer/Barnes), 1968.

Denis Gifford, *The British Film Catalogue 1895-1970*, Newton Abbott (David & Charles), 1973.

Denis Gifford, *The illustrated Who's Who in British Films*, London (Batsford), 1978.

Denis Gifford, *The British Film Catalogue 1895-1985*, Newton Abbott/London (David & Charles), 1986.

Denis Gifford, *British Animated Films 1895-1985*, Jefferson NC and London (McFarland), 1987.

Denis Gifford, *American Animated Films: The Silent Era, 1897-1929*, Jefferson NC and London (McFarland), 1990.

Denis Gifford, *The British Film Catalogue Volume 1, Fiction Films, 1895-1994*, London/Chicago (Fitzroy Dearborn), 2000.

5. Literature – Anglo-Boer War

Barthorpe, Michael, *Slogging over Africa. The Boer Wars 1815-1902*, London (Cassell), 1987.
Childs, Lewis, *Ladysmith The Siege,* series *Battleground South Africa*, Barnsley (Pen & Sword Books), 1999.
Churchill, Winston, *The Boer War*, London (Pimlico), 2002.
Farwell, Byron, *The Great Boer War*, London/New York (Random House), 1976.
Fremont-Barnes, Gregory, *The Boer War 1899-1902*, Essential Histories, Oxford (Osprey Publishing), 2003.
Germishuys, Pieter, 'Flickering Past', in *South African Panorama*, Vol. 8 No. 5, Pretoria, May 1963.
Jackson, Tabitha, *The Boer War*, London (Channel 4 Books/Macmillan), 1999.
Judd, Denis, and Keith Surridge, *The Boer War*, London (John Murray), 2003.
Mackinnon, Major-Gen. W.H. , *The Journal of the C.I.V. in South Africa*, London (John Murray), 1901.
Pakenham, Thomas, *The Boer War*, London (Abacus), 2004.
Scheibert, J., *Der Freiheitskampf der Buren und die Geschichte ihres Landes*, Berlin (A. Schröder Verlag), 1902.
Sparks, Allister, *The Mind of South Africa*, London (Heineman), 1990.
Wetton, Thomas C., *With Rundle's Eighth Division in South Africa*, Uckfield (reprint by The Naval & Military Press Ltd), 2005
Zweers, Louis, *De Boerenoorlog, Nederlandse fotografen aan het front*, The Hague (SDU), 1999.

6. Literature – Related Subjects

Barthes, Roland, *Het plezier van de tekst. (Le plaisir du texte)*, Nijmegen (Sun), 1986.
Beeton, Mrs Isabella, *The Book of Household Management*, London (Ward, Lock & Co.), 1899.
Carter, Paul, and Kate Thompson, *Sources for Local Historians*, Chichester (Phillimore), 2005.
Cunliffe, Marcus, *The Age of Expansion 1848-1917*, Springfield, Mass. (G&C Merriam), 1974
Dibbets, Karel, and Frank van der Maden (ed.), *Geschiedenis van de Nederlandse Bioscoop tot 1940* (History of the Dutch Cinema till 1940), Weesp (Wereldvenster), 1986
Donohue, Joseph, *Fantasies of Empire. The Empire Theatre of Varieties and the Licensing Controversy of 1894.* Iowa City (University of Iowa Press), 2005.
Dresden, S., *Over de biografie*, Amsterdam (Meulenhoff), 1987.
Earl, John, *British Theatres and Music Halls.* Buckingham (Shire), 2005.
Eekelen, Yvonne van (ed.), *Magisch Panorama. Panorama Mesdag, een belevenis in ruimte en tijd*, Zwolle (Waanders), 1996.
Evans, George Ewart, *Where Beards Wag All. The Relevance of the Oral Tradition*, London (Faber and Faber), 1970.
Haveman, Mariëtte, et al, *Ateliergeheimen. Over de werkplaats van de Nederlandse kunstenaar vanaf 1200 tot heden* (Studio Secrets. About the workshop of the Dutch artist from 1200 till the present day), Lochem/Amsterdam (Kunst en Schrijven), 2006.
Hobsbawm, E.J., *The Age of Empire. 1875-1914*, London (Weidenfeld and Nicolson), 1987.
Jacques, Faith, *The Orchard Book of Nursery Rhymes*, London (Orchard Books), 2000.

Martignoni, Margaret E., ed., *The Illustrated Treasury of Children's Literature*, London (Book Club Associates), (1960) 1974.

Mul, Ati, *Straatspelen, verdwenen kindercultuur* (Street games, a lost children's culture), Lelystad (Stichting IVIO: AO-reeks), 1974.

Opie, Robert, comp., *The Victorian Scrapbook*, London (New Cavendish Books), 1999.

Opie, Robert, comp., *The Edwardian Scrapbook*, London (pi Global Publishing), 2002.

Opie, Robert, comp., *The 1910's Scrapbook*, London (New Cavendish Books), 2000/2003.

Opie, Robert, comp., *The 1920's Scrapbook*, London (New Cavendish Books), 2003.

Opie, Robert, comp., *The 1930's Scrapbook*, London (pi Global Publishing), 1997/2007.

Sheail, Philip, *Wilfred Buckley of Moundsmere and the Clean Milk Campaign*, Hampshire County Council, 2003.

St John Parker, Michael, *Life in Victorian Britain*, Andover (Pitkin), 2004.

Wilson, A.N., *The Victorians*, London (Hutchinson), 2002.

7. Cinematography – General

Ayles, Allen, *Cinemas of Hertfordshire*, Hatfield (University of Hertfordshire Press), 2002.

Barnes, John, *The Beginnings of the Cinema in England*, London (David & Charles), 1976.

Barnes, John, *The Beginnings of the Cinema in England 1894-1901*, Vol. I-V. Exeter (University of Exeter Press), 1998.

Benfield, Robert, *Bijou Kinema. A History of Early Cinema in Yorkshire*, Sheffield (City Polytechnic), 1976.

Betts, Ernest, *The Film Business. A History of British Cinema 1896-1972*, London (Allen and Unwin), 1973.

Bordwell, David, Janet Staiger and Kristin Thompson, *The Classical Hollywood Cinema. Film Style & Mode of Production to 1960*, London, Melbourne and Henley (Routledge & Kegan Paul), 1985.

Ceram, C.W., *Archeology of the Cinema*, London (Thames and Hudson), 1965.

Chanan, Michael, *The Dream that Kicks. The Prehistory and Early Years of Cinema in Britain*, London, Boston and Henley (Routledge & Kegan Paul), 1980.

Dupré la Tour, Claire, André Gaudreault and Roberta Pearson. *Le Cinéma au tournant du siècle*, Quebec/Lausanne (Editions Payot), 1999.

Ferreux, Huguette Marquand, *Musée du Cinéma Henri Langlois*; Paris (Maeght éditeur), 1991.

Fielding, Raymond, ed., *A Technological History of Motion Pictures and Television*, Berkeley, Los Angeles, London (University of California Press), 1967/1974.

Gaudreault, André, 'Theatralität, Narrativität und Trickästhetik. Eine Neubewertung der Filme von Georges Méliès', in *Georges Méliès Magier der Filmkunst*, KINtop 2, Jahrbuch zur Erforschung des frühen Film, Basel/Frankfurt am Main (Stroemfeld/Roter Stern), 1993.

Grenfell, David, *An Outline of British Film History 1896-1962*. London (BFI), s.a.

Hepworth, Cecil M., *Came the Dawn. Memories of a Film Pioneer*, London (Phoenix House), 1951.

Karney, Robyn- , ed., *Chronicle of the Cinema*, London/New York/Sydney/Moscow (Dorling Kindersley), 1995/1997.

Karney, Robyn, ed., *Cinema Year by Year, 1894-2004*, London/New York/Munich/Melbourne/Delhi, (Chronik Verlag/Dorling Kindersley), 1995/2004.

Lindgren, Ernest, *The Art of the Film. An Introduction to Film Appreciation*, London (George Allen and Unwin), 1948.

Loiperdinger, Martin, *Film & Schokolade, Stollwercks Geschäfte mit lebenden Bildern*, KINtop Schriften 4, Frankfurt am Main (Stroemfeld/Roter Stern), 1999.

Loiperdinger, Martin, *Lumière-Filme aus Deutschland, 1896-1897*, VCR attachment to *Film & Schokolade*, KINtop Schriften 4, Frankfurt am Main (Stroemfeld/Roter Stern), 1999.

Low, Rachel, and Roger Manvell, *The History of the British Film 1896-1906*. London (George Allen & Unwin), 1948.

Metz, Christian, *Film Language*. New York (Oxford University Press), 1974.

Oakley, C.A., *Where We Came In*. London (George Allen & Unwin), 1963.

Rickitt, Richard, *Special Effects. The History and Technique*, London (Aurumpress), 2006.

Sauvage, Léo, *L'affaire Lumière. Enquête sur les origines du cinéma*, Paris (Lherminier), 1985.

Slide, Anthony, *Aspects of American Film History Prior to 1920*, Metuchen NJ & London (Scarecrow Press), 1978.

Smith, Albert E.- with Phil A. Koury. *Two Reels and a Crank*. New York & London (Garland), 1985.

Sopocy, Martin, *James Williamson. Studies and Documents of a Pioneer of the Film Narrative*, Cranbury NJ/London/Ontario (Associated University Presses), 1998.

Talbot, F.A., *Moving Pictures, How They are Made and Worked*, London (Heineman), 1912.

Usai, Paolo Cherchi, *The Death of Cinema. History, Cultural Memory and the Digital Dark Age*, London (BFI Publishing), 2001.

Usai, Paolo Cherchi, *Burning Passions. An Introduction to the Study of Silent Cinema*, London (BFI Publishing), 1994.

Usai, Paolo Cherchi, *The Death of Cinema. History, Cultural Memory and the Digital Dark Age*, London (BFI Publishing), 2001.

Usai, Paolo Cherchi, *Silent Cinema. An Introduction*, London (BFI Publishing), 2000

Vries, Tjitte de, *Ingmar Bergman*, Amsterdam (IVIO-AO reeks), 1966.

Vries, Tjitte de, *Hollywood B-Films 1930-1940, a programme of 40 films in 10 genres from the Depression decade*, Film International Rotterdam, 1981

Vries, Tjitte de, and Ati Mul, *Speelfilmencyclopedie*, Leonard Maltin and Thys Ockersen, eds., Haarlem (Rostrum), 1982/1983.

Wagenknecht, Edward, *The Movies in the Age of Innocence*, Norman (University of Oklahoma Press), 1962.

Archive Material

8. Documentation

The following collection is the actual *Arthur Melbourne-Cooper Archive* of Tjitte de Vries & Ati Mul, Rotterdam, which is a combination of the archive material from the Audrey and Jan Wadowski estate and the De Vries-Mul archive. For a comprehensive account, see Tjitte de Vries: 'Arthur Melbourne-Cooper (1874-1961), a Documentation of sources concerning a British film pioneer', in: *KINtop, Jahrbuch zur Erforschung des Frühen Films*, Frankfurt am Main (Stroemfeld/Roter Stern), Autumn 2005.

Copies of recordings, manuscripts and other material from this archive were

donated to the Netherlands Filmmuseum, Amsterdam, the East Anglian Film Archive, Norwich, The City Museum, St Albans, and the British Film Institute, London.

- Eighteen contemporary documents, articles, reports and papers directly dealing with Cooper, from 1905 till 1915.
- Seventeen tape recorded interviews with Cooper (see Appendix 3).
- Two articles, one manuscript article 1960-1961 based on interviews with Cooper.
- Three obituaries of Cooper in 1961.
- 51 articles about Cooper and his Alpha Trading Company, from 1961 till 2004 in English newspapers, periodicals and magazines.
- 144 audio cassettes with interviews by Audrey Wadowska with former staff of Cooper and local people.
- 3000 letters: correspondence by Audrey Wadowska with persons of the film industry, archives, etc.
- 192 audio cassettes with interviews by Tjitte de Vries with Audrey Wadowska and others re. Melbourne-Cooper.
 NOTE. This collection has since been enlarged with several letters, articles and interviews with Mrs Ursula Messenger and others.

9. Recorded Interviews

- Audrey Wadowska interviews Arthur Melbourne-Cooper, Coton, 1956-1961 (11 tapes).
- Ernest Lindgren interviews Arthur Melbourne-Cooper, BBC, London, July 20, 1958.
- Bert Barker, British Fairground Society, interviews Arthur Melbourne-Cooper, London, August 1960.
- Audrey Wadowska interviews Bob Wilmott, uniformed commissionair Alpha Picture Palace, St Albans, and more than 150 other people, actors, actresses, local people, and people from the trade, 1959-1979 (144 cassettes).
- Kenneth Clark interviews Audrey Wadowska, London, 24 October 1978.
- David Cleveland interviews Audrey Wadowska, London, 19 December 1977, 11 October 1979 (4 cassettes).
- Tjitte de Vries interviews Audrey Wadowska, London/St Albans, 1975-1982 (81 cassettes).
- Tjitte de Vries interviews Ursula Messenger, née Melbourne-Cooper, Bognor Regis, 1975-1982 and 2000-2006 (24 cassettes).
- Tjitte de Vries interviews Kenneth Melbourne-Cooper, Burnley, 2 August 983 (2 cassettes).
- Tjitte de Vries interviews Jan Wadowski, London/St Albans, 1981-1995 (31 cassettes).
- Tjitte de Vries interviews local historians and other persons connected with the subject, London, St Albans, Barnet and elsewhere 1975-2007 (54 cassettes).

10. Contemporary Sources & Archive Catalogues

- R. W. Paul, *Animated Photograph Films*, List No. 15. London (R.W. Paul), August 1898.
- R. W. Paul, *Paul's Animatographs & Films*, London (R.W.Paul), 1901.
- R. W. Paul, *Animatograph Films*, London (R.W.Paul), 1902-1904.
- Warwick Trading Company Ltd., catalogues, London, 1898-1902, 1908-1909.
- Prestwich, *Price List of Cinematograph Films*, London, 1898.
- The Charles Urban Trading Co., Ltd., *Bioscope Films*, London/New York, 1903-1907 and 1908-1909.
- L. Gaumont, *Elgy Cinematograph Films*, catalogues, London/Paris, 1902-1908.
- Walturdaw (Walker, Turner & Dawson) Trading Company Ltd., catalogues, London, 1903-1912.
- W. F. Jury's, *Animated Photographs*, London, 1905-1907.
- W. Butcher & Sons Empire Films Ltd., catalogues, London, 1906-1907, 1911, 1912, 1913.
- Cricks & Martin/Cricks & Sharp, *Monthly Film Review*, London, 1906-1912.
- *The Kinematograph and Lantern Weekly*, 1908-1913.
- *Film House Record*, 1910.
- *The Bioscope*, 1911, 1912, 1913.
- *The Kine Monthly Film Record*, 1912-1913.
- *The Cinema*, 1913.
- Joan Fulford et al, *National Film Archive Catalogue, part II, Silent Non-Fiction Films 1895 1934*, London (BFI), 1960.
- Roger Holman et al, *National Film Archive Catalogue, part III, Silent Fiction Films 1895 1930*, London (BFI), 1966.
- Roger Holman et al, *Catalogue of Viewing Copies*, London (BFI), 1971.
- Ronald S. Magliozzi, *Treasures from the Film Archives. A catalog of short silent fiction films held by the FIAF archives*, Metuchen NJ & London (Scarecrow), 1988.
- Herbert Birett, *Das Filmangebot in Deutschland 1895 1911*, Munich (Filmbuchverlag Winterberg), 1991.
- Savada Elias, *The American Film Institute Catalog, Film Beginnings 1893 1910, Film Entries*, Metuchen, N.J. & London (Scarecrow), 1995.
- Savada Elias, *The American Film Institute Catalog, Film Beginnings 1893 1910, Indexes*, Metuchen, N.J. & London (Scarecrow), 1995.

11. Unpublished Manuscripts

The following manuscripts are in the Arthur Melbourne-Cooper Archive of Tjitte de Vries and Ati Mul, Rotterdam, and copies are stated.
- Acres, Alan B., *Frontiersman to Film-maker*, Southend, 2006. (Manuscript at the The Netherlands Filmmuseum, Amsterdam.)
- Aylott, David, *From Flicker Alley to Wardour Street*, London, 1949. (Copy of ms. at the BFI, London.)
- Clark, Kenneth, *More Movements in Animation. Pioneers of British Animated Films*. Manuscript, Watford. Forthcoming publication in 2010.
- Dixon, Luke, *Pioneers of the British Films, the Work of Birt Acres and Arthur Melbourne-Cooper*, Eastern Arts Association, 1977. (Indexed ms. at the City Museum, St. Albans, and BFI, London.)

- Grisdale, John, *Portrait in Celluloid*, 277 pages, Coton/St Albans, 1960 (based on interviews with Cooper, partly recorded. Indexed ms. at the City Museum, St. Albans, and BFI, London.)
- Heseltine, Claire, *The Forgotten Visionary, The Life and Work of Arthur Melbourne-Cooper, Film Pioneer From 1892 to 1914,* Shenley, s.a.
- Lange-Fuchs, Hauke, *Birt Acres Annotated Filmgraphy*, manuscript, Kiel 2003.
- Vries, Tjitte de, *Arthur Melbourne-Cooper. The first International Film Author.* Script for a documentary film submitted to Stichting Fonds voor de Nederlandse Film. Manuscript, 1993.
- Swinson, Arthur, *Draft of Magazine Article*, Coton/St Albans, 1956 (based on interview with Cooper).
- Wadowska, Audrey Kathleen, *Arthur Melbourne-Cooper, List of Films,* manuscript, St Albans, 1981.

Photo & illustration credits

Title page: pen&ink drawing Arthur Melbourne-Cooper by Theo Gootjes.
Illustration St Adelbert Abbey by Bert Hof: page 21.
Photographs Arthur Melbourne-Cooper: nrs. 31, 33, 49, 60.
Photographs Jan Wadowski: nrs. 4, 11, 13, 17, 30, 38, 39, 41, 68, 98.
Photo reproductions Jan Wadowski: nrs. 9, 19, 22, 99.
Photographs Tjitte de Vries: photo page 19 and nrs. 10, 15, 20, 28, 36, 37, 42, 43, 44, 47, 48, 51, 52, 55, 61, 62, 63, 69, 70, 76, 107.
Photo reproductions Tjitte de Vries: nrs. 2, 3, 8, 12, 14, 21, 23, 24, 25, 29, 34, 45, 46, 53, 54, 56, 64, 65, 66, 67, 71, 72, 74, 75, 78, 79, 80, 81, 86, 87, 88, 89, 90, 91, 92, 93, 94, 95, 96, 97, 100, 101, 102, 103, 105, 106.
Photographs: Birt Acres: nr. 7.
Photographs Thomas Cooper: nrs. 6, 50.
Photographs Audrey Wadowska collection: nr. 26, 32, 109.
Photographs Kenneth Melbourne-Cooper: nr. 104.
Netherlands Filmmuseum photo-scans: cover and nrs. 27, 82, 83, 84, 85.
Richard Rigby (The Magic Lantern Society): nrs. 57, 58, 59.
Photographs NFA: nrs. 18.
Photoreproductions Kodak Museum: nrs. 73, 76.
Alfred Ellis: nr. 5.
William H. Cox: nr. 40.
Photocopy local library: The Times: 16.
British Library Newspapers, Colindale, London digital scan: 35.

B&W photographs and reproductions were developed and printed by Hans Olsson, Rotterdam.

Note:
Indemnity of copyrights of all her father's material, photographs and films was granted by Mrs Ursula Messenger to the Netherlands Film Museum and to the authors in connection with this publication.

List of All Animation Film Titles in Part Two – Filmography

incl. alternative, reissue and distribution titles

General Index of Part One

Index of Film Titles

Index of Names and Affairs